Claude Monet, *Water Garden at Giverny*, c. 1904. Oil on canvas (35½" x 36¼"). Louvre, Paris.

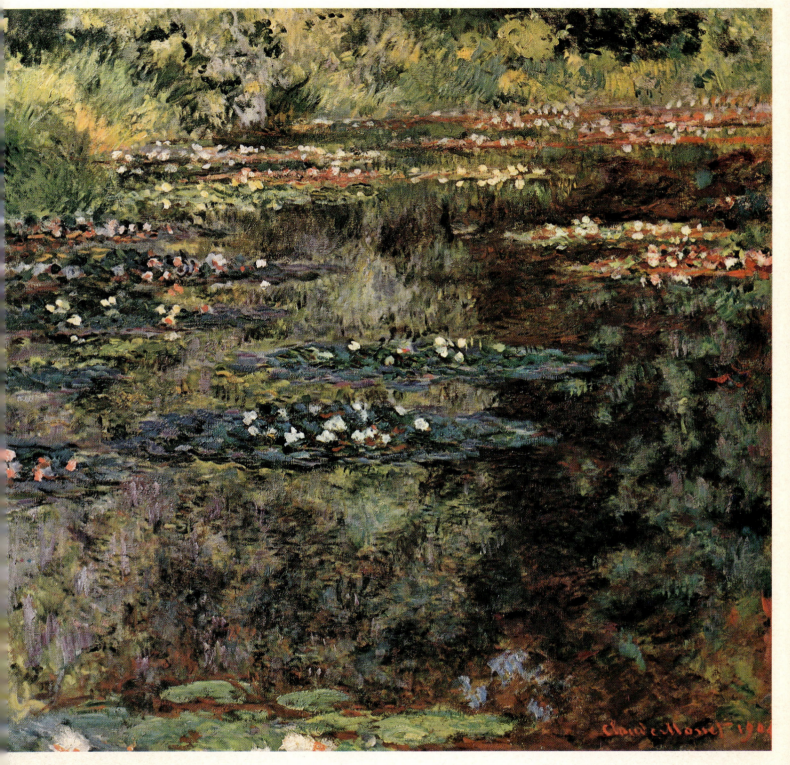

Art in Perspective:
A Brief History

ART IN PERSPECTIVE

A BRIEF HISTORY

HENRI DORRA University of California
Santa Barbara

HARCOURT BRACE JOVANOVICH, INC.
New York Chicago San Francisco Atlanta

Photo credits and acknowledgments on p. xiii

ISBN: 0-15-503475-8

Library of Congress Catalog Card Number: 72-85637

Printed and bound in Italy by Mondadori Editore, Verona.

for
Aimée
Mary
Amy
Helen

Preface

To encourage the student to look, to teach him to analyze style and expressive content, to acquaint him with some major monuments and to point out their relationship to cultural trends— these should be the aims of a first course in art history, and they are the goals of this book.

There are already several very good general art surveys that cover a large number of works of art, describing in a few lines the principal characteristics and historical significance of each. These books condense a vast amount of information, organize it in a systematic way, and present it engagingly. Their very thorough historical coverage, however, precludes a consistent concentration on the analytical approach that is so essential to future art historians and that can be so challenging to students in other fields.

There are also a number of books designed to teach the student to look at works of art analytically, without attempting to trace historical developments. Useful as they are, they cannot deal with subtleties of stylistic analysis that have significance only in historical context. The fact that an arm is foreshortened, for instance, is of little importance in itself, but it becomes enormously significant when one realizes that it marks the beginning of a rational utilization of space that in turn opens up possibilities hitherto unexplored by artists.

This book attempts to combine both aims: to establish the framework of an historical development and to analyze in some depth a substantial number of works of art. In order to render the analyses as lucid as possible, much use is made of comparison. Works that lend themselves particularly well to comparison have been chosen for discussion and illustration, and unusual care has gone into the placement of illustrations in relation to the text and to one another. Wherever possible, illustrations to be compared are placed side by side, even though one may belong to a considerably earlier or later period than the other. Full-color plates as well as black-and-white illustrations appear with their text discussions instead of being grouped separately, and illustrations are often repeated in later chapters to facilitate comparison. In addition, a systematic attempt has been made to relate the works of art to their times. Each chapter begins with a sketch of the political and social developments of the period, and as far as possible the content of the works of art themselves is related to broad cultural trends.

Sacrifices have had to be made. In the first place, by far the largest part of the book has been devoted to the history of the art of the West, and even within this limitation few attempts have been made to show that various developments have taken place simultaneously in different areas. The arts of Africa, Central and South America, and the Far East are taken up in the last section and are represented by examples that are intended to serve as bases of comparison with Western art rather than to suggest any kind of historical development.

In the second place, even within the

areas that are explored, only a relatively small number of monuments in each period could be dealt with. Discussing the statue of King Chephren and not the great pyramids of Gizeh, or dwelling on van Eyck and not mentioning van der Weyden, will seem totally arbitrary. Agonizing choices had to be made to keep the length of the work within reasonable limits. Classroom lectures can complement the text with analyses of examples carefully related to those in the book, however, and suggestions for such lectures are given in the accompanying Instructor's Manual. Or the instructor may wish to teach a detailed and comprehensive survey in the classroom and rely on the book for a more analytical approach; a sufficient number of suitable examples is given in the Instructor's Manual to make this possible.

Whatever technique the instructor may wish to adopt, it is hoped that the text will convey a little of the sense of excitement which we can all experience in the presence of great art.

The author wishes to express his appreciation to those of his colleagues whose advice he has sought. He would particularly like to thank the following, who read and commented on specific chapters: Professors Madeline H. Caviness of Wellesley College; Herbert M. Cole of the University of California, Santa Barbara; George Heard Hamilton, Director, Sterling and Francine Clark Art Institute, Williamstown, Massachusetts; George M. A. Hanfmann of Harvard University; Martin Lerner, Vice Chairman in charge of Far Eastern Art, Metropolitan Museum of Art; John R. Martin of Princeton University; Prudence R. Myer, Alfred K. Moir, Peter Meller, and David Gebhard of the University of California, Santa Barbara; and Kathleen Morand of Queens University, Ontario. He is also much indebted to Professor Larry M. Ayres, Mario A. Del Chiaro, and Joachim Remak of the University of California, Santa Barbara; Professor H. Arnold Barton of Southern Illinois University, Carbondale; and Professor Jean S. Weisz of the University of California, Los Angeles, for their valuable suggestions.

To Nina Gunzenhauser and Merton H. Rapp, editors in the College Department of Harcourt Brace Jovanovich, who have provided much encouragement and displayed great patience, and to Jeremiah Lighter and Elizabeth Early, who are responsible for the handsome appearance of the book, goes the author's most sincere appreciation. He would also like to express his heartfelt thanks to Dr. Hope B. Werness, who assisted him for two years, and to Sandra E. Knudsen, who helped with the final stages. And to his wife goes his affectionate gratitude for her constant support.

HENRI DORRA

Contents

PHOTO CREDITS AND ACKNOWLEDGMENTS

7 Hans Hinz **19–8** Hans Namuth **19–9** Estate of Kurt Schwitters, courtesy Marlborough Gallery, New York **19–10** Lent by the Edwin Janss Collection, California. Photograph courtesy Los Angeles County Museum of Art. **19–11** *Left:* Locksley/Shea Gallery, Minneapolis. *Right:* Collection of Kimiko and John Powers, Aspen, Colorado **19–12** Photograph courtesy of Los Angeles County Museum of Art **19–13** The Museum of Modern Art, New York **19–14** *Left:* Howard Wise Gallery, New York. *Right:* Tel Aviv Museum **19–15** David Gahr **19–16** Fourcade, Droll, Inc. **19–17** National Collection of Fine Arts, Smithsonian Institution, Washington, D.C. **19–18** Whitney Museum of American Art **19–19** Boeing Company

Chapter 20

20–1 Photograph Nigerian Museum **20–2** Reprinted from *African Arts,* Vol. II, No. 3. Photograph by Nancy Gaylord Thompson. **20–3** Frank Willett **20–4** The American Museum of Natural History **20–5** Courtesy of the Art Institute of Chicago **20–6** Pascal James Imperato, M.D. **20–7** Private Collection, Santa Barbara, California **20–8** Armistead P. Rood **20–9** From *Peruvian Archaeology,* by Rowe and Menzel. Reprinted by permission of Peek Publications, Palo Alto, California. **20–10** From collections of the University Museum of the University of Pennsylvania **20–11** Museo Nacional de Antropologia, Mexico, D.F. **20–12** Reprinted from *The Ancient Maya,* Third Edition, by Sylvanus G. Morley, revised by George W. Brainerd, with the permission of

the publishers, Stanford University Press. Copyright Ⓒ 1946, 1947, 1956, by the Board of Trustees of the Leland Stanford Junior University. Courtesy Stanford University Press. **20–13** Museo Nacional de Antropologia, Mexico, D.F. **20–14** Museo Nacional de Antropologia, Mexico, D.F.

Chapter 21

21–1 Norton Gallery and School of Art, West Palm Beach, Florida **21–2** Archaeological Survey of India **21–3** Archaeological Survey of India **21–4** Archaeological Survey of India **21–5** Private Collection, New York. Photograph by Charles F. Uht **21–6** Collection of the National Palace Museum, Taipei, Taiwan, Republic of China **21–7** Courtesy of the Fogg Art Museum, Harvard University. Charles A. Loeser Bequest. **21–8** Courtesy, Museum of Fine Arts, Boston **21–9** Courtesy, Museum of Fine Arts, Boston

DRAWINGS AND DIAGRAMS
Fig. 1–9 Copyright Hirmer Fotoarchiv, Munich **Fig.** 2–17 Reproduced by permission of the publisher from *Art: An Introduction,* First Edition, by Dale G. Cleaver, Ⓒ 1966 by Harcourt Brace Jovanovich, Inc. **Fig.** 3–13 Reproduced by permission of the publisher from *Art: An Introduction,* First Edition, by Dale G. Cleaver, Ⓒ 1966 by Harcourt Brace Jovanovich, Inc. **Fig.** 3–14 From *The Architecture of the Roman Empire,* Vol. I, by William L. MacDonald, Yale University Press, 1965, Fig. 10, p. 106. **Figs.** 4–4 and 4–5 Based on p. 200 A and

B of Sir Banister Fletcher's *History of Architecture on the Comparative Method,* Seventeenth Edition, revised by R. A. Cordingley, Athlone Press of the University of London, 1961. **Fig.** 4–7 Reprinted by permission of Revista di Archeologia Christiana, from *Early Christian and Byzantine Architecture,* by R. Krautheimer, Penguin Books, Baltimore, 1965, Fig. 8, p. 25. **Fig.** 5–7 Reproduced by permission of the publisher from *Art Through the Ages,* Fifth Edition, by Helen Gardner, edited by Horst de la Croix and Richard G. Tansey, Ⓒ 1970 by Harcourt Brace Jovanovich, Inc. **Fig.** 5–9 Reproduced by permission of the publisher from *Art Through the Ages,* Fifth Edition, by Helen Gardner, edited by Horst de la Croix and Richard G. Tansey, Ⓒ 1970 by Harcourt Brace Jovanovich, Inc. **Fig.** 6–3 After Beseler **Fig.** 6–6 Reproduced by permission of the publisher from *Art Through the Ages,* Fifth Edition, by Helen Gardner, edited by Horst de la Croix and Richard G. Tansey, Ⓒ 1970 by Harcourt Brace Jovanovich, Inc. **Fig.** 8–9 Reproduced by permission of the publisher from *Art: An Introduction,* First Edition, by Dale G. Cleaver, Ⓒ 1966 by Harcourt Brace Jovanovich, Inc. **Fig.** 9–14 Reproduced by permission of the publisher from *Art: An Introduction,* First Edition, by Dale G. Cleaver, Ⓒ 1966 by Harcourt Brace Jovanovich, Inc. **Fig.** 16–17 By permission of the Frank Lloyd Wright Foundation. Copyright 1942, Ⓒ 1970 by the Frank Lloyd Wright Foundation. **Fig.** 18–6 Reproduced by permission of the publisher from *Space, Time and Architecture,* Fifth Edition, by S. Giedion, Harvard University Press, 1967.

Introduction

Of all the attempts that have been made to define art, perhaps the most appealing as well as the most easily defensible is that art is an intensification of life. From the earliest known artists—the prehistoric cave painters whose pictures of roaming herds must have stood for the forces of the universe as well as for the staple of their daily existence—to the artists of the last two centuries, whose adventurous experimentation reflects an exhilarating sense of the freedom of the human spirit, man has been using artistic expression to affirm and give meaning to his life. As his needs and ideals changed, the characteristic forms and expressive message of his art reflected those changes, so that our immense artistic heritage reveals vividly, accurately, and often with a considerable degree of intimacy what man's aspirations were and how he has viewed himself and his place in the cosmos. The study of art history is thus the study of man through the evolution of his ideals just as much as through the development of his artistic techniques and styles.

Our purposes in this book will be to discover what has shaped the artist's vision and to examine how the various means he has used to convey that vision have evolved over the years. One of the most useful methods available to us for that purpose is comparison. When we compare and contrast similar works from diverse periods or cultures, or works by various artists of one period and even by one artist at several periods in his life, significant differences emerge that enable us to make observations about the manner and intent of the artist, to trace meaningful patterns of development in art down through the ages, and to recognize and appreciate the features that distinguish great works of art.

To illustrate what kinds of things such comparisons can reveal, let us look at two works of art separated in time by almost two thousand years: the geometric border of a Roman *mosaic*, a design made of small colored stones embedded in mortar, that formed part of the floor of a house in Pompeii, Italy and that dates from the first century A.D. (Fig. 0–1); and

a painting executed in 1967 by the contemporary American artist Frank Stella (b. 1936), *Island No. 10* (Fig. 0–2).

At first glance, we are struck by the remarkable similarities between the two works. Both have square configurations, both are made up of series of parallel bands that create strong diagonal accents, and both are essentially regular. (The similarity of size in the illustrations distorts the facts, of course; the floor mosaic is considerably larger than the 4'7" square painting.

In *Island No. 10,* however, wide green bands are separated by thin black lines forming squares, while in the mosaic border black and white bands of equal width form an angular dovetailing pattern. These differences reflect in part a difference in *decorative intent*. The Stella work achieves a strong visual impression through great economy of means. The artist has created a repetitive pattern using only enough geometric elements so that one cannot count them at a glance, and the green color provides a strong dominant feature. In contrast, the Roman

1

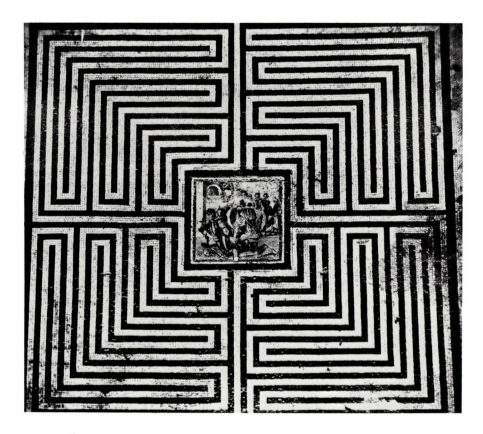

0–1 Floor mosaic, first century A.D.; marble. House of the Labyrinth, Pompeii. The center panel represents Theseus slaying the Minotaur.

artist used enough geometric elements to fill the area with a complex pattern. No single element dominates; instead, the design reveals a concern for an intricate relationship of the parts and the whole, as well as an interest in the balance of contrasting elements.

The decorative intent in a work of art is revealed not only in the arrangement of forms, or *composition* of the work, but in the materials and techniques employed in its execution—what is known as *surface treatment*. The mosaic, made up of variegated fragments of colored stone, creates a rich surface effect that is pleasing in itself and appropriate to the materials used in the construction and decoration of the entire room. The execution of the Stella is equally telling. The use of pre-dyed canvas and small, even brush strokes results in an overall blandness fully in keeping with the effect intended by the artist: "It had the nice dead kind of color I wanted," wrote Stella of the commercial paint he used. It is as if he cared little about subtleties of surface treatment, re-

lying instead on the impact of the dominant color and of the simple repetitive pattern.

Both composition and execution are intricately related to a third aspect essential to the analysis of a work of art, the *expressive intent*. What is the meaning—intellectual, emotional, or both—of the work? How does it affect us? In part, the appeal of both the Roman mosaic and the Stella painting derives from a striving for superior harmony that man has associated with simple geometric forms from time immemorial. Beyond that, however, they suggest two quite different kinds of expression. Neither the geometric border of the mosaic nor the painting can be considered *representational*—that is, neither truly depicts a physical object. The Roman mosaic, however, clearly alludes to the subject of the central panel, the legend of Theseus and the Minotaur (Fig. 0–1). The Minotaur was a monstrous creature, half-bull and half-man, to whom ancient Athens was forced to send a yearly sacrificial tribute of fourteen maidens and

0–2 Frank Stella, *Island No. 10* (black sketch), 1967. Fluorescent alkyd on vat-dyed canvas (4′ 7″ × 4′ 7″). Collection of Mr. and Mrs. Robert Kardon.

fourteen youths. The young people were kept in a labyrinth, a complex maze from which they could not escape. The Athenian hero Theseus entered the labyrinth, unwinding a ball of thread as he went, found and slew the Minotaur, and led the captives out of the maze by following the thread. When we look closely at the geometric border, we see that the white bands form a continuous strip starting in the middle of the top side and ending against the upper side of the inner panel (the outer edge at the bottom was damaged and is missing), thereby suggesting the convolutions of the original labyrinth.

Obviously, for such an allusion to have significance the viewer must be familiar with the story, which was well known in ancient Rome. The interpretation of subject matter in relation to the traditions and legends to which it refers clearly plays an important part in our understanding and appreciation of a work of art. Where figures are represented and their psychological states are expressed, a further dimension is added by the play of emotions with which we tend to empathize. The combination of subject matter and emotional message is known as *content.*

Like the geometric border, the Stella painting is *nonrepresentational,* or *abstract.* But here there are not even allegorical overtones. Instead, the artist has focused on a play of *perceptual effects,* developing with a new degree of sophistication a feature that is far less in evidence in the Roman work: a deliberate manipulation of the viewer's perceptual faculties (those faculties that enable us to integrate our sensations of the external world into coherent and meaningful relationships). The impact of this work in fact depends on the peculiarities of our perceptual response. We are so accustomed to interpreting images as having three dimensions that we instinctively try to see in the work something more than a flat design. We try to interpret it as a stepped pyramidal shape, but we are frustrated by the fact that the shape is ambiguous: is the smallest square closest to us or farthest

away? This kind of play with perceptual phenomena has become characteristic of a number of developments in the twentieth century.

If perceptual effects are not central to the artistic impact of the Roman mosaic, as they are in the case of the Stella, they are nevertheless present. The overall impression created by the mosaic depends to some extent on *optical illusionism.* Seen at close range, the design is made up of a variegated pattern of irregular stones; seen from the height of a standing person, the irregularity of the elements is ignored because of the smallness of the angle of vision, so that the viewer experiences the illusion of a rigorous and precise geometric pattern. Of course, illusionism is present to a greater or lesser degree in all two-dimensional pictures representing three-dimensional figures or objects, such as the scene in the central panel (Fig. 0–1), in which the play of shadows and the overlapping of the figures suggest volume and space to our eyes. The emphasis placed on the illusion of three-

dimensionality and the ways that have been devised to create it will be one of our concerns in tracing the developments in art history from prehistoric times to the present.

Comparing works in this manner, we find evolving the concept of *style,* similarities and differences in the arrangement of forms, colors, and technical practices that enable us to identify a work as belonging to a particular period or place or as having been executed by a particular artist. We will also become familiar with the way in which each period, and individual artists within that period, handled the content of a work of art. And we will begin to recognize those factors that please, move, or inspire us in a work of art—or more accurately, that combination of factors. For ultimately the effect of a work of art does not depend on any one element, whether an illusionistic phenomenon or a particular arrangement of forms. It certainly does not depend exclusively on the choice of subject matter or the expressive intent of the artist, nor can

it be related uniquely to the effective evocation of the taste or the intellectual or emotional climate of a period. Rather, we respond to the whole work, the sum of the appeal and suggestiveness of its organization of forms and execution, its ability to evoke the ideals of a time, and the originality, spontaneity, and emotional intensity of the artist's vision.

I

Prehistory and Antiquity

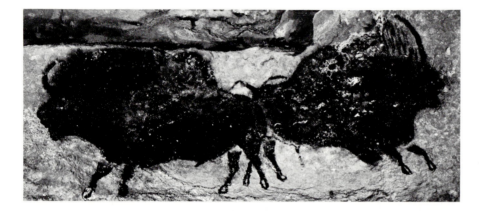

1-1 Two bison painted on wall of cave of Lascaux, France, c. 15,000–10,000 B.C. (total width 8′).

1-2 Detail of hunting scene, temple of Sahura, Abu Ṣîr, Egypt, Fifth Dynasty, c. 2480–2340 B.C.; painted stone. Berlin Museum (*comparative illustration*).

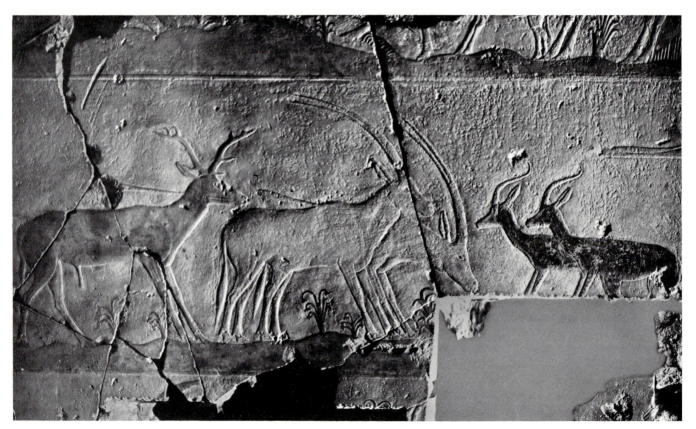

1

Prehistory and the Ancient Near East

One day in 1870 a Spanish nobleman and his small daughter entered a previously unexplored part of the cave of Altamira, near Santander in northern Spain. The girl looked up toward the ceiling and exclaimed *Toros!* ("Bulls!"). She had before her eyes a remarkable painting of a herd of wild bison, in a perfect state of preservation, dating from the late Paleolithic era, from 30,000 to 10,000 B.C., corresponding roughly to the end of the last ice age.

At first the scientific world was skeptical of the discovery. Until that day, the only Paleolithic artifacts that had been uncovered were roughly carved bones and stones. The figures of Altamira were startlingly more massive, colorful, and lifelike than any known representations of that period. During the next two decades, however, other caves with similar paintings, executed in earth colors and sometimes incised as well, were discovered in northern Spain and in southern France. It became clear that there had been numerous artists of considerable skill among

the hunters of the late Paleolithic era.

The more recently discovered cave of Lascaux, in southwestern France, has yielded what are probably the finest examples of cave paintings known to date. We can partially understand the initial skepticism about the authenticity of Paleolithic paintings if we compare two figures of bison from this cave (Fig. 1–1) with a work known to have been executed thousands of years later, during the early historic period (the period that began with the invention of writing around 3000 B.C.). This is a hunting scene from the temple of Sahura at Abu Ṣîr, Egypt, dating from around 2480 to 2340 B.C. (Fig. 1–2).

The Egyptian work is a painted stone relief—that is, the artist shaped the figures on a flat surface by carving out the area between them, so that they seem to be embossed on a flat background, and then painted the surface. The rendering of animals here appears much more conventional and static in comparison to the cave art. Ironically, the prehistoric bison are

much closer to the naturalistic ideals of recent times.

In the Egyptian work, the two neat rows of animals rest on a ground line, which, although it undulates and sprouts a few plants, is basically horizontal. The carving around them is shallow—that is, the animals are in low relief. Their bodies are shown essentially in profile against a neutral background, as if they had been compressed between two vertical planes, a device characteristic of relief carvings and paintings of the great cultures of the ancient Near East.

Furthermore, although the artist was obviously familiar with the anatomy of these animals, he seems deliberately to have *stylized* their appearance: he rendered them with utmost simplicity and economy, suggesting only their more characteristic features, and frequently rendering these in near-geometric lines. Moreover, although the scene (of which Figure 1–2 is only a detail) depicts a violent incident (a deer and an ibex have been hit by arrows), the animals are calm

and composed. The repetition of their forms, one after another, suggests a solemn procession. Like many figures in Egyptian art, as we shall see later in this chapter, they seem to be performing an elaborate sacred ritual.

By comparison, the prehistoric bison appear fully rounded and free to roam in space. Indeed, they seem to be rushing forward diagonally at some speed. Their anatomical details are rendered more naturalistically than are those of the Egyptian relief; we are much more aware of the activity of their musculature and of the patterning as well as the hairiness of their coats. Finally, both the angle of the legs of the bison and the swift rhythms of the repeated curves of their outlines evoke the thunderous motion of their massive bodies: they are incomparably livelier than the Egyptian animals.

There are representational inconsistencies in both works. In the Egyptian relief, the horns of the animals are not all rendered in strict profile as their bodies are; the deer's antlers make a V over its head as if seen from the front and not from the side. In his effort to represent the most characteristic aspects of each animal, the Egyptian artist seems to have disregarded what we would now call the correct relationship of forms. The prehistoric artist, for his part, showed the horns of the bison correctly in relation to the body, but the hoofs are turned toward the spectator. Clearly, neither artist based his work on direct observation; both relied to a considerable degree on memory, tradition, and accepted conventions. The

Lascaux artist, however, was more conscious of the life and motion of his subject, whereas the Egyptian was more dependent on rigorous rules.

Although the bison in the Lascaux painting seem well proportioned, it is difficult to gauge proportions with exactness. The two animals seem to be lunging forward at an angle to the *picture plane* (or the physical surface of the picture), but we cannot estimate this angle with any precision because there is no point of reference. Paleolithic artists did not suggest a ground line or ground plane, so that we cannot determine the true position of the animals in space, let alone the exact relationships of heights and lengths.

The Egyptian artist, on the other hand, had a consuming interest in precise measurement. The figures are not only parallel to the picture plane; they are also clearly related to the horizontal line on which they stand and to the vertical lines terminating the scene at each end. Within this set of coordinates, the artist has carefully proportioned the various parts of the figures, making use of codified rules that owed much to artistic precedent and something to the observation of nature. For all that surprises us in the stylized handling of form by Egyptian artists, such as antlers in front view combined with heads in profile, the artist's reliance on measurement represents a significant attempt to systematize man's observation of his environment, an attempt that was to have an important influence on the art of later centuries.

But the ice-age artists achieved an impression of spontaneity, immediacy, and energy that has been matched only by the very greatest artists of later periods. The Paleolithic artist most often depicted the herds that roamed the regions of Europe that had been spared by the ice caps—bison, deer, wild horses, ibexes, and other animals. There are very few representations of human beings, and these are usually much more stylized than the paintings of animals. Abstract semi-geometric designs are also frequently found, however, and their presence seems to indicate that the cave paintings were not executed for esthetic enjoyment alone but served a religious purpose. Unfortunately, very little is known about the religious beliefs of Paleolithic man and no satisfactory explanation has been given for the numerous representations of wild herds. We can only assume that the awesome feeling one experiences when looking at these lively and powerful animals as they seem to emerge from the walls of the dimly lit caves was also experienced by our prehistoric ancestors; it may well be that the artist was suggesting the forces of the universe by trying to capture in his painting the vitality of the animals with which he was most familiar.

Man's life changed wondrously in the seven or so millennia separating the late Paleolithic and the early historic periods in the Near East. Around 10,000 B.C., he took up animal husbandry and around 9000 to 7000 B.C., at the beginning of what is known as the Neolithic period, he began to cultivate the land. In the

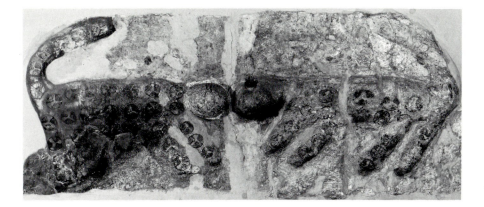

1-3 Leopard shrine, Çatal Hüyük, Turkey, c. 6000 B.C. Painted plaster (approx. 6' long). Copy at Ankara Archaeological Museum.

more fertile areas, population began to concentrate in villages of mudbrick houses. Economic forces and the need for organized defense led gradually to the appearance of cities with massive masonry structures and eventually to the sizable metropolises that sprang up in Mesopotamia and Egypt during the early historic period.

A major archeological discovery made a few years ago in southern Turkey has brought to light an important Neolithic link between Paleolithic culture and the early historic civilizations of Mesopotamia and Egypt. Excavations at Çatal Hüyük have uncovered numerous levels of habitation dating from around 6500 to 5500 B.C. The mudbrick houses of these villages are decorated with paintings and sculpture, the first instance known of works of art on manmade walls.

The painted plaster relief of two leopards shown in Figure 1–3 was found in a shrine in one of the houses. It dates from around 6000 B.C. Numerous applications of white plaster and paint had been made over the original relief, but these have been peeled off, one by one, down to a well-preserved early layer (shown here in a copy). Little of the lifelike quality and spontaneity of the Lascaux paintings is to be found here. The leopards have touches of naturalism in their characteristic shapes, in the painted eyes, mouths, and claws, and in the rosettes on the bodies, which are fairly close to the actual markings of leopards. But these animals show a much higher degree of stylization than do those at

Lascaux. The forms have been reduced to essentials. Furthermore, the parallelism in the legs of each animal, the ovoid forms of the heads, and the symmetry of the composition—the so-called *heraldic opposition,* in which two animals face each other across a vertical axis—introduce a semigeometric order. Even the spots are arranged in an abstract, nearly geometric pattern.

As in Egyptian art, the animals are in profile (although the legs on the far side have been offset in relation to the legs on the near side to make them visible), and they appear to have been flattened somewhat between two vertical planes. They are defined by outlines that are almost geometric in their simplicity. The resultant stylized and static forms derive from a *formalistic* approach—an adherence to prescribed, often neargeometric forms—which was to become characteristic of the historic cultures of the Near East.

Archeologists have surmised that the two leopards are attributes of a mother goddess who was a symbol of fertility. If this is so, the leopards' depiction in heraldic opposition may well suggest a belief in superior, orderly forces governing animal and human life—a notion that announces the belief in a cosmic order that was to be characteristic of Egyptian and Mesopotamian concepts of the universe.

Great changes occurred between the seventh millennium B.C. and the advent of the Bronze Age toward the end of the fourth millennium B.C. The invention of pottery, spinning, and weaving provided

a whole new range of creature comforts. With the smelting of copper and tin at the end of this period, man acquired efficient tools and arms and armor. The most momentous advance of all, the development of writing, may well have led to the appearance of the great civilizations of the historic period in Mesopotamia and Egypt. By 3000 B.C. the valleys of the Tigris and Euphrates rivers in Mesopotamia supported a number of city-states governed by local rulers. All were fortified and all had effective armies. At the same time in Egypt, the whole valley of the Nile was unified under a single divine king who controlled the clergy, ruled through a highly organized aristocracy, and commanded powerful armed forces. In both areas the first monumental sculptures that we know of date from this period.

The Egyptian statue in Figures 1–4 and 1–5 was executed around 2500 B.C. in diorite, one of the hardest and most difficult stones to carve. It is an effigy of King (or Pharaoh) Chephren. (The word "pharaoh" originally meant "royal palace" or "great house," before it became the title of the Egyptian rulers.) The period from which the statue dates was a time of extraordinary achievement in Egypt. In the space of a few centuries, the Egyptians produced a considerable literature that codified their religious beliefs and rules of government, but it was especially in geometry and applied mechanics that they excelled. Indeed, the Fourth Dynasty, to which Chephren belonged, witnessed the culmination of a gigantic program of

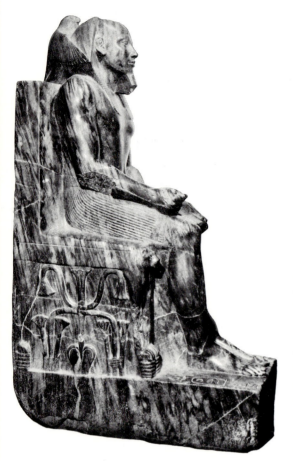

1-4 *King Chephren,* from Gizeh, c. 2500 B.C. Diorite (5′6″ high). Egyptian Museum, Cairo.

1-5 Detail of statue of King Chephren

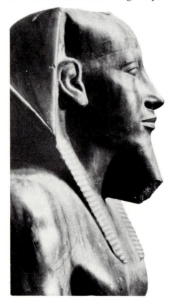

public works initiated by earlier rulers, ranging from elaborate irrigation schemes in the valley and delta of the Nile to massive burial places for the pharaohs, including the three gigantic pyramids and the monumental sphinx of Gizeh near Cairo. Chephren, who was buried in the second of the three great pyramids, had this statue erected in a small funerary temple nearby.

The two diorite fragments represented in Figures 1–6 and 1–7 are parts of statues of Gudea, a ruler of the Mesopotamian city-state of Lagash (now Telloh in Iraq) who lived around 2150 B.C. The area had been overrun by invaders at that time, but Lagash seems to have maintained its independence and to have preserved the original Sumerian civilization of the area—hence the name neo-Sumerian for the culture of Gudea's time.

The Egyptian and neo-Sumerian statues have important similarities. Although the Egyptian statue is larger than life size and the Mesopotamian examples are only half as big, they all convey a sense of monumentality through the massiveness of the forms and elimination of detail. As if to preserve the integrity of the stone, Egyptian and Mesopotamian sculptors cut into it as little as possible, keeping the limbs of the figures close to the central mass and preserving the material between the arms and the bodies and between the legs and the cube-like seats.

Both the Egyptian and the neo-Sumerian statues reveal a definite formalism. The figures are shown in a strictly frontal position, and the attitudes reflect

a great concern for symmetry. In all three works, moreover, the artists strove for a considerable degree of stylization: there is a sense of geometric order in the patterns of the muscles emerging through the smooth surface enveloping the bodies and a rhythmic regularity in the treatment of garments and accessories. Furthermore, both the Mesopotamian and the Egyptian works are generalized; they depict a type, and only the subtlest details suggest individual personalities. Yet in spite of these formalistic elements, the figures all seem intensely alive. The treatment of the muscles suggests magnificently both the tensions and the resilience of the bodies, while the expressions of the eyes and mouths convey a sense of spiritual power and energy.

The Egyptian and the Mesopotamian artists determined the proportions of the body according to sets of rules that had been evolving since early historic times, and it is evident that the rules of these two regions reveal very different physical and spiritual ideals. Portly, energetic, and endowed with a powerful physique, Gudea has some of the characteristics of well-fed burghers of all times; the neo-Sumerian tradition had obviously been established by artists with a keen eye for the proportions encountered in everyday life. The statue of Chephren, on the other hand, is much more idealized, and there is a stress on the graceful elongation of the limbs and a balanced musculature typical of a new aristocratic-athletic ideal. The Egyptian rules, incidentally, seem to have become codified during the Fourth

Dynasty and were transmitted, practically unchanged, through the subsequent two thousand years of Egyptian history. Similar but ever more refined standards of physical beauty appeared in Greek sculpture of the Classical period, and eventually affected the taste of Western man right up to our time.

There is another major difference between the neo-Sumerian and Egyptian compositions. We have seen that Egyptian artists were greatly concerned with precise measurement, and in keeping with tradition the Chephren statue is carved from carefully drawn designs on four sides of the original rectangular block of stone. This *four-square* approach may help account for a certain angularity in Egyptian composition. In the Mesopotamian works, on the other hand, the artists seem to have concentrated on the roundness of every form and of the figure as a whole.

The treatment of Gudea reflects in places a purely decorative stylization. This is especially apparent in the way the musculature of the forearms has been interpreted as continuous ridges, the way the large eyes form sphere-like bulges, the way the eyebrows have been made into twin arcs and the corners of the mouth upturned, and the way the simple and elegant regularity of the folds of the drapery has been stressed. In the Egyptian work the elements of purely decorative stylization are more limited. To be sure, the eyelids and the outline of the mouth, for instance, have been treated with nearly geometric precision, and the pleated garments are handled with almost mechani-

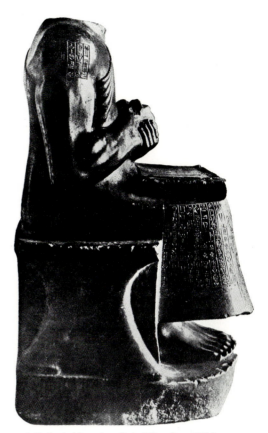

1-6 *Gudea,* holding plan of a building, from Telloh, c. 2150 B.C. Diorite (29″ high). Louvre, Paris.

cal regularity. Yet there is much greater evidence of perceptive observation in the modeling of the flesh, particularly in such details as the cheeks and the ears.

It is in their expressive content that the sculptures differ most. The lofty proportions of the body, the controlled tension of the musculature, and even the sense of permanence evoked by the precise treatment of the extremely hard material of the pharaoh's statue all suggest his exalted place in the Egyptian cosmos. Religious myths had for ancient man a much more literal significance than they have for us today, and to his subjects the pharaoh was in fact the son of Rē, the sun god and chief deity of the Egyptian pantheon. Majestic, powerful, and awesomely static in his attitude, he was a living embodiment of the immutable and eternal laws that control the universe and human life—laws that seem to have reflected the orderly rhythm of seasonal changes in Egypt. Indeed, he is shown here under the protection of the falcon representing Horus, the god of the sky and of astral bodies.

The pharaoh was also a leader of men, a "smasher of foreheads" according to a later inscription, as well as "a master of graciousness" who "conquers by love." Clearly the human aspects of the ruler had to be given some weight, which the sculptor did by allowing expressive individual features to show through the conventionalized facial mask. The eyes reveal a willful and haughty personality endowed with a sharp intellect, while the mouth, on which a smile is barely percep-

1-7 *Gudea,* from Telloh, c. 2150 B.C. Diorite (29″ high). British Museum, London.

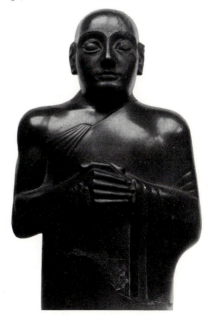

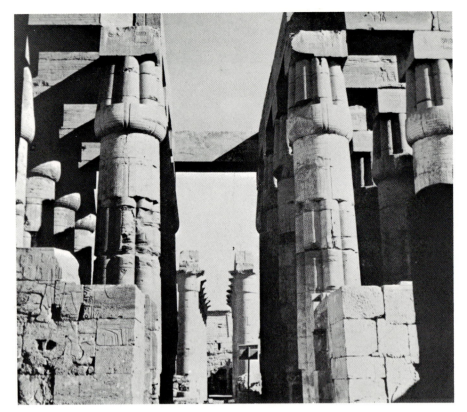

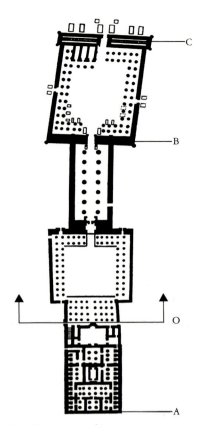

1-8 Temple of Luxor, view of the hypostyle hall from the inner court looking north, seen from O on plan, Fig. 1-9. Both sections were built by Amenhotep III, c. 1417-1379 B.C. The pylon at the end of the central aisle dates from the reign of Rameses II, c. 1302-1237 B.C.

1-9 Plan of the temple of Luxor

tible, suggests that the stern ruler was capable of magnanimity and possibly even of warmth. Nevertheless, it is the pharaoh's awesome status that has been stressed rather than the human features.

At that time Egyptian monumental statuary was religious in nature, and a work like this one, made for a funerary temple, was undoubtedly associated with burial rites. The tombs of the Egyptians were filled with personal belongings of the dead and decorated with countless representations of retainers and objects used in daily life, which were intended to provide physical and moral sustenance to the soul on its ultimate journey. For the Egyptians the purpose of the burial rites was "never to die" (in their words), and funerary statues were probably meant to help the dead maintain their identity.

Gudea was not so exalted a personage as Chephren. He was merely a priestly intermediary between his people and their chief deities. According to an inscription, his principal aim was to seek tangible benefits for his state—"a humid wind... abundance from on high...riches...water...a good weight of wool"—and he was quite willing to work hard to keep in the good graces of the gods. Indeed, one of the figures (Fig. 1-6) shows him holding on his lap a tablet on which a plan for a projected temple for the local city-god is incised.

Whereas Egyptian thought focused on the rewards of afterlife, the primary object of the Mesopotamians was achievement in their own lifetimes, and the effigies of their leaders reflect a much more practical orientation. The Mesopotamian cosmos, furthermore, was less orderly and peaceable than that of the Egyptians. Perhaps because their climate was both extreme and unpredictable, the world appeared to the Mesopotamians grim and full of uncertainties, and their gods were arbitrary and cruel. Under these circumstances their leaders had to be endowed with a special combination of energy, astuteness, and tact to gain the confidence of both gods and men. Gudea is represented here as just such a man. In spite of the highly stylized treatment, the artist stressed personal features more noticeably than did the Egyptian sculptor. More important still, the wide-open eyes, the powerful mouth, and even the ritualistically clasped hands exude the self-confidence and determination of the successful statesman.

Although the Egyptian civilization was characterized by a spectacular longevity, it went through several periods of upheaval and decline that were followed by much longer periods of prosperity and expansion, until Egyptian culture was eventually fused into the Hellenistic culture that spread around the Mediterranean after Alexander's conquests during the fourth century B.C. The first great period, the Old Kingdom, came to a close in the twenty-second century B.C. After an intermediate period of upheaval, it was followed by the Middle Kingdom (twenty-second to eighteenth centuries) and eventually by the New Kingdom (sixteenth to eleventh centuries) which marked the height of Egyptian prosperity

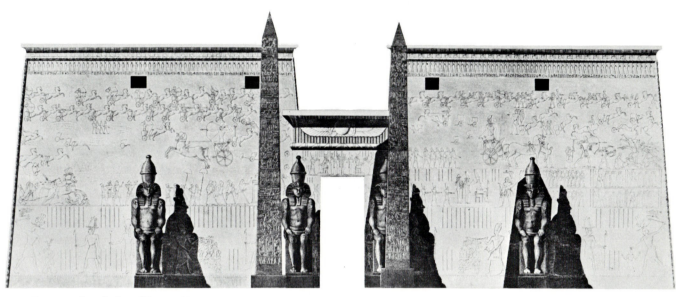

1-10 Reconstruction of pylon of Rameses II, temple of Luxor. From an 1812 aquatint.

and expansion. The centuries following witnessed a comparative decline, until the Roman conquest in 30 B.C.

The great architectural achievement of the New Kingdom is a group of gigantic temples dedicated to one or more gods. The temple of Luxor (Figs. 1-8, 1-9, 1-10) is the earliest and perhaps the most pleasing of them all. It was dedicated to Amen, local god of Thebes (near present-day Luxor), the first capital of the New Kingdom. Amen's importance had grown with that of the city, until he had become merged with the almighty sun god Rē. The temple was also dedicated to Mut, the wife of Amen, and to their son Khonsu, the moon god. To the complex of buildings erected by King Amenhotep III (reigned c. 1417–1379 B.C.), the structures shown between A and B in Figure 1-9, Rameses II, who reigned between about 1302 and 1237 B.C., added a *portico court*—a court surrounded by a gallery made up of a row of columns supporting a roof adjacent to the outer walls—and a monumental entrance (the structures

shown between B and C in the diagram).

Figure 1-8 illustrates the basic construction method used by the Egyptians for their sacred architecture: massive stone columns supporting rectangular stone *lintels,* which were in turn covered by stone slabs. The system goes back to wooden *post-and-beam* construction, the ancient practice of erecting structures by resting a horizontal beam on two vertical posts stuck in the ground. In Egypt, where suitable wood is scarce, the materials used in prehistoric times were usually reeds for the vertical and horizontal members, the structure being roofed with straw matting. Stone was substituted for more perishable materials in sacred architecture during the early historic period, and it is typical of Egyptian traditionalism that the architects merely adapted old forms to the new material. Two problems arose, however. In the first place, stone slabs make extremely heavy roofing material. In the second place, stone cracks easily under tension, and stone lintels must either be inordinately thicker (and heavier) or con-

siderably shorter than equivalent beams of wood supporting a lighter wooden roof (Fig. 1-11). As a result, covered halls are crowded with columns, and only the open portico courts are truly spacious.

Ironically, the Egyptians had been familiar ever since early historic times with *barrel vaulting,* a construction method that made it possible to span much broader areas. This technique consists of placing stones or bricks radially along an arc of a circle over the area to be covered (Fig. 1-12). When the crown is high enough, all the parts of the vault are in compression, which permits a much more economical use of materials than column-and-lintel construction. But they used it only for utilitarian structures such as the warehouse of the Rameseum near Luxor, the mortuary temple of Rameses II built in the thirteenth century B.C. (Fig. 1-13). The great temple-builders nonetheless turned their self-imposed limitations into an esthetic asset; the covered halls acquire an awesome appearance from the proliferation of tall and massive col-

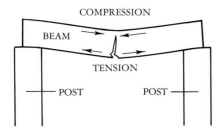

1-11 Post-and-beam construction

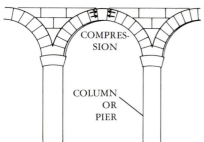

1-12 Round arch illustrating principle of barrel-vault structure.

1-13 Warehouse in the Rameseum, Thebes (near Luxor), c. 1302–1237 B.C.

umns in a darkened setting, while the porticoes of the open courts suggest an orderly and serene relationship with the natural environment.

Every aspect of Egyptian religious architecture was associated with ritualistic symbolism. Stone was selected as the sole building material because no perishable material could suggest as effectively the sense of permanence that was of prime importance in the abode of a god. The columns are based on the shape of clustered papyrus and other plants, probably because of the associations that the inhabitants of an essentially arid land must have made with plant life since the earliest stages of their civilization. The massive entrance, or *pylon* (Fig. 1-10), with its obelisks, statues of the pharaoh, and, originally, flagpoles, was clearly meant to be both attractive and majestic. Beyond this, the very shape of the twin truncated pyramids that marked the outside entrance to a temple, and sometimes the passage from one section of the temple to another, had significance. They re-

minded the worshiper of early fortifications and thus accentuated the transition from the open landscape to the holy precinct of the temple and, within it, from a lesser to a more sacred area.

The plan of the temple is strictly related to ritual and ceremonial needs. There is a progression from the open courts in which crowds could gather to darker pillared halls to which only a few dignitaries were admitted, to even smaller, still darker, and presumably more mysterious chambers leading to the sanctuary where the statue of Amen and his solar boat—the vehicle supposedly used by the sun god in his travels across the sky—were kept. The axial layout of the temple also served a specific purpose: the succession of rooms and the rhythmic repetition of columns created a majestic setting for the elaborate processions that journeyed to and from the shrine. We have a good account of the most important of the annual ceremonies that took place in the temple of Luxor from the incised and painted decorations on the walls and col-

umns. The statue of the god was placed in the solar boat and carried in procession out through the temple and along a sphinx-lined avenue to another, bigger temple of Amen at El Karnak, two miles to the north—possibly a symbolic re-enactment of the journey of the sun god across the heavens.

It is clear, then, that the artistic output of Egypt was very closely linked with religious rites. These rites sometimes reflected inconsistent and conflicting religious myths, but they were usually intended to insure the continued order of nature.

2

The Aegean and Greece

The mainland of present-day Greece, the islands of the Aegean Sea, and the western part of Asia Minor were sporadically settled during the Paleolithic period. Around 2500 B.C., perhaps under the impact of the arrival of an energetic race of seafarers who were probably related to the inhabitants of Asia Minor, a vigorous culture made its appearance in Crete. The inhabitants of this large mountainous island southeast of the Greek mainland established contacts with the older civilizations of Egypt and the Near East. By the year 2000 B.C. they had evolved a graceful and lively style in pottery and metal crafts that was characterized by animated, weaving linear patterns. They erected vast structures such as the magnificent palace of Knossos on Crete and developed a refined, luxury-loving culture called Minoan.

Minoan culture reached its zenith between 1900 and 1450 B.C. Decline seems to have been brought about by a series of natural catastrophes (earthquakes and tidal waves) and, toward the end, by in-

vasions. The first natural disaster occurred around 1700. The palaces were soon rebuilt on an even more lavish scale, but the continuing sequence of upheavals put an end to Cretan power. By 1450 B.C. what survived of the palace of Knossos was occupied by overlords from the mainland, the Greek-speaking Mycenaeans who dominated the island until their own decline after 1250 B.C.

The painting shown in Figure 2–1, executed on the side of a sarcophagus found in a burial chamber near a large villa in the modern village of Hagia Triada on Crete, dates from around 1375 B.C. Recent scholarship has linked its subject matter to Mycenaean themes, but it is Cretan in style and must have been made by a local artist. It is comparable in quality to the remarkable but poorly preserved wall decorations that mark the height of Minoan culture.

Let us compare the Cretan work with a nearly contemporary wall painting of a funerary procession from the tomb of an Egyptian court official, Ramose, dating

from the second quarter of the fourteenth century B.C. (Fig. 2–2). There are considerable differences between the two works. To be sure, the paint in both was applied in uniform color areas surrounded by continuous outlines, but the lines of the Cretan painting are definitely looser, more undulating, and altogether livelier than those of the Egyptian mural.

The color compositions reflect similar differences, particularly in the use of contrasting *hues*. Hues are determined by the wavelength of the light transmitting the color: short wavelengths produce hues in the violet-to-green range (called the cool range) and long wavelengths produce hues in the yellow-to-red range (called the warm range). In the Egyptian work the artist relied principally on two sets of hues—blue for the women's dresses and orange and reds (the first toned down with white and the second looking like ocher and brown because of the impurities) for the flesh tones and some of the garments. While the variations within each set are small, there is a vibrant con-

trast between the colors of the warm and cool ranges. The effect is one of subdued harmony, somewhat livened by this contrast and by the introduction of another hue in the touches of green in the papyrus flowers on the left. In the Cretan work, there is a greater variety of hues—blue, yellow, brick red, and red—and this creates a considerably richer effect.

Even the techniques reflect different aims and contrasting temperaments. For the most part, the Cretan artists used the true *fresco* method: pigments diluted in water were applied to a thin layer of plaster over limestone while the plaster was still wet. As a result, the pigments became part of the plaster as it hardened. Because fresco must be applied swiftly before the plaster dries, and because errors cannot be corrected, it demands simple designs as well as a swift, sure hand. The Cretan artist also added color after the plaster had dried. Egyptian artists, on the other hand, used *tempera,* a rather viscous protein-based medium that must be applied slowly, evenly, and patiently.

Both works reflect conventions that had been prevalent since early historic times: women's flesh is shown in lighter tones than men's and many of the figures have been drawn with hips in profile, shoulders in fullface, and heads in profile with the eyes in fullface. It is likely that Cretan art was strongly influenced by Egyptian art at an early date and that these practices stem from Egyptian prototypes. In both works, however, the rules are sometimes broken. In the Ramose mural, for instance, the shoulders of the crouching women are in profile, as though the Egyptian rules allowed for a greater element of naturalism in unconventional poses permitted servants, animals and, sometimes, young children. The Cretan artist, for his part, seems to have felt no compunction about showing the shoulders of some of the standing figures in profile. More important still, the outlines of the figures in the Cretan fresco, with their characteristic hourglass waists and bulging chests and hips, create, in contrast with the comparative restraint of the linear treatment in the Egyptian work, a swift, undulating linear movement on the surface that adds to the exuberant quality of the design.

There is no agreement on the subject matter of the Cretan painting. It seems to consist of a libation scene—a ritual pouring out of wine—in honor of a dead man and an offering of two statues of calves and a model of a boat to the dead man himself, who is shown on the extreme right, his feet already below ground level. Despite the fact that the subject is related to death, the positive qualities of the Cretan temperament prevail. The mourners may be performing ordained funeral rites, but they are doing so with a certain vivaciousness. They seem happy to be alive.

In the Egyptian painting, which is part of a *frieze*—a horizontal decorative strip—along the top of a wall in the main hall of Ramose's tomb, the figures depict mourners facing the sarcophagus of the dead man, which has been placed standing upright before the entrance to the tomb (not shown). Some are obviously walking in solemn procession, bearing offerings such as papyrus flowers. Some of the women are standing and others are sitting, in two tiers. They are lamenting the dead; one of them has both arms raised as though she were uttering an invocation, while others seem to be sprinkling earth over their heads (a gesture of mourning to this day in the Near East).

One of the most interesting aspects of the Egyptian mural is the difference between the solemn and austere men on the extreme left, their bodies depicted strictly according to traditional rules, and the posture of lamenting women. The latter are arranged in groups several figures deep, with an unusual freedom of attitude and gesture and a fluidity of line that help to suggest the effect of an animated crowd. Even more important, the women's arms upraised in bereavement reveal the artist's concern for the expression of feeling. When one examines the mural directly, a few tears are even visible on their cheeks.

The unusual expressiveness characterizing some secondary figures had roots in the more familiar scenes of Old Kingdom art. After this mural was completed, for a short time only during the reign of Akhenaten, it came to affect even representations of the pharaoh and his entourage. Akhenaten, a religious innovator, repudiated the old gods and instituted the cult of a single deity, represented by the sun god Aten. Akhenaten seems to have demanded a new realism even in the de-

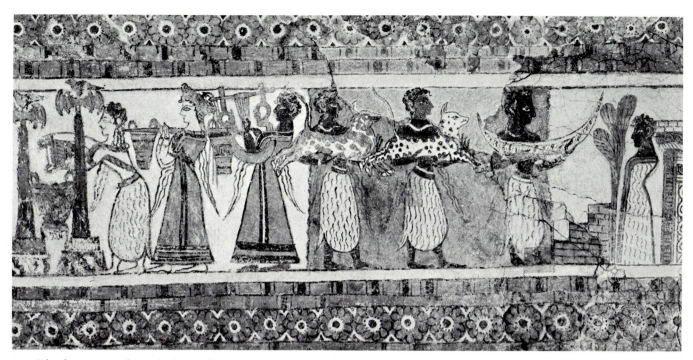

2–1 Side of sarcophagus, from a burial chamber near Hagia Triada on Crete, c. 1375 B.C. Fresco on limestone (53″ long). Heraklion Museum.

2–2 *Funerary Procession,* painted on wall of tomb of the Vizier Ramose, Thebes, second quarter of fourteenth century B.C. Tempera on limestone (*comparative illustration*).

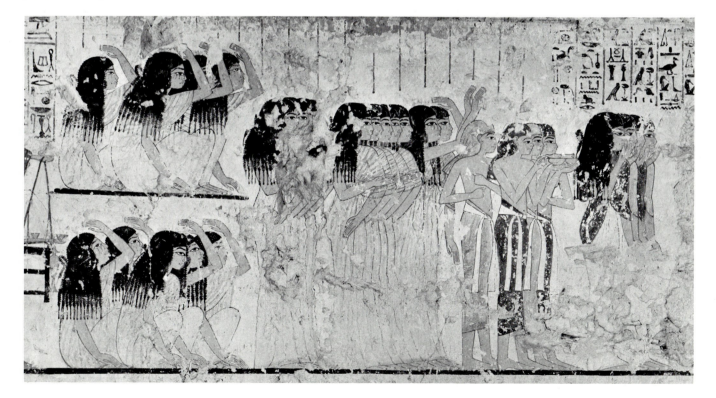

piction of his own features and to have insisted, in place of the formality of earlier representations, on a new sense of intimacy in scenes from the life of the royal household. To be sure, the means used to express grief in this painting are still quite elementary, but the effort to suggest an emotional state and to convey it by means of facial expressions and the expressiveness of line rather than conventional gestures indicates that Egypt had reached a level of artistic maturity to be surpassed only at a much later date by the Greeks. Akhenaten's religious reforms were short lived, but his artistic reforms had a lasting influence. Egyptian art was never to be quite the same again.

The stylistic developments in Egyptian art that have just been discussed may have been accelerated by contacts with Crete. Some examples of Cretan art were known and admired in Egypt (Cretan objects are represented in Egyptian murals), and it would be surprising if the Egyptians had not found some inspiration in the swift, fluid designs of Crete. The Cretans also had a decisive influence on the Mycenaeans, a group of Greek-speaking Indo-European tribes who made their appearance on mainland Greece around 1900 B.C. Crude and primitive at first, the Mycenaeans were eager to absorb new ideas and adopt a higher standard of living. They turned to the culture of Crete for inspiration and by 1700 B.C. had developed their own civilization, which reached its height around 1450–1250 B.C. The Mycenaeans were remarkable architects and excelled in painting and the

minor arts, creating a style that was somewhat more austere and perhaps also more rigid than that of Crete. From their principal stronghold of Mycenae and the great fortress of Tiryns, both in the plain of Argos in southern Greece, they had occupied much of present-day Greece and Crete by 1450.

The Mycenaean civilization seems to have come to an end around the twelfth to eleventh centuries B.C. The wholesale destruction of palaces that occurred then remains unexplained, but it is clear that the Mycenaeans' territory was gradually occupied by the much more primitive Dorians, also a Greek-speaking people of Indo-European origin. It was probably in the course of a series of conflicts slightly before or at the time of the Dorian invasion that the Trojan War of Homer's *Iliad* took place.

Following the Dorian invasion, the population of Greece seems to have returned to a nomadic or a very rudimentary village life. Even the art of writing was forgotten. This dark age lasted for approximately four centuries. The invaders made major practical contributions from the start, however. For example, their weapons were made of iron, which is harder and more resilient than bronze and other copper alloys. Furthermore, there must have been a lively oral tradition of epic poetry about the events of this time, either among the Dorian people themselves or among the surviving islands of Mycenaean culture; it was in the eighth century, some four centuries after the event, that Homer related the battles of

the Trojan War and a century later that this epic was first transcribed.

Figure 2–3 illustrates an advanced example of the art that evolved during the dark age. It shows a large vase called a *krater* from Attica (the province of Athens), of baked clay with glaze decorations. Such vases were placed on graves, and oil was poured in them as offerings to the dead. They frequently had perforated bottoms, perhaps to let the libations sink into the grave. When we compare the decoration of the krater with the Hagia Triada painting (Fig. 2–1), we see that the lively, curvilinear decorations characteristic of the Cretan and Mycenaean traditions have been transformed into severe rectilinear and circular patterns of black glaze applied in parallel bands over most of the surface of the vase—hence the appellation Geometric for the style of this era.

Geometric style is characterized by great austerity of form, texture, and surface design as well as by a measured, rhythmic quality in both the overall shape and the decorative pattern. What the Geometric tradition lost in the way of fluid grace and seductive animation, it gained in a new sense of energy and an effect of sober elegance. At first decoration was entirely abstract. In the course of the ninth century, wire-like animal forms appeared, silhouetted against rectangular fields, or *registers,* between the bands. By the time this vase was painted, in the second half of the eighth century, scenes involving men and animals, drawn in the same wire-like style but in larger fields,

were frequently depicted on such vessels.

As in the Cretan sarcophagus painting, the various scenes on this vase represent burial rites. In the upper register, rows of mourners march past the funerary couch on which the dead man rests. Their arms are raised in a traditional gesture of grief. In the second register, the funeral procession has been formed, with the horsedrawn chariot conveniently placed under the dead man's couch in the upper register. In the lower register, warriors in armor riding in chariots pay final tribute to their comrade.

According to some scholars the scenes on Geometric vases allude to events in epic poems such as Homer's *Iliad* and *Odyssey*. This is impossible to ascertain in most cases, but the vases, after all, date from the same period as the poems and reflect the same traditions and attitudes. It is not out of place, therefore, to relate the pathos of the scene on the vase with that of the funeral of Patroklos in the *Iliad*.

Some aspects of the Geometric figurative style may go back to the Cretan and Mycenaean traditions—the hourglass waists, for instance, and the fact that the legs and faces are in profile while the shoulders are fullface (the hips are an intriguing combination of both). But the mood is entirely different: the optimistic exuberance of the earlier tradition is gone. Despite their simplicity, or perhaps because of it, the wire-like dark figures on the light ground have a starkly dramatic effect. Indeed, once the human implications of these scenes are understood, the

Geometric artists' skill at evoking poignancy by means of forms that are little more than graphic symbols becomes fully apparent. However limited their means, these artists were heralding the achievements of Archaic and Classical Greece.

In the course of the eighth century, the Geometric civilization underwent rapid and profound changes. Throughout Greece, the Aegean Islands, and western Asia Minor there appeared a number of independent city-states engaged in active trade among themselves and with the powerful empires of the eastern Mediterranean. Further contact with foreign lands was made by Greek soldiers fighting as mercenaries. These changes marked the beginning of the gradual transition to the Archaic period (725–480 B.C.). Because of the close contacts with neighbors to the east, its first phase has been called the Orientalizing period (725–625 B.C.). A new alphabet, an improved version of the alphabet of the Phoenicians, was introduced, and a number of motifs and stylistic elements from Eastern countries appeared in the art of the Greek cities. Throughout the Archaic period the Greek communities became increasingly prosperous and active and established colonies as far away as the Black Sea coasts and Spain.

In art, the austerity of the Geometric era made way for a new elegance and refinement inspired largely by the tradition of Greece's eastern neighbors. The magnificent François vase of around 570 B.C. (Fig. 2-4), named after the man who discovered it in 1845, reveals much about

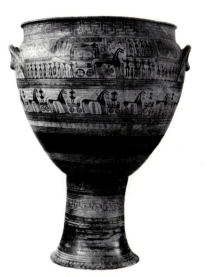

2-3 Attic krater, after 750 B.C. Baked clay with glaze decorations (48″ high). National Archaeological Museum, Athens.

2-4 Kleitias (painter) and Ergotimos (potter), François vase, volute krater, c. 570 B.C. Glazed baked clay (25¾″ high). Museo Archeologico Etrusco, Florence.

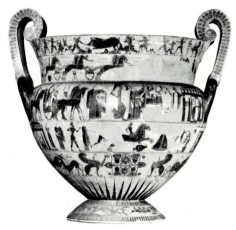

2-5 Details of the François vase. (a) Left: Hunt of the Calydonian Boar; Funeral Games of Patroklos. (b) Near right: Marriage of Peleus and Thetis; Achilles Slaying Troilus.

2-6 Details of the François vase. Far right: Artemis as Queen of the Wild Beasts; Achilles' Body Carried by Ajax.

the progress of Greek culture a few decades after the end of the Orientalizing period. If we compare it with the Geometric vase in Figure 2-3, we notice striking differences. The figures are represented in silhouette over a red background. There is now a rich variety of glazes: black for the male figures and animals (hence the name *black-figure* vases for all the pots painted in this fashion), purple and black for the garments, a chalky white for the women's flesh with brown over it for their features. These various colors, in combination with the reddish hue of the clay of the vase, create subtle harmonies. The figures are no longer wire-like. The silhouettes bounded by elegant and firm edges suggest full, if highly stylized, figures. Furthermore, painted and sometimes incised lines drawn over the bodies to indicate features, clothing, and musculature hint at the roundness (or *relief*) of the forms. (The process of suggesting the relief of forms is generally referred to as *modeling*, and lines used to suggest modeling are known as *contour lines*.) The painting, incidentally, was done after the vase had been turned on a potter's wheel and the handles attached, the vase being fired only once, after application of the glazes.

The Egyptian convention of showing legs, hips, and heads in profile and chests and eyes in fullface is respected in most of the figures but not in that of a charioteer in the funeral procession, whose shoulders are in profile (Fig. 2-5a). Some faces, furthermore, are shown frontally, a comparatively rare occurrence at such an early date. Above all, the artist fitted the

figures within each zone with a remarkable sense of surface decoration. The surfaces of both handles (Fig. 2-6), for instance, show the goddess of the hunt, Artemis, as queen of the wild beasts, holding by the neck a large feline and a stag. The wings of Artemis spread out across the width of the field, and the feline and the stag are made to fill out the zones on each side of the goddess. The design is at once taut and graceful. (Incidentally, the subject of this scene may reflect a vestigial remnant of the cult of the mother goddess we encountered at Çatal Hüyük.)

The abstract decorations that filled the surface of the Geometric vase have been replaced by designs based on animal and plant forms, and some of these, like the winged sphinxes in heraldic opposition and the palmettes (Fig. 2-4) are clearly Oriental in origin. Yet some features of the François vase are still related to the design of the Geometric vase. In both cases the figures were made to fit horizontal bands on the surface, and if the overall form of the François vase is gentler and more graceful, one nevertheless finds here the clarity of conception and the respect for balance and order that characterized the earlier work. And even in elements that are fully representational, a strong, measured, rhythmic quality brings to mind the precise patterns of Geometric vases. Thus, by the end of the Orientalizing period, not only had the forms acquired corporeality but a new love of refinement and elegance derived from the East had been integrated with

the clarity and order of the Geometric period.

The artist's new mastery over the rendering of the human figure enabled him to suggest specific scenes with as much precision as his Egyptian and Cretan-Mycenaean predecessors had done. To make quite sure that all the figures could be recognized, however, he wrote out the names of most of them. And with justified pride of achievement, he even signed his own name, Kleitias, and that of the potter, Ergotimos.

As in Geometric times, the artist did not shrink from dramatic subjects. The surface of one of the handles (Fig. 2-6) shows a poignant scene from the lost Greek epic poem known as the *Aithiopis*. The lower part of the design depicts the Greek Ajax carrying the corpse of his semidivine friend Achilles after Achilles had been wounded in his heel, the only vulnerable part of his body. Bodies and faces are too stylized for the expression of individual feeling, yet the downward movement of the hair, arms, and legs of the athletic Achilles are suggestive of profound grief.

The scenes around the vase are devoted to the stories of leading heroes of Greek mythology, and more particularly to Achilles and his father, Peleus. The upper register of the neck of the vase (Fig. 2-5a) shows the hunt of the Calydonian boar, a destructive monster eventually put to death by a group of heroes that included Peleus. Below this is a scene reminiscent of the funerary procession on the Geometric krater (Fig. 2-3); it shows

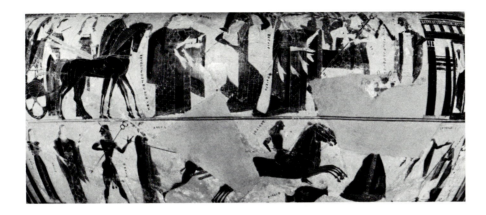
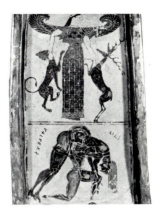

chariot races given by Achilles for his friend Patroklos slain before Troy. The next frieze down (Fig. 2-5*b*) is the wedding reception of Peleus (near his house to the right) and the sea nymph Thetis (inside the house). This wedding, attended by both gods and mortals, was taken to be the first link in a chain of events that led to the Trojan War. Because Eris, the goddess of discord, was not invited, she provoked quarrels among the gods and eventually brought about the feuds between Greek and Trojan princes that sparked the conflict. Below comes Achilles (on foot, his figure only partially preserved) slaying a Trojan prince, Troilus (on horseback), while gods and goddesses look on. Around the foot of the vase is a note of comic relief: the legendary fight of pygmies and cranes.

The scenes depicted on the François vase all pertain to Greek mythology, and yet they seem to reflect the excitement of contemporary life. Indeed, the mythology of the Greeks was but a transposition to a somewhat more heroic scale of their own life, and it conveyed vividly their characteristics and their ideals. Like the Greeks themselves, gods and heroes took great pride in personal achievement, both physical and mental, and made much of the esteem of their peers. That they could be jocular, sometimes vulgar, and occasionally unethical merely added to their broad humanity. They believed in asserting their power over each other and over their inferiors. They expected to be obeyed and were ruthlessly vengeful when their authority was challenged.

The gods could also be capricious and arbitrary, and even at the high point of Greek culture, the citizens felt obligated to propitiate them through prayer and sacrifice. But there was a vast difference between the unquestioning, all-pervasive piety of Eastern people such as the Egyptians and the much more critical attitude of the Greeks. For the Egyptians both the events in individual lives and the immutable laws of nature were manifestations of divine power. The Greeks, in contrast, made a clear distinction between developments that were beyond man's grasp and phenomena that could eventually be understood and controlled by man. The first were in the hands of fate, and fate itself was the outcome of the contests of will among the gods; thus, the Greeks linked the imponderable elements in life with the irrational aspects of their mythology. The second, which included natural phenomena, lent themselves to observation and, they felt, could be explained through deductive reasoning. In this respect, they were the founders of modern scientific thought. It is significant, for instance, that when they were speculating on the primary substance of things, one philosopher of the sixth century B.C. suggested air and another water; they did not suggest the god of air and the god of water. In the same spirit, Pythagoras tried to explain the mysteries of musical harmony in terms of ratios of the lengths of vibrating strings of musical instruments, while the fifth-century physician Hippocrates stressed the importance of studying all the physical symptoms of an

illness before prescribing a treatment. Possibly the greatest 'scientific achievements of the Greeks, far surpassing the Egyptians, were in geometry, the science that enables man to define spatial relationships.

The Greeks' intense interest in the human body and their willingness to study the physical world objectively led to extraordinarily rapid progress in the depiction of the nude. There were animated wire-like bronze sculptures as early as the eighth century, but it was in the last half of the seventh century, after the impact of Eastern cultures during the Orientalizing period, that monumental sculpture appeared.

The figure of a youth known as the New York *kouros* (Fig. 2-8), of island marble but probably carved in Attica, is a superb example of monumental sculpture dating from around 600 B.C. The general similarity with Egyptian statues is not coincidental. If we compare it with the very fine slate portrait of Thutmosis III (Fig. 2-7), a ruler of the New Kingdom (reigned 1468–1436 B.C.), we see that both figures are strictly frontal and are in almost the same position: left foot forward, arms against the body, hands clenched, and back stiffly straight. The overall proportions are fairly similar. Furthermore, like the Egyptian sculptor, the Greek used the four-square method for outlining his form, resulting in a similar block-like effect, and adhered to a system of codified proportions, or *canon,* originally acquired from the Egyptians, which evolved appreciably only when new styles

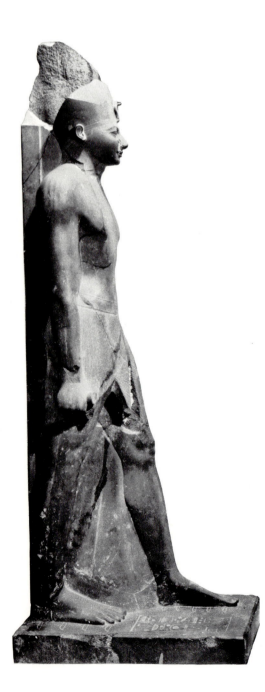

came into being. There are similarities even in some details of the execution: stylized bands around the eyes and bits of stone left in the hands, providing further evidence that Greek monumental sculpture was derived from that of Egypt.

The Egyptian statue here is somewhat more naturalistic than the Greek; the proportions of the body and the modeling of the flesh have been more closely observed, and the features seem much more clearly related to those of a living model. The protruding buttocks and hourglass profile of the Greek work, characteristic of Archaic art, stem from earlier traditions possibly going back, as we have seen, to Minoan art (p. 16). The decorative patterns of the musculature reflect a development parallel to that of Mesopotamian art, while the rhythmic quality of the outlines and incised details suggest the order and elegance of Geometric designs.

In some ways the Greek statue shows a marked progress over the Egyptian. In the first place, the space between the legs is hollowed out, and there is no vertical support to strengthen the statue from the back so that the Greek artist was thus better able to suggest the overall form of the body in space. In fairness to the Egyptians, however, it must be pointed out that it was they who had introduced the innovations before the Greeks and probably influenced them. In the second place,

2-7 *Thutmosis III,* reigned 1468–1436 B.C. Hard grayish-green slate (6'6" high). Egyptian Museum, Cairo (*comparative illustration*).

the compact and precise semigeometric forms of the musculature convey an extraordinary sense of alertness and energy.

This figure is one of a number of similar statues carved over several decades and known as *kouroi,* or "young men" (singular, *kouros;* feminine plural, *korai,* and feminine singular, *kore*). Their religious purpose is not entirely clear. *Kouroi* are frequently found on the tombs of young aristocrats. Some are thought to represent Apollo, god of light and reason, who was reputed for his beauty. Others are believed to be offerings to the gods. If this is the case, the *kouroi,* lively, self-assured, and smiling as they are, would constitute the most valuable gift the Greeks could have offered to their divinities—their own youth. The practice would also confirm the fact that the Greeks gave man a much greater importance in the scheme of things than the Egyptians had done. Significantly, the Greeks' awareness of the beauty of the human body led them to depict men and eventually women entirely in the nude for the first time in Western history.

Progress in the art of the Greeks, particularly in Attica, was rapid, for any advance won immediate widespread acceptance and was followed by further probing and new discoveries. As a result, by the end of the Archaic period the Greeks had gone well beyond the Egyptians in their understanding of anatomy. They had not yet mastered movement, however, and were very limited in their range of expression; triumphant athletes and dying heroes had the same expression,

characterized by the so-called Archaic smile.

The transition from the Archaic to the Classical style was gradual, but the year 480 B.C. has been accepted as a convenient dividing line. Major economic and political changes were taking place at that time. The Persian empire had spread from Iran through Mesopotamia and most of the Near East. Early in the fifth century B.C., Persian armies launched drives against the Aegean Islands and mainland Greece. In 479 B.C., the last of a series of Persian assaults against Greek lands had been successfully repulsed, and while the necessities of war had brought about a loose confederation of Greek cities under the domination of Athens, victory had insured a new prosperity to most of them.

Unlike the Persians and other Oriental peoples whose despotic monarchies they despised, the Greeks took great pride in their democracy—a democracy which was strictly oligarchic, accepted slavery, and was occasionally suppressed by dictators. Athens in particular, having rid itself of a dynasty of tyrants a little earlier, embarked on a period of enlightened government during which free inquiry and speculation were tolerated to a surprisingly large degree. In this atmosphere of intellectual ferment began the Classical period, resulting in achievements in all fields of human endeavor that rank among the

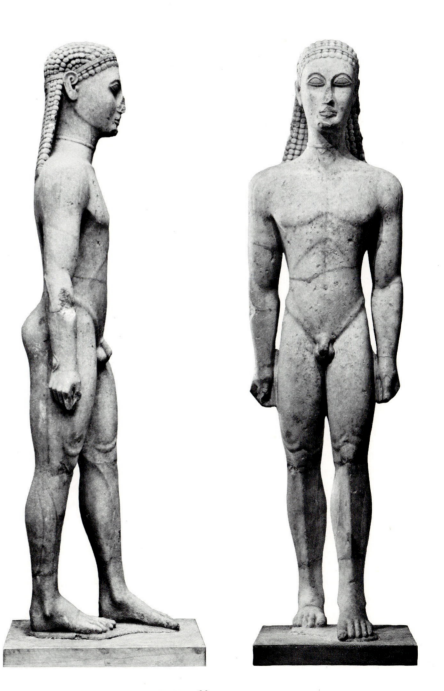

2–8 *Kouros,* c. 600 B.C. Island marble (7'2" high). Metropolitan Museum of Art, New York, Fletcher Fund.

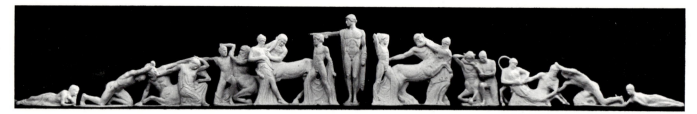

2-9 Model of west pediment of temple of Zeus at Olympia, c. 460 B.C.

most brilliant in the history of mankind.

The marble statue of Apollo of around 460 B.C. from the temple of Zeus at Olympia (Fig. 2-10) marks the height of the early Classical period. It is one of a group of figures that were mounted in the shallow space of the triangular area, or *pediment,* of the west façade of the building. The statues were carved in the round—that is, from all sides—but it is characteristic of Greek common sense that they were less highly finished in the back, where they could not be seen.

The overall proportions of the body recall the aristocratic-athletic ideal of Egyptian statuary at its best. But the block-like quality we noted in Egyptian and Greek Archaic works (Figs. 2-7 and 2-8) has almost entirely disappeared. Furthermore, the somewhat severe stylization of the modeling of the *kouros* has given way to a more subtle treatment based on a thorough understanding of bone structure and muscle articulation. So far as we know, the Greeks did not dissect corpses to study anatomy, but they had considerable experience with the treatment and healing of wounds. In their passionate enthusiasm for the beauty of the human body, artists must also have studied the movements and attitudes of athletes in the field with great acuity and infinite patience.

In two respects, however, the attitude of the Classical artist had not changed. In the first place, the composition reveals a marked interest in rhythmic patterns. We find, for instance, that the artist suggested the abdomen with a system of lines

that preserves something of the geometric regularity of Archaic times. The elegant curves of the demarcation between body and legs (the iliac crest) are themselves remnants of the exaggerated oblique muscles of the groin of the *kouros.* We also find an element of rhythmic regularity in the way in which the gentle lateral sway of the torso is accented by the hanging drapery over Apollo's shoulder on one side and over his forearm on the other. In the second place, for all the interest he showed in objective reality, the Classical artist did not actually represent a specific person. The features are obviously idealized, and even the depiction of the body could not have been based on a model, for it is unlikely that anyone could stay in this precise position for any length of time. It would seem that the artist started out with both a preordained set of proportions and vivid mental pictures of anatomic details. Thus, like the Archaic artist, he strove to implement an abstract ideal. The main difference is that the Classical artist was reacting against the formalism that had predominated in all art since Neolithic times (see Chapter 1), and his ideal had become much more closely related to observable fact.

The difference in positions is equally revealing. The Archaic *kouros* is in a strictly frontal position, the spine is straight, and the body's weight is evenly distributed between the two legs. In the Apollo, the symmetry has been broken. The right arm, which was meant to carry a bow, is stretched out, and the head is turned to the right. The weight of the

body rests mostly on the right leg. As a result, the right hip seems somewhat higher than the left, and the torso and spine have a gentle curve, while the left shoulder is slightly lower than the right. This subtle sway, so suggestive of the suppleness of the human body, is called *déhanchement* (from the French, meaning that the hips are out of alignment) and is characteristic of all Classical sculpture. The *kouros,* for all its stiffness, seems ready to burst forth into some frantic motion at any time; the Apollo, on the other hand, appears to have been caught in the course of a stately movement. Somehow the subtle asymmetry of the position and the suggestion of varying tensions in the musculature make one imagine the motions that have just preceded and those that will follow. Thus, through their understanding of muscular tensions, the artists of early Classical Greece were able to hint at the possibility of movement in sculpture. Compared with later works, the statue is nevertheless characterized by a simplicity and comparative severity typical of the early Classical period.

The handling of expressive content in the Classical piece is even more remarkable. Apollo is part of a group of single and double statues depicting the story of the wedding of King Pirithous of a mythical northern tribe, the Lapiths, to a beautiful woman, Deidameia. Among the guests were the partly human, partly equine centaurs. They were perfectly convivial at first, but after a few drinks their animal instincts asserted themselves and they began to molest the women and

the boys. A fight ensued, in the course of which the king of the Lapiths and his friend, the Athenian hero Theseus, routed the centaurs.

Although the present arrangement in the museum at Olympia shows Apollo surrounded by two groups of centaurs attacking women (Fig. 2–10), recent scholarship has shown him to have been flanked by Pirithous on one side and Theseus on the other. He was therefore at the very center of the action (Fig. 2–9). As was so often the case in Greek myths, a god was thus presiding over a fight, unseen by the participants but insuring victory for his favorites. Apollo was on the side of law and order, as indeed he would be as the god of light and reason. The myth clearly symbolizes the triumph of civilized men over barbarians, of reason over instinct. Indeed, the centaurs had been guilty of *hubris,* arrogant self-assertion in defiance of superior laws, and they were being duly punished.

The theme of the triumph of law and order was frequently used in the Classical period. Convinced that their mode of government was superior to any other, the Greeks were eager, it seems, to extoll the moral principles on which it was based, and artists often illustrated them with considerable moral conviction.

The artists of the Classical period endeavored to stress the human implications of the mythological scenes they were depicting through careful differentiation of the attitudes of the various figures. Here Apollo is shown as the ideal leader. Attractive yet full of determination, he

directs his powerful glance toward some of the fighters and seems about to utter a few quiet words of command. His whole attitude is summed up in the imperious gesture of his right arm.

In a group to his side (Fig. 2–11), Deidameia struggles with a centaur who has seized her by the waist and bared her left breast. From the standpoint of composition the group is much more complex than any sculpture we have discussed. Deidameia's body is not only receding obliquely but is somewhat twisted axially: shoulders and hips are placed in different directions. If the artist used the four-square method, he must have taken into account the inclination and twist of the body when laying out the design of each surface, a procedure implying considerable skill in applied geometry. Or he may have relied on his own sense of proportions when cutting away the marble, thereby revealing a remarkable ability to visualize forms in space.

The psychological play is equally elaborate and successful. There is graceful dignity both in Deidameia's attitude and in the harmonious flow of the thin fabric of her drapery. Only the angular form of her left arm suggests the violence of the struggle. Her facial expression is exceptionally restrained. It has the gravity of a woman who is fully aware of danger but seems confident of the outcome of the struggle and is able to maintain her composure. What is left of the battered face of the centaur, on the other hand, expresses a not unappealing lustful aggressiveness.

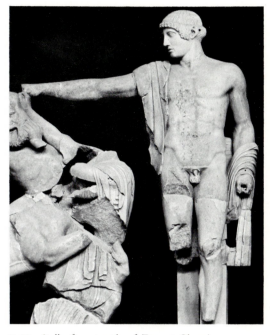

2–10 *Apollo,* from temple of Zeus at Olympia. Marble; originally stood on pediment 10′ 10″ high. Olympia Museum.

2–11 *Deidameia and Centaur,* from west pediment of temple of Zeus at Olympia; marble.

Clearly, the bodily and facial expression of each member of the group is superbly related to its role in the scene. This articulate differentiation of expressions is totally novel and represents vast progress over the achievements of the Archaic artists and, indeed, over all earlier cultures. Thanks to their study of anatomy and of psychological reactions, as well as their new control over forms in space, Greek artists introduced both a new naturalism in the rendering of form and a vast new range of possibilities for dramatic expression.

A remarkable vase painting of the early Classical period also deals with the punishment of *hubris*. The vase portrays the death of the Niobids, children of the mythical Niobe, who had boasted that she had many more children than Leto, the mother of Apollo and Artemis, whereupon Leto ordered Apollo and Artemis to avenge her by killing Niobe's children (Fig. 2-13). The scene adorns one side of a vase of glazed baked clay that dates from 455–450 B.C. (Fig. 2-12). Several works by the same artist have been identified, but none is signed, and he has been called the Niobid Painter after this vase.

In keeping with the severity of the early Classical style, the vase itself is proportionately taller and more austere than the François vase (Fig. 2-4). The artist used black or dark brown glaze almost exclusively, but by this period the black-figure technique had been reversed. The figures themselves were outlined and the area around them was filled with glaze. They thus have the reddish color of the ground and stand out against the black background. Details of clothing and anatomy are suggested by means of glaze relief lines. This method, which has been called the *red-figure* technique, appeared around 530 B.C. and came into general use at the turn of the century. It had an enormous advantage in that it made possible the depiction of normal relationships of light and dark areas. Whereas the black-figure technique reverses the light and dark, as a black-and-white photographic negative does (the flesh appears dark and the outlines light), the red-figure technique reestablishes the usual relationships (the flesh appears light and the outlines dark). This was an important step toward greater naturalism, and it enabled the vase painters to keep up with the sculptors' progress in depicting the nude, because anatomical details are more convincingly suggested on bodies in a light color than on the silhouettes of black-figure vases. Another major change can be seen in the surface treatment of vases. Rather than enclosing subjects in registers, as the early Archaic artists had done, or in decorative frames, as later vase painters had done, the artists of this time often did not delimit their scenes, preferring to make them float on the black glazed surface, more like paintings on the vase than surface decoration.

The style of the Niobid painting can be compared to that of the pediments at Olympia: in both we find a certain sparseness in the composition and an austere simplicity in the handling of line. And, as in the sculpture of Apollo, there is still a rather geometric rigor in the patterning of the muscles, especially over the abdomens of the male figures.

The mid-fifth-century vase painters almost totally discarded the conventions inherited from Egyptian times. Faces frequently appear in frontal positions, and on those in profile, the eyes are no longer fullface but in profile. Some of the bodies in the Niobid painting, as well as one face (that of the dead boy on the right) are shown in three-quarter view. When depicting an object in three-quarter view, an artist must show the parts that are farthest from the viewer smaller than they actually are. The Niobid Painter was fully aware of this; the upper part of the right arm of the dead girl, which is at an angle to the picture plane, is somewhat shorter than her forearm. This procedure is known as *foreshortening*. Earlier painters, when they did show limbs overlapping bodies, tended to keep bodies and limbs adhering to the picture plane. Foreshortening enables the artist to depict the limbs in a variety of directions. This achievement is comparable to that of the sculptors when they started to suggest receding and twisting bodies, as in the group of Deidameia and the centaur.

The Niobid Painter had even more effective devices for suggesting space that were derived, as far as can be gathered from written sources, from the innovations of contemporary mural painters. Of the two rows of figures (Fig. 2-13), the lower one is clearly in front of the upper one, for the body of the boy overlaps the ground line on which Apollo and Artemis stand. Furthermore, there are other

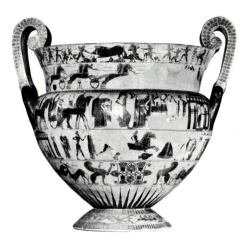

2-4 Kleitias (painter) and Ergotimos (potter), François vase, c. 570 B.C. (comparative illustration).

ground lines: one beyond Apollo and Artemis supporting the tree to the right, and one under the bodies of each of the children. These lines and the tree suggest a receding landscape rising toward the back, thereby contributing greatly to a new sense of depth. One would expect the figures in the back to be comparatively smaller than the ones in front. The upper figures appear somewhat larger in relation to the lower ones, however, the artist being more concerned, it would seem, with age and status than with optical effects.

The painters of early Classical times were nonetheless the first to attempt to suggest clearly, and with considerable logic, objects in a receding space. This was a tremendous achievement, fully in keeping with both the Greeks' dedication to speculative inquiry and their passion for geometry. Later antique artists achieved a considerable degree of illusionism in suggesting forms in space (Fig. 4–8), but none fully mastered the rule governing the diminution of objects as they recede from the picture plane. This is the law of perspective, which was not to be discovered until the Renaissance.

Although the subject of the Niobid vase painting is just as dramatic as that of the west pediment at Olympia, its representation here is much less stirring. One must assume that the limitations of the technique were too great to enable vase painters to attain the same expressive power as sculptors and, presumably, mural painters, whose work is lost to us. They were at their best during the Archaic period and the transition to the Classical period, when fashion demanded a richly decorative handling of line. A few unpretentious vase paintings of the Classical period, executed in brown glaze outline on a white ground and showing funerary scenes of dead and living figures confronting one another, are movingly beautiful, but they are exceptions. By the end of the fifth century the difference in expressive power between the art of the vase painters, on the one hand, and that of the monumental sculptors and mural painters, on the other, had become very great, and vase painting began to decline.

The monument that marked the height of Classical art in Athens was the Parthenon. Started in 448 B.C., consecrated in 438, and completed in 432, it was part of a complex of religious buildings erected by the Athenian leader Perikles on the heights of the Acropolis, where former Mycenaean fortifications had once dominated the city (Fig. 2–16). Perikles' program marked the resumption of civic and religious building after a lull of many years brought about by the Persian wars and their aftermath. The program was undertaken with remarkable diligence. "As the buildings rose stately in size and unsurpassed in form and grace," wrote the historian Plutarch, some five centuries later, "the workmen vied with each other that the quality of their work might be enhanced by its artistic beauty. Most wonderful of all was the rapidity of construction. Each one of them, men thought, would require many successive generations to complete it, but

2-12 "Niobid" vase (calyx-krater), c. 455–450 B.C. Glazed baked clay (22¼" high). Louvre, Paris.

2-13 Apollo and Artemis Slaying the Niobids, detail from the "Niobid" vase.

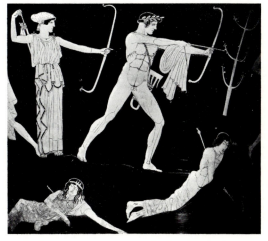

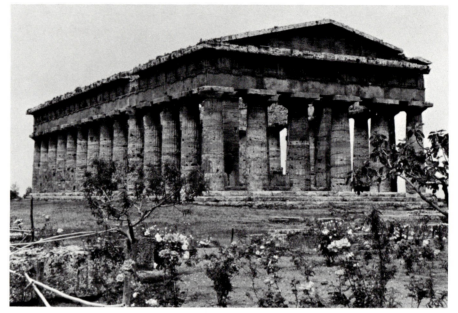

2-14 So-called temple of Poseidon, second quarter of fifth century B.C., seen through the columns of the "basilica," mid-sixth-century B.C. Paestum, Italy (*comparative illustration*).

2-15 So-called temple of Poseidon (*comparative illustration*).

all of them were completed within the heyday of a single administration." The whole project seems to have been supervised by Perikles' friend Pheidias, the sculptor (active c. 470–425 B.C.). The Parthenon itself was designed by Iktinos and Kallikrates (both active c. 470–425 B.C.), and the sculptures are the work of Pheidias and a team of assistants. The basic structure of the Parthenon goes back to prototypes of the Archaic period. A rectangular enclosure, the *cella* (here divided into two parts by a doorless partition), is surrounded by one row of columns on each of the long sides and two rows on each of the short sides (Fig. 2-17). The two short sides are surmounted by triangular pediments containing sculptural groups; the pediments are framed by protruding strips called *cornices*. Columns within the cella support the ceiling and the roof. In the larger of the two cella chambers and facing the entrance was a huge gold and ivory statue of Athena, patroness of the city.

In older temples such as the "temple

of Poseidon" at Paestum (Fig. 2-15), the cella and columns were made of stone and roof of tile. In the Parthenon and some other Classical temples, marble was used for columns, the cella, and even, in the form of thin slabs, the roof. The ceiling beams and the roof structure were of wood. In the Parthenon, however, a ceiling and lintels of marble were used between the outer columns and the cella (Fig. 2-17).

The outside columns of the Parthenon stand on a platform surrounded by two steps. They are surmounted by a marble structure known as the *entablature* (see Fig. 2-18). It consists of one or more longitudinal lintels, called the *architrave,* surmounted by a frieze divided by groups of three vertical ridges, the *triglyphs,* which appear over each column and also midway between them. On the Parthenon the slabs between the triglyphs, called the *metopes,* were all carved (Fig. 2-24). The Parthenon also has a continuous carved frieze running above the rows of inner columns and along the outside of the

two long walls of the cella (Fig. 3-5). The columns have fluted shafts (shafts decorated with semicylindrical vertical grooves) and are surmounted by very simple *capitals* consisting of a flaring cushion (*echinus*) topped by a square slab (*abacus*).

The basic scheme of the Classical temple is derived ultimately from dark-age shrines that had stone and mudbrick walls, wood columns, and thatched roofs. Such buildings have disappeared, but we may get an idea of what a simple early sixth-century shrine was like from the house of Peleus on the François vase of about 570 B.C. (see Figs. 2-5b and 2-19). The house clearly has a wood structure and stone or mudbrick walls, and we recognize many elements similar to the Parthenon, such as the fluted columns with their echinus and abacus. The abacus had a specific function in the wood structure: it helped even out the thrust between the columns and the lintel. There are triglyphs over the lintel; they must be the carved ends of the transverse beams

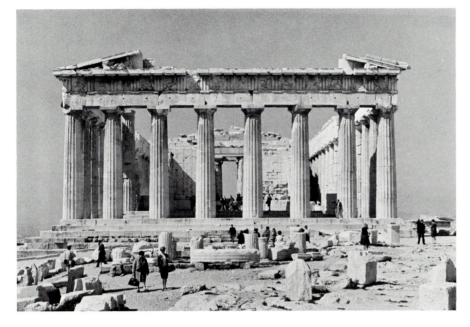

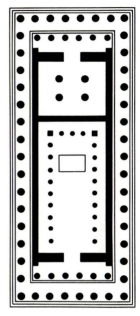

supporting the roof. The little pegs under the triglyphs, which we find reproduced in stone in later temples, are clearly meant to hold lintel and beams firmly together.

One must conclude from this that the Greeks, in creating their monumental architecture sometime in the eighth or seventh century, went through the same processes as the Egyptians had: they simply translated into stone the motifs of earlier wood constructions, making due allowance for the properties of the new material. The Greeks, however, were too practical to insist on stone for every detail, as the Egyptians had done in their temples; the Greeks' roofs were constructed of wood. This made it much easier to span the cella, and in the case of the Parthenon, for instance, to provide room for the gigantic statue of Athena, a feat that would have been totally impossible in the cluttered hypostyle hall of an Egyptian temple. The Greeks, furthermore, did not hesitate to use iron at times to reinforce individual sections and so achieve a greater lightness; there are con-

cealed iron girders supporting the pediments of the Parthenon.

The architectural details of Greek temples mentioned so far belong to what has been called the Doric *order,* or style. It was not the only Greek order. From the settlements of Asia Minor came a somewhat different arrangement known as the Ionic order, which had been developed in the sixth century. Characterized by a capital consisting of a double volute, no doubt derived from an Oriental motif, it made its appearance in Athens in the fifth century in the form of four Ionic columns in the cella of the Parthenon. In the fourth century a new capital, this time based on a foliage motif, was introduced, thus giving rise to the Corinthian order. The three orders are shown in Figure 2-18.

The extraordinary refinements that mark the evolution of the Doric order between the middle of the sixth century B.C. and the era of the Parthenon may be gathered from a study of three temples. In Paestum, an ancient Greek colony in

southern Italy, the so-called *basilica* (foreground of Fig. 2-14)—which is now known to be a temple of Hera—is a mid-sixth-century building in the Archaic style. It has tapered columns with markedly bulging sides, and the echinus atop each protrudes considerably. The pronounced curves of shaft and capital somehow bring to mind the allusions to natural forms in Egyptian columns. By comparing the columns of the "basilica" to those of the so-called temple of Poseidon (Fig. 2-15) built in the second quarter of the fifth century, and then to those of the Parthenon (Fig. 2-16), begun soon after the Poseidon temple was completed, we note a steady progression: the columns become longer and less tapered and the curvature of the sides becomes infinitesimal. The echinus is less pronounced, and the abacus is narrower. The effect is one of greater ease and refinement. Simultaneously, the entablature becomes comparatively thinner. In the boldest change of all, the short façade of the Parthenon has been given eight columns instead of the

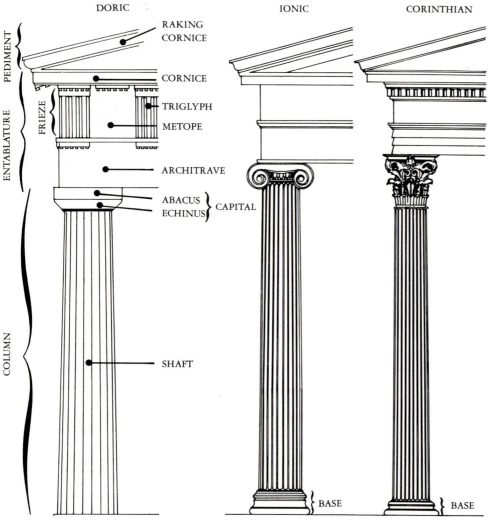

DORIC IONIC CORINTHIAN

PEDIMENT

ENTABLATURE

FRIEZE

COLUMN

RAKING
CORNICE

CORNICE

TRIGLYPH

METOPE

ARCHITRAVE

ABACUS
ECHINUS } CAPITAL

SHAFT

BASE BASE

usual six. As a result, the Parthenon and other temples of the High Classical period are characterized by a new balance between horizontal and vertical elements and they convey a new sense of ampleness, majesty, and unity.

Let us note, too, that with the advent of columns that had almost cylindrical shafts, temples took on a more geometric appearance: whether made of a rectangular block surmounted by a triangular prism, like the Parthenon, or of a cylindrical drum like certain other temples, the religious structures of Classical Greece all have striking geometric simplicity and purity. In their nearly infinite subtlety, the Greek architects went so far as to make all the horizontal lines slightly curved and convex and to make the shafts of the columns converge at the top by an almost imperceptible amount. These refinements all contributed to softening any harshness that might have been occasioned by the rigorously geometric composition of the building.

The extraordinary care that the Greeks devoted to harmonious overall proportions and to subtleties of detail is characteristic of their dedication to visual perfection. Indeed, their very search for clear and immediately pleasing forms accounts for every major difference between Greek and Egyptian temples. For instance, the Parthenon is much smaller than the temple of Luxor (Fig. 1–8). For the Greeks, size and massiveness were no

2–18 Greek orders: Doric, Ionic, Corinthian.

2-19 Detail drawing of the François vase: *House of Peleus* (see Fig. 2-5*b*), c. 570 B.C. (*comparative illustration*).

longer significant, but grace, order, and precision were. The Egyptian temple cannot be taken in all at once: from the outside one sees only high walls and pylons, and inside there is a bewildering succession of halls and courts. In contrast, standing as it does on a height, the Greek temple displays its beautifully proportioned colonnades to all and its symmetry makes it easy to grasp all at once.

Furthermore, the axial plan of the Egyptian temple is obviously related to the frequent processions required by the cult; its series of halls and courts was meant to provide a succession of moods as the participants penetrated into ever darker and more remote sacred precincts (Figs. 1–8 and 1–9). In contrast, the visitor entering the cella of a Greek temple had the statue of the god or goddess right before his eyes. In the Parthenon he was greeted by the majesty of Pheidias' Athena, faintly illuminated by the light reflected from the marble porch. For the Greeks, well-proportioned forms were tangible manifestations of a superior harmony, and the highest tribute they could pay their deities was to suggest an ideal order behind physical appearances.

The Athena has disappeared from the Parthenon and is known only from crude ancient replicas, but a number of the Parthenon's sculptures have survived. They are by Pheidias' assistants, if not by his own hand. The battered figure of Dionysos of 438–432 B.C. (Fig. 2–20), from the left corner of the east pediment, is the only reasonably complete marble male figure that has survived from any

of the great workshops of the High Classical period. Dionysos, the god of the vine, is shown here lounging nonchalantly, while behind him, in the center of the pediment, Zeus was depicted giving birth to Athena from his brow.

If we compare Dionysos to the Apollo of Olympia (Fig. 2–10), we realize at once that great progress had been made in twenty years. Despite the twist of the head, the position of Apollo is still essentially frontal. The attitude remains a little stiff, and there is a certain hardness in the modeling of the flesh; the muscles of the abdomen in particular recall, if distantly, the rigor of Archaic times. In contrast, not only is the body of Dionysos shown in a reclining position and curving gracefully in a plane parallel to the pediment, but the legs are crossed while the body is twisted axially in one direction and the head in the other. The various parts of the body are now totally free to assume any direction in space with complete ease. The muscles themselves seem to have been blocked out in broad masses linked by smooth transitions, so that if one cannot yet talk of the softness of the flesh, one is nevertheless aware of a quality of organic flow.

There is a new casualness in Dionysos' attitude, yet the nobility of the Apollo is still present. Dionysos is quietly contemplative, absorbed in thought, it would seem, as if he were distantly aware of the momentous birth of Athena behind him. The composition itself, dominated as it is by a deceptively simple system of repetitive curves, suggests both

vigor and majestic grace; the powerful muscular lines of the edge of the figure's left pectoral, the lower boundary of the thorax, and the iliac depression over the hip form a solemn and gracefully rhythmic pattern, while the slightly bent arms and legs, each in different positions and at different angles, also create stately rhythms. For all his strides toward naturalism evident in the depiction of a well-proportioned, subtly modeled body able to move freely in space, the artist was still very much interested in suggesting, through both the harmony of form and the spirituality of the expression, a lofty idealism.

It should be pointed out that Pheidias was not the only one responsible for the technical evolution that led to High Classical developments. Myron, whose activities lie between 480 and 445 B.C., succeeded in depicting athletes at the height of action, and he is probably responsible for the sense of three-dimensional freedom noticed in the Dionysos. Polykleitos, who was a contemporary of Pheidias, refined the system of proportions of the early Classical period and composed some of the most harmonious nudes of Classical times. Unfortunately, his works are now known only through later replicas.

The combination of a quite considerable interest in naturalism on the one hand and a lofty spirituality achieved through harmony of forms and nobility of expression and subject matter on the other is characteristic of the High Classical period. Indeed, the better artists attained a balance between the physical and

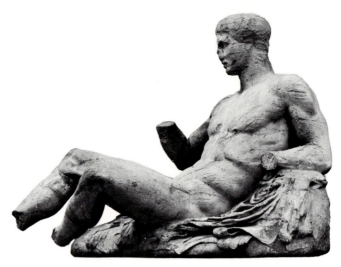

2-20 Workshop of Pheidias, *Dionysos,* from the Parthenon, c. 438–432 B.C. Marble (over life-size). British Museum, London.

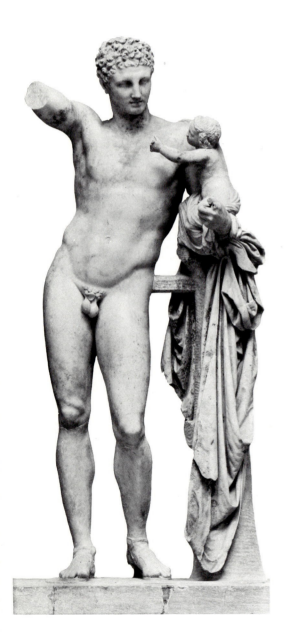

2-21 Once attributed to Praxiteles, *Hermes and the Infant Dionysos,* c. 330–320 B.C. Marble (7′ 1″ high). Olympia Museum.

the spiritual such as was never to be attained again in the course of many classical revivals of succeeding centuries. Their attitude heralds the thought of the philosopher Socrates, who lived in the second half of the fifth century B.C., and that of his disciple Plato. Attempting to see beyond the paradoxes and inconsistencies of everyday life, they postulated a superior, divinely inspired harmony, which seemed to permeate the workings of man's reason and his moral and spiritual strivings, just as a higher mathematical order seemed to permeate the functioning of the universe.

The High Classical period was not to last long, however, for Athens' political supremacy was short lived. A series of wars with her neighbors during the last third of the fifth century greatly reduced her economic power, and an added scourge, an epidemic of the plague, took a heavy toll of the population. Conditions deteriorated further during the fourth century, and the leadership of the Greek world passed from Athens to the northern kingdom of Macedonia. In 338 B.C., the Macedonian ruler Philip II conquered all Greece and made plans for a vast territorial expansion, which were carried out by his son Alexander the Great, who succeeded him in 336. First the traditional enemies of Greece, the Persians, were

defeated in a series of battles in which comparatively small, highly mobile forces led by brilliant young officers routed vast, heavily armed, but slow and tradition-ridden Oriental armies. Alexander went on to conquer Egypt and had even reached northern India when he died in 323, after which his empire was promptly broken up into huge fiefs ruled by his generals.

The significance of Alexander's conquests was enormous. A highly intelligent and highly educated Greek—he was the pupil of Aristotle, who himself had been a pupil of Plato—Alexander brought Greek ideas and ideals into the very heart of the old Near Eastern empires, while scrupulously respecting local traditions and encouraging his men to marry native women. Greeks were at the same time already well established in colonies in Sicily, Italy, Spain, and North Africa, and the process of Hellenization (after the Greeks' own name for their people, Hellenes) gained momentum throughout the Mediterranean basin and the Near East and had a decisive impact on the development of Rome. The influence was reciprocal, and Greek rulers in Africa and Asia began to think of themselves as divinely appointed, like Oriental despots. The Greek mainland remained under Macedonian rule, and the people, as aware of their potential as of the fact that fate and fortune seemed to have passed them by, developed a skepticism that verged on cynicism: all pleasure was good and might was always right.

Nevertheless, some of the greatest minds of the period were of Greek culture

and descent. Foremost among them were Aristotle (384–322 B.C.) and the members of his school. Aristotle himself was endowed with immense intellectual powers and did much to systematize Greek thought and knowledge. He established the foundations of logic and set about investigating the physical universe with what we would now call a scientific spirit. His thought dominated the various cultural centers that emerged, from the fourth century on, throughout the Mediterranean world. In such Hellenistic centers as Alexandria in Egypt and Syracuse in Sicily, the groundwork of modern mathematics, astronomy, geography, and mechanics was laid by Greeks and their students. Hellenistic thought also gave birth to philosophical systems such as Stoicism that were to have a profound impact on late antiquity and, eventually, on the formation of modern thought. Finally, the art of the Mediterranean basin and the Near East was deeply affected by Greek art. Although the term Hellenistic is reserved for the cultural developments that took place after Alexander's death, we shall see that the principal characteristics of Hellenistic style had already made their appearance in the late Classical art of the mainland in the fourth century.

The marble statue of Hermes carrying the infant Dionysos (Fig. 2–21) was once thought by some to be an original work by Praxiteles (active c. 370–330 B.C.), one of the principal Greek sculptors of the fourth century, but many scholars believe it to be a Roman copy of a lost original by that artist. It dates from about 330–320

B.C. and is thus roughly contemporaneous with Alexander's reign. Let us compare it with the Parthenon Dionysos (Fig. 2–20).

The most obvious difference is the handling of the flesh. In the older statue the transitions between muscular masses create a sense of organic flow, but the treatment of the surface retains a certain hardness; it seems that the artist still sought to preserve a marble-like quality. In the Hermes, the flesh has acquired a new softness. Indeed, the artist created over the whole surface of each body gentle modulations that produce a softly variegated pattern of light and shade and create the illusion of the consistency of the skin and the fatty tissues under it.

There are other evidences of this new optical illusionism. Looking back to the statue of Apollo at Olympia (Fig. 2–10), we notice that the hair has a quite unnatural regularity. Hermes' hair, on the other hand, is an irregular series of circular ridges in high relief that creates the same light-and-shade effect as human curls. Other effects are just as striking: the almost imperceptible transition between the gently curved edge of the lower eyelid and the eye suggests the wateriness of the eye, and even the drapery, with its almost infinite variety of light and dark transitions, suggests the consistency and weight of real cloth. The softness of the edges and the soft play of light and shade contribute to illusionism in yet another way: they suggest that the forms appeared somewhat blurred, as they would be seen through the surrounding air. It has be-

come common to refer to this treatment as simulating a delicate atmospheric sheath.

Optical illusionism, which was born in fourth-century Greece, was to become one of the important aspects of Hellenistic sculpture and reappeared in several later periods that paid much heed to the "real" appearance of things—notably the Renaissance and the nineteenth century—sometimes to the detriment of artistic values.

In keeping with this new interest in appearances, facial features are much more individualized than they were in the fifth century. Although the artist was still utilizing a complex system of proportions and was paying attention to the rhythmic quality of the design, he did not idealize the features as much as, say, the sculptor of the Apollo of Olympia (Fig. 2–10). In the Hermes we recognize a specific person.

It is difficult to judge the overall composition of the Hermes, since both legs below the knee (except for the right foot) are modern. We can see, however, that the majesty of the Parthenon figures has made way for a more graceful bearing and a sensuous manner. The ratio of body to head is larger, introducing a new elegance. The body, which leans against the support with consummate grace and a certain abandon, has a lateral sway, with the hips at an angle to the horizontal (*déhanchement*), as well as an axial twist, a rotation between the line of the hips and the line of the shoulders. This combination of lateral sway and axial twist is known as *contrapposto*. The attitude itself

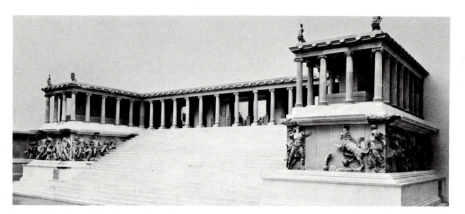

2-22 West front of the Great Altar of Pergamon, c. 180–160 B.C. (Reconstructed at the Staatliche Museen, Berlin.)

2-23 Detail of the frieze of the Great Altar of Pergamon: *Athena Battling with a Titan*. Marble (7′ 6″ high). Staatliche Museen, Berlin.

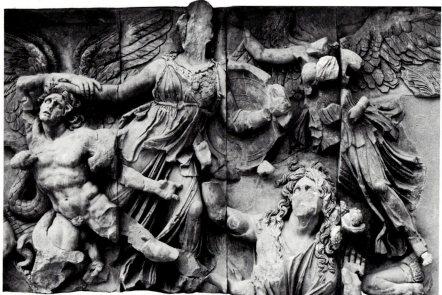

is playful; Hermes teases the child by dangling an object before him (a bunch of grapes, presumably, since Dionysos is the god of the vine) as the infant tries to reach it. Thus not only has the artist placed a greater stress on sensuous appeal than ever before; he has also introduced a new insistence on a purely human quality.

Praxiteles and his followers were particularly inclined to treat graceful and beguiling subjects. The other great sculptor of the period, Skopas, and his followers are reputed to have excelled at depicting struggling bodies and brooding expressions. The two schools, however, shared a very important new concern: their figures are even more detached from their environment than the Dionysos of the Parthenon. They are almost totally absorbed in their own thoughts and, indeed, seem to be lost in a very personal daydream. For the first time we become aware of the private world of the individual. Man is no longer an actor in a preordained sequence of events; his whole being begins to reflect a rich and varied inner life.

The Classical ideal of balance and harmony was short lived. From the end of the fourth century on, artists began to use their newly found mastery over form to stress an excessive, and therefore frequently unconvincing, illusionism and to suggest a disquieting animation in the figures. The works produced in this next period can be esthetically pleasing and exciting, but the moving simplicity of expression and lofty idealism of the Clas-

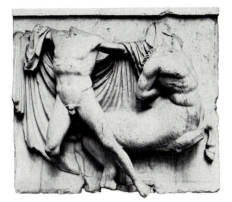

2–24 *Lapith and Centaur,* metope from the Parthenon, c. 440 B.C. Marble (4′ 8″ high). British Museum, London (*comparative illustration*).

sical phase are usually missing, and all too often drama becomes theatricality. A somewhat similar stylistic development occurred after the High Renaissance in Europe, during the brief period usually referred to as Mannerist. The term *manneristic* may therefore be applied to certain aspects of Hellenistic art of the third and later centuries.

The frieze of the Great Altar of Pergamon (180–160 B.C.) is a case in point. It was the principal decoration of a monumental altar (Fig. 2–22), erected by the Hellenized king of Pergamon in Asia Minor in honor of his predecessor's victories over invading barbarians. The subject of the frieze is the combat of the principal Greek gods and the Titans. The latter were primeval beings supposed to have inhabited the universe at its beginning. The victory of the gods over the Titans was doubtless intended to refer to the triumph of civilized values over brute force and probably also to allude to the recent Pergamene triumphs. In the section illustrated in Figure 2–23, Athena grasps the hair of one of the Titans as though to lift him off the ground, while her sacred serpent grapples with him. In the center, the giant's left foot touches the figure of his distressed mother, Gaea, the goddess of the Earth, as if to gain strength from this contact. The action is completed by a winged Victory crowning Athena. There are reasons to believe that the scene was directly inspired by the now-destroyed central part of the west pediment of the Parthenon. Since we cannot study the stylistic differences be-

tween these two, let us instead compare the Pergamene relief with the fight of the Lapith and centaur from a metope of the Parthenon of about 440 B.C. (Fig. 2–24), which, as we have seen (p. 25), also symbolizes the triumph of civilized values over brute force. The Pergamene artist obviously took delight in creating a collection of writhing human and animal forms. In addition, all the innovations of naturalism have been drawn upon. There is considerable illusionism in the richly modeled flesh and deeply carved hair, which adds to the sensuous appeal of the figures. Contracted muscles suggest violent efforts, while the varied directions of limbs and bodies, creating a crisscross of diagonals, evoke powerful movements. The elegant draperies floating in the wind add further to the sense of animation. The overall impression is one of frenzied activity.

The composition of the Parthenon metope is much more restrained. The figures of the Lapith and the centaur, which stand out in high relief, form a simple but subtle pattern against the background; the left arm of the Lapith is parallel to the back of the equine part of the centaur, while the torso of the Lapith and the human torso of the centaur form curves that converge toward the top. The outstretched leg of the Lapith creates a powerful diagonal accent across the composition that balances the gesture of his missing right arm, which is about to smash a rock against the centaur's head. The Lapith's drapery creates an elegant, nearly symmetrical pattern that sets

off the smooth forms of the bodies and helps to suggest an aura of dignity and grace about the figures.

The simple juxtaposition of the vigorous yet graceful stance of the Lapith and the struggling form of the centaur has a forceful impact, yet at the same time the harmonious sobriety of the whole design is in keeping with the artistic ideals of the time. In contrast, there is more than a touch of incongruity in the Pergamene sculpture; in this death struggle, the Titan is trapped in the serpent's coils and is being bitten on the chest, yet the artist was still too imbued with the spirit of fourth-century sculpture to suggest the full frenzy of a desperate fight; the Titan remains graceful and perhaps a little languid, and his half-imploring, half-meditative expression brings to mind the detachment and inner-directed thoughtfulness of Praxiteles' young athletes. The effect is less dramatic than theatrical. It is the superficiality of the expressions and mannered quality of attitudes and gestures, no less than the emphasis on a complex and animated surface design, that has caused this and similar Hellenistic works to be labeled manneristic. Paradoxical as it may seem, however, it is precisely in its theatricality that much of the interest of the piece lies. The artificiality of the expressions no less than the sensuous appeal of the bodies and the graceful dynamism of the overall design are magnificent echoes of a period that was as addicted to intellectual skepticism as it was to dreams of glory and the pursuit of excitement.

3

Rome

By the second century B.C., the major power in the civilized world was Rome. After ridding themselves of Etruscan overlords in the sixth century, the Romans had established an oligarchic Republic ruled by elected magistrates with despotic powers. Vigorous, disciplined, and enamored of military valor, they waged successful campaigns against their neighbors in the Italian peninsula and established their supremacy over Spain and part of the North African coast. From there they went on to break the power of Alexander's successors: Greece came under their control during the second century B.C., as did Asia Minor, and Egypt fell during the first century B.C. In the North and West, Roman generals took Gaul (present-day France), much of Great Britain, and part of Germany.

Meanwhile, however, the civil administration of Rome showed signs of serious strain. It was weakened by frequent and bitter class feuds, and the very framework of the original city government was ill suited to ruling a vast empire. Temporary

military dictatorships were frequently established, and in 45 B.C. the victorious general Julius Caesar, who had marched on Rome at the head of his army, became "perpetual dictator." His death the following year resulted in a period of anarchy. Eventually Caesar's great-nephew, Octavian, triumphed over other contenders in 27 B.C., reestablishing the old Republican institutions, but in name only, while in fact assuming absolute powers as Augustus Caesar.

Like other world conquerors after them, the Romans thought of themselves as being entrusted with a civilizing mission. They duly revered the arts, but it was with efficient government that they felt they could make their greatest contribution: "Let others," says a character in Virgil's *Aeneid,* "beat out softer lines from the bronze and draw life-like features from the marble—thou, Roman, must think of ruling the people, these are your arts: to impose law in peace, to spare the humble and tame the haughty." Indeed, the Romans were perfectly willing to accept

the artistic superiority of other peoples; they had no compunction about borrowing styles and artists from their neighbors and, on occasion, plundering masterpieces from occupied lands to adorn their cities. Art was merely a means to make everyday life more meaningful; it enhanced the dignity of government and contributed to the attractiveness of cities and the luxuriousness of the abodes of the rich.

The attitude of the Romans toward art can be explained partly by their early religious beliefs, which centered about spirits—or rather "powers"—that affected life in the home and the field. The home spirits were worshiped in various parts of the house such as the door and the hearth; the field spirits, on sacred hilltops and in groves. Unlike the Greeks, the Romans did not assign specific human forms to these early deities (their myths were not fully *anthropomorphic,* to use the technical term), and, as a result, they did not have the same sense of the sacredness of carved and painted images as had the Greeks. During the last two centuries of

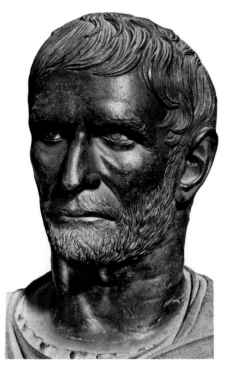

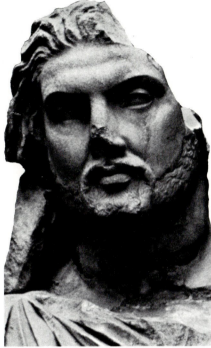

3-1 So-called *Brutus,* third or early second century B.C. Bronze (16½″ high, with neck). Palazzo dei Conservatori, Rome.

3-2 So-called *Mausolos,* from Halicarnassus, detail, second century B.C. Marble (height of whole figure, 9′ 10″). British Museum, London (*comparative illustration*).

the Republic, the Romans adopted much of the Greek mythology (simply changing the names of the gods) and of the traditional Greek ways of representing their deities, but with reservations, particularly regarding the gods' less edifying adventures. The educated classes turned increasingly for ethical guidance to the Greek philosophical systems that had blossomed in Hellenistic times. Toward the end of the Republic, in particular, there was considerable interest in Stoicism, which must have suited the Roman temperament because of its acceptance of reason as man's superior faculty and because of its stress on personal integrity and self-discipline. Stoic thought postulated the existence of a pervasive divine spirit controlling, somewhat remotely, all aspects of life and thus provided an important first step toward monotheism.

A bronze head of the third or early second century B.C. (Fig. 3-1) embodies all the elements that seem to have been blended in varying proportions in the art of the Republic. It was once thought to

be an effigy of Brutus, the legendary figure who threw the last Etruscan king out of Rome and helped found the Republic, but more likely it is a funerary portrait, quite possibly the work of the early Roman's neighbors and one-time overlords, the Etruscans. Let us compare it to a Hellenistic work of the second century B.C., a marble portrait once believed to be that of Mausolos (Fig. 3-2), a fourth-century ruler in Asia Minor near whose monumental tomb at Halicarnassus it was found. The differences are striking. We perceive individual features in the head of "Mausolos"—a massive, somewhat pudgy face, full and sensuous lips, intense eyes—and we are made aware of his thoughtful attentiveness. Nevertheless, the idealization evident in the treatment of the features and in the overall proportions suggests the lofty remoteness of the Classical tradition. Indeed, although the Hellenistic artists had given birth to a highly naturalistic manner and, in particular, to realistic portraiture, late in the fourth and third centuries B.C., they had

retained the Greeks' traditional inclination to ennoble their subjects.

The Romans of the Republican period, and their Etruscan neighbors, for their part, stressed strength of character and perspicacity, but they clearly sought to reveal the personality of their subjects with a new frankness, and did not hesitate to portray ugliness as well as beauty. In the so-called Brutus, we are struck by the artist's insistence on individual traits: the long nose, the wide, thin-lipped mouth, the massive bone structure, the leathery skin, and the care-worn furrows around the mouth all bear the stamp of a unique human being.

The artist was clearly attempting to give his subject an exalted image, as the very embodiment of Republican values. The expression is stern and impassive, as one might expect of a dedicated citizen of the Republic, while the glance has the piercing sharpness of a leader in civic affairs. At the same time, the subject's personality is frankly depicted. There is a slightly embittered, disillusioned twist

to the mouth that somehow adds a human dimension to the determination expressed in the whole face. This frankness, which scholars have referred to as *verism,* is characteristic of both late Etruscan and early Roman art. It seems to have had a special appeal to the peoples of the Italian peninsula, who obviously saw in the more realistic portraiture of Hellenistic times a rich source of inspiration.

The Roman artist had a considerable knowledge of Hellenistic technical devices. The deep grooving of the hair creates illusionistic light-and-shade effects, and there is even a touch of Hellenistic mannerism in the overly graceful curvature of some of the tufts. In one important respect, however, the sculptor betrays a less sophisticated tradition. The features, particularly the furrows around the mouth and the intersections of the lower eyelids and the cheeks, have a harsh and somewhat clumsy *linearism*—a tendency to stress the lines in a composition, sometimes to the detriment of the naturalistic modeling of surfaces—that goes back to the stress on decorative patterns of the Archaic Greek tradition. This is not surprising, for that tradition had had a profound impact on Etruscan and early Roman development.

Roman art came of age with the founding of the Empire. For the sake of convenience, the year of the recognition of Augustus as sole ruler of Rome, 27

2-21 Once attributed to Praxiteles, *Hermes and the Infant Dionysos,* c. 330–320 B.C. (*comparative illustration*).

B.C., can be taken as the dividing line between a Hellenistic-dominated and a truly Roman culture. Augustus' own great marble statue of around 19–15 B.C. (Figs. 3–3 and 3–4) was probably executed by a Greek artist, but it embodies new developments that came to be characteristic of imperial Roman art. Elements of the earlier veristic tradition are present, but they are subdued: the long, thin, slightly arched nose, the prominent cheekbones, the long furrows under the eyes, the fleshy chin, have all been carefully observed by the artist, yet the overall treatment of the features reflects the search by the Classical Greeks for harmony and idealization. Indeed, the proportions of the body and the very attitude of the emperor are derived from a lost sculpture by Polykleitos, and a comparison with a work by another sculptor, the Hermes once attributed to Praxiteles (Fig. 2–21), reveals that the figure of Augustus owes much to the *contrapposto* of Greek Classical nudes.

The artist was clearly also familiar with the more sophisticated techniques of Hellenistic sculptors; the way in which the locks of hair over the nape of the neck are suggested by deep grooves and the way in which the hair fades away at the level of the temples are both effectively illusionistic. On the other hand, one detects a simplicity of execution and a firmness of modeling that contrast with the subtle treatment of undulating surfaces and the slight blurring of edges of the Hermes and that seem to hark back to the art of fifth-century Greece. This is not

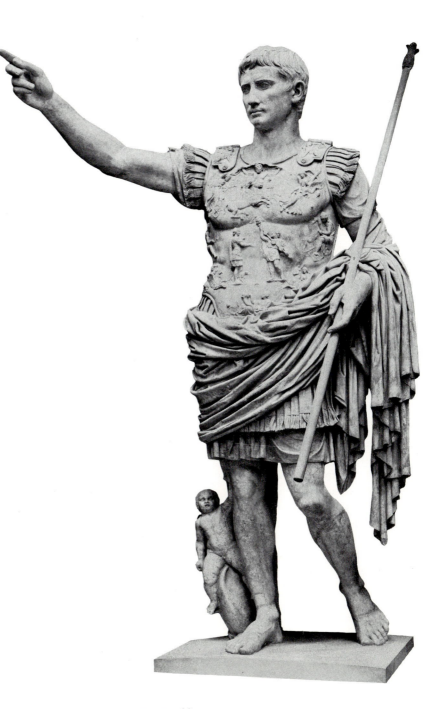

surprising, since the Augustan revival seems to have been brought about by a genuine love and understanding of fifth-century Greece among members of the imperial household and the group of writers and artists it had attracted, including the poet Virgil. This combination of Roman verism, Hellenistic illusionism, and a striving for the simplicity and sense of harmony of the Classical period set a pattern that was to characterize Roman art over the following three centuries.

Although Augustus maintained that he was only the first among equals, the statue was clearly intended to glorify the imperial regime in the person of the emperor, who was expected to combine the best attributes of the ruling classes of the Republic, and of the men who were defending and expanding the Empire. Thoughtfulness, patience, and respect for tradition belonged to the first, decisiveness, courage, and physical skills to the second. Moreover, in spite of the realism of the features, we detect not one hint that Augustus' climb to power was punctuated by crime and intrigue; traditional Roman frankness has made way temporarily for a classicizing loftiness. A number of allegorical motifs extoll the distinction and achievements of the emperor. The child and dolphin on the side allude to his divine ancestry (the dolphin is a symbol of Venus, to whom Augustus was allegedly related, and the child is the

3-4 Statue of Augustus, from Primaporta, c. 19–15 B.C. Marble (6′10″ high). Vatican Museum, Rome.

3-5 Panathenaic frieze, detail of *Men and Boys Leading Sacrificial Cattle,* Parthenon, 442–432 B.C. Marble (height, 43″). Acropolis Museum, Athens (*comparative illustration*).

3-6 *Sacrificial Procession,* relief from an imperial Roman altar, probably A.D. 47. Marble (6′4″ long). Louvre, Paris.

goddess' son Cupid), while figures on his armor symbolize the victories and the age of plenty he had brought to Rome. Judging from the statue, Augustus probably intended to be admired rather than worshiped although, in the wake of Alexander and the Near Eastern monarchs before him, he was acquiring divine stature. Indeed, in the eastern provinces of the Roman Empire, he was worshiped as a divine being and deified after his death.

Like the Eastern rulers, the Roman emperors had important events in their lives commemorated in paintings and sculpture. Many such works are battle scenes. Other events, such as the completion of administrative programs, could not be represented concretely, however, and the carved reliefs commemorating them portray the processions and sacrificial ceremonies held in their honor. The latter works were real or imagined forerunners of the group portraits of Baroque times and the official photographs of our present era.

If the theme of the glorification of

the emperor went back to the great Eastern civilizations, the actual representation of sacrificial processions seems likely to have been influenced by such Greek prototypes as the Parthenon frieze of 442–432 B.C. Figure 3–5 represents a section of that frieze in which men and boys lead cattle to sacrifice in the quadrennial Panathenaic procession in honor of the goddess Athena. Since the Parthenon frieze depicts the populace of Athens marching toward an assembly of the gods, it probably represents the mythical prototype of the ceremony at the time of the founding of the city. Figure 3–6 shows a sacrificial procession during imperial times in Rome and probably dates from A.D. 47. The figure at the right (whose face and right arm are modern) offering the sacrifice is possibly the Emperor Claudius or a senior official.

The similarities are obvious. The Roman work is still in the classicizing tradition of the Augustan era. We find the same modeling of the figures in the half round against a vertical background

as in the Parthenon frieze and the same search for linear elegance in the composition. The Roman artist, however, was much more intent on naturalistic effects. He employed optical illusionism both in the rich patterns of light and dark in the deep folds of the drapery (although the softening that suggests an atmospheric effect is less pronounced than in some Hellenistic work) and in the way that some lightly modeled figures seem to vanish into the background. The matter-of-fact depiction of the faces and the detailing of the animals reflect a characteristically Roman interest in realism. Finally, there is a much greater interest in spatial representation. The little trees behind the altar suggest an outdoor setting. The figures, gesticulating and glancing in several directions, overlap in many areas and appear to form several rows. Notice, however, that the dominant effect is still shallow: the group still seems to be contained between two vertical planes parallel to the surface.

In the Parthenon frieze, the modeling

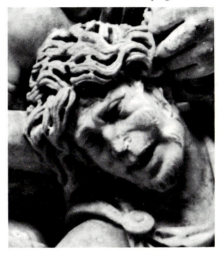

is gentler and somewhat shallower. Although the figures overlap in many places, the procession rarely appears to be more than two figures deep. Gestures and glances, moreover, run parallel to the surface, and the simple repetitive rhythms of the composition further stress the integrity of the pictorial plane.

A clear difference can also be seen in the expressive content of the two works. However well-proportioned and elegantly draped the figures in the Roman relief are, their attitudes and gestures suggest the casual confusion of a mundane occurrence. In the Parthenon frieze, the figures are just as lively, but there is a reserve in their bearing that conveys a truer piety, in keeping with the loftiness of the mythical vision. The influence of Classical Greece on Roman art is nevertheless very strong, and it should not come as a surprise that the term Classical antiquity has come to refer to the golden age of both Greek and Roman cultures. The endeavors of later men to return to their common ideals are called *classicism*.

The subsequent two centuries saw major evolutionary changes in Roman art. One of the most remarkable developments was the appearance of a dramatic narrative mode. The so-called Ludovisi sarcophagus, dating from after A.D. 250, is a mature example of this manner (Fig. 3-7). Made to contain the remains of an emperor or general, it appropriately shows him on horseback in the center of a battle between Romans and barbarians.

The work reflects a startling change of technique: the neutral background that was the rule in all earlier traditions—and that remains a hallmark of classical revivals—has disappeared. The figures are so close together and in such high relief that they seem to emerge from the dark areas around them. Furthermore, the figures themselves are deeply undercut, creating strong shadows in the areas of the hair, the eyelids, and the mouths. The result is a far more dramatic scene than we saw in the Pergamon relief (Fig. 2-23). Part of our response to the work stems from its comparative lack of clarity: the com-

position is so complex, with so many simultaneous actions, that we cannot grasp the scene all at once. We can therefore give free rein to our imaginations, visualizing the scene as more extended in time and space than the artist could possibly have represented. The very animation of the figures invites us to experience the intensity of the battle. And the potent play of light and shade over the features makes possible the suggestion of a vast range of expressions, from firmness and determination on the part of the Romans, who are going about their task with chilling efficiency, to rage, suffering, and despair on the faces of the dying barbarians (Fig. 3-8). These same techniques were to be characteristic of a later era that strove for dramatic expression in its art, the age of the Baroque.

In his eagerness to achieve an expressive illusionism, the artist overlooked the naturalistic accuracy of a number of details. The Roman commander, for instance, is shown in front of his horse, although he is obviously meant to be

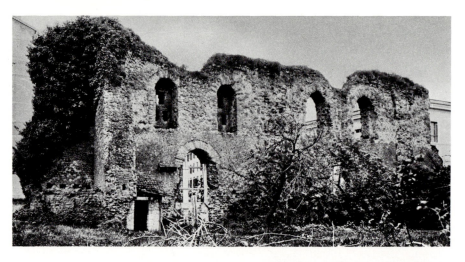

3-9 Porticus Aemilia, Rome, second century B.C.

3-10 Porticus Aemilia, reconstruction. (Model at Museo della civiltà romana, Rome.)

3-11 *Opposite page:* Pantheon, Rome, started in A.D. 118 and completed between 125 and 128.

seated on it. This marks a distinct departure from the attempt at objective rendering of forms in space that had so concerned artists of the Greco-Roman world since Archaic times. From this point until the demise of the Roman Empire late in the fifth century, such inconsistencies were to become increasingly numerous.

The Romans' chief contribution to art was in architecture. Above all else practical, they perfected concrete construction and vaulting techniques that they used to develop totally new concepts of composition in space. The religious architecture of the late Republic and early Empire was bound by tradition, and if it departed from Greek prototypes in some important aspects, it did not challenge the resourcefulness of Roman architects. Civil architecture, on the other hand, had to meet the demands of an ever more complex public life and gave architects opportunities to develop their most ingenious concepts. Figures 3-9 and 3-10 illustrate an end wall and a model reconstruction of the Porticus Aemilia, a warehouse in

Rome erected during the first half of the second century B.C., during the late Republican period. If we compare it to the warehouse of the Rameseum of the Egyptian New Kingdom (Fig. 1-13, p. 14), we realize that both consist of essentially a succession of barrel vaults supported by vertical walls. In the Egyptian work, the vertical walls have no openings, and the interior is broken up into parallel, tunnel-like, windowless galleries. In the Roman building there are not only arched openings through the vertical walls but ingeniously placed windows. Both the Roman and Egyptian buildings were fireproof, but the Roman one also provided easy access from any part to any other part of the structure, adequate lighting, and appropriate ventilation. No radically better formula for warehouse architecture was found until the introduction of iron structures in England late in the eighteenth century.

The key to this extraordinary Roman achievement was the use of concrete. From the beginning of the second century

B.C., the Romans used a mixture of stone rubble and mortar strengthened and made waterproof by the addition of a volcanic material called *pozzolana*. The result was very similar to modern concrete. It could be poured into wood forms and molded with considerable precision to create monolithic masses of great strength. The concrete was not left bare, as it often is today, but was faced with regularly cut stones and later with bricks. In the grandest buildings of imperial times, the brick itself was covered with marble.

The Romans evolved their own vocabulary of forms, in which the arch, the rotunda, the dome, and the rectangular block played major parts. The reign of Hadrian (A.D. 117–138) saw the culmination of a synthesis between the traditional forms of Hellenistic architecture, such as columns and architraves, and typically Roman concepts of space. The most audacious building of that period that has survived is undoubtedly the Pantheon (Fig. 3-11), started in 118 and completed seven to ten years later. The Pantheon

contained statues of major deities, but it was intended primarily to symbolize imperial glory and was, in fact, used by Hadrian as an audience hall.

In ancient times the building had a porticoed forecourt so that it could be viewed only from a comparatively short distance; the incoming visitor could see little more than the portico of the façade (which is still very much in the Greek tradition) and the high attic beyond it. The interior has not changed, however, and one can experience today very much the same sensations that a Roman would have felt as he entered the main part of the building. After walking between two rows of columns, one passes through a huge bronze door into an immense space defined by a cylindrical drum surmounted by a dome (Fig. 3–12). Vast though it is, the space is not awesome; somehow its proportions are reassuring. In their search for a harmonious effect the architects chose an overall height exactly equal to the diameter of the building—a simple relationship that the onlooker probably

perceives without actually being aware of doing so.

Several elements emphasize the circularity of the form: the continuous cornices, the network of intersecting ribs formed by the *coffers* (the geometric recesses of the dome surface), and finally the round opening at the top, the *oculus,* which is the Pantheon's only source of natural light. Yet the space is much more complex than appears at first glance. The surface of the drum is broken up by the rhythmic alternation of alcoves, each screened by two columns, and niches containing statues. The alcoves themselves are of two types, rectangular and semicircular. Opposite the entrance is a large semicircular domed recess, or *apse.* Niches and alcoves introduce an element of variety, articulate the space, and give an appearance of lightness to the whole design (Figs. 3–12 and 3–13). And the oculus, besides providing a surprising amount of light that is diffused gently throughout the space, allows a circular beam of sunlight to scan the wall and

floor and bring out the richness of the variously colored marble arranged in geometric patterns over their surfaces.

The technical skills that were needed to implement the vision of the architect seem awesome even in our own time. In order to reduce the weight of the dome, the builders used increasingly light and more porous rubble and gradually reduced the thickness of the shell as they proceeded from the rim to the center. The dome nevertheless creates enormous downward and outward thrusts on the rotunda, which are counteracted by the masonry walls that create piers twenty feet thick between the alcoves. The stability is further increased by heavy rings of concrete at the base of the dome and around the lower part of the drum. Within the rotunda and the lower part of the dome, series of vast tile arches help distribute the load onto certain reinforced bearing points (Fig. 3–14), a factor that must have been particularly important while the concrete was setting. The Pantheon is a considerable advance over the earlier

3-13 Plan of the Pantheon

3-14 Pantheon, diagram of structural elements

post-and-beam type construction (Fig. 1–11), which relied entirely on the effect of the weight of each stone on the stones directly beneath it. The much greater cohesiveness of the materials and the complex structural system used in the Pantheon make it superbly capable of resisting thrusts in a variety of directions. Not surprisingly, a great many Greek temples were destroyed by earthquakes within a few centuries of their completion, but Roman vaulted concrete constructions have shown remarkable hardiness.

The aims of the architects of this building differed totally from those of the men who built the temples of Egypt and Greece. Gone is the focus on the central axis and the processional effects of the Egyptians; gone is the emphasis on harmony and balance of the Greeks. Here the visitor is drawn into a space that is striking for its vastness and its simplicity, for its effect of lightness and airiness, for the richness of the wall decoration, and above all for the suggestion of the engineers'

easy triumph over gravity. The Romans compared domes to the vault of heaven, and there can be no question that this temple, in addition to symbolizing the majesty and glory of the emperor who built it, invited associations between the power and beneficence of Roman government and the eternal cosmic forces.

The major transformation that took place in the art of the Roman world in the third and fourth centuries marks the end of the first era of man's cultural development, the age of antiquity. The religious upheavals of the early centuries after Christ resulted in new attitudes and traditions and brought about a whole new era in the arts.

II

Early Christian and Medieval Eras

4

Early Christian and Byzantine Art

Religious life in pagan Rome was governed by strict rules. All Romans, particularly men in high office and their families, were expected to manifest devotion to the emperor and to the official gods. This did not prevent a great many people from worshiping gods of their own choice as well, however, and a host of minor cults, often inspired by Oriental religions, sprang up during the Empire. By the end of the first century A.D. a new religion, Christianity, had spread from the Near East and begun its profound impact on Western civilization.

The teaching of Jesus was essentially practical. For him, the kingdom of heaven was accessible to the true believer right on this earth. Jesus had little taste for metaphysics and, far from questioning the faith in which he was raised, he sought to make the Jewish Scriptures more alive to the masses through vivid parables. As the new faith was spread by the Apostles throughout the Hellenized world, however, it was profoundly colored by Greek philosophical thought. The Greek ideal of

ultimate perfection became embodied in God the Father, while Jesus became his incarnation on earth. The kingdom of heaven became more remote, to be attained only after death. To reach the minds of the people, suitable imagery was drawn from both the New and Old Testaments so as to give concrete form to the theoretical aspects of the new faith, much as ancient mythology had illustrated pagan beliefs.

From the very beginning, the violent death of Christ on the cross was interpreted as an atonement for human sin. As a wave of mysticism swayed men's minds in the second and third centuries, it came to symbolize the ultimate freeing of men's souls from the fetters of the material world and their eventual union with a divine being. The theme of the emancipation of the soul through Christ's sacrifice was to become central to Christian ritual and to much of the Christian artistic tradition.

The teachings of Christ appealed to men's simplest and most basic humanity

and for that reason had an early and profound effect on the humbler people, particularly in the large urban centers. During the first two centuries, congregations of Christians met in private dwellings. Houses used exclusively for worship were inconspicuous, and surviving monuments erected in honor of martyrs are equally modest. By A.D. 250 the new faith had gained so many converts, and vast congregations under the leadership of a well-organized clergy had become so influential, that large middle-class residences came to be converted into Christian community houses.

This growth had undoubtedly been accelerated by the momentous crises that were shaking the Roman Empire. Throughout the second half of the third century, Rome was attacked along all her borders. The various armies succeeded in protecting the great centers, but they themselves created chaos on the home front; on a number of occasions victorious leaders were proclaimed emperor by their troops and marched on the capital

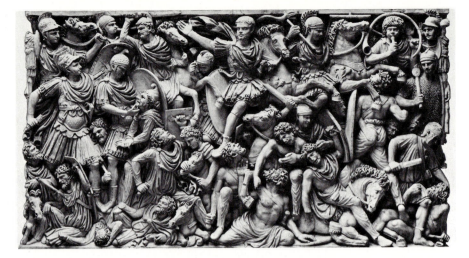

3–7 "Ludovisi" sarcophagus, after A.D. 250 (*comparative illustration*).

4–1 Christian sarcophagus in Santa Maria Antiqua, Rome, c. A.D. 270; marble.

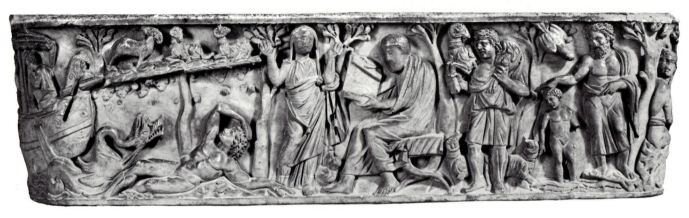

in an attempt to usurp power. The resulting disruption of political and economic life and widespread anxiety seem to have led to an increasing concern with spiritual matters and a renewed interest in mysticism.

Around the middle of the third century, the Roman authorities became seriously concerned with the growth of the new faith, particularly with the Christians' refusal to perform military service and to participate in official ceremonies in honor of the emperor. For about one decade, repressions, which had been isolated and sporadic until then, became particularly widespread and savage. After 260, however, the persecutions subsided, and Christian monuments clearly identified as such by recognizable symbols began to appear in increasing numbers. Paganism died slowly, however. Aristocratic and intellectual groups in many areas of the ancient world remained faithful to the old cults, and the Academy at Athens that had been founded by Plato and later became dedicated to the teach-

ing, called Neo-Platonism, of the more spiritual aspects of that philosopher's thought, remained an active center of paganism until it was closed by order of Byzantine Emperor Justinian early in the sixth century.

A comparison of the Ludovisi sarcophagus (Fig. 3–7) and a Christian sarcophagus of around 270 (Fig. 4–1), in the church of Santa Maria Antiqua in Rome, reveals the beginnings of an artistic language suited to the new faith. The vivid illusionism and the sense of dramatic narration that were so fully developed in the Ludovisi piece have all but disappeared in the Christian sarcophagus. If anything, the "processional" arrangement of the figures and objects against a vertical background takes us back to such classically inspired works as the frieze of the sacrificial procession from an imperial Roman altar of the first century A.D. (Fig. 3–6). And yet there are striking differences from that work as well. The figures in the Santa Maria Antiqua sarcophagus are crudely carved. The heads are too large

for the bodies, and spatial relationships are disregarded; the man lying on the beach, who is none other than the Old Testament Jonah, is far too large to have been swallowed and regurgitated all in one piece by the monster at his feet. Furthermore, the sense of continuity of the earlier scene is lost, and we are faced with a succession of apparently unrelated actions.

There can be no doubt that the sarcophagus was executed by craftsmen of limited competence and that this artistic decline reflects, in turn, the political and religious turmoil of the period. And yet this cannot be the only explanation for the change in artistic standards. Works of art of the highest craftsmanship were still being produced in Rome and the provinces, so we know that outstanding skill was available when there was a demand for it. It is much more likely that the attitudes of art patrons had changed; they no longer expected works of art to emulate physical reality but rather to allude to the life of the soul through a

4–2 Portrait of an unknown man, c. A.D. 240. Marble (8⅜" high). Capitoline Museum, Rome.

4–3 Head of a colossal statue of Constantine, A.D. 324–330. Marble (8' 6" high). Palazzo dei Conservatori, Rome.

language of visual symbols. The relative largeness of the head of each figure is thus undoubtedly meant to draw attention to it as the center of spiritual experience. And even more important, the drama and excitement of life in this world that characterized the Ludovisi sarcophagus is here replaced by a vision of peace and fulfillment in the next. Thus almost all the figures are allegories of salvation and the immortality of the soul. To the right the baptism of Christ alludes to his mission in this world. He reappears as the Good Shepherd, a motif drawn from the pastoral lore of the Hellenistic tradition, suggesting here that the delights of heaven are the only worthy ones. Next to him are effigies of the dead couple. Evidently the original intention was to carve their faces into likenesses, but this was never done. They are shown as a poet and his muse, a traditional theme that the early Christians reinterpreted to suggest contact with the next world, the man by his reading of the Scriptures and the woman by her praying.

Jonah is derived from a traditional Classical representation of Endymion, the youth of ancient mythology who was seduced by the Moon in his sleep. Here, Jonah's sojourn in the monster's belly is equated with the magic sleep of Endymion. In pagan sarcophagi the seduction or rape of mortals by deities was symbolic of the freeing of the soul from material cares and fetters. By using Endymion as a model for Jonah, the artist turned the motif into a Christian symbol of the immortality of the soul; more specifically, the resuscitation of Jonah was meant to prefigure the resurrection of Christ. Thus, much as the lack of interest in technical perfection reflects a rejection of earlier naturalistic trends, the allegorical significance of each of the figures marks a new spirituality.

Roman portraiture reflected the spiritual crises of the times. The treatment of the superb head of an unknown man (Fig. 4–2) sculpted around 240 is still essentially naturalistic; indeed, the illusionistic suggestion of the texture of the

hair and the softness of the flesh surpasses the greatest achievements of Hellenistic times. But there is a new interest in purely spiritual elements; although the disillusioned mouth and the anxious brows express a profound weariness, the kindly upturned eyes hint at a capacity for meditation and an awareness of some superior truth.

Figure 4–3 shows the marble head of a colossal statue, made in 324–330, of Constantine, who, after a wave of persecutions, became the first Christian Emperor of Rome. Constantine, who claimed for himself the same spiritual status as the Apostles, was in fact a shrewd and ruthless military leader. During his youth the Empire had been divided by Diocletian into four areas for the sake of administrative expediency. Constantine managed, by dint of intrigue and military prowess, to become emperor of the northwest province. He then undertook to march on Rome, taking up the banner of Christianity during his progress. He took the city in 312, thus becoming emperor of the

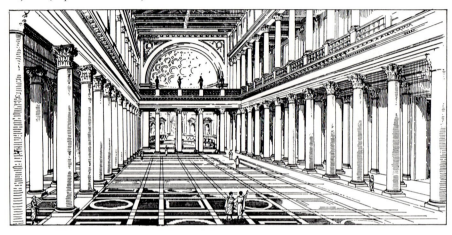

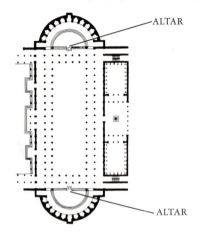

ALTAR

ALTAR

West, and eventually he controlled the whole Roman Empire and established the new faith as the state's official religion.

Constantine's reign marks a return to central rule and the beginning of a period of comparative peace for the Empire. The portrait in Figure 4–3 attempts to suggest at once the power and majesty associated with imperial rule and the new emphasis on the life of the soul. Gone is the illusionism of the head of the unknown Roman (Fig. 4–2). The modeling in powerfully curved surfaces accentuates the features to the point of caricature. The hair is rendered in a harshly stylized manner. Most important, the enormous protruding eyes, heavily outlined by the edges of the lids, look ecstatically upward. The figure has an awesome power and a new spirituality, as if through mystical contact with a divine being. The balance between the physical and the spiritual that had characterized Classical art was now finally and irretrievably destroyed. From this point on, through most of the development of Byzantine and Medieval

art, the emphasis was to be on man's spiritual life, to the detriment of naturalistic representation.

By the beginning of the fourth century, Christianity had gathered so many adherents that the early meeting houses were no longer adequate to the needs of their congregations. And after Constantine's adoption of Christianity as the official religion, the simplicity and humility that had characterized the rites of the early church had to make way for a new magnificence more in keeping with imperial patronage. During Constantine's reign, a vast church-building program was initiated throughout the Empire.

Although many pagan temples were converted at one time or another into Christian churches, the religious leaders seem to have preferred buildings designed especially for the new cult, and their architects sought a model in such public buildings as the Basilica Ulpia (Figs. 4–4 and 4–5), which had been erected in Rome by Emperor Trajan (reigned 98–117) to serve as a covered market and also provide

appropriate space for magistrates' courts.

The Roman civic basilica was oblong in form and usually had a trussed wooden roof supported by the outer walls and two or more rows of piers inside the building. It was terminated at one or both ends by an apse in which a statue of the emperor was usually placed, before which official functions were performed.

Significantly, the first large Christian church buildings erected during Constantine's reign were called basilicas. All these have been altered over the centuries, but archeologists have been able to determine their original form by examining foundations and studying them in engravings and paintings that antedate many of the alterations.

The earliest of the Constantinian churches is Rome's Saint John Lateran (Basilica of the Savior), begun around 313. Like the civic basilicas, it is oblong, has a trussed wooden roof, and is terminated at one end by an apse (Figs. 4–6 and 4–7). The axial emphasis of the floor-plan is accentuated by the four rows of

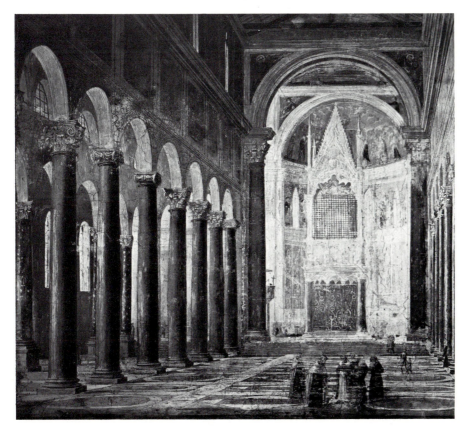

4–7 Saint John Lateran, reconstruction of building as it must have appeared in 320.

CHOIR

NAVE

AISLE

AISLE

piers that divide it into a major central space, the *nave,* and two narrower spaces on each side, the *aisles.* There is a smaller lateral wing on each side at the apse end. The main entrance is directly opposite the apse. It is preceded by a porticoed forecourt, or *atrium* (not shown in the illustrations). Except for a few variations, this was to remain the basic plan of Christian churches in the West for centuries.

From a strictly architectural standpoint, the structure is neither as bold nor as complex as that of the Pantheon (Figs. 3–12 to 3–14). It returns to the post-and-beam construction, thus precluding the creation of the vast space, uncluttered by columns, that was made possible by resting a dome on a drum as in the Pantheon. Nor was the basilica made fireproof as the Pantheon had been, with its concrete vaulting. From the exterior, the appearance of the comparatively simple façade of brick-lined concrete masonry of the Lateran basilica in no way compares with the majesty of the columned portico of the Pantheon.

In their endeavor to relate its architecture to the needs of the cult, however, the designers of the Christian basilica showed outstanding ingeniousness and originality, evolving practices which became standardized in the fourth and fifth centuries. The axial layout of the church helped draw the attention of the congregation to the altar, which was placed in front of the apse. The very division of the interior into nave and aisles is believed to have made it possible to isolate unbaptized converts in the outer aisles, which were probably curtained off at certain points during the services. The atrium provided an area where the clergy could meet the heathen.

Let us note that two important characteristics of later churches had their roots in features already present in early Christian basilicas. The altar was at a little distance in front of the apse, and the space in between was used to seat the clergy; this was to become the choir of later churches. There were two small wings used for storing accessories on each side

of the building near the apse end. These were sometimes larger structures as high as the nave; known as *transepts,* they gave these and later buildings the characteristic Latin cross layout of Western European churches. Incidentally, although the axes of the early Christian basilicas pointed in a variety of directions, in later churches the choir and apse almost always point toward the East, in the direction of Jerusalem, and the entrance opened toward the West.

However plain its exterior, the basilica's interior was sumptuous. Figure 4–6 shows the nave as it appeared to a seventeenth-century artist. It had already been much altered, but the overall effect in the early Christian era must have been fairly similar, though the transept that creates a transverse space at the level of the altar is definitely a Medieval addition.

The fact that the ceiling of the basilica was of wood, and was therefore light, presented a distinct advantage. It enabled the architect to surmount the nave arcades with high walls with numerous win-

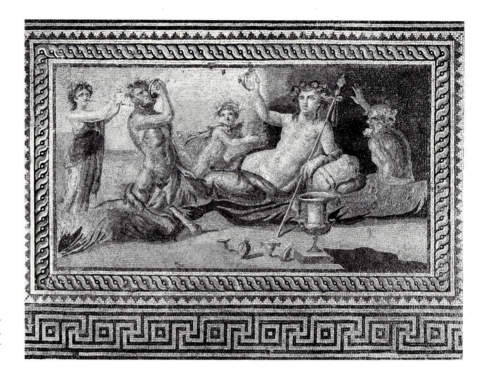

4-8 *Drinking Scene,* floor mosaic, Antioch-on-the-Orontes (Antioch in Syria), c. A.D. 50–100. (32″ × 59″). Worcester Art Museum, Massachusetts (*comparative illustration*).

dows. The walls provided ample surface area, and the windows abundant light, for the series of decorations illustrating Holy Scripture.

Unfortunately nothing has survived of the wall decorations of Saint John Lateran, and we have to turn to a later building in Rome, Santa Maria Maggiore (432–440), for the best preserved fragments of basilica decoration. In several parts of this church mosaics of the fifth century have survived. The scenes shown in Figure 4–9, which appear on the triumphal arch spanning the nave, depict the Annunciation to Mary and the Adoration of the Magi. To get an idea of the extent of the revolution in mural decoration since late antique times, let us compare these with a mosaic from the dining room floor of a Roman dwelling found in Antioch in present-day Turkey, a drinking scene (Fig. 4–8), dating from the end of the first century A.D. and probably based on a Hellenistic painting of the second century B.C. The latter work is made up of small pieces of variously colored cut

stones (known as *tesserae*) embedded in mortar.

The reclining figure brandishing an empty cup is, in all likelihood, Dionysos, god of the vine. The kneeling figure is said by some authorities to represent the mythological hero Herakles in the process of losing a drinking contest with the god, while others believe him to be the former tutor and frequent companion of Dionysos, Silenus, a lesser divinity who was part man and part goat. To the right is an older man cheering on the drinkers, while a child seems to be clapping and a woman flutist plays on.

The artist seems to have been primarily concerned with naturalistic effects. Considerable attention was paid to the handling of forms in space. In the first place, the figures have been carefully modeled by means of a knowledgeable use of shading. The artist has used darker colors on receding surfaces as if these were covered by shadows, allowing protruding parts to remain lighter. (The relative lightness or darkness of any area is called

value—high value referring to colors nearest to white, and low value to colors nearest black—so that the modeling of figures by means of shading can also be called *value modeling*.) Secondly, the artist has clearly located the figures in a stage space; the objects in the foreground define a receding floor, while vertical planes act as backdrops. Finally, the play of shadows on the surfaces no less than the overall lightness of the color effectively suggests natural light.

Only a few inconsistencies reduce the plausibility of the scene. The kneeling figure is too small in relation to Dionysos, the directions of the cast shadows are totally arbitrary, and the figure of the god is so crowded between the child and the kneeling figure that there is no room for his legs. On no account can the scene be assigned a profound meaning. At most, it is a reminder that mythological figures can hold their wine, and possibly, also, that gods can hold it better than mere heroes or lesser divinities—a fitting subject for a dining room floor!

4-9 *The Annunciation to Mary; The Adoration of the Magi,* section of a mosaic from the triumphal arch, Santa Maria Maggiore, Rome, fifth century.

The Santa Maria Maggiore mosaics are made of tesserae of opaque, colored cut glass, some of them covered by gold leaf protected by a thin layer of transparent glass. The colors have greater *intensity,* or purity, than in marble mosaics, and the brilliance is heightened by the way in which the pieces are laid unevenly so as to create a scintillating effect when light hits them. To be sure, an interest in value modeling persists, but this is offset by the strong linear patterns created by the folds of drapery and the edges which tend to flatten the figures, and by a certain crudeness in the proportioning of the bodies.

The chief aim of the artist was to suggest the spirituality of the new era. The bodies in Figure 4-9 are elongated and insubstantial in appearance, seeming to float against the gold setting, their feet barely touching the ground, and their eyes gazing into the distance with an ecstatic stare. Rather than presenting a unified scene in a stage space, as the earlier mosaicist had done, the early Christian artists spread out the figures in a repeti-

tive pattern reminiscent of the processional motifs of earlier Roman, Greek, and Egyptian friezes—an appropriate way to decorate the long surfaces of the basilicas' walls. The clarity of the presentation made it possible to identify the figures from a great distance, and this, in turn, suited the didactic purposes of the Church.

Before being entrusted to artists, the themes of the decoration of the whole church were carefully worked out by theologians whose long-range goal it was to establish symbols to be used in representing the various scenes of the lives of Christ and the principal saints. Despite numerous modifications introduced by later generations, these symbols and the rules affecting their use, known as Christian *iconography,* have survived to a remarkable degree through the development of Western art. The chief purpose of the arrangement of symbolic elements (or iconographic scheme) of the Santa Maria Maggiore mosaic seems to have been to stress the divinity of the Christ child and the importance of the Virgin.

In the upper register, Mary, dressed as an imperial princess and playing a musical instrument, is flanked by a group of angels that surround her like court officials. To the left is her house, looking like a small shrine. Above, the angel of the Annunciation blesses Mary while the Immaculate Conception is symbolized by the Holy Ghost in the form of a dove flying into her right ear. Far to the right, an angel reassures Joseph. In the lower register, the infant Christ sits in glory on a huge throne. The courtier-angels stand behind him. To his right is Mary, still in a royal robe. To his left is a figure that has not been positively identified by scholars, though it is probably Saint Anne, mother of Mary. Two of the Magi, still following their guiding star that is shining just over Christ's head, have come from distant lands to pay homage to the new king. The fortified city on the right, crowded with classical buildings, is probably meant to be Bethlehem. Clearly the theologians intended to stress the importance of Christ's mission on earth by

4-11 Detail of *Justinian*

recasting the stories of the Annunciation and the Nativity in an imperial setting.

Let us notice, incidentally, that many of the figures have halos. This device originated in Mesopotamia, where it signified that the person under it received the protection of the sun. In late Roman art it came to be regarded as a symbol of majesty and sanctity, and in Christian art it became characteristic of the representation of members of the Holy Family, angels, and saints.

In 326 Constantine established a new residence in the small town of Byzantium in Asia Minor, in the Empire of the East, which grew into a sizable city by 330 when he named it Constantinople (present-day Istanbul). After Constantine's death in 337, the Empire was divided once more, and Constantinople eventually became the capital of the eastern part, henceforth known as Byzantium, which soon outstripped the West as a center of political power. Perhaps because of the preponderance of Greeks in Asia Minor, there were strong survivals of the old

Hellenistic culture, and Greek eventually became the official language.

The Byzantine Empire survived the multiple attacks of barbarian tribes from the North, the East, and the South that overpowered the rest of the Roman Empire late in the fourth and the fifth centuries. It provided a bridge between antiquity, on the one hand, and the Middle Ages and the Renaissance on the other. The first stage in its development lasted up to a time of religious and political crisis in the seventh and eighth centuries, but its most glorious period, known as the Byzantine First Golden Age, reached a peak during the reign of Justinian from A.D. 527 to 565.

Like so many emperors, Justinian was a willful opportunist, but he set up an effective government, achieved spectacular military successes, and devoted endless efforts and enormous sums of money to the creation of masterpieces of Christian art. For an example of the mural decorations of his reign, however, we must look outside Constantinople, for no vestiges

remain of the figurative representations he commissioned. Indeed, the best, and perhaps only, example of figurative church decoration in the Justinianic court style are two mosaic panels, executed from 546 to 548, in the church of San Vitale in Ravenna on the eastern coast of Italy, one representing the emperor and his retinue and the other the Empress Theodora and hers (Figs. 4-10 and 4-12).

Ravenna had become the capital of the Western Empire early in the fifth century. When Italy was totally overrun by the barbarians in 476—a date, incidentally, that may be taken as the beginning of the Middle Ages in Europe—Ravenna fell, and the last emperor of the West was formally deposed. The city was reconquered by the armies of Justinian in 540 and remained a Byzantine bastion on the peninsula for the next two centuries. Understandably, Justinian took a personal interest in the completion of San Vitale. The panels were clearly intended to affirm both the authority of the emperor over the land wrested from the barbarians and

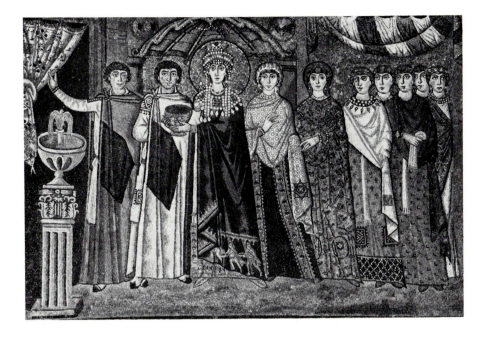

4-12 *Empress Theodora and Her Retinue,* San Vitale, Ravenna, apse mosaic, 546–548.

4-13 Detail of *Theodora*

the ecclesiastical power of Maximian, archbishop of the Church of Constantinople (shown in the Justinian panel) in opposition to that of the leader of the Western Church, the pope.

The panels are located in the apse of the church above the altar and on each side of it. Their most remarkable quality is the way the artist successfully synthesized the naturalistic elements of earlier Greek and Roman art with the new spirituality. In the faces (Figs. 4–11 and 4–13) the artist arranged the multicolored tesserae to convey the hues and modeling of the flesh with a degree of illusionism harking back to the Hellenistic tradition. The translucency of the irises of the empress' eyes, in particular, is nothing short of extraordinary. The individual characterization is also essentially Greco-Roman. Notice the difference between the lofty expression of the lean Maximian and the self-confident, firm, and almost extroverted look of the emperor. The expression of the empress, a famous stage beauty before she married Justinian, combines

personal charm with a regal haughtiness.

And yet these mosaics reflect as great an interest in spirituality as do those of Santa Maria Maggiore. The emphasis on the curved eyebrows and the upturned pupils suggests an ecstatic awareness of the Beyond. The bodies are just as ethereal as those in the earlier mosaic, although modeled with much greater delicacy and delineated with an innate sense of grace. Floating as they do against the gold background, their feet pointing limply toward the ground (and occasionally stepping on neighboring feet without adverse effects), they suggest total weightlessness. They are clearly meant to be thought of as seen in a vision, suspended in front of the picture surface in the church itself.

The artist paid meticulous attention to hierarchic considerations. Although there is no real depth and the figures are literally compressed into one plane, bodies of high-ranking figures overlap those of lesser ones. The only exception is the archbishop, who, perhaps because he is a

spiritual leader, is allowed to place his leg, if not his arm, in front of the emperor's mantle. Furthermore, although it is obviously impossible to speak of physical movement as it was understood in Hellenistic times, the artist suggested a directional thrust through the arrangement of these rhythmically disposed forms. By crowding the figures at one end of each panel and allowing more space for those at the other end, he was able to suggest that each group is beginning to form a procession to move toward the altar. The emperor and empress are shown preparing to carry respectively to the altar the patten to hold the bread, and the chalice to hold the wine, of the sacrament of the Eucharist. According to the Roman and Eastern Churches, the bread and wine not only commemorate Christ's Last Supper and subsequent martyrdom but become the very substance of the body of Christ. In carrying the bread and the wine themselves, the emperor and empress are reenacting a practice dating back to the earliest Christian times, when each mem-

3-11 Pantheon, Rome, started in A.D. 118 and completed between 125 and 128 (*comparative illustration*).

3-13 Plan of the Pantheon (*comparative illustration*).

3-14 Pantheon, diagram of structural elements (*comparative illustration*).

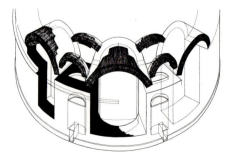

ber of the congregation brought bread and wine to the altar as sacrificial offerings. In Byzantine times, the emperor and empress were the only laymen allowed in the vicinity of the altar. In all likelihood, in choosing to be represented at the very moment of bringing their sacrificial offerings to the altar, they wished to show that they performed this ritual and stood before the deity as emissaries of their people, and, conversely, that they enjoyed a semidivine status. Not surprisingly, the figures are represented against a gold background, suggesting the glow of heaven, and Justinian and Theodora even have halos—a reminder that the emperor claimed himself to be the equal of the Apostles.

The major architectural achievement of Justinian's reign is the huge cathedral of Hagia Sophia ("holy wisdom" in Greek) in Constantinople (Fig. 4–14), erected between 532 and 537. The emperor entrusted the design not to professional architects but to two applied mathematicians, Greeks named Anthemios of

Tralles and Isidoros of Miletos. Like the Pantheon (Figs. 3–11, 3–13, and 3–14), Hagia Sophia at one time had a porticoed forecourt and, like the Pantheon, it is based on the central plan that was to be favored by the Byzantine clergy, the axial plan of the Roman basilicas being preferred by the Church of Rome. It is a domed structure that surrounds a unified inner space. A glance at the outside reveals immediately that the design of Hagia Sophia is more complex and considerably bolder than that of the Pantheon. It should be noted, however, that the original dome was lower but was raised on a ribbed base at the end of Justinian's reign. The massive *buttresses* (vertical masonry abutments) applied to the external walls were Medieval additions, while the four minarets were erected by the Islamic Turks after their conquest of Byzantium in 1453.

The interior space of Hagia Sophia is much vaster and higher than that of the Pantheon. There are also major structural differences. Whereas the dome of the

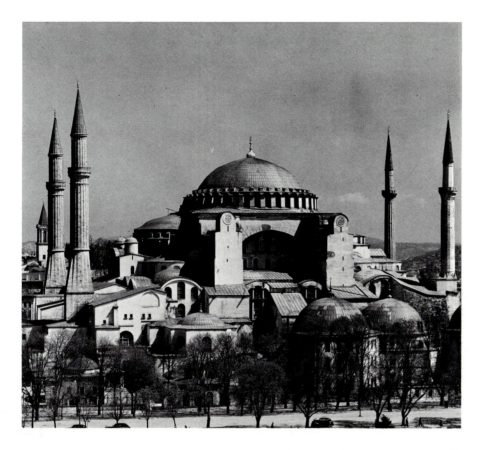

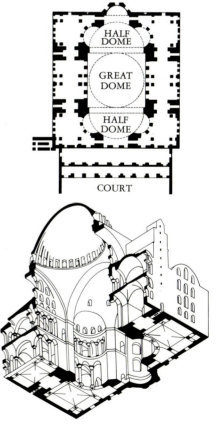

4-15 Plan and reconstruction of Hagia Sophia; and section as seen from below.

Pantheon rests on a massive concrete drum, that of Hagia Sophia rests on a system of four huge piers supporting arches of carefully cut stone, the outlines of which can be clearly seen (Fig. 4–16). To provide a transition between the square area between the piers and the circular base of the dome, the corner between each pair of adjoining arches is linked to the base of the dome by a concave triangular surface, or *pendentive,* which is a portion of a sphere larger than the dome.

Present opinion tends to regard the flanking apses and their half domes (Figs. 4–14 and 4–15) as serving no structural purpose. The dome rests wholly on its supporting piers, which were later strengthened by the buttresses and external arches. The fact that the weight of the dome is transmitted through the pendentives to the piers and buttresses results in the carrying of comparatively little weight by the side walls. Because of this, not only are the walls of Hagia Sophia much thinner than the walls of the Pan-

theon, but the architects found it possible to pierce them with many window openings (which were originally much larger than they are now), letting in an abundance of light. The walls of Hagia Sophia are made up of several rows of thin bricks alternating with a row of limestone at regular intervals, all imbedded in and separated by thick layers of mortar. They are thus much lighter than the concrete walls of the Pantheon. The domes and half domes themselves are made of bricks pitched on their sides and held together by mortar. The interior decoration was even more sumptuous than that of the Pantheon. The side walls are covered with richly striated marbles, while the domes and half domes were originally decorated with mosaics on gold and silver ground. Some scholars believe that colored glass in the windows added to the optical richness.

The relationship of the interior spaces is extraordinarily complex. Although Hagia Sophia is built on the central plan and its periphery is nearly square, the

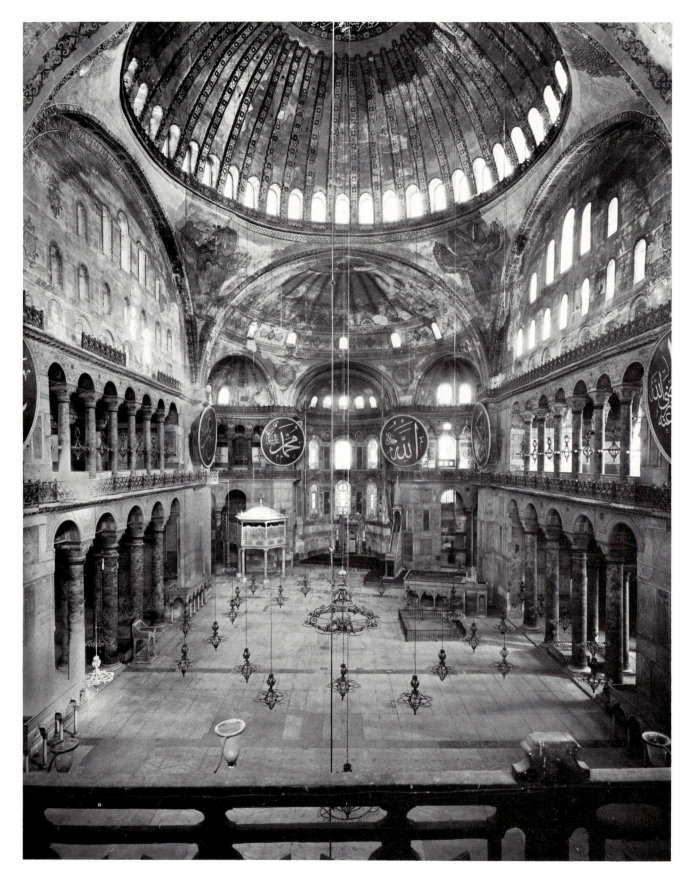

4-16 *Opposite page:* Interior of Hagia Sophia

4-17 *This page:* Interior, from the south aisle, of Hagia Sophia.

nave, with its two apses, is oblong and therefore has a mild directional emphasis—a carry-over, perhaps, of the strong directional axis of the Roman basilicas. And yet one's eye is not drawn primarily in the direction of that axis but rather through the soaring piers, upward to the harmoniously integrated arches, domes, and semidomes, which seem to be floating over a pool of light.

The nave area was strictly devoted to the elaborate liturgy of the Eastern Church, and only members of the court and clergy were allowed to enter it. The public watched the ceremony from the aisles and the galleries (Fig. 4-17). From there the fragmentary view of curved and flat walls, windows, arcades, and arches must have been as complex and intriguing to the congregation as the snatches of the service it could see and hear; these were glimpses of a superior order that only the fully initiated could entirely apprehend.

The age of Justinian was followed by a period of comparative decline. Not only

did new waves of barbarians completely overrun the Western Empire and threaten Constantinople from the North, but the formidable threat of Islam arose in the South. Originating among Arabian tribes, the new religion proclaimed the supremacy of its single god named Allah. It spread rapidly throughout the Near East in the seventh century, and Islamic armies swept to the very gates of Constantinople where they were narrowly but decisively defeated in 717.

Concurrently with this military crisis, Byzantium went through a religious upheaval. Certain theologians and an important segment of the lay population had come to believe that the use of sacred images, or *icons,* for the purposes of the cult was essentially idolatrous, and in 726, responding to their pressure, the same emperor who had repulsed the Islamic armies proclaimed that the sacred and venerable images should be overthrown. Thereupon, the figurative painting and mosaics of most churches were covered over and replaced by abstract decorations,

occasionally based on animal and vegetal motifs.

The repudiation of sacred imagery (*iconoclasm*) might easily have led to the disappearance of the human figure in Byzantine art, but the more conservative elements of the population retained a strong attachment to it. Many monasteries disregarded higher authority and preserved their icons, and there are indications that artists in the more remote provinces simply went on making them. Giving in to increasing popular pressure, a later Byzantine emperor finally sanctioned icons in 843 and allowed their use in places of worship, thereby preparing the way for the Second Golden Age of Byzantine art that came to an end with the conquest of Byzantium by the Turks in 1453.

5

Pre-Romanesque Art

The rejection of the human figure in art was by no means confined to Byzantium. Islam, following the Judaic tradition, abhorred graven images. And although little is known of the artistic traditions of the invading barbarians prior to their exposure to Roman culture, there is evidence that their art was essentially abstract, sometimes based on highly stylized animal and vegetal motifs but very rarely on the human figure. If the image of man survived in the West, it is largely because Christian monks from such eastern provinces as Egypt and Syria and from Rome itself established monasteries in the barbarian nations, spreading both the Christian faith and a reverence for sacred images, which were derived more or less directly from late antiquity. Although the popes were theoretically responsible to the Byzantine emperors, they stood firmly in favor of sacred images and came to look upon the papacy as a stronghold of traditional values and as the last bastion of the culture of imperial Christian Rome.

The most important factor that led to the disintegration of the Empire and of antique civilization was the succession of barbarian invasions that took place between the fourth and eighth centuries. The Romans' treatment of the barbarians in lands neighboring the Empire was inconsistent. On the one hand, Roman armies had fought barbarians in Gaul, Great Britain, and Germany for several centuries. On the other hand, Roman commanders frequently made alliances with some barbarian groups to fight others, and some tribes were formally invited by the Roman Senate to settle within the Empire. From the fourth century on, bordering tribes exerted increasing pressure on the defending armies and occasionally succeeded in making deep incursions. Eventually, wave upon wave of invaders from central and northern Europe, and as far away as western Asia, migrated westward and southward in search of land and cattle, burning and destroying much of what they found on the way. Rome was first captured by a barbarian king in the fifth century A.D.

The various groups of invaders established colonies throughout the Empire and became landowners. Their attitude toward Roman culture was ambivalent. They adopted Christianity yet in many ways remained faithful to earlier beliefs. They frequently showed scrupulous respect for local traditions and customs, even for Roman laws where their tenants were concerned—presumably in order to exploit them as effectively as possible. In dealings among themselves and in their attitude toward their warrior neighbors, however, they followed their own unwritten codes. Occasionally they claimed to owe allegiance to the emperor of the West as long as there was one, but their own "nations" were ruled by chieftains as in the days of the migrations.

The process of assimilation was further hampered by long and bloody wars among the barbarian nations and constantly changing political conditions, by desperate economic crises, and, ultimately, by a momentous decrease in the popula-

5-1 Purse lid from Sutton Hoo, before c. A.D. 656. Gold, garnets, and colored glass (7½″ × 3″). British Museum, London.

5-2 Roman necklace and hair ornament, first to third centuries A.D.; semiprecious stones and gold. British Museum, London (*comparative illustration*).

tion of Western Europe. This period, which has been called the Dark Ages, came to an end with a new economic stability only in the tenth and eleventh centuries. It was at that time that a dynamic synthesis occurred between barbarian and late antique traditions to give birth to Romanesque art.

We can get an idea of the extraordinary achievements of some of the "barbarian" peoples from the remarkable purse lid from Sutton Hoo (Fig. 5-1) in East Anglia (Suffolk) in eastern England. The purse lid was found in a grave filled with the armaments and other belongings, ranging from sea-going ships to jewelry, of a king of Teutonic origin, Anglian or Anglo-Saxon. The burial is believed by modern archeologists to have taken place probably before 656. Although Christian objects were found near by, the highly stylized figures on the purse lid—eagles attacking ducks, and men, such as they are, being devoured by animals—must certainly allude to barbarian myths.

The influence of older cultures cannot

be discounted. The device of using colored glass in a metal setting was much used by the Romans and the native craftsmen in the northern parts of the Roman Empire. The technique used here is the so-called *cloisonné,* which consists of brazing strips of metal onto a base plate to create compartments in which to set the colored fragments, a lip being brazed over the strip to hold the fragments in position. The technique of cloisonné may have derived from the contacts of the migrating tribes with northern India and Persia. In the case of the Sutton Hoo piece, the metal is gold, and the colored elements are garnets and colored glass.

Despite these precedents for the technique, the Sutton Hoo object is characterized by distinctly barbarian elements. Indeed, comparison with a Roman necklace and hair ornament of the first to third centuries A.D. (Fig. 5-2) in semiprecious stones and gold, reveals to what degree the East Anglian artist stressed a vigorous and animated linearism, lively color contrasts, and flat decorative patterns as

5–3 Portrait of Menander, wall painting, house of Menander, Pompeii, c. A.D. 70 (*comparative illustration*).

against the more delicate color relationships and the much more sculptural quality of the Roman pieces.

The Sutton Hoo motif of pairs of highly stylized serpentine animals in heraldic opposition is reminiscent of similar devices in the reliefs of Çatal Hüyük (Fig. 1–3) and may well go back to common Neolithic sources. The lively, elaborately rendered interlacing pattern of the animals in the central group above the eagles and ducks may be derived from weaving patterns characteristic of Egyptian Christian (or Coptic) art, and ultimately from Roman and Hellenistic decorative motifs based on geometric, illusionistically rendered interlace decoration. But another element is characteristically barbarian, the tendency to render all forms, including organic ones, by means of vigorously curving lines. This tendency has been related to a decorative style based on spiral motifs ultimately deriving from the Central Asiatic steppe peoples as far back as 1000 B.C.

These designs based on interlacing

animal patterns, known as *zoomorphic* interlace, were much in favor among the barbarian tribes and were to become characteristic of the art of the Dark Ages. Possible debts to antique traditions notwithstanding, the sense of precision in the design of the pieces, the refinement in the choice of colors, and the skill in execution reveal that the makers of the Sutton Hoo piece were outstanding craftsmen in their own right.

The art of the barbarian nations was profoundly affected by the mass conversion to Christianity of people after people. The Roman and Eastern church missionaries who traveled northward and westward were flexible toward the traditions of newly converted nations. They tolerated the survival of pagan feasts while insisting that these be dedicated to local martyrs. Similarly, they encouraged the use of native styles in religious works of art, but they also demanded scrupulous adherence to the iconographic motifs of approved models from Rome and from the Christian East (some of which, amus-

ingly enough, had pagan sources). The result was a new, sometimes very strange, and often remarkably lively, decorative, and powerful interpretation of Christian themes in the visual language of the barbarians.

The *miniature* (a small colored illustration) of Christ in Majesty (Fig. 5–4) from the *Book of Kells,* an illustrated (or *illuminated*) manuscript on vellum, is a splendid example of these developments. It was executed in the *scriptorium,* or writing and copying workshop, of one of a group of Irish monasteries with outposts in England and Scotland that was particularly productive in the seventh and eighth centuries. The artists of these monasteries constituted a vigorous school known today as Hiberno-Saxon, which had both strong stylistic ties to its native pre-Christian past and, by the time the *Book of Kells* was executed, definite links with the Carolingian school on the continent (see p. 65).

Despite its obvious differences, the *Book of Kells* owes much to late antique

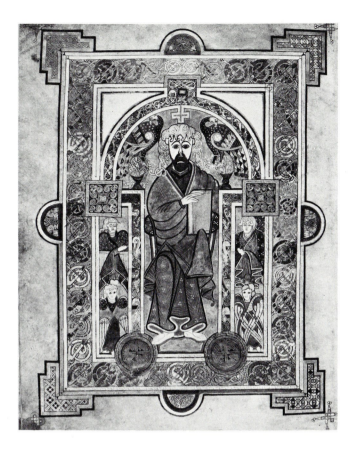

5–4 Christ in Majesty, from the *Book of Kells,* late eighth to early ninth centuries. Illuminated manuscript, tempera on vellum (13″ × 9½″). Trinity College, Dublin.

and early Christian art. The practice of making bound books with cut pages of *vellum* (treated and dried skin of calf, kid, or sheep) dates back to Hellenistic times. The full-page images of evangelists and, as in this case, of Christ may well have had distant prototypes in late antique portraits such as that of the poet Menander from a wall painting of around A.D. 70 (Fig. 5–3) found in a Roman house in Pompeii. The gesture of blessing of Christ's right hand, the book of Holy Scriptures held in his left hand, the cross over his head, the four courtier-angels surrounding him, and the peacocks (symbols of incorruptible flesh as well as of Christ's resurrection), all derive from early Christian iconography. The chalices allude to the Eucharistic wine and the martyrdom of Christ. The vine tendrils go even further back, since they are attributes of Dionysos, the ancient god of the vine. They, too, have a Christian significance, however; by late Roman times the pressing of the grapes had become symbolic of Christ's martyrdom. Clearly, then, the

iconography of the work must have been taken from one or more of the numerous manuscripts from Italy and the Christian East known to have been collected avidly by Irish monks. The symbols allude specifically to Jesus' role on the Day of Judgment, when, Christians believe, mankind will be resurrected (as Christ was himself after the crucifixion) and the word of God will triumph.

We have only to compare the page from the *Book of Kells* with the portrait of Menander to realize to what degree the Irish artist's concepts of space and form were different from those of Classical antiquity. The lace patterns and zoomorphic elements are borrowed from native metalcrafts. The animated linearism of the designs, drawn freehand with great care and repeated at regular intervals over the surface, are clearly in the barbaric tradition. In addition, the Irish artist stressed geometric or nearly geometric elements also characteristic of barbarian art: spirals in the border, squares and circles along its inner edge, and a succession of scalloped

bands, stripes, and dots on the bodies of peacocks.

It is evident that the artist was concerned primarily with filling the page with a rich surface design through the repetition of elements. This approach can be referred to as *additive;* adding to or removing from the work a single decorative unit would not substantially alter the impact of the design; its richness and animation would remain unimpaired. On the other hand, while the façade of the Parthenon (Fig. 2–16) also has repetitive elements, adding to or removing from it a single column would have drastic consequences. The Classical architect conceived his design as a unified, integrated whole; the Irish artist conceived his as a sum of individual parts.

The tendency toward geometric and additive decoration is characteristic of the so-called Dark Ages. Looking back over other works we have examined so far, we can see that the early products of all cultures are usually additive and geometric compositions. This is certainly true

of Greek Geometric art, and even of the early phase of Greek Archaic art. The repetition of figures in each register of the François vase, for instance (Fig. 2–4), is additive, while the registers themselves are geometric entities. Such examples of barbarian art as the Sutton Hoo work can also be said to be additive; it has some geometric characteristics as well. It is in Classical times that the concept of an overall balance uniting an indivisible whole seems to have evolved, while geometric concerns appear to have become limited to general principles of composition and are often concealed by the apparent naturalness of individual figures. The same is true of periods that were influenced by Classical antiquity, such as the Renaissance.

The difference in the treatment of the human figures is equally staggering. The body of Menander in the Roman work, in spite of a certain clumsiness in draftsmanship, is a unified, compact mass occupying a definite space. The subtle shading of the mantle and a slight blurring of all the edges effectively suggest lighting and atmosphere. In contrast, the body of Christ is made up of a frequently repetitive arrangement of flat-looking, nearly geometric parts juxtaposed on the surface, as if through additive processes similar to those that govern the overall decorative scheme. The Irish artist was clearly attempting to reconcile the requirements of Christian iconography with his native artistic tradition. He had so little concern for spatial representation that Christ's chair becomes a strange contraption at-tached to the back of the figure, and he was so steeped in traditional techniques that the temptation to interlace Christ's hair proved irresistible. Indeed, nothing could be more foreign to the artist of the *Book of Kells* than the concept of antique naturalism. His primary aim was to suggest the full splendor of the figure of Christ through the richness and vitality of linear decoration.

The Christ in Majesty of Figure 5–5 is from the *sacramentary*—an illuminated manuscript devoted to the text of the Mass and other religious ceremonies—that was executed on the continent around 870 for Charles the Bald (823–877), a member of the Carolingian dynasty who reigned over much of present-day France. Although it dates from seven decades later than the *Book of Kells,* it reflects new affinities with antique stylistic traditions. There is a definite element of illusionism in the way in which the folds are darker in certain areas, suggesting shadows, and the curvature of the folds themselves stresses the roundness of the body. Delicate modulation of hues in the halo creates a striking impression of light, while the gradations of blues and greens around the figure of Christ suggest atmospheric depth. A comparison with Menander (Fig. 5–3) points unmistakably to a late antique source for the execution of the body, while the elongated face with its regular linear features may well reflect a Byzantine influence.

The iconography, while essentially Christian, also reveals in several ways a renewed interest in antiquity. Christ is represented as lord of the universe. His power is cosmic: not only is he in a *mandorla*—the almond-shaped frame surrounding him which symbolizes the heavenly spheres—but he is sitting on a globe and carrying an orb in his right hand. His authority over the heavens is symbolized by the two six-winged angels (the Old Testament seraphim) and his material power is suggested by the two figures at his feet, signifying the elements of water (on the left) and earth (on the right), which derive from pagan antique statuary. Water is represented by an ancient river god seated on a sea serpent such as is found in the corners of pediments of Greek temples. (His attitude recalls that of the Dionysos of the Parthenon in Figure 2–20.) Earth, in the antique manner, holds horns of abundance and breast-feeds two infants to symbolize fertility.

Despite these indications of antique influence, the work bears the unmistakable imprint of the Dark Ages. The body of Christ lacks the compactness of the body of Menander (Fig. 5–3). It is made up of individual parts presumably based on a prototype and assembled without much regard for anatomical plausibility. More important still, instead of creating an integrated composition the artist separated the figure of Christ from the other figures by means of the mandorla, which creates a dominant semigeometric surface pattern. The borders, which consist of antique vegetal and precious-stone motifs, reflect the characteristic barbarian love of rich surface effects, and there is a new

sense of energy in the rendering of the figure's drapery, especially in the spiraling treatment of the surface of the abdomen and the fluttering drapery ends. For all the attention paid to antique prototypes, barbaric dynamism is still very much in evidence.

The very deliberate attempt to return to antique traditions evident in this work was characteristic of the so-called Carolingian Renaissance, which was initiated by the grandfather of Charles the Bald, Charlemagne. Charlemagne was from 768 to 814 king of the Franks, a group of Teutonic tribes that had settled in northern France and the Rhine valley and had played a major role in European politics. It was Charlemagne's grandfather, Charles Martel (c. 688–741), who at the head of Frankish troops had repelled an Islamic invasion near Tours in central France in 733. The Moslems had totally overrun the Spanish peninsula and posed a threat to Europe, as they had threatened Byzantium a few years earlier. Charlemagne himself took part in campaigns against the Moslems in Spain and secured a foothold in the north of that country that became an asylum for Spanish Christians and a staging ground from which Spain was eventually reconquered in the name of Christianity. Besides playing this major role in the defense of Europe, the Franks

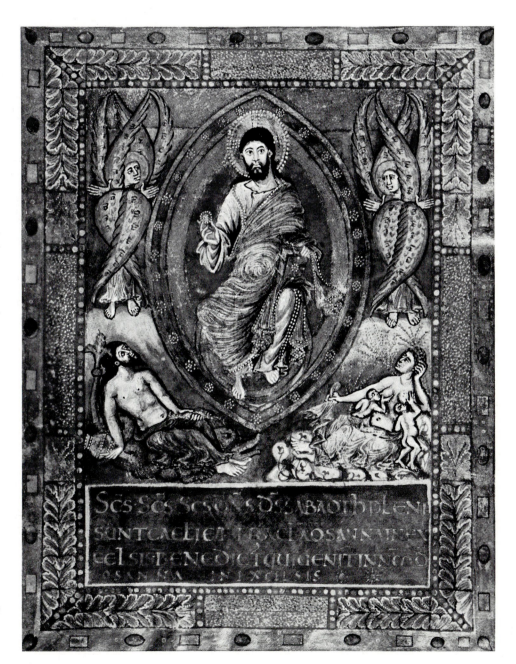

5-5 Christ in Majesty, from the sacramentary of Charles the Bald, c. 870. Illuminated manuscript, tempera on vellum. Bibliothèque nationale (Lat. 1141), Paris.

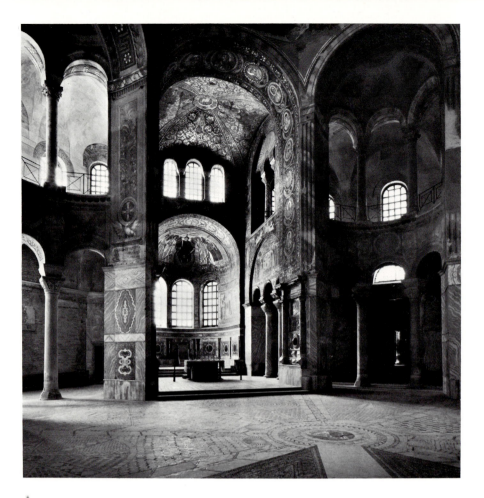

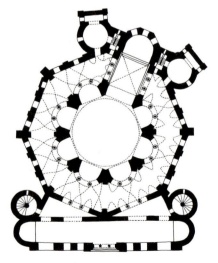

5-6 Interior of San Vitale, Ravenna, consecrated in 547 (*comparative illustration*).

5-7 Plan of San Vitale (*comparative illustration*).

established their hegemony over the other tribes that had dominated Western Europe, Charlemagne eventually extending his domain to include most of present-day Germany, France, and Italy and being crowned emperor of the West by the pope in Rome in 800.

Charlemagne's empire did not last long; divided by his three grandsons and eventually broken up into small units by the ever more powerful members of the nobility, it was forced into economic decline by a succession of invasions by Scandinavian sea raiders, the Vikings. Nevertheless, Charlemagne is accounted the first ruler of the Holy Roman Empire, the Medieval attempt to recover the political and cultural greatness of the ancient Roman Empire. Charlemagne's cultural endeavors had an enormous impact: although himself a man of little formal education, he surrounded himself with learned clerics from Italy as well as from

Ireland and England, and in his enthusiasm for knowledge he taught himself Latin and Greek in his middle age. He obtained ancient manuscripts and had copies made in his newly founded scriptoria, and after trips to Italy he brought back skilled workmen as well as statues and architectural fragments. Through every possible means he attempted to give impetus to a new tradition that would rival the splendor of imperial Rome.

The most significant Carolingian building to survive is the chapel of the palace of Aachen (Fig. 5-8), in the Rhineland, Charlemagne's principal city of residence. Dedicated in 805, the chapel had a central plan clearly inspired by the Byzantine-type church of San Vitale in Ravenna (526–547, Fig. 5–6). There are revealing differences between the two buildings, however. The inner space of San Vitale, with its series of graceful arcaded alcoves covered with semidomes, evokes a truly Byzantine sense of balance and love of complexity. At Aachen, the dominant vertical accents of the piers

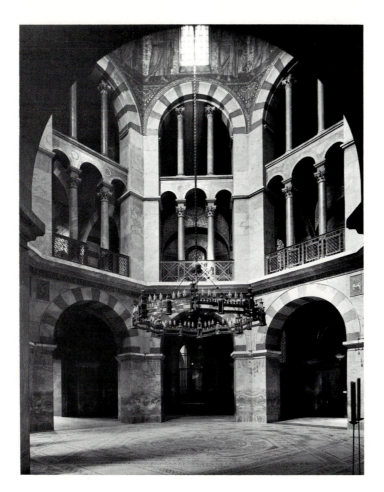

5-8 Interior of palace chapel, Aachen, dedicated in 805.

introduce a new starkness, while the arcaded screens simply and forcefully define an octagon (of which the figure shows three sides)—both features introducing a new simplicity and new vigor.

San Vitale is constructed of the traditional Byzantine brick and mortar. Its walls are light and subtly articulated. Aachen, in contrast, is built of massive masonry with heavy Roman-inspired vaulting over the aisles. Finally, Charlemagne had antique-looking columns fitted into the arches of the two upper stories (the shafts may have been taken from Roman buildings, while the capitals are of Carolingian manufacture), and these add a strange touch of delicacy in an otherwise severe edifice.

There is another noteworthy element in the Aachen chapel. Like San Vitale, it was flanked by a massive entrance porch that housed two spiral staircases on the western side (Figs. 5-7 and 5-9). Such structures herald the monumental western façades of later Medieval churches.

All in all, the dynamic yet severe

architecture of the Carolingian Renaissance was characterized by the incomplete absorption of antique and Byzantine elements into a Teutonic idiom. Definite progress was made toward the integration of antique and barbarian traditions, however, during the reign of Otto I. Otto was a Saxon king who had asserted his authority during his reign over Germany (936–973) and northern Italy after the collapse of the Carolingian empire. He was crowned Holy Roman Emperor by the pope in 962, and the Ottonian period, which spanned his reign and the reigns of his successors through the early part of the eleventh century, was marked by comparative peace and prosperity and by a new cultural flowering in Germanic lands and, eventually, in much of Western Europe.

The significant changes that took place in Ottonian times are illustrated well by a page from a gospel book, made

5-9 Plan of the palace chapel, Aachen

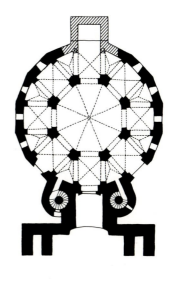

5-10 Christ the Savior in the Tree of Life, page from a gospel book, early eleventh century. Illuminated manuscript, tempera on vellum. Bayerische Staatsbibliothek (Cod. Lat. 4454 f 20v), Munich.

early in the eleventh century, showing Christ the Savior (Fig. 5-10). As in the page from the sacramentary of Charles the Bald (Fig. 5-5), the artist symbolized the power of Christ by surrounding him with the mandorla and by representing cosmic entities, here in the form of a male face surrounded by red rays for the Sun on the left and a female face placed in front of a white crescent for the Moon on the right. He added the four fantastic beings, surrounding the image of the enthroned lord, that are mentioned by the Apostle John in the apocalyptic vision described in the biblical book of Revelation. The four have become symbols of the four evangelists: the angel, Matthew; the lion, Mark; the bull, Luke; and the eagle, John. What can only be the head of God was placed above Christ, and Christ stands in the "tree of Life which is in the midst of the paradise of God" (Rev. 2:7).

As in the sacramentary, the artist used some iconographic elements that go back to antique pagan art. The Christian symbols of the evangelists and the tree of life are all carried by barebreasted female figures that are amusing versions of ancient *caryatids* (columns in the form of human figures that appear to bear the weight of a lintel) and may be remotely connected with Atlas, the male hero of Greek mythology who was thought to support the heavens on his shoulders. If they do suggest that pagan antiquity is paying tribute to the symbols of the new era, the figures also introduce a touch of fantasy that was to become an important characteristic of Medieval art.

The work reveals major stylistic developments. The elements of antique illusionism still apparent in the Christ of the sacramentary are much less pronounced. Here the dominant influence is Byzantine, which manifests itself in the linear design and the shallow modeling and elongation of Christ's body. This change is not surprising; there were close contacts between the Ottonian dynasty and the East, and Otto III married a Byzantine princess. There are still elements of the agitated linearism of the barbarian tradition, but they are few, being principally the sweep of the edges of Christ's mantle and the flutter of the drapery ends. The emulation of the Byzantine manner here has led to a much more successful compromise than Carolingian art achieved between the interest in modeling of antiquity and the agitated linearism of the barbarian tradition—a compromise that heralds Romanesque art.

6

Romanesque Art

While the Ottonian flowering was taking Germany out of the Dark Ages, appreciable strides were also being made in the rest of Europe. The threat of Islam in the South had waned, and new waves of hordes from the East had been held in check. The Viking raids began to subside during the second half of the tenth century, and some of the Viking warriors settled in certain areas such as Normandy (from which one of their leaders, William I, called the Conqueror, invaded England in 1066 and established there a long period of French influence). Converted to Christianity and "civilized," the Scandinavians soon began to dominate—by conquest, alliance, and marriage—many of the ruling families that controlled the remains of Charlemagne's fragmented empire and they became the core of a venturesome, energetic, and forever warring feudal aristocracy.

The monasteries, frequently supported and protected by powerful families and usually spared by fighting factions,

began to play a major role, both spiritually and economically. The life of the monks revolved around prayer and meditation, but the vast establishments they controlled were islands of prosperity in peace and war. Some of them ran inns, hospitals, and schools and performed other essential social services. Above all, the monastic orders constituted the principal source of moral power in the Christian West; in the absence of unified civil governments, they came to affect every phase of secular life, forming a supranational authority answerable, in theory, if not always in fact, only to the pope. The monasteries were important also as the chief repositories of contemporary knowledge. The more learned and inquiring monks of the tenth and eleventh centuries prepared the way for the intellectual ferment of the twelfth century and the advent of the Gothic age.

The pace of progress in what is now France, the Low Countries, northern Spain, and northern Italy soon outstripped that of Germany. It gave impetus

to Romanesque art proper, which can be said to have spread throughout Europe in the eleventh century and lasted through the first half of the twelfth century in and around Paris, somewhat longer in other areas.

The distinctions between Romanesque and Ottonian art are tenuous (at least one scholar writes of Ottonian Romanesque and Carolingian Romanesque) but they exist nonetheless. Where Ottonian artists had produced a few very impressive monumental sculptures in wood and bronze, the Romanesque era witnessed a proliferation of monumental sculpture in stone. Ottonian churches remained comparatively plain, but in Romanesque churches the arrangement of window openings and structural elements was more elaborate, and many were decorated with sculptured reliefs actively and ingeniously related to the architectural forms. Finally rejecting all semblance of antique illusionism, Romanesque sculptors and painters, who now frequently emphasized volume quite vigorously, did

so with a much greater concern for expressive and decorative effects than for verisimilitude.

Let us compare a half life-size marble figure of Christ in Majesty (Fig. 6–2), an architectural fragment from the original façade decoration of the abbey church of Saint-Sernin in Toulouse, which dates from around 1090, and a remarkable bronze panel from a door now on the church of Saint Godehard in Hildesheim, West Germany, representing Adam and Eve being reproached by God (Fig. 6–1), made in 1015, presumably under the supervision of Bishop Bernward (c. 960–1022). This Ottonian work is itself transitional, already revealing Romanesque elements. The elongated figures and the linearism of the design are still close to the treatment of the Christ of the Ottonian gospel book (Fig. 5–10). And related to antiquity, perhaps by way of Byzantium, where memories of the Classical past persisted, are the distinct relief of the figures and the fact that the smooth background is adorned with stylized vegeta-

tion in low relief, distantly recalling such reliefs as the Roman sacrificial procession (Fig. 3–6). There are new elements, however. The regularity of the folds of Christ's garment, for instance, announces the love of strong and simple geometric designs of Romanesque times. The willful manipulation of volume also heralds a new age. The heads are in much higher relief than the bodies. Also new is the attempt to convey a powerful expressive message, both through the attitudes and gestures and through the organization of forms on the surface. In an attempt to stress the wrath of God, his whole body is made to lean toward the sinners as he points his finger at them, while Adam points to Eve and Eve to the serpent as if to transfer the blame; the bodies of Adam and Eve literally recoil under the impact of God's anger.

The Saint-Sernin sculptor, for his part, is even further removed from antique illusionism than the Hildesheim artist. The throne seen on each side of Christ is purely emblematic and, of

course, so are the four symbols of the evangelists; the background in no way suggests a setting. The proportions of Christ's body show little concern for direct observation; indeed, the shoulders are made narrow to conform to the shape of the mandorla just as the knees are spread out for the same purpose. Moreover, the folds and decorations of Christ's garment form an elaborate rhythmic arrangement of radiating curves and provide a vigorous accompaniment to the shape of the mandorla. The whole design is subordinated to a simple geometric pattern.

The considerable depth of carving marks a new departure, and it is likely that the artists of southern France had been emboldened in this respect by seeing remains of antique sculptures in the round. Symbolic and expressive elements have been strongly emphasized by the plastic handling of the forms. This is Christ on the Day of Judgment; his left hand holds the book of divine law, and his right gives a blessing, overlapping the mandorla as if the artist had wanted to

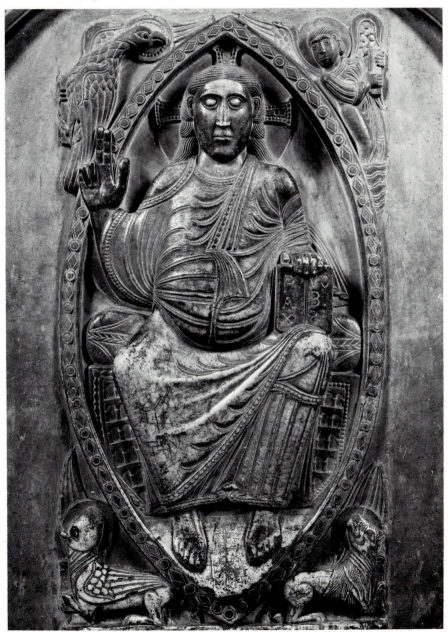

6-2 Christ in Majesty, from Saint-Sernin, Toulouse, c. 1090; marble (half life-size).

stress the symbolic significance of the gesture. The head, sculpted in high relief, has a firm mouth and bulging eyes that give it a singular air of authority well suited to conveying the power of the ultimate judge. In conclusion, the Romanesque artist was very much concerned with relating organic form to simple geometric patterns, and his play with surface patterns and volume was intended to be symbolically expressive as well as decorative.

The awesome expression of the Saint-Sernin Christ reveals a major change in the concept of the survival of the soul that had taken place since antique times. Belief in eternal life, which stemmed from Egypt and was regarded with favor in the Hellenistic world, was central to Christian doctrine. Like the God of the Jews, however, the Christian God could be an avenger. The virtuous man was assured of a blissful afterlife in the New Jerusalem, which, according to John's Revelation, was "garnished with all manner of precious stones" (Rev. 21:19) and bathed in

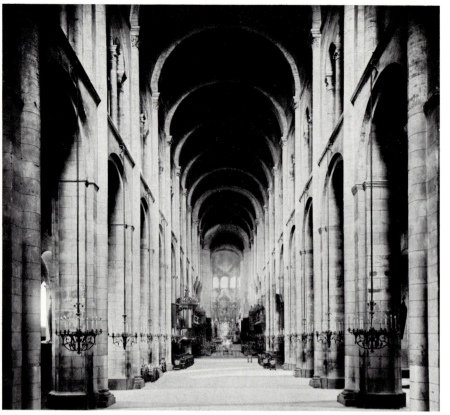

6-4 Interior of abbey church of Saint-Sernin, Toulouse, nave begun in 1077, choir consecrated in 1096; nave completed early twelfth century.

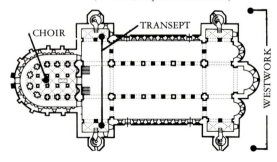

4-7 Saint John Lateran, reconstruction of building as it must have appeared in A.D. 320 (*comparative illustration*).

6-3 Plan of Saint Michael's Church, Hildesheim, 1001–31 (Ottonian, *comparative illustration*).

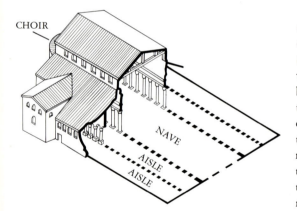

a light "like unto a stone most precious, even like a jasper stone, clear as crystal" (Rev. 21:11). The sinful man, however, was to be allotted "the lake of fire and brimstone," and therein he would "be tormented day and night for ever and ever" (Rev. 20:10). These beliefs provided the Church with a formidable weapon, more and more frequently employed from that time on: as the servant of Christ in this world, it had the power to excommunicate men and to withhold the last sacraments, thereby condemning them to an afterlife of torment.

Innovations in Romanesque architecture were as bold as those in sculpture. In contrast to the central plan favored in Constantinople and the eastern Mediterranean, the buildings erected under the auspices of the Church of Rome had the strong axial emphasis of early Christian basilicas (Fig. 4-7) and usually pointed toward the East. In Carolingian and Ottonian times, the practice of stressing the importance of the western end of the church had led to the addition of another

transept (or *westwork*) and sometimes an apse serving as a chapel (Fig. 6-3). In Romanesque times there was an almost general return to the Latin cross, but a number of variations suited to the needs of local clergy were developed. Figure 6-4 shows the nave of the abbey church of Saint-Sernin at Toulouse, which was completed early in the twelfth century. It is characteristic of the so-called pilgrimage-road churches, which were erected by monastic orders along the principal arteries from central and southern France to Santiago de Compostela in Spain, a pilgrimage center second only to Jerusalem and Rome at that time. The churches that have survived were all built of carefully cut stone. They are vast; their *crossings* (the area where nave and transept intersect) are surmounted by towers or *lanterns*—structures with openings to admit light. Perhaps in order to provide room for processions, the aisles of the nave were extended into a passageway around the choir, called the *ambulatory*. On the east side of the transept and around the apse

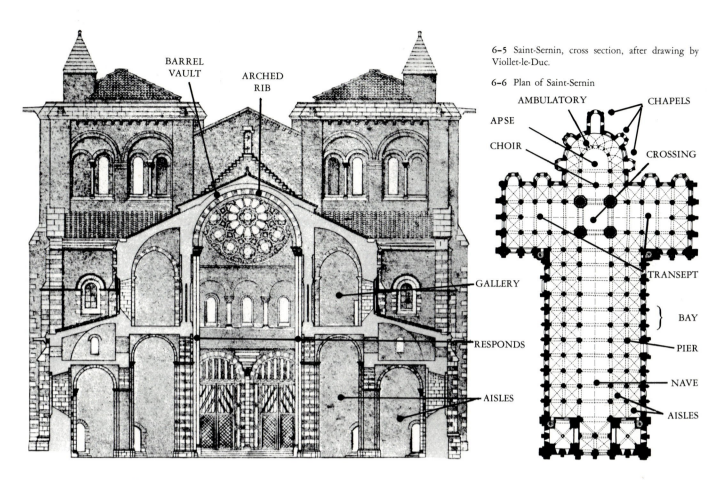

BARREL
VAULT

ARCHED
RIB

6-5 Saint-Sernin, cross section, after drawing by Viollet-le-Duc.

6-6 Plan of Saint-Sernin

AMBULATORY

CHAPELS

APSE

CHOIR

CROSSING

GALLERY

TRANSEPT

RESPONDS

BAY

PIER

NAVE

AISLES

AISLES

are a number of small chapels to honor various saints and to allow for several simultaneous services (Fig. 6–6).

We saw earlier that the principal articulation of early Christian basilicas was the rhythmic effect of the arcades. (By *articulation* is meant the arrangement of elements such as openings, projections, ribs, and pilasters that give emphasis to the overall configuration of a building.) Aside from window openings at regular intervals, the walls above the arcade were smooth. Romanesque churches carried the rhythmic effect even further. In addition to the massive piers providing vertical accents along the nave, there were often sets of half pillars (or *responds*) protruding from the piers and rising to the vault, forming arches (or *ribs*). As a result, the whole design of Romanesque churches seems to have been conceived in terms of repetitive rectangular units, or *bays,* frequently delimited by pairs of piers along the nave, and most of the elements of the overall structure and the decoration were related to the dimensions

of these bays. Romanesque churches thus combine the strong axial emphasis of early Christian basilicas with a powerful new rhythmic articulation based on this system of bays, which stressed the structural organization of the masses. The general effect is orderly, majestic, and overpowering.

The practice of adding up individual units to compose the overall plan of the building is similar to the way in which decorations of the Dark Ages were made up of regularly repeated elements. Both approaches are essentially additive and geometric.

The other major development of Romanesque architecture was the extensive use, from the middle of the eleventh century on, of masonry barrel vaults over large new naves. Such vaults were used in antiquity to cover wide areas, as in the Rameseum (Fig. 1–13) and the Porticus Aemilia (Fig. 3–10). In Carolingian and Ottonian times, however, they were sometimes used in *crypts* (underground vaults) and over the naves of small

churches and the aisles of large ones; the naves of large churches had timber roofs. The chief reason that Romanesque architects turned to masonry barrel vaults to cover large naves is that they greatly reduced fire hazards. The major disadvantage of these vaults was that their weight created a considerable lateral thrust requiring massive or heavily buttressed supporting walls. This shortcoming was to create major problems for the Romanesque architects and was finally—and elegantly—solved only by the initiators of Gothic architecture. A cross section of Saint-Sernin (Fig. 6–5) reveals an ingenious device for coping with the lateral thrust of the main vault: each aisle is surmounted by a gallery, itself covered by a half vault that abuts the main vault. In this fashion, the lateral thrust of the main vault is transmitted to the heavy masonry of the massive outer piers and walls, and overall stability is achieved. The arched ribs spanning the nave also serve a structural purpose. Carefully built of cut stone, they provide a firm support for the

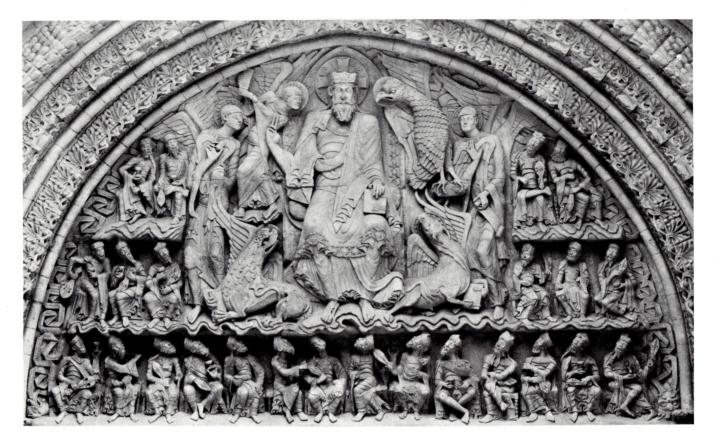

main vault and probably helped prevent deformation at the time the supporting scaffolding was removed, when the mortar was still soft, the drying process taking months.

There is a serious drawback to this system of abutting arches, however. In the majority of early Christian basilicas, nave windows let in abundant light from the outside. In buildings such as Saint-Sernin, the light has to cross the gallery and aisles before it enters the nave, and these churches are consequently rather dark.

Even before they made extensive use of barrel vaults, Romanesque builders had shown a predilection for the semicircular arch, both in the arcades of the nave and in the designs that frequently adorn the walls of the façade and the interior. This led nineteenth-century art fanciers to associate (no doubt with some justification) the churches of this era with Roman architecture, which also relied extensively on the semicircular motif: hence the name Romanesque.

A sculptural ensemble, probably completed by 1115, from the abbey church of Saint-Pierre at Moissac near Toulouse (Fig. 6–7) is a splendid example of the adaptation of Romanesque sculpture to the purposes of architectural decoration. It is carved in the *tympanum,* a semicircular slab of stone fitting within the arch over the door of the portal of the south transept. Like most Romanesque sculpture, it was originally painted in vivid colors. The basic theme is the same as that of the relief of Saint-Sernin (Fig. 6–2)— Christ in Majesty surrounded by the symbols of the evangelists of the Revelation of Saint John the Divine—but the figure of Christ, bearded and serene yet still rather forbidding, is obviously derived from a source totally different from that of the Saint-Sernin relief. There is, moreover, a new ease in the handling of volume; the forms of Christ's body have a mellow roundness and his proportions are more graceful. In contrast with the severe stylization of the folds of the garments of the Saint-Sernin Christ, those of the

Moissac effigy have a gentler flow and in certain areas break out into rich flounces and pleats.

The Moissac artist added two seraphim to the central group, as in the sacramentary of Charles the Bald (Fig. 5–5). He also drew on other elements in Revelations: "round about the throne were four and twenty seats; and upon the seats I saw four and twenty elders sitting, clothed in white raiment; and they had on their heads crowns of gold" and "every one of them [had] harps, and golden vials full of odors which are the prayers of saints" (Rev. 4:4, 5:8). The undulating bands between the horizontal rows of figures must be the "sea of glass like unto crystal" mentioned later in the same text (Rev. 15:2).

In keeping with the additive principle, the artist placed rows of elders on each side of Christ, thus covering the whole surface of the tympanum with figures. He was also interested in subordinating the composition to a simple geometric pattern: the figure of Christ, clearly related

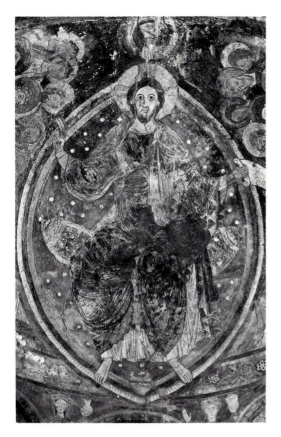

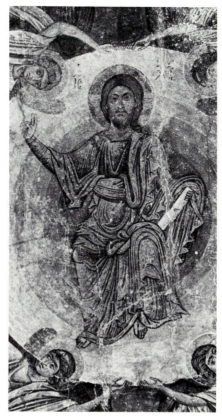

6-7 *Far left:* Christ in Majesty Surrounded by the Elders of the Apocalypse, from tympanum of the south portal, abbey church of Saint-Pierre, Moissac, probably completed by 1115; stone.

6-8 *Center:* Christ in Majesty, from priory of Berzé-la-Ville, Burgundy, completed by 1150; tempera.

6-9 *Right: The Ascension,* from cathedral of Saint Sophia in Ohrid, first half of eleventh century; tempera *(comparative illustration).*

to the form of the mandorla (barely visible at the top), constitutes a dominant accent, corresponding to the vertical axis of the arch, which, incidentally, is slightly pointed. The symbols of the evangelists and the seraphim form a circle around Christ, while the elders are disposed in horizontal registers of nearly equal height. Finally, the gaps between the elders at the end of each row and the arch itself are filled on each side by a band forming a meander design, no doubt derived from an antique motif. These bands seem to spring out of lion-like monsters, in the best tradition of barbarian zoomorphic interlace. Neither monsters nor bands can be immediately related to the subject matter of the tympanum; they introduce an element of fantasy, just as the caryatids of the Ottonian gospel book (Fig. 5-10) did.

The overall arrangement is powerfully expressive. The size and placement of the figures are determined strictly by hierarchic precedence. The symbols of the evangelists are nearest to the massive central figure of Christ. The seraphim are smaller than Christ and further away, and the elders are still smaller and still further away. The very distribution of the masses heightens the expressive content, for the grouping of the figures suggests widening ripples around the figure of Christ, while the richly varied accents created by the limbs and instruments of the other figures suggest excited dancing motion around the serenely majestic figure of the lord. Indeed, the composition itself echoes the ecstatic delight of the elders in the text of Revelations: "Thou art worthy, O Lord, to receive glory, and honor, and power: for thou hast created all things, and for thy pleasure they are and were created" (Rev. 4:14).

For an example of Romanesque wall painting, let us examine the apse decoration showing Christ in Majesty with the twelve Apostles of the little church of Berzé-la-Ville in Burgundy (Fig. 6–8), which was executed in tempera and completed by 1150. It is interesting on three scores. In its own right, it is a very fine example of late Romanesque monumental painting. Furthermore, it is probably an elaboration on a small scale of the apse decoration of the nearby abbey of Cluny, the headquarters of the Benedictines, the most powerful monastic order in tenth- and eleventh-century Christendom, and the largest and most sumptuous building of its time, now mostly destroyed. Thus it is a unique and important vestige of Cluniac painting. Finally, it reflects yet another of the waves of Byzantine influence that so frequently renewed the links of the Middle Ages with the Mediterranean basin.

The rendering of Christ may have been based on a Byzantine source, which seems also to have influenced a detail of a mural of the Ascension in the cathedral of Saint Sophia in Ohrid in southern Yugoslavia (Fig. 6–9), a work characteristic of the Byzantine Second Golden Age that dates from the first half of the eleventh century. At first we are struck by the differences. In the Ohrid Christ we recognize, for all the linearity of the

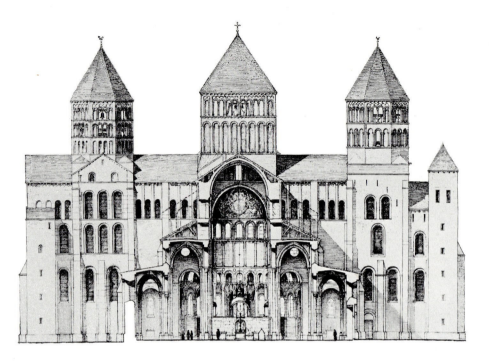

6-10 Third abbey church of Cluny, 1088–c. 1130. (Reconstruction by K. J. Conant.)

treatment, an ease in the attitude, a cohesiveness in the drapery, and a certain three-dimensionality that point to a distant classical prototype. The design of the Berzé-la-Ville Christ, in contrast, has been deliberately distorted to follow the overall form of the mandorla: the S curve of the seated body has been strongly emphasized, while the breadth of the hips has been exaggerated. The hands and feet are placed rather artificially over the mandorla. Moreover, the linear animation and the arbitrary undulation of the drapery are only remotely related to the human form. As for the faces, that of the Ohrid Christ looks almost naturalistic and is humane and compassionate in comparison to that of the Berzé-la-Ville Christ, which is as disturbingly elongated as its stare is awesome.

And yet there can be no question that the pattern of the drapery folds is basically the same. The use of several polished layers of plaster on the wall before the paint was applied also points to the influence of the refined craftsmanship of By-

zantium on Romanesque painting. More importantly still, new restraint and dignity are present in the form of the Berzé-la-Ville Christ and the color harmonies have a new subtlety and richness that point to a genuine appreciation of Byzantine art.

Before we turn to Gothic art, a word about the architecture of the now mostly destroyed abbey church of Cluny is essential. A cross section of the nave of this ambitious structure, built from 1088 to around 1130 (Fig. 6–10), reveals three significant differences from the pilgrimage-road churches (Fig. 6–5). In the first place, the barrel vaults of the aisles are pointed, reducing the lateral thrust of these vaults in relation to their weight and insuring greater stability. The pointed arch, incidentally, was to become a characteristic feature of Gothic art. Secondly, there is a stress on verticality that also heralds the Gothic age; the nave is taller and there are no galleries over the aisles, which can therefore be higher. Finally, to provide better interior lighting, there is

a row of windows above the roof of the aisle, which forecast the development of rows of vast nave windows in Gothic churches.

7
Gothic Art

The distinction between Romanesque and Gothic art, like that between Ottonian and Romanesque art, is not easily defined. The chief difference is one of mood, which led to a new synthesis of elements already present in the earlier style. Major cultural and political developments were taking place all through the eleventh and twelfth centuries, perhaps the most important of which was a tremendous expansion of intellectual horizons. At its worst, mental activity in the monasteries of the early Middle Ages had been confined to an endless and spiritless repetition of liturgical texts. Yet Saint Augustine himself, as early as the fifth century, had advocated the study of the scientific and philosophical thought of the ancients as an aid to the interpretation of the Scriptures.

In the more enlightened monasteries, consistent efforts were made during the tenth, eleventh, and twelfth centuries to study the pagan authors of Rome and Greece. Meanwhile, contacts with Islamic centers exposed the West to the cultural achievements of Islam, particularly mathematics, astronomy, and other sciences.

The Medieval Christian mind was most receptive to ideas that could be adapted to its own beliefs. Plato's notion of a superior harmony, for instance, became associated with the blissful vision of the New Jerusalem. The study of Aristotle led to a new interest in precise reasoning, which was sometimes carried to absurd lengths, and to persistent attempts to systematize human knowledge. These attempts, however, were often marred by an excessive tendency to categorize everything from the seven deadly sins to the twelve labors of the months. More specifically, the influence of Aristotle led Medieval schoolmen to attempt the rational formulation of the doctrines of the Church that became known as scholasticism. Every aspect of the Old and New Testaments, every thought expressed by the fathers of the Church, had to be given an elaborate interpretation to be conveyed with clarity and cogency to the faithful; conversely, every philosophical problem had to be resolved in terms of fixed religious dogma.

The Medieval intellectual outlook was further expanded through ever broadening interregional exchanges. Famed relics, whether in the Holy Land or Santiago de Compostela, Rome or Saint-Denis, attracted constant streams of pilgrims seeking eternal salvation. Above all, during the twelfth and thirteenth centuries, a succession of vast expeditions known as the Crusades, intended to wrest the Holy Land (present-day Israel and Jordan) from the Islamic powers and establish a Christian kingdom there, exposed large numbers of Westerners not only to the culture of Islam but to Byzantine art and culture and to vestiges of Greek and Roman antiquity encountered along the way.

However limited these contacts were with the ancient world and foreign lands, and however naive and incorrect the ideas were that Medieval men drew from them, they prompted a realization that Romanesque culture was parochial and limited and drove men to reach for much higher

7-1 *Prophet Isaiah,* door-jamb sculpture from abbey church of Sainte-Marie, Souillac, c. 1130 (*comparative illustration*).

goals in all their endeavors. Significantly, when showing visiting dignitaries the treasury of his newly rebuilt abbey church, Abbot Suger of Saint-Denis, near Paris, would inevitably ask how its holdings compared with the treasures of Constantinople.

In Medieval politics, the twelfth century saw the height of the temporal power of the pope, who felt free to excommunicate recalcitrant rulers (including, at one point, the king of Germany and future Holy Roman Emperor) and even to attempt to depose some. During the thirteenth century, however, power passed imperceptibly to the leading royal families, who were imposing stricter control over their vassals and enlarging their private territories. By the fifteenth century, the French kings in particular had expanded their domain, the Île de France—which in the twelfth century had extended some one hundred miles from Paris—into an area almost the size of modern France, and they turned it into the most powerful nation in Europe.

Major changes were also taking place in the economy. Life for the peasant population remained abysmal, but with the growth of trade and industry there appeared in the cities a prosperous middle class that was soon to impose its own cultural patterns. Not surprisingly, the major building effort of the twelfth and thirteenth centuries was directed toward

the metropolitan cathedrals, and the cathedral schools became the most active centers of learning, in many cases evolving into the great modern European universities.

The artistic changes that were taking place in the twelfth century are magnificently illustrated by the differences between the stone door-jamb sculpture of the prophet Isaiah (Fig. 7-1) from the abbey church of Sainte-Marie (c. 1130) at Souillac in southwestern France and the stone statues of four biblical figures (a prophet, a king, a queen, and another king) from a door-jamb of the West (or Royal) Portal of the cathedral of Chartres, erected in about 1145 (Fig. 7-2). Iconographically, the biblical figures of Chartres serve a purpose similar to that of the prophet of Souillac. We have seen on the sarcophagus of Santa Maria Antiqua from a little over nine centuries earlier (Fig. 4-1) that Jonah was intended to symbolize the resurrection of Christ. During the twelfth and thirteenth centuries, such parallels were frequently drawn, in an effort to elucidate every passage of the Old Testament in terms of the life of Christ. Standing as they do at the entrances of their respective buildings, the prophet and royal figures are meant to prefigure the coming of Christ. The prophets are an allusion more specifically to Christ's apostolic mission, and the kings and queen are allusions to Christ's presumed royal lineage. The interior of the church itself, incidentally, symbolizes the New Jerusalem.

Stylistically, Isaiah's animated gestures

and flowing draperies, which tend to fill the rectangular field of the composition, as well as the elegant and rather arbitrary modeling of the body and the contorted attitude, place the figure squarely in the Romanesque tradition. The Chartres kings, on the other hand, reveal only partial connections with Romanesque art. There is still a considerable arbitrariness in the handling of volume; the figures are elongated to establish a plastic parallel with the cylindrical form of the columns to which they are attached; the curvilinear patterning of certain folds reflects a touch of fantasy, and the wide eyes still seem fixed in an ecstatic stare. Other elements, however, link the statue with a new tradition, and its style can be called Transitional Gothic. In the first place, the frantic gesticulation and awesome stare of Romanesque works have given way to a new stillness and dignity in the attitude and to refinement and kindliness in the features. Perhaps more importantly, although each statue is in one piece with the column, it was executed almost in the round.

This new stress on three-dimensionality marks a significant departure from Romanesque trends. It was brought about by, among other things, renewed contacts with antiquity through the art of Byzantium. The Île de France workshops in which the Gothic manner was evolved were also profoundly influenced by the

7-2 *Old Testament Prophet, Kings, and Queen*, door-jamb statues from West (or Royal) Portal, Chartres Cathedral, c. 1145.

7-3 *This page:* Renier of Huy, baptismal font, Saint-Barthélemy, Liège, 1107–18. Bronze (25″ high) (*comparative illustration*).

7-4, 7-5, and 7-6 *Opposite page, left, center, and right:* West (or Royal) Portal, Chartres Cathedral, c. 1145–70.

thriving Romanesque school of metal-workers and jewellers of the region of the Meuse, a tributary of the Rhine that flows through northeastern France and Belgium. The bronze baptismal font of 1107–18 (Fig. 7–3) by Renier of Huy, in the church of Saint-Barthélemy in Liège is one of that school's finest products. Not only does it reflect a sense of grace and harmony in the arrangement of the figures, but the artist has tentatively suggested a recession in space by means of a wavy band suggesting a tilted floor on which the various figures stand, some clearly in front of others. The figures themselves, moreover, stand out in consistently high relief against the background and reveal considerable fluency both in the modeling of bodies and limbs and in the convincing treatment of the antique-looking draperies. All these elements point to strong Byzantine influences. These can readily be explained by the fact that the Meuse valley was the cradle of the Carolingian dynasty, which had encouraged the emulation of antiq-

uity and fostered contacts with Byzantium, a tradition that seems to have been sustained through Ottonian and Romanesque times.

The innovations apparent in the Royal Portal of Chartres reflect a shift from the love of the monstrous and fantastic of Romanesque times to a new ideal of humaneness and urbanity. Indeed, they are characteristic of a widespread reaction against what the leading religious reformer of the twelfth century, Saint Bernard of Clairvaux, had called the "misshapen shapeliness and shapely misshapenness" of Romanesque art.

Another element that emerged from one of the principal characteristics of the Romanesque style itself is a new orderliness in the relationship between sculpture and architecture, for each figure fits exactly in front of a column. This sense of order is also apparent in the layout of the statues in the *archivolts,* the concentric recesses of the arches, which are arranged in parallel rows and cut from stones of equal size (Figs. 7–4, 7–5, and 7–6).

The statues of the Royal Portal constitute an elaborate iconographic scheme carefully planned by the cathedral schoolmen to illustrate aspects of their theological thought. The central tympanum seen in Figure 7–5 is devoted to a Christ in Majesty surrounded by the symbols of the evangelists, while in the inner archivolt there is a row of angels and in the outer are two rows of the elders of the Apocalypse, a subject that goes back to Moissac (Fig. 6–7) and other great Romanesque tympana. Below Christ are fourteen men —the twelve Apostles, who will help him on the Day of Judgment, and two prophets who will return to earth just before that event to give mankind a last chance to mend its ways, a reference, no doubt, to the spiritual responsibilities of the clergy in Medieval society.

The left tympanum (Fig. 7–4) is devoted to the ascension of Christ. The miraculous nature of the event is stressed by the gestures of the four angels under him, who are pointing and gesticulating to attract the attention of the Apostles

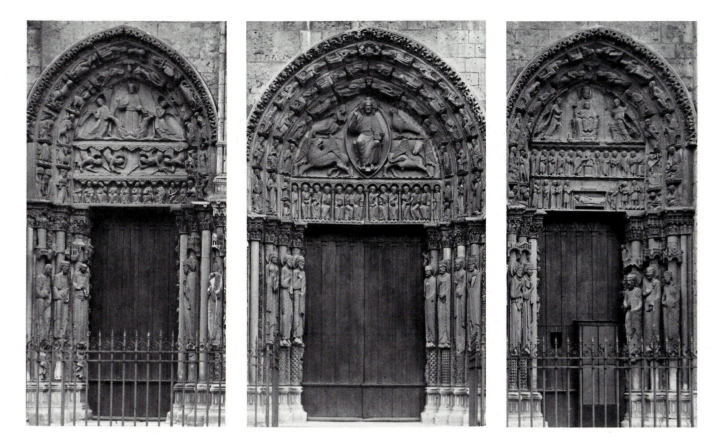

seated below. Through the placement of the signs of the zodiac and the labors of the months in the archivolts, the designers linked the supernatural powers of Christ with the mysteries of the cycle of the seasons.

The right tympanum (Fig. 7-6) is devoted to the Virgin Mary, who was the patroness of this cathedral. Here the infant Christ is literally enthroned on the lap of his mother, as if to prefigure his role on the Day of Judgment, and is thus shown at once as child and judge, as human and divine. This is in keeping with the doctrine of the double nature of Christ, which greatly concerned Medieval theologians. The two lintels refer to the role of the Virgin in bringing Christ into the world of men. In the lower one, from left to right, we see the Annunciation (an angel informs Mary of the Immaculate Conception), the Visitation (Mary and her cousin Elizabeth apprise one another of their pregnancies), and the Nativity (Joseph stands at the head of Mary's bed, at whose foot are an angel

and three shepherds who have come to pay homage, while the infant Christ lies on the canopy over the bed, as if on a sacrificial altar). The upper lintel shows the presentation in the temple; this time Christ stands on a real altar. Joseph and Mary are at his side, and two lines of giftbearers converge toward the center. The moment heralds the recognition of Christ's divinity and at the same time his ultimate sacrifice. In the archivolts are figures of the seven liberal arts, in the form of people holding objects symbolic of their occupations, accompanied by appropriate pagan authors (Cicero for rhetoric, Euclid for geometry, Pythagoras for music, and so on), indicating, no doubt, that the intellectual and professional activities of the school of Chartres were intended to serve theology. Thus the decoration had a dual purpose. As in earlier times, it was intended to make the Scriptures easily apprehensible to the worshipers. In addition, it was meant to make subtle points of dogma totally, one might even say tangibly, explicit, in keeping

with the didactic aims of scholasticism.

The sculptural scheme was not entirely original. It was inspired in good measure by the façade of the abbey of Saint-Denis, which was partially rebuilt under Abbot Suger from 1137 to 1144. Aside from the new iconographic scheme of the façade, the additions at Saint-Denis were characterized by a bold exploitation of structural elements first developed in Romanesque times. The outcome was the first manifestation of the Gothic style, which we have referred to as Transitional Gothic. The term Gothic, by the way, was coined by the men of the Renaissance to refer to what they saw as a period of decadence beginning with the overrunning of the Roman Empire by the Goths and other barbarians and lasting until their own era.

The impact of the new architecture was enormous. Saint-Denis was the patron saint of the French monarchy, and the abbey was the traditional burial place of the French kings. Suger was the trusted adviser of the royal family and was to

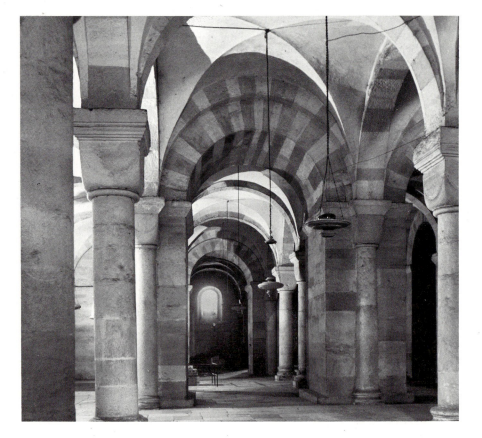

7-7 *This page, top:* Speyer Cathedral, crypt, 1030–60.

6-4 *Opposite page, left:* Interior of abbey church of Saint-Sernin, Toulouse, nave begun in 1077, choir consecrated in 1096, nave completed early twelfth century (*comparative illustration*).

7-9 *Opposite page, right:* Interior of Sens Cathedral, begun in c. 1140.

7-8 *This page, bottom:* Durham Cathedral, vaulting of choir aisle, 1093–96 (*comparative illustration*).

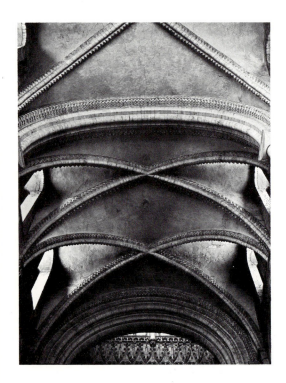

some extent responsible for its successes. There can be no question that the new style came to be associated with the political fortunes of the kingdom.

Gothic elements appeared simultaneously in other cathedrals of the Île de France and eventually spread through the whole of France and Western Europe. The Gothic style maintained its dominance until the prolonged and very uneven transition to the Renaissance took place in the fifteenth, sixteenth, and (in some areas) seventeenth centuries.

We may get an idea of the architectural innovations of Suger's day by comparing the interior of the cathedral at Sens, near Paris, which was begun around 1140 and can be called early Gothic (Fig. 7–9), with that of Saint-Sernin (Fig. 6–4). One is immediately struck by the fact that walls and piers are much less bulky at Sens than at Saint-Sernin. The Sens architect further stressed the effect of lightness by more delicately articulating the piers themselves; they are made up alternately of double columns and complex clusters

of semicircular and rectangular shafts. This alternation of solids and voids creates light-and-shade effects that add to the feeling of ethereality.

The interior of the cathedral at Sens also has much better lighting. At Saint-Sernin the light has to cross the aisle or the gallery before entering the nave, but at Sens the larger windows of the upper story (appropriately called the *clerestory*) admit light directly from the outside. (It should perhaps be added that the windows were enlarged in the course of thirteenth-century restorations.) The gallery itself is much smaller than at Saint-Sernin so there is, consequently, more room for the clerestory.

Perhaps the most notable difference with Saint-Sernin is the use of pointed arches (already observed at Cluny) and the complex crossribbed vaulting. The use of pointed arches in connection with crossribbed vaulting was to become the dominant characteristic of Gothic architecture, and a note on the development of this system is therefore in order. *Groin*

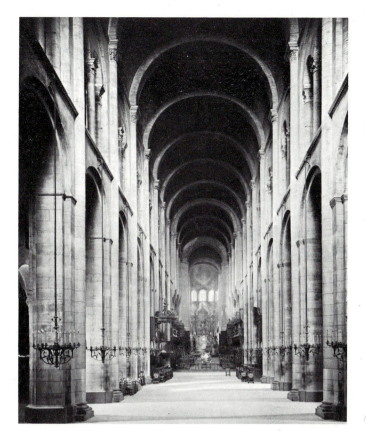

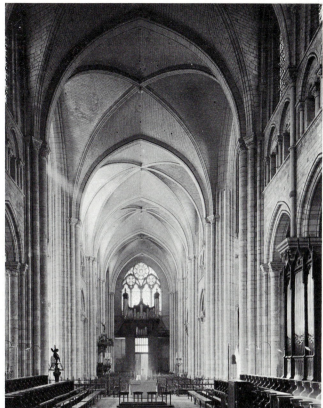

vaults, such as one sees in the crypt of the Romanesque cathedral at Speyer in Germany, built between 1030 and 1060 (Fig. 7–7), had been widely used by Roman architects and appeared frequently over small areas in Romanesque churches. Such vaults are made up of the intersection of two semicylindrical barrel vaults at right angles. They present a considerable structural advantage over continuous barrel vaults in that the groins bear most of the load and distribute it onto the four supporting piers. Groin vaults nevertheless present a serious practical problem to the builder: the line of the groins is a complex three-dimensional curve that the men of the Middle Ages had no way of determining mathematically. As a result, most groins, like the ones in the illustration, have a somewhat irregular appearance.

The solution to this problem seems to have been devised in Romanesque (usually called Norman) England. In the vaults of the choir aisle in Durham Cathedral, which were begun in 1093 and finished in 1096 (Fig. 7–8), the builders seem to have first erected carefully assembled cut stone arches and crossribs. Rather than tackle the problem of groins created by the intersection of semicylindrical barrel vaults, the Durham builders devised simple and convenient ribbing, consisting of circular arches and crossribs. Using these as guides, they then simply filled in the masonry membranes (or *webs*) above them. These webs were no longer semicylindrical surfaces and were, in fact, mathematically quite complex, but they could be made to look tidy. What is more, the temporary wooden forms, or *centering,* used to lay the courses of the webs and support them until the mortar had dried, could be given similar shapes, so that corresponding webs in each bay would be alike. At times the wooden forms were laid temporarily on the crossribs and arches themselves, thereby reducing scaffolding expenses.

The next step was the development of pointed arches and, eventually, pointed crossribs. The crossing bay at Sens (the first full bay visible in Figure 7–9) is made up of circular crossribs, pointed arches, and webs meeting at an angle along the top (the other bays display a complex early Gothic variation of this combination). The chief advantage of this arrangement is that the crown of the vault is higher than it would have been in a semicylindrical barrel vault or groin vault. This in turn reduces the lateral thrust of the vault in relation to its weight and increases the stability of the structure. In addition, the interplay of webs can be compared to a corrugation, strengthened by crossribs and arches, which increases the overall rigidity. The arrangement is beneficial in two ways: it makes possible the use of lighter masonry for the webs, and thus taller and wider naves; and it also makes possible the localization of the thrusts at the piers, even more effectively than with groin vaults, enabling the architect to devote more wall area to stained-glass windows.

A little later Gothic architects were to combine pointed arches with pointed crossribs, as can be seen clearly in the

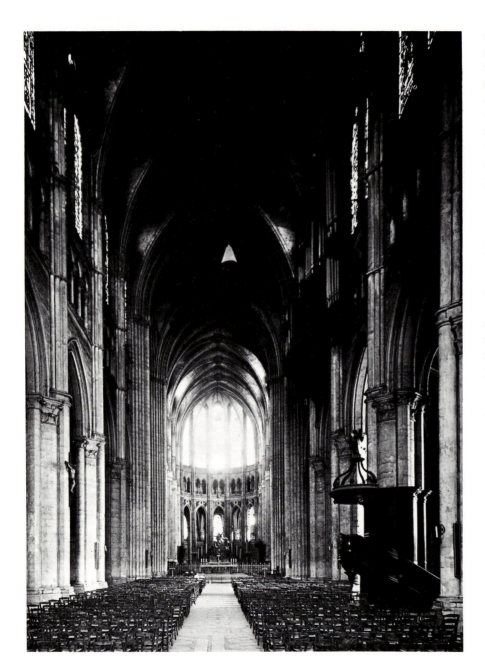

interior of Chartres Cathedral, completed in 1221 (Fig. 7–10). Here the profile of the vault is more pointed, thus insuring even greater stability; in addition, the crown of the crossribs is a little higher than that of the arches, so that the vault over each bay is slightly domed.

Aside from any practical considerations, the articulation provided by piers, webs, crossribs, and arches constitutes a neat, orderly, and handsome three-dimensional network that seems to reflect the directions of the structural thrusts in the masonry. The Gothic builders succeeded in evoking the play of structural forces in a building by means of the manipulation of the stone.

The High Gothic period was ushered in with the rebuilding of Chartres, begun after a fire destroyed all but the west façade in 1194 and completed in major part by 1221 (Fig. 7–10). It was here that the elongated forms that came to characterize High Gothic style first appeared. The row of openings of the middle story is even narrower than at Sens, allowing more space both to the clerestory above it and to the arches below it. The windows of the clerestory themselves occupy the whole width between the piers to let in a maximum of light through their multicolored stained glass, and the combination of pointed arches and pointed crossribs rising higher than the arches

7–10 Interior of Chartres Cathedral, 1194–1221.

contributes a new sense of lightness and grace to the vault while adding to the overall stress on verticality. The comparative thinness of the piers, arches, and ribs, moreover, transforms the edifice into a delicate framework of stone that seems to express the architect's triumph over gravity. In point of fact, the thinness of the piers is deceptive. Gothic architects made a practice of placing the bulk of the masonry of each pier on the outside, so that it is not readily visible from the inside of the church. Furthermore, they surrounded the tall parts of the building with arches abutting the wall, called *flying buttresses,* intended to resist the lateral thrusts (Fig. 7–11). These flying buttresses function in the same way as the gallery arches of the pilgrimage-road churches (Fig. 6–5). Since they are not covered, however, they do not prevent outside light from entering the clerestory. In fact, they create a stone skeleton that restates the articulation of the nave esthetically and complements it functionally.

To walk along the nave of Chartres is an almost overpowering experience. The axial thrust toward the altar and the vertical thrust of the pointed nave create a strong dynamism. At the same time the repetition of bays along longitudinal and transverse axes produces a startling multiplicity of effects; the relationship of arches and piers in the aisles alters constantly as

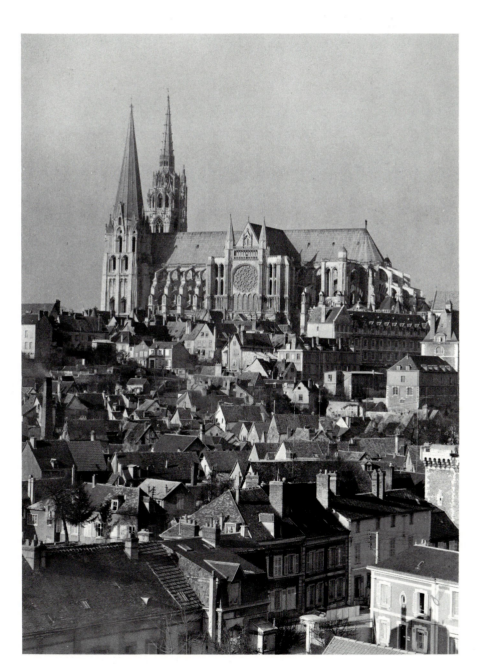

7–11 Chartres Cathedral, 1194–1260

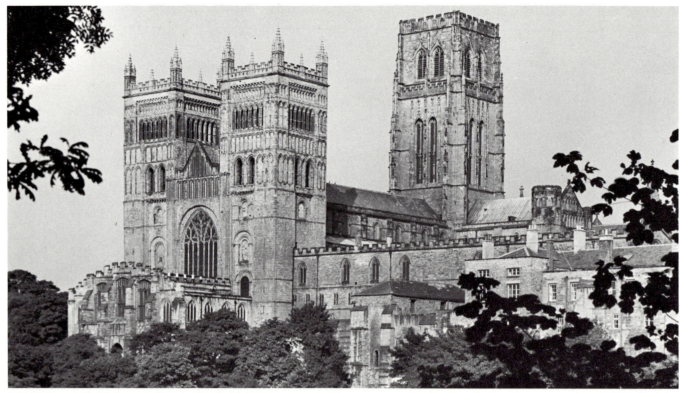

7-12 Durham Cathedral, begun in 1093 (*comparative illustration*).

one advances. The slightest change in the position of the onlooker induces changes in the appearance of the large and complex structure.

Even more striking is the effect of the stained-glass windows. The huge windows of the outer aisles, side chapels, ambulatory, and clerestory are made of innumerable small fragments of colored glass. Each window consists of several medallions depicting religious scenes (the figures and objects are painted on the glass and then fired) surrounded by lavish decorative patterns. The scenes themselves are as clear and brightly colored as are those of Medieval manuscripts such as the Morgan Bible (Fig. 7-16), benefiting in addition from the luminosity created by the filtering of outside light through the glass. Despite the large size of the windows, incidentally, comparatively little light penetrates through the colored fragments, so that the interior of the cathedral is fairly dark and the windows appear even brighter by contrast.

The elegance and refinement of the proportions as well as the ethereal lighting of Chartres—and indeed of other High Gothic cathedrals—would have pleased Abbot Suger, who had looked for a "superior and well-tempered harmony" in church architecture and who exclaimed, after the completion of his own additions at Saint-Denis, "bright is the noble edifice that is pervaded by the new light."

The evolution of the façade of Gothic churches parallels the interior changes. The westworks of Carolingian and Ottonian architecture (see pp. 67, 72 and Figs. 5–9 and 6–3) had set a trend toward massive west façades dominated by two powerful towers. A clear illustration is the magnificent Romanesque cathedral of Durham in England, begun in 1093 (Fig. 7–12), in which the assemblage of cube-like forms creates an impression of overwhelming solidity that is barely relieved by the few horizontal lines and the blind and true arcades. (The large window dates from the late Gothic period.) At Notre Dame, the cathedral of Paris, begun in

1163 and largely completed by 1270 (Fig. 7–13), in contrast, the architects showed a typical Gothic interest in an explicit differentiation between the various levels of the building. They left large areas of unadorned wall on the lower story, thus stressing the massiveness of the masonry. They created an effect of greater lightness with the larger openings of the second story, particularly with the rose window and its delicate tracery of stone. On the third story they placed a lace-like arcade that unites the towers and the space between them. And, finally, they so textured the piers of the soaring towers themselves that one tends to forget that they are made of stone. For all this display of virtuosity, however, the façade of Notre Dame has a remarkably stable appearance. This may be due to the designers' reliance on simple proportions: the area between the floor level and the top of the arcade is a square, and the height of the towers above that is half the height of the square. Such simple, not immediately obvious, mathematical relationships are not un-

usual in Gothic buildings. They reflect at once a continuance of the taste for geometric relationships of the Dark Ages and the Romanesque period and the search for harmony in Gothic times.

The evolution in sculpture from Transitional to early and High Gothic was as rapid and as startling as was that between the Archaic and Classical periods in ancient Greece; indeed, some of the achievements of the Gothic sculptors can be compared to those of fifth-century Greek sculptors and, in fact, were partly influenced by them.

Figure 7–15 shows a tympanum of about 1235 on the south transept of the cathedral of Strasbourg in eastern France. The subject, the death of the Virgin and her ascent to heaven, is derived from a body of legends that had been written around the Scriptures. A comparison with the figures of the Royal Portal of Chartres

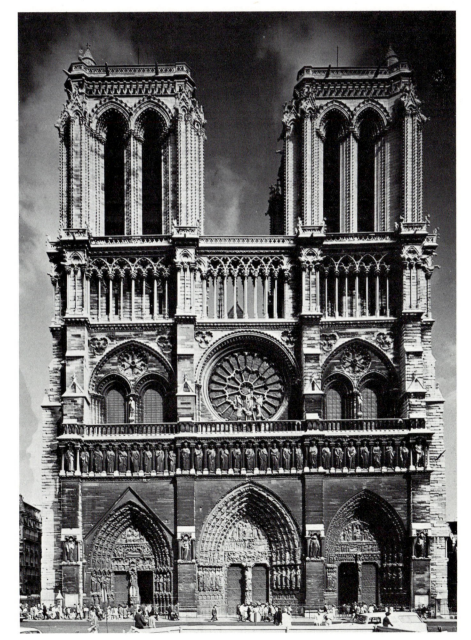

7–13 Notre Dame Cathedral, Paris, begun in 1163 and largely completed by 1270.

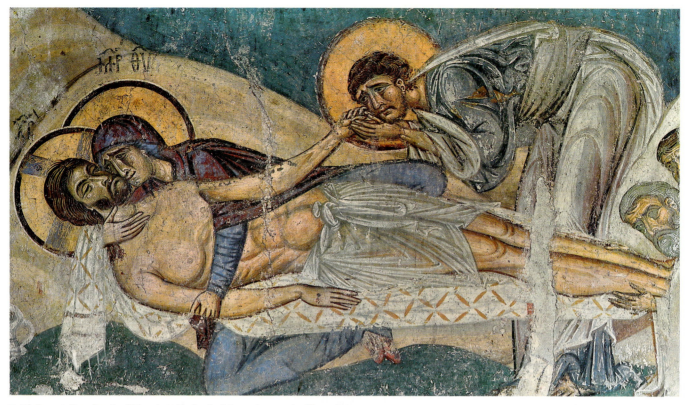

7-14 *Lamentation,* church of Nerezi, 1164; detail of fresco (*comparative illustration*).

(Fig. 7-2) reveals immediately that the rigidity of the transitional style has disappeared. The variety of the positions of the bodies implies a full freedom of motion in space. But there is an even more important departure in that the composition is not made up of distinct compartments, as in the tympana of Moissac and Chartres (Figs. 6-7 and 7-4); the figures all exist in a unified space.

There can be no doubt that these achievements are partly due to antique influences. Indeed, the new controlled plasticity of the modeling, the illusionistic play of light and shade on the folds of drapery, the swaying and twisting of the figures (particularly the exaggerated *contrapposto* of the figure of Christ in the center of the composition), and the unified space all point to Greco-Roman prototypes. And yet there are telling differences. In comparison with the figures of the sacrificial procession from the imperial Roman altar in Figure 3-6, the courtly swaying and twisting Gothic figures are distinctly mannered and their bodies are

more distorted. One detects, in the handling of both the outlines and the folds of the draperies, the animated surface linearism characteristic of Medieval art since the barbarian invasions (notice in particular the attractive but implausible curvature of the bed). And, finally, there are traces of the additive and geometric approaches to composition: the figures in the background have been repetitively juxtaposed over the surface to fill the semicircular arch.

In one important respect the Strasbourg relief shows a marked technical improvement over the Roman work. The figures on the Roman altar, as we noticed earlier (p. 40), seem to be sandwiched between two transparent vertical planes. The reason for this is that the heads are all more or less on the same level, and the same is true of all the feet; it is therefore impossible to get an idea of the arrangement of the figures in depth. By selecting a high point of view, on the other hand, the Strasbourg sculptor managed to give us a much better idea of the

distribution in depth of the various figures. The heads of the Apostles do not quite line the periphery; they emerge at each end and add to the sense of space. The depth of carving around the Strasbourg tympanum figures also contributes to spatial illusionism.

We have noted that one of the great achievements of Greek Classical art is a new ability to relate attitudes, gestures, and expressions of the figures of a group in space to produce a convincing dramatic effect (see p. 26). The greatest Gothic artists made use of this achievement to articulate and refine their expressive message. We can illustrate this by comparing the Strasbourg tympanum with an outstanding mural executed in 1164 for a member of the Byzantine imperial family in the church of Nerezi in Yugoslavia (Fig. 7-14). The mural shows to a remarkable degree the expressiveness achieved by artists of the Second Golden Age of Byzantine art. We see the body of Christ just after it was lowered from the cross, being venerated by the Virgin

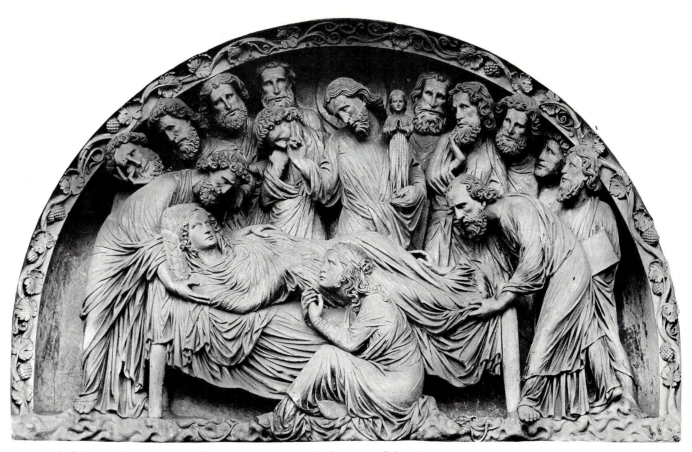

7-15 *Death of the Virgin,* from tympanum of the south transept portal, Strasbourg Cathedral, c. 1235.

and a number of disciples. The artist expressed the bond that unites the mother and her dead son by placing their weary faces cheek to cheek and practically enveloping the body of Christ with the body and limbs of the Virgin. In like manner, he stressed the grief and devotion of Saint John by bending his body so far forward that it seems to continue and complete the curvature of Christ's arm. The stark blues and whites of the design seem to add to both the desolation and the radiance of the scene.

The artist did not seriously attempt to differentiate individual expressions, however; the Virgin and Saint John have the same conventionalized distressed look. Nor did he pay much attention to psychological relationships among the figures; he did not have sufficient control over the forms in space to indicate clearly in what direction the various figures are looking. It is through the physical contact between the figures, as well as the suggestive quality of line and color, that the artist achieved his expressive intent.

In the Gothic relief, on the other hand, while the gently upturned eyes of the principal figure still suggest something of the ecstatic quality characteristic of Christian art since late antique times, and while several figures have similar bone structures and expressions, the artist was able to differentiate more effectively between the expressions of the principal characters and relate them to the role of each in the scene. What is more, a new awareness of space introduces a convincing sense of interaction between the figures. This, in turn, enabled him to suggest a complex network of psychological relationships. Tender and anxious, Mary Magdalen's face is turned toward the dying Virgin, whose own head is turned toward the apparition of Christ. Christ blesses his mother, his attitude and features seeming to send out a message of compassion and encouragement. His whole figure is imbued with an aura of spirituality; indeed, he brings a promise of heavenly bliss, holding in his left hand a small figure of the praying Virgin as

she is about to make her ascent. Finally, the Apostles express a variety of emotions from grief to meditative sorrow.

The result is a startling new clarity of dramatic exposition, and the progress achieved by Gothic sculptors in so lucidly describing complex psychological relationships can be compared only to the success of Gothic builders in evoking the play of structural forces in their constructions and to the concern of Gothic theologians in evolving elaborate programs to make spiritual beliefs explicit. These endeavors to take advantage of spatial relationships and psychological interactions in order to stress the drama of a specific situation were to become a major characteristic of the art of succeeding centuries.

Little is left of the monumental paintings of the High Gothic era, and only a few stained-glass windows and exceptional illuminated manuscripts can give us an idea of what they must have been like. The so-called Morgan Bible, executed in Paris around 1245–50 (Fig.

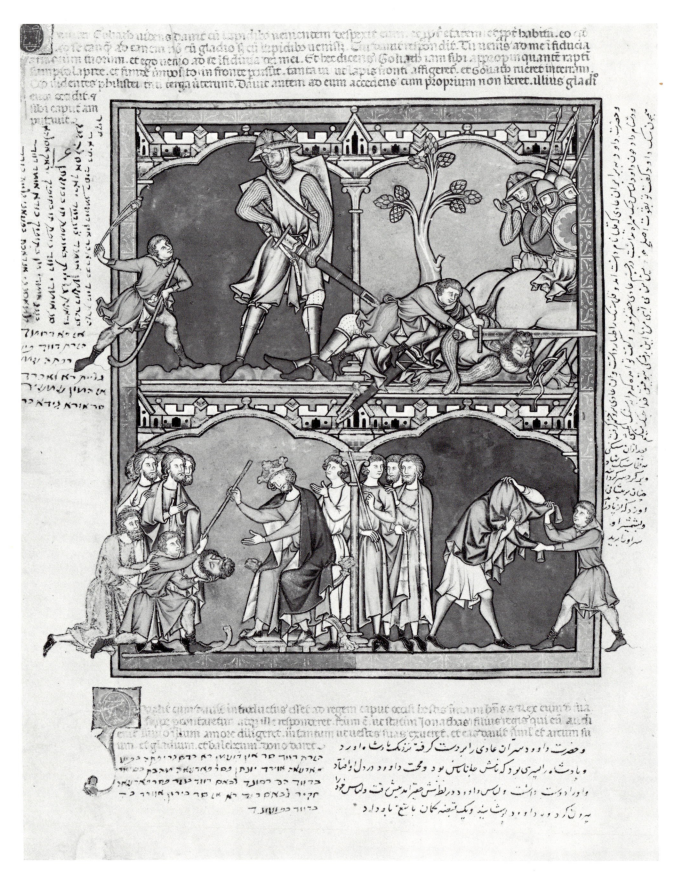

90

7–16), is one of those exceptional manuscripts; there is a sense of ease and a clarity and monumentality in some of the scenes that suggest that these drawings may well have been executed by men skilled in mural painting. The page reproduced here consists of four scenes of the life of Old Testament King David. During a war between the Israelites and the Philistines, when he was still a youth, David accepted a challenge issued by the Philistine giant Goliath to fight in single combat. David was able to defeat Goliath through his swift and skillful handling of a sling.

The scenes are set against a highly decorative background that consists of alternating red and blue areas surrounded by a band of red and blue strips, the color of each strip being the opposite of that of the adjoining ground area. The scenes are separated from one another by a simple framework consisting of a thin column supporting one arch on each side, the arches being surmounted by a stylized city motif. Both the arches and the city motif, incidentally, have a long history; the arches originated in the decoration of late antique sarcophagi, the city motif in such early Christian schemes as that of the triumphal arch of Santa Maria Maggiore (Fig. 4–9).

The figures themselves stand out boldly against the background, which takes on the appearance of a stage backdrop. An irregular brown area at the bottom represents the ground, and an occasional object, such as a tree or a throne, suggests the setting. The handling of forms in space is nonetheless rather ambiguous; the feet stand sometimes right on the edge of the ground area and sometimes on the surface below the edge, while some figures overlap the framework and protrude beyond the limits of the picture. The figures have a certain relief created by the play of light and shade, which suggests the drapery folds as well as the roundness of the bodies, but this effect is offset by the continuous flowing outlines and fairly uniform color areas, which tend to stress the picture plane and, thus, to flatten the whole design. Let us notice, incidentally, a tendency on the part of the artist to give every line a free and elegant flow that sometimes breaks into precise and regular convolutions; this tendency has been called *calligraphism* because it is reminiscent of the scrolls and flourishes of ornate handwriting.

Despite these inconsistencies, there is a much more sustained attempt to relate the figures to a fairly tangible setting than there is in, say, the Romanesque Christ of Berzé-la-Ville (Fig. 6–8), in which the figure is set against the cosmos itself, suggested by a star-studded sky. However inconsistent the spatial relationship between figures and setting in the Morgan Bible illustration may be, even so it sug-

gests a development parallel to that of the Strasbourg tympanum (Fig. 7–15). In the first scene, David is confronting Goliath. He is swinging his sling, about to throw a stone at his opponent, but we see another stone apparently reaching the giant's forehead, indicating that the artist combined into one scene two successive moments of the action for the sake of narrative explicitness. The artist heightened the sense of movement conveyed by David's body by making his left leg create a strong diagonal accent that overlaps the framework. There is a certain interest in psychological relationships; David's face and posture suggest defiance, while the expression on Goliath's face is one of mocking disdain.

In the scene to the right, the body of Goliath has fallen and David is cutting off the giant's head with the latter's own sword. To the right, Philistine warriors are departing, making gestures that could signify horror or regret or both. Below, on the left, the commander of Israel's forces kneels with David before their king, while on the right an admirer takes off his cloak to present it to the young hero.

In none of these last three scenes is the play of expression as developed as in the first; the artist attempted primarily to represent the features as delicate and well-bred. Together with the graceful *déhanchement* of some of the bodies and a certain daintiness of the gestures, they convey, above all else, a consummate urbanity. The Morgan manuscript was most probably intended for a royal or princely

7–14 *Lamentation* (detail), church of Nerezi, 1164 (*comparative illustration*).

7–17 Giotto, *Lamentation,* 1305–06. Fresco, Arena Chapel, Padua.

patron and fully reflects the refinement and taste for rich and precious objects of French court circles. It also reflects a love for lively, and even diverting, narration. It is not surprising, under these circumstances, that none of the scenes of the manuscript is comparable in dramatic impact to the Strasbourg tympanum.

A small group of painters from the city-states of Florence and Siena in central Italy was the first to apply to painting the new control over space and the new definition of psychological relationships achieved by the greatest Gothic sculptors. The most revolutionary and most powerful among them was the Florentine painter and architect, Giotto (c. 1267–1337). He had been trained in the Byzantine tradition prevalent among Italian painters of his time, but he seems to have been influenced by examples of central Italian Gothic sculpture and he may have even been exposed to remnants of frescoes dating back to Roman times.

Let us compare Giotto's *Lamentation* (Fig. 7–17), a section of his fresco decoration of the Arena Chapel in Padua (1305–06), with the Nerezi *Lamentation* (Fig. 7–14). In both, despite the intense expression of grief, the scene is to be taken not as a final episode but as an intermediate stage in the story of the death and resurrection of Christ and therefore as one step in the symbolic evocation of the redemption of mankind.

The Byzantine artist presented his figures as if they were paper cutouts pinned to the surface of the wall. They all float on the pictorial surface. Giotto,

for his part, treated the painted frame as a window opening onto the world of the picture. Indeed, the edge of the frame cuts off parts of several of the figures. Beyond this open window, the artist clearly indicated a narrow horizontal stage space delimited by a receding wall of rock at the back, on which we look down from a raised point of view. Within the stage space, Giotto assigned a definite area to each figure, depicting it as a well-rounded, solid mass resting firmly on the ground.

Outlines are still very much in evidence in the work of Giotto; indeed, they played a crucial role in the fresco technique used by the artist and his assistants. An area of wall that could be painted in one day's work was covered with a layer of fresh plaster, on which the master would make a careful outline of the painting. The master or his assistants then applied the paint before the plaster dried. (In some cases the sketch or *sinopia* was painted on the wall before the plaster was applied and redone over the wet plaster.) Some of the more delicate colors were applied at a later time.

Giotto's major innovation is the powerful modeling of the surfaces that he achieved through his use of color. He distinguished clearly between the broad zones exposed to the light and those in the shadow by systematically adding white to the hues in the zones in light to heighten their value, and graying hues to obtain lower values in the zones in shadow. His figures therefore have a far greater massiveness than Byzantine artists could possibly have achieved with their

rather arbitrary and shallow modeling and can truly be called sculptural, even monumental. In place of the multiplicity of linear folds of the Byzantine work—obviously a carry-over from the art of metal and ivory craftsmen—Giotto sought a new simplicity by depicting comparatively few folds, carefully formed and shaded after direct observation of nature. In addition, all traces of the overly graceful gestures and attitudes of the figures of the Strasbourg relief (Fig. 7–15) have disappeared. The sculptural quality, the effective value modeling, the interest in natural form, and the new directness and simplicity of attitudes and gestures all point to the art of the early Renaissance, which we shall be considering in the next chapter.

In the Nerezi fresco, as we have seen, expressiveness was achieved primarily through physical contact among the figures and through the manipulation of linear patterns on the surface plane. In Giotto's *Lamentation,* as in the Strasbourg tympanum, a complex network of psychological interrelations is suggested through attitudes and facial expressions. Against the solemn vertical rhythms created by the weeping women at the left, the Virgin holds the torso and head of Christ on her knees while bending over his face with poignant tenderness. Here, the heads of mother and son do not touch, as if Giotto wished to stress the gap between life and death, and their separation is even more moving than their contact in the Byzantine *Lamentation.* The contrast between the high values of

Christ's body and the Virgin's dark blue dress further heightens the tension.

Almost duplicating the formal function of Saint John in the Nerezi fresco, one of the mourning women in Giotto's painting holds the hands of Christ, the direction and shape of her body continuing the curvature of Christ's arms to the right. Giotto, however, introduced powerful new devices to bring out the emotional content of the scene. John bends over Christ with arms outstretched, expressing his grief in a dramatic gesture. The two standing disciples at the extreme right obviously take a more sober view of the scene; their calm bearing seems to express their confidence in Christ's eventual return. The harmonious grouping of a number of figures, forming a vaguely oval pattern around Christ and the Virgin, and the delicacy of the pinks, blues, greens, and purples of their clothes create an aura of radiant tenderness around the principal characters.

Perhaps aware of the dangers of excessive pathos, Giotto was not overly explicit in the depiction of individual expressions. Facial features are less detailed than in the Nerezi fresco. The artist nevertheless made superb use of the deep shadows over eyes and mouths; however stylized and impersonal the features are, the shadows transform the faces into dramatic masks onto which the viewer is invited to project appropriate expressions according to the place and role of each figure.

That Giotto still remained very much concerned with traditional Christian symbolism is evident from the upper part of the picture. To the right, all withered, stands the tree of knowledge of the garden of Eden, from which Eve picked the fateful apple—an allusion to man's original sin, the primary cause of Christ's martyrdom. In the sky, angels flutter in all directions as if to evoke the cosmic significance of Christ's death and man's redemption.

The main group of figures, however, is separate and distinct from the symbolic elements. There can be no question that Giotto intended to dramatize the human aspects of the scene and that the new naturalism in the rendering of forms and light, no less than the new precision of spatial and psychological relationships, was meant to make the drama all the more plausible and moving.

Technically Giotto did little more than translate into paint the achievements of the sculptors of the High Gothic period. He went beyond Gothic sculptors, however, in taking advantage of the new control over form to achieve dramatic expression, and in doing so he opened up a whole new era in art. It took about one hundred years for Giotto's lessons to be fully understood, but once they were they paved the way for the Renaissance.

The emergence of a more objective vision and of a more human interpretation of traditional themes corresponded to major economic and political developments in northern and central Italy. Disturbed though they were by endless wars and an almost perpetual state of internal upheaval, Florence and other cities became centers of European finance and cradles of entrepreneurial industry. For brief periods, merchants, industrialists, and bankers controlled communal governments in those cities, sometimes against the bitter opposition of the nobility and almost always in the face of threats of conquest by soldiers of fortune and would-be tyrants. More practical and objective than the feudal lords, the merchant class was without doubt partly responsible for the new spirit in art.

The influence of Giotto spread rapidly throughout Europe. Figure 7–18 reproduces an illustration of the entombment from the *Book of Hours of Jeanne d'Evreux,* a French prayer book containing prayers for every hour of the day, decorated by Jean Pucelle (active c. 1300–1350). The artist may have taken a trip to Italy in the 1320s and there may well have seen works by Giotto and other great Italian masters. His *Entombment,* executed in 1325–28 in tempera on vellum, is in many ways less advanced stylistically than the *Lamentation* by Giotto, but it shows marked technical progress over the Morgan Bible. In contrast to the Italian examples, the figures are grouped into a geometric pattern, a square, while angels float in a horizontal band above it. This stress on a simple geometric surface configuration harks back to earlier Medieval practices. As in some groups in the Morgan Bible, moreover, the figures seem crowded behind one another and are differentiated only through the various positions of their heads. In addition, there is still a certain ambiguity in the spatial

relationship between Christ's body and the surrounding figures: Christ's head is in front of Saint John's body, and yet Saint John is meant to be in front of the sepulcher.

As in the Morgan Bible, there is an architectural framework, but here it is used much more effectively to suggest a shallow stage space: it consists of two protruding wings that together with the background create a box-like enclosure around three sides of the group of figures. The full modeling of the bodies is considerably in advance of that in the Morgan Bible and reflects a new awareness of volume, probably derived from Giotto and his contemporaries. The folds of the draperies are much ampler and more carefully and elegantly modeled. They create graceful overall linear patterns that seem to constitute an exaggeration of earlier trends. These patterns appear slightly more precious and mannered than the linear elements of the Strasbourg tympanum (Fig. 7–15) and are clearly marked by an accentuation of the calligraphic tendencies noted in the Morgan Bible. Finally, the suggestion of piety and suffused despair reflects the endeavors by artists of the period to convey human feeling.

Let us notice also that Pucelle depicted two little figures, part human and

7-18 Jean Pucelle, entombment scene from the *Book of Hours of Jeanne d'Evreux*, Paris, 1325–28. Illuminated manuscript, tempera on vellum. Metropolitan Museum of Art, New York, Cloisters Collection (f. 82v).

7-19 Interior of Lady Chapel, Ely Cathedral, begun in 1321–c. 1350.

part animal, supporting the weight of the architectural framework. Such marginal designs were intended primarily to provide comic relief to worshipers who might wish to be distracted from reading their prayers. In many cases they also served a moralizing purpose and may even be related to the subject matter of the principal picture. Like the caryatids of the Ottonian gospel book (Fig. 5–10), these figures may well symbolize the subservience of the heathen world. *Drolleries,* as these designs are called, became common in the West just after the middle of the thirteenth century, but they may well be related to the "misshapen shapeliness and shapely misshapenness" of Romanesque art decried by Saint Bernard and beyond that to the fantasies of the zoomorphic interlace of the age of the invasions. This grotesque tradition was to make a sensational comeback at a later time when it provided a valuable precedent for the often incongruous vision of Bruegel and others.

The stress on elegance and a nearly

precious refinement of the style of Jean Pucelle was also characteristic of late Gothic developments in architecture. During the second half of the thirteenth century, architects began to stress lightness and airiness to the extent that some of the most advanced buildings took on the aspect of glass-covered cages surrounded with a lace-like stone tracery. This style became known as *rayonnant.* By the early fifteenth century the stone tracery of some buildings had acquired a flame-like animation and complexity that earned it the appellation *flamboyant.* These developments parallel those of other artistic eras, particularly the trend toward formal complexity and linear excitement in Hellenistic art.

The elaborate interior of the Lady Chapel (Fig. 7–19) of the cathedral at Ely, England (begun in 1321–c. 1350), cannot strictly speaking be called either rayonnant or flamboyant, but in it we can see affinities with the first style and the beginnings of the second. A comparison with the interior of Chartres (Fig. 7–10)

reveals that the Ely decorative scheme no longer reflects purely structural considerations. Against a loadbearing wall is built an arcade whose sole function is to enliven it visually. Through the proliferation of vegetal ornaments on the surface and the scalloping of all the edges, the stonecarver succeeded in manipulating almost beyond recognition the shape of the Gothic pointed arch and suggested a complicated arrangement of solids and voids, light and shade, that creates an ethereal sheath around the room. There is, furthermore, a remarkable animation in the individual curves of the decoration, the top of the arch having been made to bulge outward, for instance, so that the overall design has acquired a flame-like quality. The rayonnant and flamboyant styles were to become much more fully developed in France; the Lady Chapel at Ely nonetheless reflects stylistic mannerisms and a preoccupation with artifice characteristic of the architecture of the time.

III
The Renaissance

8

The Early Renaissance

The Renaissance in Western art is generally considered to have begun early in the fifteenth century and to have lasted late into the sixteenth. It was so broad and all-embracing a movement that it cannot be defined as a period except in the most general terms. Indeed, it began simultaneously in two regions quite remote from each other—the Low Countries (roughly speaking, present-day Belgium and the Netherlands) and northern and central Italy—and manifested itself in a very different way in each. In the Low Countries artists favored essentially Gothic forms throughout most of the fifteenth century but were enormously innovative in other respects, while in Italy the most progressive masters as early as the first decade of the century were frankly drawing inspiration from antiquity, setting an example that was continued by succeeding generations.

In spite of these differences, there were common elements in the new artistic traditions of the Low Countries and Italy that were to give impetus to new styles and new ideas throughout Europe. In the first place, the men of the Renaissance were moved by a new love and understanding of nature and were determined to conquer the representation of visual reality. In the second place, they went further than the artists of the Middle Ages in stressing a new sense of humanity in their depictions of religious themes. Finally, and perhaps as an outcome of this, they developed a considerable interest in the uniqueness of the individual and his psychological make-up.

Economically and politically the Renaissance was a period of extraordinary ferment. Not only did commercial activity inside Europe greatly increase during the fifteenth and sixteenth centuries, but a succession of maritime discoveries opened up vast new areas to Western traders. The middle classes grew more prosperous, and in a few cases vast fortunes were accumulated by individuals. The monarchies of the larger countries and their military and civil establishments extended their territories and consolidated their power. Con-

versely, many of the smaller countries lost their independence, and the city-states that remained free tended to become governed by princely dynasties. This was particularly true of the prosperous, nearly independent, and democratically controlled city-states of the Low Countries and northern Italy. The city-states in Belgium and the Netherlands fell under the domination of the powerful dukes of Burgundy and in 1477 were acquired through marriage by the German imperial family, the Hapsburgs of Austria. In central and northern Italy, all the city-states, with the notable exception of Venice, lost their own form of oligarchic democracy and acquired dynastic rule by early in the fifteenth century. In Florence in particular the Medici banking family gradually gained control of the government, first through subtle manipulation of its democratic machinery and eventually through hereditary rule. From the time of the French invasion of 1494, Italy increasingly became a battleground for foreign armies, and the successive wars that left much of

8-1 *This page:* Limbourg brothers, *Coronation of the Virgin,* from *Les Très riches heures du Duc de Berry,* 1413–16. Illuminated manuscript, tempera on vellum. Musée Condé de Chantilly, France.

8-2 *Opposite page:* Lorenzo Monaco, *Coronation of the Virgin,* 1414. Tempera on wood (8'1⅜" × 12'3⅙"). Uffizi, Florence.

the country under Spanish control after 1530 seem to have reduced Italy's vitality somewhat.

The Church suffered most. The new spirit of critical inquiry, even if it did not radically alter men's religious beliefs, led to widespread questioning of ecclesiastical authority. The Reformation, sparked by Luther's denunciation of some abuses of the Church in 1517, marked the establishment of Protestantism. England, the northern part of the Low Countries, the Scandinavian lands, and much of what is now Germany repudiated the Church of Rome, and France was plunged into bitter civil strife. In regions in which Protestantism did not take hold, widespread religious unrest eventually had to be appeased by the so-called Counter Reformation within the Catholic Church.

All the while, the sources of artistic patronage were multiplying. The most powerful families lived in unprecedented luxury and employed large numbers of artists. Rulers were lavish in their patronage of artists and purchases of works of art and thereby they laid the foundations of the great national collections of Europe. The mercantile upper middle classes, becoming increasingly rich, sometimes played a more original and creative role as art patrons than the often faltering nobility. The two major centers of art, Florence and the Low Countries, were semi-independent city-states with the result that artists received strong support from trade and craft guilds as well as from individual families.

At least two Renaissance popes, Julius II and Leo X, proved to be more inspired and more munificent in their artistic patronage than most political rulers. It was primarily these two popes who attracted the principal Italian artists of their time to Rome to work for the Vatican, where the golden age of the Italian Renaissance flourished from about 1495 to 1520. The sack of Rome by northern European and Spanish troops in 1527 ended its dominant role and the artistic fulcrum seems to have shifted to Venice, but Rome was to play a major role once again at the end of the sixteenth century in establishing the trends for the art of the Counter Reformation and in giving birth to the Baroque.

The status of artists was continually changing at this time. From being regarded as superior craftsmen, as they were throughout most of the Medieval period, artists late in the Middle Ages became sought after by popes and princes and began to assume the stance of exceptional beings. Early in the Renaissance, artists like Jan van Eyck and Filippo Brunelleschi played a leading role in intellectual circles, and by the early sixteenth century some artists, Leonardo and Michelangelo at least, came to regard themselves as divinely inspired geniuses isolated from ordinary mortals.

The art of the Renaissance was ushered in by a courtly and refined transitional manner that was still closely related to the Middle Ages and, in many ways, more conservative than that of Giotto. This development, the outcome of a variety of artistic influences as farflung as the

Low Countries, the Rhineland, Italy, and Bohemia (present-day Czechoslovakia), originated around 1380 in Paris. The manner spread rapidly throughout the continent, hence the name International style, and by 1400 it was the dominant style.

Figure 8–1 shows the coronation of the Virgin, an event believed to have taken place after her ascent to heaven, from a page of one of the most splendid books of the period, *Les Très riches heures du Duc de Berry* (*Very Rich Book of Hours of the Duke of Berry*), illustrated from 1413 to 1416 by three Low Countries masters of the new style, the Limbourg brothers. The manuscript was illuminated by them in Paris for the younger brother of the king of France, the duke of Berry, who was one of the most munificent royal patrons of his time and who took special delight in ordering such works. Figure 8–2 shows a large altarpiece of the same subject in *egg tempera* on wood with gold leaf for the halos and other details. (In this type of painting, egg is used as a

binder for the pigments and the paint is applied over several layers of a variety of plaster-like substances called *gesso*.) The panel was painted in 1414 for a Florentine church altar by a Sienese, Lorenzo Monaco (c. 1370–1425). The artist was a major painter of the region during the first two decades of the century who was much influenced by the International style.

In several ways both works remain Medieval. The compositions are closely related to the overall geometry of the surface: notice in *Les Très riches heures* how the curve of the Virgin's train continues the circular form of the left edge of the picture, and how the rows of saints on the right are neatly arranged to fit within the curve of the right edge. Similarly in Lorenzo Monaco's painting, the elegant Gothic canopy behind Christ and the Virgin fits nearly into the central arch of the decorative frame. In both works, moreover, the gentle sway of the bodies and the courtliness of the attitudes are definitely Gothic, the calligraphic sweep

of the draperies reminding specifically of those of Jean Pucelle and similar artists (Fig. 7-18). The assortment of delicate colors—blues, light pinks, light greens, and a great deal of gold—still reflects the Medieval taste for rich surface effects. In both, furthermore, a certain attenuation of the bodies and an intense interest in the refinement of the costumes and the elaborateness of the jewelry and metal-work are characteristic of late Medieval mannerism.

And yet a number of important elements herald future trends. There are indications of a new interest in naturalism in the comparatively firm modeling of the figures and in the suggestion of space. In Lorenzo Monaco's altarpiece, an effect of depth was achieved through the ingenious use, at the bottom of the picture, of star-studded, curved bands that symbolize the heavenly spheres. Although the figures are on top of the set of bands, as if to imply that they are literally above the vault of heaven, the artist presented the bands as if they were the outer por-

tion of a circular carpet on the floor, actually representing angels kneeling on the surface of the "carpet." As a result, the first row of saints appears to be arranged in a vast arc of a circle markedly receding in space. The raised viewpoint enables us, moreover, to see several rows of figures and adds to the effect of depth. Clearly this is an enormous improvement over the awkward handling of forms in space encountered in the works by Jean Pucelle (Fig. 7-18). In *Les Très riches heures,* the artists went so far as to link the foreground and the very far distance by means of the swirling rows of saints on the right that suggest recession into the infinite heights of heaven.

Finally, there are revolutionary touches of realism. The gold leaf in the Lorenzo Monaco piece is a survival of the abstract background against which Byzantine figures were made to float. In *Les Très riches heures,* in contrast, the little translucent clouds and the treatment of the blue of the sky, which acquires a higher value and a lower intensity toward the horizon, reveal a new objectivity in the study of nature. In both works facial types have been carefully and sometimes amusingly observed and rendered: fat monks, dainty damsels, placid elders, all seem to have been drawn from life (or at least from an assorted store of carefully selected models). And no pain was spared to stress the verisimilitude of individual details. In both works the participants are shown as courtiers taking part in some royal ceremony. The Limbourg brothers even suspended from the Virgin's crown

a long and delicate gauze veil such as was worn by the best-dressed women of the day.

Despite the close observation of figures and objects in both paintings, neither work is as convincing or as dramatic as Giotto's work, nor were they intended to be. Artists of the International style were more interested in overall decorative effects and a graceful linearism than in the precise interrelation of figures in space, more interested in the evocation of the exquisite refinement and luxury of aristocratic life (and sometimes the quaintness of peasant life) than in the suggestion of powerful emotions, more interested in the richness and elaborateness of material objects and in the variety of facial types than in the moods of nature and the individuality of men. Their chief artistic aim was the creation of lively and lovely court pageantry.

In one form or another the International style lingered on almost to the end of the fifteenth century and became the hallmark of the more conservative artists. In Italy, however, as early as the 1420s, a young Florentine painter named Masaccio (1401–28) succeeded in breaking away and developing a new approach to painting fully in keeping with the spirit of the Renaissance. Masaccio, one must add, was much influenced by the art of his two older friends, the sculptor Donatello and the sculptor and architect Brunelleschi, whose works will be discussed later in this chapter. These two men were keen students of antiquity and had made great strides in the handling of forms in space.

Masaccio's *Madonna and Child* (Fig. 8-3) of 1426 is the central section of an altar, painted for a church in Pisa, that included many other scenes on a smaller scale. It is in tempera on wood, with abundant gold leaf. At first the picture may seem conservative and not very dissimilar in spirit and execution to Lorenzo Monaco's *Coronation of the Virgin* (Fig. 8-2). The gold background and the rich combination of colors reveal a Medieval love of jewel-like surface effects. The frame, with its pointed arch, is definitely Gothic. The painting's symbolism is still rooted in the Medieval tradition; we have already found the theme of the Madonna holding her infant on the Royal Portal of Chartres (Fig. 7-6). The grapes in her hand, which symbolize the martyrdom of Christ and therefore man's redemption, also have a long history; we have seen them in the decoration of the Christ figure in the *Book of Kells* (Fig. 5-4), for example. The angels playing musical instruments are the first cousins of those that adorn the floor area of the Lorenzo Monaco altarpiece and are certainly related to the courtly angels shown with the Holy Family in early Christian mosaics (Fig. 4-9).

The handling of the forms is not novel, since it goes back to Giotto's achievements. Apparently reacting against the rich patterning of surfaces, calligraphic treatment of folds, and excessive concern with decorative effects of the International style, Masaccio seems to have sought Giotto's guidance in the broad planes in which he modeled his

figures, the sculptural quality of the work, and the pursuit of abstraction and simplicity (compare Fig. 7–17). The modeling of the features, however, reveals a much closer observation of an individual type than we find in the work of Giotto and a greater degree of facial characterization than is present in pictures in the International style. There is a new ease in the attitudes, moreover, and the plump nude infant seems particularly lifelike. In addition, the rendering of fabrics is much more ambitious than in any earlier painting; notice in particular the subtle modeling of individual folds of drapery. In some areas the folds seem to be detached from the body and break up under their own weight into apparently haphazard arrangements. Notice also the use of delicate lines and areas of greatly diluted pigments to achieve the marvelously illusionistic rendering of the gauze veil over the Virgin's head.

Even more important is the artist's new stress on the human aspects of the scene. To be sure, the richness of the colors, the beauty of the garments, the elaborateness of the throne, and even the presence of the little musicians are meant to evoke a blissful vision of heaven. But the Virgin is a specific individual, and not a particularly glamorous one at that. Masaccio went beyond the purely religious symbolism of the grapes to empha-

8–3 Masaccio, *Madonna and Child*, Pisa altarpiece, 1426. Tempera on wood (4′5⅜″ × 2′4¾″). National Gallery, London.

size the human aspect of the drama; the child's innocent gesture implies his acceptance of his destiny, while the expression of the Virgin, at once apprehensive and determined, suggests a poignant stoicism in the face of impending tragedy.

Several apparently minor details in the painting reflect extraordinarily important developments in the cultural history of the Renaissance. At first sight, the Virgin's marble throne brings to mind the architectural framework in the Pucelle entombment scene (Fig. 7–18). Indeed, the practice of surrounding figures with an elaborate architectural setting is essentially Gothic. But on looking more carefully we notice that the decoration of the throne is derived from antiquity. There is a new balance of vertical and horizontal elements that is reminiscent of the basic configuration of Greek and Roman temples, and both the columns and the carving of the base seem derived from such antique monuments. Earlier artists who borrowed motifs and forms from antiquity had ruthlessly altered them to suit their own iconographic and esthetic purposes. Here Masaccio showed a real interest in and understanding of the details and the spirit of ancient art.

This change, which was nothing short of revolutionary, corresponds to a new enthusiasm for antiquity that developed in Italy and eventually spread throughout Europe. As early as 1338 the Italian poet Petrarch exclaimed, in the presence of the monuments of ancient Rome, "After the darkness has been dispelled, our grandsons will be able to walk back into the pure radiance of the past." While remaining devoutly Christian, the men of the new age found Medieval culture limited and felt that only a return to the ideals of Classical antiquity could usher in a brighter future.

This new love of antiquity first manifested itself in the movement known as humanism. Beginning in the middle of the fourteenth century with the rediscovery of the languages, literature, and philosophy of ancient Greece and Rome, it gained much from ever closer contacts between Italian and Byzantine scholars and reached a climax after the fall of Constantinople in 1453, when many Byzantine scholars sought shelter in Florence, Rome, and other parts of Italy. With the invention of printing, ancient texts became more readily accessible, and the movement spread throughout Europe.

Humanism was the outcome of the several waves of antique influence during the Middle Ages. During the Renaissance, however, there was a change in emphasis. For Medieval men, the study of antique sources was intended primarily to buttress theological thought; for the new era it became a wellspring of human insights and provided a number of alternatives to scholastic philosophy. Over the centuries the word "humanism" has come to mean man's concern with the study of man. Inasmuch as this concern became prevalent during the Renaissance, as opposed to the Medieval preoccupation with the next world, the modern definition of humanism also applies to the developments of the Renaissance.

The men of the Renaissance were highly conscious that this return to the antique tradition would infuse new life into all phases of activity, and indeed by 1500 it had affected all human endeavors. Significantly, the Italian term *rinascita* (rebirth) had been used since the fifteenth century, though the French equivalent, *renaissance,* gained universal acceptance in the nineteenth.

In spite of the new familiarity with pagan thought, Renaissance men remained essentially Christian. They were in fact aware of the impact of ancient philosophies on Christianity itself, and it is significant that one of the most influential philosophical trends of the Renaissance, a spirited revival of Neo-Platonism, laid particular emphasis on the parallelism between Plato's concept of a superior harmony and the Christian notion of eternal bliss. Furthermore, a strong interest in Stoic ethics led to a new rationalism and a revival of the ancient ideals of fortitude and self-discipline, which became equated with Christian abnegation.

Another development apparent in Masaccio's altarpiece reveals momentous changes in man's approach to physical reality. Already in Giotto's *Lamentation* (Fig. 7–17) the recession of the stage space had turned the enframing rectangle into a window that opens out onto the pictorial world. The same can be said of Masaccio's work, but here the various objects in the composition were rendered in correct perspective, as if an observer looking through the hypothetical window had made accurate measurements of the

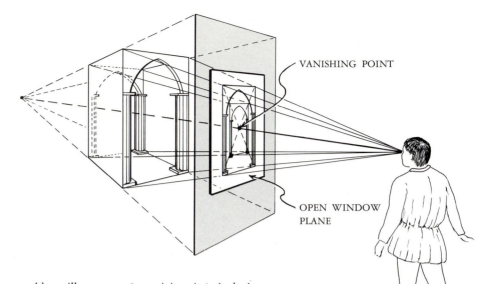

VANISHING POINT

OPEN WINDOW PLANE

8-4 Arches as seen in projection on the plane of an open window, corresponding to the picture plane in a painting or drawing.

size of the various parts as they would appear on the window pane (Fig. 8–4), their size diminishing in proportion to their distance from the window. As a result, all the parallel receding lines converge toward a single point (Fig. 8–5). More specifically, all lines perpendicular to the picture plane meet at a point level with the horizon (known as the vanishing point). Christ's halo, which is inclined with respect to the vertical, is elliptical rather than circular, because a circle becomes an ellipse when foreshortened.

The first man to determine the laws of perspective as they apply to the lines perpendicular to the picture plane was the architect Filippo Brunelleschi (1377–1446). He actually undertook to look at an object from a fixed viewpoint through a rectangular opening, tracing the appearance of the various parts of the object on a grid affixed to the opening. He was able to establish that all the lines perpendicular to the opening appear to meet at one point. This provided him with a mathematical system, known as *linear* (or *point*) *perspective,* for determining the relative size of objects in the picture space. The laws of perspective became a source of endless delight to the men of the Renaissance: they enabled artists to depict the physical world with a new objectivity and at the same time introduce in their compositions a truly mathematical rigor.

Masaccio initiated yet another technical refinement in his treatment of light and shadow. Giotto had used shading to model bodies but did not indicate cast shadows, and some northern manuscript

illustrators (or *miniaturists*) had shown cast shadows but had not always rendered them consistently. Masaccio, in his Pisa Madonna, showed clearly and accurately the shadows cast by one wing of the throne onto the backrest and by the form of the Madonna herself on the other wing. Indeed, the configuration of these shadows is so precise that we can estimate the angle at which the sun comes from the left (45° to the horizontal). Furthermore, Masaccio recognized that areas in shade are often illuminated by reflections from neighboring objects, and he varied subtly the value of all the surfaces in the shade; notice in particular the linear highlights on the columns of the throne. Aware also that forms in shade become less distinct, he blurred certain edges, such as in the drapery by the left elbow of the Virgin, making the drapery seem to emerge from a dark, faintly vaporous atmosphere. In paintings in which distant figures are seen, the edges of these figures too are blurred. These developments mark a first departure from the uncompromising linearity of Gothic edges.

The earliest contributions of Brunelleschi, the founding architect of the Italian Renaissance, and of the first sculptors, Lorenzo Ghiberti (c. 1378–1455) and Donatello (c. 1386–1466), preceded those of Masaccio. It was around 1418 to 1420 that Brunelleschi asserted himself as a man of superlative vision and skill and as an exponent of the new humanistic interest in Classical antiquity (which we have referred to as classicism) in architecture, but we shall examine a later work

8-5 Masaccio, *Madonna and Child,* diagram showing perspective construction.

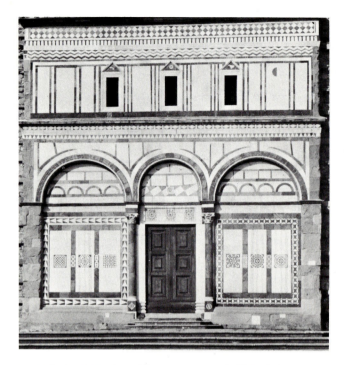

8–6 Badia church, Fiesole, twelfth century (*comparative illustration*).

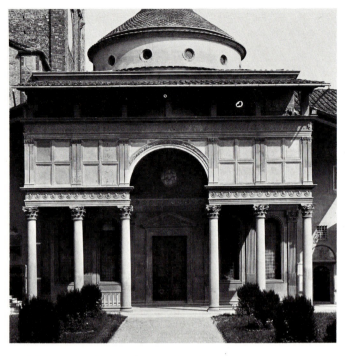

8–7 Filippo Brunelleschi and others, Pazzi chapel, Santa Croce, Florence, possibly begun in 1443.

that is probably his most attractive and most original creation: the Pazzi chapel on the grounds of the church of Santa Croce in Florence (Figs. 8-7 to 8-10), which he may have begun in 1443 but left unfinished; it was partly completed by others. The façade and porch were probably begun after Brunelleschi's death, so we shall discuss only the interior.

If we compare this interior (Figs. 8-8 and 8-10) with that of the cathedral of Chartres (Fig. 7-10), we notice that the stress on verticality has made way for a new balance between vertical and horizontal elements. Instead of the soaring pointed arches of the Gothic building, we find a ribbed dome on pendentives carried by arches on two sides and narrow coffered barrel vaults on the other two sides. Instead of the strong axial emphasis toward the altar of Gothic churches, we find an interior space that is wider than it is long and that is more reminiscent of the central plan than of the basilica type. In the Gothic building both the stress on verticality and the axial emphasis

seem to invite movement; in the Renaissance building, the order, symmetry, and balance of each wall demand that we examine it from a central point. The impact of the Gothic building may therefore be said to be dynamic, that of the Renaissance building static. The Gothic stress on ethereality is replaced by a new interest in subtly articulated but continuous and essentially flat surfaces. Continuous walls are ornamented with shallow *pilasters* (decorative flat columns affixed to the wall), *roundels* (circular decorative elements), rosettes, and moldings. Indeed, in spite of his friendship with painters, Brunelleschi made no allowances for frescoes. The "open window" effect of painting in the new manner would have compromised the integrity of the wall. Instead, the walls are adorned with a few many-colored ceramic decorations that are essentially sculptural in feeling.

Finally, there seems to be hardly any concern for relating forms to structural requirements as had been done in Gothic buildings. Whatever steps were taken to

absorb the structural thrusts are not immediately apparent. The artist was clearly much more interested in the subtle relationship of pure geometric forms than in the suggestion of structural integrity: form and structural function have been divorced.

The Pazzi chapel unquestionably reflects Brunelleschi's extensive and detailed study of the ancient monuments of Rome made early in his career. The arches, coffered barrel vaults, roundels, rosettes, pilasters, and capitals are obviously all based on ancient Roman prototypes, and the new balance between horizontal and vertical accents reveals a subtle appreciation of Classical antiquity.

The chapel also shows strong affinities with Romanesque buildings of the region around Florence, which were themselves much influenced by the Greco-Roman heritage. Let us compare it with the twelfth-century marble façade of the Badia church at Fiesole, near Florence (Fig. 8-6). The elegant geometric black and white designs of the Badia may well have

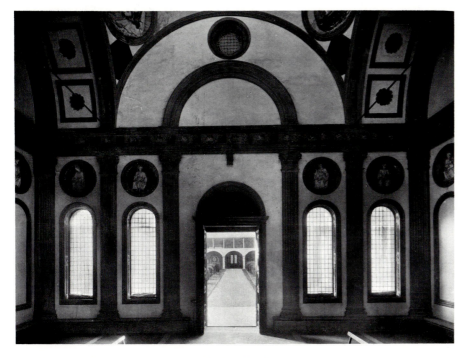

8-8 Filippo Brunelleschi and others, interior of the Pazzi chapel.

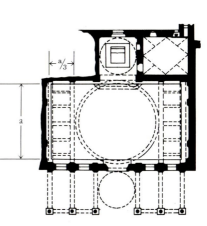

8-9 Filippo Brunelleschi and others, plan of the Pazzi chapel (after Geymüller).

8-10 Filippo Brunelleschi and others, interior of the Pazzi chapel.

inspired Brunelleschi to stress articulation by contrasting dark and light elements. In one very important respect, however, Brunelleschi was much closer to the spirit of antiquity than the Romanesque architect was. The composition of the Badia is essentially additive: the various surfaces are filled with a conglomeration of repetitive individual designs. The Pazzi chapel, on the other hand, conveys a commanding impression of unity through the new simplicity, clarity, order, and balance in the arrangement of the parts. Almost as much as in the Parthenon, altering a single element would have drastic effects. A statement by the younger architect Leone Battista Alberti (1404–72), who was thoroughly familiar with Brunelleschi's ideas, documents this attitude explicitly: beauty is "a certain regular harmony of all the parts of a thing of such a kind that nothing could be added or taken away or altered without making it less pleasing." Significantly, the statement paraphrases a text by Vitruvius, the Roman architectural theorist of the first

century A.D., and derives ultimately from Aristotelian thought.

Some Renaissance architects, Brunelleschi among them, sought harmony through the consistent application of numerical relationships to every element in their buildings. The plan of the Pazzi chapel, for instance, is made up of a square, the side of which we will call a, flanked by two oblong rectangles, the short sides of which are $a/3$ (Fig. 8–9). The radius of the arches is necessarily $a/2$, and many other simple ratios can be found. Alberti explained: "The same numbers by means of which the agreement of sounds affects our ears with delight are the very same that please our eyes and our mind." The Neo-Platonic ideal of a superior harmony based on mathematical order is here applied to architecture.

The reliance on numerical relationships in the design of buildings is not new. We have already noticed such relationships in the façade of Notre Dame (Fig. 7–13). The proliferation of repetitive

8–12 Lorenzo Ghiberti, *Saint John the Baptist,* detail of head.

4–3 Head of a colossal statue of Constantine, A.D. 324–330 (*comparative illustration*).

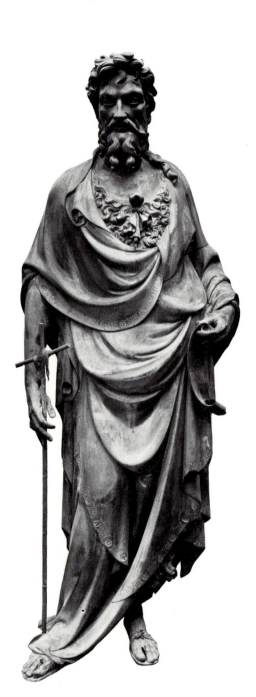

8–11 Lorenzo Ghiberti, *Saint John the Baptist,* 1412–16. Bronze (10′ high). Or San Michele, Florence.

detail on Notre Dame's façade, however, makes it so complex that these subtleties are not readily perceived. In the Pazzi chapel, the unity and simplicity of the composition make the arithmetical ratios all the more noticeable and all the more satisfying.

Ghiberti was still working much in the tradition of the International style when he executed, between 1412 and 1416, his large bronze sculpture of Saint John the Baptist (Fig. 8–11), which had been commissioned by one of the merchant guilds to be placed in a niche outside the Florentine church of Or San Michele. Although there were already strong indications of antique influences in some of Ghiberti's earlier works, this particular statue goes even further in recapturing the relaxed *contrapposto* of antiquity. The bulging brows, salient cheek bones, and subtly modeled lips (Fig. 8–12) reveal to what degree Ghiberti had followed the example of antique artists in his study of the configuration of bones and muscles. And yet a swaying quality of the body accentuated by the graceful twist of the right foot, the calligraphic sweep of the drapery folds, and especially the elegant delineation of the features and clothing, like the work of a goldsmith, belong unmistakably to the International style.

In one important respect, however,

the Saint John belongs fully to the new era. The ecstatic facial expression that had characterized all figures from the colossal head of Constantine (Fig. 4–3) to the Christ of the Strasbourg tympanum (Fig. 7–15) seems to be making way for a new concern with worldly matters. Less interested in suggesting a spiritual aura, the Renaissance artist sought to convey a variety of personal moods through the expression of the facial features.

At the time when Ghiberti was still working in the International style, Donatello had already broken away from it. Indeed, he had shown an even greater understanding of human anatomy and a more intense enthusiasm for antique sculpture in a statue of Saint George, also fashioned for Or San Michele, in the years 1411 to 1413. If we discuss a later work, it is because this work demonstrates Donatello's outstanding achievement in the realm of expression.

The marble Old Testament prophet affectionately referred to by Donatello as *Zuccone,* or "pumpkin," because of his baldness (Figs. 8–13 and 8–14), was commissioned for one of the niches of the bell tower (or *campanile*) of the cathedral of Florence and was executed from 1423 to 1425. In comparison with Ghiberti's Saint John, the stance of the *Zuccone* is more restrained. All signs of swaying motion have disappeared, and while the elegant surface design of the draperies of Saint John the Baptist still links the statue with the design of the Gothic niche in which it was placed, a new austerity in the outlines of the *Zuccone* makes

8–13 Donatello, *Old Testament Prophet* (so-called *Zuccone*), detail of head.

it totally independent from its own architectural setting. The Medieval tradition that related the statue to its background has thus come to an end.

The proportions of the *Zuccone's* body, with its broad shoulders and massive hips, are closer to antique prototypes, just as the flowing drapery at the prophet's left shoulder is reminiscent of the Roman toga. A new realism manifests itself in the detailed rendering of the emaciated body's muscles, veins, and tendons, the loosely billowing folds of the drapery, the remarkable illusionism of the beard, the relaxed quality of the right hand, wedged between belt and body, and especially in the strikingly ugly yet appealing face. That Donatello studied his model (or models) with extraordinary care cannot be doubted. Yet all these elements have their roots in antiquity. The frank depiction of the features of the face, in particular, brings to mind the verism of such Roman works as the so-called Brutus of the third or second century B.C. (Fig. 3–1). There is a striking difference between the expression of the Brutus and that of the *Zuccone,* however. Stern, determined, and only fleetingly embittered and disillusioned, the old Roman has the air of authority of a man who deals with certitudes. Donatello's prophet, on the other hand, who looks down on imaginary crowds below him with kindliness and compassion, has a perplexed, almost haunted look. Clearly, the new psychological characterization of the features detected in Ghiberti was developed much further by Donatello, who was thus able

to probe temperament and mood with superb incisiveness.

All north and central Italian painters of the next generation were enormously influenced by the first luminaries of the early Florentine Renaissance. This is certainly true of Piero della Francesca (before 1420–92), a native of Umbria, the province southeast of Tuscany. Piero's masterpiece is a series of frescoes begun in 1452, largely completed by about 1459, and certainly finished by 1466 in the church of San Francesco at Arezzo in Tuscany, not far from his birthplace. The series is devoted to the legend of the true cross as related by a thirteenth-century cleric Jacopo da Voragine. The two scenes in Figure 8–15 are based on one of the episodes in the story, the queen of Sheba's visit to Solomon. Arriving from her land in southern Arabia to "hear the wisdom" of the king of Israel, the biblical queen almost stepped on a beam, originally intended for Solomon's temple in Jerusalem, that happened to be lying on the ground. Realizing miraculously that this wood was to bear the savior of the world, she knelt before it in adoration. Piero depicted this scene to the left of the central column and, to the right, the queen is greeted by Solomon. The successful spatial rendering of the setting and the sculptural quality of the figures show that Piero was fully familiar with Brunel-

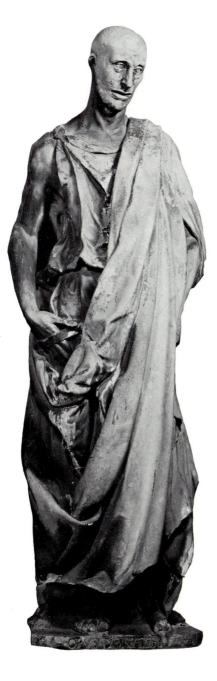

8–14 Donatello, *Old Testament Prophet* (so-called *Zuccone*), 1423–25. Marble (7'7″ high). Museo dell'Opera del Duomo, Florence.

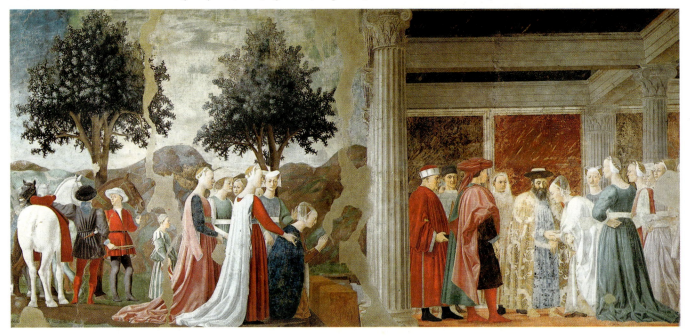

leschi's study of perspective and the art of Masaccio. The fluted columns and the sculpted beams, moreover, reflect the contemporary taste for fanciful archeological reconstruction.

To modern eyes, one of the most striking and pleasing aspects of Piero's work is the almost mathematical purity of his forms. Faces and bodies seem to have been simplified to stress a geometric quality: the faces are ovoid and the bodies are made up of smoothly rounded surfaces. The arrangement of the figures seems nearly mathematical. The picture is divided in two parts horizontally by a line formed by the headgear of most of the figures, and there is a certain regularity in the arrangement of columns and figures along the surface.

Piero went further and arranged the figures in depth as though he were an architect laying out a building. On the left, the attendants of the queen form a segment of a circle behind her kneeling figure, while on the right the courtiers form two symmetrically disposed arcs

around the king and queen. Although not immediately obvious, this system introduces a strangely satisfying sense of order that is heightened further by the regularity of the patterns created by the drapery folds and by the foliage.

Piero also showed a remarkable combination of daring and sensitivity in handling light. He chose the lighting of overcast days and shunned the definite shadows of Masaccio, stressing instead a diffuse pearly-gray light in the whole composition. He went further than Masaccio, however, in depicting reflected light in the shadows and made skillful use of it to liven some of the forms; notice how the chin of the kneeling queen and the lower edge of her hand, both in the shade, have highlights. This subtle play of light on the figures serves two purposes. In many instances it helps differentiate the figures from the darker background; in all cases it contributes a delicate glow to the surfaces.

Piero was an outstanding colorist. Despite the overall pearly quality, there

are sumptuous contrasts between the warm and cool colors of the garments—red and green, red and blue, and blue and gold, for example. Even the severe Tuscan landscape in the background is suggested by subtle gradations of hue and value.

The almost mechanical precision of the design in combination with the magic of light and color seem to take us to the point where the world of the artist meets the world of the scientist. Indeed, Piero belonged to both worlds toward the end of his life; then blind, he wrote the most comprehensive treatise on perspective that survives from the early Renaissance. Fascinated as we are by science in our own time, we are particularly sensitive to Piero's clear and precise definition of form, and it is significant that one of the founding fathers of modern art, Georges Seurat, developed his own epoch-making style only after he had studied a nineteenth-century copy of the Piero della Francesca frescoes in Arezzo.

We can perhaps best assess the

8–16 Jan van Eyck, *Giovanni Arnolfini and His Bride*, 1434. Oil on wood (33″ × 22½″). National Gallery, London.

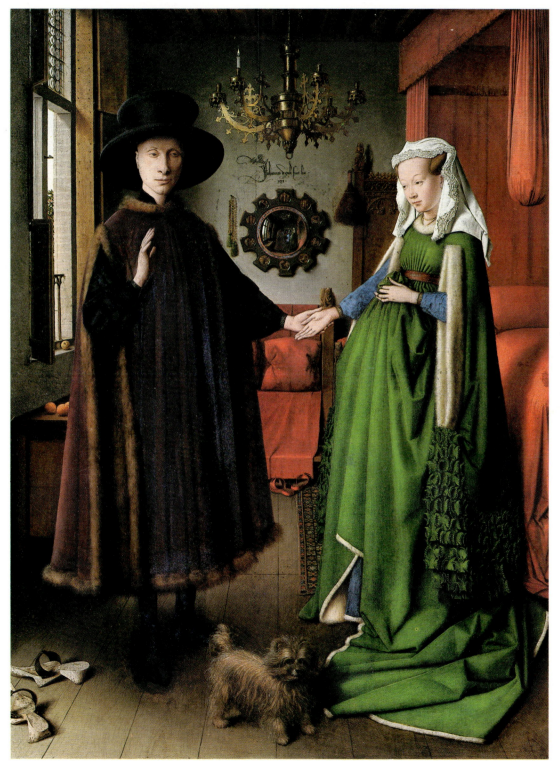

8-17 Sandro Botticelli, *A Member of the Torna-buoni Family and Allegorical Figures,* 1486. Fresco from the Villa Lemni, Florence (6'11½" × 9'3½"). Louvre, Paris.

achievements of the northern Renaissance by comparing a painting by Jan van Eyck (c. 1380–1441), the leading genius of the Low Countries and principal painter for the duke of Burgundy, with a pair of frescoes by Sandro Botticelli (1445–1510), a Florentine artist and a favorite of the Medici family. The van Eyck work, painted in 1434, is a double portrait of Giovanni Arnolfini and Jeanne Cenani, his wife (Fig. 8–16). The Botticelli frescoes, executed over half a century later, in 1486, are said to depict a member of the Tornabuoni family and allegorical figures (Fig. 8–17) and a young woman also with allegorical figures (Fig. 8–18). Scholars have disagreed as to the identity of the principal figures, but it is generally accepted that they were painted to commemorate an important event, and the odds are in favor of a marriage. Let us accept this assumption. Both works deal with love and the sacrament of marriage, and both embody superbly the artistic tradition and the intellectual attitudes of their respective cultures.

Let us first notice the distance that seems to separate Botticelli from earlier Italian artists such as Piero della Francesca. To be sure, the simple and effective modeling, a certain abstraction in the handling of details, the interest in the play of light, the clear definition of a stage space, all go back to his predecessors, while the way in which a delightful array of colors emerges through a pearly atmosphere is characteristic of the Florentine fresco technique. But Botticelli showed little concern for the archeological accuracy that so often preoccupied his predecessors and contemporaries. The references to antiquity allude to the spirit rather than the letter of Greco-Roman art; the light, billowing drapery of some of the figures, in particular, brings to mind the windswept garments of Hellenistic times (Fig. 2–23). Shunning the rigorous application of the laws of perspective, Botticelli trusted his own eye in disposing figures in the stage space. In the left-hand fresco, the grouping of the seated figures, which are seen from a

slightly raised point of view, suggests elegantly and effectively a recession in space. But Botticelli's eye was not entirely trustworthy; there are several discrepancies in the scale of the figures. Botticelli also paid little attention to the equilibrium of his figures, and in particular the standing female figure guiding the young man does not seem to rest firmly on the ground. Finally, Botticelli did not subdivide his composition into geometric zones as Piero had done, nor did he arrange his figures according to a rigid order; he strove instead for a linear rhythmic quality through subtle repetitions. We find recurring linear elements, for instance, in the curved backs of the three figures in the foreground of Figure 8–17 and the symmetrical effect of the joined arms of the standing figures. Such devices reaffirm the Renaissance striving for order in the apparently free and fluid design of Botticelli.

The graceful handling of figures and draperies, the diaphanous colors, and the elegance of the rhythmic linear surface

8-18 Sandro Botticelli, *Young Woman and Allegorical Figures,* 1486. Fresco from the Villa Lemni, Florence (6'11½" × 9'3½"). Louvre, Paris.

pattern all lead to a unique and delightful ethereality. In a way, of course, Botticelli's cavalier attitude toward spatial relationships and his stress on animated linearism and ethereality are all backward-looking, and Botticelli's style has justly been said to be somewhat Gothic in feeling.

The subject matter itself, however, reflects the most advanced Renaissance trends. Indeed, Botticelli's vision seems to have captured the poetic overtones of the rather mystical form of Neo-Platonism fashionable in Florence in the latter part of the fifteenth century. Man's soul, according to Marsilio Ficino, the humanist who founded the Medici Platonic Academy in Florence, strove for "the knowledge or possession of God alone." The means of achieving this was love—not Christian love of God alone but also the highest forms of amorous love and friendship. Love itself, Ficino said, "has the enjoyment of beauty as its end," and there were for him three forms of beauty, "the beauty of bodies," "the beauty of

souls," and what he called the "beauty of sounds." The definition was most ingenious since it gave a spiritual aura to the seemingly hedonistic enjoyment of physical beauty in the antique world, paid tribute to the Christian exaltation of spiritual values, and at the same time acknowledged the Platonic quest for a superior harmony as expressed in music and, presumably, in appropriate combinations of line and color.

In the context of Ficino's definition, the marriage of two people who are beautiful of body and soul and who are in love becomes a momentous event, and this is precisely what Botticelli stressed by means of allegories. In addition to having a pleasant and youthful appearance, the bridegroom is clearly dedicated to intellectual pursuits, for he is being introduced to the seven liberal arts (already encountered on the West Portal of Chartres, Fig. 7–6); the figure introducing him is usually thought to be Venus, the Roman goddess of love. The young woman, for her part, is receiving a pres-

ent, quite possibly also from Venus, whose three companions can be assumed to be the three Graces. Whether these stand for beauty, love, and voluptuousness, as they apparently did for Ficino, or for splendor, mirth, and abundance, as they usually did in ancient mythology, is of little importance; they personify desirable attributes of a young bride. The scene is completed by two figures of Cupid, the son of Venus, whose role is to ignite amorous passion and keep it burning.

It is obvious that figures standing for such abstract concepts cannot be shown as ordinary mortals. Botticelli skillfully contrasted the more substantial forms and opaque coloring of the bride and groom with the more ethereal forms and lighter coloring of the conceptual figures. It is also important that an allegorical scene not be represented as an everyday occurrence; appropriately, Botticelli's figures are highly idealized and have the aloofness of dancers performing a stylized ballet. The attempt to establish direct psychological relationships between the figures

that was so important to earlier artists has thus been partially forsaken for a new remoteness—a trend that was to become characteristic of the High Renaissance.

The van Eyck double portrait (Fig. 8–16) takes us into a very different world. The interest in realism already in evidence in such northern examples of the International style as *Les Très riches heures du Duc de Berry* has blossomed into a veritable passion for detailed observation; every form and every texture, from the dog's coat to the lace of the lady's bonnet, from the glass of the window to the brilliant mirror, has been rendered with microscopic accuracy. In addition, the light coming from two windows, one of which can be seen behind the man, the other barely detectable in the distance in the reflection in the mirror, has been rendered meticulously as it illuminates the forms and creates a soft glow throughout the interior. The features of the figures themselves are painstakingly accurate and reveal superbly the patience, astuteness, and aloofness of Giovanni Arnolfini, an Italian merchant who resided in Bruges in the Low Countries, and the gentle charm and coy reticence of his wife.

The precision of the modeling and the lighting reflects the extraordinary patience of northern Renaissance artists in general and Jan van Eyck in particular. It would not have been possible, however, without an innovation introduced a little earlier in the Low Countries, the use of linseed oil instead of egg yolk or other protein as the binder for pigments in tempera. Oil paint had a finer consistency and could be spread in smooth, quick-drying layers. It could also be used in dense opaque masses (*scumble*) or in diluted translucent layers (*glazes*) to obtain

an until-then unattainable brilliance or transparency or both. And the most subtle modeling could be achieved by applying layer upon layer of tinted glazes over the *local color* (the color an object has when seen in a pure light).

In all these respects the northern artists showed a striving for objectivity comparable to that of their Italian contemporaries. But here the similarities end. The northern artist did not study the art of representing forms in space for its own sake. To him, physical reality was still, as in the Medieval tradition, a manifestation of spiritual truths. In the words of Saint Augustine, the world around us consists of nothing but "corporeal metaphors of things spiritual."

This attitude has been said to account for two characteristics of northern painting. First, northern artists were much slower than their Italian counterparts to use the laws of perspective with mathematical exactness. In the Arnolfini portrait the ceiling beams and the floorboards converge on the same general area, but not on a single point. It is as if, in the course of the century or so separating Jean Pucelle from van Eyck, a succession of artists had given substance and plausibility to the flimsy architectural framework of such Gothic compositions as Pucelle's *Entombment* (Fig. 7–18) without ever tackling the theoretical problems of representation in space. Second, a good many of the objects represented, as well as the figural group itself, have specific symbolic meanings that infuse the painting with religious significance. The dog at the feet of the woman, for instance, is a symbol of loyalty, while the statue carved on the chair in the background is of Saint Margaret, the patron saint of

childbirth. The single candle traditionally lit in the room of newly-weds stands for the presence of Christ, whose martyrdom and resurrection are depicted in the ten medallions carved around the frame of the mirror. Even more specifically, the artist suggested that the vows of marriage were being made before him at that very moment in the bridal chamber; Giovanni is raising his right forearm in solemn oath while holding Jeanne's hand on the other side. And as if to carry the symbolism to its extreme conclusion, the artist has shown himself and another man beyond the reflection of the couple in the mirror to act as witnesses and has inscribed over the mirror "Jan van Eyck was here," thus turning the painting into a certificate of the holy occurrence. It is no wonder, then, that in spite of the obvious striving for realism in so many details, the attitudes are slightly stiff, the expressions reserved, the faces unnaturally bright and smooth, the clothes more brilliant and luminous than they would be in reality, and the composition solemnly symmetrical. The scene pertains at once to daily life and to the world of mystical experience; it symbolizes both the union of two human beings and the spiritual significance of the sacrament of marriage.

It can be said that van Eyck went further than any of the Italian artists in his careful rendering of lighting, textures, and accurate and subtle colorations. In contrast to the Italian artists, who conveyed their spiritual message through the harmonious handling of somewhat abstracted forms and allegorical motifs, however, northern artists invested everyday reality with symbolic meaning and made it as tangible as possible.

9

The High Renaissance

The name High Renaissance is given to the brief period from about 1495 to 1520 when the so-called grand manner flourished in Italy. The norms of this new manner are not readily definable, but in general artists remained as dedicated as their predecessors to the cause of naturalism. Their figures, however, became more monumental and a new stress was placed on what might be referred to as "orchestral" movement. Compositions were larger and settings deeper but with every detail subordinated to a generally simple overall scheme. A sensitive appreciation of the best in the antique tradition can be seen in the harmonious proportions of the figures and the idealization of the features, in the striving for order, balance, and clarity of composition, and in the new loftiness of concept. The results can justly be called classical.

The Florentine Leonardo da Vinci (1452–1519) ranks among the earliest major figures of the High Renaissance. Primarily a painter, and a most revolutionary one, he wrote a treatise on art that admirably reflects many of his own artistic aims and reveals much about the esthetic concerns of his time. In addition, he excelled as a military and civil engineer, and his prolific writings and drawings abound with startlingly perspicacious scientific observations as well as visionary engineering projects.

Although one cannot speak truly of a High Renaissance in the North of Europe—the climate of the Reformation did not favor the sustained development of a monumental art—Italian and antique influences had been felt there since the late fifteenth century. They became particularly evident in the paintings, drawings, and prints of Albrecht Dürer (1471–1528), a native of Nuremberg in what is now West Germany, who had spent two long periods in Italy. Like Leonardo, Dürer was an articulate theorist of art and was endowed with extraordinary gifts of observation.

Although both Leonardo and Dürer worked at times on a large scale, it may be appropriate to represent them by small drawings. Renaissance artists realized that drawings, because they were executed swiftly and spontaneously, often captured best the excitement of the moment of creation. "A sketch executed...by one artist in one day...may be better than a [painting] labored over by another for a whole year," Dürer wrote, "and this gift is miraculous." Both works that we shall discuss, incidentally, are on paper, a material that came to be preferred over costly vellum by most artists in the late fifteenth century.

Leonardo's *Head of Leda* (c. 1506–09, Fig. 9-2), in black chalk and ink, is a study for a now-lost painting of Leda and the swan. Another drawing, a *Kneeling Leda* (c. 1504, Fig. 9-1), which is a study for an earlier, slightly different version of the painting, gives an idea of Leonardo's intentions for the composition. Unfair as at first it may seem, let us compare the young and beautiful Leda with Dürer's portrait of his old and ailing mother, *Barbara Dürer,* a charcoal drawing made in 1514 (Fig. 9-3).

9–1 *This page:* Leonardo da Vinci, *Kneeling Leda*, c. 1504. Pen and ink over black chalk (4$\frac{15}{16}$″ × 4$\frac{1}{4}$″). Museum Boymans-van Beuningen, Koenigs Collection, Rotterdam.

9–2 *Opposite page, left:* Leonardo da Vinci, *Head of Leda*, c. 1506–09. Pen and ink over black chalk (6$\frac{11}{16}$″ × 5$\frac{7}{8}$″). Windsor Castle, Collection of Her Majesty the Queen.

9–3 *Opposite page, right:* Albrecht Dürer, *Barbara Dürer*, 1514. Charcoal (21$\frac{7}{8}$″ × 23$\frac{1}{16}$″). Kupferstichkabinett, Berlin.

Despite the fact that Dürer shaded his figure with broad smudges and Leonardo his with fine lines, the forms in the Dürer are firmer and more definite, in the tradition of the early Renaissance. Leonardo spread shading lines over part of the background and face as if to create a light veil of shadow serving several purposes. First, the artist does not merely darken receding parts, but seems to lighten the protruding ones, as if to make the latter emerge from the shadow. The shadow itself suggests an atmospheric film, thereby adding to the illusionism of the effect. In addition, the veil results in a slightly hazy rendering of the forms that appeals to the imagination and suggests a poetic aura. This attempt to convey modeling as well as atmospheric effects by means of gradations and contrasts of light and dark areas is called *chiaroscuro* (a combination of the Italian words for light and dark).

Let us notice that in striving for this slight haziness, Leonardo blurred certain lines, such as the parting of the lips and the lower edge of the lower lip. This device is known as *sfumato* (an Italian word for smoky). The drawing of Barbara Dürer, on the other hand, consists of more precise, continuous lines and well-defined shading areas that tend to adhere to the pictorial surface, so that the forms suggest the shallow relief on a coin.

Both Dürer and Leonardo made abundant and careful observations from nature and seem to have achieved a mental synthesis of their observations before putting them down on paper. Notice how Leonardo stressed the individuality of certain features: the asymmetry of the lips, for instance, and the slight swelling of the left cheek at the level of the mouth. But also, in typical Italian fashion, he abstracted the details to a considerable degree; the contours of the nose and Leda's right eyebrow, for example, are joined in a graceful sweeping line. And, beyond this, there is a striving for balance, purity, and harmony in the features that reflects a profound understanding of the norms of Classical antiquity. Even the aloof, inwardly directed expression of the eyes

seems to point to the more introspective figures of Hellenistic times.

In one respect Leonardo was much influenced by earlier Florentine artists such as Botticelli (Figs. 8–17 and 8–18); there is a graceful rhythmic quality in his linear composition. Whereas Botticelli was mostly interested in stressing rhythmic patterns on the surface, however, Leonardo created arrangements of rhythmic lines that are fully three-dimensional. In the *Head of Leda* this is particularly true of the parallel curves of Leda's left shoulder and pectoral muscle and the two wrinkles around the neck, which create a spiral around the figure. The twisting outlines of the *Kneeling Leda* (Fig. 9–1) also form three-dimensional rhythmic lines.

These spiraling rhythmic lines suggest movement in space, but a movement not necessarily related to physical action. Leonardo was a master at depicting galloping horses and fighting soldiers; both figures of Leda, however, are motionless. The rhythm of the lines in these two drawings

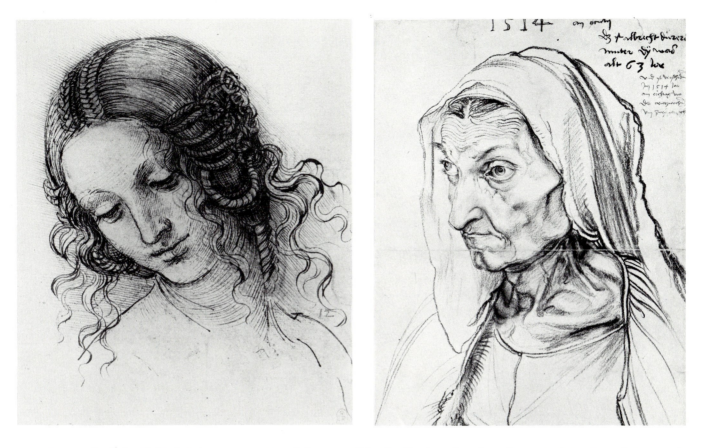

suggests not physical activity but inner striving. It is what Leonardo called "the spiritual movement" from which "originates the force that exists in man's limbs." So keen was he to stress this "spiritual movement" that the spiraling lines have a particular swiftness. In fact, rather than draw more slowly, Leonardo chose not to mind apparent "faults," which he corrected with incredible virtuosity. Thus, on Leda's left shoulder in the *Head of Leda,* two segments of an outline that do not meet are simply joined by a transverse dash.

Leonardo's composition reflects another important development. For all the subtlety in the handling of lines, the design is subordinated to a simple overall configuration. In the *Head of Leda,* the face and neck are contained in a pear-shaped form; in the *Kneeling Leda,* woman and swan are contained within a vague pyramidal form. The design of the lost painting of Leda is of extraordinary historical importance. The monumental forms, the chiaroscuro and *sfumato* treat-

ment, and the successful subordination of detail to rhythmic spiraling curves that give a generalized sense of movement were to become characteristic of the High Renaissance; they also heralded the Baroque age in many ways.

The forms of the Dürer drawing are less abstract and reveal not the slightest concern for classical balance, purity, and harmony. Indeed, in spite of the apparent looseness of the execution, the German artist was close to the northern tradition of detailed realism. He made a point of stressing, as he put it, "the strange lines" that delimit "the brow, the cheeks, the nose, eyes, mouth, and chin, with their indentations, projections, and individual shape," not omitting "the tiniest wrinkles and prominences" that so delighted him when he painted a portrait. Even in Leonardo's grotesque figures, the rhythmic quality of the lines detracts from the deformities; here it seems to accentuate them. Notice how the repetition of the lines of the woman's right eyelashes and eyebrow protruding over the veil creates

jagged accents that stress what can only be a physical deformity, the divergence of the two eyes. Nor do we find Leonardo's generalized sense of movement; the wavy quality of certain lines, like the wrinkles of the old lady's forehead, is more reminiscent of the animated surface linearism of the Middle Ages.

Both artists went far beyond the depiction of physical reality, but their aims were different. Through the slightly mysterious shadowy veil surrounding the head of Leda, one perceives pensive eyes and a half-suggestive smile that are at once enigmatic and blissful. Although much has been made of the riddles of the expressions of Leonardo's figures, here the artist's intentions are made clear by the story, an episode from Greek mythology. Enamored of Leda, a beautiful mortal woman, the god Zeus took on the form of a swan in order to win her love. The outcome of the story is shown by Leonardo in the form of human children hatching from eggshells. Taken literally, this dalliance is, of course, monstrous. It

is without doubt a poetic interpretation of feminine sexuality that Leonardo was attempting to suggest in this vision of the graceful young woman. But it is an interpretation that reveals a new objective spirit. On the one hand, the scene reflects an acute observation of the attitudes, movements, and expressions of living beings, the type of observation one can truly call scientific. On the other hand, Leonardo was able to evoke, from an old myth, his own intuitive awareness of man's psychological motivations.

A note written by Dürer after his mother's death, shortly after he drew the portrait, gives us a certain insight into the personality of the old lady:

> She often had the plague and many other severe and strange illnesses, and she suffered great poverty, scorn, contempt, mocking words, terror, and great adversities. Yet she bore no malice!...She feared death much, but she said that to come before God she feared not....I saw how death smote her two great strokes to the heart, and how she closed her mouth and eyes and departed with pain.

The statement, for all its acute observations, is brimming with Medieval mysticism; the old lady could visualize herself face-to-face with God and it is death personified that struck her.

All that Dürer wrote about the strength of character and forbearance of his mother is eloquently conveyed by the features in the drawing. The mystical element itself is transposed into purely human terms in the expression of the tired eyes looking out with a certain fixity but with tranquility, as if the woman were indeed prepared to face death with confidence.

Dürer's insistence on past experiences and current anxieties is characteristic of a new development. We have already discussed the concern with psychological observation in the work of such Italian artists as Donatello (p. 109) and Leonardo himself. Dürer for his part achieved an unprecedented directness in presenting to us the inner life of the sitter. From now on, Western artists were to become increasingly concerned with the temperament and mood of the individual, in keeping, perhaps, with the Reformation's new stress on human values.

The innovations of Leonardo had a profound impact on the principal Italian artists of his time. In Venice, for instance, a tradition that had favored brilliant and subtle color effects became profoundly affected by Leonardo's application of chiaroscuro and *sfumato* techniques. The *Sleeping Venus* of about 1508 (Fig. 9–4) was painted by one of Venice's most original geniuses, Giorgione da Castelfranco (c. 1475–1510), with the assistance of his pupil, the young Titian. (It was unfortunately somewhat overpainted later; the figure of a cupid has been completely covered over.) It is painted in the oil technique that has spread to Italy in the 1470s. Instead of wood, which tends to warp and crack with age, the artist used a suitably primed canvas, another innovation from the Low Countries.

The use of oil glazes in sections of the painting made it possible to suggest subtle gradations of hues and values as

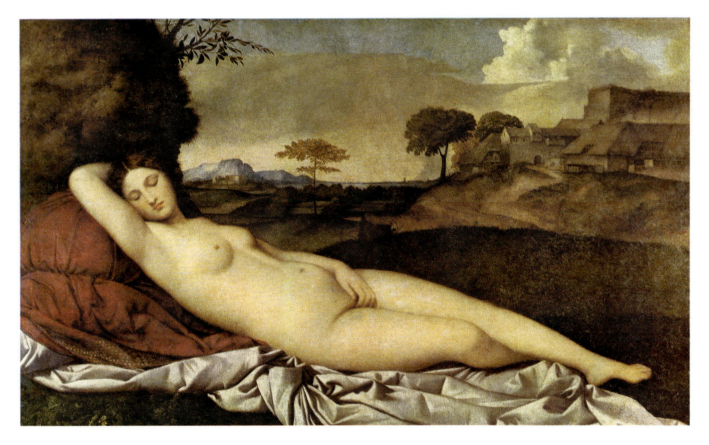

well as a dazzling array of textures, all bathed in a rich golden glow. On the grass areas, swiftly juxtaposed brushstrokes of different hues effectively suggest the vegetation. The *sfumato* technique, doubtless derived by Giorgione from Leonardo's paintings, is particularly evident around Venus' face and left breast. Together with the chiaroscuro modeling of much of the body, it provides an added touch of naturalism, surrounding as it does the solidly formed figure with an atmospheric film. Although we are still aware of a dominant linear pattern, particularly in the body, the vibrant brushwork in several areas of the picture and the nebulous treatment of edges and contours tend to make us think of the forms in terms of masses of colors rather than as surfaces defined by linear edges.

The nude Venus creates a curved accent in the foreground, parallel to the picture plane, that is continued vertically in the outline of the earth mass to the left. Beyond the figure is a luminous landscape consisting of a succession of

slightly curved ridges that lead the eye rhythmically to the silver-blue band of water and the hills in the far distance. The artist stressed warm as well as cool hues in the foreground, but only cool ones in the distance, while he made distant objects appear to be blurred—a practice known as *aerial perspective,* adopted first by northern European illuminators late in the fourteenth century. It is based on the observation that, because of the filtering properties of the atmosphere, distant objects appear to be bluer and less distinct than near objects. The naturalistic effect is enhanced by the remarkable rendering of the lighted clouds.

In keeping with the norms of the High Renaissance, the human figure here is monumental and it brings to mind the most refined feminine nudes of Hellenistic times. However complex the arrangement of the limbs may be, the overall configuration of the body is simple. There is a slight axial twist (Venus' left thigh is higher than her right, and her right shoulder is higher than her left) and

the whole figure spirals in a clockwise direction toward the top.

If the expression of Leonardo's Leda (Fig. 9–2) was directed inward, that of Giorgione's Venus is inscrutable, for the figure is asleep. In this the artist was following antique precedents, since some of the more frankly sensual figures of antiquity are shown sleeping. The fact that Venus is asleep makes her more aloof and remote from everyday reality than she would otherwise be, while at the same time it establishes a parallel between the beauty of her motionless body and the poetry of the surrounding landscape.

The High Renaissance in Rome was dominated by the personalities of two popes, Julius II and Leo X. Julius attracted the young and versatile Florentine sculptor Michelangelo Buonarroti (1475–1564) to his service and asked him to decorate in fresco the ceiling of the Sistine Chapel in the papal palace of the Vatican. Michelangelo, after first protesting that he was a sculptor and not a painter, carried out the commission between 1508 and

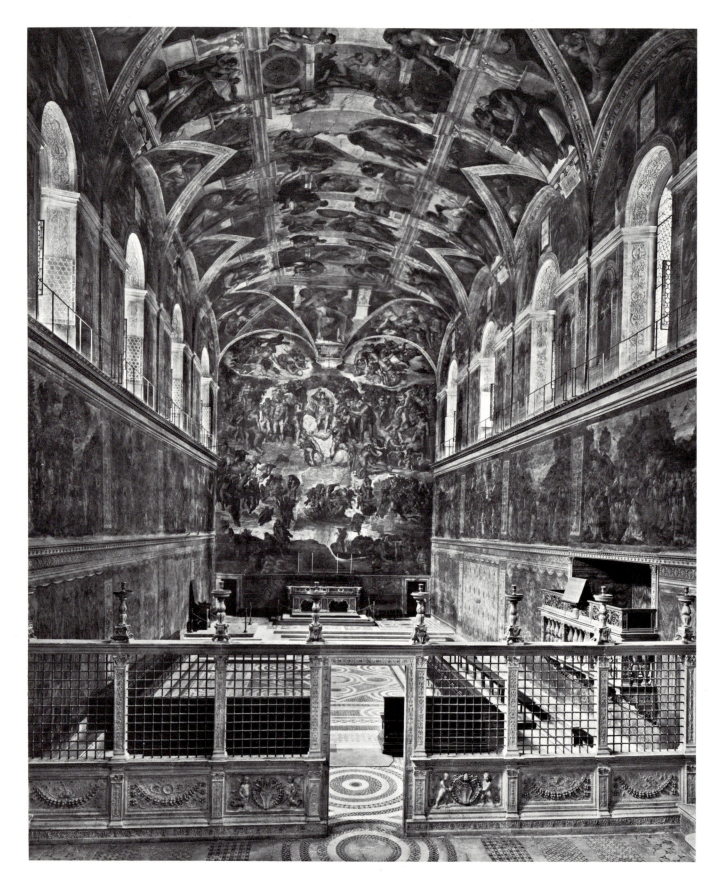

9-5 *Opposite page:* Michelangelo, Sistine ceiling,
Vatican, Rome, 1508–12.

9-6 *This page:* Michelangelo, detail of fresco from
the Sistine ceiling, 1508–12.

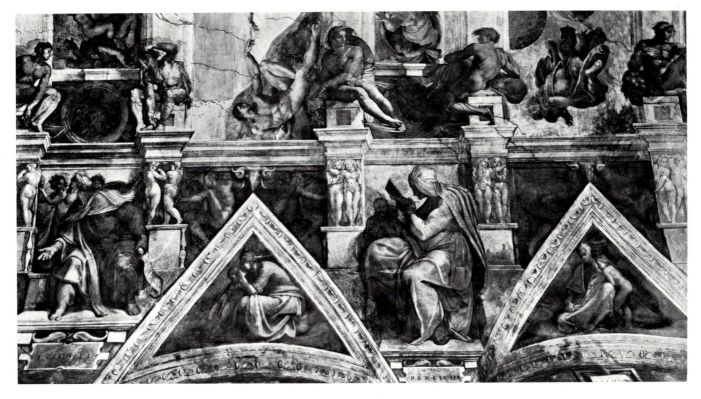

1512, doing much of the work lying on his back atop a high scaffolding (Fig. 9-5).

Michelangelo conceived the decoration as an illusionistic architectural design (Fig. 9-6). Painted double pilasters rise from both sides between the groins of the window openings. They are linked at the top by painted arches, forming an architectural ensemble above the actual ceiling. Because the painted vault does not appear to rise appreciably higher than the actual vault, however, the decoration does not jeopardize the integrity of the ceiling.

Michelangelo's iconographic scheme, based on the Old Testament, was as vast and complex as the designs in Gothic cathedrals and must have been based on instructions received from papal theologians. The overall arrangement reflects the impact of Neo-Platonic thought, with which the artist was thoroughly familiar. To mention but the highlights, the figures between the pilasters are alternately Sibyls and Old Testament prophets, who are presumably heralding the coming of

Christ, as Isaiah does at Souillac (Fig. 7-1), for instance. The Sibyls were oracular figures of Greco-Roman mythology who were acknowledged by early Christian texts and who provided convenient antique counterparts for the prophets. Above the pilasters are the monumental figures of vigorous adolescents known as the *ignudi* (or nude ones), tendered as though they were massive sculptural ornaments around the rectangular Old Testament scenes along the central axis of the ceiling. They are not mere decorations, however; a broad range of expressions from indolence to fury seems to suggest various stages of emotional ferment. The Old Testament scenes appear as "real" frescoes in the fictitious architectural scheme. Their subject matter spans the Book of Genesis from the Creation to the Flood and seems to symbolize the relationship of man to God himself: God creates the universe and man, punishes Adam and Eve, and saves Noah, the worthiest of their descendants.

A comparison of the part of the fresco

called the *Creation of Adam* (Fig. 9-7) with a marble relief of the same subject (Fig. 9-8) from a portal of San Petronio in Bologna, executed about 1430 by Jacopo della Quercia (c. 1374–1438), a Sienese contemporary of Donatello, will reveal the iconographic imagination, sense of design, and expressive power of Michelangelo. The relief still shows traces of the swaying linearism of the International style, while the rock under Adam and the small tree we have already encountered in such austere backgrounds as that of Giotto's *Lamentation* (Fig. 7-17). The two figures, however, reflect the progress made by Masaccio and his contemporaries—that of Adam, in particular, revealing a sound understanding of the athletic ideals of antiquity.

Michelangelo, who had been to Bologna and must have seen the della Quercia relief, reinterpreted the scene in his immensely powerful pictorial language. The two principal figures are closer to the classical spirit than della Quercia's are. Both are loosely based on antique proto-

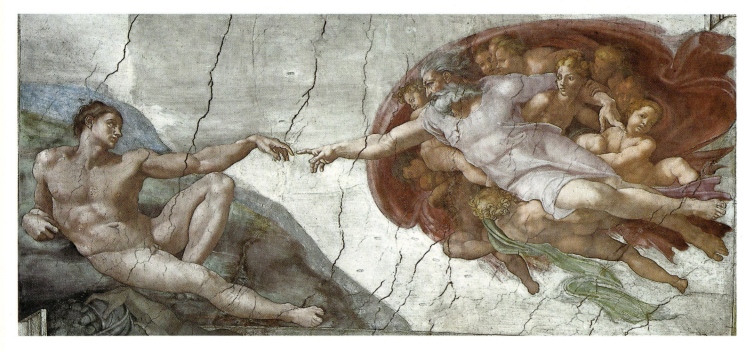

9-7 Michelangelo, *Creation of Adam,* fresco from the Sistine ceiling, Vatican, Rome, 1508–12.

9-8 Jacopo della Quercia, *Creation of Adam,* c. 1430. Marble (34½″ × 27½″). San Petronio, Bologna (*comparative illustration*).

types and have a new monumentality. Moreover, through the subtle play of shadow on the surfaces and the masterly handling of clear and definite outlines, Michelangelo was able to suggest with striking naturalism the contrast between the vigor of God and the languidness of Adam—a contrast that culminates in the opposition between God's energetic pointing finger and Adam's limp hand.

Also in keeping with new trends, the composition is dominated by three-dimensional rhythmic lines; the curvature of the shell-like mantle of God is echoed by the spiraling curves of the two sides of Adam's torso, while the extended arms provide a powerful transverse accent. The sparseness of details and the restraint of the color scheme—only the purple mantle and pale lilac tunic of the Creator, the green flowing drapery, and the greens and blues in the landscape enliven the essentially gray and brown harmonies—are characteristic of Michelangelo and make the Sistine ceiling one of the most severe works of the High Renaissance.

Instead of depicting God standing at Adam's side, Michelangelo showed him in midair, surrounded by wingless genii and enveloped in his billowing mantle (an updated version of the Medieval mandorla) thus stressing his exalted position in the universal scheme. Rather than blessing Adam, moreover, he is stretching his arm out so that his finger is almost touching Adam's, about to transmit the spark of life. Adam, in response, seems to awake from a deep slumber, his body about to rise. Michelangelo, it would seem, intended to transmute the Old Testament story into an allegory of the life-giving process itself, life being compared to some intangible spirit that flows from the more dynamic to the still-static being. Adam, able to see God face-to-face, seems to experience total bliss and to achieve "the knowledge or possession of God," in the Christian and Neo-Platonic sense. This face-to-face contact with God, incidentally, may well be interpreted as a prime example of the self-confidence of Renaissance man.

9-9 Raphael, *Parnassus,* fresco, Stanze della Segnatura, Vatican, Rome, 1510–11.

Among Michelangelo's chief contributions was his infusion of a new energy and a new sense of drama into the classically inspired human forms of the High Renaissance. The energy was to lead to the restlessness of the Mannerist era and to the love of movement of the Baroque era; the new sense of drama was to lead to the theatrical intensity of the greatest Baroque artists. And, however specific were the iconographic directions he may have received from the Church authorities, Michelangelo proved as original as Leonardo in creating striking and moving pictorial expressions for very complex concepts.

Michelangelo's chief rival was the painter Raphaello Sanzio, or Raphael (1483–1520), a native of Urbino who was barely twenty-five when, in 1508, he was commissioned by Pope Julius II to decorate a series of official rooms known as the Stanze in the Vatican. *Parnassus* (Fig. 9-9), executed in 1510–11, is one of four frescoes decorating the walls of the papal study, the Stanze della Segnatura. The three other frescoes are devoted to theology, philosophy, and law; this one symbolizes poetry. It shows Apollo as god of the arts and as an accomplished musician, surrounded by the nine Muses, the spirits of the arts, who listen to his music in their sacred precinct on Mount Parnassus. On each side of Apollo and the Muses are grouped the greatest poets of the past. We recognize, among others, blind Homer on the left, standing just in front of Dante and Virgil.

The lessons of his seniors were not lost on Raphael; the muscular bodies and energetic poses of several figures remind us of Michelangelo. But Raphael had his own remarkable contribution to make. The arrangement of the figures may appear to be casual, but as we follow the forms of the exquisitely modeled and beautifully proportioned bodies we are led from one figure to another, from one group to another, so that the composition becomes a garland of airy, delicately colored, and subtly intertwined forms. In keeping with one of the key principles of the High Renaissance, the individual forms are subordinated to a simple, fairly symmetrical overall pattern, in this case two curves fanning out on each side of Apollo. Raphael was particularly ingenious in his arrangement of these groups of figures. They serve a dual purpose: they gracefully fill the semicircular surface, conveniently accommodating the rectangular opening for the awkwardly placed window at the bottom, and they also form a majestically rhythmic design that recedes along an inclined plane and links the foreground with the cluster of trees at the center and lead to the open space beyond. It seems appropriate to refer to the relationship of individual parts and the whole composition as orchestral movement. This distribution of the figures marks a great stride forward; compared with Piero della Francesca's figures of Solomon and Sheba (Fig. 8-15) crowded into the stage space, Raphael's composition suggests sweeping arrangements of forms in space that herald the Baroque era.

8-8 Filippo Brunelleschi and others, interior of the Pazzi chapel, Santa Croce, Florence, possibly begun in 1443 (*comparative illustration*).

Raphael revered Classical antiquity. It is known that he drew several of the *Parnassus* figures from antique prototypes, although he was in no way concerned with archeological accuracy and even took the liberty of depicting Apollo holding a viola instead of the traditional lyre. But Raphael's appreciation of Classical antiquity can be seen especially clearly in the balance of the composition, the fluent distribution of the forms in space, the idealization of the features, and the loftiness of the expressive content, all going back to the ideals of Greco-Roman art.

The subject matter itself was both imaginative and poetic. Drawn from diverse periods and various traditions, the characters are shown communing at a courtly gathering in the sacred precinct, at once suggesting the universality of man's creative spirit and evoking an idyllic vision of an imaginary golden age.

A new idiom was also being devised in architecture. Around 1450, the Florentine architect Leone Battista Alberti (1404–72), whose theoretical views we

have already encountered, designed a new masonry exterior for the existing church of San Francesco at Rimini (Fig. 9–10). Although the remodeling was never completed, a comparison of this building with Brunelleschi's Pazzi chapel (Fig. 8–8) reveals clearly that a second Renaissance style in architecture, much closer to the spirit of Classical antiquity, was being evolved in the middle of the fifteenth century. In both buildings we find the same satisfying relationship between individual parts and between each part and the whole. (Alberti, incidentally, was the first Renaissance architect to write of the virtues of numerical proportions.) Alberti's design, however, shows a greater interest in the spirit of Greco-Roman architecture. Instead of the refined, shallow pilasters and moldings applied over the smooth surfaces of the Pazzi chapel, we find here semicircular engaged columns with protruding capitals, a pronounced cornice, and, on the side, a deep arcade. These are not handled with archeological accuracy, but they nevertheless

bring to mind the virile detailing of specific antique buildings. Where Brunelleschi had treated walls as decorated screens, Alberti stressed their massiveness and solidity.

The first architect who belonged fully to the High Renaissance was Donato Bramante (1444–1514). His Tempietto ("little temple"), erected in the courtyard of San Pietro in Montorio (Fig. 9–11) in Rome in 1502, can be taken as a significant prototype of the buildings of the new era. Like some of the finest classical temples based on the central plan, this chapel is circular. Both the Doric colonnade and the blind niches, furthermore, are derived from antiquity. Bramante incorporated them in the overall design with complete ease. He clearly and forcefully articulated all the details but subordinated them nonetheless to a simple overall design: a cylindrical drum topped by a smaller one surmounted by a semispherical dome (originally intended to be somewhat taller). The proportions, based on simple numerical ratios, are harmoni-

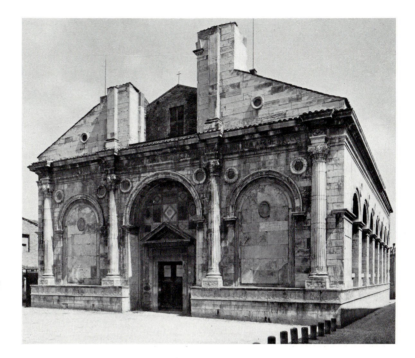

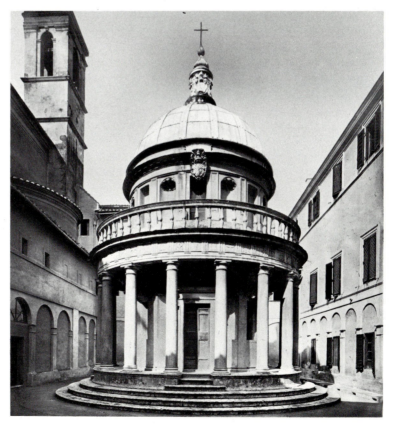

9-10 *Top right:* Leone Battista Alberti, church of San Francesco, Rimini, c. 1450.

9-11 *Bottom right:* Donato Bramante, Tempietto, San Pietro in Montorio, Rome, 1502.

ous and monumental. If it had been surrounded by a circular court enclosed by a colonnade, as originally planned, the Tempietto would have had that lofty and serene relationship to its environment that was so much sought after by High Renaissance architectural planners. Like Raphael's *Parnassus,* it ranks as the most classical work of its time.

The greatest building of the High Renaissance was started by Bramante and is based on the same general concept as the Tempietto. It is the cathedral of Saint Peter in Rome, the principal church of Catholic Christendom, ordered by Julius II to be built on the site of the older basilica. Bramante's design of 1506 was for a centrally planned church surmounted by a semispherical dome. After Bramante's death in 1514, several architects, among them Raphael, redesigned the building, but it fell to Michelangelo to give it the dominant features of its present-day appearance. Except for the dome, which is more pointed than Michelangelo had intended, the view we see in Figure 9–12

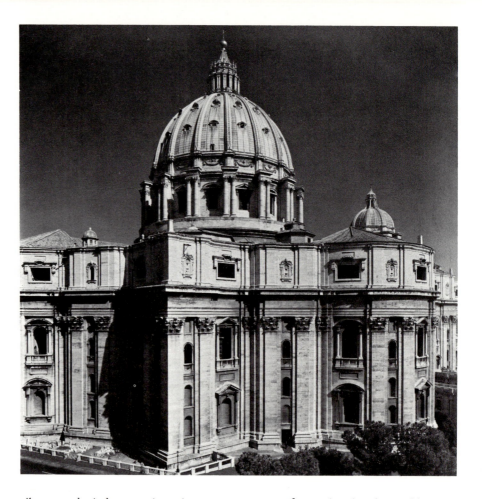

9-12 Michelangelo, Saint Peter's, Rome, 1546–64. (Dome completed by Giacomo della Porta, 1590.)

gives a clear idea of the concept he evolved from 1546 to the time of his death in 1564.

His plan consists of a square abutted by semicircular apses on three sides and by a rectangular section terminated by a pedimented portico on the fourth (Fig. 9–14). Four massive piers at the center support four arches. These in turn support the dome and open up onto two pairs of barrel-vaulted bays at right angles to one another.

What we see in Figure 9–12 is a corner of the square flanked by two of the apses. The protruding parts of the stone wall act as powerful buttresses, resisting the thrusts of the barrel vaults and the dome. Far from stressing the structural function of the wall, however, Michelangelo treated it as an independent entity, making it curve around niches and apses and jut out at the corners; it thus creates an exciting sense of flowing as it defines the interior space. The outside presents an arrangement of lateral, longitudinal, and oblique surfaces adorned by

pilasters and window openings that seem to have been sculpted like the facets of a precious stone.

In contrast to the predominantly horizontal lines of the wall, Michelangelo placed a number of vertical rows of windows between pairs of two-story-high pilasters, thus creating a repetition of vertical accents around the building. Such pilasters, which constitute what is known as the *giant order,* provided powerful vertical elements without jeopardizing in any way the impression of massiveness created by the walls. The very simplicity of the scheme helps unify the vast and complex building. The vertical motif is repeated in the twin columns of the drum below the dome and in those of the lantern above. Yet Michelangelo may have changed his mind in the latter phases of construction and played down these accents; the wide band of the massive-looking attic with its horizontal openings seems to contain the upward thrust of the pilasters, while the roundness of his intended semispherical dome (Fig. 9–13) introduces another ele-

ment of restraint in the architecture.

There are other deliberate contrasts. The sense of flow conveyed by the peripheral wall seems in opposition to the precise and intricate faceting of the decoration. The plan itself (Fig. 9–14) can be read as two different configurations; it can be seen either as a cross formed by barrel-vaulted arms intersecting under the cupola or as a square determined by the passageway around the central piers. And yet there are powerful unifying factors. The relationship of the dome to the whole body of the church, in particular, is little more complex than that of Bramante's Tempietto. As a result, the overall effect is one of great cohesiveness and harmony. It is as if the aging genius had carefully stressed the contrasts of apparently conflicting elements while at the same time achieving an integration of these elements in the overall design.

The search for monumentality, harmony, and (despite the complexity of the parts) overall simplicity makes Saint Peter's the most significant and charac-

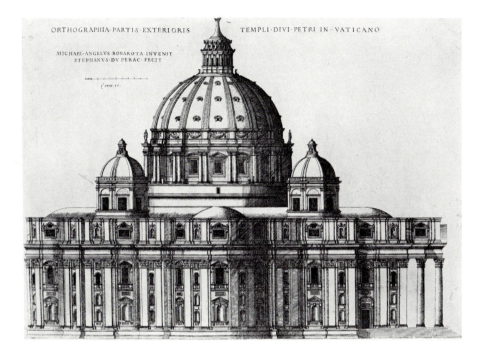

ORTHOGRAPHIA·PARTIS·EXTERIORIS TEMPLI·DIVI·PETRI·IN·VATICANO

MICHAEL·ANGELVS·BONAROTA·INVENIT
STEPHANVS·DV·PERAC·FECIT

9-13 Michelangelo, Saint Peter's, section. Engraving by E. Dupérac, 1569, based on Michelangelo's intended design.

teristic architectural achievement of the High Renaissance. In three important respects, however, Michelangelo's building announced future developments. First, he displayed a new originality in handling antique motifs and, in so doing, anticipated some of the achievements of younger architects, who were to feel increasingly free to adapt antique elements in an entirely new spirit. In the second place, Michelangelo treated walls as flowing masses that could be manipulated at will by the architect, thus paving the way for the suggestion of flowing masonry in Baroque architecture. Finally, he stressed contrasts of conflicting elements, thus heralding the dynamism of the Baroque era in general.

Even before he began work on Saint Peter's, Michelangelo had devoted more than a decade to an architectural and sculptural ensemble that was also prophetic of the future and was to have a very profound impact on younger artists: the Medici tombs. This ensemble was commissioned in 1520, shortly before the

death of the Medici Pope Leo X. It involved adding a wing, the new sacristy, to the church of San Lorenzo in Florence and erecting tombs for the pope's father, Lorenzo the Magnificent, his uncle Giuliano, and two younger relatives who had recently died. The sculptural scheme was first conceived in 1521 and was executed between 1524 and 1534. Although it originally included individual tombs for all four men, only those for the younger two were actually built, against two adjoining walls of the sacristy, those for the older ones having been relegated to a tomb under the statues of the Virgin and saints against a third wall.

The monument shown in Figure 9-15 is the tomb of one of the younger Medici, Giuliano, duke of Nemours. It has an elaborate architectural marble setting that is itself dominated by a wall articulation reminiscent of the early Renaissance— dark pilasters and moldings on a white surface—in keeping with the decoration of San Lorenzo's old sacristy by Brunelleschi. The architectural setting consists

9-14 Michelangelo, plan of Saint Peter's

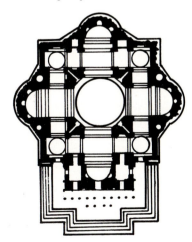

9-15 *This page, top:* Michelangelo, tomb of Giuliano de' Medici, San Lorenzo, Florence, 1524–34. Marble (height of central figure, 5'11").

9-17 *Opposite page, left:* Michelangelo, allegorical figure of *Night,* from tomb of Giuliano de' Medici.

9-18 *Opposite page, right:* Michelangelo, allegorical figure of *Day,* from tomb of Giuliano de' Medici.

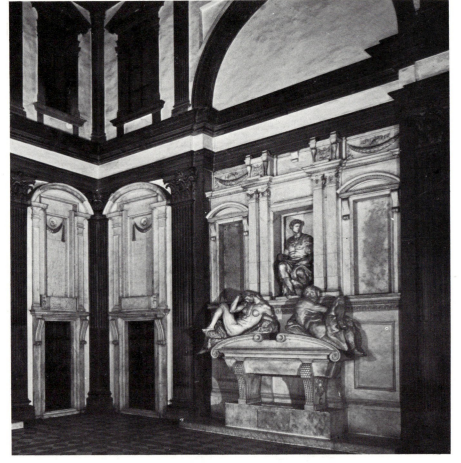

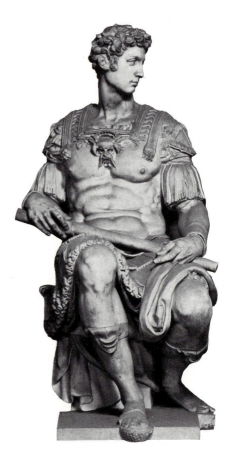

9-16 Michelangelo, *Giuliano de' Medici,* from tomb of Giuliano de' Medici.

of three vertical slab-like marble sections that fit between the dark pilasters, all based on elements freely adapted from the antique. Indeed, Michelangelo seems to have handled classical motifs with an arbitrariness that is sometimes startling. If we examine the two outside panels we notice that there are brackets on each side of the doors as if prepared to carry a lintel, but there is none, and in its place there is only a thin slab, which needs no such support. On this slab is a block that serves no purpose. In addition, the niches are surrounded by frameworks consisting of pilasters and rounded pediments not unlike the window decorations on the exterior of Saint Peter's (Fig. 9–12), but here, in the case of the two external units, the niches rise into the interior of the pediment and expand laterally into a T. There are no precedents for these practices

in antique art, and the inconsistencies were quite deliberate. Furthermore, the various architectural elements are in shallow relief, in marked contrast to the massive ornaments that had been in favor since Alberti's work (p. 125), and they tend to stress the rhythmic quality of the surface design rather than the articulation of walls in depth that had become characteristic of High Renaissance architecture. Clearly, Michelangelo was freely and imaginatively adapting and rearranging antique motifs in order to create elegant and eerie surface effects. The result was most suitable for a monument that, with its blind windows and false doors, suggests the façade of an otherworldly palace.

The sculptural program of the Medici tombs was never completed; there were to have been two pairs of figures of reclining river gods on the floor. The existing figures may have been worked on by other sculptors after Michelangelo abandoned the project, and in some areas they too remain unfinished. The present grouping is nevertheless extraordinarily expressive:

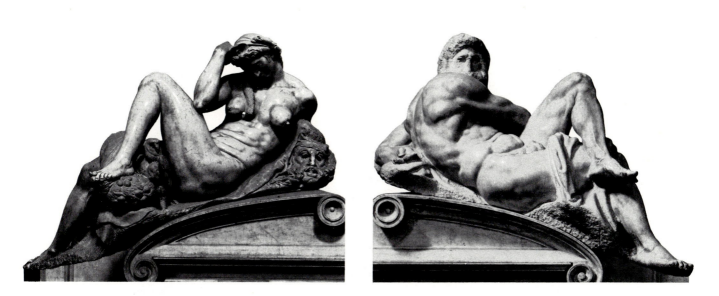

the moods of the figures are carefully differentiated, and their interplay is pregnant with symbolic overtones.

Giuliano (Fig. 9–16) is obviously idealized; indeed, Michelangelo is reported to have said that in a thousand years' time nobody would care whether or not it was a true likeness. The duke is dressed as a Roman warrior (see Fig. 3–4), but his armor is made to take on the form of his body so faithfully that it appears to be melting away to reveal the dead man as a heroic antique nude. However precise the modeling, the proportions are so elongated as to suggest spirituality. Giuliano's head is turned toward the statue of the Virgin against the adjoining wall, but he does not seem to be looking intently; his melancholy gaze suggests rather some spiritual inner vision, while the gracefully rising spiraling curves created by the twist of his legs and the languidly turning torso convey a sense of detachment from things material.

Michelangelo referred to the two allegorical figures resting on the sarcophagus lid as Day (on the right, Fig. 9–18) and Night (on the left, Fig. 9–17). The features of the first are barely roughed out, but its Herculean body seems weighted, almost inert, as though it could raise its torso and head only through a massive muscular effort. The long and lithe body of Night is that of a woman past her prime: a distended musculature shows through her rather flabby flesh. Her morosely downcast eyes and resigned mouth, no less than the passivity of her attitude, suggest lassitude and despondency. And the three emblematic objects on the couch—the owl, the mask, and the bunch of poppies—stand for night and death.

The figures of Day and Night stand in formal relationship to the figure of Giuliano in much the same way that the *ignudi* stand in relation to the Old Testament scenes of the Sistine Chapel (Fig. 9–6). As in the ceiling, there is here no direct psychological relationship between the decorative figures and the scene above them. The only common bond is a mood

of sorrowful withdrawal. In Michelangelo's words,

Day and Night are speaking and they say: with our speedy course we have led Duke Giuliano to his death; and it is right that he should take revenge for this, as he has done. The revenge is this: that just as we have killed him so he in death has deprived us of our light, and with his closed eyes he has closed our eyes, which no longer shine upon this earth. What then would he have done with us while he was still alive?

Michelangelo made superb use of attitudes, gestures, facial expressions, setting, allegorical motifs, and overall composition to convey a complex and powerful symbolic message, and he did so beautifully and movingly. His Medici tombs had considerable influence on a group of younger artists, the Mannerists, who attempted to be as ingenious in their iconographic invention and as artful in their handling of artistic devices. They lacked Michelangelo's imaginative power and depth of feeling, however, and achieved effects of an entirely different order.

10

The Late Renaissance and Mannerism

The developments that took place in art during the final phase of the Renaissance have been linked with the social and political upheavals that were shaking the whole of Europe and that were particularly violent in Italy. Endless wars and massive inflation caused by the importation of vast quantities of precious metals from the New World threatened the European economy. The spread of Protestantism and the ensuing Counter Reformation, moreover, created grave crises: the humanistic spirit that had given support to the Reformation through its stress on free inquiry was being threatened both by the puritanical zeal of the reformers and by the new dogmatism of the Catholic reaction. In Italy matters were made even worse by successive foreign invasions, the serious decline in the fortunes of the papacy, and the establishment of new trade routes that by-passed the Italian ports and commercial cities. Aside from any political, economic, and religious considerations, the classical High Renaissance seems to have

run its course by 1520, the year that Raphael died, when artists and patrons alike were thirsting for novelty.

The dominant trend (but by no means the only one) that characterized Italian art from around 1520 to 1600 and eventually affected most European schools was Mannerism. Typified by a search for elegance and a haunting restlessness, the new style nevertheless led to the development of major features of the more vigorous and positive manner of the early Baroque age.

The so-called *Madonna with the Long Neck* of about 1535 (Fig. 10–1) by Francesco Mazzola, called Parmigianino (1503–40), an artist who spent much of his time in Rome, is a landmark in the development of Mannerism. The work is characteristic of the reaction then prevailing against the norms and ideals of the High Renaissance, particularly the more classical aspects of the art of Raphael. Ironically, the term *maniera,* from which the word Mannerism is derived, referred in the fifteenth century to the formal

accomplishments of Raphael and his great contemporaries. During the Mannerist period itself, it seems to have meant "style," but more specifically it referred to the tendency toward abstraction and idealization that was already present in works of the High Renaissance. The Mannerist artists stressed these elements to the point of abandoning the naturalist preoccupation of their predecessors and striving for a new complexity of composition, an elongation of forms, a strained elegance of the figures, and generally speaking a stress on artifice. It is no wonder, then, that in later centuries the words *mannerist* and *manneristic* came to mean mannered, precious, and artificial.

Parmigianino's Madonna is characteristic of the more courtly tradition of Mannerism, a tradition that derived in many ways from both Raphael and Michelangelo. A comparison between Parmigianino's *Madonna* and any figure in Raphael's *Parnassus* (Fig. 9–9) reveals the same interest in beautifully rounded forms leading the eye from one element

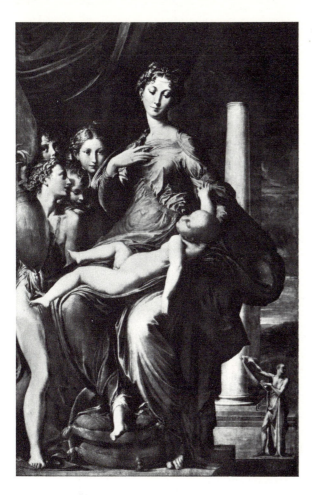

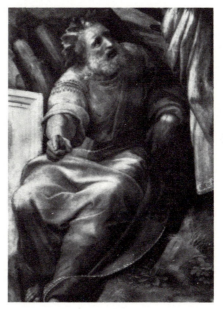

10-1 *Left:* Parmigianino, *Madonna with the Long Neck,* c. 1535. Oil on wood (7′1″ × 4′4″). Uffizi, Florence.

9-9 *Below:* Raphael, detail of *Parnassus,* 1510–11 (*comparative illustration*).

to the next in the picture; notice how the body of the infant Christ follows the curve of the left arm of the Virgin and how his left leg curves around the Madonna's right thigh and finally almost touches the leg of the standing youth at the left. But there are differences; Parmigianino's figures have an unclassical elongation of the bodies. Some forms, such as the sweeping outline of the Virgin's mantle, have acquired a serpentine animation. There is something hard, almost brittle, about the handling of the surfaces. Colors have a metallic brilliance. And the principal group of figures has been strangely compressed in the foreground. There is, clearly, a new interest in a jewel-like handling of the pictorial surface, to the detriment of the logical articulation of forms in space. This is not to say that Parmigianino ignored the principal sources of inspiration of the High Renaissance, but rather to say that he used them to very different ends. The folds of the draperies themselves, for instance, reflect a careful study of Hellenis-

tic folds such as those of the Pergamene Athena (Fig. 2–23), but the artist made use of them not so much to render fabric and flesh illusionistically as to suggest a marble-like surface. Going further, he then accentuated the folds created by the nipple of the Virgin as if to reverse the metaphor and make the marble look like flesh and fabric after all.

The handling of the figures in space reveals the same striving for artifice. The artist seems to have made a point of testing his skill at grouping seven figures effectively and gracefully in a confined space while opening up a broad vista in the background, in which we see the colonnade of an incomplete, classical-looking temple and the solitary figure of an Old Testament prophet in a theatrical attitude. What is more, Parmigianino chose to depict the Virgin from a very low point of view—her head and shoulders are disproportionately small compared with her legs—and to show the landscape below eye level, as if to startle us by the juxtaposition.

If the graceful intertwining of the forms owes much to Raphael, many of the more affected attitudes and gestures are derived from Michelangelo. The Virgin's small head, her elongated body, elegantly curved neck, and languid hands, her twisting torso, the inclination of her legs, and the difference in level between her knees are all exaggerations of similar features of the statue of Giuliano de' Medici (Fig. 9–16). The new disregard for spatial relationships and stress on complex and artificial surface effects, furthermore, echoes Michelangelo's innovative principles in the design of the architectural setting behind the tomb. The spirit of the two works, however, is totally different. The calm meditative gaze and slow twisting motion of Giuliano suggest a poignant detachment from worldly concerns. The mask-like face of Parmigianino's Madonna, on the other hand, conveys little more than aristocratic reserve, while the gracefully languid, almost caressing gestures of the various figures suggest, at most, a refined and diffuse eroticism. The

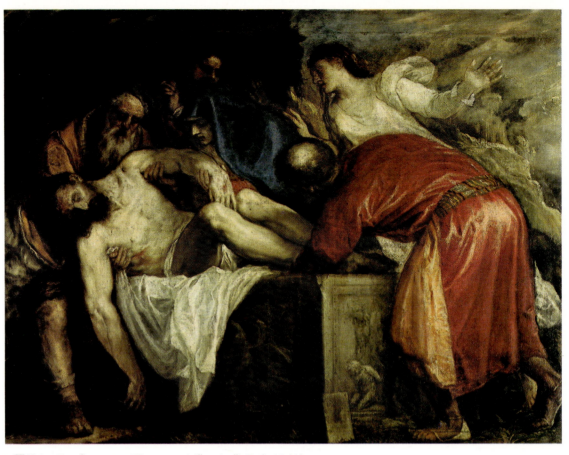

10-2 Titian, *Entombment,* 1559. Oil on canvas (54″ × 68¾″). Prado, Madrid.

picture does convey a sense of exultation, however, which is derived primarily from the jewel-like quality of the surfaces, the restless animation of the forms, and the elegant linearity of the figures.

Mannerism took different forms in the work of different artists. Some of its exponents went further than Parmigianino in stressing restlessness and immateriality; others explored weird lighting with an end to creating disquieting effects. In general, however, there was a definite reluctance to express powerful emotions. Their chief endeavor was to find novel and arresting ways to rephrase traditional themes, often through the use of obscure and complicated allegories, and in the process to display their exquisite skill at handling form and color. Not surprisingly, the figures in the Mannerists' work became totally self-controlled, their faces beautifully inexpressive masks; attitudes became elegant and contrived, settings ornate and insubstantial. The pictorial world of the artist was divorced from the real world; ingenious theatricality

became a prime source of artistic delight.

Not all Italian artists of the late Renaissance were Mannerists, however. The vigorous Venetian school, in particular, produced several artists who, although they were all somewhat affected by Mannerist developments, remained more faithful to the ideals of naturalism and the love of monumentality of the High Renaissance. Some of these were of a stature to take advantage of Michelangelo's successful endeavors to achieve intense expressiveness. The greatest figure among them was unquestionably Tiziano Vecellio, or Titian (c. 1490–1576), whose career provides the most continuous and consistent link between the High Renaissance and the Baroque era.

Titian's work should be compared with that of Domenikos Theotokopoulos, known as El Greco (c. 1541–1614), an artist who was closer to the Mannerist tradition but benefited both from that tradition and from the example of Titian and other Venetian masters to achieve a pitch of religious fervor quite unlike the

mood of the principal Mannerists. He was born on Crete, an island that had a Greek population and an essentially Byzantine culture, but was occupied by the Venetians at the time. He was trained in Venice in the workshop of Titian, and after spending some years in that city settled in Toledo in Spain.

Titian's *Entombment* of 1559 (Fig. 10–2) still has strong connections with the High Renaissance: the forms are massive and they are gracefully linked to create a vaguely pyramidal structure. There are important departures from the High Renaissance style, however. Technically Titian has elaborated on the method of painting already used by his master and former colleague Giorgione. Here an even larger portion of the surface is executed in multicolored areas, as was the grass in Giorgione's *Sleeping Venus* (Fig. 9–4, p. 119). The colors, however, are more intense and the effect more vibrant, and the multicolor technique is now used for the figures. Drapery folds are suggested by means of curving and sometimes angular

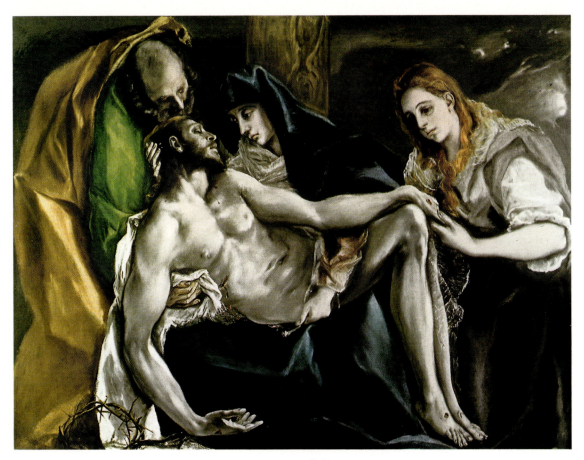

10-3 El Greco, *Lamentation*, c. 1580–82. Oil on canvas (45½″ × 57″). Collection of Stavros S. Niarchos, Paris.

streaks of colored glazes for highlights and shadows, which alternate with the hues of the fabrics themselves; and flesh areas by means of glazed masses of varying and often vivid hues. The lines themselves have lost the clarity they had in High Renaissance times: in some areas they disappear in dark shadows, while in others they are overlapped by stray strokes. The tradition of smooth color areas bounded by continuous outlines or edges which remained essentially characteristic of the High Renaissance and of such Mannerist works as Parmigianino's *Madonna with the Long Neck* (Fig. 10–1) has made way for a new manner in which forms appear to be rendered principally by means of patches of color and their edges seem to be partially dissolved in light. This manner has been called *malerisch* by German scholars, a term which can be translated in English as *painterly.* It derives both from the tendency of Giorgione to use vibrant juxtaposition of color and from Leonardo's interest in chiaroscuro and *sfumato* effects. The technique involving

smooth surfaces and precise edges and outlines prevalent through most of the Renaissance, on the other hand, is usually referred to as *linear* or *draftsmanly.* The painterly technique offers the artist a much greater freedom of execution. The very vibrancy of the surface suggests the slight haziness that is an ingredient of chiaroscuro, and the pattern of brush-strokes often seems to create rich textural effects. Areas, such as certain highlights, where the medium is applied in a thick paste, incidentally, are called *impasto.*

The composition of the *Entombment* itself departs in significant ways from High Renaissance practices. In the first place, the strong chiaroscuro, if it helps to stress the depth of the somber sepulcher to the left, also tends to confine the group of figures to a narrow, dramatically lighted stage space. This contrasts markedly with the tendency to show forms receding in a spacious setting, as in Raphael's *Parnassus* (Fig. 9–9), and results in a Mannerist stress on surface animation. In the second place, High Renaissance

symmetry has made way for Mannerist imbalance, for although the pyramidal structure is fairly symmetrical, the body of Christ and the torsos of Mary Magdalen and the man to the right create strong diagonal accents toward the sepulcher in the upper left.

Finally, there is a new expressiveness in the arrangement of forms and colors and in the handling of attitudes and gestures which is in marked contrast with the restraint and loftiness of the High Renaissance. Powerfully rhythmic lines and forms distorted to the point of exaggeration help stress dramatic effects. Although the participants can only be moving slowly and cautiously at the moment depicted, there is something dynamic in their configuration: the back of the man to the right has been excessively curved, as if to magnify the effort of lowering the body of Christ; Mary Magdalen is leaning so far forward that she seems to be lunging toward Christ under the effect of an overwhelming inner impulse; the Virgin and the man to the left are more re-

strained in their attitudes, but they also convey affection and grief as they bend over the left arm and shoulder of Christ; less visible in the background, Saint John wrings his hands in anguished prayer, as if to summarize the feelings of the group; finally, the figure of Christ suggests even more intensely than Michelangelo's Day (Fig. 9–18) a titanic exhaustion and conveys a total surrender to death.

The colors too are expressive. In contrast to the sober hues of Michelangelo's Sistine ceiling or the airy and delicate tonalities of Raphael's *Parnassus,* Titian's color has a dramatic richness. The deathly creamy-greens of the body of Christ contrast with the blood stains, the warm shadows, and the reddish garments of the men. And at the very center of the painting the striking red and blue juxtaposition of the Virgin's dress draws our attention to the most aggrieved of the mourners. The handling of chiaroscuro, moreover, emphasizes the principal figure, that of Christ, and the one that is most animated, Mary Magdalen. It also provides shade over most of the eyes and mouths, so that although the features are rendered summarily, the artist calls on our imaginations to invest them with appropriately dramatic expressions. The accentuation of expressive elements is in keeping with the artifices of Mannerism, yet there is a major difference: Titian utilized them to achieve a depth of dramatic feeling worthy of the greatest artists of the High Renaissance.

El Greco's *Lamentation,* executed in Toledo around 1580 to 1582 (Fig. 10–3), is marked by an exaggeration of Titian's

manner. The painterly technique has acquired flame-like characteristics, surfaces as well as edges now appearing to dissolve in the light. The fantastic play of broad striations of hues and the juxtaposition of swiftly painted highlights and shadows over the draperies, together with the silvery illumination of the flesh, render the figures almost as insubstantial as the stormy clouds in the background and contribute a remarkable animation to the whole design. The figures are even more crowded toward the surface; elongated and flattened, they form a vaguely triangular pattern on the picture plane.

Here too, forms and colors have been handled expressively. The disposition of the three mourners echoes the pathetic configuration of Christ's body. The elongation and attenuation of all four figures, and more particularly that of Christ, contribute powerfully to the sense of grief. In keeping, perhaps, with the mask-like appearance of Mannerist faces, the features are more impersonal and less communicative, although they are more clearly defined than in Titian's *Entombment.* The attitudes, on the other hand, are subtly expressive: there is extraordinary gentleness in the gesture of the man bending over the head of Christ and almost kissing it; infinite tenderness in the way in which the form of the Virgin carries and nearly envelops the body of Christ; loving reverence in the gaze of Mary Magdalen as she bends over the pierced left hand of Christ; and an arcane refinement in the elegantly drooping right arm and hand of Christ. As for the colors, the cool hues of the

tunic of the Apostle and the garments of the women, heightened by contrast with the golden yellows, are at once tender and mournful.

There can be no question that the distortion of the forms and the stress on surface animation are related to Mannerism, as are the delicacy and refinement of the attitudes. Certain elements, however, can be related to another, much older tradition. The excessive elongation of forms may well stem from the examples of Byzantine religious art that El Greco must have seen in his native Crete. The restless animation of areas in light and shade may likewise be linked to the complex surface patterns of Byzantine draperies. The insubstantiality of the forms may be associated with the spirituality of Byzantine art, while the great delicacy of the gestures and the impassive stares may be related to the stylized grace and mask-like expressions of Byzantine figures such as those in the Nerezi *Lamentation* (Fig. 7–14). It appears that when he left Italy to settle in Toledo, El Greco drew on his memories of Byzantine art to elaborate a highly original style, achieving a visionary insubstantiality that reflected the religious exaltation of the Counter Reformation.

Stylistically both Titian and El Greco had considerable influence. Titian's painterly technique, his use of receding diagonal accents to link figures to the far distance, and his reliance on dynamic three-dimensional patterns to stress pictorial animation were to lead to the principal characteristics of the High Baroque era. El Greco's impact was more local, at

least until the late eighteenth century, when his visionary fluidity of execution may have influenced Goya. In the early twentieth century the spiritualizing elongation and ethereality of his figures struck a responsive chord in several artists.

Iconographically Titian's *Entombment* and El Greco's *Lamentation* share some very important features. Discarding complex allegories and Neo-Platonic allusions, the artists presented the scenes as simply as possible, adhering as closely as they could to the Scriptures. In this they were both reflecting the ideals of the Counter Reformation. The Protestants deprecated religious pictures as smacking of idolatry, but the Catholic Church advocated their use as conducive to greater piety. The papacy made consistent efforts, however, to regulate the content of church decorations. The assembly of bishops known as the Council of Trent—called together in 1545 by Emperor Charles V of Austria in the hope of healing the rift between Catholics and Protestants but resulting in the opposite—promulgated in its closing session of 1563 edicts that forbade "any image...suggestive of false doctrine." Later ecclesiastical writers advocated simplicity of representation, the need for accuracy, and the avoidance of any allegory not clearly intelligible. Henceforth, artists were to aim at fostering a better understanding of, and greater intimacy with, the sacred events as they were supposed to have taken place. Although mythological subjects, even erotic ones, were entirely permissible in lay works under the guise of "poetry," there was to be no taint of paganism in religious art, and complete nudity was no longer tolerable in church decoration.

El Greco's work can perhaps be related to the thought of certain leaders of the Counter Reformation. In a world that was reacting against the spirit of free inquiry of the Renaissance, the ecstatic visions of such Spanish mystics as Saint John of the Cross and Saint Theresa of Avila were taken as incontrovertible evidence of the power of faith. It may well be that El Greco had in mind accounts of the visionary experiences of these and other Counter Reformation saints when he evolved his flame-like imagery.

The overall design of late Renaissance Italian churches was considerably affected by the spirit of the Counter Reformation and the general reevaluation of ritual practices that derived from it, while the influence of Michelangelo and Mannerism also had a profound stylistic impact. The church called Il Redentore in Venice (Fig. 10–4) was designed by Andrea di Pietro, called Andrea Palladio (1508–80), one of the most versatile and imaginative artists of the period. It was begun in 1577 and completed in 1592, twelve years after the architect's death.

Unlike Bramante, who strove to preserve a serene simplicity in his use of antique elements (see Fig. 9–11), Palladio showed great delight in the spirited and ingenious manipulation of these elements for decorative purposes. The façade of the church, with its main pedimented portico surmounted by a high attic, is clearly based on the Pantheon (Fig. 3–11). Two pedimented porticoes—one tall and narrow to mark the nave, the other lower and broader to protrude over the aisles—were cleverly integrated to create an exciting design, while at the same time they echo the relationship of interior spaces. The pediment motif, furthermore, recurs in the framework surrounding the door, and there are half-pediments over the buttresses flanking the nave.

The imaginative handling of antique motifs, the complexity of the design, the jewel-like elaborateness and precision of surface details, and the interest in creating elaborate rhythmic patterns on the surface rather than articulating forms in depth all reveal a typical Mannerist attitude. In part it derives from the refined improvisations of Michelangelo's architectural background for the Medici tombs (Fig. 9–15).

The interior of Il Redentore reflects the new requirements of the Counter Reformation. The architects of the Renaissance had favored centrally planned churches (see pp. 124–27), and Palladio himself had stressed the virtues of the circular plan because "every part being equally distant from the center, such a building demonstrates extremely well the unity, the infinite essence, the uniformity, and the justice of God." The clergy felt differently; they considered the central plan to be "pagan" and found it awkward for officiating before large congregations. As a result there was a return to the basilican plan. Saint Peter's was itself extended after Michelangelo's death to give it such a plan. Palladio had submitted both a central type and a basilican design

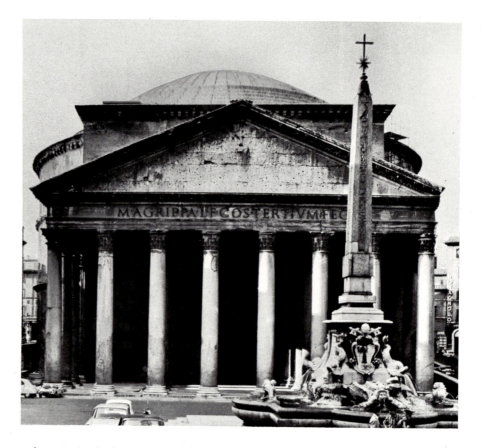

3-11 Pantheon, Rome, started in A.D. 118 and completed between 125 and 128 (*comparative illustration*).

for Il Redentore, and the latter was accepted.

The plan of the church, however, constitutes a compromise attempt to terminate a nave with a centrally designed structure. This structure consists of a spacious crossing extended laterally by shallow, semicircular transept wings (Fig. 10-6), and surmounted by an ample, well-lighted dome. This combination, no less than the plain barrel vault lighted by large semicircular windows, or lunettes, was to have considerable popularity in later years. The division of the aisles into chapels (here connected by narrow passages) also became a common feature.

The modeling of the walls and vault as flowing masses of masonry delimiting the interior space (Fig. 10-5) stems from Michelangelo and heralds Baroque art. The elegant and elaborate gray half-columns and entablature applied against the white walls reveal a Mannerist interest in the elaboration of the surface. There is a touch of Mannerist playfulness, furthermore, in the way in which the colon-

nade at the level of the choir is no longer applied to the wall but becomes a screen detaching itself against the well-lit space of the apse.

For all his Mannerist affinities, Palladio's conscious pursuit of the balance and harmony of antiquity (with the help of an all-embracing system of numerical proportions that he had evolved) and his own serene temperament precluded his indulging in the eccentricities or displaying the uneasiness that characterized the most typically Mannerist architecture.

In the Low Countries, Italian influences permeated the local tradition through much of the sixteenth century and were even responsible for a sophisticated Mannerist school. One major master, however, developed a powerful and independent style; he was Pieter Bruegel the Elder (c. 1525–69), an artist who lived in Flanders (present-day Belgium). His *Parable of the Blind* of 1568 is shown in Figure 10-7.

Bruegel assimilated many of the lessons of the Renaissance. The loose and

rich brushwork in the landscape areas is an elaboration of earlier developments in the Low Countries but is fully in keeping with the Italian trend toward a painterly technique. The landscape, which convincingly depicts a humble Flemish village by a river, can be compared to that of Giorgione's *Sleeping Venus* (Fig. 9-4). There is the same tendency to treat forms in terms of colored masses, but here the brushwork is swifter and more vibrant and suggests quite effectively the textures of grass and foliage, and even the reflections on the water.

The figures are in purer hues than the landscape, and they detach themselves from the background. Both the vigorous modeling of their surfaces and their firm delineation give them a sculptural quality. Paradoxical as it may seem, the chain-like succession of bodies creating a curving diagonal in space is of Italian origin and may have an antecedent in such High Renaissance masterpieces as Raphael's *Parnassus* (Fig. 9-9). Little seems to have remained of the harmonious rhythm and

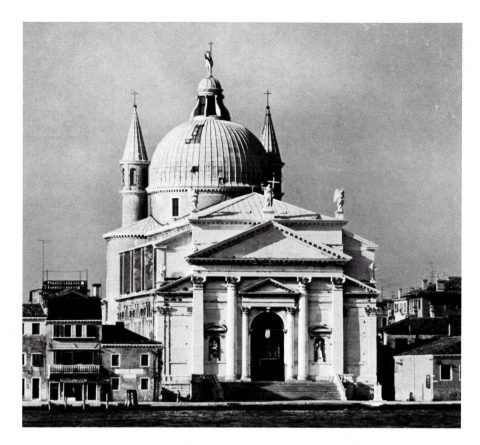

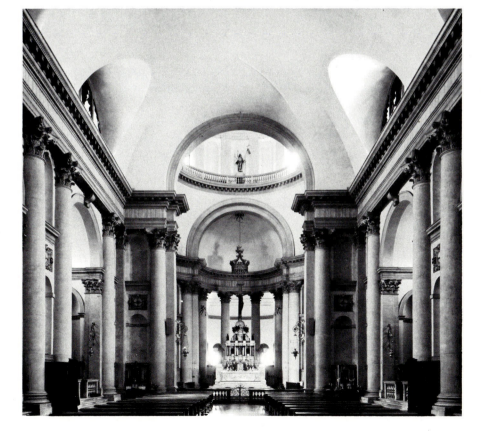

10-4 Andrea Palladio, Il Redentore, Venice, 1577–92.

10-5 Andrea Palladio, interior of Il Redentore

10-6 Andrea Palladio, plan of Il Redentore

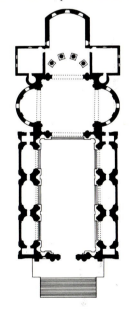

10-7 Pieter Bruegel the Elder, *Parable of the Blind*, 1568. Tempera on canvas (7′2″ × 12′10″). Museo nazionale, Naples.

lofty attitudes and expressions of the Italian master, however. Indeed, there is a willful irregularity in the arrangement of the figures, stressing both the weird predicament of the characters and the physical and psychological tensions it creates.

The subject of most of Bruegel's works is the humble life of common people. In one respect it perpetuates an interest in picturesque peasant lore that can be traced back to the International style. In another respect, it is linked to the tradition of detailed realism that characterized the great fifteenth-century Flemish masters such as van Eyck. In this picture we detect a taste for grotesque figures and absurd subject matter that takes us back even further, to the monstrous fantasies of Medieval art (pp. 68 and 96) and, more specifically, to the drolleries of High and late Gothic manuscripts. As is sometimes the case in the drolleries, moreover, the paintings of Bruegel usually carry a veiled moralizing message, often hinted at by an allusion to a proverb, a passage of the Scriptures,

or even a contemporary text. The subject of this painting comes from the Gospel of Saint Matthew. Having been reproved by the Pharisees because Christ and his disciples "wash not their hands when they eat bread" in the "tradition of the elders" (Matt. 15:2), Christ retorted by calling the Pharisees "blind leaders of the blind. And if the blind lead the blind," he added, "both shall fall into the ditch" (Matt. 15:14).

Stressing lustily realistic detail, Bruegel created a plausible vision of a topsy-turvy world. Indeed, not only did he paint the beggars with painstaking verisimilitude; he also stressed magnificently their wide range of expressions, from the helplessness of the man at the extreme left to the terror of the figures at the right. The scene culminates with the tragicomic notes of the leader sprawling down the bank of the ditch, leaving the others in imminent danger of the same fate.

Several interpretations are possible. The most obvious is that men who, like

the Pharisees, follow tradition blindly are heading for disaster. Bruegel may also have intended to predict a dire fate for those of his contemporaries who were indifferent to the light of God. Finally, he may also have wanted to allegorize man's chronic incapacity to face the problems that beset him. The painting then becomes a poignant fable of the follies of a humanity that had only recently begun to express its faith in itself and its future.

IV

The
Baroque Age

11
The Seventeenth Century in Italy and Spain

The Renaissance witnessed the consolidation of most of the great European states into roughly their present-day geographic configurations and the centralization of power in the hands of their monarchs. In the Baroque age, which spans the seventeenth and eighteenth centuries, this process of centralization led to a very high degree of personal power being exercised in many European countries. At their most successful, Baroque rulers commanded efficient and devoted administrations that controlled most areas of life, from the raising of taxes to conscription into the fighting forces, and from the policing of the lanes of commerce to the management of vast industrial operations. Understandably, they came to see themselves as absolute rulers by the grace of God. The cult of power seems to have permeated all classes of society. The English philosopher Thomas Hobbes found in all men "a perpetual restless desire of power, after power, that ceaseth only in death." The self-confidence and the hedonism

that had characterized the Renaissance rulers developed into a self-importance that often verged on the uninhibited enjoyment of the exercise of power and all that power can bring.

The early Baroque age was deeply affected by the political and moral crises of the late Renaissance. Having failed to unite Catholics and Protestants, the Council of Trent reasserted Catholic dogma, and its attitude, no less than the attitudes of the reformed churches, led to a division of Europe into two camps. Within each camp, moreover, aggressive proselytizers were asserting the superiority of their own faith; among the Catholics the militant Jesuits were evolving a subtle and effective rhetoric to win the hearts of man to orthodoxy, while the Calvinists led Protestant endeavors to put the stricter tenets of the Reformation into practice.

Inevitably, political rulers rallied to one side or the other. The king of Spain and the German emperor (whose true power was by now limited to his Austrian

and eastern European territories) were the chief defenders of Catholicism. In France, Protestantism was tolerated after the wars of religion, which raged through most of the last four decades of the sixteenth century, but was eventually outlawed by the authoritarian Louis XIV in 1685. England was firmly committed to Protestantism and in the 1650s was dominated by the Puritan lord-protector Oliver Cromwell. The Low Countries had been divided after a protracted war of independence against Spain. The northern provinces became virtually free in a truce of 1609 and in 1648 were formally recognized as the Republic of the United Netherlands (also known as the Dutch Republic or the Netherlands), a loose federation of states run by a Protestant oligarchy that united under a single leader only in times of war. The southern provinces known as Flanders retained the Catholic faith and remained under Spanish domination—hence their name, Spanish Netherlands. In Germany, the division between powerful Catholic and Protestant

princes, who were vassals to the emperor in name only, led to the longest and bloodiest of the religious wars—a war in which most European nations became embroiled during the first half of the seventeenth century.

In contrast with the upheavals of the late Renaissance, the Baroque period was characterized by steady economic progress despite its own religious and political turmoil. A new quest for wealth had grown out of the attitudes of the Renaissance. Emulating the leadership of the trading republics of Italy and the Low Countries, Baroque rulers fostered commerce and industry to an unprecedented extent and undertook major colonial ventures to secure trade outposts and, eventually, raw materials. The Netherlands, which had acquired important colonies and had surpassed Spain as a naval power even before the truce of 1609, became Europe's foremost trading nation and for more than five decades were the center of a vigorous and sophisticated cultural life. France first experienced major political and economic difficulties but by mid-century had organized one of the most efficient centralized governments yet known to man. After Louis XIV assumed the reins of power in 1661, that country embarked on an aggressive industrial and commercial expansion that was coupled with a policy of territorial aggrandizement in Europe and the New World that soon assured her precedence over Spain as the most powerful Western nation. Louis' policies pitted him against the Spaniards in the late 1660s and, in the early 1670s,

against the Dutch, whose form of government he abhorred and whose imperialism and mercantilism he justly feared. The grievous blows he dealt the Dutch put an end to their period of spectacular economic growth and, eventually, to their cultural prominence. After a series of early successes, however, Louis spent the remainder of his long life fighting inconclusive wars. His vast expenditure on royal palaces and lavish court life sapped the French economy and jeopardized the financial stability of the nation throughout the eighteenth century. England itself had waged war on the Dutch during Cromwell's regime in the 1650s and the ensuing period of the Restoration of the monarchy, and finally wrested maritime supremacy from them. By the end of the century England was well on the way to building up the empire that turned it into the first colonial power of the eighteenth century and the principal industrial nation of the nineteenth.

All the while, momentous undercurrents were at work against absolutist tendencies. The mercantile aristocracy of the Netherlands provided a splendid example of what an oligarchic republic could achieve. In England, burghers and country squires took advantage of the successive political upheavals of the century to impose constitutional restraints on their monarch. In France, the successors of the despotic Louis XIV, who died in 1715, continued his absolutist policies, but a spirit of unrest arose that was one of the principal causes of the bloody revolution of 1789–95, an event generally ac-

cepted as marking the end of the Baroque age.

As if wearied of the clash of ideologies, men were meanwhile devoting enormous energies and skill to the sciences. Where the Renaissance had distinguished itself through its gifts of observation, Baroque mathematicians and scientists such as Descartes, Boyle, Newton, and Leibnitz made strides in quantitative analysis and in the mathematical formulation of scientific laws. During the seventeenth century, nevertheless, the possible conflict between the rationalist spirit of scientific inquiry and religious dogma did not create intellectual problems. For Descartes, for example, objective studies and scientific reasoning were "neither so strong or so evident as those arguments which lead us to the knowledge of our minds and of God."

It was only in the eighteenth century that the rationalist approach of scientific thought began to sap the theological system inherited from the Middle Ages. Simultaneously, an enterprising middle class, made ever more prosperous and self-confident by a succession of technological advances and rapid industrial and commercial expansion, became increasingly distrustful of the mechanics of absolutist regimes and resentful of the privileges of the Church and the aristocracy. The men who best expressed this attitude were a group of French writers, scientists, and philosophers who became known as the *Philosophes*. Their thought was essentially materialistic, rationalist, experimentalist, and deistic if not atheistic. It

gave birth to numerous, often conflicting, sociopolitical theories from which have sprung the modern social sciences and which did much to bring about the French Revolution.

In contrast with the uncompromising intellectualism of the *Philosophes,* there also arose a new interest in the simplest human values and a new faith in man's innate feelings that has been referred to as the cult of sentiment. The chief apostle of this trend was Jean-Jacques Rousseau, whose most influential works appeared in the 1750s and 1760s. He believed that man was born good and was corrupted by society, and he devoted many beautiful pages in his novels to the sensibilities of supposedly ordinary people. The cult of sentiment, however, had nevertheless been in evidence considerably earlier and affected, in particular, a few great artists during the first half of the eighteenth century.

Baroque art was provocative and persuasive—admirably suited to the proselytizing aims of the age. The rulers of the period spared no money or effort in order to immortalize their more valorous deeds and erect splendid palaces and create urban settings for the whole world to admire. Art was also put at the service of religion, and if the Protestant churches were hostile to sacred art, the Church of Rome made concerted efforts to adorn its places of worship in the most sumptuous manner possible and to use art as a weapon of propaganda.

Despite the all-too-apparent striving for worldly power, the Baroque age re-mained essentially idealistic. Very much like the absolute monarchs who claimed to rule by divine right, the protagonists in Baroque art, as in Baroque drama, seem animated by forces of a higher order, which they themselves sometimes seem hardly to have comprehended. Indeed, in the most characteristic Baroque paintings and sculpture, the figures seem literally linked by their vigororous, rhythmically curved gestures and motions to superior entities dwelling in the distant reaches of space, and the buildings jut out into the surrounding atmosphere as if moulded by invisible forces. For the Baroque artist, the physical world, however convincingly it was represented, was but a transitory manifestation of spiritual truths. Indeed, he took delight in creating ambiguities—sometimes even playful ones—between reality and artifice, between fact and fiction, and, in the actual composition of a work of art, between solids and voids, to make objects more evocative and ideas and emotions more tangible.

The features most usually associated with seventeenth-century Baroque are an exaltation of energy and drama, a love of pomp and even of ostentation, a cultivation of elements of surprise, and a powerful appeal to the senses. The artists favored dramatic light and dark contrasts, sumptuous colors, and an animation suggestive of whirling movements of masses in space. These features are particularly prominent in the so-called High Baroque phase of the second quarter of the century.

There were other trends, however.

The works of the first quarter of the seventeenth century have a sober and vigorous dramatic impact that clearly was a reaction against the over decoration and the cultivated artifice of Mannerist works, and although the century's love of pomp and excitement generally mitigated against sobriety, certain schools, notably in the Netherlands, cultivated a solid realism throughout much of the period. This realism did not in any way conflict with the essential spirituality of the time. By treating a religious scene as a tangible, everyday event, the artist by implication heightened its miraculous nature. When depicting objectively a landscape or a man's face, he revealed his fleeting awareness of the cosmic forces that seem to affect man's environment as well as man's emotional make-up. Indeed, the Baroque artist frequently alluded to moral or spiritual dramas through naturalistic imagery, often stressing spontaneity and directness of vision in order to give greater impact to some religious or philosophical concept.

The High Baroque phase was followed by a search for serenity, order, and clarity that took the form of a conscious return to the classicism of the High Renaissance. (In fact, the term *baroque,* which means irregularly shaped or grotesque, was first used disparagingly toward the end of the Baroque era by proponents of classicism, to condemn the more extreme aspects of the art of the seventeenth and eighteenth centuries.) This classical trend may well mark the height of Baroque theatricality, since it presupposes

10-2 Titian, *Entombment, 1559 (comparative illustration)*.

that the turbulent contest of fate and human passions can be reduced to a solemn and formalized ritual.

Finally, the new interest in the play of human emotions that is characteristic of all phases of Baroque art is an early manifestation of Romanticism. The great lyrical and dramatic landscapes of the seventeenth century that were meant to echo complex moods, portraits that suggest the most subtle individual emotions, and the cult of sentiment that grew in the eighteenth century all led directly to the Romantic revolution.

Baroque art was born in Italy and stems in part from a conscious reaction against, and in part from a development of, Mannerist trends. The *Deposition* reproduced in Figure 11-1 was painted around 1602–03 by Michelangelo Merisi, known as Caravaggio (1573–1610), an artist of Lombard origin who had settled in Rome and who, in the course of his relatively short and turbulent life, provided a major impetus to the development of Baroque art. Other artists had reacted against the excessive serpentine linearity, the arbitrary handling of forms in space, and the search for dazzling surface effects of Mannerism by returning to a more classical restraint. Caravaggio's contribution was to return to a compact grouping of figures and solid modeling of bodies. He went further, however, and gave a new appearance of reality. In the *Deposition,* for instance, the play of muscles and the swelling veins under the skin have been carefully observed, and even the soles of the feet and the toenails have been painted to convey

the impression of being slightly dirty.

Like those in Titian's *Entombment* (Fig. 10-2), Caravaggio's figures stand out against a dark, cavernous space. In the Titian, however, the lighting is diffuse and seems to dissolve the sumptuously colored forms; in the Caravaggio, the lighting is more concentrated and, although the colors remain rich, the vibrant interplay of hues in Titian's work has nevertheless given way to fairly uniform areas shaded in careful gradations of value. Caravaggio's technique is less exciting, but the verisimilitude of figures and objects is greater and the chiaroscuro more dramatic. In keeping with Caravaggio's greater concern with realism, his figures are more firmly defined than Titian's and more solidly poised on the ground. The group in fact appears quite static. Less use has been made of rhythmic distortions to stress pictorial animation; what animation exists is due to the way in which the various masses seem to emerge out of, and penetrate into, the darkness.

As in the compositions of the Renaissance, the grouping of the figures is subordinated to a dominant pattern, but here the pattern is more complex and more fully three-dimensional than anything we have studied so far. In the Titian, for instance, the arrangement of the figures is totally subordinated to a roughly pyramidal construction with an implied apex at the center. In the Caravaggio, a complicated arrangement of curving forms suggests a slanted, irregular pyramid, culminating in the head of Mary Magdalen, which stresses strong receding

diagonal accents from the lower left to the upper right and creates a marked asymmetry. The complexity, the emphasis on receding diagonals, and the lack of symmetry are all characteristically Baroque.

The design is enriched by the pronounced subsidiary patterns. The heads of the two male mourners and the white shroud form an oval configuration surrounding the central part of Christ's body, and the raised arms of Mary Magdalen (reminiscent, incidentally, of the similar figure in the Titian and of Saint John in Giotto's *Lamentation,* Fig. 7-17) suggest the lower end of a vast slanted parabola sweeping around the small group and linking it to the heavens above.

These three-dimensional linear patterns that link figures to one another and to the vastness of space are characteristic of Baroque art. Sometimes they serve an expressive purpose; here, for instance, the circular pattern around Christ helps stress the combination of reverence and intimacy demonstrated by the mourners, while the raised arms of Mary Magdalen suggest personal grief and, at the same time, raised as they are toward the heavens, seem to question providence. In other cases, they suggest movement and tension. They have a vigorous and often graceful rhythmic quality, the principal purpose of which is to stress the structural coherence of the design, both on the surface and in depth. Because such three-dimensional patterns serve to define the direction of the various masses of the composition, much as magnetic lines de-

termine the direction of iron filings near a magnet, it is appropriate to refer to them as *lines of force*.

It is perhaps in his use of light that Caravaggio made his chief expressive contribution. On the one hand, the lighting brings out the pathos of the scene; on the other, it makes the figures shine in the surrounding darkness with near-miraculous intensity. The light-dark contrasts have been handled with a certain arbitrariness in order to bring out the most expressive elements of the composition. The figure of Christ, with its open wound, and its face still marked by the death agonies, is most strongly lighted. The four figures above him seem to catch less light, and the artist skillfully left the eyes and mouths in the shadow, so that we are invited to imagine each individual reaction. The prevailing mood is vividly brought out by the strongly lighted figure of Mary Magdalen, whose upturned face and raised arms summarize the grief of Christ's family and friends. For Caravaggio and his Baroque successors, light was a device for dramatic emphasis and was also equated with divine revelation.

Following the example of Titian, Caravaggio rejected the aloofness of the High Renaissance, but the facial expressions of his *Deposition* are more subdued than those of Titian's *Entombment*. This

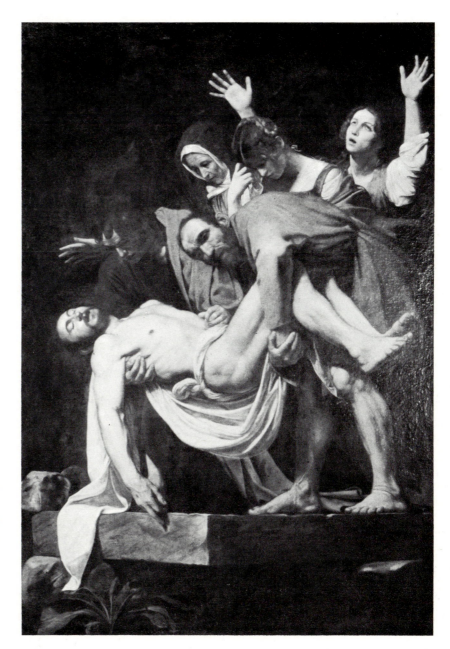

11–1 Caravaggio, *Deposition,* 1602–03. Oil on canvas (9′8″ × 6′7″). Vatican, Rome.

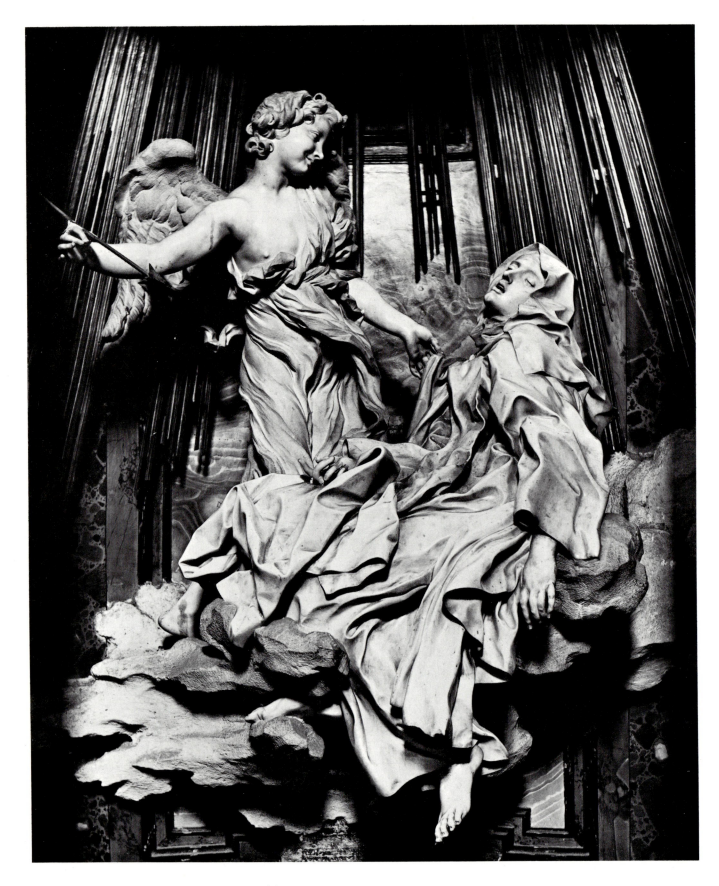

new restraint, together with the realism of the figures, adds to the impact of the picture. We get the impression that the artist has revealed a tangible, momentary vision of the scene in all its original simplicity, and in this way has succeeded in appealing vividly to our senses.

Caravaggio's matter-of-fact presentation, demanding as it does that we relive the dramatic events of the Holy Scriptures, is in keeping with the spirit of the Counter Reformation. Specifically, it seems to reflect the teachings of Saint Ignatius of Loyola, the Spanish founder of the Jesuit order (in 1534) and one of the leading figures of the Counter Reformation, who urged the faithful to look on the events of the lives of Jesus and the saints as essentially human instead of focusing on the ecstatic experiences of mystics. In addition, the artist may have been influenced by the teachings of Saint Philip Neri, a preacher who was active in Rome when Caravaggio arrived there and whose immense popular appeal rested in part on the naturalness, humility, and vividness of his religious teaching.

The transition from early to High Baroque is usually ascribed to the mid-1620s, when a number of artists abandoned the solid surfaces of Caravaggio's style to return to the more vibrant painterly manner of Titian (Fig. 10–2). There were other developments as well, however; some artists chose to cultivate classi-

cal elements, while others stressed a realistic approach.

The *Ecstasy of Saint Theresa* in the Cornaro chapel of Santa Maria della Vittoria in Rome (Fig. 11–2) of 1645–52 is by Gianlorenzo Bernini (1598–1680), the greatest Roman architect and sculptor of the High Baroque era and also a distinguished painter. Paradoxical as it may seem, the surface treatment of this sculpture may be said to be painterly; the extraordinary animation of all the surfaces creates a vivid play of light and dark that in turn imparts a vibrant and ethereal quality to fabrics, flesh, hair, and the angel's feathery wings, much as it suggests the immateriality of the metal light rays and the marble clouds. The device introduces a high degree of illusionism by appearing to merge the solid forms with the surrounding atmosphere.

Although the two figures are white, they are surrounded by multicolored marbles, the rays are of glittering metal, and the background is of yellow alabaster, so that a colorful polyphony adds to the overall richness. Finally, not only is the group placed in an alcove surrounded by a massive marble framework acting as a picture frame, but the statues are illuminated from above by a concealed window, which admits a flood of light to produce what can only be called a scenic effect (Fig. 11–3). Much as Bernini stressed the pictorial elements of the sculptural group, his assistants introduced sculptural elements in the chapel's painted ceiling. The colored plaster clouds are in relief and protrude beyond the surface of the vault.

Like Caravaggio, Bernini based his composition on a system of definite lines of force. The figures in particular are linked by the graceful sequence of the two left arms and by the implied trajectory of the angel's arrow. The body of the saint, moreover, suggests a series of curves spiraling upward and both figures are linked to the luminous, angel-filled sky of the ceiling by the golden rays that surround them.

Like Caravaggio, also, Bernini endeavored to suggest with utmost plausibility the moment of maximum dramatic intensity. According to Saint Theresa herself, an angel "belonging to that order of the celestial hierarchy whose angels seem to burn" transpierced her heart repeatedly with a flaming golden spear. "The pain was so great," she wrote, "that I screamed aloud; but simultaneously I felt such infinite sweetness that I wished the pain to last eternally. It was not bodily but psychical pain, although it affected to a certain extent also the body. It was the sweetest caressing of the soul by God." Accordingly, Bernini showed the angel poised between successive thrusts. He has a gentle smile not devoid of sadness (Fig. 11–2), as if he were aware that together with celestial bliss he brought suffering. The saint is represented in a trance. Her left hand and one bare foot are limp; her half-closed eyes and open mouth have a death-like quality. Her torso, however, is raised as if by some inner force, and her whole figure suggests an immense spiritual energy.

Also in keeping with the ideals of the

11–2 Gianlorenzo Bernini, *Ecstasy of Saint Theresa*, 1645–52. Marble (life-size). Cornaro chapel, Santa Maria della Vittoria, Rome.

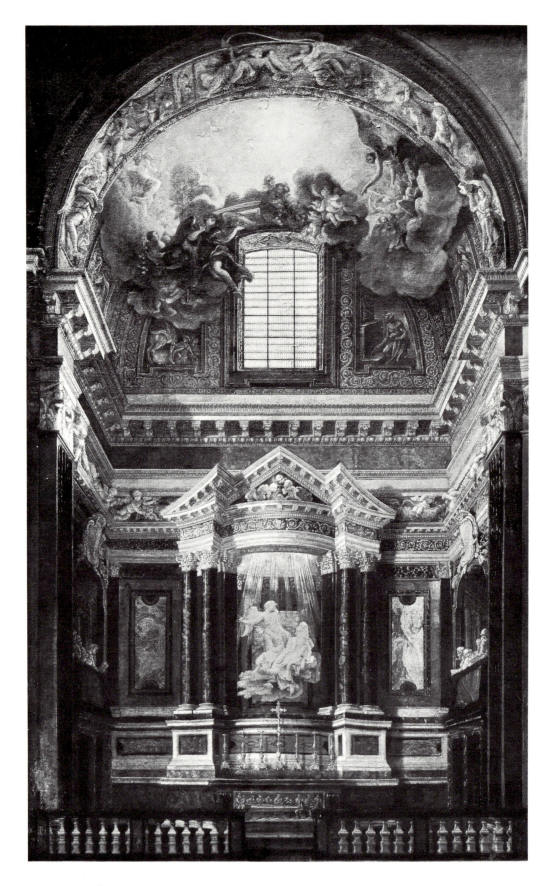

Baroque age is the dazzling play between reality and artifice, between fact and fiction. While the treatment of the figures is undeniably realistic, the painterly handling of the surfaces, no less than the fact that the figures are bathed in a golden glow and rest on a cloud, suggest that we are seeing an apparition. Indeed here, just as in the Caravaggio, light partakes of divine revelation. There is more than an element of artistic whim, moreover, in the treatment of the draperies. The cascading folds of the saint's garment reflect her "being aglow with love," as she expressed it, while the angel's tunic has a flame-like pattern that suggests delightfully that he is one of the angels that "seem to burn." The artist introduced further ambiguity by representing members of the Cornaro family as witnesses to the miraculous event from alcoves on either side of the chapel; he thus equated these stone spectators with the human worshipers in the church (Fig. 11–3).

Some later artists were to use similar willful ambiguities for the sheer amusement and delight of the beholder. There can be no doubt, however, that Bernini made use of all of these devices for one purpose only; by creating a bridge between reality and artifice, he stressed the drama of the physical scene while preserving its miraculous character. The majesty of the design, the monumentality of the marble framework, and the otherworldly radiance created by the light, turn the transitory scene into a permanent expression of the power of religious exultation. Above all, the work was intended to suggest that miraculous events could, and did, take place. The mysteries of the religion could be related to the experiences of everyday life and could be readily understood by the faithful.

Baroque architects were just as enamored of antiquity as were those of the late Renaissance, but their handling of antique elements is characterized by a new dynamism fully in keeping with developments in painting and sculpture. Francesco Borromini (1599–1667), whose church of Sant'Ivo della Sapienza in Rome was begun in 1642 and largely completed by 1650 (Fig. 11–4), is one of the great exponents of the Roman High Baroque in architecture. In contrast to Palladio's Il Redentore (Fig. 10–4), the detailing of the façade of Sant'Ivo is much more restrained; it consists of arched door and window openings accented by arch-and-pilaster decorations in low relief that continue the two-story arcade of the previously existing courtyard. But there is a masterful manipulation of forms in space. The whole façade is curved to make it merge with the courtyard arcade, while a narrow recess on each side marks its separation from that arcade. What is more, the concave sweep of the façade, countered by the convex surface of the drum of the dome, creates a powerful animation. The drum itself is made up of cylindrical segments laid out around a hexagon, suggesting a rhythmic succession of circular accents. The artist also created a rhythmic sequence vertically: the accents of the pilasters of the façade are repeated in the pilasters of the

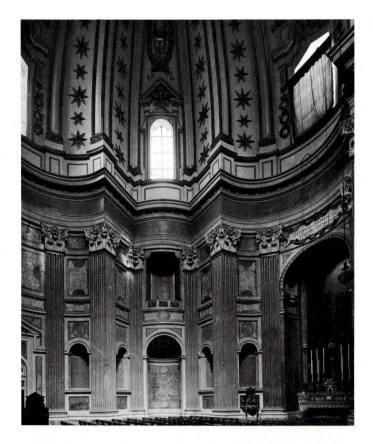

11–5 Francesco Borromini, interior of Sant'Ivo della Sapienza, Rome, 1642–50.

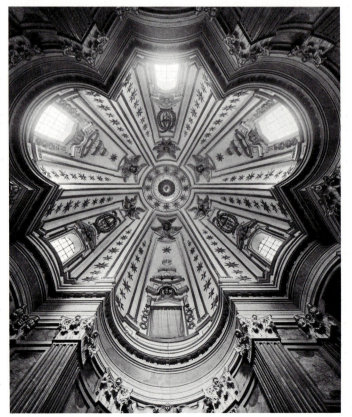

11–6 Francesco Borromini, interior of dome of Sant'Ivo della Sapienza

drum, in the buttress-like ribs rising above it, in the double columns of the lantern, and, finally, in the conical helix of the spire rising toward heaven.

Unlike Gothic builders, Baroque architects did not even pretend to relate the articulation of their buildings to structural considerations. The various rhythmic accents of Sant'Ivo do not seem to be specifically related to the pull of gravity: they suggest, instead, dynamic lines of force curving the façade and connecting it with the existing buildings to either side, while the spiral at the top links it with the sky.

Sant'Ivo, originally intended as a college chapel and comparatively small, was built on the central plan. The treatment of the interior (Fig. 11–5) is characteristic of the vigorous manipulation of masonry so prevalent in High Baroque buildings. The rationale of the alternation of convex, flat, and concave surfaces in the interior of the drum is difficult to interpret at first. The interior plan is, in fact, based on the intersection of an equi-

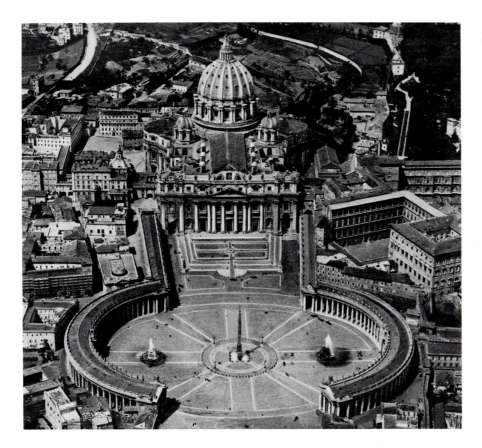

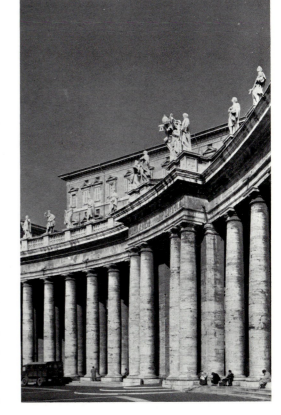

lateral triangle (cut off at the tip) and a *trefoil* (Fig. 11-6), a three-lobed pattern. The effect of initial surprise is thus pleasantly offset by the basic regularity of the design, and it is this sense of order that the architect underlined with considerable subtlety by means of the unobstrusive, classically inspired pilasters and other applied ornaments. The articulation of the walls is carried through vertically to the apex of the dome, which rises over the inner space with as much energy as the outer spiral rises toward the sky. On the inside, just as on the outside, the articulation of masonry and space is determined by the interplay of vigorous lines of force.

The most brilliant example of Roman High Baroque architecture is the colonnade designed by Bernini, and begun in 1656, to create a monumental approach to Saint Peter's (Fig. 11-7). Intended to contain the large crowds that are blessed by the pope at Easter, it had to be huge, and yet it had to be low enough not to dwarf the basilica itself. Bernini conceived the idea of two slightly convergent straight arms followed by curved segments that delimit a vast oval piazza. The immense columns are placed four deep and are surmounted by a balustrade and a row of gigantic statues (Fig. 11-8). The colonnade is not a building in the traditional sense of the word; it is a device to define space. Bernini achieved this aim by resorting to a simple arrangement of masses shaped by clear and vigorous lines of force. As one walks toward the cathedral, the majestic rhythm of the columns, no less than the divergence of the straight portions, seems to prepare one for the magnificence of the building and the sacredness of its relics. The very length of the colonnade seems to link this principal church of Catholicism with the rest of the world. The symbolism was fully intended by Bernini, who compared the circular segments to arms of the Church that "embrace Catholics to reinforce their belief, heretics to reunite them with the Church, and agnostics to enlighten them with the true faith."

The vigor and ingeniousness of Ital-

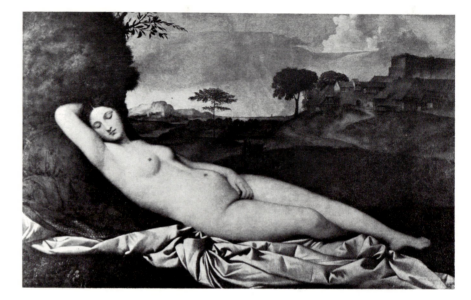

9-4 Giorgione da Castelfranco (completed by Titian), *Sleeping Venus,* c. 1508 (*comparative illustration*).

ian Baroque developments and their relevance to the mood of the times were bound to capture the imagination of artistic communities throughout Western Europe. The most remarkable and original exponent of the new manner in Spain—and the greatest among Spanish painters—was Diego Velázquez (1599–1660). Let us examine his *Venus and Cupid,* also known as the Rokeby Venus (Fig. 11–10), which was executed around 1644–48. As was frequently done by even the greatest Baroque artists, Velázquez drew inspiration for his picture from a rather mediocre earlier work, in this case a print by Philip Galle, an engraver from Antwerp in the Spanish Netherlands, of a now-lost painting by Anthonis Blocklandt, a minor Mannerist artist from the Dutch Republic (Fig 11–9). Beyond this direct source of inspiration are several reclining Venuses by Titian that Velázquez must have admired in Italy as well as in Spain, and Titian himself must have been influenced by the Giorgione *Sleeping Venus* (Fig. 9–4), which he probably completed.

Velázquez skillfully adapted Blocklandt's somewhat precious, contorted, and cramped Mannerist design to the easier, more graceful, flowing, and naturalistic idiom of Baroque art. The forms of his Venus are fuller than those of Blocklandt's, and yet Velázquez created a similar elongation by concealing the edges of certain parts of the body in folds of the drapery. And, instead of the harsh, flayed-looking musculature of the figures in the print, Velázquez suggested a delicate modeling of the flesh through the most subtle play of hues and values. Above all, the composition has been simplified, and one is struck by the graceful curve of the left thigh and hip, which seems to be countered by the sweep of the spine, while the sinuous curve of the whole body is underlined by the folds of the drapery. The bent leg of the Cupid is parallel to the extended leg of Venus, while the rising accent of his body echoes the curvature of her torso and head, suggesting a vast parabola that extends upward on each side of the picture. The

curves and countercurves of the body and drapery and the dominating parabola can all be read as Baroque lines of force that impart a graceful vitality to the composition.

Reflecting the earlier impact of Caravaggio's chiaroscuro (Fig. 11–1), Velázquez made the bodies stand out in high values against the draperies. But he avoided the solid surfaces and firm lines of Caravaggio; his superb painterly technique manifests itself in the softness of the fabrics and in a certain blurring of the edges of the bodies that gives draperies and figures a touch of insubstantiality. Finally, the flesh tones of the body are heightened by contrast with the subdued grays, whites, and browns of the fabrics on the couch and echoed in a higher key in the orange-reds of the drapery in the background. The color composition shows a much greater concern with the soberly and elegantly seductive harmonies typical of Spanish painting than with the perception of everyday reality.

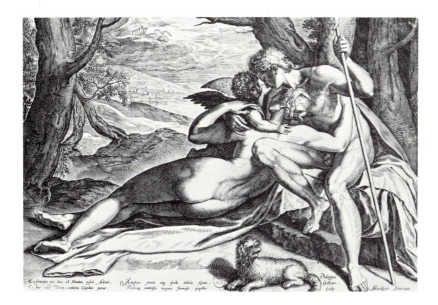

11-9 Philip Galle, after Anthonis Blocklandt, *Venus, Adonis and Cupid,* c. 1590; engraving. Bibliothèque nationale, Paris (*comparative illustration*).

11-10 Diego Velázquez, *Venus and Cupid,* c. 1644–48. Oil on canvas (3′11⅞″ × 5′9¼″). National Gallery, London.

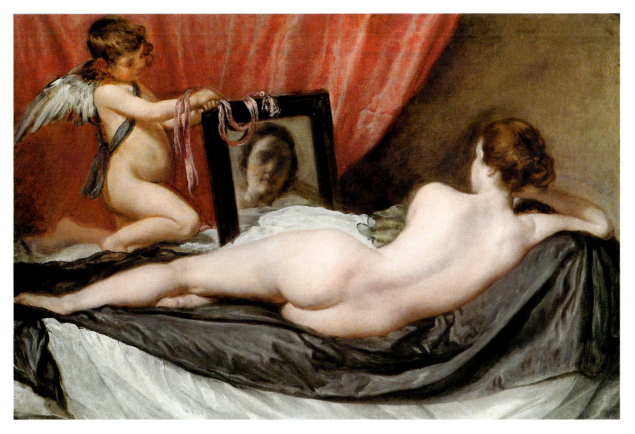

153

The ingenious Baroque device of the mirror is effective both pictorially and expressively. Velázquez did not stress the relationship of the figures with the infinitude of space as much as some of his contemporaries did (Rubens, for example, in *The Rape of the Daughters of Leucippus,* Fig. 12–1). The parabola created by the figures, in particular, has been only mildly emphasized. Instead, by placing the mirror near the center of the design, he opened up a window onto a further space endowed with a near-magical character by the silvery ethereality of the reflection.

Significantly, it is through the figure in the mirror that the artist revealed the more subtle aspects of the painting's message. This becomes evident when we compare it with the Blocklandt picture, in which the goddess Venus, assisted by her son Cupid, is endeavoring to retain the young Adonis, who is more interested in hunting than in the charms of the mature woman. Shortly afterward, according to the myth, Adonis was killed by a fierce wounded boar, and Venus

experienced insuperable grief at his loss.

There is nothing so dramatic or explicit in the Velázquez, but the pink silken ribbons with which, presumably, Cupid binds people in love are hanging loosely over the mirror, unused. And the pensive and wistful expression of the reflection of Venus' face suggests disillusionment with amorous pursuits. Reared in the oppressively devout atmosphere of seventeenth-century Spain, Velázquez apparently could not bring himself to extoll feminine beauty and take delight in the sensuousness of line and color of this quite provocative back without also warning against the price of sensual love.

Originating as it did in Italy, High Baroque art achieved a special degree of pictorial excitement, emotional intensity, and monumentality there. Spain, which had very close ties with Italy at that time, was affected by similar developments, restrained on occasion by the innate delicacy of such men as Velázquez. In both countries spectacular artistic enterprises were intended to add to the

prestige of the Catholic Church and of the ruling monarchs. We can refer to these developments as the "grand manner."

The art of Italy had a profound impact on that of the Low Countries and France, and eventually of the rest of Europe. The realistic tendencies and dramatic chiaroscuro of Caravaggio were emulated by numerous artists who attempted to introduce a new sense of immediacy in religious art or, conversely, a new sense of drama in scenes based on everyday life. They greatly strengthened the tendency toward realism in the North, and more particularly in the Protestant countries. The High Baroque grand manner had its impact there too, particularly affecting the court tradition of Flanders, where it was to blossom in the art of Rubens, and finally leading to the classically oriented Baroque art of France, culminating in the achievements of Poussin.

12

The Seventeenth Century in the Low Countries and France

The political division of the Low Countries into the Spanish Netherlands and the Dutch Republic led to two distinct artistic traditions. The former (whose principal province was Flanders, hence the designation *Flemish*) strongly upheld Catholicism and was much affected by the courtly life that centered around the regents appointed by the king of Spain. Its principal artistic luminary was Peter Paul Rubens (1577–1640), who, besides being a painter of genius, was a humanist of considerable distinction. He was also a diplomat renowned for his tact and personal charm and was entrusted with several sensitive missions to various European courts.

At the time Rubens was learning his trade, the principal trends in Flanders were a complicated Mannerism and a somewhat dry classicism, occasionally enlivened by memories of Bruegel. Rubens' own vigorous and sensitive personality began to manifest itself fully in the course of a stay of several years in Italy. He was profoundly impressed by Michelangelo

but studied Raphael, Titian, Leonardo, and other Renaissance masters as well. He also took notice of Caravaggio, who was his senior by only a few years.

The Rape of the Daughters of Leucippus (Fig. 12-1) was painted about 1618, after Rubens returned to Flanders, where he settled in his family's native city, Antwerp. In one way the picture still belongs to the early Baroque; the figures and horses form a compact, relief-like arrangement not unlike that of Caravaggio's *Deposition* (Fig. 11-1). (The work may in fact stem from a round antique relief.) Rubens adopted a painterly manner that is closer to the vibrancy of execution of such Flemish masters as Bruegel and that reflects an excitingly fluent adaption of Titian's technique. He rejected Caravaggio's strong chiaroscuro and stressed light, blond tonalities throughout much of the surface. There are golden yellows and reds for the silken draperies and delicate gradations of blue, blue-green, green, and yellow for the sky and the hilly landscape. The result is a remarkable fluidity

of masses and sumptuous coloristic effects that clearly point to High Baroque trends. The powerful, muscular bodies bring to mind Michelangelo's figures, but there is a new stress on the soft, rather fatty tissues of the flesh of these well-fed ladies that is in the tradition of Bruegel's lusty realism.

Like Caravaggio's *Deposition,* the composition is dominated by lines of force creating powerful three-dimensional patterns and linking the figures to one another and to the infinitude of space. Rubens also utilized these lines of force with incomparable skill to stress both the physical animation and the dramatic content of the scene. The reactions of both women are suggested by what Leonardo would have called "spiritual movement." The lower sister seems to lunge to the right, turning her head upward as if imploring mercy; her desire to escape her abductor is expressed by the semicircular sweep of her body and left arm and by the rhythmic undulations of her musculature. Her sister similarly stretches her left

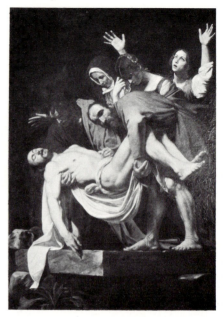

arm toward the distant heavens, as if groping for celestial assistance, but her body, belonging as it does to the same orbit as the head and arms of her abductor, already hints at future compliance. The determination of the men, on the other hand, finds expression in the upward and inward pull they are exerting on the women, which is reflected in the pyramidal organization of the group and is finally echoed and amplified in the vertical thrust of the rearing horse.

The subject matter presents something of a riddle. The first thing we must assume is that the devoutly Catholic and gentlemanly Rubens did not intend to idealize rape. The two horsemen are Castor and Pollux (the sons of Leda, incidentally; see p. 117), the heroes of antique mythology who, in at least one version of this legend, abducted the daughters of Leucippus but, being honorable young men, married them and lived happily ever after.

Rubens' treatment of the subject seems to confirm this interpretation. The robust and sensuous corporeality of the youthful figures, no less than the barely suggested compliance of one of the women, holds the promise of rewarding unions. Furthermore, two little Cupids, sent perhaps by the gods in answer to the women's pleas, are shown reining in the fiery horses, which are traditionally associated with unbridled passions; love will obviously dominate the baser instincts and bring humanity and understanding to the relationships. Finally, the design itself, resolving opposing elements as it does into a graceful overall pattern, suggests that the physical conflict will end in harmony.

The treatment of the subject is allegorical, for Rubens made use of a well-known story from the past to express a philosophical thought. The main motif is clearly the triumph of love but, more specifically, Rubens seems to have wanted to idealize the instant when the male asserts his masculinity and conquers the woman's heart. Beyond the purely human aspects of the scene, it is likely that he

also intended us to reflect on the fact that the women are being abducted by demigods, who thus represent the working of divine love by which mortals are deified. The analogy with Bernini's *Ecstasy of Saint Theresa* (Fig. 11–2) cannot be overlooked. The interest in the contest between individuals, coupled with the fact that the conflict seems controlled from the heavens, is an instance of the play between human passions and destiny that is so characteristically Baroque. The dynamism and monumentality of the composition and the powerful appeal to the senses help stress both the idealism of the allegory and the humanity of the drama.

Side by side with Rubens' grand manner, a number of Flemish artists devoted themselves to the depiction of everyday life (known as *genre* painting) and more specifically to scenes of low life. In this they were much closer to the spirit of an earthy middle-class culture, and were indeed continuing the tradition of Bruegel's peasant scenes. The major artist working in this vein was a young man much ad-

12–1 Peter Paul Rubens, *The Rape of the Daughters of Leucippus*, c. 1618.
Oil on canvas (7'3¾" × 6'10¼"). Alte Pinakothek, Munich.

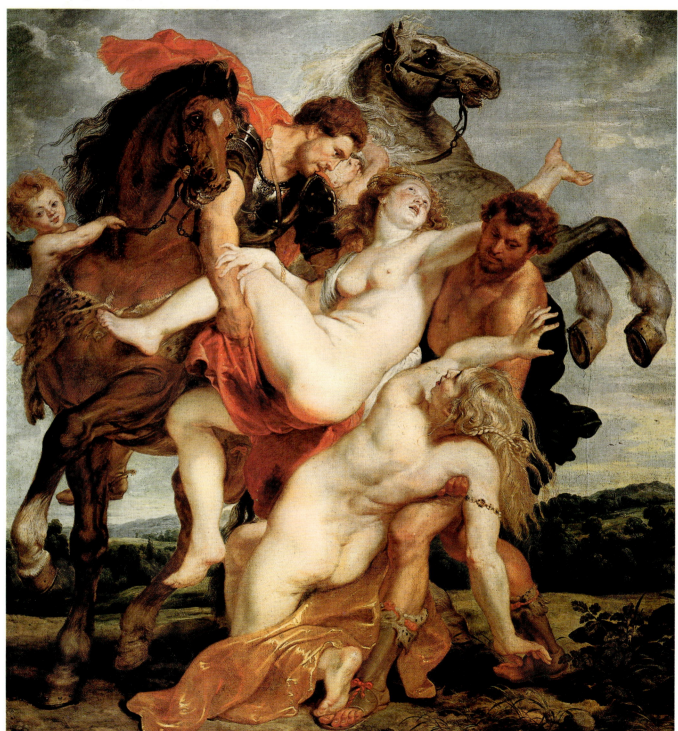

10-7 *This page:* Pieter Bruegel the Elder, *Parable of the Blind*, 1568 (*comparative illustration*).

12-2 *Opposite page:* Adriaen Brouwer, *The Smokers*, 1636-37. Oil on wood ($17^{15}/_{16}'' \times 14^{1}/_{4}''$). Metropolitan Museum of Art, New York, Michael Friedsam Collection.

dicted to drinking, smoking, and other such pleasures, Adriaen Brouwer (c. 1605–38). His *Smokers* of 1636–37 (Fig. 12-2) is one of the masterpieces of northern Baroque realism.

Brouwer's warm tonalities, interest in low-life subjects, and enthusiastic rendering of even the lowliest details bring Bruegel (Fig. 10-7) to mind. Brouwer, however, went even further than Bruegel in his vibrant use of the brush. In a manner that is both richly painterly and remarkably convincing, he rendered clothes, hair, skin surfaces, the subtly shaded plain walls of the room, and even a dirty rag, a crumpled piece of paper on the floor, the glossy surface of a pot, and the very smoke in the atmosphere. His virtuosity, incidentally, impressed Rubens and Rembrandt, among others, who both owned his works.

There is a greater restraint in Brouwer's palette than in Bruegel's, but he managed to achieve an extraordinary animation through very subtle variations of hues and values in his successive brushstrokes and by an occasional use of purer hues, as in the red trim of the suit of the principal figure—Brouwer himself, incidentally—and the contrasting cool areas of the shadows on his suit and the blue coat of his neighbor.

The composition seems to be entirely spontaneous and thus stresses the casualness of the scene, yet there is evidence of the most subtle planning. The artist's own figure, slightly turned with respect to the picture plane and leaning back, creates powerful diagonal accents. With the leaning broom at the left and the vertical door at the right, it forms a fan-like pattern. The figures of the artist's companions, moreover, form a sweeping human wall around him. Both the animation of this arrangement and the fact that the door opens onto a winding road that links the figures with the far distance are essentially Baroque.

Unlike Bruegel, whose parable had a powerful impact, Brouwer was not so much interested in telling a story or preaching a sermon as he was in expressing the sensuous delight with which he perceived his familiar world. And yet there is a message; the aura of conviviality that surrounds the motley group seems to stress a humanity that transcends middle-class conventions. Brouwer stressed the point further by aping the shocked indignation of a hypothetical onlooker while arrogantly blowing smoke in the intruder's face. This latter device, incidentally, elicits the amused attention of the observer and is, in its element of surprise, as Baroque as the artist's swagger.

The political, social, and religious climate of the Dutch Republic was different from that of the Spanish provinces to the south. Although it had almost as many Catholics as Protestants and tolerated the practice of Catholicism, the Republic was nevertheless officially Protestant, and as a result there was little call for religious art. The ruling classes, furthermore, were proud of their bourgeois status and, until the middle of the century, affected to despise the pomp associated with court life. Dutch paintings tended therefore to be small in size to fit the compact Dutch interiors and appeared sober and restrained in comparison with the more sumptuous courtly paintings of Flanders. Subjects from classical mythology were less frequent than in areas that had been affected earlier by humanistic currents, at least until the middle of the seventeenth century. In keeping with the taste for objectivity of a nation of traders, realistically rendered still lifes, landscapes, genre paintings, interior scenes, and portraits were most sought after by art collectors. Artists and patrons alike, furthermore, admired a technical virtuosity that led to an almost palpable verisimilitude.

Having mentioned these general rules, one must hasten to add that the greatest Dutch artist, Rembrandt van Rijn (1606–69), broke every one of them. He often painted huge canvases, was extremely sensitive to the human implications of religious subjects, found mythological themes challenging, and achieved an unsurpassed splendor in the very handling of his medium; if he made use of naturalistic devices it was usually with an eye to achieving a greater spirituality. His astonishing technical prowess, the vitality of his style, and his exuberant handling of the High Baroque idiom assured him of a solid popularity, first in his native Leiden, then in the capital city of Amsterdam, until the middle of the 1640s. At that time a gradual change in his manner took place. His pictures became increasingly dominated by a reflective mood, and as if to bring out man's innermost thoughts and emotions he began to favor

12-3 Rembrandt van Rijn, *Bathsheba,* 1654. Oil on canvas (55″ × 55″). Louvre, Paris.

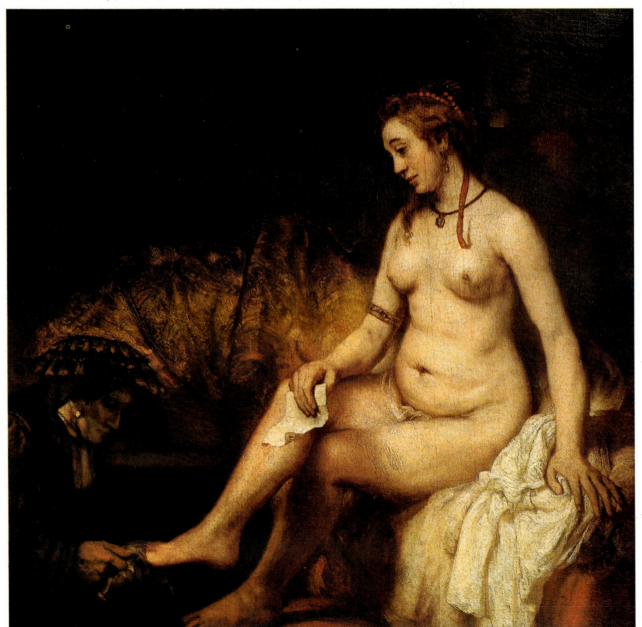

a new looseness of execution and somewhat disembodied forms emerging softly from a tinted half-light. This ran counter to the taste of his compatriots, and Rembrandt lost popularity, ending his days in comparative poverty and neglect.

His *Bathsheba* of 1654 (Fig. 12–3) is a splendid example of Rembrandt's mature style. The story is drawn from the Bible. Having risen from his bed to stroll on his palace roof, King David "saw a woman washing herself; and the woman was very beautiful to look upon." The king had messengers bring her to his palace, "and she came in unto him, and he lay with her....And the woman conceived" (II Sam. 11:2, 4–5). David's behavior is cast in an even less favorable light when we learn that Bathsheba was the wife of one of his officers and that he ordered the husband sent out into battle so that "he may be smitten, and die" (II Sam. 11:15), which duly happened. David married Bathsheba, who bore him a son, but God was displeased and as a result their child died. David, however, "comforted Bathsheba his wife, and went in unto her, and lay with her: and she bare a son, and he called his name Solomon: and the Lord loved him" (II Sam. 12:24). As in the case of *The Rape of the Daughters of Leucippus* (Fig. 12–1), a love story that began with a despicable act has a happy ending.

Rembrandt chose to depict Bathsheba after she has received the message from the king, lost in meditation as an attendant completes her toilet. There are still Baroque elements in the composition, and they have been used with consummate skill, but they are subdued; the inclination of Bathsheba's torso with respect to the picture plane links the figural group with the depth of the dark space beyond, while the edges of her body create a magnificent cascading rhythm leading us to the dark form of the attendant in the lower left corner. More than anything else, it is the technique that is Baroque. The painterly treatment of the drapery in the background suggests excitingly and convincingly some sumptuous brocade. Even more strikingly, although she is no longer very young nor very beautiful, Bathsheba's soft flesh is handled in a lively and seductive way by means of the play of subdued light and transparent shadows.

Rather than stressing the verisimilitude of external appearances as had so many of his fellow Dutch artists, or the height of physical action as had Rubens, Rembrandt evoked Bathsheba's state of mind before the unfurling of the drama. If she at first responded to David's message with indignation, or even surprise, no trace of this remains. One senses more than a touch of feminine pride in her bearing and sadness in her eyes and mouth. She seems to have given in to some instinct that has urged her to accept the inevitable and trust herself to God. Rembrandt made use of his extraordinary technical skills to heighten his expressive intent; the subtle chiaroscuro envelops the figure in a soft warm glow that contributes to the effect of intimacy, while the partly dematerialized forms suggest that nothing is real aside from the experience of man's inner moods and responses.

The fact that the human drama is sparked and controlled by forces beyond man's comprehension is still very much in the Baroque tradition; but the way in which the artist concentrated so insistently on the unraveling of human emotions, and succeeded in establishing such a degree of intimacy with the subject, makes Rembrandt one of the great early forces behind the Romantic revolution. Indeed, after a period of neglect of over a hundred years he was to have a profound influence on artists of the nineteenth century.

Paradoxical as it may seem, we sense the same concern for man's inner life in the greatest Dutch landscape paintings. Let us compare Rembrandt's grandiose *Mill* (Fig. 12–4), executed in the early 1650s, with the superb *View of Delft* (Fig. 12–5) of about 1660 by his compatriot Jan Vermeer (1632–75).

Vermeer's composition respects the usual rules of Dutch landscape painting. The horizon line is placed at one-third of the height of the picture. Because of the flatness of the landscape, the artist could not draw the eye of the observer to the horizon by means of a succession of diagonal ridges, as Giorgione had done in the *Sleeping Venus* (Fig. 9–4); instead he took advantage of the gentle curvature of the channel to lead our attention gradually to the middle distance. Beyond that, the variously lighted steeples, towers, and chimneys suggest the expanse of the city and draw the eye further to the clouded sky. Vermeer also employed aerial perspec-

12–4 Rembrandt van Rijn, *The Mill,* early 1650s. Oil on canvas (36½″ × 41½″). National Gallery of Art, Washington, D.C., Widener Collection.

tive, stressing warm hues in the foreground and cooler hues in the distance and, aware that vast, faraway expanses appear to reflect more light than objects in the foreground, he heightened the value of distant areas of the city.

The sky, which occupies two-thirds of the picture, is the most obviously Baroque part of the painting, for the individual clouds suggest, if only vaguely, sequences of majestic rhythmic curves in space. It too, incidentally, is lighter in the distance than in the areas directly overhead and draws our attention toward the horizon.

Unlike some of his contemporaries, Vermeer avoided depicting with microscopic accuracy such details as the ships' timbers and the stones, bricks, and tiles of the buildings. Instead, he treated all the objects by means of a most painterly combination of subtle striations and tiny bright spots that evoke rather than describe the details of their surfaces and suggest the surrounding atmosphere by their vibrancy. In this Vermeer followed

a trend set by some of his Dutch predecessors, who understood that the eye can perceive only a limited number of details at any one time and that attempts to be overly detailed detract from the overall optical truthfulness of a scene. Indeed, we must distinguish at this point between the search for obvious verisimilitude, which we may call *realism,* and the search for a convincing overall visual impression, which we may call *naturalism.* Artists like Vermeer were clearly evolving from realism to naturalism.

In one respect Vermeer's technique is uniquely Baroque. It has recently been proved that he used a device known as a *camera obscura* in painting his pictures. This device consists of lenses, and sometimes a mirror as well, that project a clearly focused image on the far side of a dark box or dark room (this farther side may be, for the sake of convenience, a translucent paper, ground glass, or, in the case of a room, a white wall). The primary purpose of the camera obscura is to achieve an accurate perspective rendering

of a scene. Vermeer, however, saw other possibilities in it. The unique pearly quality of his tonalities may be due to the fact that his images were projected on a silvery wall or a ground glass. The occurrence of tiny bright spots and a certain blurring of the edges, furthermore, were certainly willful exaggeration of highlights created by the optical imperfections of the device. The result was a subtle, rich, and delightfully animated surface that is as Baroque as the artifice of seeing nature through a camera. (Both the name and the basic principle of the modern photographic apparatus, incidentally, are derived from the camera obscura.)

Vermeer spared no effort to suggest the instantaneousness of his vision. The apparently random placement of the figures, the shimmering reflections on the water, the animation of the clouds, and even the vitality of the sweeping lines of the channel indicate that he tried to convey a constant state of flux and merely singled out a particular instant when water, city, and sky appeared particularly

12-5 Jan Vermeer, *View of Delft,* c. 1660. Oil on canvas (38½″ × 46″). Mauritshuis, The Hague.

majestic and serene. As always in Baroque art, by concentrating on a single instant the artist revealed an awareness of the momentous forces that affect nature and man. In the case of Vermeer, his pictures give us a uniquely lyrical intimation of a superior reality.

Rembrandt, in his *Mill,* chose a moment at dusk when the dark masses of the landscape stand out against the residual soft glow of the sun, which has already set beyond distant hills. He sought principally, therefore, a play of value; there are varied golden tonalities in the sky and in the reflections on the water and dark browns in most of the other areas. The ground areas are primarily in somber earth colors, but Rembrandt is always a colorist at heart, and we find occasional strokes of more vivid colors: yellows and reds for the bare ground and olive greens for the vegetation, which provide a few sumptuous notes. Only the areas that are most strongly lighted are depicted precisely. The windmill, for instance, stands in clear outline against the

sky. The darker areas are rendered with remarkable painterly freedom; out of an apparently haphazard play of heavy brushstrokes and occasional glazes, a few highlights suggest individual forms in the darkening atmosphere.

The objects that are most clearly defined are also the most tranquil. The arms of the windmill have obviously come to a stop. A washerwoman by the edge of the river is the cause of a few leisurely concentric ripples in the water, and a rowboat glides peacefully to shore. In contrast, there are hints of activity and even turmoil in the darker and less visible areas, which Rembrandt has deliberately emphasized. The stormy clouds to the left, for instance, are quite ominous, and the diagonal climbing path at the foot of the hill leads to the darkest and most nebulous region of the landscape. The bend of the river itself draws our attention to the invisible valley beyond the mound. All these elements suggest that the life and drama of nature extend beyond what is immediately perceptible, and

they are thus clearly intended to challenge the imagination of the onlooker.

The stress on dark and indistinct areas may be considered as yet another Baroque device for creating ambiguities between reality and artifice, between fact and fiction; it contributes to the contrast between the fleeting peace of an instant and the timeless drama of nature and, ultimately, of man's own soul. But the use of these devices went beyond the scope of Baroque art. The obscurity and nebulousness that challenge our imagination, the juxtaposition of fleeting stillness and permanent turmoil, and the parallel between nature's and man's moods were all to become dominant aspects of nineteenth-century Romanticism.

Rembrandt was unquestionably the greatest portraitist of his time, and by comparing his *Self-Portrait* of 1669 (Fig. 12-6) with Dürer's drawing of Barbara Dürer (Fig. 9-3) we may get an idea of the remarkable awareness of the dignity, the self-reliance, and also the burden of responsibility of the individual that char-

9-3 *This page:* Albrecht Dürer, *Barbara Dürer,* 1514 *(comparative illustration).*

12-6 *Opposite page:* Rembrandt van Rijn, *Self-Portrait,* 1669. Oil on canvas (32″ × 27¼″). National Gallery, London.

acterized the age. In the Rembrandt, all tendency for the linear design to adhere to the pictorial surface has disappeared. The forms are softly rounded in the luminescent atmosphere, creating a vaguely pyramidal structure. Although the composition appears simple and the colors restrained, there is a characteristic Baroque sumptuousness in the striations created by the red fabric and dark shadows and in the play of the golden light on the surface, occasionally heightened by the reflection of the gold trim of the coat. There is also a subtle sense of Baroque excitement in the interplay of hues on the surface of the flesh; yellows, pinks, blues, greens, and white highlights seem to emerge from the skin colors, contributing to modeling and texture and creating a restrained surface richness.

There is nothing here of the fixity of Barbara Dürer's stare. Rembrandt showed himself as he might have appeared to us in his studio at the age of sixty-three, the year, as it happened, in which he was to die. The quiet, self-possessed, leisurely attitude, no less than the restrained richness of the attire, suggests maturity and inner peace. Upon close inspection of the features one gets remarkable psychological insights. The weary eyes are sharply focused and penetrating. They express a remarkable combination of worldly wisdom and fortitude. The slightly pouting mouth hints at a certain bitterness, even cynicism, acquired over years of struggle and disappointments. And the unusually large nose and puffy cheeks have been revealed with candor, as if to express the artist's calm acceptance of his physical imperfections and the effects of old age. The overall impression is one of immense serenity and inner richness; the discreet splendor of the composition and mild glow of the lighting more than offset the imperfections of the features, while the forcefulness and dignity of the expression transcend the implications of human shortcomings. With remarkable frankness the artist explored a human personality and presented it to us as if he had caught the figure at a specific moment; but, in keeping with the Baroque tradition, this awareness of an instant suggests the continuing drama of man and fate.

At this point it may be appropriate to reflect on the contributions of the leading artists of the Protestant countries. It would be misleading to say that they ignored religious subjects; Rembrandt himself was one of the greatest painters of Old and New Testament scenes. Furthermore, his landscapes and portraits are infused with a spiritual quality that ranks in intensity with, say, the religious fervor of a Caravaggio. Even the peaceful scenes of Vermeer, as we have seen, seem to transcend direct impressions and are infused with intimations of a superior reality.

Beyond the new directness and immediacy in their depiction of everyday life, northern Baroque artists achieved a remarkable sense of drama in their suggestion of spiritual truths. Better than anyone else they were able to evoke the contest of man and fate and also assert the essential dignity of the individual. In

9-9 *This page:* Raphael, *Parnassus,* 1510–11 (*comparative illustration*).

12-7 *Opposite page:* Nicolas Poussin, *Eliezer and Rebecca,* 1648. Oil on canvas (45⅛″ × 30¾″). Louvre, Paris.

this respect they are the chief exponents of the new concern with man's inner life that characterizes the Reformation.

The seventeenth-century artist who most actively upheld the classical ideals of the High Renaissance was Nicolas Poussin (c. 1593–1665), a Frenchman who spent a major part of his life in Rome. He started out in an Italianate Mannerist vein that was popular in France in the first decades of the century, but he soon fell under the spell of the great Renaissance masters and also immersed himself in the study of antiquity, all the while being subjected to the influence of Roman Baroque art.

Poussin's *Eliezer and Rebecca* of 1648 (Fig. 12–7) is yet another variant on the Baroque theme of love and fate. The story is drawn from the Bible. Determined that his son Isaac should not marry a local woman, the aging Abraham sent his servant Eliezer to Abraham's homeland in Mesopotamia, to bring back a suitable bride. Having arrived there, Eliezer stood by a well and said "O Lord God of my

master Abraham...the damsel to whom I shall say, Let down thy pitcher, I pray thee, that I may drink; and she shall say, Drink, and I will give thy camels drinks also: let the same be she that thou has appointed for thy servant Isaac" (Gen. 24:12, 14). Almost instantly Rebecca appeared, and the ensuing dialogue satisfied the servant that she was the chosen one. Poussin selected the moment when Eliezer has offered her an earring and two bracelets—as tokens of his master's intentions—and is asking to be taken to her father's home.

The work reveals many classical elements: the polished execution, the firmness of the modeling of the figures, their precise delineation and careful proportioning, the smooth and precise rendering of flesh and draperies, the graceful restraint of attitudes and gestures, the loftiness of the expressions, and the frieze-like arrangement of the figures in the foreground. It even brings to mind such antique examples as the sacrificial procession from the imperial Roman altar (Fig.

3–6). But the purity of line and the grace of the design of certain figures, such as the kneeling woman to the left, reveal the influence of Raphael, and it may well be from such compositions as Raphael's *Parnassus* (Fig. 9–9) that Poussin derived the loosely rhythmic sequence of the group of figures receding to the right. The group to the left, on the other hand, with its complex interrelation of limbs, its sweeping curves, and its pyramidal configuration, is more typically Baroque, as is the lack of symmetry between the two groups. The overall effect, however, is still one of restraint and harmony, in keeping with the ideals of the High Renaissance.

The colors are more intense than in Raphael's work, and the artist further heightened the effect of individual colors by painting almost all the garments in pairs of contrasting hues. Set off, as they are, against the neutral tones of the ground and the architectural elements, these areas of color introduce a touch of Baroque splendor.

Poussin apparently took infinite pains

in composing his pictures, first reading carefully all the texts he could find on the subject, then making elaborate sketches, and even modeling wax figurines, which he dressed elaborately in linen draperies and set out as if on a stage. Occasionally he would look at real figures, but the paintings were executed entirely from the figurines. Facial expressions and psychologically revealing gestures and attitudes were the outcome of endless reflection, and he clearly intended these to be carefully "read" by the onlooker. This approach had two results. In the first place, however animated the figures were intended to be, they sometimes appeared as frozen as statues. Rarely do we find in Poussin's work powerful rhythmic thrusts expressing "spiritual movements" such as we have observed in Leonardo and the later Renaissance and Baroque masters. In the second place, the facial expressions and gestures are so clearly defined that little is left to the imagination. Perhaps for that reason, in the more dramatic works the most violent expressions tend

to be strained and unconvincing. On the other hand, in works such as *Eliezer and Rebecca,* in which the action is subdued and the mood gently lyrical, individual expressions are varied and convincing. There is something very eloquent in the attitude of the servant, offering the jewel in his right hand. Rebecca's attitude and features convey a girlish reticence and barely concealed delight. And a whole range of expressions, from idle curiosity and surprise to cynicism and a touch of envy, are seen in the other women. Finally, the grouping of the figures has expressive connotations; the arrangement of the figures on Eliezer's side is much more animated than that of the figures behind Rebecca, as if to contrast male and female principles.

Several other compositional elements help convey the emotional message of the work. Although the figures are located in a stage space, they are linked with the receding landscape through two skillfully used devices. The semigeometric forms of the vases in the foreground are echoed

in the geometric architectural elements behind the figures and the various buildings that lead into the distance. And there is a subtle gradation of lighting, from the moderately strong chiaroscuro on the figures themselves to the pearly illumination of the buildings in the middle distance, to the luminescent haze in the far distance, and finally to the silvery glimmer of the stylized cloud formations. The artist thus linked the figures to a magically still, orderly, and majestic landscape. He also established a parallel between Rebecca's acquiescence to the wishes of the stranger and her premonition of future happiness, on the one hand, and the lyrical mood of nature, on the other. For all the classical restraint of the composition and the sedateness of the figures, Poussin was relating a miraculous occurrence. In typical Baroque fashion, he intimated that men are controlled by intangible forces. Shunning the dramatic effects of so many of his contemporaries, however, he suggested divine intervention as benign and orderly and stressed the por-

12-8 Attributed to Raphael, Palazzo Vidoni Caffarelli, Rome, c. 1515–20 (*comparative illustration*).

tentous aspects of the scene through the harmony of forms, color, and light.

Poussin's gradual shift toward classicism reflected developments taking place in France. Beginning in the second quarter of the seventeenth century, a strong nationalistic current led to a disenchantment with Italian fashions, the more extreme aspects of the Baroque being among them, while an ever growing enthusiasm for humanistic education fostered among the upper and middle classes a new admiration for the rationalism, restraint, and even Stoicism of some of the greatest ancient Roman authors.

These trends must have played a considerable part in inducing young Louis XIV in the middle 1660s to foster the development of a style that, if it remained sumptuously ornate, was nevertheless more concerned with geometric order and altogether closer to classical precedents than the High Baroque. A group of royal architects and designers elaborated the new idiom, which became mandatory for every official commission in Paris and the provinces. Because the style was adopted by the new French Academy of Fine Arts, it was systematically taught to younger architects and artists and eventually spread throughout most of Europe.

The most spectacular example of the style is the palace of Versailles near Paris, erected by Louis XIV around an existing hunting lodge as his principal residence. The original project, executed by Louis le Vau (1612–70), was afterward much altered, but we can get an idea of what it was like from a print of 1669 (Fig.

12-9) while the details can be studied from the picture of the present building's garden façade (Fig. 12-10), which was completed between 1678 and 1685 by Jules Hardouin Mansart (1646–1708).

The le Vau building owes a good deal to High Renaissance Italy. Indeed, the principle followed for the horizontal division of the façade stems directly from such Roman town palaces as the Palazzo Vidoni Caffarelli (Fig. 12-8) of about 1515–20 (subsequently somewhat altered, particularly by the addition of the top story), attributed to Raphael, who was himself strongly influenced by Bramante. At Versailles, as in the Palazzo Vidoni, the lower story is *rusticated* (made of blocks separated by deep grooves at the edges), and it has arched openings; similarly, the second story is taller than the first, is decorated with columns, and has a substantial cornice. The practice of topping the building with a low attic is also Italian, while the surmounting of the balustrade by urns and trophies may well have derived from those over the colonnade of Saint Peter's piazza (Fig. 11-8).

Italian town palaces are, essentially, a rectangular block with an interior court. At Versailles, le Vau designed a three-wing arrangement for the second and third stories, thereby providing a terrace over the lower story and opening up the court on one side for a view over the gardens; in so doing he created an interplay of geometric masses that reflects the French classical variant of the Baroque taste.

To keep up with Louis' ever more extravagant way of life, the palace was

vastly expanded by Mansart after 1678. The terrace area was filled in to provide a continuous façade, and two huge wings, set considerably back, were added on the sides (Figs. 12-10 and 12-11). The architect merely repeated the original decorative motifs over the much larger surface. No doubt in order to introduce an element of variety, the pilaster motif between the second-story windows is interrupted by series of columns at regular intervals, which do not, however, overcome an effect of monotony.

As in the earlier building, the arrangement of geometric forms is in keeping with the French variant of Baroque taste. In addition, the very vastness of the building produces a sense of excitement that also links it with the Baroque tradition. It is almost impossible to apprehend the building in its entirety, and from almost any point in the garden at least one wall seems to recede, its upper edge forming a powerful diagonal against the sky. Furthermore, the extended wings of the huge garden façade encompass a vast orderly park that is bordered by dense forests and by hills in the far distance, thus linking the dwelling of the king to the infinitude of space. Finally, the very location of the palace is pregnant with Baroque symbolism. Dominating as it does the vast and beautiful landscape, the garden façade seems to open up onto the life of hunting and outdoor pleasures of which the king was so fond. On the other side, the radiating roads connect the seat of government to the city and a world of loyal subjects.

12-9 *Top:* Louis le Vau, Versailles, garden façade, 1669. (Engraved by Silvestre.)

12-10 *Middle:* Louis le Vau and Jules Hardouin Mansart, Versailles, garden façade, 1678-85.

12-11 *Bottom:* Louis le Vau and Jules Hardouin Mansart, Versailles, aerial view.

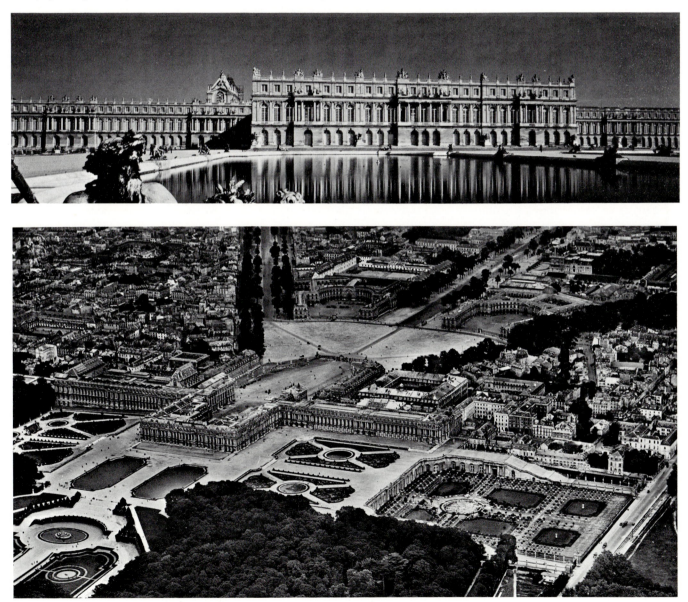

13

The Eighteenth Century

The transition between the artistic trends of the seventeenth century and those of the eighteenth was gradual; indeed, many characteristics of the High Baroque survived. There were numerous variations in style and mood, however, starting with the Rococo fashion early in the century, which cultivated a gaily decorative manner and a predominantly lighthearted mood and frequently favored works on a smaller scale and in a more intimate manner than in earlier decades. New styles that were derived from a variety of historical sources appeared throughout the second half of the century, the foremost among them being Neo-Classicism and the Gothic Revival. There was a growing cult of sentiment that during the first half of the century sometimes resulted in a new stress on nostalgia and in many works of the second frequently manifested itself in sentimental moralizing and coyness. It also led to a renewed interest in the observation of nature, as well as an increasing emphasis on personal feelings that was to hasten the advent of the Romantic period.

The Rococo style was named by a young Romantic artist at the end of the eighteenth century because of its reliance on seashells, pieces of rock, and other motifs known by decorators as *rocaille*. It laid a new stress on asymmetry, on complex yet graceful curves, and on light, gay color schemes. Works of art were usually smaller in scale and of a more intimate nature than works of the previous century had been. The style derived from the light and airy decorations commissioned by Louis XIV himself, as early as 1700, to provide relief from the ornate and slightly oppressive classicizing Baroque of Versailles. It was received with favor by other members of the aristocracy and the upper bourgeoisie who were beginning to cultivate a subtle extravagance of taste and a carefree hedonism. Taking a new vigor after young Louis XV became king in 1715, it reached its peak around 1730, by which time it had spread to most of Europe and survived, along with other manners, through much of the century.

The greatest French exponent of Rococo was an artist who came from the border area between France and Flanders, Jean Antoine Watteau (1684–1721). His masterpiece, *Pilgrimage to Cythera* (Fig. 13–1), was executed in 1717. The characteristics of the Rococo style of decoration can be seen clearly in the prow of the boat in the lower left corner of the painting. It is still essentially Baroque in its animation and ornateness, but the design is fancifully and intriguingly asymmetrical—curved lines seem to rise to an apex and descend again without rhyme or reason—and the overall effect is particularly graceful and airy. Right at the center of the prow is the seashell that is the frequent motif of Rococo decoration.

The execution of the painting recalls the art of Rubens. As in *The Rape of the Daughters of Leucippus* (Fig. 12–1), the composition is dominated by lines of force, but these now consist of series of typically Rococo, irregularly scalloped curves, which are more graceful, more complex, and altogether less vigorous

than anything we have seen in the seventeenth century. There is, for instance, a curve that starts from the head of the statue of Venus on the right and descends gracefully to link the first three couples. It peaks at the level of the third couple and is repeated in a more leisurely fashion in the line of pilgrims descending toward the boat. Yet another curve is created by the *putti*—winged infants serving the same general purposes as Cupid—that fly away from the neighborhood of the boat and link it with the distant sky. We find similar graceful, irregular scallops in the outline of the foliage, the crest of the mountains, and the tortuous shape of the coastline.

The superb painterly technique and the luscious colors also recall Rubens, but there is now a definite preference for the most pleasing of pastel hues. Watteau, furthermore, initiating a practice that was to become popular among his followers, alluded through the very colors and textures of the objects to pleasing sensory experiences not immediately related to the

scene. The colorful silky dresses have been made to look like delectable sweets, the flesh like smooth, glossy, and delicately tinted porcelain, the foliage like soft feathers, and the distant mountains like mounds of sherbet seen through a gentle mist. The Baroque appeal to the senses has led to the exquisite stimulation of tactile and gustatory as well as visual perception.

The subject was inspired by frequent references in literature and the theater to Cythera, birthplace of Venus, a mythical island propitious to love. Watteau, however, chose here to represent couples not on their way to the island (although such a painting by him did exist) but about to embark on their return trip. Thus, like Rubens' *Rape of the Daughters of Leucippus,* this painting deals with an aspect of love, but a very different aspect. Rubens focused on the dramatic moment in a romance when the male asserts himself; Watteau mused on the quiet dalliance of elegant and aristocratic couples who have just experienced amorous enchantment

13–1 Jean Antoine Watteau, *Pilgrimage to Cythera,* 1717. Oil on canvas (4'3" × 6'4½"). Louvre, Paris.

and are quietly and reluctantly returning to the cares of everyday life.

Watteau showed remarkable psychological acumen and sensitivity in evoking the mood. A couple nearest to the statue of Venus is still absorbed in amorous conversation, and a small boy (none other than Cupid, a quiver of arrows lying beside him) attempts to detain the lady by pulling at her skirt. The next couple is about to depart; the man helps the lady to her feet. The third couple is starting to walk toward the boat, but the lady looks back wistfully while the man seems to urge her to move forward. All the others seem to have become reconciled to leaving the enchanted island and are talking animatedly as they stroll toward the boat, urged along by *putti.* There can be no doubt that Watteau tried to suggest

a sense of delight through the composition, attitudes, and gestures, but he also hinted that, even if total amorous bliss were attainable, it would necessarily be followed by a return to a more prosaic state. He thus introduced an element of nostalgia that, like the delicate sensuousness of the scene, reflected an aspect of his own temperament.

We have noted Titian's capacity for suggesting powerful emotion, Rembrandt's skillful evocation of the most private moods, and Poussin's semiscientific description of emotional states. Watteau had a new interest in capturing the ebb and flow of man's subtlest feelings. In this he heralded the new cult of sentiment that emerged in literature later in the century and that was to lead directly to Romanticism. More specifically, the pursuit of evanescent love, here treated so delicately, was to become the agonized search for self-fulfillment of the Romantic age.

The mood of the *Galatea* (Fig. 13-2) of 1740 by François Boucher (1703-70)

is characteristic of the more frivolous aspects of French Rococo. The artist made a dizzying display of his painterly skills. Through a masterful handling of high value and low intensity hues in scumbles and glazes, he rendered flesh, fabrics, water, clouds, and glittering foam as though they were the succulent creations of an inventive confectioner. Rococo, too, are the fusion and contrasts of pastel colors and the graceful scalloped curves linking the bodies to one another and to the far distance.

It would be futile to look for a profound meaning in the picture; attitudes and gestures aim at little more than seductively exposing the bodies of barely nubile young women. Indeed, the lack of significant subject matter is compensated by the lighthearted eroticism. Boucher, it should be added, was the favorite artist of the all-powerful mistress of Louis XV, Madame de Pompadour. Through her Boucher became chief court painter and director of the French Academy; he exerted considerable influence on taste in

France and in other European countries as well.

Perhaps the most spirited and vigorous form of Rococo evolved in Germany and Italy. The dining room (known as the *Kaisersaal*) of the *Residenz*, or palace, of the prince-bishop of Würzburg is one of Germany's most sumptuous examples (Fig. 13-3). The building had been designed and erected between 1719 and 1744 by a Bohemian architect, Balthasar Neumann (1687-1753), and this room was decorated between 1750 and 1753 by the Venetian painter Giovanni Battista Tiepolo (1696-1770), assisted by his sons. The oval plan was much favored by Rococo architects because it suppressed corners and transformed walls into continuous curved surfaces. The architectural scheme can be compared to Borromini's Sant'Ivo (Fig. 11-5). Although here the classical ornaments are much more prominent, the attempt to relate their vertical accents to the radial webs between the lunettes is somewhat similar. The ornamental decoration of the *Kaisersaal*, how-

13-3 Balthasar Neumann, *Kaisersaal, Residenz,* Würzburg, 1719-44. (Painted decorations by Giovanni Battista Tiepolo and his sons, 1750-53.)

ever, with its use of white, gold, pink, and gray, is both richer and more playful; there is more than a touch of graceful fantasy in the interplay of the pink outlines of the lunettes and the irregularly scalloped forms of the gold decorations on and around them, and there is charming artifice in the way in which the murals seem to open up on a colorful and luminous unreal world.

The painted murals serve another purpose. Rococo architects had already manifested their boredom with traditional rectangular rooms by showing a special affection for oval ones. Their use of painted murals with deep perspectives, frequently combined with large mirrors, enabled them to introduce even more varied effects in the organization of space. Where such painted decorations as Bernini's Cornaro chapel ceiling (Fig. 11-3) merely expanded the space of the room in one direction, the murals of the *Kaisersaal* open up illusory spaces in a variety of directions and introduce a new complexity in the overall scheme.

The central part of the ceiling is covered by a fresco executed in 1751–52 by Tiepolo (Fig. 13–4), depicting Apollo conducting Duchess Beatrice of Burgundy to Emperor Frederick Barbarossa (both twelfth-century figures). The design, with its clear, colorful, and luminous masses against the blue sky, brings to mind Bernini's Cornaro ceiling and numerous other seventeenth-century mural decorations. The way in which an occasional leg straddles the ornate gilded frame, furthermore, brings to mind the use of similar devices by Bernini to link the real and illusory space.

In an amusing display of illusionism, Tiepolo has depicted figures and objects in bold foreshortening as if seen from below, and showed the figures that are meant to be standing on solid ground as rising from beyond the edges of the fresco. The illusionism, however, is only relative; the brilliant pastel colors and the translucency of the figures convey the immateriality of the vision. It is as if we were lying, face up, on the bottom of a swimming pool and saw floating above us a universe of supernatural splendor. Baroque lines of force are still in evidence; streaks in the clouds suggest the flight of Apollo's chariot from the lower right to the upper left. In addition there is a subordinate design made up of Rococo scalloped curves forming peaks at various points of interest: the allegorical figure holding a torch to the right, groups of figures along the edges, the allegorical figure hovering over Frederick, and others.

As in Boucher's *Galatea,* the subject matter is little more than a pretext. We do see Beatrice, wearing a large ruff like Venetian ladies of earlier days, seated below Apollo on his chariot. And we see Frederick, nude like a Greek god under his imperial mantle, seated atop the large stone pedestal to the left and extending his arm toward his bride-to-be while a *putto* carries his sword. These are but a few of the many strangely foreshortened and animated figures participating in the splendid pageant. Unlike Watteau and Boucher, Tiepolo does not appeal to our tactile and gustatory senses, but there is just as much artifice in the way in which the figures have become an assortment of almost abstract luminous forms moving in a limpid atmosphere for our visual delight.

The fresco is one of a group of murals that decorate the room, forming a cycle dedicated to the Holy Roman Emperor and German king of Romanesque times, Frederick I, called Barbarossa. The picture glorifies his marriage with the Burgundian duchess, which had taken place in Würzburg. In typical Baroque fashion the artist pointed to the impact of celestial forces on human life, the bride being brought to Frederick by a mythological deity—no lesser a figure than Apollo, god of light and truth as well as of the arts.

Frederick, it should be pointed out, had been married earlier to a blood relative and had had that marriage dissolved. Since the Catholic Church condemns the first practice and disapproves of the second, one may wonder how this particular

13-4 *Opposite page:* Giovanni Battista Tiepolo, *Apollo Conducting Duchess Beatrice of Burgundy to Emperor Frederick Barbarossa*, 1751-52. Fresco ceiling of the *Kaisersaal, Residenz*, Würzburg.

13-5 *This page:* Jean Baptiste Siméon Chardin, *Le Bénédicité* ("Saying Grace"), c. 1740. Oil on canvas (19 1/16″ × 14 5/8″). Louvre, Paris.

wedding came to be chosen to decorate a bishop's palace. But Frederick was one of the most illustrious of Medieval German emperors, and the whole decorative scheme devoted to him may be regarded as an attempt to revive the distant glories of the German imperial past.

In any case, by no stretch of the imagination can one detect evidence of Christian piety in the three Rococo paintings we have discussed. As a matter of fact, most of the religious pictures of the eighteenth century that have survived are insipid. This lack of religious conviction reflects the temper of the times, for although some people in all classes of society remained deeply devout, religious institutions in general fell into a discredit that manifested itself most vigorously in the writings of the *Philosophes*.

At the same time, as we have already seen, the uncompromising intellectualism of the *Philosophes* was being countered by the growing cult of sentiment, a trend that found its most subtle and convincing expression in the work of Jean Baptiste

Siméon Chardin (1699-1779) of France.

Stylistically, Chardin's *Le Bénédicité* ("Saying Grace") of about 1740 (Fig. 13-5) is a successful compromise between the sobriety and simplicity of the bourgeois realist tradition—the artist had frankly emulated the seventeenth-century Flemish manner early in his career—and the more exciting and freely decorative aspects of the Rococo manner. As in Brouwer's *The Smokers* (Fig. 12-2), the whole background is rendered in a vibrant application of warm, subdued, low-value hues. In keeping with Rococo taste, however, Chardin's palette was richer and more delicate than Brouwer's; there are fresh and bright hues in the stripes of the upholstery, a subtle contrast between the warm colors of the dress of the woman and her bluish apron, much purer reds and blues in the garments of the children, and delicate vermilions to heighten the complexions. Areas that seem to be almost uniform in color are occasionally livened by the juxtaposition of strokes of vividly different hues. To mention one

such instance, there are pink, yellow, and blue streaks in the white tablecloth. These not only heighten the contrasts between the highlights and the shadows, in warm and cool hues respectively, but also help suggest both the texture of the fabric and the atmosphere around it, and in this respect the technique marks yet a further step toward the development of a naturalist tendency already observed in Vermeer's *View of Delft* (Fig. 12-5).

At first sight there is a stark simplicity to the arrangement of forms, but here too the composition is artfully livened by Rococo devices. A sensitive chiaroscuro technique singles out the three figures and the tablecloth within the darkened atmosphere of the room, stressing the rich textural quality of the fabrics, the pink-cheeked freshness of the children's skin, and the paler but equally attractive complexion of the mother. What might seem to be a uniform background is made up of two walls meeting at right angles near the central axis. This device enabled the artist to suggest a richer and more com-

plex play of light and shade on the background. The oblique walls, furthermore, suggest the recession of the space—a recession further emphasized by the diagonal crisscross pattern of the floor tiles—which adds to the overall animation. The three figures are located with architectural precision around the table; they also provide discreet Rococo accents to enliven the pictorial surface. The outline of the back of the mother sweeps quietly from the lower right to the upper left. Its curvature is echoed in reverse by the back of the chair, and complemented by the curve of the younger child's skirt. In sum, the linear composition contributes as much as the color scheme to the sense of grace and quiet excitement in the scene.

Despite the fact that the children are saying grace before the meal, this can in no way be construed as a religious picture. Chardin's chief merit in the eyes of one of his contemporaries was that he had achieved the "greatest truth in the tones and in the effects." But beyond this, his admirers were intrigued by his capacity for seizing what was "most naive and piquant." Chardin himself was perhaps most apt in clarifying his aims: "Who tells you one paints with color?" he asked. "One makes use of colors, but one paints with feeling." Indeed, even his humblest still lifes are tributes to the quiet delights of a simple life, and a more complex picture such as *Le Bénédicité* is a lyrical evocation of the intimacy and charm of middle-class domesticity.

By the middle of the eighteenth century, there emerged a new interest in a broad range of earlier traditions. A taste for the exotic had already appeared in the previous decade in the frequent use of Chinese lacquers and Far Eastern motifs in Rococo decoration and, in literature, in an enthusiasm for tales of life in distant lands (sometimes turned into pretexts for not-so-gentle satires of Western mores). Ultimately this interest in other cultures led to an intensive study of various artistic traditions of the past. Artists in particular drew inspiration not from a single earlier phase, such as Roman antiquity, but from several; an architect, for instance, might have submitted two plans for a new building, perhaps one in the Gothic manner and the other in the classical manner. The result was a series of revivals during the latter part of the eighteenth and early part of the nineteenth centuries, starting with the Gothic and Neo-Classical flowerings.

Gothic architecture never completely died out in England. Even major architects of the seventeenth century built in the style (usually to match existing buildings), and during the first half of the eighteenth century a number of small buildings in fanciful variations of the Gothic manner were erected. The first large private house in the Gothic Revival style was Strawberry Hill (Fig. 13–6). Originally in the classicizing Georgian style, it was transformed by its owner Horace Walpole (1717–97) and a group of his friends, with the assistance of the architect William Robinson (c. 1720–75), into what they hoped was a convincing approximation of a Gothic residence.

Walpole's program of alterations and extensions was started in 1748, and was not completed until the 1780s. The Gothic Revival to which Walpole and his friends gave considerable momentum was to gain increasing favor during the first half of the nineteenth century, particularly in England.

Also about the middle of the century, the renewed interest in antiquity led to the Neo-Classical style—a brand of classicism which, while going through many transformations, survived through the second half of the nineteenth century. The Petit Trianon (Fig. 13-7), a small but palatial residence erected at Louis XV's order by Ange-Jacques Gabriel (1699–1782) between 1762 and 1768 as a retreat for a royal mistress in the park of Versailles, is an attractive example of Neo-Classicism.

This new style demanded at least a partial dedication to the architectural ideals of antiquity, and the prominence given to the four fluted columns of the façade, with their elaborate capitals, to the entablature and to the precise, geometric articulation of the stonework are thus in keeping with the new taste. An emphasis on horizontal and vertical lines, a fondness for unadorned surfaces in at least some areas, and the enforcement of strict symmetry are also Neo-Classical and reflect an admiration for the more sober and geometric creations of Classical antiquity. The architect of the Petit Trianon, nevertheless, was faithful to some of the ideals of the immediate past; the refinement of the detailing, the elegance of the proportions, and a certain lightness and airiness conveyed by the large areas of glass and the open work of the balustrade have a Rococo flavor. The small scale of the building itself points to the trend toward intimacy. And beyond these affinities with the Rococo, there are ties with the previous century. The walls are massive and are made to protrude and recede in a manner reminiscent of the manipulation of masonry in Baroque buildings, although the process is performed with greater restraint.

In Strawberry Hill the pointed arches and tracery of the windows, the towers, and the battlements and pinnacles are taken from the Gothic idiom, although here too a Rococo element, the daintiness of many of the supposedly Gothic details, is noticeable.

In contrast to the symmetry, regularity, and compactness of the Petit Trianon, Strawberry Hill is asymmetrical, its decorative elements are varied, and its layout rambling. There are windows of different sizes and shapes, a multiplicity of chimneys and towers on the roof, and delicate stone tracery alternating with plain brick walls articulated by means of shallow buttresses. The ivy itself, which covers much of the surface, provides its own varied textural patterns. Clearly, Walpole and his friends were not at all interested in the balance and order associated with classicism. They sought instead to provide effects of surprise as the visitor walked around the building, discovering one aspect after another. This endeavor was in keeping with the love of what was

13-8 William Blake, *A Breach in a City the Morning After a Battle,* c. 1783–84. Watercolor with pen (11¾″ × 18½″). Charles J. Rosenbloom Collection.

then called the *picturesque,* a taste for varied, quaint, and even bizarre visual experiences which found particular gratification in the complexity and variety of Medieval architecture as well as the irregular configuration of ruins of all periods.

One of the most telling aspects of this difference of attitude was in the treatment of walls. In the Petit Trianon the walls appear massive. The forceful yet controlled manipulation of their form is an important contribution to the esthetic impact of the building, and the rigid symmetry of the design precludes our receiving any indication of the internal layout of the building. In Strawberry Hill the variety of surface treatments and, more particularly, the alternation of solid brick walls and delicate stone tracery make us much less aware of the massiveness or even the substance of the walls. The irregularity of the window openings, moreover, makes us much more aware of interior spaces, and so does the fact that there are numerous bow windows and engaged towers protruding from the surface.

To some degree these developments reflect Walpole's lack of professionalism, but they also point to a new approach that was to become prevalent in later times, based on the notion that walls are merely the outer envelopes of buildings, to be treated as decorative entities at the whim of patrons and architects. And continuing a trend already incipient in Walpole's building, some architects of the late nineteenth and early twentieth centuries were to attempt in a much more systematic way to reflect the internal layout and functions of the building in the design of the enveloping walls.

Both Neo-Classicism and the Gothic Revival had broad cultural roots. The first was fostered by a widespread interest in archeology spurred, in particular, by excavations of the buried Roman cities of Herculaneum and Pompeii. Lavish books illustrating the principal Greek and Roman ruins circulated widely, and a German scholar, J. J. Winckelmann (1717–68), published very influential studies on antiquity which claimed a

unique place for Greek art, extolling above all its "noble simplicity and calm grandeur in action and expression." In addition to the return to classical ideals in architecture, Neo-Classicism accounted for a predilection for Stoic subjects in painting and sculpture, often stressing Winckelmann's "noble simplicity and calm grandeur," and the emulation in both of the high finish and precision of antique statuary. Ironically the sometimes naive linearism of Greek vase designs was occasionally imitated in paintings and drawings, often to introduce an unclassical preciosity. What is more, the subject matter of both painting and sculpture was frequently affected by prevalent moods of the time, the cult of sentiment often adding a touch of melodrama to Stoic situations, and Rococo hedonism sometimes contributing an erotic touch.

The Gothic Revival, for its part, was kindled by a renewed interest in the literature of the Middle Ages and gave rise to novels and poems inspired by some of the most imaginative Medieval stories

known as *romances* (whence, probably, the word "romantic"). In the fine arts it affected architecture much more than painting and sculpture—the men of the eighteenth century having as yet a limited understanding of the idiom of Medieval painters and sculptors. The awesome and sometimes eerie settings that fired the imagination of the readers of Medieval-inspired novels, on the other hand, were conducive to a real interest in surviving Medieval buildings which were henceforth studied with a new seriousness.

In its most extreme manifestation, the Gothic Revival was associated with what was then called "the horrific," a taste for the most gruesome aspects of Medieval stories and, incidentally, of the tales of horror that abound in Greco-Roman mythology. The first novel reflecting this tendency, incidentally, was Walpole's *Castle of Otranto* of 1764. Paradoxically, despite the apparent contradiction between the horrific and the ideals of order and balance of Neo-Classicism, horrific subjects are not infrequent in the paintings of the Neo-Classical manner.

The interplay of these various trends is apparent in *A Breach in a City the Morning After a Battle* (Fig. 13–8), a watercolor of about 1783–84 by the English poet and artist William Blake (1757–1827). The painting still retains a Rococo grace in the attitudes of its figures, but it illustrates Neo-Classical developments as well as the impact of the taste for the horrific. The smooth, delicately highlighted surfaces and the linear treatment of the figures seem meant to evoke the simplicity and purity of design of antique works. The corpses, mourners, and hovering bird of prey as well as the eerie light, gloomy atmospheric effects, and the intriguing irregularity of the ruins, create a sufficiently nightmarish scene to cater to the taste for the horrific. It should be pointed out, incidentally, that the undulating linearism of the design and the attendant exaggerations in the rendering of the figures, while clearly related to the Rococo tradition, also reflect a variety of nonclassical influences. Without doubt

Blake must have been familiar with the rhythmic linearism and distortions of Archaic Greek vase painting and perhaps also with the animated linearism of Medieval designs. This return to nonclassical traditions to achieve a somewhat precious effect is an early indication of nonnaturalistic tendencies that were to recur in the work of such nineteenth-century masters as Ingres.

It took the vision, courage, and forthrightness of a remarkable man to transcend the conflicting trends that characterized the art of the 1770s and 1780s to create a forceful new style. The man who managed to do so was the French painter Jacques Louis David (1748–1825). It was David who first succeeded in making a complete break with Rococo stylistic practices and, while ostensibly cultivating a stark Neo-Classical manner and seeking to express an austere Stoicism, he achieved a new directness and intensity of expression that were important contributions to the Romantic era.

David was a protégé of Boucher and

11-1 *Left:* Caravaggio, *Deposition,* 1602–03 (*comparative illustration*).

12-7 *Below:* Nicolas Poussin, detail of *Eliezer and Rebecca,* 1648 (*comparative illustration*).

had been trained by Joseph Vien (1716–1809), an uninspired Parisian Neo-Classicist, but during a sojourn in Italy he developed an intense interest both in antique art and in the more severe aspects of seventeenth-century art. His *Oath of the Horatii* (Fig. 13-10), executed in 1784 during his second visit to Italy, is the outcome of a conscious and successful cultivation of these new interests and was intended as a manifesto of a new style that we may call Davidian Neo-Classicism. The scene is said to have been inspired by the subject of the play *Horace,* a profoundly Stoic tragedy by the seventeenth-

century French playwright Pierre Corneille. In the course of hostilities between the Rome of pre-Republican times and its neighbor Alba, the leaders of both nations decided to determine the outcome of the war by a fight between three Roman brothers, the Horatii, and three Alban brothers, the Curiatii. The decision, which was intended to save countless lives, was particularly hard on the two families; not only were the men cousins, but one of the Horatii had married the sister of their opponents and one of the Curiatii was engaged to a sister of the Horatii. In David's painting, the father of the Horatii makes his sons take an oath of allegiance to Rome before the combat—a scene not mentioned by Corneille, and that may well have been conceived by David himself.

The stylistic boldness of David is perhaps best demonstrated by comparing the work with a preparatory drawing (Fig. 13–9). In the drawing a Baroque element can be seen in the continuous line of force that links the arms of the father and the

arms of the three sons, curving gracefully, vigorously, and rhythmically and receding in space. There is also a touch of Rococo delicacy in the graceful and complex lines that model the bodies. The painting, however, reflects a new approach to the handling of forms in space. The body of the father has been brought forward, and the line of force has been replaced by a triangular arrangement parallel to the picture plane. Instead of locating the various figures at different depths and linking them by graceful, receding lines of force, David conceived the group as an antique relief, compressed, so to speak, between parallel vertical planes. Accordingly, the lines linking the various figures are mostly parallel to the picture plane and make up a simple, easily recognized configuration: a semigeometric arrangement of straight lines for the group of men and their swords, a set of graceful curves for the women and children.

In contrast to the rich painterly treatment of Rococo works, there is a new insistence on fairly uniform color areas

13-9 *Opposite page, top:* Jacques Louis David, sketch for *The Oath of the Horatii,* before 1784. Pencil and pen on paper (7¹³⁄₁₆″ × 10⁷⁄₁₆″). École des Beaux-Arts, Paris.

13-10 *Opposite page, bottom:* Jacques Louis David, *The Oath of the Horatii,* 1784. Oil on canvas (10′9⅛″ × 13′10¼″). Louvre, Paris.

and on modeling by means of a smooth gradation of values, as well as an uncompromising linearism in the treatment of the edges. Together with the flattening of the design, the return to a narrow stage space, and the distribution of the figures into groups forming strong and distinct surface patterns, this treatment marks a clear departure from preceding stylistic ideals and the end of Baroque art.

There can be no question that the firm and precise modeling and the relief-like treatment of the figures stem from David's high regard for antiquity. The moderately intense and diffuse lighting was similarly associated with classical serenity, and the costumes and setting show a genuine concern for archeological correctness (although even one of David's contemporaries justly chided him for showing arches over columns in such an early Roman building).

In other ways the picture looks back to seventeenth-century sources. Long before David, Poussin had emulated antique reliefs in the firmness of his modeling, the precise delineation of the forms, and the frieze-like arrangement of the figures (Fig. 12–7). In all these respects, David may have been influenced by Poussin. And, like Poussin, he was concerned with the careful psychological characterization of his figures, suggesting lofty idealism in the father, virile determination in the sons, and quiet anguish in the women. Finally, the realism of the facial features and of the anatomy, based on careful study of the Roman models who posed for him, no less than the severe manner

of treating shadows on the surfaces and of depicting the figures against a plain and comparatively dark background, points to the influence of Caravaggio (Fig. 11–1). Like Caravaggio, moreover, David skillfully shaded the eyes and mouths of the principal figures to appeal all the more effectively to our imagination.

The painting had been commissioned by the government of Louis XVI in recognition of the young artist's talent, but also in keeping with an official policy of fostering works of art that would be morally edifying. When it was first shown in Paris in 1785, at the exhibition of the Academy of Fine Arts, or *Salon,* it created a sensation, for not only did the critics and public see in its execution an invigorated version of the Neo-Classical manner, but they also understood it to be an extremely eloquent call for patriotism and fortitude in troubled times (the French Revolution was to begin in only four years).

In fact, David had taken advantage of the advent of Neo-Classicism to arrive at a stark and moving expressiveness through the handling of the forms themselves. There is a powerful contrast between the almost electric tension suggested by the layout of the bodies and swords of the men and the subdued, rounder forms of the group of distressed women and children. There is also a strong opposition between the virile reds and blues of the clothes of the warriors and the restrained pale yellows, russets, blues, and whites of the women. Both these devices allowed the artist to drama-

tize superbly the emotions of the participants and at the same time to express his own patriotic fervor.

David ignored the Baroque practice of showing mythological figures hovering above the scene to symbolize the intervention of supernatural forces. This scene is all the more dramatic in that the fate of two families and two nations rests entirely on the decision made by men. Thus, completely upsetting the stylistic conventions of the Rococo era and ignoring both the mythological fantasies of his predecessors and the sentimentality of so many of his contemporaries, David arrived at a sober and powerful expression of deeply felt emotions related to momentous current events. This effort to convey with intensity and directness the artist's personal moods and emotions and, as often as not, to relate them to contemporary events opened the way to the Romantic movement.

V

The Nineteenth Century

14

Romanticism and Romantic Naturalism

The nineteenth century was an age of some momentous impulses that brought about major political, social, and economic changes. The two crises that paved the way for new political attitudes—the American Revolution of 1776 and the French Revolution of 1789—actually occurred in the eighteenth century, setting the pattern for the movement toward participatory democracy in most Western nations.

The French Revolution ended with the disaster of the Terror and led to the dictatorship of Napoleon, who assumed power between 1799 and 1802 and pursued an aggressive militaristic policy until defeated by Britain and her allies in 1815. Napoleon's wars spread devastation throughout occupied countries, but his propaganda machine helped disseminate ideas inherited from the rationalists and the deists of the eighteenth century, sowing the seeds of a new egalitarianism. His final defeat was followed by widespread political conservatism in Europe and, in many areas, a revival of Christianity. But

there were pressures from revolutionary elements that led to the upheavals that shook France in 1830 and 1848, as well as 1870, and affected other countries as well. Ultimately the tug-of-war between conservative and liberal or revolutionary elements led to the acceptance of representative governments in most European countries by the early part of the twentieth century.

All this time a determined and hardworking breed of industrial and commercial leaders was changing the face of the world. England had been the first nation to take advantage of the power loom and the steam engine and to succeed in large-scale industrial production. The industrial revolution spread to France by the middle of the century and soon after to the German territories. In the more economically advanced nations, the growth of industry attracted workers from the country to the city, where, together with the independent craftsmen who were the losers in the struggle for economic survival, they became the nucleus of an ever

expanding, powerful urban proletariat.

In the upper strata of society, the old nobility had become entrenched in ministerial, diplomatic, and military posts, but they were frequently joined by commoners, some of whom were men of great personal distinction. The industrial and commercial classes, for their part, came to wield unprecedented economic power and significantly influenced the tastes and artistic outlook of the century as well.

In the realm of international politics, England's victory over Napoleon and ever increasing commercial and industrial prosperity gave it a position of prominence that was maintained throughout the century. France gained strength more slowly, only to be defeated by Prussia in the war of 1870–71, an event that marked the unification of the German territories under the king of Prussia. From then on the newly created German Empire became a leading world power.

Nowhere was the process of industrialization and economic development more rapid than in the United States. The ex-

pansion toward the Pacific and the enormous influx of European immigrants turned this land of wilderness into a major industrial nation and eventually into the dominant force of the Western hemisphere. On the other continents, European colonialization led to the domination of as much as 85 percent of the world by the early twentieth century, and widespread attempts were made to impose the values of the industrial West on countless peoples totally unprepared for them. Ironically, first the art of the Far East, then several primitive traditions were to have a profound influence on the art of the Western world beginning in the second half of the nineteenth century.

Following the trends established by their Baroque predecessors, the rulers of the nineteenth century backed their countries' commercial, industrial, and territorial growth with military power. More important still, the citizens of individual Western nations became proudly aware of the complex ties that united them to their countrymen and became intensely loyal to the abstract concept of the nation. The result was a powerful nationalism. At times nationalism extended beyond immediate political boundaries to join different principalities sharing a common language and a common culture; even before Germany was unified, the various states of Italy were merged into a single kingdom.

The later nineteenth century also witnessed vast humanitarian undertakings, including a massive improvement in social services. Decent medical care—in some countries, at any rate—became available even to the poor. Penal systems became more humane. If the universities remained restricted to the elite, elementary schools became available to all, while on occasion more promising students were given assistance toward a higher education. It was also the era that saw the founding of the Red Cross, the beginning of effective organization of labor, the launching of movements to preserve green areas in the cities, and the first attempts to grant women the same political rights as men.

In literature, the eighteenth-century cult of sentiment had evolved into a deeply emotional, occasionally morbid striving for self-fulfillment. The transition came with the so-called *Sturm und Drang* ("storm and stress") movement in Germany, which found its most eloquent expression in Goethe's *Werther* of 1774, the story of a sensitive and introspective student whose unrequited love leads him to suicide. It was this movement that set the tone of nineteenth-century Romanticism. A generation of artists cultivated imagination in all its forms, a longing for freedom (freedom from social tradition as well as established artistic rules), a tendency toward introversion, a subordination of formal content to expressive intent, and a passionate urge to relate the changing picture of society and nature to the tumultuous ebb and flow of their own emotions. These trends culminated in what we might call High Romantic art, which dominated the second quarter of the century and survived in the work of its leading exponent, Eugène Delacroix, until his death in 1863.

At the same time, side by side with the more emotional aspects of Romanticism appeared a school of thought called Positivism. Gigantic strides were being made in all scientific fields, and the hope arose that the precise observations and systematic reasoning that bore such fruits in the sciences could be applied to every aspect of human endeavor, including human relations. The enthusiasm for the spirit of scientific inquiry led the French writer Émile Zola to declare that "The naturalist novel is a genuine experiment carried out by the author in order to study man through observation." Zola nevertheless remained unwittingly attached to the more subjective tradition of Romanticism in his belief that "a work of art is part of the universe seen through a temperament," which was tantamount to asserting the importance of the author's individual emotional experience.

The Positivist attitude manifested itself in art in a new, direct study of nature, particularly in landscape paintings that were increasingly free of the intense emotionalism of the High Romantic artists. At most these works reveal a quiet reverence, or a touch of meditative nostalgia in the presence of nature. The artists working in this vein can justly be called Romantic Naturalists. They paved the way for the striving for directness and immediacy in the depiction of everyday scenes characteristic of Courbet and eventually for the achievements of the Impressionists, whose use of color analysis to

13-10 *Right:* Jacques Louis David, *The Oath of the Horatii,* 1784 (*comparative illustration*).

12-1 *Below:* Peter Paul Rubens, *The Rape of the Daughters of Leucippus,* c. 1618 (*comparative illustration*).

capture fleeting light and atmospheric effects marked the height of naturalism in art.

The cult of Positivism gained momentum during the third and fourth quarters of the nineteenth century, as great scientific and technological strides seemed to promise unlimited material progress. It did not go unchallenged, however. An increasing number of thinkers came to feel that scientific attitudes and a rational point of view could not resolve man's most fundamental problems. The last decades of the century witnessed a revival of religious thought, and in literature and art a renewed interest in emotions and ideas. These, however, were expressed more subjectively than they had been in Romantic art, principally through the suggestiveness of line and color and through complex and often ambiguous allusions. This trend culminated in the Symbolist developments of the 1880s and 1890s.

In some instances this increased subjectivity took the form of a somewhat precious and even morbid detachment from the realities of everyday life. In others—and this is true of the great Post-Impressionist artists—it led to the spontaneous and vibrant expression of the artist's responses to the physical world and to an unprecedented immediacy and frankness in the exploration of his own psychic life. All the while, a rising enthusiasm for the art of the Far East and for primitive traditions accelerated stylistic innovation.

The nineteenth century saw a major change in patronage of the arts. Kings and princes played a lesser part as collectors than in earlier times, but, following the example of Napoleon, many rulers established fine-arts museums and purchased works of art from living artists for the museums and public buildings. In France purchases were mostly made from the Salons and primarily reflected the tastes of the art academy. They tended to be uninspired, although on occasion works by the more innovative artists were acquired.

The ever more prosperous middle classes provided another major source of patronage. Originally much influenced by official taste, these collectors were to assert themselves as the chief patrons of Romantic Naturalist artists around the middle of the century. The shock of Impressionism was too violent for most of them, however, and it took nearly two decades for the works of Monet and his companions to begin to be appreciated by the public, and even longer for them to be acquired by museums. The fate of the Post-Impressionist artists was even worse; they achieved full recognition only in the twentieth century.

The Romantic characteristics that dominated the beginning of the nineteenth century were powerfully heralded by the expressive intensity of David's *Oath of the Horatii* (Fig. 13–10). They were much magnified in the work of his contemporary, the Spaniard Francisco Goya y Lucientes (1746–1828). Goya, like David, had been reared in the Rococo tradition, but during the first decade of the nine-

teenth century he developed a pictorial technique and an intensity and individuality of expression that make him a major Romantic artist. His *Third of May, 1808* (Fig. 14–1), painted in 1814–15, commemorated an event that took place in Madrid when Spain was occupied by Napoleon's armies. A contingent of imperial troops was attacked by a street mob, and on the following day hostages were shot in reprisal.

Goya followed David's example in making the dramatic implications of the scene immediately obvious through the configurations of the bodies. The attitudes of the soldiers has a diagrammatic simplicity, accentuating the deadly precision of their action; the group of condemned men is dominated by a rebel, whose raised arms and parted legs seem to radiate defiance as he screams invectives at his executioners; the other prisoners form a writhing human chain on each side of the central figure, while on the ground earlier victims lie in a shapeless, bloody pile.

Like David, and so many artists before him, Goya stressed a moment of emotional climax. David, however, chose the instant of decision; the subsequent battle is only implied. He was therefore able to preserve a restraint and dignity in keeping with classical ideals. Goya chose a scene of carnage in all its atrocity, combining a characteristically Baroque appeal to the senses with a delight in gruesome effects.

Goya, who had had ample opportunities to study works by the greatest Baroque and Renaissance artists, remained in many ways wedded to these earlier traditions. As in the case of many Baroque narrative paintings, strong chiaroscuro stresses the dramatic climax of a continuing action in his *Third of May*. The white shirt of the man raising his arms and the light projected by the lantern provide islands of vivid brightness in the otherwise gloomy setting. The painterly technique is Baroque and the flame-like handling of the surfaces of the figures and the trembling quality of the setting, which do much to convey the full

horror of the scene, go further back to the manner of El Greco. Baroque, too, is the relationship of figures and space. The line of soldiers, curving gradually beyond the right edge of the frame, is a line of force linking the scene to the far distance. The raised arms of the man facing the guns similarly link the prisoners to the sky above. The ridge on the left counters the curve of the row of soldiers with another dynamic accent.

In all these respects the composition remains much more Baroque than does that of David's *Oath of the Horatii*, and yet there are major differences between Goya's painting and such a masterpiece of Baroque art as Rubens' *Rape of the Daughters of Leucippus* (Fig. 12–1). In the Rubens the lines of force spread out in clear and powerful rhythmic accents throughout the picture and the surfaces are firmly and smoothly rounded. The main curves of the Goya, on the other hand, are less assertive, and their pattern is more broken up. The extreme painterliness of the treatment gives the surface a

flickering quality, and the overall effect is more fragmented. In one respect, in particular, the composition reflects a new attempt to subordinate form to expressive intent: the angularity of the figures of the soldiers stresses the mechanical quality of their action. Clearly the reaction against Baroque tradition, which was responsible for David's break with the past, was also affecting Goya.

The impact of the picture is tremendous. Doubtless influenced by the eighteenth century taste for the horrific, and devising potent pictorial means to express it, Goya conveyed the nightmarish quality of the scene by accentuating the facial expressions and stressing attitudes to the point of caricature. The helplessness, fear, and angry defiance of the prisoners are opposed to the impersonality of the soldiers. The artist even shows the man about to be shot with his arms upraised, as if to allude to the martyrdom of Christ. The work also reflects Goya's own mood and temperament; there is a touch of sarcasm in the way in which the soldiers

have become mechanical devices and the prisoners grotesque puppets. The artist's angry sneer at the destructiveness and helplessness of man dominates the expressive message.

The vaporous, almost flame-like handling of the forms, the insistence on gory details, the nightmarish quality of the scene, and even more importantly the utilization of all these devices to express with agonized intensity the artist's individual response to external conditions all make this a characteristically Romantic work. Furthermore, the survival of vigorous Baroque elements make it an important forerunner of the style of High Romanticism.

We find similar preoccupations in the huge *Raft of the Medusa* (Fig. 14–2), painted in 1818–19 by the Frenchman Théodore Géricault (1791–1824), which can be taken as marking the transition to High Romanticism in French art. The picture is based on a shocking episode that had taken place in 1816. While on an official mission to Senegal, the sailing

ship *Medusa* foundered on a sandbar off the coast of West Africa. The ship was abandoned, and passengers and crew took to the lifeboats and a large makeshift raft. The raft, which was laden with one hundred and forty-nine men, was pulled by the boats for a while, but in the dark of the night the towline was cut and the raft left to its own fate. During twelve days at sea, savage fights took place between officers and sailors; ultimately there were instances of cannibalism. Only fifteen desperately weak survivors remained when the raft was finally spotted by a rescue ship.

Géricault studied the published account that had been written by two survivors and interviewed these men at length. He made numerous studies of dead and dying men and carried his concern with realism to the point of having a raft built in his studio and piling it up with assistants and friends.

In several ways Géricault, who was a pupil of a follower of David, owed something to Davidian Neo-Classicism; the

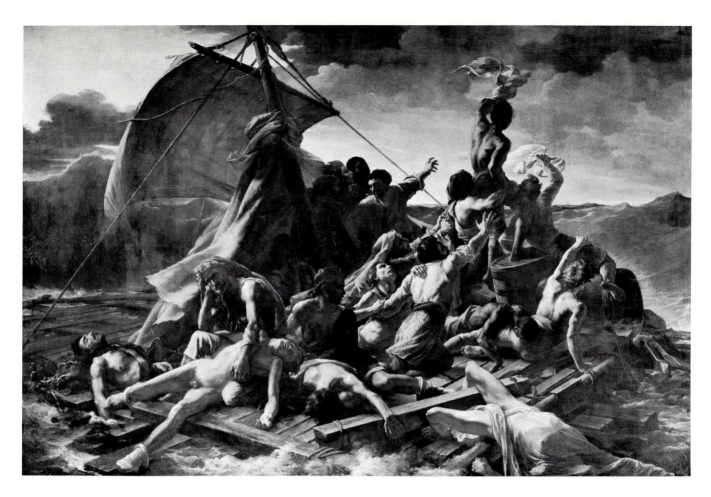

firm modeling of the flesh, the realism of the figures, and the precise play of light and shade over the surfaces go back to David (Fig. 13–10) and, beyond him, to Caravaggio (Fig. 11–1). There were also strong links with earlier traditions. The powerful and expressive musculature of the figures reveals the influence of Michelangelo whom Géricault greatly admired (Figs. 9–17 and 9–18). From the Baroque era came not only the Caravaggesque elements absorbed by Davidian Neo-Classicism, but also several compositional features. In one way, however, Géricault was closer to Baroque ideals than Goya in his *Third of May, 1808:* none of David's diagrammatic clarity survives. The raft is foreshortened into a diamond shape, its sides constituting receding diagonals, and the bodies of the living and the dead form complex and vigorous three-dimensional patterns, bringing to mind Baroque lines of force. One such line starts with the dead youth at the lower left and rises toward the sky along the arm of the rag-waving

black man, and another starts with the corpse at the lower right and ends with the mast to the left. As in Baroque paintings, also, there are pyramidal configurations: the group around the black man and the tent-like arrangement around the mast. Both the deliberate lack of clarity and the vigorous, almost Baroque interaction of the forms in space were to become characteristic of High Romanticism.

In several respects, however, Géricault departed from Baroque precedents. The two pyramidal structures instead of one make the composition less unified. And the overall pattern of lines of force is fragmented, and somewhat disorderly. In both these respects the work shows evidence of the modification of Baroque characteristics already noticed in Goya's *Third of May, 1808.*

The range of hues of the *Raft of the Medusa* is limited. There are but a few muted greens, reds, and blues among the dominant areas of browns. If the bodies and draperies are executed in smooth gradations of values going back to David's

technique, the complicated overall pattern of light and dark is essentially painterly. The human figures and the raft itself stand out as a dark mass surrounded by the fluid forms of the waves and clouds. The tenebrous effects and turbulent handling of the forms suggest a ghastly dream image, just as in the picture of Goya.

The painting can be interpreted on several levels. Unquestionably the work was intended to have political significance, and when it was exhibited at the Paris Salon of 1819 at least one critic asked maliciously why the official catalogue did not mention the painting's true title but merely referred to it as a shipwreck scene. The fact was that the loss of the *Medusa* had caused great embarrassment to the monarchical regime that succeeded Napoleon in France. The king and his entourage had made sustained efforts to fill official positions with émigrés, the old-time aristocrats who had been exiled during and after the Revolution and were now returning to France. Many of them were

totally unqualified for positions of responsibility, thereby causing widespread resentment. The captain of the *Medusa* was an émigré and the government rightly interpreted the subject of the picture as an attempt to deride it (and stubbornly refused to purchase the picture until after the artist's death, even though the director of the Fine Arts administration had recommended its acquisition, and the price was most reasonable). Seen in this light, the raft with its human cargo, lost in the immensity of the ocean, became a symbol of France's political helplessness after the restoration of the monarchy.

On a different level, the subject reflects the turbulent mood of Géricault's own generation—young men raised in the era of intense patriotic and militaristic fervor of the Napoleonic expansion who suddenly found themselves vegetating in a country ruined by war and controlled by a weak and excessively conservative government. Indeed, the artist must have intended to extoll the heroism of those survivors who had gathered enough energy to wave rags at the vessel barely visible on the horizon.

Beyond this, the work reflected fully and openly the personality of the artist. Géricault was known for his personal refinement, his warmth and generosity toward his friends, his passionate amorous involvements, and his dedication to the most energetic sports. He was also reckless and lost a sizable fortune in speculation. Ignoring warnings of illness, he continued to participate in strenuous sports, and died at the early age of thirty-two. Unquestionably it is his own love of frenzied activity and dazzling achievement that we recognize in the struggle of the survivors of the *Medusa*. And we can detect his own inclination toward pessimism and sadomasochism in the more morbid aspects of the work. It is as if the nightmarish and tumultuous vision were intended to project the artist's own most agonizing conflicts.

The unbridled emotionalism of the work and, more specifically, the desperate longing for self-fulfillment are characteristically Romantic, as is the attempt to relate the ebb and flow of the artist's own moods and the peculiarities of his temperament to a current event.

In the same way, Romantic artists often chose historical, biblical, or mythological subjects for their works, always in order to allude to an emotional state of paramount significance to them. When Eugène Delacroix (1798–1863), the chief exponent of High Romanticism in France, requested friends and acquaintances to attend the formal opening in 1861 of the Chapel of the Angels of the church of Saint Sulpice in Paris, the decoration of which he had just completed, he wrote of the chapel's mural depicting the biblical struggle of *Jacob and the Angel* (Fig. 14–3):

> Jacob brings herds and other gifts to Esau, whose anger he hopes to assuage. A stranger presents himself, stops him, and engages him in a relentless fight which only ends when the adversary touches the sinew in the hollow of Jacob's thigh and renders him powerless. This struggle is looked upon by the Holy Scriptures as an indication of the ordeals to which the Lord sometimes subjects the chosen ones.

Delacroix's interest was thus not merely historical or religious; the wrestling bout of Jacob and the angel became emblematic of the struggle of those who attempt to serve a high ideal, and Delacroix must have counted artists, including himself, among the chosen ones. The fight thus symbolizes the painter's relentless and agonizing struggle with his own inspiration and with the expressive means at his disposal. Indeed, Delacroix frequently referred to such a struggle in his voluminous journal: "In truth, painting," he wrote at the time he was working at Saint Sulpice, "harasses and torments me in a thousand different ways, like the most exacting mistress....What appeared easy at first now offers me horrible and endless difficulties."

Delacroix had received his early training from the same master as Géricault and had thus also been exposed to Davidian Neo-Classicism. He was soon profoundly influenced by the somewhat older Géricault, whom he greatly admired, and what changes took place in his manner after that time made him even more representative of High Romanticism.

The figures of Jacob and the angel form a pattern of intertwining three-dimensional curves—*arabesques,* Delacroix

14-3 Eugène Delacroix, *Jacob and the Angel,* 1849–61. Mural in oil and wax (23'2½" × 15'9½"). Chapel of the Angels, Saint Sulpice, Paris.

191

called them—that are nothing more than a complex and fragmented version of Baroque lines of force characteristic of the High Romantic style. Highlighted as though by a soft, imaginary light, the figures occupy only part of the stage space. Behind them is a dark cluster of huge trees rising toward the sky, their trunks powerfully twisted as though in response to the animated struggle below. To the right Jacob's horses, herds, and attendants are seen following what must be the riverbed mentioned in the Bible, and to the extreme left an opening in the mountain indicates the valley of the river. These two areas imply a climbing diagonal path beyond the trees, much as Rembrandt, whom Delacroix greatly admired, suggested that the bend of the river continued behind the central mound of *The Mill* (Fig. 12-4). Both areas, furthermore, are brightly lighted in contrast with the central mass, as if to provide relief from the main drama.

Whatever Caravaggesque precision in the modeling of the flesh and the shading of the figures was evident in Géricault's *Raft of the Medusa* (Fig. 14-2), none has survived in this painting. Delacroix's treatment, in keeping with his appreciation and understanding of Rubens' technique, is more consistently and exuberantly painterly, and in this respect he is more fully a High Romantic artist than Géricault. The outlines are free and fluid, and every area of the picture is made up of a variety of colored elements ranging from variegated blobs to long, thin colored streaks, the latter sometimes forming crisscross patterns. The forms, as a result, acquire an ethereal, flame-like existence in space. Indeed, like Rembrandt before him, Delacroix believed in cultivating a certain lack of definition. "Imagination loves vagueness," he once wrote. "It expands easily and embraces vast objects even though stimulated by summary indications." He went further and explained that this lack of definition invited the onlooker to project something of his own temperament into the picture: "I strongly believe that we always mix in something of ourselves with feelings that come from the object that strikes us."

Delacroix, furthermore, was most interested in the color theories expounded by physicists and estheticians of the time, who had discovered that if the hues of the rainbow are placed in a circle (with the addition of purple, which does not exist in the rainbow) and such a circle is spun, the colors cancel each other out and the result is white (or gray, because of the impurities in the hues). Hues diametrically opposite on the color circle, called *complementaries,* were thought to heighten one another and produce a more luminous and, especially, a more harmonious overall effect. Delacroix made abundant use of complementaries and near complementaries; the orange of Jacob's socks, for instance, seems to be complementary to the bluish hue of his garment. He also made use of a phenomenon that he had observed in nature and that had been interpreted scientifically: the shadows are rendered in blue-violet, as may be clearly seen in the shaded areas of the flesh. According to the nineteenth-century French scientist Michel Eugène Chevreul, when two different colors are placed side by side an optical illusion causes each to produce a zone of its complementary hue on the other side of the dividing line. The same is true of value; each color seems to project a strip of contrasting value onto the other. Thus, sunlighted areas that are high in value and have an orange-yellow cast appear to cause areas in the shade to be low in value and to have a blue-violet cast. This discovery tended to confirm the practice of earlier artists who had depicted areas in the sunlight in warm colors and areas in the shade in cool colors (see p. 175). Delacroix had also observed that colored objects exposed to sunlight tend to project their colors onto other objects, and such colored reflections may be observed in many areas of this picture.

Aside from naturalistic considerations and from the harmonious effect they produce, the lively juxtaposition of colors serve an expressive purpose; the contrasting hues of the garments of the figures add to the excitement of the struggle, while the dominant blue-greens of the setting introduce a note of peace and serenity into the whole composition. Certain linear patterns likewise play an expressive role. The complex, curving outlines—which, incidentally, occasionally violate the laws of anatomy—effectively suggest the animation of the fight. Beyond this, the dance-like grace of the stance of the two figures seems to be amplified by the upward twist of the trees.

In his handling of line, just as much as in his choice of colors, Delacroix expressed a mood of subdued elation, not so much in celebration of victory, since the fight was inconclusive, as in recognition of the opportunity to struggle for a holy cause. Writing in 1861, after lamenting the agonies of creation, the artist asked: "Why is it that this eternal combat, far from running me down, uplifts me and occupies my mind even when I am away from my work?" The answer, he explained, lay in "a happy compensation for the things that the years of youth have taken away with them, a noble use of the moments of creeping old age, which still leaves me the strength to overcome physical pain and spiritual suffering."

This sublimation of the Romantic agony in a mellow and harmonious serenity is characteristic of all Delacroix's late works. There is little doubt that the artist attempted to express this attitude symbolically in this painting through the very choice of subject matter, for the biblical story ends with the angel telling Jacob, "Thy name shall be called no more Jacob, but Israel: for as a prince hast thou power with God and with men, and hast prevailed" (Gen. 32:28).

Delacroix's conscious use of combinations of colors and patterns of lines to achieve harmonious effects and to complement the expressive message of the picture was discussed at length by Charles Baudelaire, who was not only a poet but the most significant French art critic of the nineteenth century. Elaborating on

Delacroix's ideas, he wrote, "Everyone knows that yellow, orange and red inspire and convey the idea of joy, richness, glory, and love." As for line, he said, "A well-drawn figure fills one with delight totally extraneous to the subject. Voluptuous or terrible, this figure owes its charm only to the arabesque it cuts out in space." This alleged capacity of color and line to affect us independently of subject matter was to become one of the favorite notions of later artists, who compared it to the power of musical chords and rhythms to affect us, even though the composer may not actually have been telling a story. We shall refer to this property as *musicality*. Of course, artists had made use of musicality since the beginning of time, and our frequent references to "rhythmic quality," "harmony," and the expressiveness of forms and colors in connection with earlier works could well be included under that heading. The important idea introduced in the nineteenth century was that the effects of line and color could be "totally extraneous to the subject," a concept that was to justify flagrant distortions in the work of the Romantic artists and certain of their successors and was to lead to abstract art in the twentieth century.

Jean Auguste Dominique Ingres (1780–1867) could be more extreme than Delacroix in his distortions of the human body, although he claimed both an unfailing allegiance to nature and a blind devotion to the standards of antique art. Ingres was a pupil of David and as such had received a Neo-Classical training. In

the 1820s and 1830s, when French academic circles were dominated by former pupils of David, he became the foremost advocate of classicism and detractor of Romanticism. Ingres and Delacroix thus became the leaders of two opposite factions in French artistic circles and carried on a fight that had its roots in artists' quarrels dating back to the latter part of the seventeenth century. Those who placed drawing above color, sought a high degree of finish in their work, aspired to a classical loftiness, and saw themselves as the heirs of Poussin gathered around Ingres, while those who placed color above drawing, believed in a certain spontaneity of execution, pursued a Romantic ideal of emotional exuberance, and paid homage to Rubens gathered around Delacroix.

As is so often the case in such quarrels, the protagonists had much more in common than they admitted. However much certain aspects of Ingres's execution may link him with the classical tradition, his musicality and the very personal quality of his expressive message made him a Romantic. These tendencies may be traced to Ingres's artistic training, for there was, as we have noted, a truly Romantic fervor in that model of Davidian Neo-Classicism, *The Oath of the Horatii* (Fig. 13–10). David's workshop also harbored a group of young radicals who, following a trend we detected in Blake (Fig. 13–8), favored the quaint and elegant distortions they associated with archaic art and the Gothic manner and were therefore at odds with the truer

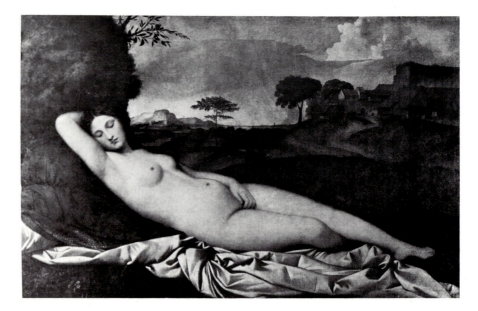

9-4 *This page, right:* Giorgione da Castelfranco (completed by Titian), *Sleeping Venus,* c. 1508 *(comparative illustration).*

14-4 *Opposite page:* Jean Auguste Dominique Ingres, *Grande Odalisque,* 1814. Oil on canvas (35¼″ × 63¾″). Louvre, Paris.

10-1 *This page, below:* Parmigianino, detail of *Madonna with the Long Neck,* c. 1535 *(comparative illustration).*

classicists. Ingres was undoubtedly much influenced by them.

The outcome may be judged from a work of his maturity, the *Grande Odalisque,* painted in 1814 (Fig. 14-4). It is in the tradition of the great Renaissance and Baroque reclining nudes such as Giorgione's *Sleeping Venus* (Fig. 9-4) and Velázquez's *Venus and Cupid* (Fig. 11-10), but the differences are startling. Comparing it with the Giorgione nude, we notice immediately that it has the precisely delineated edges and firm, smooth surfaces that we have consistently associated with the classical tradition and certainly it owes much to David himself. The proportions, however, are anything but classical. In fact, the artist has indulged in a poetic license that shocked many of his contemporaries when the picture was exhibited at the Salon of 1819 (in which Géricault's *Raft of the Medusa* was also shown). One critic complained that the odalisque had three extra vertabrae, and Baudelaire, at a later date, made fun of Ingres's practice of painting "a breast which points too much toward the armpit." Indeed, Ingres stressed the roundness and continuity of the outlines of the body and flattened and elongated most of the forms. He also seems to have compressed the whole composition toward the picture plane, thus repudiating the ideal of deep space that had been so important to Western artists since the late Middle Ages. The details are hardly anatomically correct, but the result is nevertheless a refined, sensuous, and almost precious rhythmic quality.

We find similar artifice in the handling of color. Although Ingres advocated "grayness rather than brilliance" and called color an "ornament of painting, but...no more than a handmaiden to it," he was a very subtle colorist. Not only did he achieve a superb silky effect with the highlights on the curtain, but he livened the dominant blue of the fabric with the contrasting orange-red of the woven design. The turban and jewelry on the woman's head are rendered with meticulous precision but nevertheless

produce an effect of painterly vibrancy as well as sumptuous harmonies of green-yellow, copper, and ruby-red. Finally, a close inspection of the flesh reveals a great variety of low-intensity colors from pink and copper to blue in the shadows. The blue is applied in subtle transitions to suggest an exquisite modeling of the surface comparable, perhaps, to that of some shallow enamel or ceramic relief. And, with an uncanny sense of surface design, Ingres repeated the most vivid tonalities of the flesh—copper, red, and blue—in higher intensities in areas around the figure, much as the composer of a musical work includes notes of a soloist in the orchestral accompaniment.

If Ingres's taste for linear eccentricities can be linked to an early attachment to Archaic Greek and to Gothic art, his handling of form and color may also reflect another influence, that of certain Italian Mannerists. Indeed, the arbitrary elongation and flattening of the oda-lisque's body, the serpentine animation of the edges, and the jewel-like handling of

the surface all bring to mind Parmigi-anino's *Madonna with the Long Neck* (Fig. 10–1). Even the pouting detachment of the expression evokes the Madonna's aristocratic coldness. Ingres was certainly familiar with examples of Mannerist art. Beyond the purely formal relationships between this painting by Ingres and Mannerism, there is a remarkable similarity of mood; the diffuse eroticism of such artists as Parmigianino has now become a controlled and highly refined sensuality. In the *Grande Odalisque* the subtle tonalities of the flesh no less than the taut yet roundly feminine curves of the body and the richness of the textures suggest a vision of sublimated lascivious abandon.

The subject of the *Odalisque*—a beautiful inmate of the harem of some Eastern potentate leading a life of inaction and occupied mainly with her sensual dreams—occurred in several contemporary novels and tales of Eastern travels that fascinated the nineteenth century. It was an essentially Romantic theme, implying a long agony made bearable only through the

stimulation of the senses, and must have struck a responsive chord in Ingres, who painted many such subjects.

The mood of Ingres's work could range from sublimated lasciviousness to arcane loftiness, all the while reflecting the artist's refined sensuality. His manner varied considerably to fit the subject, and his ability to subordinate form and color to individual mood can be linked to Delacroix's musicality. The term High Romantic should nevertheless probably be reserved for artists such as the fully mature Géricault and Delacroix, who cultivated an intense emotionalism and favored compositional devices of the Baroque age to suggest animation and achieve some coordination of the forms in space. Ingres, with fairly uniform color areas and his arrangement of figures parallel to the picture plane, still remained linked to Davidian Neo-Classicism.

Some of the landscape painters active during the first half of the century sought to express intense emotion and a sense of drama and were close to the more

14-5 Joseph Mallord William Turner, *Cottage Destroyed by an Avalanche* (*The Fall of an Avalanche in the Grisons*), c. 1810. Oil on canvas (35½″ × 47½″). Trustees of the Tate Gallery, London.

exalted aspects of Romanticism; others were interested in near-scientific observation and a more subtle and restrained expressiveness. The Englishman Joseph Mallord William Turner (1775–1851) was unquestionably among the former. His *Cottage Destroyed by an Avalanche* (Fig. 14–5), executed around 1810, must have been painted from imagination; Turner had traveled in the Alps, but it is unlikely that he actually witnessed an avalanche. Like other examples of Romanticism, it shows affinities with Baroque principles of composition. The design is dominated by the diagonals created by the falling rock and the edge of the dark clouds, on the one hand, and the slope on the right, on the other. In the central area of the picture, two whitish mountain masses form a receding line toward the far distance. Unlike Baroque works, however, these accents are disconnected, and the overall effect is somewhat fragmented.

In some respects Turner shared the interest of his contemporaries in suggesting a truthful overall impression, and in this he had affinities with Romantic Naturalism. Occasionally applying color with a palette knife to create striations and a rough surface, he made use of a rich painterly technique that admirably suggests both the turbulence and the transparency of clouds and drifting snow, thus creating a stormy atmosphere that pervades the whole scene and unites the various parts of the composition. He shocked many of his contemporaries with the spontaneity verging on untidiness of his swift and nervous individual brushstrokes and with his abandonment of the precision of individual details that had characterized earlier realist traditions. In our own time, conditioned as we are by recent abstract art, this freedom of execution conveys to us a sense of energy and excitement that seems to reflect the unique personality of the artist. In his later works, Turner applied his paint in bold streaks and soft washes of high-value and often high-intensity color; these add further to the surface excitement and, when viewed at a distance, heighten his atmospheric effects with a poetic, delicately colored glow.

In one way the mood of his *Avalanche* reflects the excessive emotionalism associated with the taste for the horrific. Nature is made to appear at its most demented, as a particularly large rock still carrying a number of trees is crushing what must have been a quaint Swiss cottage. A poem written by Turner in connection with this picture fully corroborates this impression:

> its pine clad forests
> And towering glaciers fall,
> the work of ages
> Crashing through all!
> extinction follows,
> And the toil, the hope of man
> —o'erwhelms.

Beyond this sense of doom, however, is the notion that the artist can catch at such moments of turmoil "the full manifestation of sublimity," as his admirer John Ruskin put it, an idea that in turn hints at the ubiquitous presence of God the creator. In one of his most passionate eulogies of Turner, Ruskin wrote,

He stands upon an eminence, from which he looks back over the universe of God and forward over the generations of men. Let every work of his hand be a history of the one, and a lesson to the other. Let each exertion of his mighty mind be both hymn and prophecy; adoration to the Deity, revelation to mankind.

The Romantic artist had thus become a seer, who was somewhat isolated from the world of ordinary men and whose intensely personal vision of nature embodied the "living energy," as Ruskin put it, of the universe. The practice of his art enabled him to convey to others, however sketchily and incompletely, something of this inner exaltation, which may well constitute the greatest form of self-fulfillment for the Romantic mind.

A contemporary of Turner, John Constable (1776–1837), evolved a much more objective approach to the natural world and became one of the leading exponents of what we have called Romantic Naturalism. He was entranced by the humblest aspects of the English coun-

tryside. "But the sound of water escaping from mill-dams, etc., willows, old rotten planks, and brickwork, I love such things," he once wrote, and he set out to depict them with utmost faithfulness and at the same time to infuse his pictures with a potent personal lyricism. Indeed, although Constable had, in some respects, the objective attitude of a scientist, he was also intuitively aware of a life force pervading the natural world that he associated with a divine being: "Everything seems full of blossom of some kind," he wrote to his wife after a springtime walk. "And at every step I take, and on whatever object I turn my eyes, that sublime expression of the Scriptures: 'I am the resurrection and the life,' seems as if uttered near me."

Constable's *Whitehall Stairs,* or *The Opening of Waterloo Bridge* (Fig. 14–6), started around 1819 and completed by 1832, is a remarkable example of his work. Although it is a finished picture sent to the Royal Academy exhibition, it has much of the freshness of execution that

characterized his more spontaneous preliminary oil sketches. The work depicts the ceremonies held in London to mark the second anniversary of the battle of Waterloo (in which the British defeated Napoleon and put an end to his career), in the course of which the new Waterloo Bridge was inaugurated. It shows the royal barge departing from the prime minister's house to take the prince regent to the bridge, which can be seen in the distance. Since the painting was started two years after the ceremony, the artist must have relied on his memory and perhaps to some extent on his imagination.

In some respects the work reveals a lingering attachment to Baroque devices—not surprisingly, since Constable professed a great admiration for the leading landscapists of the seventeenth century. One senses, for instance, the energy of Baroque lines of force in the curvature of the two trees to the left. The configuration of the clouds, moreover, creates a diagonal cutting across the sky. Also the horizontal

14-6 John Constable, *Whitehall Stairs (The Opening of Waterloo Bridge)*, c. 1819-32. Oil on canvas (4'3" × 7'1"). Private collection: reproduced by permission of the owner.

accents created by the top of the wall to the left, some of the boats, and finally the bridge in the distance lend a sense of structure to the composition, as do the architectural elements in Poussin's *Eliezer and Rebecca* (Fig. 12-7).

Nevertheless, one is much less aware of these compositional devices than in Baroque works. Much more evident is a new and intense interest in naturalistic elements. The artist paid much attention to the luminosity of sky and atmosphere and to the shimmer of the vast expanse of water as he might have observed them in the course of his many sketching expeditions. The clouds, the treatment of which reflects Constable's painstaking and sensitive study of the sky over the years, are tinged in part with a light pink. Without doubt the artist was attempting to suggest reflections of the reddish afternoon sun; he must also have wished to take advantage of the contrast of the pink with the neighboring blue areas of the sky. Such juxtapositions had been used to decorative ends by Rococo artists; here

the contrast contributes a great deal to the impression of airiness and luminosity of a spring day in London, while also adding a touch of excitement.

In keeping with earlier practices, Constable depicted the area of water in the far distance in low-intensity, high-value tones, suggesting the large amount of light reflected by the receding landscape. These higher value areas attract attention to the distance, as do the glistening white bridge and the even whiter burst of smoke from a gun saluting the prince. The areas of water in the foreground are in much lower value, but here Constable suggested the variegated reflections, caused by the ripples, by means of irregularly, almost scratchily, applied areas of white, heightened in places by pinkish reflections. In so doing he suggested beautifully the silvery quality of the water surface while introducing a remarkable degree of painterly excitement through the liveliest contrasts of hues and values. The colorful boats themselves add to the richness of the scene. The house and wall

at the left, furthermore, provide neutral tones that make the hues of water and sky all the more lively, while the dark mass of the trees beyond the house makes the gray clouds faintly luminous.

To a remarkable extent Constable attempted to show the scene as the human eye sees it. The bridge is seen as clearly as possible through the atmospheric haze, as though the artist's eye were focused on it. The areas in the foreground are shown somewhat blurred, as they would be if seen only peripherally. Taking advantage of this deliberate fuzziness, the artist painted the near walls and the bushes to the left in a lively multitude of independent brushstrokes.

The work differs from Turner's in its more complex and more orderly composition. Far from suggesting one of the more turbulent moods of nature, Constable evoked an almost enchanted relationship between the harmonious majesty and delicate luminosity of the landscape and the fleeting vision of the procession of boats. Above all, however, Constable was much

14-7 Camille Corot, *View of Genoa,* 1834. Oil on paper, mounted on canvas (11⅝" × 16⅜"). Art Institute of Chicago, Ryerson Collection.

more concerned with optical truthfulness than Turner.

In addition to catching the likeness and mood of the scene, and in keeping with the stress on personality of Romanticism, Constable was unquestionably projecting his own temperament. The whole picture reveals a robust yet reflective, forceful yet sensitive, gentle and warm, personality. Significantly, after the death in 1829 of the wife he loved deeply, he became increasingly subject to fits of depression, which seem to have found an echo in the brooding quality of many of his later works.

Constable's use of comparatively pure hues in a bold painterly technique was little short of revolutionary, for the results are as naturalistic as they are exciting. Not only was Delacroix impressed by his technique when he saw one of his works in 1822, but several of the artists of the vigorous French Romantic Naturalist school owed much to him.

The earliest exponent of Romantic Naturalism in France was Camille Corot

(1796–1875), whose *View of Genoa* (Fig. 14-7) is one of many pictures executed during a stay of several months in Italy in 1834. Corot was among the first to execute finished paintings out of doors, and the *View of Genoa* illustrates superbly his achievement of one of the effects that must have been most challenging to a Romantic Naturalist artist: the suggestion of the full luminosity of a clear sunny day. He seems to have noticed that in areas exposed to the full sun the surfaces are somewhat dazzling and the details are therefore rather indistinct. Any strong hues, furthermore, appear faded. Significantly, the sides of the houses in the center that are most exposed to the sun reveal few details and are shown as almost uniform areas of creamy white. The darker areas also appear to be somewhat indistinct, as though the eye that has adjusted to the strong light cannot easily differentiate the darker forms. Accordingly, the brush in the foreground and the trees to the left and right are rendered in a loose array of green and

brown stipples and strokes that create a somewhat blurred overall effect. In the areas of the houses, moreover, the juxtaposition of the simplified areas of light and dark walls creates cube-like arrangements. The most fully detailed areas are those in medium values. The pink house to the left, which is at an angle to the sun's rays, is not exposed to their full intensity. Here, making use of a loose and deft painterly technique, the artist suggested with remarkable economy and effectiveness the details, texture, and actual color of the masonry.

Corot seems to have noticed, furthermore, that areas in the shade are lighted by reflections; one detects a subtle luminosity in the shadows on the climbing path to the right and on the darker sides of the houses in the center. Finally, Corot's shadows are usually not gray. There is a violet tinge to most shaded areas, indicating his awareness that the overall luminosity could be intensified by stressing warm hues in the areas exposed to the sun and cool hues in the areas in

14-9 John Soane, Bank of England, Colonial Office, London, 1818-23.

the shade. Incidentally, both the subtle use of light reflections and the use of cool hues in the shadow and warm hues in the sunlight anticipate the color theories evolved in subsequent years by Delacroix.

Despite this extraordinary dedication to the truthfulness of visual effects, Corot always managed to introduce formal order in his pictures. There is a clear balance between the mass of the house to the left and the trees to the right, while the group of houses in the center form a V. And the outline of the city against the sea sloping down to the right is offset by the thin band of blue clouds in the far distance that rises to the right. Thus, for all its apparent spontaneity, the scene is dominated by an intricate and harmonious arrangement of diagonals, verticals, and horizontals. The overall effect is remarkably controlled and serene, while the silvery luminosity of the atmosphere conveys an aura of meditative detachment. Like the great majority of Corot's pictures, the *View of Genoa* is characterized by gentle lyricism and nostalgia.

Developments in architecture during the period we have been discussing included a number of revivals. The Gothic and Neo-Classical styles inherited from the eighteenth century survived, often developing into archeologically purer forms through the nineteenth. In addition there were returns to various Renaissance styles, a Baroque style, and even a Romanesque style. As a rule these revivals affected primarily the surface decoration of buildings; all the while, steady progress was being made in devising ways of designing structures and interior layouts to fulfill the varied and increasingly complex demands of public and domestic life.

The Colonial Office in the Bank of England in London (Fig. 14-9), designed by John Soane (1753-1837) and erected between 1818 and 1823, belongs to the Neo-Classical revival. The design relies even more emphatically on smooth surfaces and precise geometric articulation of the walls than does that of the Petit Trianon (Fig. 13-7), and stresses with much greater boldness a manipulation of

14-10 Joseph Paxton, Crystal Palace, London, 1851.

the masonry. Even more remarkably, the architect attached great importance to the geometric purity of the overall configuration, particularly the round arches and the circular base of the cupola, which delimit the solids and voids with clarity and precision. This spartan treatment of the surfaces and nearly mathematical handling of forms characterized the most severe aspect of the Neo-Classical style and seems to have heralded the tendency toward geometric purity of the International style of the twentieth century.

London's Houses of Parliament (Fig. 14-8), designed by Charles Barry (1795–1860) and built from 1840 to 1865, is one of the landmarks in the progress of the Gothic Revival in England. The very fact that the commission appointed to award the contract requested designs in the "Gothic or Elizabethan style" marked a victory for the anticlassical factions, and it is significant that Barry, who had hitherto distinguished himself primarily through his residences in Renaissance style, submitted a design in a fairly

authentic version of late English Gothic.

The principal distinction of the building lies in the ingenious arrangement of assembly halls, committee rooms, offices, restaurants, and no less than twelve inner courts, intended to facilitate the workings of Parliament and lend dignity to its activities. In contrast to the complexity of the interior, the flat and regular river façade is little more than an ornamental screen. In keeping with the taste for the picturesque, however, great care was lavished on the decoration of the façade, which has the ornate delicacy of some of the best late Gothic stonework (Fig. 7–19), and an element of asymmetry was introduced in the two larger towers, which are unequal in size and out of alignment. It was undoubtedly Barry's concern with ornaments that would be both archeologically accurate and visually pleasing that led him to secure the services of a much younger man for much of the detailing—the architect A. W. N. Pugin (1812–52), who was a serious student of English Gothic architecture.

Inevitably, the growing dichotomy between the function of a building, reflected in the arrangement of its interior spaces, and its surface decoration led to a dramatic evolution, one that was first felt in semi-industrial buildings but eventually had a profound impact on civic and residential architecture. In 1850 a governmental committee announced a competition for a building to house the Great Exhibition of the Works of Industry of All Nations, to be held in London in 1851. The building was to cover some twenty-one acres and had to be capable of being assembled and disassembled in a short time. Joseph Paxton (1801–65), the architect eventually selected for the project, chose a kind of greenhouse construction, which had the advantage of providing uninterrupted spaces for the exhibits and a bright and airy setting to enhance them. The result was the so-called Crystal Palace (Figs. 14–10 and 14–11), the major achievement of Victorian architecture. The building was pulled down after the exhibition, rebuilt with

14-11 Joseph Paxton, Crystal Palace, interior, London, 1851.

modifications in another part of London, and ultimately destroyed by fire in 1936.

Paxton played an extraordinary role, not only in designing and engineering the building, but in getting it built. Having persuaded the committee to adopt his design over one it had itself prepared, he established the plans and obtained the contractor's bids in a matter of weeks. The success of the operation lay in his ingenious utilization of standard, easily manufactured units throughout the construction and his design of iron pillars, girders, and tension wires carefully calculated to be as light as possible and yet resist expected stresses.

For all Paxton's interest in practicality and economy, great attention was paid to esthetic considerations. The noted decorator Owen Jones went over the design of every single part to make sure that it was pleasing and that the finished building would be harmonious. The overall color scheme was handled with equal care. According to a visitor, when one looked down the nave, the ends seemed to disappear in a light blue fog. Much of the metalwork was indeed blue, but the underside of the girders was painted red, and this color recurred behind the gallery railings and on screens in the exhibition area, providing rich and lively contrasts.

The building carried to its logical conclusion an idea already implemented in the Houses of Parliament, that the walls of a building could be treated like screens. Here the architect went a step further and distinguished between the glass areas that provided protection (while letting in a maximum of light) and the metal framework that provided structural strength. This distinction, of course, had been vaguely foreshadowed by the practices of Medieval architects, who channeled structural stresses within piers and ribs, treating the webs of the vaults and the glass and tracery of the windows like a skin. It reflected also the subtle change that took place in the early stages of the Gothic Revival, when walls came to be considered as an envelope to be treated with a casualness bordering on whimsi-

cality, as Horace Walpole had demonstrated at Strawberry Hill (Fig. 13-6). Eventually the concept that the outside walls were little more than screens was used to remarkable advantage by the American architects of the 1870s and 1880s who developed the skyscraper.

The Crystal Palace was important in two other respects. Seen as a whole, the interior with its multitude of girders, struts, and tension wires created a vaporous effect. At close range, not only did the interplay of the various members prove bewildering, but movement of the observer in one direction or another created a multiplicity of effects. We have already noted the Gothic interest in complexity based on a multiplicity of effects (p. 85) and have detected a similar interest in the handling of painted vistas and the use of mirrors in the Rococo period (p. 173). The Gothic Revival of the nineteenth century and the development of industrial architecture reasserted the validity of this device, which was to play a major role in the twentieth century.

15

Realism, Impressionism, and Romantic Symbolism

The cause of naturalism in France was given considerable impetus in the middle of the nineteenth century by both the artistic achievements and the attention-seeking polemicizing of the painter Gustave Courbet (1819–77). After first drawing inspiration from such Romantic masters as Géricault and Delacroix, as well as from seventeenth-century Dutch and other old masters, Courbet developed a manner and an ideology that he called Realism. His fundamental ideas may well have been derived from the circle of literary men he frequented in the 1840s, writers of Romantic bent who based novels and dramas on the life of the Bohemian milieu to which they belonged, thereby introducing a new touch of veracity, and at times a new social consciousness, into literature. In the course of the 1840s and 1850s the notion that the painter should depict everyday life gained momentum, and in 1855 Courbet defined his Realism in a manifesto that stated as his principal aim "to translate the customs, the ideas, the ap-

pearances of my epoch." The Realist artist thus became a reporter recording the life of his own time for posterity and in this respect reflected the trend toward Positivism.

Stylistically such a work as *The Meeting* of 1854 (Fig. 15–1) is still closely related to the innovations of Corot (Fig. 14–7). Courbet suggested the play of light and shade over the surfaces by means of broadly painted areas of various values, and he successfully achieved the effect of strong sunlight, primarily through the purity of the blue sky and the comparatively high values of the greens and earth colors of the landscape. The shadows are in comparatively cool hues and seem illuminated by reflections. On the other hand, Courbet was less successful than Corot in achieving visual unity. The picture was composed in the studio from portrait and landscape studies, and not only do the three principal figures seem less brightly lighted than the setting, but their solid edges stand out somewhat harshly against the sky.

Courbet's most important innovation lies in his approach to subject matter. He was not always content, as the Romantic Naturalists had been before him, to suggest his meditative reaction to the beauties of the landscape. In many of his works he was clearly seeking a new sense of immediacy; in some he was attempting to convey a social message. Much is now known about the circumstances under which *The Meeting* was painted, and Courbet's source of inspiration, in particular—a detail of an eighteenth-century woodcut print called *The True Portrait of the Wandering Jew* (Fig. 15–2)—is most revealing. Courbet's painting shows the artist himself, at the right, meeting his friend and patron Alfréd Bruyas and the latter's manservant as he is walking in the countryside. It is likely, however, that such an encounter never occurred and that the artist devised this particular scene for symbolic purposes. Indeed, Courbet had just visited Bruyas and secured a loan from his wealthy friend to help him present a one-man exhibition at the Paris

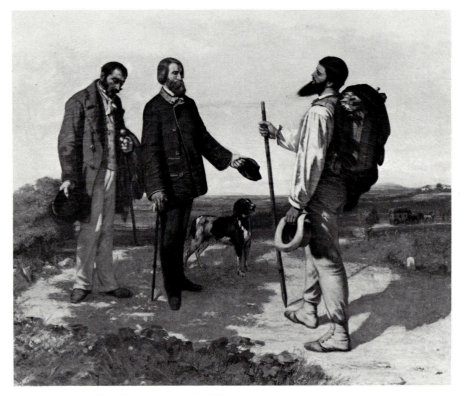

15-1 Gustave Courbet, *The Meeting,* 1854. Oil on canvas (4'2¾" × 4'10⅝"). Musée Fabre, Montpellier, France.

15-2 Anonymous, *The True Portrait of the Wandering Jew,* detail. 18th century woodcut. Collection of L. N. Pommer (*comparative illustration*).

Exposition of 1855, which he called the Pavilion of Realism. In all likelihood, the painting was meant to stress the friendly relationship between the genial Courbet and the generous Bruyas, but, beyond the personal level, Courbet may well have intended to express a social message. The print represents an exchange of greetings between the Jew, a member of a social group that had hitherto been ostracized, and the well-dressed city dwellers, representatives of a tradition responsible for the ostracizing. Although the Jew is still deferential in his attitude and the Gentiles appear distant, the new urbanity may be intended to suggest the beginning of courteous relations after centuries of mutual distrust. Courbet's painting may thus have intended to oppose the working class, to which the artist, an ardent socialist, claimed to belong, and the moneyed classes, to which Bruyas certainly belonged. Amusingly, it is Courbet's bearing that is proud, while Bruyas's gesture seems both admiring and deferential and the valet's attitude is obsequious; the

artist is clearly asserting his sense of emancipation. Beyond this, the artist may also have meant to suggest the dawn of a new era of cooperation between classes. What better way of leveling financial iniquities, from Courbet's standpoint, than for rich men to assist promising young artists?

The remarkable thing about the symbolism of the work is that it does not rely on well-known motifs to express spiritual values, like Venus and the liberal arts in Botticelli's fresco (Fig. 8–17), for only a very few people could have recognized the theme of the Wandering Jew. Nor does it rely on a nightmarish occurrence to express the artist's political views and emotional state, as Géricault's *Raft of the Medusa* had done (Fig. 14–2). Instead Courbet seems to have drawn together a series of complex and not altogether explicit associations and compressed them into a single, specific incident, which he tried to make as life-like as possible. The figures are at once themselves and symbols of the

principles and social values for which they stand.

Gone is the sense of drama of Romanticism; Courbet painted ordinary scenes from everyday life. Gone too is the meditative nostalgia of such Romantic Naturalists as Corot; Courbet strove for a new directness and a sense of immediacy. Like a reporter, he had sought to allude to the interplay of complex social forces while remaining faithful to his observation of physical reality.

Courbet was not averse to injecting personal elements into his work. In this particular painting he seems to have taken delight in the self-assured stance of his own figure, as if to evoke his own good-humored arrogance. But beyond the handling of content, his personality emerges in all his works through his painterly technique: there is something both energetic and sensuous in his thick application of paint in impastos and scumbles and in the subtle play with values.

The example of Courbet profoundly affected developments in the second half

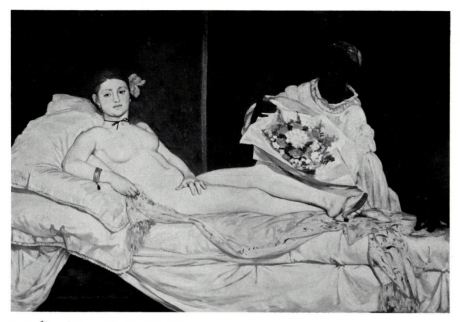

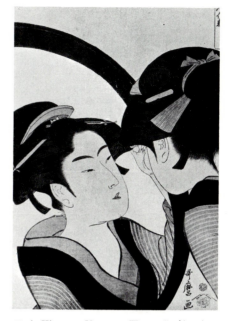

15-3 Édouard Manet, *Olympia,* 1863. Oil on canvas (4'3¼" × 6'2¾"). Louvre, Paris.

15-4 Kitagawa Utamaro, *Woman Looking in a Mirror,* c. 1790. Woodcut (10" × 11"). Museum of Fine Arts, Boston, Spaulding Collection (*comparative illustration*).

of the century. The significance he attached to everyday scenes, his dedication to humble subject matter, and above all his striving for spontaneity gave a new meaning and a new vigor to the naturalist tradition and led to the last and most appealing manifestation of naturalism, Impressionism. The man who paved the way for the developments of Impressionism was unquestionably Édouard Manet (1833–83), although he in turn was to follow the younger members of the movement in adopting a truly Impressionistic technique. Manet's revolutionary contribution is already fully apparent in his *Olympia* (Fig. 15-3) of 1863. The subject, if it appears to be uncommon, belongs nevertheless to everyday life. Olympia was a secondary character, a lady of easy virtue, in Dumas fils' novel *La Dame aux Camélias,* and there could be no doubt in anyone's mind as to what the picture represented; lying nude on her bed, a high-class prostitute looks somewhat haughtily at an unseen visitor, while a black servant holds a large bunch of

flowers—the offering, probably, of another admirer.

The handling of form and color reveals considerable concern with naturalistic effects. The firm delineation of the graceful body of Olympia, no less than the suggestion of a certain flabbiness of the cheeks, shows the artist's scrupulous attention to the appearance of the model. The handling of color, moreover, is skillfully calculated to suggest a specific lighting effect. The high values of the figure of Olympia, the bed, and the garment of the servant, on the one hand, and the low values of the background, the face of the servant, and the cat, on the other, create a strong contrast. In both light and dark areas the artist simplified the forms, as if to suggest that the contrast has caused a loss of sharpness in the onlooker's visual perception. Corot had suggested the simplifying effect of strong light and shadow in his landscapes (p. 199) and had conveyed superbly the effect of bright sunlight. Here Manet suggested with remarkable immediacy the crude intensity

of natural light illuminating part of a dark interior. The artist also magnificently rendered, through his occasionally free painterly technique, the soft quality of the flesh and the silky texture and sheen of the fabrics.

Manet made use of evocative allusions to add to the overall impact of the painting. In the first place, the colors themselves seem to have an associative value. Departing from the dominant earth colors of Courbet, Manet made use of the most delicate blues, pinks, and reds in the foreground and browns and greens in the background, as if to recapture something of the coloristic richness of the old masters. Even more important, the subject matter brings to mind a succession of great nudes that includes Ingres's *Grande Odalisque* (Fig. 14-4) and goes back to Giorgione's *Sleeping Venus* (Fig. 9-4). Manet, in fact, had once copied a Venus by Titian inspired by the Giorgione. Thus, both the freshness and richness of the color scheme and the pose of the model were meant to enhance this vision

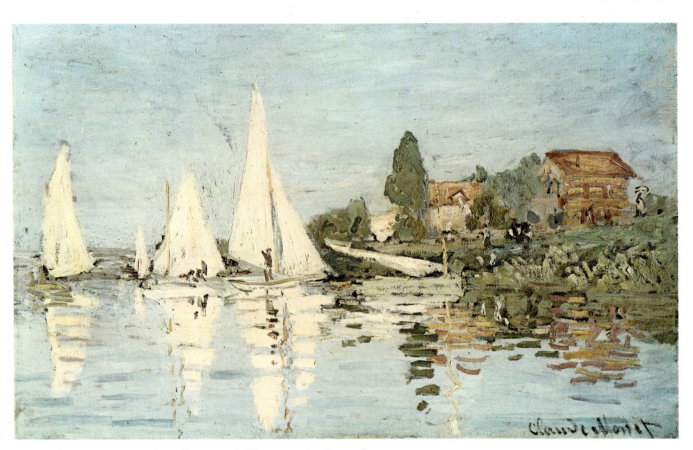

15-5 Claude Monet, *Regatta at Argenteuil*, c. 1873–74. Oil on canvas (18¾″ × 28½″). Louvre, Paris.

of a modern courtesan with memories of the polychromatic richness and graceful composition of older masterpieces of Western art.

Another association is seen in the way in which Manet's simplification of the strongly lighted and dark areas led him to model the body of Olympia by means of a narrow zone of half-shadow, which creates a graceful band-like outline around the body. This treatment brings to mind the Japanese woodcuts then becoming increasingly admired in Parisian artistic circles, such as the eighteenth-century print by Kitagawa Utamaro (1754–97), *Woman Looking in a Mirror* (Fig. 15–4). Indeed, it is likely that the novelty of Manet's simplifications and linearism was meant to be associated with the more abstract qualities of what the Japanese called Ukiyo-e, or "images of the floating world" and what, to Western eyes, was a refined tradition, exotically remote and yet surprisingly true to everyday life.

The subject of the courtesan in the luxury of her apartment was full of lit-

erary associations, yet Manet was careful to avoid any intellectual or moral comment and to steer as clear of satire as of melodrama. In spite of the directness of Olympia's stare, Manet presented a woman as detached and self-contained as a Renaissance Venus and so stressed the immediate and purely sensory appeal of textures, color, and light that he in effect transformed figures and objects into a sumptuous still life. Thus, like Courbet, Manet relied on a play of associations to add to the purely visual impact of his pictures, but whereas Courbet turned his figures into allegories of their individual moral and political stand in life, Manet attempted to establish a parallel between his reactions to visual reality and his reaction to the art of the past and of distant lands.

The freshness and spontaneity of Manet's vision, his love of intense and harmonious color schemes, his attachment to subjects of everyday life, and his faithfulness to observed lighting and atmospheric effects were to be a source of

inspiration to a number of men who rallied around him in the 1860s and formed a group dedicated to what a hostile critic called, in 1874, Impressionism. Indeed, the Impressionists went further than Manet had in their objective attitude toward physical reality and developed a technique that enabled them to suggest a greater luminosity and more vibrant surface effects. The boldest innovator among them was Claude Monet (1840–1926), whose *Regatta at Argenteuil* of about 1873–74 (Fig. 15–5) is a prime example of the new manner. The artist made use of intense hues applied in distinct strokes, and he varied the size and shape of the strokes according to the objects he depicted; the waves and the reflections on the water have been rendered in long, horizontal strokes, the trees and greenery to the right in multidirectional dabs suggesting the complexity of the vegetation, and the sails and sky in streaky impasto.

The use of high-intensity colors in landscapes was in itself not novel; Corot and Constable had used fairly pure hues,

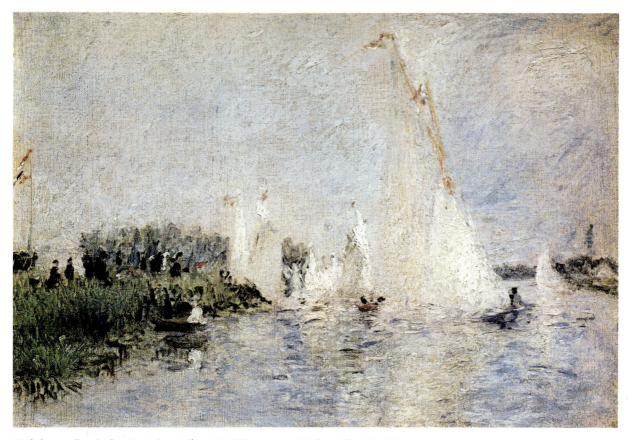

15-6 Auguste Renoir, *Regatta at Argenteuil*, c. 1874. Oil on canvas (12¾" × 18"). Ailsa Mellon Bruce Collection, National Gallery of Art, Washington, D.C.

No one, however, had been as bold as Monet and his fellow Impressionists. He had without doubt been influenced by the color theories of Delacroix (he had once surreptitiously watched the older master painting in his garden), but he was much more concerned with naturalistic effects and was much more daring in his juxtaposition of strokes of different colors. Here, the artist stressed very strong contrasts of almost pure hues, as for instance in the red-orange of the houses against the blue of the sky (very nearly complementaries) and the similar relationship between their reflection in the water and the color of the water. These contrasts of high-intensity color seem to add to the overall luminosity and sense of animation. In addition, the brilliant reflections of the sails on the water and the dark reflections of the trees constitute rhythmic patterns of contrasting values that also contribute to the illusion of immediacy while adding to the overall vibrancy of the scene. Finally, the sail of the boat to the left is tinged with a golden yellow, as though

it were directly hit by the afternoon sun, while others have purplish-mauvish tones caused presumably by a combination of reflections of the shadows in the water and reflected sunlight.

Monet, like Corot before him (Fig. 14-7), attempted to depict the intense luminosity of a clear sunny day, but here nothing is left of Corot's meditative nostalgia. The animated execution, the intensity of the colors, and the boldness of the contrasts make a direct and powerful impact on the senses. With unprecedented directness and vigor, they suggest an instantaneous impression of nature. In this last respect the Impressionists were the true heirs to Courbet, but they achieved an even greater sense of immediacy than he had.

Monet and his friends were fully aware of their debt to the past, but they also considered themselves part of a movement that literary figures were calling Naturalism. "The Naturalist school," the critic Castagnary wrote in 1863, "asserts that art is the expression of life

in all forms and on all levels, and that its sole aim is to reproduce nature by bringing it to its maximum strength and intensity: it is truth in equilibrium with science." The leading literary exponent of Naturalism, the novelist Émile Zola, had become a friend of Manet in 1866 and supported the Impressionists through their early struggles.

It should be pointed out that, from the standpoint of realistic representation, what Monet and his friends had gained in directness and spontaneity they had lost in another way. The Impressionist technique was carrying further a process observed as early as 1814 in Ingres's *Grande Odalisque:* in the Ingres work, the form of the figure seems compressed in a shallow space; in Monet's *Regatta,* the animated, colored brushstrokes blur the individual shapes, while the dazzling contrasts of hues and values make it difficult to locate the various objects precisely in depth. The result was the same: the repudiation of the ideal of deep space.

The apparent looseness and sponta-

neity of the execution had another important consequence. We have already seen in Turner's *Cottage Destroyed by an Avalanche* (Fig. 14-5) how the handling of the paint reflected the love of variety and energy characteristic of the artist. Here the distinct and powerful brushstrokes have become a veritable handwriting. We have only to compare this painting to another Impressionist work, also a *Regatta at Argenteuil,* by Monet's friend and fellow Impressionist Auguste Renoir (1841–1919) (Fig. 15-6), to become aware of differences between the two men. Monet's use of areas of fairly pure color to interpret his visual impressions reflects a lucid and vigorous intellect as well as a sensitive temperament. Renoir's strokes, on the other hand, are more gently blended. The forms are more vaporous and the tonalities more diluted and silvery, suggesting a more sensuous and perhaps a more instinctual nature. "A work of art," as Zola had said, "is part of the universe seen through a temperament."

Finally, much as Manet had enhanced his vision of the courtesan with stylistic allusions to Renaissance and Japanese art, Renoir's and Monet's rich painterly execution brings to mind the sumptuous performance of such colorists as Watteau, Chardin, and Delacroix, and adds to the perception of a sunny, balmy instant a fleeting memory of the excitement occasioned by these masters' technique.

The Impressionists' manner seemed so uncontrolled and confused to the majority of their contemporaries that some members of the group had a very difficult time earning a livelihood from their work until the 1880s, others until much later. The juries of the official Salons were frequently hostile to them and from 1874 through 1886 they found it convenient to organize their own exhibitions. One of the chief participants, aside from Monet and Renoir, was Degas. Manet, for his part, preferred to exhibit at the Salon.

The style of Edgar Degas (1834–1917) was somewhat different from that of the other Impressionists. Although he fre-

quently made use of their characteristic multicolored vibrant strokes, he had had a passionate admiration for Ingres's drawing from the beginning of his career and was also fascinated by Japanese prints. From these two traditions he derived a lively and elegant linearism that gave his forms a greater degree of definition than his Impressionist colleagues and friends cared to achieve in their own works.

Like Monet and Renoir, Degas took delight in catching the fleeting impression of a scene. His drawing in pastels (a chalky crayon) of *Miss Lola at the Circus Fernando* of 1879 (Fig. 15-7), is a remarkable and certainly successful attempt at capturing an instantaneous impression of an acrobat being drawn to the ceiling of a circus by a rope clenched between her teeth. The vibrant strokes of color create a flashing vision of the sheen of her costume and of the glare from the light ceiling. The firm outlines reveal her total muscular control, and the twist of her leg suggests the slow rotation of her body at the end of the rope. Degas loved

to show the human figure from unusual points of view. The body of the woman has a markedly angular configuration, and in foreshortening the face Degas seems to have had in mind the attraction that unusual profiles held for Japanese printmakers (Fig. 15–4).

This pastel is one of a series of studies Degas made of the acrobat, each showing her in a somewhat different attitude, that enabled him to arrive at the final synthesis in his oil painting of the same subject (Fig. 15–8). In the painting, the still firmer outlines and the smooth modeling of the body suggest an even surer physical control on the part of the acrobat. The alterations Degas made in the position of the figure eloquently reveal his artistic aims. The body has been turned slightly, so that the right arm and the legs have become aligned with the ribbing of the architecture. In this way he established a parallel between the structural cohesiveness of the building and the equilibrium achieved by the acrobat. Furthermore, the rendering of the various parts of the body

involves us in the action and feelings of the acrobat. There is an easy and graceful poise in the relationship of extended arms and bent legs. The hands are even more expressive; the now-visible right fist is clenched, as if to suggest concentration, while the left hand is stretched out as if to imply a partial release from tensions. Degas thus added to the Impressionists' concern with visual perception an awareness of the momentary physiological reactions of the figures he depicted.

A marked change in the attitude of most of the Impressionists took place around 1886, the year of their last group exhibition. From that time on many of them began to abandon their overriding concern with visual perception and to cultivate a more poetic and subjective approach. A late painting by Monet, the *Water Garden at Giverny* (Fig. 15–9), executed around 1904, illustrates well this second phase of Impressionism. Here the lighting is less strong and definite, while the color combinations are more subtle and perhaps a little precious (lilac and

green in some areas). The objects are rendered more loosely and are less distinct. Their location in space is even less clear than in earlier Impressionist works, and the space itself is less well defined. The artist willfully created a certain ambiguity by simultaneously showing us water lilies on the surface of the water, algae under the surface, and reflections of the sky. The horizon line, furthermore, is shown so high that it transforms the receding plane of the water into a two-dimensional design, which fills the pictorial surface with delicate, capricious, and sumptuous color arabesques that have a slightly Eastern flavor.

The picture may be compared to a tone poem in music. Deliberately, it seems, the artist confused our perception of material objects and stressed the evocative significance of line and color—just as certain late-Romantic composers relied on tonal effects to provoke moods in the listener. Everyday reality becomes a pretext for daydreams in which artist and viewer are meant to lose themselves. The

artist was still very attentive to his responses to the physical world, but what he has shown us is a slightly dimmed afterimage.

This change of attitude is reflected in a gradual repudiation of naturalistic ideals in art and literature and a return to a more fully Romantic point of view. This new Romanticism—let us call it Romantic Symbolism—found its first literary expression in Baudelaire's *The Flowers of Evil,* a book of poems published in 1857, and was analyzed most lucidly in the poet's several critical essays. Baudelaire took a frankly antinaturalist stand: "Nature is ugly," he wrote, "and I prefer the monsters of my imagination to Positivist triviality."

We have already discussed the concept of musicality that had been evolved in the course of Baudelaire's conversations with Delacroix (p. 193). Baudelaire explained further: "Line and color make us both think and dream. The pleasures we derive from them are totally different from those occasioned by the subject of the painting.

They are just as important but totally independent of them." In keeping with his antinaturalist attitude, the poet had little time for the scrutiny of physical reality. Objects, he felt, could serve best as a source of associations of ideas. Referring to his mistress he once wrote, "These treasures, this furniture, this order, these perfumes, these miraculous flowers are you." In a passage he attributed to Delacroix, he stresses further the evocative power of objects: "Nature is but a dictionary....The artists who follow the dictates of the imagination seek in their dictionary the elements that fit their conception; even so, modifying them with a certain art, they give these objects a new appearance."

The work of art, if it was to appeal to our imagination, could not be too explicit: "Painting is an evocation, a magical operation (if only we could consult the souls of children on this point)." This idea led to a search for mysteriousness and a love of ambiguity that sometimes resulted in inconsistencies,

conflicting viewpoints, and even willful incomprehensibility—developments that were also to be characteristic of Symbolist literature. The object of the artist was to harness the creativity of the viewer. As the Symbolist poet Stéphane Mallarmé is reported to have said in the 1890s, "to name an object is to suppress three-quarters of the pleasure of the poem, which consists of the delight of gradual realization." Finally, Baudelaire advocated with greater fervor than anyone had ever done the search for subjective expression, "the invisible, the impalpable, the dreams, the nerves, the soul." Art, indeed, must reveal the supernatural, like "nature perceived through oversensitive nerves."

In many respects these theories were based on the thinking and achievements of Delacroix. And yet there were to be major differences. In the first place, Delacroix, for all the instances of deliberate vagueness in his execution, was fairly clear about his expressive intent. The artists we will refer to as Romantic Symbolists, on the other hand, were less explicit about

their expressive purpose and cultivated a certain reticence that ranged from calculated vagueness to deliberate use of ambiguities. In the second place, where Delacroix remained attached to stylistic idioms going back to Renaissance and Baroque times, Baudelaire foresaw the break with recent tradition: "I want to talk of an inevitable, childlike, synthetic barbarity that often remains visible in a perfect art (Mexican, Egyptian, Ninevite) that springs from the need to see things broadly, and to consider above all their total effect." Significantly, a later generation of artists, the Post-Impressionists (several of whom felt a strong affinity with the ideals of the literary Symbolists), were bold stylistic innovators and in many cases stressed simplifications derived from ancient and non-Western traditions.

The work of a number of artists whose styles matured in the 1860s revealed strong affinities with Baudelairian esthetics. James McNeill Whistler (1834–1903), an American who lived mostly in London and who had had close contacts with naturalist developments in France late in the 1850s and early in the 1860s, subsequently broke away from naturalism to develop a style that suggests vaporous, poetic visions. In his *Nocturne in Blue and Green, Chelsea* of 1871 (Fig. 15-10)—the title borrowed from the musical repertory of Romanticism—he showed almost no detail, stressing instead a sparse asymmetrical arrangement of forms and achieving a flat decorative effect. Stylistically the stress on asymmetrical patterning goes back to a similar tendency in Japanese prints, which Whistler much admired (Fig. 15-4), and the sparseness and delicate haziness, also Far Eastern in origin, may well have had their ultimate source in the nebulous quality of the Southern Sung School in China (see detail of Fig. 21-6). These elements were admirably suited to the new esthetic. The simplified forms were not intended to describe specific objects but rather to hint at a lyrical dream world. In his own words, Whistler preferred nature when "the evening mist clothes the riverside in poetry...and fairyland is before us." And he added a Baudelairian thought: "As music is the poetry of sound, so painting is the poetry of sight, and the subject matter has nothing to do with the harmony of sound or of color." The parallel with the attitude of Monet and other Impressionists in their late works (Fig. 15-9) is obvious. With Whistler, incidentally, we become conscious of the fact that the artist has little interest in representation or in any of the moral or spiritual values that have been associated with art for so many centuries. The expression "art for art's sake" reflects such artistic detachment.

The French sculptor Auguste Rodin (1840–1917), who was only a little younger than Whistler, was also beginning to transcend naturalism at about the same time and he can be included among the Romantic Symbolists. Let us compare his *Age of Bronze* of about 1876–77 (Fig. 15-13) with a small sculpture, *Ratapoil* (Fig. 15-11), by the caricaturist Honoré Daumier (1810–79), who was closer to

15–11 *This page, left:* Honoré Daumier, *Ratapoil,* 1850–51. Toned plaster (18⅛″ high). Albright-Knox Art Gallery, Buffalo, New York (*comparative illustration*).

15–12 *This page, right:* Honoré Daumier, "Beautiful lady, may I offer you my arm?" "I do not trust your love, it came too suddenly!" 1851. Lithograph (10″ × 8⁹⁄₁₆″). Boston Public Library (*comparative illustration*).

15–13 *Opposite page:* Auguste Rodin, *The Age of Bronze,* c. 1876–77. Bronze (5′11″ × 2′4″). John R. Van Derlip Fund, Minneapolis Institute of Arts.

the mainstream of Romanticism than was Rodin. Daumier earned his living as a political cartoonist and he has often been called a realist. It is true that he captured salient physical and moral characteristics magnificently in his figures, and like Courbet—indeed, much more effectively and compassionately than Courbet—he expressed a strong awareness of social problems. Daumier, however, never had naturalistic aspirations, and his reliance on imagination and the emotional intensity of his message, no less than his fluidity of forms and occasional Baroque-like manner, link him to High Romanticism.

"Ratapoil" literally means "hairy rat" and in those days referred to the most extreme advocates of dictatorial and militaristic policies. The work must therefore be interpreted as lampooning the henchmen of Louis Napoleon (who was to become Napoleon III) when he was making his bid for power after the popular revolution of 1848.

The statuette was cast in plaster from a clay original from 1850–51. The surface is heavily textured, revealing the marks of a combing tool that bring to mind the striations in Delacroix's paintings as well as the swift, nervous pencil or crayon strokes in Daumier's own graphic work (Fig. 15–12). These marks create low sharp ridges that suggest a somewhat nebulous atmospheric sheath around the figure. The modeling of the principal forms suggests powerful three-dimensional arabesques and also brings to mind Delacroix. Daumier's unique caricatural skill comes through in the bulging

left hip and in the angular arms and spindly legs that poke fun at the skinny appearance of the personage and hint at his craftiness and arrogance. Beyond the immediate political references, the figure alludes to the cheap demagogues who always seem to threaten democratic government in times of crisis.

Daumier also made use of his figures of real and imaginary political characters in his numerous cartoons. During the nineteenth century, the political cartoon had come into its own as an effective means of political and social expression, largely as a result of the development of *lithography.* In this process, prints are made directly from a stone on which a design has been drawn with a greasy substance that holds the ink. Because the number of prints that can be made is almost limitless, the process was particularly suitable for illustrating newspapers and magazines. Figure 15–12 reproduces a lithograph showing Ratapoil slyly offering his arm to a prim lady in antique dress, who personifies the French republic. "I do not trust your love," she retorts; "it came too suddenly!" This was at the time when the supporters of Louis Napoleon were beginning to round up votes to take over the government.

Whatever form Daumier's satirical attacks took, they revealed a passionate vehemence in their condemnation of social injustice and human greed and pettiness, and in so doing they share the intense emotionalism and comparative explicitness of High Romantic art.

Rodin's work belongs more appro-

priately to what we have called Romantic Symbolism. On first impression one is struck by the naturalism—much more pronounced than Daumier's—of *The Age of Bronze* (Fig. 15–13), of around 1876–77. Indeed, when the sculpture was examined by the jury of awards of the Paris Salon of 1878, it was believed to have been cast from a living model. And yet, the modeling of certain muscles has been accentuated, to break up the smoothness of the surface and to suggest an atmospheric sheath. Furthermore, anyone trying to assume the same pose would soon find that the various parts of the figure have been fitted together rather arbitrarily. Rodin, in fact, was more interested in suggesting a powerful overall rhythm than in a physically correct interrelation of parts; the soft, rising spiral movement created by the forms of the legs is continued in the tenser lines of the abdomen and torso and seems to burst out in the flaring angular movement of the arms.

Clearly, Rodin was trying to depict something more than the physical effort made by the figure as he raises himself, gripping an imaginary staff (the staff actually used in the studio was not incorporated in the statue). The pursuit of mysteriousness and ambiguity was characteristic of Romantic Symbolism, and unlike Daumier, whose meaning was always expressed with directness and pungency, Rodin was not entirely explicit about his intent. The original title of the statue was *The Vanquished,* but even that may have been too specific, for he changed it later to the much vaguer and more

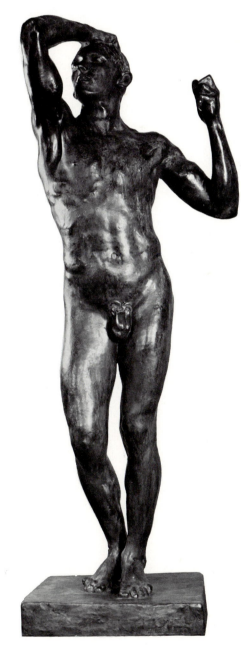

encompassing *Age of Bronze.* The attitude of Rodin toward subject matter was perhaps best expressed by the Austrian poet Rainer Maria Rilke, who at one time was closely associated with Rodin:

> When he searched through a face he saw that it was full of motion, as full of unrest as the dashing of waves. In the flow of the lines there was movement; there was movement in the contours of the surface; shadows stirred as in sleep, and light seemed lightly to touch the forehead. Nothing possessed rest, not even in death, for decay too meant movement, dead matter being still subject to life.

Indeed, in *The Age of Bronze* there is no reference to any specific drama, and it seems to be an awareness of the flux of life itself, of the conflicting sufferings and hope of man's condition, that Rodin was trying to convey through the rhythmic motion of the tensing, rising body and the contracted features of the face. Rodin's themes were never fully stated: he said that they were meant to "awaken the imagination of the spectator without outside help. And yet, far from confining it within narrow limits, they give it rein to roam at will." Clearly some of the explicitness and intense emotionalism characteristic of High Romanticism had been lost; instead, the artist has invited the viewer to give freer play to his fantasy.

One artist who can be associated with what we have called Romantic Symbolism, the Frenchman Gustave Moreau (1826–98), presented the most gruesome scenes while using every means at his

disposal to soften their dramatic impact, thus creating a willful discrepancy between subject matter and expressive message. In his 1876 watercolor *Apparition* (Fig. 15-14), Salome performs a lascivious dance, in the course of which the decapitated head of John the Baptist appears to her. The picture was inspired by a text by the German poet Heinrich Heine, itself based on a Medieval variant of the biblical story. Salome was in love with the saint, who was then a prisoner in her father's palace, but her advances had been spurned. Out of a desire for revenge she asked her father to have John beheaded, and he promptly obliged her.

In contrast to the gruesome nature of the subject, however, Moreau stressed

15-14 *This page:* Gustave Moreau, *Apparition,* 1876. Watercolor (41¾″ × 28½″). Louvre, Paris.

15-15 *Opposite page:* Odilon Redon, *The Eye, Like a Bizarre Balloon, Drifts Towards Infinity (to Edgar Poe),* 1882. Lithograph (10³⁄₁₆″ × 7¾″). Art Institute of Chicago.

what he called "beautiful inertia": languid and affected poses giving the scene the appearance of a sensual ballet. And in his enthusiasm for what he called "necessary richness," he lavished attention on a profusion of jewel-like details. This conflict creates a sense of puzzlement and elicits associations at once cruel and sensuous. Moreau said that he was "opening windows on artificial worlds which seem carved of marble and gold, and on spaces that are necessarily monstrously fanciful." This notion that artistic experience should be precious, somewhat rarefied, and essentially escapist makes him one of the major adherents of estheticism, an attitude that was to become prevalent in the 1880s and 1890s. Like the advocates of art for art's sake, the adherents of estheticism maintained that the artistic merit of a work is totally independent of any moral or social implications it may have. They made a point of cultivating an elegance and refinement that often appeared precious, and even affected, in contrast to the dramatic subject matter.

Odilon Redon (1840–1916) went even further than Moreau in his utilization of strange associations, deliberately juxtaposing objects taken out of their ordinary context. He intended the viewer to speculate on a variety of possible interpretations. "The essence of the mystery" in his work, he said, "is to preserve a state of ambivalence, through double, and triple possible interpretations, through mere hints of interpretations (images within images), through forms that will materialize, but will do so only in the consciousness of the spectator."

In the lithograph *The Eye, Like a Bizarre Balloon, Drifts Towards Infinity* (*to Edgar Poe*) (Fig. 15–15), executed in 1882, Redon seems to have taken literally the French expression for "letting one's thoughts wander off," and shows an eye detached from its socket and floating in midair. In keeping with the weird parallel between organic and inanimate forms, the gondola is made up of a skull on a plate. Not only does this seem to be a distant allusion to Moreau's gruesome image of

John the Baptist's head on a platter, but the eye itself evokes the levitating head of the saint as it is represented in Moreau's watercolor (Fig. 15–14). The eye, in turn, can be associated with spirituality and the survival of the soul, in contrast to the skull, which can be taken as symbolic of death and decay. Finally, the upturned iris suggests an agonized and imploring look of some martyr of Renaissance or Baroque art. No sooner has one accepted these possible interpretations, however, than one realizes that the eye is held to a certain altitude by its ballast; man's spirit, it seems, is kept in check by purely material factors.

This incongruous juxtaposition of elements thus gives us not one but several possible clues, all vaguely associated with one another. This play of associations was intended to suggest uniquely personal attitudes. Redon himself stressed the purely subjective aspects of his fantasies, the outcome, he wrote, of "docile submission to the emergence of the unconscious."

16

The Post-Impressionists, Art Nouveau, and the Chicago School of Architecture

The next generation of Parisian artists was extraordinarily vigorous and innovative. All its members had at some point been dedicated Impressionists. All had become familiar with the Baudelairian doctrine, some of them having established close contacts with the several groups of Parisian literary Symbolists active in the mid-1880s who claimed to be spiritual descendants of Baudelaire. And all rejected the imaginary subject matter of the Romantic Symbolists and returned to the subjects of Impressionism—landscapes and familiar portraits, and group, café, and nightlife scenes—that they now often invested with complex and profoundly personal significance. They are often called the Post-Impressionists, although they represent several distinct styles.

The first one among them to make a clear break with Impressionism was the Frenchman Georges Seurat (1859–91), who together with a number of friends formed a group that called themselves the Neo-Impressionists. Let us compare his

large *Sunday Afternoon on the Island of the Grande-Jatte,* painted in 1884–86 (Fig. 16–1), a picture that caused a major sensation when shown at the last Impressionist group exhibition in 1886, with Renoir's *Luncheon of the Boating Party* of 1881 (Fig. 16–2). Renoir's painting depicts a group of his friends finishing their lunch at a small café on the bank of the Seine a few miles from Paris. While the artist stressed clear modeling of forms, precise linear definition, and smooth finish of arms and faces (he was paying discreet homage to the hallowed tradition of the High Renaissance), the vibrant juxtaposition of pure hues and the exuberance of the brushwork convey brilliantly the effect of light and atmosphere around figures and objects on a warm sunny day and, thus, are characteristic of Impressionism.

The surface treatment advocated by the Neo-Impressionists, on the other hand, is characterized by a much more patient and systematic application of specks of paint. Seurat had been pro-

foundly influenced by the Impressionists' exhibition of 1879 and had enthusiastically adopted their technique. Of a scientific bent himself, he had then proceeded to read the most up-to-date textbooks on optics and had evolved his own much more systematic color theory. He set out to decompose the color of each object into five components, which he applied independently, first in elongated strokes and then, by the time he was completing the *Grande-Jatte,* in small dots. These five components were the local color of the object, the color of the surrounding light (orange-yellow in the sun at noon, blue-violet in the shadow), the color of the light reflected by the object (the result of the optical combination of the color of the object and the color of the light, located halfway between them on the color circle), the color reflected from neighboring objects, and the color produced by the illusory effect known as Chevreul's law (see p. 192). To a greater or lesser degree all these rules were respected by Seurat in the execution of this

16-1 Georges Seurat, *Sunday Afternoon on the Island of the Grande-Jatte,* 1884–86. Oil on canvas (6'9¼" × 10'¼"). Art Institute of Chicago (Helen Birch Bartlett Memorial Collection).

16-2 Auguste Renoir, *Luncheon of the Boating Party,* 1881. Oil on canvas (4'3" × 5'8"). Phillips Collection, Washington, D.C. (*comparative illustration*).

16-3 Georges Seurat, *Le Bec du Hoc,* 1885. Oil on canvas (25¼″ × 31⅛″). Trustees of the Tate Gallery, London.

painting. The other Neo-Impressionists were soon to follow Seurat's leadership and apply the rules with as much, or almost as much, earnestness as he did himself. The purpose of the method was to enable the artist to suggest the colorations of objects and light with unprecedented accuracy; in fact, it also enabled him to achieve superb harmonies through a judicious choice of hues.

The Renoir painting shows a rather cavalier attitude toward scientific perspective, reflecting the declining interest in the rendering of space that has already been noticed in connection with Monet and Whistler. The two long edges of the table should converge at the vanishing point, but in fact they converge on the spectator's side of the picture plane. Renoir was nevertheless very much concerned with creating a clearly three-dimensional arrangement of the figures. Casual as their placement seems to be, they are set in a vaguely pyramidal grouping in the stage space and create a number of dominant accents, such as the diagonal

that links the man at the lower right with the woman leaning against the railing.

Seurat's composition, by contrast, is characterized by a willful ambivalence. On the one hand, the true-to-nature atmospheric effects, the curve created by the river, and the repetition of shapes on an ever smaller scale toward the distance suggest a precise and convincing recession in space. On the other hand, the continuous linear patterns, the systematic, rhythmic juxtaposition of horizontal and vertical accents, and, despite the effects of the multicolored brushstrokes, the comparative uniformity of color over large areas (green for the grass, blue for the river, for instance), tend to flatten the design.

The use of fairly uniform color areas and continuous outlines and the partial flattening of the composition seem to have been inspired by a perceptive study of Japanese art. Seurat shared the enthusiasm of Manet and the Impressionists for the Japanese woodcuts, but he went much further in his analysis of Japanese compositional devices than they did. His *Le*

Bec du Hoc (Fig. 16–3), painted during the summer of 1885, suggests that he was influenced by the composition of specific Japanese prints even when painting from nature. In this case the sweeping delineation and uniform color areas of works like *Boat Fighting Wave* (Fig. 16–4), an early nineteenth-century woodcut by Katsushika Hokusai (1760–1849), were clearly in Seurat's mind. In the *Grande-Jatte,* the sweep of the edge between the sunlit and shaded areas in the foreground, the arbitrary patterning of the cast shadows beyond it, and the rhythmic arrangement of vertical and horizontal accents throughout the composition can be shown to have been derived from particular Japanese prints.

In addition, the shallow modeling of the figures and their formalistic, almost geometrically stylized outlines, no less than the fact that they are usually shown either fullface or in profile, all bring to mind the essentially two-dimensional friezes of pre-Classical antiquity and contribute further to the flattening of the

16-4 Katsushika Hokusai, *Boat Fighting Wave,* early nineteenth century; woodcut. Museum of Fine Arts, Boston, Spaulding Collection (*comparative illustration*).

composition. A shocked contemporary compared the picture to a "pharaonic procession."

In contrast to the impression of casualness preserved in the composition of the Renoir piece, Seurat composed his surface design according to a system of proportions elaborated in cooperation with his friend Charles Henry, the author of several treatises on "scientific" esthetics. To give but two examples, the woman with the young girl is exactly at the center of the picture, while the upper boundary of the area of shade in the foreground cuts the right side of the picture exactly three-eighths of its height. Both the ratios 1:2 and 3:8 were considered by Henry to be harmonious.

Henry's theories were not limited to proportions. The Neo-Impressionists appear to have selected hues from the color circle according to similar numerical formulas designed to insure harmony, and to have chosen both colors and directions for their supposed expressive properties: warm hues and rising lines were thought

to be happy, cool hues and dropping lines sad.

The Renoir painting conveys a sense of hedonistic well-being, both through the subject matter, a cheerful and relaxed group of his friends on a happy occasion, and through the delightful animation of colors and forms in the sunlit atmosphere. Seurat, for his part, was also depicting an outing on a sunny day, but he stressed to the point of caricature the stiff formality of Parisians all dressed up in their Sunday best. Unlike the Impressionists, Seurat was not primarily concerned with "the accidental and the transitory," as his friend and critic Félix Fénéon put it: the purpose of the stylization of figures and landscapes was "to synthesize the landscape and thereby give it a definitive appearance that perpetuates the sensation of the artist."

There seems to have been no doubt in the minds of Seurat and his friends that the rules they followed constituted a systematic formulation of the theory of musicality that had already been enunci-

ated by Baudelaire. For Baudelaire, however, subject matter was "just as important, but totally independent" from the expressiveness of line and color. For the Neo-Impressionists, who had been influenced by the strong antimaterialistic stand of the young literary Symbolists of the mid-1880s, subject matter played a secondary role. Much as the Symbolist poet Jean Moréas "derived from objective reality only a simple and succinct point of departure," the Neo-Impressionists, according to Fénéon, saw in objective reality "a simple theme subordinated to the creation of a sublimated reality." Indeed, in Seurat's case, physical reality had become a mere pretext for the artist's search for a superior harmony, an abstract perfection, in the Neo-Platonic sense.

In their common search for a superior harmony, however, the Neo-Impressionists never lost sight of the artist's individual identity. "Each one of them," wrote Fénéon, "imperiously stresses his uniqueness—be it only through his personal interpretation of the expressive signifi-

cance of color, and through the degree of sensitivity of his optic nerves to this or that stimulus." Through these unique characteristics the personality of the artist "transfuses itself in the superior and sublimated reality." This was totally in keeping with the importance that the Symbolist poets attached to the expression of a subjective attitude.

The very demanding technique of Neo-Impressionism was practiced by only a small number of enthusiasts. The artistic theories enunciated by Fénéon, on the other hand, had a profound influence on other Post-Impressionists. Chief among them was Paul Gauguin (1848–1903), a one-time clerk in the office of a stockbroker, who had been working in the Impressionist manner for over a decade when he undertook, in 1888, a work in a new style, the *Vision After the Sermon, Jacob Wrestling with the Angel* (Fig. 16–5).

Gauguin had had frequent contacts with the Neo-Impressionists. At the time he was painting this picture, moreover, he was staying in a small village in Brit-

tany where he had met a former Neo-Impressionist painter, Émile Bernard, who had given up the small-dot technique but retained the almost uniform color areas and continuous outlines derived from Japanese prints. Gauguin's painting displays a similar technique, with large areas of vivid hues surrounded by vigorous, undulating dark outlines. Also in keeping with Japanese (and, incidentally, pre-Renaissance Western) practices, Gauguin raised the background, flattening the whole composition into a decorative surface pattern, and eliminated cast shadows. As if to pay tribute to the various sources that influenced him, Gauguin seems to have based the figures of Jacob and the angel on a series of characters from a sketchbook of woodcuts by Hokusai (Fig. 16–6), while their draperies have a Romanesque stylization. The coarse-featured figures of the peasants, furthermore, seem based on the crude carving style of traditional Breton peasant sculpture, which had roots in the distant past.

These simplifications made it possible

to stress the play of line and color and to emphasize their musicality with unprecedented power, for there can be no doubt that the glowing orange-red of the background, livened by the contrasting cyanide blue of the dresses, and the powerful and graceful rhythms of the lines is intended to heighten the impression of the naive fervor of the peasants. Gauguin and Bernard called the new manner Synthetism, possibly because it tended to "synthesize the landscape and...give it a definitive appearance," to use Fénéon's words. The style has also been linked with Medieval stained-glass windows and with the *cloisonné* techniques of Medieval jewelry (p. 61) and Far Eastern pottery.

In keeping with the esthetics of the literary Symbolists, Gauguin used the scene of the peasant women and priest leaving church as a mere pretext for the expression of what the Symbolist poets would have called the "Idea." Gauguin himself explained: "I have attained in these figures a great rustic and superstitious simplicity....To me in this paint-

16-5 *Opposite page:* Paul Gauguin, *Vision After the Sermon, Jacob Wrestling with the Angel,* 1888. Oil on canvas (28¾″ × 36¼″). National Gallery of Scotland, Edinburgh.

14-3 *Below:* Eugène Delacroix, detail of *Jacob and the Angel,* 1849–61 *(comparative illustration).*

16-6 Katsushika Hokusai, *Policeman and His Prisoner,* nineteenth century. Woodcut (5″ × 7″). Museum of Fine Arts, Boston, Spaulding Collection *(comparative illustration).*

ing the landscape and the struggle exist only in the imagination of these praying women as a result of the sermon. This is why there is a contrast between these real people and the struggle in the landscape, which is not real and is out of proportion."

Although Gauguin did not specifically say so, the scene lends itself to a play of associations: it can be no accident that the peasant women are seeing a vision of Jacob and the angel. Gauguin must have had in mind the painting by Delacroix (Fig. 14-3), according to whom the struggle represented "the ordeals to which the Lord...subjects the chosen ones" (see p. 190) and, by implication, the desperate yet rewarding endeavors of the creative artist. Gauguin himself was experiencing great material difficulties at the time, and there can be little doubt that he could have found Delacroix's metaphor a most suitable allusion to his own situation. Gauguin, however, introduced a characteristically ironic twist. In the Delacroix piece, the attendants guiding Jacob's

flocks are unaware of the fight; Gauguin, on the other hand, stressed the impact of the struggle on the peasant women, who are kneeling down in awed admiration and are praying. Someday, he seems to have hinted, even peasants would admire and respect the new art.

Gauguin was thus true to Baudelairian esthetics. He achieved a new level of expressive musicality; he indulged in a play of associations to express abstract ideas; he suggested an important message without being too explicit; and he chose for a message a highly personal and therefore subjective statement. In his experiments with style, moreover, he not only broke with the naturalist tradition but cultivated what Baudelaire referred to in a prophetic moment as "an inevitable, childlike, synthetic barbarity" and in this respect went far beyond the Romantic Symbolists. And, unlike Romantic Symbolists such as Redon and Moreau, whose subject matter consists of improvisations on mythological, religious, literary, or historical themes or of outright fantasies,

Gauguin's basic motif in this picture is a group of peasants in a field, a typically Impressionist theme. The presence of Jacob and the angel introduces a supernatural element, but such intrusions are rare in Gauguin's Symbolist work; he preferred, like all Post-Impressionists, to invest apparently ordinary scenes with symbolic meaning, ultimately going to the islands of the South Seas, where, for him at any rate, reality itself had an aura of enchantment. When there are allusions to Western or Polynesian religious traditions in the works he did there, they are veiled, and the figures usually dress and behave like the men and women around him.

A third major Post-Impressionist artist, Vincent van Gogh (1853–90), went even further than Gauguin in delving into his own moods and emotions, and he expressed them with unprecedented intensity. Born in the Netherlands, van Gogh settled in Paris in 1886, where he became acquainted with the technique of Impressionism and, shortly afterward,

16–7 Vincent van Gogh, *Night Café*, 1888. Oil on canvas (28¼″ × 36¼″). Yale University Art Gallery, New Haven, Connecticut, bequest of Stephen Carlton Clark.

with the theories and practices of the Neo-Impressionists and the doctrines of Symbolism. Like Seurat, Bernard, and Gauguin, all of whom he knew personally, he developed a great interest in the art of the Japanese printmakers. His *Night Café* of 1888 (Fig. 16–7) was painted a few months after his departure from Paris for Arles in southern France, where he had gone in search of quiet, warmth, and sunlight.

The occasional large areas of almost uniform hues, the intensity of the colors, and the strong outlines delimiting certain objects all reflect van Gogh's partiality to Japanese art and his sympathy with the innovations of Seurat, Bernard, and Gauguin. In many areas the brushwork creates heavy impastos, bringing to mind Impressionist technique at its most animated, and yet it is more nervous, more arbitrary, and more forceful than in any of the Impressionists' works.

Perhaps as a result of his familiarity with the theories of the Neo-Impressionists, van Gogh was enormously interested in the expressive power of color. Like Seurat and his friends, he believed that certain color combinations were harmonious and therefore pleasing, but he was not dedicated to the pursuit of abstract perfection; when it suited his expressive purpose, he made deliberate use of color combinations he believed to be discordant to create disquieting and even ugly effects. Certain colors also had strong associative values for him.

In keeping with well-established Symbolist principles, van Gogh attempted to invest everyday scenes with an intensely personal and moving symbolic significance by depicting objects that lent themselves to a complex play of associations. Café scenes are frequent in the repertory of Impressionism, but this particular establishment has little in common with the congenial gathering place depicted by Renoir (Fig. 16–2). In van Gogh's words, it is a place where "night prowlers can take refuge when they have no money." He included himself metaphorically among the prowlers: "I always feel I am a traveler going somewhere and to some destination," adding with a note of anxiety, "though the somewhere and the destination are nonexistent." In other words, the café had become a symbol of his isolation and aimlessness.

Not just a haven for lost souls, the tavern takes on an even more ominous significance: it is "a place where one can ruin oneself, go mad, commit a crime." And the artist explained how he made use of the associative value of individual hues and the disquieting effects of discords: "I have tried to express, as it were, the powers of darkness in a low saloon by means of soft Louis XV greens and malachite, contrasting with yellow-green and hard blue-greens, all this in an atmosphere like a devil's furnace of pale sulfur." He summed up his intentions by relating the contrast of dominant hues to an agonized vision of human distress, "I have tried to express in this picture the terrible passions of humanity by means of reds and greens," and he stressed that ultimately his point of view was subjective: "the color is not locally true from the...realist point of view; it is a color suggesting some emotions of an ardent temperament."

It is not surprising, then, that except for the ghost-like figure of the proprietor and a few drowsy figures at the tables, the café is mournfully empty. Nor is it surprising to find that individual forms have been distorted to an unprecedented degree. Romantic artists have already subordinated the play of form and color and even their choice of stylistic idiom to expressive intent; in this work, not only have individual colors been heightened and altered with little or no reference to physical reality, but chairs have been twisted as if they were made of rubber and the convergence of the two ends of the billiard table has been exaggerated. The lines of the floorboards are weirdly uneven, and the lighting fixtures seem strangely animated, while the light they emit creates totally unnatural, vibrant concentric halos. Even the brushstrokes have an angry and nervous agitation. The artist may have wanted to simulate a trance-like vision of his environment, as if to suggest the impact of his most extreme emotions on his perceptions.

This total, almost violent, subordination of design to the expressive intent of the artist is an extreme form of musicality and constitutes yet another manifestation of the antimaterialist tendencies of Symbolism. It was to become the principal characteristic of Expressionist trends in the late nineteenth and twentieth centuries.

224

16-8 *Opposite page:* Paul Cézanne, *View of Gardanne,* 1885–86. Oil on canvas (31″ × 25″). Metropolitan Museum of Art, New York, gift of Dr. and Mrs. Franz H. Hirschland.

16-9 *This page:* Photograph of Gardanne, by Erle Loran, from *Cézanne's Compositions* (Berkeley: University of California Press, 1943).

Van Gogh never found peace in Arles. A visit of a few months by his friend Gauguin came to an end with a violent quarrel. It was at that time that ever more acute attacks of insanity forced him to spend much of the remainder of his life in mental institutions. He committed suicide in 1890.

Paul Cézanne (1839–1906) had also at one time espoused the ideals and adopted the techniques of Impressionism. Changes occurred gradually in his style from the middle years of the 1870s through the middle part of the 1880s, however, and they led to what has been called his constructive manner. The *View of Gardanne* of 1885–86 (Fig. 16–8) is an excellent example of his constructive manner, and a comparison with a photograph of the village (Fig. 16–9) will provide some idea of Cézanne's artistic aims.

Allowance must be made for the fact that, as is so often the case, the lens used by the photographer makes the objects in the foreground appear larger in relation to objects in the background than they

do to the human eye. The configuration of buildings has also changed in the intervening years. The similarity, nevertheless, is quite striking. Rather than obscuring the relative position of objects in space by means of animated brushstrokes that blur the edges of the forms, as the Impressionists had done, Cézanne rendered the various facets of the walls and roofs of the houses with considerable care, bounding them with definite outlines. He intensified some of the colors—occasional brick-red and bluish areas stand out against the ochers of the walls and the many white areas of canvas—and within each area the largely parallel strokes of slightly varying hues, value, and intensity constitute an orderly, yet subtly vibrant variation of Impressionist technique.

Cézanne, to be sure, must have been influenced by the geometric nature of the houses themselves, but even more complex forms, such as the hills in the distance, tend to be transformed into planes bounded in part, at least, by outlines, and covered with subtly variegated brush-

work. This rough geometric stylization, which often involves curved planes, is found to a greater or lesser degree in all the works of Cézanne's constructive period, and although the facets are only occasionally as distinct as in this picture, and in some works are almost dissolved by the vibrant effect of the colored strokes, one is always aware of the interaction in space of colored surfaces. Cézanne stated that his works were "constructions after nature." Indeed, the geometric quality and a certain translucency of the planes result in an effect reminiscent of clusters of rock crystals.

The process was essentially one of analysis, which the artist related to his own way of seeing. He wrote of "an optical sensation occurring in our visual organs, which leads us to classify according to the light—half-tones or quartertones—the planes suggested by our color sensations." In keeping with the importance attached to pragmatic reasoning in an era of giant scientific strides, he explained: "Everything, in art especially, is

theory developed and applied in contact with nature." He also stressed the considerable intellectual effort that the method required. Having "penetrated what he has before him," the artist must "persevere, and express himself in the most logical possible way." At times this presented problems: "Abstractions do not allow me to cover the whole canvas, nor to complete the delineation of objects," a fact that can readily be observed in his many unfinished paintings, of which this is one.

Attempting to explain the esthetic purpose of his method, Cézanne expressed the impossibility of being true to his immediate responses to the visual world: "I do not have this magnificent richness of coloration that animates nature," and he wrote elsewhere that "art is a harmony parallel to nature." One may gather from these comments that the interplay of intersecting planes, no less than the juxtapositions of colored areas rendered in vibrant tones, evoked an excitement that was meant to be the equivalent of the "intensity that manifests itself to [the artist's] senses." Like his childhood friend Émile Zola, furthermore, he stressed the importance of the artist's personality in the creative process. The painter, he wrote, "concretizes, by means of drawing and color, his sensations, his perceptions." And he considered one of his chief aims to be the "knowledge of the means of expressing our emotions."

Cézanne frequently took liberties with the perspective rendering of the various elements of the picture. The two sloping sides of the roof of the tall, narrow house to the left, for instance, converge toward the onlooker instead of toward the far distance, and the façade of the house slants backward. Rather than respecting the actual relationship of the planes, he increased certain angles, decreased others, and twisted or bent certain surfaces. These distortions may well have resulted from Cézanne's practice of looking at various parts of his subjects from different points of view. Indeed, he once wrote, describing the impressions he experienced as he was sitting on the bank of a river: "The same object seen from a different angle becomes a subject for study of the greatest interest, and so varied that I think I shall be able to keep busy for months without moving, simply by inclining my head sometimes more to the right, sometimes more to the left." Recombining these various impressions enabled him to achieve an exciting multiplicity of effects on a single canvas. The result was a condensation of his protracted sensations into an equivalent arrangement of colored planes.

The fact that for Cézanne art was "a harmony parallel to nature," that he attached so much importance to the analysis of his own sensations, and that he attempted, through this analysis, to stress the uniqueness of his own vision and temperament, all reveal to what degree even this ardent lover of nature had been affected by Symbolist thought.

The last decade of the nineteenth century saw the flowering of a widespread movement of British origin known as Art Nouveau. Connected in some ways with the doctrines of Symbolism, it particularly affected architecture and the decorative arts. Among the purest exponents of the style was the English book-illustrator Aubrey Beardsley (1872–98) whose *The Climax* of 1894 (Fig. 16–10) was one of a series drawn to illustrate Oscar Wilde's play *Salome*. It reflects a mood that was called "Decadent" at the time: an insistence on morbid themes, a general ennui intended to flout middle-class values, a pungent humor, and a delight in the preciosity and escapism of estheticism, all of which were antithetical to popular tastes and enthusiasms. The subject of *Salome* enabled Beardsley not only to indulge a propensity for morbid eroticism but to explore wittily what Moreau had called "artificial worlds." Beardsley is very likely to have known Moreau's *Apparition* (Fig. 15–14), and was probably influenced by it, but he rejected the hazy atmospheric effects and subdued lighting, which linked it to the dream-like nebulousness of many Romantic works. Instead, he made a point of drawing with sharp clear lines and characterized both figures humorously; Salome is a fiendish nymphomaniac enjoying the macabre intimacy with her prey, while John's head is that of a wan and rather vapid youth, who could never have coped with the young woman's emotional intensity.

The sophisticated refinement of the execution is in contrast with the gruesome aspects of the scene. Emulating the Japanese printmakers such as Utamaro (Fig. 15–4), whom Beardsley greatly admired, he employed black and white uniformly over large areas, bounding these

with graceful, continuous curved outlines and edges that sweep across the pictorial surface. These devices flatten the composition and create surface designs of starkly elegant simplicity. The asymmetrical arrangement may also be linked to Far Eastern art. Finally, as in Japanese prints, our attention is drawn to the background with almost as much insistence as to the solid forms, and this introduces an element of ambiguity.

In addition to their enthusiastic emulation of the Japanese, Art Nouveau artists drew from a number of other sources. In England, particularly, several of them were partial to the Gothic tradition, and one senses a certain affinity between the handling of the drapery of Salome and the somewhat angular arrangement of folds in such works as the Morgan Bible (Fig. 7–16). The interlacing of the hair of Saint John, furthermore, points to another source of inspiration, Medieval Irish manuscripts (Fig. 5–4).

5–4 *Far left:* Christ in Majesty, detail from the *Book of Kells,* late eighth to early ninth century (*comparative illustration*).

15–4 *Center left:* Kitagawa Utamaro, *Woman Looking in a Mirror,* c. 1790 (*comparative illustration*).

15–14 *Near left:* Gustave Moreau, detail of *Apparition,* 1876 (*comparative illustration*).

16–10 *Right:* Aubrey Beardsley, *The Climax,* from *Salome.* Reproduction of a drawing of 1894, Folio XV, in *A Portfolio of Aubrey Beardsley's Drawings Illustrating Salome by Oscar Wilde* (London: John Lane, 1907). Originally published in: Oscar Wilde. *Salome. A Tragedy in One Act.* London, 1894, Folio XV. Translation by Lord Alfred Douglas.

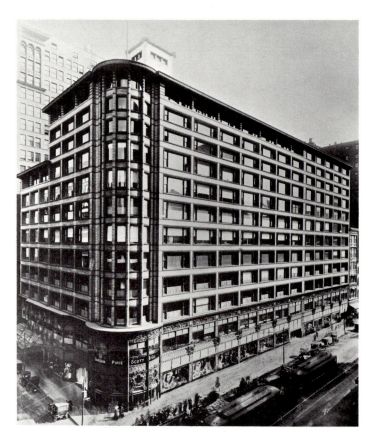

16–11 *This page, right:* Louis H. Sullivan, Carson Pirie Scott department store, Chicago, 1899–1900, 1903–04.

16–12 *This page, below, top:* Louis H. Sullivan, Carson Pirie Scott department store, detail of decoration of corner pavilion.

7–19 *This page, below, bottom:* Detail of the arcade, Lady Chapel, Ely Cathedral, 1321–c. 1350 (*comparative illustration*).

One aspect of Art Nouveau linearism has been said to be unique: the lively serpentine curve, known as whiplash, such as the one formed by the blood dripping from John's head, which evokes particularly aptly the fascination for plant and animal life and organic growth that characterized the movement. The whiplash can also, however, be interpreted as a nervous, two-dimensional version of the Baroque and Rococo line of force and may have been partially inspired by Blake's wavy line (see p. 179); it certainly owes much to the undulating curves of Japanese art.

Most Art Nouveau decoration incorporates organic motifs, usually languid-looking flowers and animals that are closest to man's idea of monsters and that lend themselves best to linear treatment: snakes, dragonflies, frogs, spiders, octopuses, crabs, and so on. Such motifs often have a symbolic significance; here the lilies growing out of John's blood allude sardonically to the young man's purity as well as to his spiritual rebirth.

In an era that set new standards of size and economy in its commercial buildings, Art Nouveau decoration provided a useful antidote to the terse language of the structural engineers. A few gifted architects combined most successfully the new severity of structural forms and the fluid richness of the Art Nouveau style.

The Carson Pirie Scott department store in Chicago (Fig. 16–11), designed by the American architect Louis Henri Sullivan (1856–1924), is a splendid example of such a conciliation of extremes. The original section (the nine-story portion at the extreme left of the photograph) was erected in 1899–1900 and the remainder in 1903–04. Although it is not very tall, the building was based on structural principles evolved in New York and Chicago, in the 1870s and in the early 1880s, that led to the advent of the skyscraper. We have already noted (p. 178) that during the eighteenth century the exterior of the walls came to be regarded by some architects as nothing more than an envelope. During the nineteenth century, architects

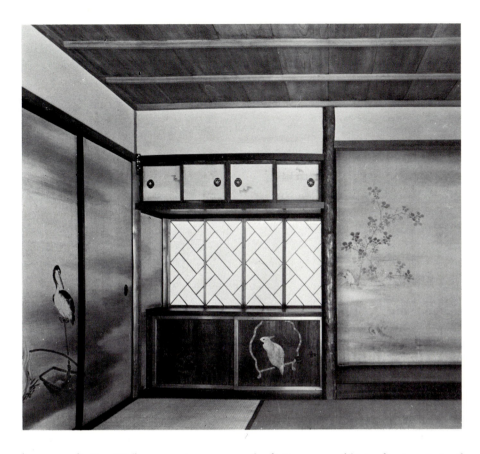

16-13 Chōsetsu, tearoom in the imperial palace, Kyoto, nineteenth century (*comparative illustration*).

began to distinguish between the structural skeleton and the outer skin, which could be made of glass. The developers of the American skyscraper were thus able to erect buildings of unprecedented height, without increasing the thickness of the lower-story walls, by erecting a structural framework (first of iron, later of steel) and treating the walls as independent partitions supported at each story on horizontal girders. This development, together with the introduction of safe and reliable elevators, made the erection of very tall buildings a practical possibility and insured a much more efficient use of land in crowded cities than had hitherto been possible.

The outer appearance of Sullivan's building is clearly related to its steel structure. Sullivan did not hesitate to let the exterior of the building suggest the interplay of the structural members; thin terra cotta-covered horizontal and vertical strips mark the location of girders and struts. In addition, since the outer walls do not bear any part of the structural

load, it was possible to devote much of the surface of each bay to wide windows that admit an abundance of daylight, essential to the life of a department store when artificial lighting was weak and expensive. No better summation of Sullivan's radical aims can be given than the one he himself wrote in 1901: "It is evident that we are looking at a department store....Its purpose is clearly set forth in its general aspect and the form follows the function in a simple straightforward way."

In spite of the functional aspect of the design, much attention was paid to decoration, which, as Sullivan put it, "when creative, spontaneous, is a perfume. It is...the smile of a sentiment, the last line in the sonnet." There are, in fact, two subtly interrelated decorative systems. The lower stories are adorned with florid patterns of swirling scrolls and foliage motifs in cast iron (Fig. 16–12), which were designed, in all likelihood, by Sullivan's assistant, the Scottish-born George Grant Elmslie. These, if not directly influ-

enced by English Art Nouveau, stem from the same combination of Irish and Gothic, if not necessarily Japanese sources, and the same fascination for organic motifs (compare Figs. 5–4 and 7–19). The treatment of the upper stories, on the other hand, is plainer. The architect seems to have wanted to preserve the block-like quality of the basic shape of the building; only the starkly protruding cornice and the circular bay at the corner offer relief. And yet the design reveals considerable sophistication in the relationship of masonry and window areas and in the placement of mullions within the windows. The stress on simplicity may well derive from the more spartan aspects of warehouse and industrial architecture in England and America; yet the elegant relationship of horizontal and vertical elements and the refinement of the details may also point to a general interest in, if not the specific influence of, the architecture of Japan (Figs. 16–13 and 16–14).

The greatest figure in American archi-

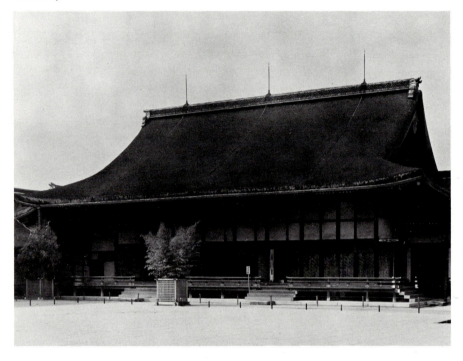

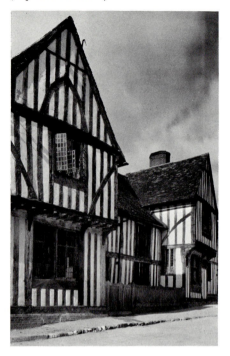

tecture of the late nineteenth and early twentieth centuries was Frank Lloyd Wright (1867–1959), who for some years was Sullivan's assistant. The Willits house of Highland Park, Illinois, built in 1902 (Fig. 16–16), is typical of the so-called Prairie Style he created around 1900. Wright's work of this period can best be understood in the light of the Arts and Crafts movement in England, which had been gaining momentum since around 1875. Aimed at the revival of the decorative arts, it stressed the unity of purpose of artists and craftsmen and promoted a sound working collaboration between the two to produce objects designed better, with a greater respect for the intrinsic qualities of the materials used, than those coming out of the ever more prolific mills of industry. The leading men of the group started out under the spell of the Medieval revival but were soon affected by Japanese and other Eastern influences. One outgrowth of the movement was the development of Art Nouveau in England and on the continent; another was the

development in architecture of an elegant and restrained manner that laid special stress on Medieval domestic styles while paying discreet homage to the simple horizontal and vertical accents of Japanese architecture.

Wright had kept abreast of this latter development, and it is no surprise to see, in the gabled profile and in the play of dark wooden elements against white plaster surfaces of the Willits house, allusions to English Medieval domestic buildings (Fig. 16–15). With respect to the Japanese influences, Wright went much further than his English predecessors and contemporaries had gone. The long, low lines of the house, accentuated by the driveway overhang at one end and the porch on the other, bring to mind such gems of Japanese architecture as the Seiryō-den in Kyoto (Figs. 16–13 and 16–14), and the geometric precision of the designs created by the dark woodwork against the white walls seems clearly influenced by them.

In one important respect the building differs dramatically from Japanese archi-

tectural schemes: the façade is made of a complicated arrangement of planes at right angles to one another, giving it a new and exciting complexity. We have already seen a broad trend toward complexity in the search for variety in Rococo interiors and in the return to a multiplicity of effects in some Gothic Revival buildings; this continuing trend was to lead to the search for excitement through the manipulation of flat planes and geometric spaces that characterized some of the best of twentieth-century architecture.

Like Sullivan, Wright believed that form should follow function. He tried to devise practical arrangements for his interiors and to reflect the internal layout in the exterior appearance of the building. In the Willits house, the cross-shaped lower-floor plan (Fig. 16–17) has a major advantage in that it provides views on three sides from the principal rooms and allows for abundant contact with the surrounding greenery. The various parts of the house, moreover, are all close to

16-16 *Top:* Frank Lloyd Wright, Willits House, Highland Park, Illinois, 1902.

16-17 *Bottom:* Frank Lloyd Wright, plan of Willits House. Copyright 1942, © 1970 by the Frank Lloyd Wright Foundation. Used by permission.

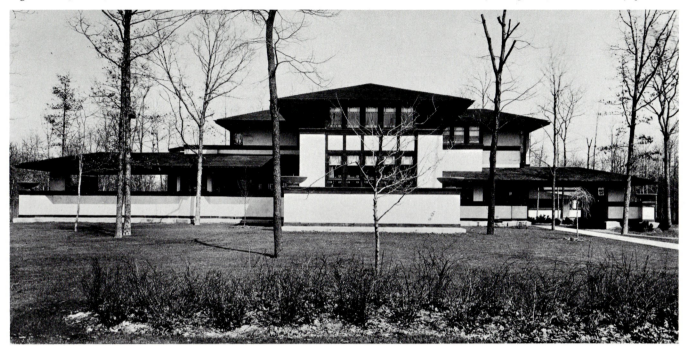

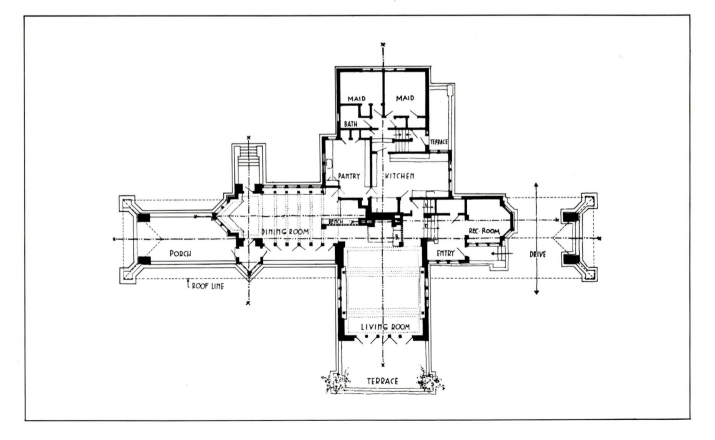

16-18 Frank Lloyd Wright, Willits House, living room.

the centrally placed pantry and kitchen; and the maids' quarters are conveniently placed near kitchen and stairs. Even more important, perhaps, the vertical and horizontal accents of the structure relate it to the ground and the surrounding trees, while the interplay of balconies, terraces, and open porches suggests the interpenetration of inner and outer spaces.

In the tradition of the architects of the European Arts and Crafts and Art Nouveau movements, Wright designed the furniture for this house to the last detail (Fig. 16–18). The chief criterion seems to have been comfort, as is manifested by the squarish armchair and the low table, the top of which is within reach of a person seated in the chair. Like many of the Art Nouveau decorators, who took advantage of the texture and color of the materials in their designs, Wright delighted in revealing large expanses of wood, relieving the uniformity of flat areas through the discreet use of horizontal and vertical decorative elements. He made a point, furthermore, of

creating pieces that served several functions; the table is also a cabinet, and on top of the bookshelves in the back is a long compartment in which to deposit books waiting to be properly shelved. And, like his Art Nouveau predecessors, he believed in making the furniture an integral part of the decoration of the room; the bookshelves are attached to the far wall, and the ledge over the window corresponds to the one underneath. Finally, like many of the Arts and Crafts and Art Nouveau architects, he devised elaborate decorations for the window-panes, here too adhering to a geometric linearism clearly influenced by the Japanese tradition (Fig. 16–14).

Despite these strong ties with his immediate predecessors, Wright's bold attempt to relate appearance to need and his vital understanding of the esthetic possibilities inherent in the play of flat planes and geometric linear elements make him one of the most significant links between the nineteenth century and the twentieth.

VI

The Twentieth Century

17

Before the First World War: Fauvism, Cubism, Futurism, Expressionism, Pre-Dada, and Metaphysical Painting

The years 1900–14 were marked by an unprecedented prosperity in the West, and for a while it appeared that man would profit from the material progress brought about by science and technology but still, among the prosperous classes at any rate, enjoy the amenities of earlier times. Electoral reforms had led to the adoption of representative government in most countries, and yet the old aristocracy still occupied many positions of responsibility, particularly in the diplomatic service and the armed forces.

The workers had achieved some notable improvements in their economic status, yet the entrepreneurs were as powerful and secure as they ever would be. The industrial revolution had given birth to large urban centers, but most of them were still limited in size and pleasant to live in, and rural life went on practically unchanged. The colonial and mercantile policies of Western nations had led to a pattern of ever growing world trade, and yet the average Westerner was blissfully unaware that underdeveloped areas were

soon to face certain crippling problems.

Several cultural developments occurred almost simultaneously, although they seem to have affected the fine arts at intervals of a few years. In response, perhaps, to the aura of material progress, there was a strong revival, at least among the general public, of nineteenth-century Positivist philosophy. It led to what we might call a hedonistic materialism. Vigorous minds and vigorous bodies, it was believed, would take advantage of the miracles of technology, resolve most of man's problems, and insure prosperity and well-being for all. How exciting it must have been to realize that hydroelectric power and the internal combustion engine would eliminate the smoke of coal-burning steam engines!

And, yet, the very progress of science and human thought released forces that undermined the Positivist attitude. With the discovery of radiation and the elaboration of modern atomic theory, it became apparent that there is little correlation between the scientific interpretation of

matter and man's perception of his surroundings. This became a pretext for a greater subjectivity in artistic creation; man began to accept that what he experiences in the presence of a cow in a field or of a beautiful woman takes place primarily in his mind and, conversely, that cows in fields and beautiful women are not by any means essential to esthetic gratification. Such reasoning is at the root of abstract developments in the art of the period.

Finally, a new interest in man's motivations, particularly Sigmund Freud's investigation of the subconscious, threw new light on the irrational aspects of unconscious thought and behavior. The novels of the period favored frank and occasionally painful introspection. In art, experimentation with incongruous and jarring associations intended at first as good-humored fantasies led after the First World War to serious attempts to reflect the life of the subconscious.

The dominant mood of confidence in the early twentieth century was shattered

by the onset of the First World War in 1914. The conflict was prompted by a struggle for hegemony among European nations. Fed by intense nationalist feeling and a truly popular enthusiasm for things military, it turned out to be by far the most destructive war the world had yet experienced. Aside from its immediate political consequences, such as the dismemberment of the Austro-Hungarian empire, the war led indirectly to the Communist revolution in Russia and more directly to America's growing world influence.

The period following the war witnessed drastic social changes. Income taxes and inheritance taxes as well as a succession of financial crises tended to weaken the less productive segments of the moneyed classes, while aggressive, enterprising industrial and financial leaders seized upon the opportunities afforded by scientific management and technological progress to amass enormous fortunes. At the other end of the scale, despite major economic fluctuations, the benefits of mass production, no less than the impact of trade unions, were vastly improving living conditions among the lower and middle classes.

Not surprisingly, it was a period of considerable political unrest. The disruptive effect of the war on most Western nations was aggravated by a series of economic crises that culminated in the Great Depression of the 1930s. And, whereas most Western countries retained democratic forms of government through these upheavals, first Italy and then Germany

were taken over by fascist dictators.

A little more than two decades after the First World War, Europe was ravaged by an even fiercer conflict, the Second World War (1939–45), which resulted in the occupation of a number of central European states, including the eastern half of Germany, by a much strengthened Russia, while the United States became closely allied through military treaties and economic ties with a number of Western powers. Partly as a result of the war, most of the colonial possessions of Western European powers either were granted or won their independence, and a large portion of the world sought to emancipate itself from Western influences.

The United States, now acknowledged as the industrial giant of the world, achieved spectacular material advances. In Western Europe several countries that had adopted totalitarian regimes returned to democratic forms of government, and all countries profited from a vast expansion in industrial output, giving great masses of people a level of freedom and material comfort that half a century before had been available only to the privileged few.

One result of this increased prosperity has been a change in the patterns of patronage of the arts. For the first time in history, artistic developments are followed by a broad section of the public. Increasingly active museums in the big cities, the popular press, art books, and films constantly bring the arts of the past to the attention of the public as well as introduce new developments. Furthermore, the small minority of people who

are able to collect on an appreciably large scale has been growing and has driven the prices of old and even modern masters to astronomical heights. Some collectors are acquiring works by unknown artists, and while the contemporary art market fluctuates with rapidly changing tastes, a few lucky younger artists are achieving unprecedented financial success.

The first of the periodic jolts to which the gallery-going public has been subjected during the course of this century was the 1905 Salon d'Automne in Paris. (The *Salon d'Automne* was an annual, nonofficial, juried exhibition dedicated to recent trends.) One critic referred to a room devoted in part to the work of Henri Matisse (1869–1954) and some of his friends as a den of wild beasts (*chez les fauves,* in French), and these young men came to be known as the Fauves. One of the works included was Matisse's portrait of his wife, *The Green Stripe,* of 1905 (Fig. 17–2). A comparison with an earlier portrait, Édouard Vuillard's *Self-Portrait* of 1892 (Fig. 17–1), will point up the explosive quality of the Fauvists' technical performance and their concern with a frank and forceful appraisal of their perceptions.

Vuillard (1868–1940) was a member of a group called the Nabis (after *nabi,* the Hebrew word for prophet), made up of young painters who had developed a profound reverence for Gauguin and his innovations. These men took a strongly antinaturalist stand, deriding manual dexterity and looking to the musicality of line and color to convey personal moods.

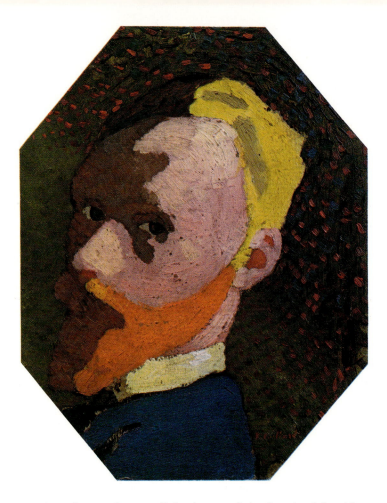

17-1 Édouard Vuillard, *Self-Portrait,* 1892. Oil on cardboard (14″ × 10¹⁵⁄₁₆″). Private collection, Paris (*comparative illustration*).

Vuillard's *Self-Portrait,* with its large areas of almost uniform and comparatively intense colors, reminds one of Gauguin's technique. But there are differences. There are none of the continuous dark outlines as in Gauguin's *Vision After the Sermon* (Fig. 16–5), the edges tend to be blurred, and the artist took pleasure in leaving brushmarks that emphasize the spontaneity of the execution. The background wallpaper was rendered by means of a rich pattern of multicolored strokes, vaguely reminiscent of Seurat's technique, which adds to the overall pictorial excitement.

The Nabis, like Gauguin, were interested in the play of associations, but their associations tended to be based on visual puns rather than on historical or biographical allusions. Here, the shadow that covers the eyes and adds a touch of mystery to the reflective stare also creates a fanciful design along the forehead, the edge of the nose, and the surface of the beard, turning the whole head into a playful arrangement of orange, yellows, pinks, and browns somewhat reminiscent of the

designs of Japanese printmakers such as Utamaro's *Woman Looking in a Mirror* (Fig. 15–4). Quite humorously, the features of the serious young man have been turned into an intriguing pattern of hues and values that, together with the excitement of the design of the wallpaper, contribute to a mood of lighthearted lyricism.

Matisse, who had admired all the great Post-Impressionists at one time or another, had also been much influenced by Vuillard and the latter's Nabi friends. The differences between his portrait and Vuillard's are nevertheless very great. Matisse had returned to a forceful, if sporadic, use of outlines to define the forms. At first sight his brushwork appears only a little coarser and more spontaneous than that of Vuillard; on closer inspection, it reveals a willful and disturbing disregard for natural forms, as in the angular pattern of dark strokes on the chin. And, if the overall impact of the colors is one of remarkable richness and power, some areas seem intentionally weird and somewhat unpleasant. The

lighted part of the face is pink with a violet cast, while the other half is a yellowish-ocher. The shadows are an acid green (an ironic reminder of Impressionist and Neo-Impressionist practices, since green is the complementary of the pink-violet on the lighted side of the face), and what can only be a gross exaggeration of a shadow is rendered as a broad green stripe covering the center of the forehead and the nose.

In Vuillard's *Self-Portrait* the decorative handling of color areas on the pictorial surface produces a flattening effect. And yet, by showing the head in three-quarter profile, with the line of the eyes clearly receding in space, by suggesting the roundness of the cheek through the curvature of the upper edge of the beard, and especially by emphasizing value contrasts between the areas that are lighted and those that are shaded, a substantial modeling has been suggested. Matisse went much further in accentuating ambiguities in his handling of volume. The pointed neckline and the curved top of

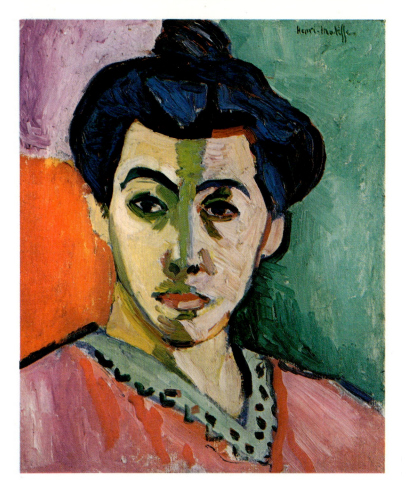

17-2 Henri Matisse, *The Green Stripe*, 1905. Oil on canvas (16″ × 12¾″). Royal Museum of Fine Arts, Copenhagen.

the forehead suggest strong modeling, but the almost uniform color of each side of the face and the strong linearity of the features tend to produce a pronounced flattening of the surface.

In one respect, Matisse, like all the Fauves, was perhaps closer to the Impressionists than to Gauguin and the Nabis: he was very much concerned with immediate sensations; but he was much more concerned with finding powerful pictorial equivalents to his sensations than were the Impressionists. When asked why he painted, he explained, "To translate my emotions, my feelings and the reactions of my sensibility into color and design." Like Cézanne, who had said that "art is a harmony parallel to nature," Matisse felt that rather than copy nature the artist should create a pictorial equivalent to his personal response to nature. "Construct by relations of colors, close and distant— equivalents of the relations that you see upon the model," he told a student.

Matisse did not content himself with the aura of gentle hedonism that the

Impressionists evoked in their response to nature—nor, for that matter, with the reflective quality and the lighthearted lyricism of the Nabis. His reactions to the physical world have a new and occasionally dramatic emotional intensity, for he analyzed his sensations with a frankness verging on brutality. There is, in the features of Madame Matisse, a full measure of the simplicity and quiet human dignity of his wife, but there is also something awesome in the mask-like configuration of the face and, as we have seen, a jarring note in the color scheme. It is as if Matisse had caught some of the more forbidding aspects of another being and had allowed himself to dwell on his own response.

Matisse may have been referring to his emotional reactions to his environment when he wrote: "The model...must awaken in you an emotion which in turn you must seek to express." It happens that his reaction could have intense and sometimes disturbing psychological overtones. An American writer who saw the

picture shortly after it was painted exclaimed, "He teaches you to see in [Madame Matisse] a strange and terrible aspect."

Although Fauvism can be considered as marking the culmination of trends going back to the innovations of the 1880s, the Fauvists' ability to evoke even their most fleeting reactions to their environment with nearly explosive force was to affect profoundly the German Expressionist artists, who sought to exteriorize the subtlest nuances of their subconscious life with an intensity verging on violence.

The next development produced an even greater shock in Parisian art circles and had an even greater impact on the art of our century. Cubism was inaugurated with a large canvas showing five monumental pink women against blue and brown draperies, *Les Demoiselles d'Avignon,* painted in 1906–07 (Fig. 17–3) by the Spaniard Pablo Picasso (b. 1881). The title refers to a street in the red-light district of Barcelona, the city in which the artist had spent several years before

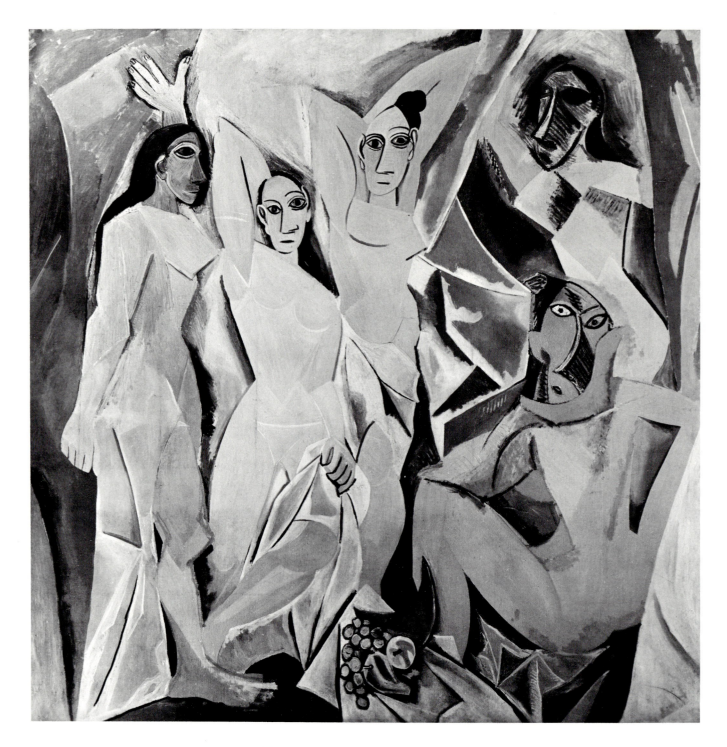

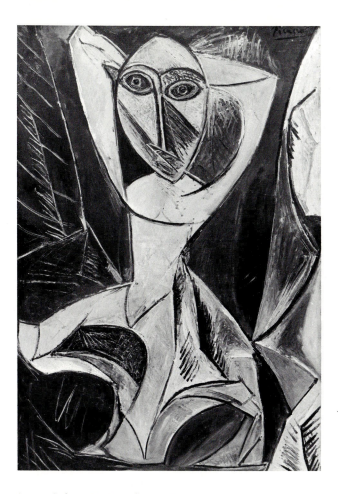

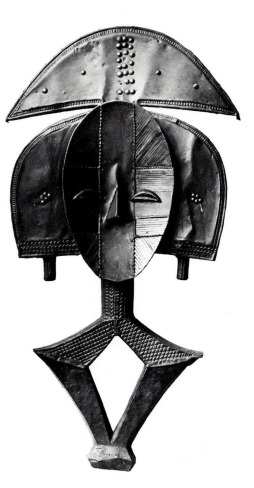

he settled in Paris early in the century as a young man.

The bodies of the women and the draperies are made up of an interplay of smooth geometric fragments that convey a sense of violent energy surpassing even anything produced by the Fauves. And if Madame Matisse's face (Fig. 17-2) has the impersonal and hermetic quality of a mask, the eyes of these young women have ominously fixed stares.

In all these respects—the geometric handling of form, the suggestion of in-

17-3 *Left:* Pablo Picasso. *Les Demoiselles d'Avignon,* 1906–07. Oil on canvas (8′ × 7′8″). The Museum of Modern Art, New York. Acquired through the Lillie P. Bliss Bequest.

17-4 *Top, left:* Pablo Picasso, *Dancer,* 1907. Oil on canvas (4′11″ × 3′3¼″). Collection of Walter P. Chrysler, Jr., New York.

17-5 *Top, right:* Bakota funerary fetish, brass sheeting over wood, probably twentieth century. Smithsonian Institution, Washington, D.C. Herbert Ward Collection (*comparative illustration*).

tense energy, and the awesome expressions—Picasso's Cubist manner owes much to a new understanding and love of black African art among the young painters and writers of the Parisian avantgarde. Only two or three years earlier, artist friends of Matisse had acquired a number of African masks, whose sculptural merits they greatly admired. This recognition represents a major new development; with the notable exception of Gauguin, who had made perceptive borrowings from primitive artistic traditions, interest in primitive artifacts up to that time had been primarily scientific. Indeed, it would seem that Western man began to develop an enthusiastic appreciation of the native art of European colonies just a few decades before the colonial empires of most European nations dissolved.

That Picasso was directly inspired by black African art is beyond doubt. His *Dancer* of 1907 (Fig. 17-4), one of the paintings associated with *Les Demoiselles* and more specifically linked to the central figure in that painting, was probably in-

spired by a Congolese Bakota funerary fetish such as that illustrated in Figure 17-5. Not only was the overall configuration of the *Dancer* based on the geometric stylization of the African piece, but the sense of energy conveyed by the interplay of angular facets was clearly derived from the powerful terseness of the geometric forms of the fetish. Even the striations and the crisscross patterns seem to have been inspired by the decoration of the Bakota piece. The ominous fixed stare has much in common with the awesome expressive power of the simply carved eyes of the magical figure.

The swiftness and spontaneity of the execution may well stem from Fauvist attitudes. On the other hand, the suggestion of geometric facets points to the influence of Cézanne, and the contrast between the strong relief of certain areas and the flat decorative patterning of others, no less than the opposition of uniform areas that appear solid and striated surfaces that appear transparent, suggest a brutal exaggeration of the incon-

16-8 Paul Cézanne, detail of *View of Gardanne*, 1885–86 (*comparative illustration*).

sistencies of Cézanne's constructive manner.

Picasso's approach to the subject matter of *Les Demoiselles d'Avignon* is revealing. An early sketch for the picture shows a sailor surrounded by nude women, while a man carrying a skull enters the room, suggesting that Picasso's original intention was to evoke associations of carnality and death. It is significant that the artist eliminated the two male figures to play down the associative element and stressed instead the brutal angular treatment of the forms of the women; Cubist art was to become increasingly abstract.

In 1907 Picasso met Georges Braque (1882–1963), a Fauve painter who shortly afterward began to stress an energetic interplay of geometric facets in his own work. The two men had become fast friends by 1909, and a spirit of competitive cooperation led them to make revolutionary strides in Cubist abstraction over a period of a few years. Braque's *The Portuguese* (Fig. 17-6), painted two years later, in 1911, is characteristic of the Analytical Cubism that he and Picasso evolved.

In contrast with *Les Demoiselles d'Avignon, The Portuguese* was executed almost entirely in grays, browns, blacks, and silvery whites; the occasional touches of blue, green, pink, and purple do not detract from the essentially monochromatic quality of the composition. The facets themselves are no longer smooth in appearance; the paint in general was applied in parallel dabs, reminding one both of Seurat's small dots and of

Cézanne's vibrant strokes. The figurative elements, moreover, dissolve in a maze of interpenetrating geometric facets that seem to float in a fairly shallow space beyond the picture plane. Some of the facets are opaque, others transparent; some appear to reflect light, others to generate it. As a result, before one recognizes an eye, a nose, a mustache, or a guitar, one is faced with a strangely ethereal and faintly luminescent arrangement of planar fragments.

The systematic decomposition of forms into individual geometric fragments of varying translucency brings this work even closer to Cézanne's "analysis" (Fig. 16–8) than is *Les Demoiselles d'Avignon*. Picasso and Braque had indeed been much influenced all through this phase of Cubism by the older master, whose retrospective exhibition of 1907 had been greatly admired in Paris. In fact, one of the early apologists of Cubism, the artist Jean Metzinger, explained the Cubist decomposition of form in the following terms: the Cubists "have allowed themselves to move around the object, in order to give, under the control of intelligence, a concrete representation of it, made up of several successive aspects. Formerly a picture took possession of space; now it reigns also in time." It will be remembered that Cézanne expressed a fairly similar idea when he wrote that by moving his head a little one way or the other he could experience an exciting variety of impressions (see p. 226). The result is that the onlooker perceives in one instant a multiplicity of effects nor-

mally perceived over a certain length of time.

Some theoreticians of Cubism went further, claiming that Cubist esthetics was entirely based on the relationship of simple geometric forms. A poet friend of the Cubist artists, Pierre Reverdy, explained "it will be evident that what has to be done is not to reproduce [the object's] appearance but to extract from it...what is eternal and constant (for example, the round form of a glass, etc.) and to exclude the rest." In this respect the Cubists denied much more sweepingly than earlier artists had done the usefulness and even the validity of representation in art. Their thinking in this matter happened to run along lines parallel to that of the scientists who were questioning man's ordinary perception of the physical world. The early writers on Cubism were quick to notice this and larded their articles with references to the most recent theories of physicists and mathematicians.

Braque was fully aware of the esthetic potential of abstract relationships. "I couldn't portray a woman in all her natural loveliness," he is reported to have said; "I must, therefore, create a new sort of beauty, the beauty that appears to me in terms of volume, of line, of mass, of weight, and through that beauty interpret that subjective impression." His views were thus close to Cézanne's "Art is a harmony parallel to nature" and to Seurat's understanding of musicality as a search for a superior harmony.

Much as the Cubists stressed abstract relationships of forms, their works con-

tained recognizable elements. One distinguishes a guitar player in Braque's *The Portuguese,* while the fragment of a pier and two mooring posts in the upper right suggest that the scene is located near a harbor. The letters D BAL probably come from "GRAND BAL" and if so refer to some dance in a popular district for which the Portuguese might have been playing his guitar. Objects and letters, it would seem, allude only distantly to physical reality, or to a memory of physical reality, through a play of associations.

There is, of course, a touch of irony in all this. The bits of matter suggested by the planar fragments appear to be much more real than the musician and the setting. And as if to compound the humor, the letters and numerals, which have been applied to the surface of the picture as if it were the side of a packing crate, tend to reaffirm the existence of the pictorial surface and thus negate any illusion of space created by the interplay of fragments. To an even greater degree than the Baroque artists, the Cubists took delight in an ambivalent play between reality and artifice.

Early in 1912 a change occurred in the approaches of both Picasso and Braque. Rather than starting out with an object and decomposing it into a multitude of monochromatic facets, they seem to have begun with a flat linear design

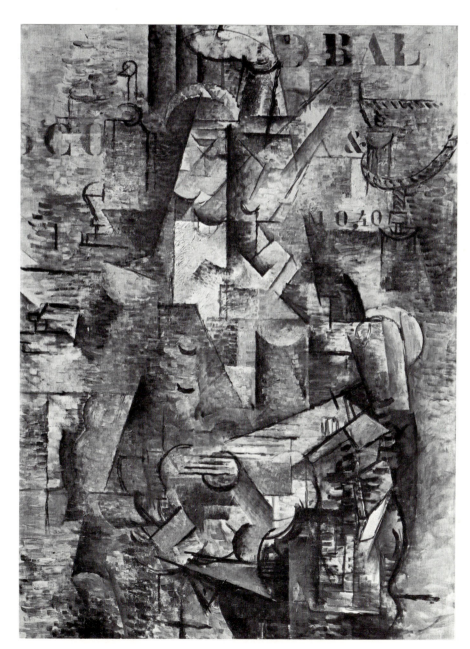

17-6 Georges Braque, *The Portuguese,* 1911. Oil on canvas (45⅞" × 32⅛"). Kunstmuseum, Basel.

and filled it out with planes of various hues, creating bold geometric color patterns over the surface. The colored planes may be totally abstract, or suggest recognizable objects, or be made up of fragments of "real" objects such as pieces of newspaper or wallpaper glued over the surface (a technique called *collage*). But the fragmentation of objects and the suggestion of transparency that characterized the earlier phase continued to be evident in many works. This new manner, which has been called Synthetic Cubism, was to characterize the work of Braque and Picasso until the outbreak of the First World War and to reappear in various guises in their later production. Braque's *Clarinet* of 1913 (Fig. 17–7) is a characteristic Synthetic work. The cutouts, made up of imitation wood-graining, newspaper cuttings, and painted paper, are integrated into the surface design to form a simple, semigeometric configuration. The principal object, the clarinet, is made to appear solid and flat, although a vitreous transparency is quite incon-

gruously suggested over part of it. Braque was just as inconsistent in suggesting the glass as seen from inside and out simultaneously, thus preserving within this item the fragmentation of Analytical Cubism. Humorously, a poetic element is suggested by the "real," the applied paper object: the name of the newspaper is *L'Echo d'A...,* as if in response to imaginary music produced by the instrument, while the wood-graining effects seem to allude to its particular register.

Picasso's *Musical Instruments* of 1914 (Fig. 17–8) is a sculpture of the Synthetic period. The solid fragments of Synthetic Cubism were assembled to make up a fairly simple geometric configuration. The various forms allude to two instruments. The cutout portion of the protruding sheet of wood suggests the curvature of the back of a mandolin, which seems to be jutting out in front of the fingerboard. The cylindrical piece at the bottom has been turned into a wind instrument with painted black dots along its surface, a short and narrow cylinder at one end, and

a crude circular disc at the other. But beyond any hint of representation, the work's quietly lyrical appeal lies in the interplay between solids and hollow forms and between straight and curved lines, and in the subtle multiplicity of effects. In keeping with Cubist humor, the very roughness of the wood contrasts with the traditional idea of the delicate, highly finished woodwork of musical instruments. And, carrying further the play between artifice and reality, Picasso applied a few streaks of glaze over certain areas as if to suggest that they are transparent.

Cubism had an immense influence on the development of twentieth-century art. Among the first to take advantage of its innovations was a group of Italian artists who called themselves Futurists. They had been profoundly affected by an Italian poet living in Paris, Filippo Tommaso Marinetti, who had issued an "Initial Manifesto of Futurism" in 1909. Marinetti was an early apostle of the machine age, in which he saw an infinite range of

esthetic possibilities: "We declare," he wrote, "that the world's splendor has been enriched by a new beauty; the beauty of speed. A racing motorcar, its frame adorned with great pipes, like snakes with explosive breath...a roaring motorcar, which looks as though running on shrapnel, is more beautiful than the Victory of Samothrace," the celebrated Hellenistic statue.

The Futurist artists evolved a style suitable for the expression of these feelings only after having become acquainted with the innovations of the Parisian Cubists; yet both their intentions and their handling of form were different from those of the Cubists. *States of Mind: The Farewells* of 1911 (Fig. 17–9) by Umberto Boccioni (1882–1916) shows the same predilection for monochromatic color, the same fragmentation of objects, the same striving for a multiplicity of effects, as Cubist works and makes the same use of numerals applied flatly over the surface, as if to reassert the integrity of the picture plane (see Fig. 17–6). The differences are major, however. The Cubist artists decomposed objects into animated planar fragments, but what could be perceived of the objects themselves appeared totally static; as Metzinger had put it, it is the artists who "have allowed themselves to move around the object." For the Futurists, who may have been consciously reacting against this Cubist concept, "the spectator lives in the center of the picture," and the artist attempts to re-create "the sum total of visual sensations that the person...has experienced." The implication is that what they were trying to evoke was the very animation of life around them. The Futurists added that the picture must be the synthesis *"of what one remembers and of what one sees."*

Their chief concern, however, was the suggestion of speed and motion. The artist, they claimed, must render *"the dynamic sensation,* that is to say, the particular rhythm of each object, its inclination, its movement, or, to put it more exactly, its interior force." Not surprisingly, Boccioni's picture is filled with a variety of superposed views of a locomotive and carriages as the artist might have recorded them mentally in a railway station or in the course of a trip. What is more, the artist used a number of devices to imply the state of constant and rapid change so typical of modern life. The most clearly represented image of the locomotive has its pointed boiler facing left as if to imply motion in that direction, while an undulating line rising toward the right suggests the turbulent slipstream that it creates. Such lines were called *force lines* by the Futurists, and they were meant, according to Boccioni, to reveal how the object "would resolve itself were it to follow the tendencies of its forces." The connection with the Baroque lines of force cannot, of course, be dismissed and it is not a little ironic that a movement dedicated to modernism should rely on a three-century-old device to achieve a sense of dynamism. The rounded line of the hills in the upper left is repeated several times as if to indicate the "vibration and motion [that] endlessly multiply

17-10 Kasimir Malevich, *Basic Suprematist Element: The Square,* 1913; drawing. Russian State Museums, Leningrad.

each object," to quote Boccioni, and thus it suggests the relative movement between train and landscape. The artist further emphasized the idea of energy by livening the dominant gray-blue-green tonalities of the picture with streaks of orange-red, suggesting the glow of the locomotive's furnace as the train speeds through the night.

The Futurists' attitude toward subject matter was very different from that of the Cubists. The Cubists had preserved remotely representational elements in their works but had eliminated all trace of emotionalism, while the Futurists intended to evoke "states of mind" that could be permeated with intense and even violent emotions. The forms themselves were meant to be expressive; describing *The Farewells,* Boccioni wrote, "horizontal lines, fleeting, rapid and jerky, brutally cutting into half-lost profiles of faces or crumbling and rebounding fragments of landscape, will give the tumultuous feelings of persons going away." He also made use of symbolically expressive ele-

ments: in the lower left a human form leans out of an opening that suggests a carriage window, in order to embrace another figure, and this motif is repeated several times on a smaller scale in other parts of the painting. It is significant that the two most vivid hues of the whole picture are those of the composite images of the yellow headlight of an advancing locomotive in the lower left corner, and that of a red rear light of a last departing carriage right in the center of the picture. The artist was clearly alluding to the trauma of separation. In his own words, he was "blending, so to speak, the painted canvas with the soul of the spectator."

Although the Russian Kasimir Malevich (1878–1935) had totally repudiated any attempt to suggest motion, he too was trying to convey states of mind through the handling of form. He founded a movement that he called Suprematism, which used a visual language even more abstract than that of the Futurists. Referring to a picture such as the drawing *Basic Suprematist Element: The*

Square, of 1913 (Fig. 17–10), Malevich wrote:

No more "likenesses of reality," no more idealistic images—nothing but a desert.

But the desert is filled with the spirit of nonobjective sensation, which pervades everything.

...a blissful sense of liberating nonobjectivity drew me forth into the "desert," where nothing is real except feeling... and so feeling became the substance of my life.

This was no "empty square" that I had exhibited, but rather the feeling of nonobjectivity.

Beyond this expression of faith in the esthetic potential of geometric abstraction, Malevich believed with a truly mystical fervor that geometric forms can be invested with a subtle yet pervasive emotional significance.

Before turning to Expressionism—a movement that evolved from Fauvism and developed, primarily in Germany and northern European countries, at about the same time as Cubism—we should point out that a number of major artists bor-

rowed formal elements from Cubism while seeking at the same time a degree of expressiveness through the handling of forms that linked them with Expressionism. The sculptor Constantin Brancusi (1876–1957) can be included in this group. He was born in Rumania but moved to Paris early in his career. After having been much influenced by Rodin, he developed an intense interest in primitive art and adopted some elements of the Cubist idiom. His *Bird in Space,* dating from about 1928 (Fig. 17–11), shows a geometric simplicity that is fundamental to the Cubist approach to form, while the play of reflections on the highly polished bronze surface may be associated more specifically with the exciting interplay of translucent areas of Analytical Cubist painting. A comparison with a typical Cubist sculpture such as Picasso's *Musical Instruments* (Fig. 17–8), however, reveals major differences. Picasso's allusions to physical reality are remote; the musical instruments are barely distinguishable. Brancusi, on the other hand, hinted with

considerable insistence at recognizable objects. The subtle curvature of the belly and the undulations of the footing evoke eloquently the tense and graceful forms of a soaring bird. At the same time the extreme streamlining of the forms and the smooth and shiny surface must necessarily be associated with a speeding mechanical device.

What is more, for all the crudeness of its execution, the Picasso sculpture expresses a quiet lyricism. Brancusi's *Bird in Space* has more specific emotional overtones. The artist himself had called earlier versions of the work *Maiastra,* the name of a magical bird of Rumanian folk tales. The speed-suggesting streamlining and pronounced upward elongation of the piece, furthermore, had a near-mystical meaning for Brancusi: "Like everything I have done," he once said of *Bird in Space,*

17–11 Constantin Brancusi, *Bird in Space,* 1928(?). Bronze, unique cast (54″ high). Collection, The Museum of Modern Art, New York.

16-7 Vincent van Gogh, detail of *Night Café*, 1888 (*comparative illustration*).

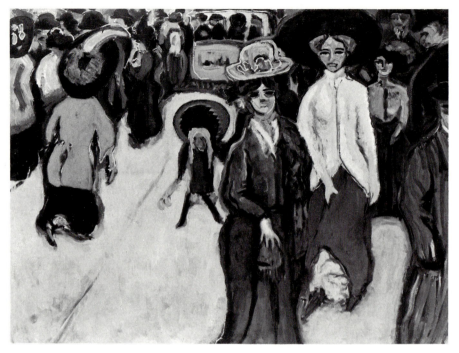

17-12 Ludwig Kirchner, *Street, Dresden*, 1908-09. Oil on canvas (4'11¼" × 6'6⅞"). Collection, The Museum of Modern Art, New York, Purchase.

"it strives toward heaven." The series of works to which this one belongs is clearly intended to give this striving its most tangible expression, and as such it reflects a state of the soul with remarkable simplicity and intensity. This subordination of form to expressive intent is one of the main characteristics of Expressionism.

The Expressionist movement in Germany evolved during the first years of the century; it came of age around 1905-07. Like the Fauves, with whom they had strong affinities, the early German Expressionists remained essentially representational. Their work, however, is characterized even more by a willful subordination of form and execution to expressive intent and by a broad range of frequently morbid subjects.

Street, Dresden, 1908-09 (Fig. 17-12), is by Ludwig Kirchner (1880-1957), a member of a group founded in Dresden called Die Brücke (The Bridge), that presented its first exhibition in the winter of 1906. The figures are as ghostly as are those of van Gogh's *Night Café* (Fig.

16-7); indeed, they are defined by means of powerful rhythmic curved lines that correspond only loosely to their anatomy and suggest both a strangely disembodied quality and a high degree of animation. The colors add disquieting notes: the work is dominated by marked contrasts between warm and cool colors of various intensities that recur even on the faces of the figures (one of them is a pale bluish-green with orange eyes and lips). Finally, the artist formed deliberate spatial ambiguities between the strong surface pattern created by the continuous outlines that link certain figures and the strong spatial emphasis created by the recession of the road toward the streetcar.

The swiftness of the linear treatment and the brilliance and boldness of the color scheme seem to be derived from Fauvism. But the return to symbolic devices and the new expressive intensity go back to van Gogh. The man at the right is casting a leering glance toward the women just behind him, who are making gestures that are less than decent, while

the small girl is performing a clownish dance ominously in the path of the streetcar. To Kirchner, apparently, the vision of a crowd has become a pretext for the projection of a profound sense of anxiety and hostility. Men and women are symbols of lechery and greed, and the small girl seems to be courting disaster, while jagged rhythmic lines and the clash of brilliant colors add powerfully, and splendidly, to the sense of alienation. Figures and objects seem to have been perceived in a state of emotional crisis, and the forms and colors reflect an almost explosive intensity of feeling. For the Expressionists the act of painting was a release of psychic energy.

Another Expressionist artist who was even more concerned with the pictorial evocation of spiritual energy was the Russian-born Wassily Kandinsky (1866-1944), who had settled in Munich in 1896 and played a leading role in avant-garde circles there, eventually founding Der Blaue Reiter (Blue Rider), a group that was active in Munich from 1911 until the

17-13 Wassily Kandinsky, *Study for Composition No. 2*, 1910. Oil on canvas (3'2⅜" × 4'3¾"). Solomon R. Guggenheim Museum, New York.

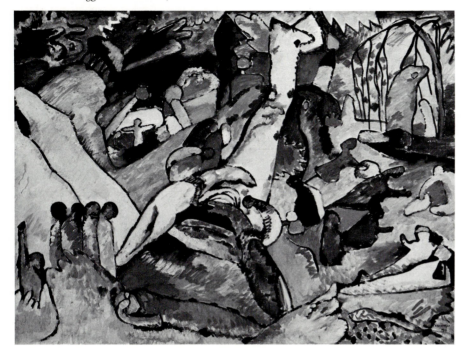

17-13 Wassily Kandinsky, *Study for Composition No. 2*, 1910. Oil on canvas (3'2⅜" × 4'3¾"). Solomon R. Guggenheim Museum, New York.

onset of the First World War. Endowed, like his compatriot Malevich, with a mystical bent, he conceived the possibility of an art that would increasingly ignore material objects and attempt to communicate exclusively through the play of line and color.

Kandinsky's *Study for Composition No. 2* (Fig. 17–13) was executed in 1910 at a fairly early stage of this transformation, and a few physical objects are still recognizable, albeit highly distorted. The artist explained to what extent he relied on the expressive musicality of the medium: "Color is the keyboard, the eyes are the hammers, the soul is the piano with many strings. The artist is the hand that plays, touching one key or another purposefully, to cause vibrations of the soul." He felt that the partial and sometimes total elimination of material objects enabled the artist to establish a rapport between his own subconscious and that of the viewer. Several years after he painted *Study for Composition No. 2,* he expressed in poetic terms the role that unconscious mecha-

nisms, and even pure chance, played in this process:

As in a struggle, as in battle, fresh forces pour out of the tube [of paint], young forces replacing the old. In the middle of the palette is a curious world of the remnants of colors already used, which wander far from this source in their necessary embodiment on the canvas. Here is a world which, derived from the desires of pictures already painted, was also determined and created through accidents, through the puzzling play of forces alien to the artist. And I owe much to these accidents.

Kandinsky's attempt to convey tumultuous feelings while underplaying or eliminating representation has been called by later critics Abstract Expressionism. It is at the root of a tradition of uninhibited spontaneity and reliance on chance in the handling of artistic media that was to have a profound influence on Western art right up to our own time.

A group of young men who did not share the Cubists' interest in formal relationships, and who nevertheless were fas-

cinated by their defiance of man's ordinary perception of the universe, derived from Cubism an inspiration for their own pursuit of the absurd. These men were in the forefront of what were to become the Dada and eventually the Surrealist movements, and their style can be referred to as Pre-Dada. The most ingenious among them was probably Marcel Duchamp (1887–1968), who, after having explored the language of Cubism, set out to create what he called "Readymades." A Readymade, Duchamp explained, is "a common object turned into a work of art solely by reason of its having been chosen by the artist."

Beyond this creation of works of art by fiat, so to speak, Duchamp frequently invested his works with humorous overtones. His *Bicycle Wheel* of 1913 (Fig. 17-14) carries to even greater heights the spirit of audacious and witty irreverence inaugurated by Braque and Picasso, and fully evident in Picasso's *Musical Instruments* (Fig. 17-8). In the Picasso we are amused by the contrast between the crude

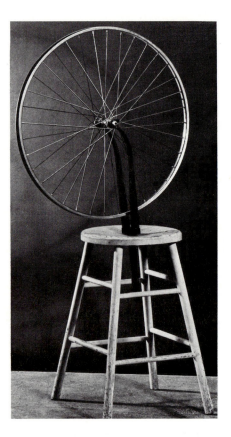

17-14 Marcel Duchamp, *Bicycle Wheel*, 1951; third version, after lost original of 1913. Assemblage: metal wheel mounted on painted wood stool (4′2½″ high). Sidney and Harriet Janis Collection. Gift to The Museum of Modern Art, New York.

execution and the faint suggestion of a quiet lyricism. Duchamp also played with conflicting elements, but his mood was more sardonic. A bicycle wheel suggests motion, and a stool suggests repose, yet this wheel is incapable of horizontal displacement—at most it can spin on its axle—while the stool cannot be sat upon because of the presence of the wheel. There is a touch of buffoonery in the way each object has been rendered useless by the other, and sophisticated humor in the way the concepts of motion and rest have been made to counteract and neutralize one another. The idea of taking objects out of their ordinary context and juxtaposing them so as to suggest conflicts between the ideas and moods that we ordinarily associate with them was to play a major role in subsequent developments, leading to the Surrealists' juxtapositions of objects loaded with subconscious meaning.

Duchamp's work has been called Pre-Dada, sharing as it does the principal characteristics of the movement that was named Dada by a group of artists and poets in Zurich in 1916. Duchamp himself described Dada in a text written much later:

> Dada was an extreme protest against the physical side of painting. It was a metaphysical attitude; it was intimately and consciously involved with "literature." It was a sort of nihilism to which I am still very sympathetic. It was a way to get out of a state of mind—to avoid being influenced by one's immediate environment, or by the past: to get away from clichés—to get free. The "blank" force of Dada was very salutary. It told you "don't forget, you are not so blank as you think you are!"

At about the time that Duchamp was experimenting in the Dada spirit, the Italian Giorgio de Chirico (b. 1888) was developing what he later called his Metaphysical Art. De Chirico had been strongly marked by a stay in Munich, where he had been profoundly influenced by German artists who fall within our category of Romantic Symbolists. In 1911 he settled in Paris, where he developed a style that reveals the imprint of Cubist developments.

On first impression de Chirico's *Nostalgia of the Infinite* (Fig. 17–15) appears to be a stylized vision of a Renaissance or antique city-scape. On closer inspection, one detects a play of geometric elements in space clearly reminiscent of Cubism: the marked difference in values between the two sides of the tower, for instance, implies a strong three-dimensionality, and yet the receding lines of the arcades on the sides diverge instead of converging toward a point. There is a suggestion of haze in the distance and the flags over the tower seem to wave in the breeze, yet the clear delineation of even distant architectural details and the clearly defined shadows imply the absence of an atmosphere. The arbitrary scale is also startling: the figures are tiny in comparison to the buildings. Finally, the long shadows point in varying directions, as if they had been created not by the light of the sun or even the moon, but by imaginary giant electric light bulbs behind the near building.

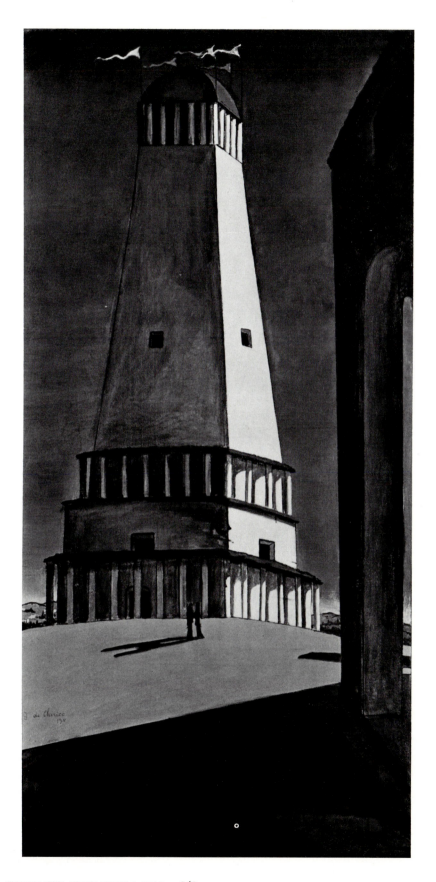

17-15 Giorgio de Chirico, *The Nostalgia of the Infinite,* 1913-14(?)—dated on painting, 1911. Oil on canvas (4'5¼" × 2'1¼"). Collection, The Museum of Modern Art, New York, Purchase.

The subtle manipulation of form and light has essentially removed the individual objects from their ordinary context and turned what could have been a plausible landscape into a strangely obsessive vision. The artist wrote at about this time: "To become truly immortal a work of art must escape all human limits: logic and common sense will only interfere. But once these barriers are broken it will enter the regions of childhood vision and dreams."

This process can be associated with Duchamp's juxtaposition of a bicycle wheel and a stool, but the effect was not intended to be humorous. It also recalls Redon's juxtapositions, but these are more fantastic and seem to pertain more exclusively to the world of the imagination (Fig. 15-15). It may well be that the dismayingly obsessive quality of de Chirico's picture lies in the very familiarity of the objects and figures and in the fact that they appear as weirdly definite and are arranged as improbably as in some of our most ordinary dreams.

18

Between the Wars: Dada, Surrealism, and Geometric Abstraction

During the First World War Switzerland, an island of peace in the midst of the European conflict, became a haven for young intellectuals from various nations. A group of poets and artists sympathetic to the nihilistic antitraditionalism and the cult of the absurd of Parisian Pre-Dada art founded a night club, the Café Voltaire, in Zurich and there they presented nightly performances that ranged from poetry readings (sometimes consisting of several free-verse poems read simultaneously to the accompaniment of African drums) to dance improvisations and pantomimes. According to one account, in 1916 a German poet in the group, having noticed in a French dictionary the word *dada*—children's gibberish for hobbyhorse—proposed it as a name for the elusive ideals of the movement, and the idea was enthusiastically taken up by his friends.

The organizers of Dada founded an art gallery in 1917, where works were displayed by a group of artists working in very different manners but sharing a desire to break away from earlier styles and earlier iconography. The most gifted among them was unquestionably the Alsatian-born Hans Arp (1887–1966). His *Plant Hammer* of 1917 (Fig. 18–1) is a collage of pieces of wood in which areas of uniform color create a nearly-abstract configuration over the surface. In both technique and style it goes back to the Synthetic Cubist phase of Picasso and of Braque. Arp referred to such works as concrete art, and like Kandinsky (Fig. 17–13), whose ideas must have been familiar to him, he thought of artistic composition as a nearly-magical process in which unconscious mechanisms operate according to what he called "the law of chance...which embraces all laws and is unfathomable like the first cause from which all life arises [and] can only be experienced through complete devotion to the unconscious." The attempt to permit the laws of chance, operating through the unconscious, to control the handling of line and color came to be known by artists and critics as *graphic automatism*.

Arp's work is considerably simpler and clearer in its arrangement of lines and planes than Kandinsky's and does not have the same expressive intensity. The characteristic curved edges, vaguely suggesting the forms and motion of organic matter (hence the name *biomorphic* given to similar "doodles" by later critics), and the almost abstract purity hint at what Arp called a "mystical reality."

Dada soon spread to other European cities. Among its chief new proponents was Max Ernst (b. 1891), who took it up in Cologne after the war but moved to Paris in 1922. One of the masterpieces of his Dada years is *Mankind Shall Know Nothing of It,* painted in 1923 (Fig. 18–2). Ernst returned to the precise definition of objects already used by de Chirico in his early metaphysical pictures, but he went much further in juxtaposing disparate objects that give rise to jarring associations—what Ernst himself called "the chance meeting of two distant realities on an unfamiliar plane." Occasionally, as in this work, the associations are endowed

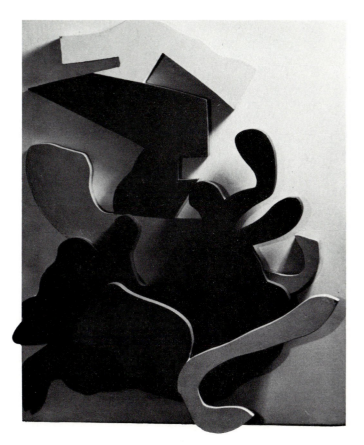

with the kind of sexual symbolism that has come to be known as Freudian.

A cryptic note by the artist gives some idea of the kind of free association in which he indulged in composing this particular picture: "The hand conceals the earth. Because of this very movement the earth takes on the appearance of a sex organ." One may therefore read in the picture a suggestion of the attraction between astral bodies, which the artist reinforced by means of an erotic parallel, and interpret its subject as an awesome myth filled with psychoanalytical overtones.

The appearance of Freudian overtones in Ernst's imagery at this time is not accidental. In the course of the summer of 1921, he, Arp, and two poets, the Rumanian Tristan Tzara and the Frenchman André Breton, vacationed in the Austrian Tyrol. The four men, particularly Breton, who had been an orderly in a mental clinic during the war, were enormously interested in the theory of psychoanalysis. In the course of this vacation,

Breton took a short trip to Vienna to visit Sigmund Freud, and from that time on members of the Dada group began to react against the nihilistic character of the Dada movement and attempted to introduce in their works of art the kind of obsessiveness and cohesiveness that, according to Freud, characterizes human dreams.

The self-appointed leader of this development was Breton, who in 1922 named it Surrealism, which he later defined as "pure psychic automatism by which one intends to express verbally, or in writing, or by any other method, the real function of the mind; dictation by thought, in the absence of any control exerted by reason, and beyond any esthetic or moral preoccupation." He went on to explain that "Surrealism is based on the belief in the superior reality of certain forms of association heretofore neglected, in the omnipotence of dreams, in the undirected play of thought."

This definition of Surrealism was intended to apply to both literature and art.

18–1 *Above, left:* Hans Arp, *Plant Hammer,* 1917. Oil on wood slabs (24⅜″ × 19⅝″). Collection of François Arp, Paris.

18–2 *Above, right:* Max Ernst, *Mankind Shall Know Nothing of It,* 1923. Oil on canvas (31⅝″ × 25⅛″). Trustees of the Tate Gallery, London.

17–13 *Below:* Wassily Kandinsky, detail of *Study for Composition No. 2,* 1910 (*comparative illustration*).

18-3 Joan Miró, *Painting*, 1925. Oil on canvas (45⅝" × 35"). Collection of Mr. and Mrs. Ralph F. Colin, New York.

In fact, two principles of the definition had already been put to use by earlier artists. Kandinsky, and Arp after him, had successfully attempted to subordinate line and color to the laws of chance and the dictates of the unconscious, an approach called graphic automatism. The "certain forms of association" mentioned by Breton we have already encountered in Duchamp's juxtapositions of objects taken out of their ordinary context and, indeed, we found them as far back as the Romantic Symbolists. The most novel aspect of Breton's theories was the stress on "the omnipotence of dreams," which reflected a Freudian viewpoint. As we have seen, however, Max Ernst's works anticipated Breton's formulation in this respect. Indeed, Ernst's *Mankind Shall Know Nothing of It* is essentially Surrealist, although the phase of the artist's development to which it belongs has been called Proto-Surrealist.

A few artists who had gathered around Breton rallied under the banner of Surrealism. They presented individual exhibitions in 1924 and 1925 and, in the latter year, organized a group exhibition consisting of the work of Arp, de Chirico, Ernst, Klee, Miró, and others. Picasso, who never formally joined the Surrealist movement, was sympathetic to its aims and was also represented.

The aspect of Surrealism that was to dominate the movement for a time was graphic automatism. Chief among its exponents was Joan Miró (b. 1893), who had become familiar with Cubist and Dada trends in his native Barcelona before arriving in Paris in 1919. His *Painting* (Fig. 18-3) is characteristic of the work he did in the early years of Surrealism (this one in 1925) and it reveals an almost total surrender to what Breton called "the undirected play of thought." The background is made up of a fairly uniform area of paint suggesting, through occasional striations and stain-like washes, something of the colorations and translucency of vast fluid masses—air or water—and, by association, the expanses surrounding us. This attempt to concentrate on the infinitude of space can be compared to the endeavors of Eastern mystics to arrive at a total detachment from material considerations. Going one step further, however, Miró allowed himself to visualize in his imagined space simple, naively drawn configurations. We find biomorphic forms similar to those in Arp's work: an area with a wavy edge reminds us of a hand with five outstretched fingers; an ovoid patch with a dark spot in its center evokes an amoeba. Other forms elicit cosmic associations: a crescent shape makes us think, if not of the moon itself, at least of some gondola fit for celestial navigation, while a black disc with four trails of smaller dots seems to be a shooting star. These various objects clearly pertain to the fairyland world of our childhood dreams, and it is a tribute to Miró that he has been able to convey the beguiling whimsy of such dreams with complete spontaneity. As in the case of Arp, the artist seems to have relied on the dictates of the unconscious both for the choice of objects and for the

18-4 Piet Mondrian, *Composition with Red, Yellow, and Blue,* 1921. Oil on canvas (15⅜″ × 13⅝″). Collection Haags Gemeentemuseum, The Hague.

handling of line and color; yet the even greater freedom of Miró's technique makes him a more mature exponent of graphic automatism.

In contrast to the complex play of associations of one form of Surrealism and the spontaneity of execution of the other, another group of artists was pursuing the geometric abstraction of the Cubists to a new level of purity, and helping to introduce it in all phases of architecture and the applied arts. The boldest among them was the Dutchman Piet Mondrian (1872–1944), who had assimilated the Cubist idiom in Paris in the prewar years, and in Holland during the war developed a style based on the purest geometric abstraction. His 1921 *Composition with Red, Yellow, and Blue* (Fig. 18–4) brings to mind the work of Malevich (Fig. 17–10). Indeed, Mondrian expressed a total devotion to the most basic geometric design elements. In order to shun "natural form and color," he wrote in 1917 in the first issue of *De Stijl* (a publication to which he actively contributed), the new art

"must seek a means of expression in the abstraction of all form and color, that is, in the straight line and in clearly defined primary color." In the same essay he stressed the importance of the right angle. Furthermore, where Malevich had invested his geometric forms with a nearly mystical significance, Mondrian stressed what he called the "duality of matter and spirit." He was particularly aware of the esthetic significance of proportions and attached to them as much importance as had Seurat: "The balanced ratio is the purest representation of universality, of harmony, and of the sense of unity, which are the unique attributes of the human mind." Thus he was one of the true believers in musicality as a search for harmony.

In keeping with the spirit of Cubism, Mondrian was not interested merely in balance; his compositions have a sense of tension and a subtle complexity despite their apparent simplicity. "The equilibrium of which we speak in nonfigurative art," he explained, "is not without move-

ment or action, but is on the contrary a continual movement." He stressed the importance of "dynamic rhythms," and his means of achieving these effects were obvious and yet infinitely subtle. "All symmetry," he wrote, "shall be excluded." Significantly, the quadrilateral that fills most of the space of this picture is not quite a square and is off center; to compensate for this unbalance, the artist juxtaposed on each of three sides a thin vertical strip of blue, a larger rectangular area of yellow, and the small area of red-orange at the top creating a colorful, asymmetrical pattern on the periphery of the design. It is precisely in this contrast between the apparent purity and harmony of the overall effect, on the one hand, and the unbalance of the various elements, on the other, that Mondrian's abstractions convey their excitement.

The ideas of *De Stijl,* which lent its name to the movement, were to be enormously influential in avant-garde circles in Europe, and the theories of Mondrian himself were to become one of the key-

18-5 Walter Gropius and Adolph Meyer, Bauhaus, Dessau, 1926.

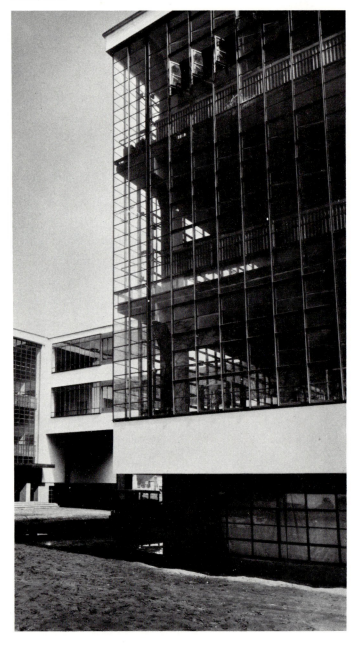

18-6 Walter Gropius and Adolph Meyer, plan of the Bauhaus

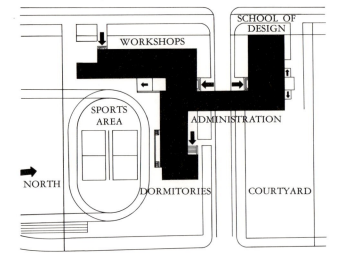

18-7 Walter Gropius and Adolph Meyer, Bauhaus, aerial view.

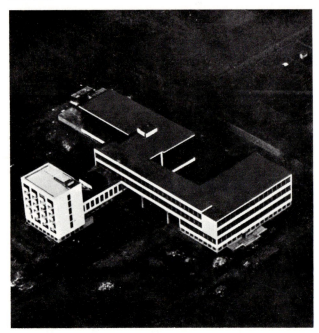

254

16–12 Louis H. Sullivan, Carson Pirie Scott department store, 1899–1900, 1903–04, detail of decoration of corner pavilion (*comparative illustration*).

stones of abstraction in the 1920s and 1930s. Another factor that led to the geometric abstraction of the period, however, was the revolution in architecture that had started with the achievements of architectural engineering of the nineteenth century and gained momentum with the innovations of Frank Lloyd Wright and others at the turn of the century. The outcome of this revolution was the so-called International style of the 1920s.

One of the most celebrated early examples of this style is the Bauhaus (Figs. 18–5 to 18–7), erected in Dessau, Germany, in 1926 by Walter Gropius (1883–1969) and Adolph Meyer (1881–1929). The Bauhaus was as famous for the school of art, applied arts, and architecture that it housed as it was for its own considerable merits. The faculty of the Bauhaus believed in an esthetic based on the spirit (if not always the principles) of engineering. According to the artist Josef Albers, an instructor of design in the school:

Learning and experimentation based on a technical and economic approach rather than on formal considerations result in the understanding of static and dynamic balance. This attitude helps establish links between the organic and technical worlds, and reduce their contrasts. Apart from leading one to think in terms of building and construction, they develop the rarer quality of spatial imagination.

The idea was not strictly new—some of the Cubists, the Futurists, and a Russian group known as the Constructivists had been sensitive to the esthetic potential of machines and machine-made objects—but it was to take on a new importance at the Bauhaus, where, according to Gropius, who founded the school, there was to be "no essential difference between the artist and the craftsman" and where the school administration actively sought industrial design contracts to be carried out by faculty and students.

The design of the Bauhaus building is appropriately free of applied ornamentation and in this respect shows a marked departure from Sullivan's Carson Pirie

Scott department store (Fig. 16–12), with its interlace decoration, and even from Frank Lloyd Wright's Willits house (Fig. 16–16), with its overlay of wooden beams. The exciting quality of the Bauhaus design lies in the juxtaposition of different materials, all of which purport to be functional: alternating strips of glass and white wall in the wing housing the school of design; the glittering surface of the glass wall surrounding the workshop; the orderly layout of the windows and concrete slab balconies of the dormitory building. The design of the three wings and connecting passages was based on a careful study of the various needs of the school, and the plan (Fig. 18–6), in particular, reveals clearly the three principal functions, fully reflecting the influence of Wright, whose own plans were adapted to practical requirements (Fig. 16–17).

The spatial composition of the building is a masterly embodiment of more recent trends. The various parts were fitted into an asymmetrical and complex arrangement of rectangular units that

BETWEEN THE WARS 255

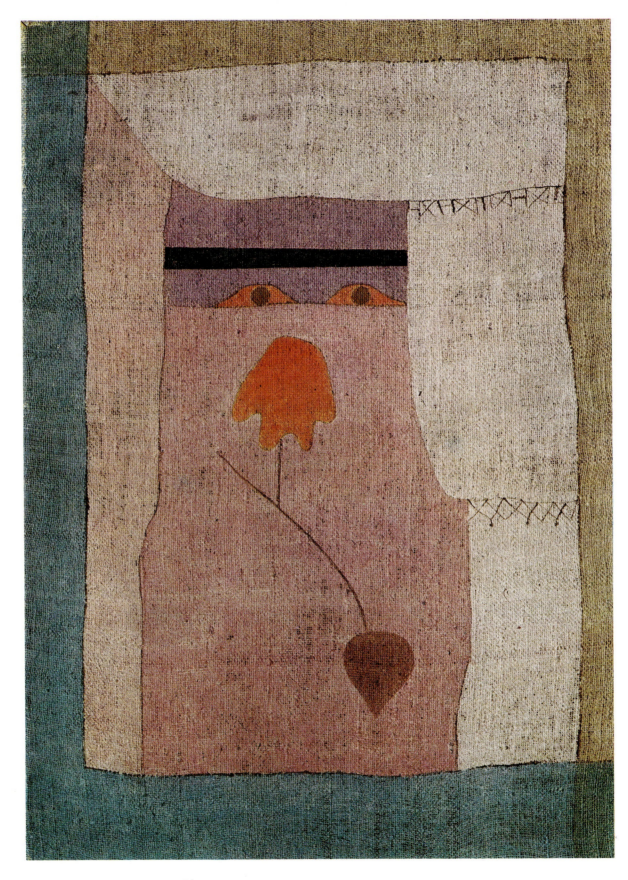

18-8 Paul Klee, *Arab Song,* 1932. Oil on burlap (36″ × 25¼″). Phillips Collection, Washington, D.C.

reflects the search for geometric purity and dynamic balance of the art of Mondrian and the *De Stijl* movement. In addition, the relationship of planes, no less than the interplay of solid and transparent surfaces, is both more intricate and bolder than Wright's (Fig. 16–16), and fully reflects the actual impact of Cubism.

The aim of the Bauhaus was to develop creative attitudes in students rather than to foster a specific style. During the time Gropius was director, from 1919 through 1927, he attracted to the teaching staff a number of remarkable painters, sculptors, architects, and designers with widely differing viewpoints. The most distinguished among them were Kandinsky and another erstwhile member of the Munich Blue Rider group, the Swiss-born Paul Klee (1878–1940).

Klee's *Arab Song* of 1932 (Fig. 18–8) was executed just after the artist had left the Bauhaus. Throughout his life, Klee's style was constantly changing, and not infrequently he varied it to suit his expressive intent. While he was at the Bauhaus, he employed fairly definite edges and semigeometric shapes in many of his canvases. The fact that he never totally accepted geometric abstraction, however, can be seen in a certain whimsicality in the stylization of objects, a nervous, sensitive, and willfully erratic use of line, and a propensity for organic-looking forms.

Originally an Expressionist artist and later associated with Surrealism, Klee remained faithful to the basic tenets of both movements. He conceived the role of artistic creation as a complex sequence of psychic activities beyond the full grasp of the artist's conscious self. In 1920 he wrote: "A certain fire, an impulse to create, is kindled, is transmuted through the hand, leaps to the canvas, and in the form of a spark leaps back to its starting place completing the circle—back to the eye and further (back to the source of movement, the will, the idea)." Accordingly, his compositions are based on imaginative and often very witty visual metaphors that often reflect the most personal moods with extraordinary directness. At first sight *Arab Song,* with its coarse texture and painted stitches, brings to mind the crude patchwork of the tents of nomadic Arabs. The pinkish vertical form can be interpreted as the silhouette of a veiled Arab woman, her forehead, headband, and eyes forming a horizontal design over the edge of the veil. At the time when the work was painted, Rudolf Valentino's sentimental movie *The Sheik* and a popular operetta called *Desert Song* imbued the life of desert Arabs with Hollywood-type romance. The association of Western sentimentality and the lore of nomadic tribes was, of course, totally incongruous, and it is its inherent humor that Klee seems to have brought out with his uncanny and disarming graphic ingenuousness. In front of the veil is an orange flower linked by its stem to a brown leaf. As if to imply that the woman is completely isolated by her veil and dress, no hands are shown holding the flower. The presence of the flower itself introduces a sentimental note; beyond this, the leaf covers the woman's heart and recalls a playing card symbol—not a red heart, as might have been expected, but by means of a playful process of transposition, a spade. A problem is posed by the flower, which seems raised to the woman's nose: can she smell it through the veil?

Through his extraordinarily adept play with objects as forms and objects as symbols, which he treated on a small, intimate scale, Klee was able to evoke incongruous associations that are as disconcerting, amusing, and personal as some of our dream fantasies.

Similar strains of Surrealism are apparent in the work of Picasso of the same period, and it seems appropriate to conclude this chapter on the years between the wars with a war picture that is one of the great monuments of the time, Picasso's *Guernica* (Fig. 18–9). The Spanish Republican government had commissioned a work for its pavilion at the 1937 Paris World's Fair. Spain was then in the throes of civil war, and the painting commemorates the bombing of the government-held city of Guernica by the German air force supporting the Insurgent army. It was the first instance of the massive destruction of a Western city from the air, and Picasso clearly intended to suggest the cosmic proportions of modern warfare and its impact on humanity. The manner is related to Cubism; we find on occasion the interplay of translucent planes characteristic of Cubism (Fig. 17–6), such as in the geometric areas in various values to the right of the central axis. The objects themselves are distorted and even fragmented, but they

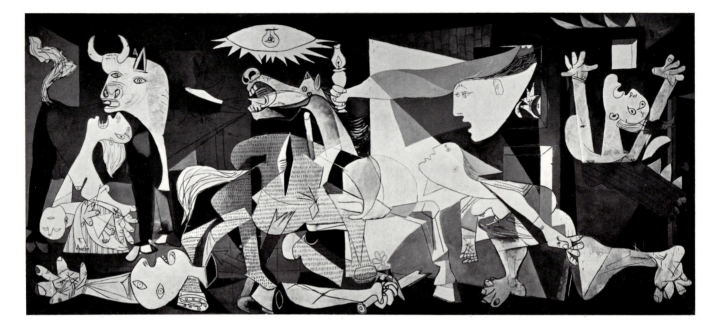

18-9 Pablo Picasso, *Guernica,* 1937. Oil on canvas (11'5½" × 25'5¾"). On extended loan to The Museum of Modern Art, New York, from the artist.

17-6 Georges Braque, detail of *The Portuguese,* 1911 (*comparative illustration*).

have clearly defined, continuous, swiftly drawn, and vigorously curved outlines—hence the name Curvilinear Cubism given to the style that characterized much of Picasso's output in those years.

Asked if the bull at the left stood for fascism, Picasso answered: "No the bull is not fascism, but it is brutality and darkness....The horse represents the people....The Guernica mural is symbolic...allegoric." Indeed, the work unfolds like some ancient frieze, its various figures seeming to represent not only incongruous and obsessive nightmarish apparitions but timeless and somewhat enigmatic symbols of panic and destruction. To the far right a shrieking woman, her face contorted as if by pain, her arms raised and her fingers twisted in distress, seems engulfed by the flames of a burning structure. A little to the left a terrified woman looks out of a window, holding a candle as if to illuminate the scene, her neck absurdly elongated to suggest an impulsive urge to lunge forward in order to escape. Beneath her, a struggling

woman seems to emerge from under the rubble. In the center a warrior lies dead, his sword broken, while his grossly contorted horse collapses, a bayonet point sticking out of its tongue as if to stress the agonized quality of its last cry. To the left a desperate woman holding a dead child evokes the most excruciating distress, while the bull, symbolic of the very causes of the carnage, stands above her, momentarily immobile and triumphant. A dark plane over the left half of the picture suggests a ceiling from which hangs what can be taken either as an electric bulb under a shade or an obsessive gigantic eye watching the holocaust. The color scheme itself—black, white, and various shades of gray—suggests a lighting that is as artificial as it is dramatic.

In sum, Picasso, at the height of his creative powers, chose to take advantage of both the fragmentation of Cubism and the jarring juxtapositions of Surrealism to convey a vision that has the obsessive quality of nightmares and is immensely expressive.

19

After the Second World War

One of the most distinctive developments in art in recent years has been the tendency artists have shown toward stylistic constancy. While the great artists of the early part of the twentieth century changed their individual styles freely and sometimes quite dramatically, the artists who rose to fame after the Second World War showed a remarkable disposition to evolve highly personal manners and to remain faithful to them, at most indulging in subtle variations from one work to the next. This may be due partly to the role that the communications media have played in exposing the work of many different artists. An artist wishing to establish his identity in the public consciousness finds it necessary to evolve a clearly recognizable manner and abide by it, at least until he has become well known. Once his reputation is established, he may find that drastic changes are disappointing to dealers and patrons. Another reason for this stylistic constancy may be the highly subjective approach of contemporary artists;

since the style reflects the personality of the artist, it remains as consistent through the years as that personality itself, or at any rate it evolves slowly. If a few exceptional artists such as the mercurial Picasso have developed different manners reflecting the various attitudes and moods of specific phases of their careers, others like Pollock and Rothko, once they reached their artistic maturity, have allowed themselves only a narrow range of experimentation.

The late 1940s and 1950s saw the emergence of two principal trends. On the one hand the period experienced a rebirth of abstraction, lyrical and restrained in Europe, more exuberant and dynamic in the United States. On the other hand a new attachment to the human image, albeit crudely and often hauntingly distorted, was particularly evident in Europe. The Swiss-born sculptor and painter Alberto Giacometti (1901–66) ranks high among the Europeans who remained faithful to the human image. A dedicated member of the Surrealist group

in Paris in 1930, he had returned to the study of the living model some five years later—and was duly expelled from the Surrealist group for this act of defiance. His *Bust of Diego* of 1954 (Fig. 19-1) is characteristic of the very personal manner that he developed after the war and to which he remained faithful for the remainder of his life.

The expressionistic accentuation of the features and the forceful, almost arbitrary handling of the surface relief go back to Rodin (Fig. 15-13). But Giacometti went further than had Rodin in preserving finger marks and tool scratches on the original wax model and in suggesting the appearance of raw material in many areas of the finished surface. To a considerable degree, Rodin heightened the relief of the surface to suggest the play of light and atmosphere around his figures, thus contributing naturalistic effects; Giacometti seems to have accentuated irregularities for their own sake, as if to create a tension between our awareness of the model as a person and our perception of the bat-

259

tered piece of metal, which appears to have gone through a natural disaster. The play with surface irregularities and distortions must of course be associated with the tradition of graphic automatism of the Surrealists; it is powerfully expressive in itself and contributes to the mood of the work just as much as the manipulation of features.

We may get an idea of the artist's expressive intent from his own statement:

> I began to see heads in a void, in the space that surrounds them. When for the first time I was able to determine clearly that the head I was looking at was freezing up, becoming immobile in an instant, definitively, I began to tremble with fear, as I never had before....It was no longer a living head, but an object. I was looking at...an object like any other object; or rather, no, not like any other object, like something alive and dead at the same time.

Not only is the roughness of the surface treatment evocative of death and decay but the eyes stare in a trance-like daze, while the partially opened mouth suggests a dolorous detachment. The mercilessly flattened head, the thin and irregular neck, and the skull elongated to a point are all evocative of a superhuman agony. Indeed, the imprecision of the surface effects and the cataclysmic distortion of the forms suggest that the perceiver himself is in a state of trance. It may be

19-1 Alberto Giacometti, *Bust of Diego,* 1954. Bronze (24½″ high). The Hirshhorn Museum and Sculpture Garden, Smithsonian Institution, Washington, D.C.

argued that both the evocation of simultaneous life and death in the figure and the suggestion of a trance-like perception are in keeping with the concerns with nightmarish states of mind that characterize Surrealism. "To be truly immortal," as de Chirico put it, "a work must escape all human limits." The same concerns dominate all Giacometti's late output. Even the variations in character and expression from work to work seem intended to do no more than convey different aspects of a unique and very personal state of mind.

This approach marks the height of the subjective trend that had been so apparent in Romantic art, had become one of the principal aspects of Symbolism, and had dominated the various manifestations of Expressionism. In the second half of the twentieth century, this stress on individuality stands out as a protest, conscious or unconscious, against conformism, while the emphasis on a near-morbid spirituality seems to be a reaction against the delights as well as the frustrations of a materialistic civilization.

The Frenchman Jean Dubuffet (b. 1901) was equally successful in creating haunting images while asserting the uniqueness of his manner. He too made the most of the accidents of execution. In his *Tree of Fluids* (*Body of a Lady*) of 1950 (Fig. 19–2), a thick application of layer upon layer of paint created a complex network of ridges all over the surface. The essentially warm colors themselves are intermixed, creating a strange iridescence in many areas. Like Giacometti,

Dubuffet was subordinating form and execution to individual expression. He himself exclaimed, "What would a work of art be worth, in which each of the smallest parts—the least stroke—did not describe, in one sweep, its author's entire philosophy?"

We get some glimpses of that philosophy from the artist's own writings. He makes a distinction between what he calls "cultural art," which is "spread through the community and imposed upon it by the officers of the state," and an art based on "modes of thought totally liberated from the mimicry in which culture locks itself up and becomes blind." He associates himself with the group of "liberated artists," which includes "children, primitive people and madmen," and he stresses the prevalence of such artists among those "denounced as antisocial and deprived of their citizenship." He refers to this trend as "non-civism."

Indeed, Dubuffet's whole output is marked by a brilliant "non-civism." It is in the spirit of an undisciplined, rebellious, often cruel but always good-humored adolescent that he lampoons the "cultural" world. In *Tree of Fluids,* there is a definite element of cynicism in the way the woman's body has been transformed into a flat shape as if it had been squashed by a steam roller. The arms are drawn in a childish scrawl not unlike that

19-2 Jean Dubuffet, *Tree of Fluids* (*Body of a Lady*), 1950. Oil on canvas (45⅝" × 35"). Secrétariat de Jean Dubuffet.

sometimes found on lavatory walls. The crudely drawn features are grossly caricatural, and both the texture and the coloration of the surface elicit visceral associations. In a fit of adolescent prankishness, moreover, the artist exaggerated the pudendum and made it look particularly revolting. The unpleasant aspects of the scene are nevertheless relieved by the urbane perkiness of the features and the delicacy of the overall color effects. Dubuffet, it would seem, attempted a deliberate identification with the rebellious mood of adolescence in order to arrive at a "cerebral creation bursting forth with total spontaneity and ingenuousness, in a state of brutish purity." In an essay of 1948, he referred to the products of such endeavors as *art brut* ("brutish art").

The search for brutality also found expression in architecture, beginning with the work of the French architect Le Corbusier. This trend was fully evident in his Palace of Justice (Fig. 19–3), erected in 1953 as part of a vast building complex

at Chandigarh, India, one of the most inspiring urban developments of our time. A pioneer of modern architecture since the 1920s, the Swiss-born Parisian Charles Édouard Jeanneret, better known as Le Corbusier (1887–1965), actively endorsed the ideals of the International style from its inception (see p. 255). He was profoundly dedicated to the esthetics of the machine age, and it was he who said that a house should be a machine for living. And yet, from the very beginning, despite Le Corbusier's dedication to flat surfaces, angular organization of planes, and the intrinsic beauty of construction materials, as well as his genuine concern for practicality and economy, he loved occasional eccentric features, which he tried to justify rationally in his prolific writings. His emphasis on brutality, which first became apparent in the late 1940s, manifests itself here in the striking imbalance of various elements of the design, in the coarse finish of the concrete surfaces, and especially in the marked contrasts between the powerful accents and rough appearance of the

arches, on the one hand, and the relatively fine detailing of the screens, on the other.

In some aspects, the design of the building reflects the ideals of the International style of the 1920s almost as fully as the Bauhaus (Figs. 18–5 and 18–7): the courtroom units are grouped into rectangular blocks with a glass façade. The screen over the façade itself serves a practical purpose, since it shields the rooms from the full impact of the Indian sun. On the other hand, the lobby cannot be justified from a utilitarian standpoint alone. It provides a vast, high-ceilinged space as impressive as the interior spaces of Roman civic buildings such as the Basilica Ulpia (Fig. 4–4), a suitable setting for the sculptural treatment of the flying stairways, which, together with the irregular holes in the adjoining wall, create a powerful three-dimensional design (Fig. 19–4).

The least justifiable element from the standpoint of functionalism is the series of arches covering the building. One critic describes them as "a huge parasol of con-

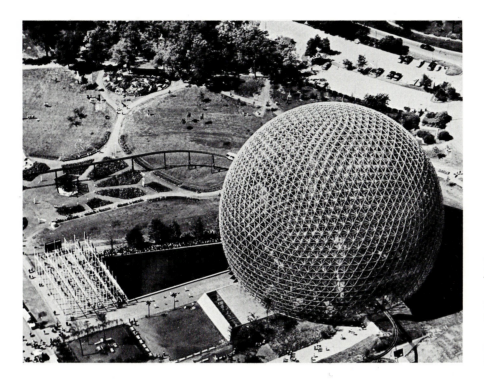

19-3 *Opposite page, left:* Le Corbusier, Palace of Justice, Chandigarh, 1953.

19-4 *Opposite page, right:* Le Corbusier, interior of the Palace of Justice, flying stairways.

19-5 *This page:* R. Buckminster Fuller, United States Pavilion, Expo '67, Montreal, 1967.

crete [that] cools and shades the building," but there can be no question that the same purpose would have been achieved much more effectively and economically by a layer of insulating material. The "parasol" was obviously intended to impart a powerful rhythmic articulation to the whole structure.

It is in this last respect that Le Corbusier departed furthest from the esthetics of the Bauhaus. Little is left of the subtle dynamic balance between asymmetrical elements of the Dessau building; there is an almost primitive quality in the repetition of the arches. And, instead of the carefully proportioned surface areas of glass and masonry of the Bauhaus, here there is an abrupt contrast between the boldness of the overall rhythm and the delicacy of the details.

The exponents of the International style found inspiration in machine-age esthetics, rejecting the revival styles of the nineteenth century. Le Corbusier, for his part, deliberately superimposed on an essentially functional building a rhythmic

framework that brings to mind the monumental quality of such ancient ruins as the warehouses of the Egyptian Rameseum (Fig. 1–13) and the market of the Porticus Aemilia (Fig. 3–9). Indeed, even the roughness of the surface showing the marks of the wooden forms into which the concrete was poured recalls the weather-beaten aspect of long-abandoned monuments, so that the building has both the basic simplicity and apparent coarseness of some ancient ruin rising solemnly in the windswept plain.

The man who has come closest to taking full advantage of the esthetics of the machine age is the American R. Buckminster Fuller (b. 1895). Known since the 1920s for visionary and sometimes impractical designs for a wide range of products—from a highly streamlined car to a circular aluminum house suspended from a central mast—Fuller got the idea sometime in the 1950s of building hollow domes by assembling metal or other struts in groups of linked polygons, which he called geodesic domes. Such

frameworks distribute the stresses evenly among their members, so that the resulting structure is both very light and very rigid. The great advantage of Fuller's dome over a traditional masonry dome is that it can withstand tension as well as compression, whereas masonry can safely withstand only compression. As a result Fuller's dome needs no ribbing, no heavy masonry drum (Fig. 4–14), and no buttresses (Fig. 3–14); its cohesiveness makes it strong for the same reason that an eggshell is strong. The areas between the struts are filled with protective membranes, which can be transparent if sunlight is to be let in.

Such domes, which can be built in a variety of materials and to any dimensions, are the most economical way of covering any given area. They are also esthetically pleasing because of the ingenious and orderly way in which the individual members of the structure fulfill their functions. They have been used to house stadiums, fairs (Fig. 19–5), and factories, and Fuller thinks that they may

19-6 Jackson Pollock, *Autumn Rhythm,* 1950. Oil on canvas (8'7" × 17'3"). Metropolitan Museum of Art, New York, George A. Hearn Fund.

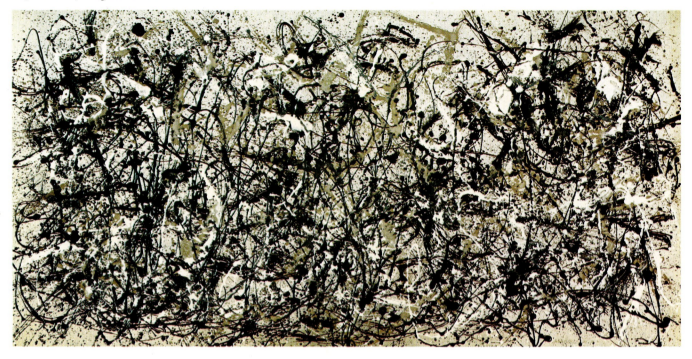

someday be used to contain entire cities.

As if in opposition to the cult of precision and rationalism normally associated with modern technology, there emerged in New York during the 1940s and 1950s a group of artists who attached exceptional importance to the instinctual gesture in art. The group has been variously called American Abstract Expressionists and Action Painters. Among these artists there is a considerable variety of styles, and *Autumn Rhythm* of 1950 (Fig. 19-6) by Jackson Pollock (1912–56) and *Red White and Brown* of 1952 (Fig. 19-7) by Mark Rothko (1903–70) are characteristic of two of the more divergent trends.

Perhaps one of the first and most articulately expressed aims of the group was to repudiate the more superficial aspects of the earlier abstract movements of the twentieth century. Although familiar with Cubism, the new group rejected its playful manipulation of form. The artists also wanted to avoid the subtle balance of asymmetrical geometric elements of

Mondrian and his circle. And they were less committed than either group to purely formal relationships. Indeed, despite their own dedication to abstraction, they claimed to pay great attention to content. In an article of 1943, Rothko and another member of the group, Adolph Gottlieb, wrote:

> It is a widely accepted notion among painters that it does not matter what one paints, as long as it is well painted. This is the essence of academism. There is no such thing as good painting about nothing. We assert that the subject is crucial, and only that subject matter is valid which is tragic and timeless. That is why we profess a spiritual kinship with primitive and archaic art.

Like all such manifestos, this one tended to be somewhat intemperate. Subject matter had played a considerable part in Cubism, as we have seen (p. 241), and even artists as dedicated to abstraction as Malevich and Mondrian were conscious of investing a superior significance in their geometric designs. Finally, primitive and

archaic art had had a major impact on twentieth-century developments even before Picasso's *Les Demoiselles d'Avignon* (Fig. 17-3).

Rothko and Gottlieb undoubtedly had in mind one of the favorite notions of the Surrealists, that they could express a sense of inner drama through graphic automatism (p. 250), as well as Kandinsky's notion that the artist's psychic life can find expression through a purely abstract language (p. 247). It is significant that the members of this loosely organized group had been profoundly affected by such Surrealists as Breton, Ernst, and others, who had been in New York during the Second World War. Furthermore, both Miró and de Chirico were well known through their works. Duchamp was also in New York, ever the witty and articulate leader of artists in exile. Finally, a memorable selection of Kandinsky's works was available at what was then called the Guggenheim Museum of Non-Objective Art, and the essence of Kandinsky's theories was being conveyed

19-7 Mark Rothko, *Red White and Brown,* 1952. Oil on canvas (8'2" × 6'8¼"). Kunstmuseum, Basel; gift of Switzerland National-Versicherungs-Gesellshaft.

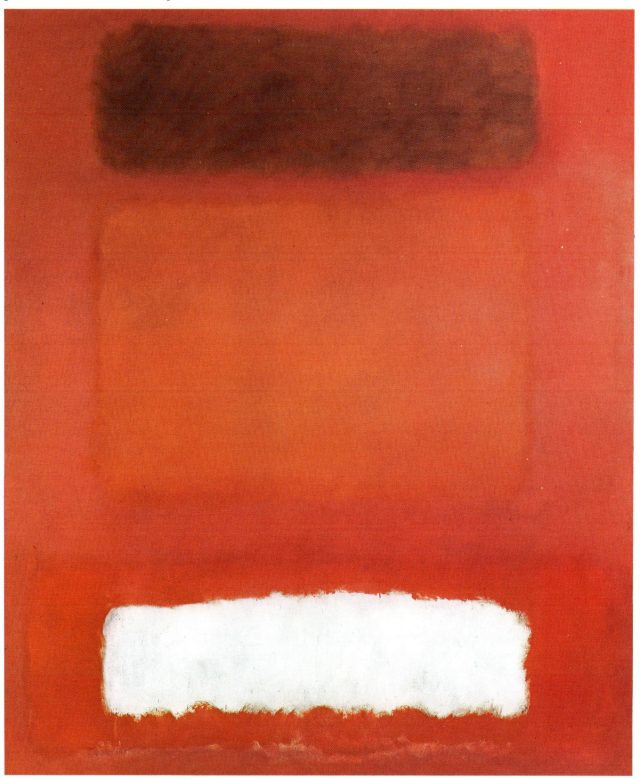

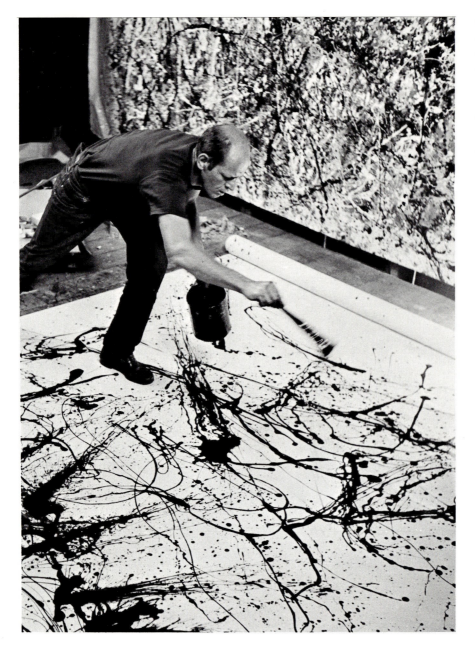

to younger men by a most dynamic teacher and dedicated Abstract Expressionist, the Munich-born Hans Hofmann, who was also in New York.

The members of the group insisted that they did not start out with a preconceived idea or plan for a picture. In terms reminiscent of Kandinsky, they claimed that the act of creation was irrational and was profoundly affected by the workings of the subconscious. Much as the earlier artist maintained that "as in ...battle, fresh forces pour out of the tube, young forces replacing the old," Rothko stated:

> I think of my pictures as dramas: the shapes in the pictures are the performers....Neither the action nor the actors can be anticipated, or described in advance. They begin as an unknown adventure in an unknown space. It is at the moment of completion that, in a flash of recognition, they are seen to have the quantity and function which was intended.

Among recent critics, none has expressed better than Harold Rosenberg the dynamics of the process of creation as conceived by the Action Painters:

> The canvas began to appear...as an arena in which to act—rather than as a space in which to reproduce, redesign, analyze, or "express" an object, actual or imagined. What was to go on the canvas was not a picture but an event. The painter no longer approached his easel with an image

19-8 Jackson Pollock painting, 1951. Photograph by Hans Namuth.

in his mind; he went up to it with material in his hand to do something to that other piece of material in front of him. The image would result of this encounter.

At times some of the artists of the group introduced forms alluding to primeval myths in order to heighten the sense of struggle they so often conveyed. These artists were not trying to illustrate, or even dwell on, the meaning of those myths but rather to take advantage of the associations that they aroused in the mind of the onlooker in order to heighten the dramatic impact of the composition. Most of their works, however, were totally abstract; for these artists, the play of forms itself alluded to undisclosed private myths.

The feature that most clearly distinguishes the works of this group from those of the Surrealists and the German Abstract Expressionists is what the artists themselves called directness: an emphasis on simple, powerful gestures in the act of painting and a stress on forms that, whether simple or complex, are easily recognizable. Size also played a major part; not only did the artist want to be, in Jackson Pollock's words, "*in* the painting" as he struggled with it, but he used largeness to help achieve the assertiveness that was his aim.

There were other major differences from earlier abstract and near-abstract traditions. Although in works by Arp an occasional form was made to extend beyond the limits of the picture area (Fig. 18–1) and although Mondrian's linear patterns can be thought of as extending

beyond the edges of the painting to infinity (Fig. 18–4), the designs of the works of these earlier Abstractionists were carefully balanced and seemed harmoniously related to the picture's edges. Such designs also seemed centered on one or more principal points of interest. In works by the Action Painters group, all sense of internal balance is gone. The forms on the surface seem endowed with a new energy causing them to press against the edges of the picture. The overall design is also much more diffuse.

As we may judge from *Autumn Rhythm* (Fig. 19–6), Pollock's emphasis on gesture led to his manner of dribbling paint on canvases lying on the ground (Fig. 19–8) in apparently haphazard fashion. Actually there was much greater control than the uninitiated might assume. Pollock selected colors with care and saw to it that the overall density of application was fairly consistent. Even his sweeping gestures introduced a certain order, since the body has its own rhythmic motions, as every dancer knows. The outcome is a rich and vibrant calligraphic design, jagged and irregular in its details, yet strangely vigorous and elegant in its overall impact.

Rothko's characteristic manner was much more sedate, as can be seen in *Red White and Brown* (Fig. 19–7). The light areas, which have slight variations of value and intensity over their surface, suggest a faint glow. The imprecise edges make it difficult to concentrate on the exact shapes of the color areas and tend to imply movement on the surface. And

because low values and cool hues tend to recede while high values and warm hues tend to come forward, we also see the various areas as advancing or receding in space. As a result, Rothko's basically simple arrangements of colored shapes have some of the animation, and perhaps also some of the sense of mystery, of the images that sometimes trouble our closed eyes, and they seem as familiar and immaterial.

It was inevitable that the more pervasive aspects of our industrial-commercial culture, and more particularly of the world of advertising, would sooner or later have a major impact on art. The often alluring images, strong colors and simple forms, tiresome exaggerations and cynical clichés of the mass media provided both sources of inspiration and irritants that triggered sarcastic responses. The Dada artists were the first to become aware of the potential of advertising art, wittily incorporating its idiom in their compositions and addressing their nihilistic wit to its materialism. The Pop movement that grew in the 1950s and early 1960s undertook wholesale adoptions of some of the most obvious aspects of the visual language of the mass media and more particularly of advertising, while cultivating an essentially Surrealist attitude, and arrived at even more devastating results. Taking advantage of the conditioned reflexes sparked in us by the objects shown in advertisements and the containers in which standard products are sold, the Pop artists have presented such objects and their containers either in

splendid isolation or under incongruous circumstances, and they have made us realize—amusingly, nostalgically, or both—to what degree we are emotionally involved with them.

Pop Art appeared almost simultaneously in the United States and Great Britain. In London, a group of young artists began to make collages out of items cut from popular magazines. This form of collage was in itself not new; it had been popular with certain Dada artists several decades earlier, but for different purposes. Let us compare a collage of 1956, *Just What Is It That Makes Today's Homes So Different, So Appealing?* (Fig. 19-10) by Richard Hamilton (b. 1922) with one from 1921 by the German Dada artist Kurt Schwitters (1887–1948), *Mz 180 Figurine* (Fig. 19-9). Both are made up essentially of cuttings from the popular press.

Schwitters indulged primarily in a play of forms and built a vigorous Synthetic Cubist composition around the vapidly elegant forms of a figure cut out

of a fashion magazine, using wittily the fine type of a clipping to suggest the texture of a garment and larger type to the left and right of the figure to provide horizontal accents offsetting the vertical figure. The humor of the piece lies in the handling of scraps of paper to create a much more exciting and pleasing composition than what we can see of the original illustration, thereby making fun of the artificiality of fashion illustrations.

Hamilton had different aims. In his collage he utilized entire figures and objects cut from magazine advertisements and illustrations. The incongruities lie in the juxtaposition of items taken out of their ordinary context: the muscular and vapid-looking young man, presumably from a physical fitness advertisement, is juxtaposed with a woman whose mannered pretentiousness belongs to a cosmetics advertisement. We are immediately aware of the improbability of any tenderness growing between them. The artist even mocks the element of sex-appeal so prevalent in advertisements: the woman's

breasts are unnaturally large, while the man carries a giant lollipop marked "pop" over his groin. The objects shown in the room are equally dismaying. A Medieval lectern is adorned with the gaudy emblem of an automobile manufacturing company, no doubt symbolic of the amenities of our industrial civilization, while the more immediate past is suggested by a nineteenth-century ancestor portrait, and romance is evoked by an enlarged comic-strip figure. Although the furniture of the room suggests a certain degree of comfort, the lighted marquee of a movie house seen through the huge ground-floor window indicates the devastating encroachments of big-city hucksterism. The spatial layout is no less disturbing: the very long flight of stairs in a corner of the modest-sized room contributes yet another element of Surrealist incongruity. Hamilton's collage shows much less concern for design than Schwitters' but it is just as witty and even more devastating, relying as it does on a tongue-in-cheek manipulation of the language of the mass

media to elicit conflicting associations that bring out the hollowness and inconsistency of some aspects of our daily existence.

A statement published by Hamilton and other members of this London group a little later can be taken as definitions of the whole Pop Art movement; its aim was to produce art forms that were:

Popular (designed for mass audiences).
Transient (short term solution).
Expendable (easily forgotten).
Low cost.
Mass-produced.
Young (aimed at youth).
Witty.
Sexy.
Gimmicky.
Glamorous.
Big business.

A similar point of view was adopted with particular enthusiasm in the United States and produced a new level of deadpan humor. Andy Warhol (b. 1930) has specialized in, among other things, replicas of commercial packaging designs, sometimes meticulously precise, sometimes

slightly varied. His two *Campbell's Soup Cans* of 1965 (Fig. 19–11) accurately reproduce the can designs, but substitute a fresher combination of hues for the traditional red, white, and gold.

Most Pop Art objects are essentially ordinary and, like Duchamp's Readymades (Fig. 17–14), are "turned into [works] of art solely by reason of [their] having been chosen by the artist." Pop artists, however, do not generally use available objects but create new ones that are either replicas or altered versions of the originals. While lacking the uniquely personal humor of Duchamp's Readymades, Pop Art nevertheless goes much further in its play on our own responses. Indeed, Warhol's cans make us acutely aware of the kind of conditioned reflexes produced in us by real soup cans: the range of tastes and smells of the various soups that come to our minds, the sense of hunger or mild nausea we experience according to whether we happen to be hungry or satiated at the time, memories of the mild anxiety of choosing between

19-9 *Opposite page, left:* Kurt Schwitters, *Mz 180 Figurine,* 1921. Collage (6¾″ × 3⅝″). Estate of Kurt Schwitters, courtesy Marlborough Gallery, New York.

19-10 *Opposite page, right:* Richard Hamilton, *Just What Is It That Makes Today's Homes So Different, So Appealing?* 1956. Collage (10¼″ × 9¾″). Los Angeles County Museum of Art, lent by the Edwin Janss Collection, California.

19-11 Andy Warhol. *Top, left: Large Campbell's Soup Can,* 1965. Silk screen on canvas (3′ × 2′). Locksley/Shea Gallery, Minneapolis. *Top, right: Campbell's Soup,* 1965. Oil on canvas (3′ × 2′). Collection, Kimiko and John Powers, Aspen, Colorado.

19-12 Edward Kienholz, *Back Seat Dodge '38,* 1964. Tableau (20' × 12' × 5'6"). Collection, Lyn Kienholz.

different flavors in a grocery store, and our knowledge that the cans of each variety taste monotonously alike. And yet, by presenting the cans outside their ordinary context, Warhol also makes us focus on the cans as arrangements of forms and colors. At times he scrupulously respected the original, drawing our attention to the efforts of industrial designers to put us in an optimistic and confident mood; at other times, as in this case, he indulged a witty fantasy and evolved color schemes that are bold or precious but always harmonious and that bring out by contrast the conventionality of the original. By taking the object out of its ordinary context, Warhol has made us more aware both of our unconscious responses to it and of the esthetic properties of its design.

Other artists have attempted similar effects by utilizing the associative value of discarded or "junk" objects. *Back Seat Dodge '38* of 1964 (Fig. 19–12) by Edward Kienholz (b. 1927) reveals a fractured world of disturbing images ranging from suggestions of a youthful drunken esca-

pade to hints of destruction and death. The assemblage consists of parts of a car salvaged from a junk heap and reassembled into a body lacking its central section and looking both somewhat battered and strangely compressed. Here again the artist relied on our conditioned reflexes to achieve his emotional impact, for most of us have been raised to admire the shiny and colorful shapes of new or well-kept automobiles. But the artist went further: by placing a scantily dressed female store manikin lying down in the car with a wire-mesh form suggesting a man beside her, and by showing what looks like vomit on the edge of the window and placing an empty beer bottle on the ground near the car, he has invoked memories of excesses in the light of which the compressed form of the car takes on an ominous significance. The artist, let us add, did not actually describe a scene of debauchery or an accident; he manipulated found objects as hints that unleash our own emotional reflexes.

Still other artists have explored the

use of physical motion in their work, which has been called Kinetic Art. The idea of animating a work of art is not new; for many years art lovers have derived enjoyment from the mobiles of Alexander Calder (b. 1898), an American artist living in Paris. His *Lobster Trap and Fish Tail* of 1939 (Fig. 19–13) is made of metal sheets cut into biomorphic shapes derived from the language of Surrealism and held in balance by bent wire rods. At the faintest breeze, the pieces revolve with grace, ease, and considerable freedom, evocative of vegetal and animal forms moving lightly in their natural surroundings.

Artists who introduced motion in their work in the 1950s and 1960s generally relied on mechanical power and were more concerned with specific illusionary effects. The New Zealand-born artist Len Lye (b. 1901), for instance, suggested a water spray by using an electric motor to activate vibrating metal strips in *Fountain II* of 1963 (Fig. 19–14).

It might be argued that our reactions

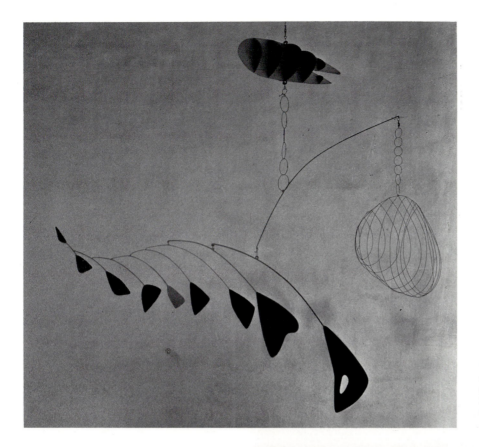

19-13 *Top, left:* Alexander Calder, *Lobster Trap and Fish Tail,* 1939. Hanging mobile, steel wire and sheet aluminum (approx. 8′6″ × 9′6″). Collection, The Museum of Modern Art, New York. Commissioned by the Advisory Committee, for the stairwell of the Museum (*comparative illustration*).

19-14 Len Lye, *Fountain II,* 1963. *Below, left:* at rest; *below, right:* in motion. Steel rods (7′5½″ high). Tel Aviv Museum.

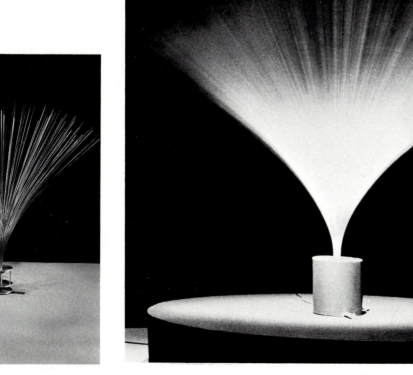

271

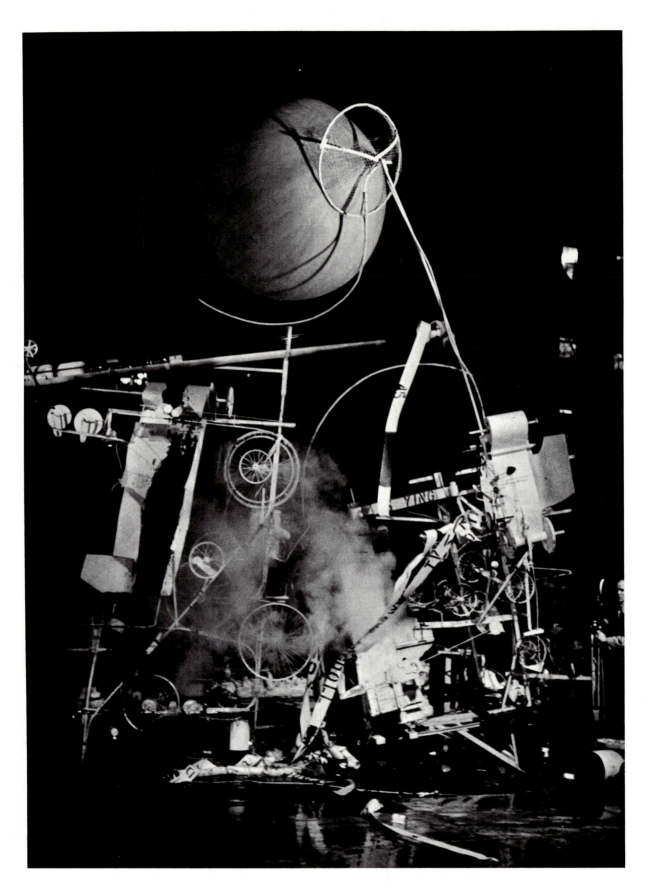

19-15 *Opposite page:* Jean Tinguely, *Homage to New York,* 1960; iron and steel.

19-16 *This page:* Tony Smith, *Die,* 1962. Steel (6' × 6' × 6'). Knoedler Gallery, New York.

to such works are so predictable that the long-term effects are bound to be monotonous. Some claim, however, that this is a virtue: the very monotony of the esthetic experience can bring about a superior concentration and a sense of release, not unlike the experience of, say, a Buddhist monk seeking a higher consciousness through concentrating on a grain of sand.

Perhaps in response to the problem of monotony, however, one of the more inventive and whimsical exponents of Kinetic Art, the Swiss-born artist Jean Tinguely (b. 1925) conceived of an animated contraption made of discarded machine parts that would perform only once and destroy itself in an explosion. Such a machine, called *Homage to New York,* was built for the New York Museum of Modern Art in 1960 (Fig. 19-15). It performed for a distinguished audience but in the end failed to explode because the New York City Fire Department had been alerted and stopped it in time—thereby contributing another unexpected touch

to the event. Not all Tinguely's junk machines are meant to be self-destroying. Most go on turning, clanking, and grinding with the persistence of real machines and suggest both humorous and ominous visions of satanic engines capable of carrying on long after all else has stopped.

The nihilistic trends that had begun to manifest themselves in the work of Duchamp and his friends before the First World War reached a climax in the 1960s in Minimal Art. *Die* of 1962 (Fig. 19-16) by the American Tony Smith (b. 1912) is a large rectangular block. Its proportions are not remarkable. They do not in any way suggest a pursuit of balance or harmony such as we have encountered in Mondrian. Its dull black finish is no more interesting than that of countless ordinary boxes, and the most that can be said of the object is that it exists.

It is in its impact on its environment and in the element of surprise it may contribute that the work is effective: a large black mass is bound to affect strikingly any setting in which it is placed.

And in keeping with the aims of artists since Dada and Surrealist times, this work may be meant to stimulate a play of conflicting associations. Smith himself quoted a passage in which Herodotus, an ancient Greek historian, expressed his sense of awe upon seeing in a temple a block of stone over sixty feet square, hollowed out to form a chapel, as if to allude to the primeval forces that have led men from time immemorial to undertake long and arduous monumental projects. Ironically, Smith's pieces are usually simply fabricated of flat sheets of material, steel or plywood, and this particular piece was ordered from a construction firm over the phone. Other pieces of Minimal Art do not even elicit associations: flat stainless-steel plaques applied against the walls of a room or metal slabs extending from a wall like shelves merely alter the environment by drawing our attention to simple geometric forms and basic materials.

Since the middle of the 1950s, a considerable number of painters have at-

19-17 Gene Davis, *Black-Grey Beat*, 1964. Acrylic on canvas (8′ × 16′). On loan to the National Collection of Fine Arts, Washington, D.C., from the Vincent Melzac collection.

tempted to explore a variety of optical effects. The whole canvas in *Black-Grey Beat* of 1964 (Fig. 19–17) by the American Gene Davis (b. 1920) is covered with parallel vertical strips of equal width. Unlike the work of Mondrian and the *De Stijl* group (Fig. 18–4), there is no attempt here to suggest a subtly balanced geometric composition. One is tempted to seek a repetitive arrangement of the colors, but no definite order is apparent. The excitement in the work derives both from the juxtaposition of contrasting hues and from the hints of rhythmic order in the repetitions of similar colors. Our reactions to this particular painting are further complicated by our own optical response: the eye has a device that makes it lock in position when looking at objects so that even if it drifts off for an instant, it is immediately set back in the right direction. For some reason this locking device is less effective when we look at stripes, especially stripes that are strongly contrasting in value, so that we get the impression that the whole surface trembles.

Works such as this depend on simple arrangements of uniform color areas with definite edges (called hard edges by modern artists) and have been grouped under such labels as Color Painting, Field Painting, and Systemic Art. This particular work relies partially for its effects on the purely physiological reactions of the eye and can also be included in the broad category of Op (for Optical) Art.

Other recent artists such as Ellsworth Kelly (b. 1923) have returned to the simple geometric abstractions of some of the followers of Cubism. In a work such as *Green Blue Red* of 1964 (Fig. 19–18), however, we do not sense the subtle balancing of a composition by, say, Mondrian. The double emphasis created by the two large cool areas on the warm field is in itself disturbing, for we normally try to unite the various elements of a picture into a whole and here cannot do so. The effects of the reactions of our optical systems are even stronger in this work than in the Davis; the complementaries of the blue and green are slightly different

in hue from the background, so that the complementary haloes we tend to project around each colored area (according to Chevreul's law of contrast, see p. 192) create subtle variations in hue and intensity over the whole picture. As with some Kinetic Art, our reactions to such effects are predictable after a while, but here again it can be claimed that monotony itself can be a source of interest.

Another significant trend of our time is the remarkable interaction of art and technology in recent years. Buckminster Fuller's geodesic domes have already been discussed; they constitute one of the most challenging developments in architecture. Some designs for land and air transportation are equally satisfying. The design of a jet aircraft (Fig. 19–19), for instance, can be remarkably pleasing. The overall configuration of the plane is very largely determined, of course, by purely technical considerations: the wings must have a certain surface area to lift it; they must be located at a certain point of the fuselage to ensure stability; wings and

fuselage profiles must have certain forms to reduce wasteful air turbulence; the fuselage must be sufficiently long and broad to carry an economical number of passengers; and, finally, the materials must be extremely light and strong. The designer nevertheless has a certain leeway in devising forms that will fulfill these functions, and he deliberately seeks proportions and visual effects that are not only pleasing in themselves but suggest speed and comfort and appeal to the imagination of the traveler. Not surprisingly, the streamlined fuselage has affinities with *Bird in Space* (Fig. 17–11) of 1924 by Brancusi, who was himself attempting to suggest a soaring form.

The problems of city planning are also essentially technical, and the opportunity for making pleasing and even inspiring designs is just as great. At a time when man's encroachments upon nature are ever more devastating, it is essential to think of enhancing vast areas of the landscape. Mention should also be made of photography and cinematography as art

19-18 Ellsworth Kelly, *Green Blue Red,* 1964. Oil on canvas (6'1" × 8'4"). Whitney Museum of American Art, New York.

17-11 Constantin Brancusi, *Bird in Space,* 1928(?).
Collection, The Museum of Modern Art, New York
(*comparative illustration*).

19-19 Boeing aircraft

forms. Their possibilities are as great as paintings and they have the added advantage of catching a scene as it happens when desired and, in the case of cinematography, of capturing actual movement. They offer infinite opportunities to people with discerning eyes and a profound understanding of life, and their impact through mass distribution is so great that they may well constitute the form of expression in which inspired vision can have the broadest influence in our time.

We are also very much affected in our daily lives by all kinds of messages that use visual means to impress us in a variety of ways, from telling us which brand of cigarette to smoke to urging us not to smoke at all. Judged superficially, the implications of advertising are unpleasant: advertisers are, in fact, attempting to manipulate us and are therefore constantly challenging our freedom to act independently. Yet there can be no question that advertising plays an essential role in our economic and political life and that

imaginative advertising artists can contribute to the quality of both. Indeed, a society has to arrive at a consensus in a great many activities in order to survive, be it in sponsoring certain products that can be manufactured on a large and economical scale or in fostering certain ideas essential to its well-being and even its survival. Artists can do both, much as they can, of course, remind us of the basic rights and liberties essential to a healthy society. Perhaps even more important, there will always be artists who are eager to explore new esthetic avenues and devise techniques that we cannot yet imagine. It is even possible that man may once again realize that no great artist has ever ignored the art of the past and may return to time-honored traditions in painting, sculpture, and architecture to give permanent form to the moods and aspirations of mankind.

20

African and Pre-Columbian Art

By far the major part of this book has been devoted to the art of the Near East, Europe, and North America. There have been rich and varied traditions in the rest of the world, all of which remained little affected by Western influences until the nineteenth century. In some cases, as in that of Pre-Columbian America, the isolation from Western nations must have been total. In other cases, such as that of India, there were abundant exchanges with the Near East and Hellenistic Greece. But whenever such exchanges did occur, foreign influences were thoroughly absorbed into native traditions. Since the middle of the nineteenth century, on the other hand, the exchanges have been much more abundant and thorough, and if countries like Japan have adopted the way of life of Western industrial nations, the art of the West itself has been completely revolutionized by Asiatic, African, and to a lesser degree Polynesian and American-Indian influences. We have made numerous references to these influences in the last few chap-

ters; the next two chapters are intended to throw a little light on some of the cultures responsible for them.

Every work of art becomes more meaningful when discussed in its cultural context. In the case of China and India, where a vast body of literature is available, it is comparatively easy to discuss works of art in relation to their cultural background. The art of ancient Central and South America, on the other hand, cannot be so readily related to broad cultural trends, since few meaningful texts have survived. In many cases conjectures have had to be based on the reports of early travelers and the data and theories of modern anthropologists and ethnographers.

There are few relevant texts pertaining to the cultural traditions of black Africa written prior to the period of European exploration in the fifteenth century, and those were the work mostly of Moslem chroniclers. But archeological finds, as well as art forms, rituals, and oral traditions studied scientifically since the

nineteenth century, have yielded important information on older cultural patterns.

A baked clay head found near the city of Ifé in the Western State of Nigeria in West Africa (Fig. 20-1), is believed to date from the thirteenth or fourteenth century A.D. It is not only characteristic of one of the very few African cultures with a strong naturalistic bent—a culture that flourished from the eleventh through the fourteenth century around the city of Ifé, thought to be the spiritual capital of the Yoruba people—but clearly one of the most sensitive and harmonious depictions of the human face of all time. The naturalism of works from Ifé and the fact that the Medieval Yorubas used a highly sophisticated bronzecasting technique have led to the speculation that Ifé art may reflect an influence of Near Eastern art dating to 1000–500 B.C. But whether or not this connection existed, the artists of Ifé and neighboring areas developed their own sustained and vigorous artistic traditions.

20-1 *Above:* Male head from Ifé, in the Western State of Nigeria, thirteenth or fourteenth century A.D. Terra cotta (4⅞″ high). Ifé Museum, Nigeria.

1-5 *Above:* Detail of *King Chephren,* from Gizeh, c. 2500 B.C. (*comparative illustration*).

20-2 *Left:* Oremadegun, traditional ruler of part of the community of Odogbolu, in western Ijebu, Yoruba country; in ceremonial regalia. Photograph by Nancy Gaylord Thompson.

There is no way of establishing the identity of this Ifé personage. The head is, however, closely related to a series of roughly contemporaneous heads in brass or baked clay that are now thought to have been funerary effigies of monarchs and court members. Comparison with the head of the Egyptian Pharaoh Chephren of about 2500 B.C. (Fig. 1–5) reveals that the Ifé sculptor was inspired by a negroid type: the nose tip is well rounded, the nostrils flare and the lips are fleshy. Indeed, the features bring to mind those of people living in the same area today. (Fig. 20–2 shows a present-day tribal ruler, Oremadegun, in ceremonial dress.)

The African sculptor was just as concerned with the naturalistic rendering of the face as was the artist who carved Chephren, yet, like the Egyptian artist, he sought a subtle idealization in his treatment of the human figure. The face is ageless, free of blemishes and subtly proportioned, and the artist clearly had in mind a generic type. Indeed, only a few details such as the curvature of the lips

suggest a specific personality. In addition, the artist introduced elements of traditional formalism: a fold of the upper eyelid becomes a continuous decorative line, and the surfaces above and below the eyelids have been flattened to the point of intersecting along a well-defined line where they meet at the corner of the eye. Finally, reflecting either a prevailing fashion of the period or a stylistic convention, there are no eyebrows. In both cases, furthermore, the artists clearly tried to idealize a figure through the overall harmony of the design, no doubt to suggest the majesty and appeal of members of a superior caste. The Ifé head nevertheless shows a much greater intimation of spontaneity in the handling of the features and a more developed sensuous awareness in the modeling of the flesh.

The remains of a standing figure in brass of an *oni,* or king, of Ifé of about the same period (Fig. 20–4) show clearly, however, that the artists of Ifé were not as concerned with naturalistic proportions as the Egyptian sculptor. The ratio of the

head to the whole is somewhere between 1:3 and 1:4, as against the 1:6 to 1:8 of Western art, which is much closer to actual human proportions. Moreover, despite the naturalistic rendering of the fleshy abdomen and the navel, details of the body are less precisely and sensitively rendered than those of the face. Both the size and the superior treatment of the head probably stem from the importance attached by black Africans to the head as the center of life, a characteristic they shared with the early Christian and early Medieval artists of Europe.

The Ifé artist's interest in surface decoration can also be compared to that of Medieval Europeans (Fig. 6–2). The ornament on the chest of the *oni,* the collar, the tassels, and the elaborate crown, all of which are undoubtedly badges of office, are rendered with detailed accuracy. The same can be said of the gracefully curving scarification marks of the face and abdomen, achieved through incisions of the skin. These elements reflect a true passion for orderly, richly textured linear surface

20–3 *Above:* Photograph of a man from the Northeastern State of Nigeria.

20–4 *Right: Oni* of Ifé, thirteenth or fourteenth century A.D. Cast brass from Wunmonije in the Western State of Nigeria (13⅝″ high). Ifé Museum, Nigeria.

designs that we find to this day in the fairly similar scarification patterns of some inhabitants of Nigeria, such as the man show in Figure 20–3, from the northern part of the country.

The Ifé examples reflect the general (but not invariable) tendency in Africa toward naturalism in the art of politically centralized societies. Such heads as these are often effigies of rulers and are presumably designed to stress the temporal aspects of power. Indeed, it may well be that the Medieval people of Ifé had an elaborate political organization such as is characteristic of the Yoruba who occupy most of western Nigeria today. The Yoruba are very conscious of rank and hierarchy, and although they tend primarily to the land, they often live in large cities. Most African peoples, however, lacking the technical and organizing skills of the Yoruba, live in small villages. Their art often represents remote supernatural and nature spirits, which are usually rendered more abstractly. The Bambara, an agricultural people living in a compara-

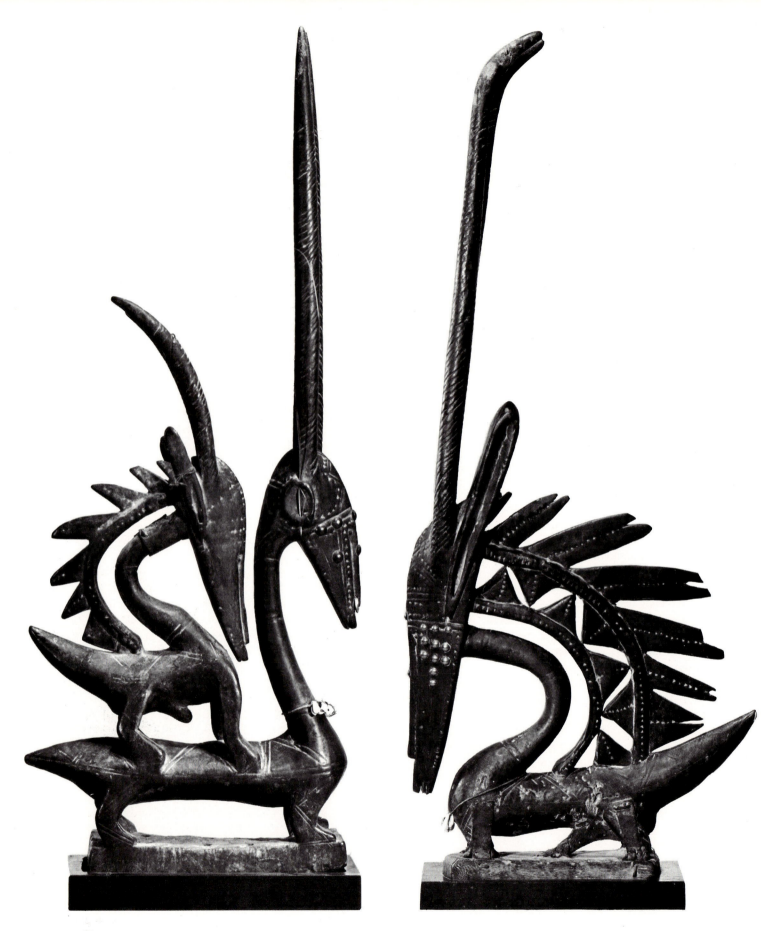

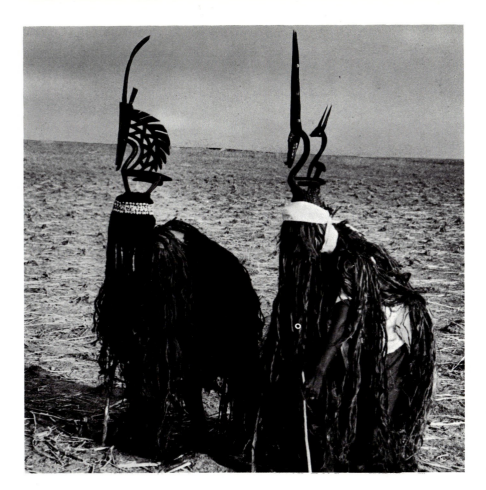

20-5 *Opposite page:* Bambara antelope headdresses, Mali, presumably twentieth century. Wood, brass tacks, string, cowrie shells, and iron (38¾″ high; 31¼″ high). Art Institute of Chicago (Hertle Fund).

20-6 *This page:* A pair of *tyi wara* dancers. Photograph by Pascal James Imperato.

tively arid area of Mali on both sides of the upper Niger, are a good example. Sculptures of antelopes known as *tyi wara* (Fig. 20–5) were used by the Bambara as headdresses in ceremonial dances. They are carved out of wood and acquire a brownish-black color by exposure to smoke. We get a good indication of how such pieces are worn from Figure 20–6, which shows modern dancers in traditional garb.

The formalism of these sculptures is characteristic of much of the art of black Africa. If we compare the various pieces with the Egyptian frieze from Abu Ṣîr (Fig. 1–2), we become aware of the extent to which the artist relied on semi-geometric elements for creating a vigorous and pleasing interplay of solids and voids. Individual African sculptural forms are strongly conventionalized and vary greatly from tribe to tribe, and to some extent according to the tastes and inclinations of individual artists. Bambara antelopes vary considerably from one part of the area to another, and no two pieces

are quite identical, yet certain traditional norms are generally respected. In most cases, the bodies are diminutive in relation to the necks, heads, and horns; the males' heads (even that of the baby male riding on its mother's back) are proportionately bigger than the females'. The Bambara artist was clearly interested in perpetuating a traditional symbolic language, in which, as so often in the art of black Africa, special importance is attached to the head. Other symbolic elements exist: the snout is similar to that of the anteater, regarded in this area as a symbol of longevity, and the males' ears are very large because they are the organs through which courage is supposed to enter the body. The emphasis of the male reproductive organs may also be intentional.

Despite deliberate distortions and a high degree of stylization, the carver was very much aware of natural forms. The relationship of snout, ears, and horns effectively suggests the overall appearance of some types of antelope, while the graceful and vigorous bent necks of the

males evoke simultaneously their suppleness and swiftness. The males' manes, furthermore, are swept outward, as if the animals had been frozen in motion. Beyond the expressive and symbolic concerns of the artist, however, and beyond his indebtedness to physical observation, he showed a remarkable mastery of composition through the interplay of geometric surfaces, of solids and voids, and of sweeping curves and jagged accents.

There are various accounts of the ritualistic use of the *tyi wara*. Today, when the Bambara have by and large abandoned their animistic religion, which attributes souls to objects and natural entities, and have adopted Islam, dances associated with the *tyi wara* are little more than an aspect of village merrymaking. In those rare villages in which earlier traditions have remained stronger, however, the dances take place in the fields, usually just before the rainy season in the spring when the land is parched with heat. They are performed by a group of young men who have been initiated together and thus

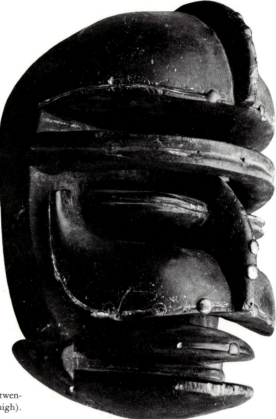

20-7 Bété mask, Ivory Coast, presumably twentieth century. Wood, iron nails (11⅝″ high). Private collection, Santa Barbara, California.

belong to the same socio-religious organization, also called *tyi wara.* The two best dancers wear the male and female headpieces and are the leading performers. The dancer with the male headdress occasionally imitates the sounds and leaps of the antelope. The other men watch or provide a rhythmic accompaniment and sometimes a chorus. The songs praise Tyi Wara, a divine creature, who in myth is the child of an old woman and a serpent. Tyi Wara originally taught the Bambara how to cultivate the land. As the primordial and ideal farmer, he inspires in young men the energy and perseverance necessary to excel as farmers. He also provides propitious conditions for an abundant harvest. Thus the dancers try to emulate Tyi Wara's heroic achievements. Significantly, the dancers maintain stooping positions and carry sticks while dancing, as if to allude to Tyi Wara's own presumed physique, his mother having been stooped and aged. Furthermore, some of the frankly sexual overtones of *tyi wara* dancing are meant to stimulate

human fertility as well as that of the fields. There is a tradition, for example, that in older times anyone standing between the dancers wearing the male and female antelopes, thereby interfering with the all-important fertility rites, exposed himself to imminent death.

Another sculpture will illustrate yet another aspect of the varied artistic traditions of black Africa. This is a mask of the Bété tribe of the coastal area of West Africa several hundred miles to the west of Ifé in the Ivory Coast (Fig. 20–7). Bété tales attach considerable importance to grotesque creatures personifying natural forces and frequently allude to man's need to harness the resources of nature to insure his own survival. Masks such as this one are intended to propitiate these mysterious creatures and help channel their powers to ends that will benefit the tribe.

For ceremonial dancing, a cloth hood is attached to the wooden mask by means of holes and hooks along its edge. The headdress is further decorated with a

straw beard, red cap, patches of fur and feathers, and white shells. Below this, the dancer wears a short loose vest to which an ample, flaring raffia skirt is attached (Fig. 20–8). This whole combination of costume, mask, and man is the spirit that dominates village life. Among its public acts, this spirit greets dignitaries, cleanses the village of alien forces, officiates at funerals, and formerly led men hunting and to war.

When contrasted with the Ifé head (Fig. 20–1), the Bété mask seems remarkably abstract—it is, in fact, one of the most abstract manifestations of the art of black Africa. Like the *tyi wara* antelope, the Bété mask is of wood with a shiny dark brown finish. Unlike the Ifé head the surface of which is a continuous envelope corresponding to the configuration of the human face, this particular Bété mask is composed of a number of protruding parts: a section of a spherical mass for the forehead, a semicircular band at the level of the eyebrows, flat curved masses grooved around the edges and protruding

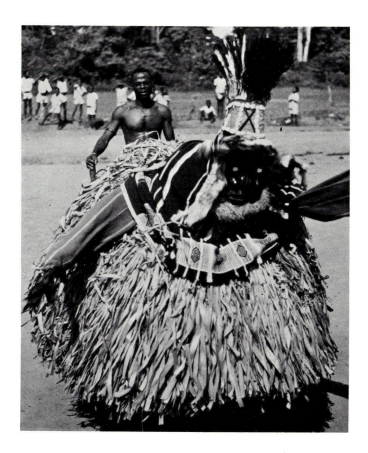

20-8 Bété dancer from the village of Zahia. Photograph by Armistead P. Rood.

horizontally for the eyes, a vertical wedge with a curved profile for the nose, two bulging, horn-like projections reminding one of a massive handlebar mustache for the cheeks, flattened horizontal projections for the upper and lower jaws, and a slightly raised platform emerging from the lower jaw for the tongue. The recesses between the various masses are carved very deeply, up to four inches in certain places. (The wood partition over the wearer's face, incidentally, is cut with holes to enable him to see and breathe.)

The relationship to the human face is remote; the artist was clearly conceiving forms in terms of a highly schematized vision of reality. Yet he was also pursuing expressive effects; the strong near-vertical light of the African sun would produce deep dramatic shadows around the protruding eyes. To modern observers both the bold interplay of solids and voids and the vigorous and precise sweep of individual surfaces are not only pleasing and exciting in themselves but also suggestive of enormous inner power. It is no wonder

that it is precisely this latter quality in African art that influenced the early Cubist artists at the time when they were attempting to suggest a new sense of energy through their manipulation of geometric forms.

The Ifé, Bambara, and Bété pieces give but a limited view of the broad and varied artistic achievements of black Africans. Many of our observations, however, are characteristic of the majority of artistic tribal traditions: the relative importance given to individual details often reflects a symbolic purpose; the frequent geometric stylization of designs is vigorous and pleasing; and, in spite of an often high degree of abstraction, individual forms suggest a keen awareness of the shapes and movements of men and beasts.

The American continent produced cultures that filled with amazement the European conquerors of the sixteenth century. Some of the earliest indications of sophisticated civilization are sculptures and architectural remains dating from 1000–700 B.C., found in northern Peru.

Sharing a number of stylistic elements that probably reflect common religious beliefs, they have all been given a single name, Chavin, after one of the principal archeological sites. The Chavin culture lasted several centuries, eventually merging into later traditions.

The remains of Chavin buildings are large, imposing, and occasionally covered with rich and intricate decoration. The feline shown in Figure 20-9 is a tracing made from a design on the underside of a cornice on the major temple at Chavin. The original work consists of shallow incisions made with pointed stones in the surface of the masonry. A comparison with the leopards from Çatal Hüyük of 6000 B.C. (Fig. 1–3) reveals a very different approach to form. The Çatal Hüyük leopards retain a touch of naturalism despite the drastic stylization. The shape of the Chavin animal, on the other hand, brings to mind a fabulous dragon. Indeed, the Chavin artist seems to have been primarily interested in the play of ribbon-like elements that is strongly decorative and may

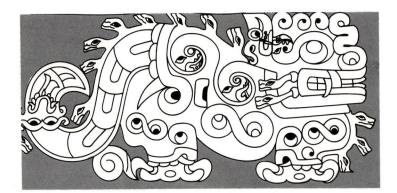

20-9 *This page, above:* Archeologist's drawing of a feline from the incised relief of the underside of a cornice, temple of Chavin, Peru, 1000–700 B.C. or later (18¼″ × 39″). After drawing by John Howland Rowe.

20-10 *This page, below:* Mortar in the form of a feline, Chavin culture, after 1000–700 B.C. or later. Stone (13″ long). University Museum, Philadelphia.

20-11 *Opposite page:* Head from the Tomb of the Inscriptions, Palenque, late seventh or early eighth century; stucco. Museo Nacional de Antropologia, Mexico City.

also have had a symbolic meaning. Pairs of spots on the feline's coat are linked by a band forming a serpent-like figure eight. The nostrils and eyes are treated with the same type of decoration. The outline of the back and the corner of the mouth are studded with protruding serpents' heads. The tail seems to emerge from the upper jaw of a feline. Near the end of the tail is another feline's head, this one upside down, holding the tip as if it were a tongue coming out of its mouth. The feet terminate in eagle's claws. The mouth of the figure, however, with its row of rectangular teeth and protruding backswept canines, seems to allude specifically to a feline.

Judging from the way in which the overall configuration of the jaguar fits into a rectangle, we can surmise that the artist was greatly concerned with filling a specific surface area with a decorative pattern. The relationship of the ribbon-like details to one another, furthermore, indicates a concern with achieving a fairly even density of surface decoration. The

feline motif recurs frequently in Chavin work; so do the serpent and eagle designs in the decoration. Referring as they do to animals hostile to man, all three may have been symbolic of the awesome power of nature.

Chavin artists also created three-dimensional sculpture. The stone mortar in the form of a feline (Fig. 20–10) has overall proportions similar to those of the work just discussed, but the artist made more determined efforts to stress the feline features of the head. The massive and compact forms of the mortar seem designed as much to avoid the removal of much stone in the carving process (taking the artist's rudimentary stone tools into consideration) as to evoke the poise and strength of the animal. Here, too, the surface is covered with what are probably symbolic designs; we recognize the serpent-like ribbons, while the crosses may stand for spots or, perhaps, stars.

Considerably more is known about the Mayan culture of southern Mexico and parts of present-day Guatemala and

British Honduras than about the Chavin culture. The Mayan culture was at its height during the so-called Classical period, from about A.D. 300 to about 900. The head of a man in modeled plaster, or *stucco* (Fig. 20–11) can be ascribed quite accurately to the late seventh or early eighth century. In its great delicacy of modeling and the almost Baroque richness of the handling of form in space, it is an excellent example of the height of the late-Classical phase. The present coarseness of much of the surface is due to the flaking of the layer of reddish paint originally covering it and the irregular loss of plaster over the surface. The features remain nevertheless remarkably sharp. A comparison once more with the head of Chephren (Fig. 1–5) reveals an even greater concern with individual life; there is a definite asymmetry in the handling of the brows and lips, for instance, that one would never find in Egyptian art and that creates a remarkable impression of immediacy.

Despite the obvious naturalistic in-

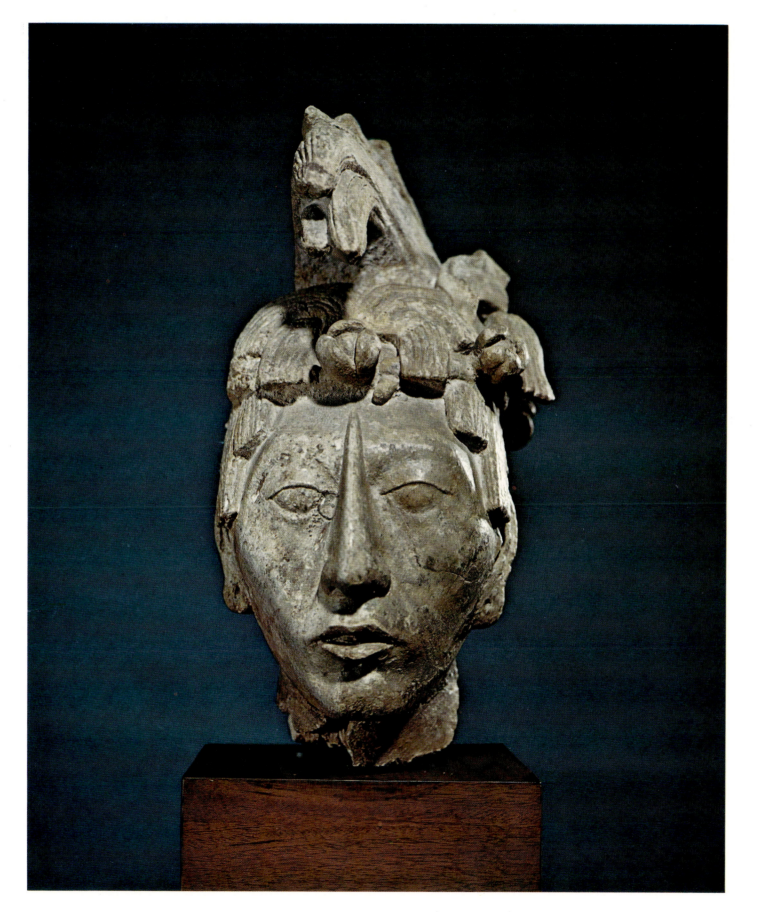

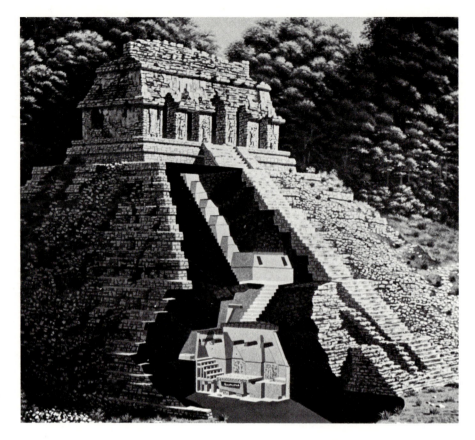

20-12 *This page:* Temple of the Inscriptions, with section showing crypt, late seventh or early eighth century.

20-13 *Opposite page, left:* Vessel in the form of a feline, Aztec, c. 1483. Stone (35⅞″ high). Museo Nacional de Antropologia, Mexico City.

20-14 *Opposite page, right:* The gods Tezcatlipoca and Huitzilopochtli, incision in the receptacle of vessel in the form of a feline (Fig. 20–13).

tent, one is aware of definite formalistic elements. The long line of the ridge of the nose dramatizes a known physical characteristic into a convention of Mayan taste. A small jade object was apparently sometimes worn over the bridge of the nose in order to make the nose appear to start on the lower forehead, and there can be no doubt that the figure here depicted wore such an ornament. It creates an elongated pyramidal accent in the center of the face that is emphasized by the diverging lines under the eyes and around the mouth. The headpiece seems to be made of a number of feathers intertwined to create an arrangement of curving and straight bands; these form a complicated geometric design that adds to the formalism of the composition.

The exact purpose of the head is unknown, but it was found in a tomb and is probably related to funerary rites. The expression of the head is one of calm dignity and determination, but it also suggests infinite resignation. It is known, incidentally, that the Mayas, like all American Indians, accepted the dictates of fate, including death, with remarkable equanimity.

The head was found in the crypt of the so-called Temple of the Inscriptions at Palenque in southern Mexico (Fig. 20-12). This is a pyramidal structure like those in many religious centers of Central America: a masonry building with a carefully detailed stone facing and, originally, stucco decorations on the outside. Flights of narrow steps lead to a graceful pavilion at the top. This particular temple contains several rooms, and a slab in one of them concealed the entrance to an interior stairway, filled with rubble, that ultimately leads to the crypt.

The Mayas used a distinctive vaulting method. If we examine the arches of the temple façade, we notice that they are *corbeled* vaults, constructed with successive courses of masonry progressively protruding over the space to be spanned and meeting at the top. Each of the protruding blocks is held in position through pressure from above and below, so that corbeled arches are most stable when under a considerable weight. Indeed, much Mayan architecture is very massive, with heavy, elaborate superstructures above small rooms and narrow openings.

This stucco head and another similar to it were found near the sarcophagus of a chieftain (or a priest or king) in the crypt, together with ornate jewelry. As with many early cultures, the Mayan dead were buried with their personal possessions and, in many cases, wives, slaves, and attendants. Significantly the bodies of several young adults were found just above the entrance to the crypt, and it is possible that the heads were meant to symbolize those of beings, human or divine, who would escort the dead on his last journey. Thus the use of funerary statuary in Mayan tombs seems to parallel that of ancient Egypt (see p. 12).

Let us conclude this brief look at Pre-Columbian America with a stone vessel in the form of a feline (Fig. 20–13) made around A.D. 1483 in what was then the capital of the mighty Aztec empire

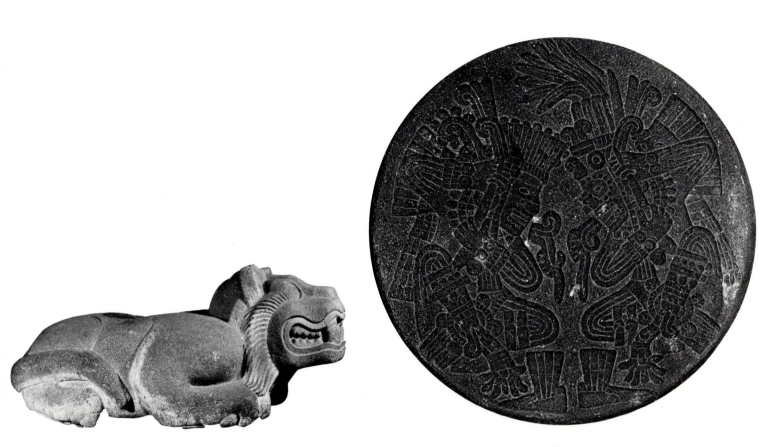

and is now Mexico City. The Aztecs were recent conquerors who had come from the west and dominated the other people of the Valley of Mexico around 1427, eventually coming to rule much of Central America. They borrowed extensively from the artistic traditions of their predecessors and relied heavily on the local craftsmen still active in the areas they had overrun. They nevertheless imposed their militaristic outlook on the arts, resulting in a stark but powerful expressiveness.

The feline vessel is in the hard, rough-grained stone employed for much Aztec sculpture. In several respects it resembles the Chavin animal mortar (Fig. 20–10); the head of the Aztec feline is as large in relation to the body as in the older work, and the forms are as extraordinarily compact. The Aztec sculpture, however, reveals a much greater concern for naturalism. Despite the blocky quality of the joints, one is aware of the lively quality of the limbs of the feline. There are, nevertheless, strong elements of decorative stylization; the fur around the jaws

has become a pretext for an orderly and graceful linear pattern, and the contour of the nose forms a continuous line with the eyebrows. Finally, the curvature of the lips is accentuated into a vigorously undulating pattern that emphasizes the powerful canines. This decorative insistence on the snarling mouth, incidentally, can be related to the importance given to the same feature in the Chavin piece and is probably intended to suggest cruelty or aggressiveness.

The purpose of the vessel has been fully established: it held the hearts of human sacrificial victims. Significantly, the images of two of the principal gods of the Aztec pantheon are engraved inside the receptacle in the feline's back—Tezcatlipoca, god of the night sky (whose favorite disguise is as a feline), and Huitzilopochtli, god of war and the sun, who were both great consumers of human hearts (Fig. 20–14). In keeping with a tradition going back to such works as the Chavin feline (Fig. 20–9), the artist has made skillful use of linear patterning, at

once filling out the surface area with a rich and vigorous design and effectively indicating the forms of the gods in their full regalia performing an awesome ritual.

A spanish cleric, Bernardino de Sahagun, who collected abundant information on the religious practices and beliefs of the Aztecs in the sixteenth century, gave a detailed account of the sacrificial ceremony on the feast of Tezcatlipoca. A handsome and intelligent youth was chosen from among prisoners a year before the feast. He was maintained in luxury and treated like a god. The last five days were spent in procession through the city, during which he was worshiped publicly. On the last day, his pages took him to an isolated temple. The young man mounted the steps himself, breaking his flute as he climbed to the top. There, four priests took him and threw him across the stone block. One priest opened his breast with a stone knife, tore out the heart, and offered it to the sun (and, one must presume, threw it into a vessel such as this one).

21

India, China, and Japan

The few examples from India, China, and Japan we can study can do no more than help us pinpoint some aspects of their vast and complex cultural achievements. The development of metallurgy and the transition from nomadic to village and finally urban life occurred slightly later in Asia than it did in Egypt and Mesopotamia (see p. 9). This evolution probably took place in the Indus Valley of northwest India around 3000 B.C. and in China around 1600 B.C. The first work we shall consider is one of the very great specimens of the Chinese Bronze Age, a *kuang,* or ceremonial vessel, of the Shang Dynasty in northern China, which dates from the fourteenth to the eleventh century B.C. (Fig. 21–1). The vessel was originally a copper-bronze color, but centuries spent in an underground tomb caused it to be covered by a thick crust of oxides which, when partially removed by mechanical or, more rarely, chemical processes, have left a surface film, or *patina,* of marble-like, delicately variegated greens and browns. The

vessel was cast in clay molds carved in reverse by hand in several small sections, the sections being carefully doweled together before the metal was poured. The degree of precision achieved in rendering the sharp edges of the decoration elicits the respect of the most skillful modern foundry specialists.

A comparison with the Chavin example we have discussed (Figs. 20–9 and 20–10) reveals surprising similarities. The Chinese artist showed an even more marked tendency than Chavin artists to assemble forms pertaining to different animals. The lid has two animal faces, one at each end. As in Chavin art, furthermore, there are zoomorphic decorations all over the surface. If one looks carefully, one notices a band starting at the ears of the head at the left, descending along the side of the vessel and terminating in a squarish spiral. This represents the body of a dragon rearing up on its hind legs with its front paws thrust forward, terminating in the bovine head that forms the front of the vessel. Practically all the other

surface designs suggest animals or combinations of animals; for instance, one can see an elephant with a raised trunk on the right side of the lower register.

Both the zoomorphic forms and the spaces between them are filled with the squarish spiraling ridges that characterize the Shang style. It is likely that animals, dragons, and spirals all had symbolic meanings. This ribbon-like decoration, incidentally, may have some of the same ingredients that gave rise to the zoomorphic interlace of the barbarian art in Europe (Fig. 5–1). The spirals themselves are probably related to those of the art of the central Asiatic steppe.

There is yet another vague likeness between the Chinese and the Chavin works: that between the designs of the bovine head of the first and the feline head of the second. These and the other points of similarity are the basis of conjectures that the early art of the Americas was affected by Asiatic influences. If this is indeed the case, one can still speculate as to whether the influence is due to

21-1 *Top: Kuang,* ceremonial vessel, Shang Dynasty, fourteenth to eleventh century B.C. Bronze (7½″ long). Norton Gallery and School of Art, West Palm Beach, Florida.

5-1 *Bottom, left:* Detail of purse lid from Sutton Hoo, before 656 (*comparative illustration*).

20-9 *Bottom, right:* Detail of archeologist's drawing of a feline from the incised relief of the underside of a cornice, temple of Chavin, Peru, 1000–700 B.C. or later. After drawing by John Howland Rowe (*comparative illustration*).

communications or to the fact that the people of the Americas originally came across the Bering Straits from Asia and continued to evolve in a manner roughly parallel to the cultures they left behind.

The design of the *kuang* is quite remarkable. The lower part of the vessel is basically regular and compact. It is the profile of the opening that introduces an element of graceful asymmetry, suggesting as it does the flow of a pouring liquid and elegantly merging with the curvature of the handle. The asymmetry is accentuated by the dissimilar animal heads of the lid. The ornamentation, no less than the patina acquired over the centuries, contributes a remarkable richness of surface effects. The whole design, down to the smallest dragons and even the squarish spirals, is marked by a vigor, an elegant rhythmic quality, and a graceful asymmetry that were to remain characteristic of the best of Chinese art through the ages.

In India, in the meantime, the basis was being laid for one of the greatest

sculptural traditions that the world has known. Of the several principal trends that had become apparent by the first century A.D., one is clearly related to earlier local traditions. Another shows a pronounced influence from the West, particularly from the Romans, but still with a definite concern for local taste. Out of the union of these two trends emerged a style that had a profound impact on much of Asia.

The so-called donors from Karle in central India (Fig. 21-2), a larger than life-size stone relief from A.D. 100 to 120, belongs to the first of these trends. The title "donors" is probably misleading; the couple is the earliest known in a long series of similar figures whose sensual poses clearly point to their true meaning as fertility symbols. This interpretation is confirmed by the survival in present-day Indian villages of nature fertility cults going back to the earliest-known culture of the Indian continent.

Comparing these figures with that of Apollo of Olympia of 460 B.C. (Fig. 2-10), we see immediately that the patterning created by the bone structure and musculature under the skin of the Apollo is all but nonexistent. In the Indian figures, the surface of the flesh seems even to be gently distended by some inner breath. Much less concerned with the naturalistic proportioning of the bodies than the

Greeks, the Indian artist exaggerated the size of the young man's pectoral muscles and stressed the breadth of his shoulders and hips and the narrowness of his waist to emphasize his athletic physique. The young woman is endowed with enormous breasts and a huge lower abdomen, perhaps to stress her fecundity and her potential as a partner in amorous dalliance. The rhythmic quality of the outline adds to the expressiveness of the composition. A repetition of vigorous, somewhat asymmetric curves stresses the liveliness and stability of the man, while the position of the woman suggests a sinuous flow from the lower left to the upper right that brings out both her feminine grace and her emotional and physical dependence on her partner.

The rhythmic quality of the design is so pronounced that we are led to imagine that the figures are seen in a moment of rest in the course of an elaborate and very sensual dance. Even the expanded chests suggest the intake of air which, like the gentle swelling of the flesh, is intended to show the bodies literally expanding with their sacred exertions. The dancers' clothing is minimal: headgear with elaborate earrings; a girdle around the woman's loins, a belt around the man's; anklets on the woman's legs; a thick veil around the hips and legs of the woman which is gathered into pleated folds between her legs, and a similar transparent garment with pleated folds falling between the legs of the man, supplemented by heavy twisted scarves or sashes. The ornaments have the same

weighty and sensual quality as the bodies. They, too, seem to be swelled by the gentle pressure of some inner breath.

These figures can be related to a series of earlier fertility symbols intended to extoll the life-giving properties of nature. Indeed, the "donors" relief belongs to a very old Indian tradition characterized by its unique stress on full-bodied sensuality and powerful overall movement. It is now well established that the prototype of such sculptures were wooden and clay figures, the transition to monumental stone sculpture having occurred during the reign of the central Indian monarch Ashoka (c. 270–230 B.C.) There were sustained contacts between the court of Ashoka and the civilizations of Mesopotamia and that of Persia, and it is not impossible that stone carving techniques neglected since prehistoric times were reintroduced in India by itinerant craftsmen from that area.

Both figures rest their weight on one leg, thus giving the sculptor the opportunity to stress the *déhanchement* of the two bodies. A similar device was used in the Apollo of Olympia (Fig. 2-10), and one may conjecture that, in their attempt to convey a powerful swaying motion of the bodies, Indian sculptors had arrived at the same solution as that used by the Greeks to evoke the tension and relaxation of various parts of the body. One detail may conceivably be derived from similar practices in Persian art that may ultimately be of Greek origin: the draperies between the legs of the dancers are made of neatly superposed pleats with zigzag edges, a

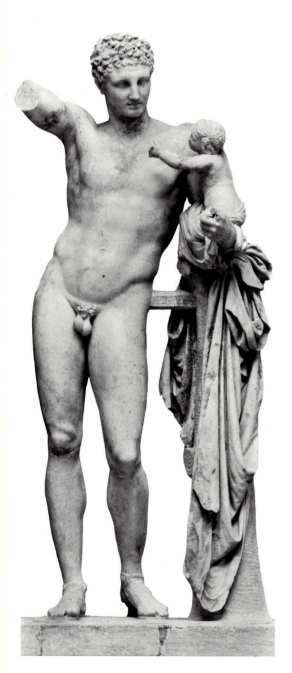

device comparable to similar practices in the art of Archaic Greece that are still apparent in the fragment of drapery of the Lapith woman next to Apollo.

The standing figure of the Buddha from Hoti-Mardan in West Pakistan (Fig. 21-3) is fully characteristic of the trend in Indian art reflecting the influences of the West. It was executed in the second century A.D. in the empire of the Kushan, a dynasty established a century earlier that ruled over Afghanistan and northwest India. The Kushan kings were foreign conquerors from central Asia and were only partly dedicated to older Indian ideals. Furthermore, the northern area of their kingdom had been ruled mostly by Greeks after the invasion of northwest India by Alexander the Great in 330–325 B.C., until it was conquered by the no-madic Scythians from the area to the northwest of the Black Sea in 130 B.C. By the time of the Kushan, moreover, the ancient province of Gandhara, an area adjoining Afghanistan in the northwest, had become an important thoroughfare between India on the one hand and Mesopotamia and the Mediterranean on the other. The Kushan court was thus exposed to the influence of Classical an-tiquity, more particularly that of Rome. Traveling artisans trained in Mesopotamia and in the Roman Empire were probably retained in the area to adorn the cities,

2-21 Once attributed to Praxiteles, *Hermes and the Infant Dionysos,* c. 330–320 B.C. (*comparative illustration*).

palaces, and temples of the Kushan princes—hence the name Romano-Indian given to the new artistic developments.

The Hoti-Mardan Buddha belongs to this second trend and is, indeed, one of the Indian monuments most influenced by the cultures of the Romanized Medi-terranean basin. The attitude of the body is marked by a graceful *contrapposto,* the Praxitelean flavor of which becomes par-ticularly evident when compared with the Hermes formerly attributed to Praxi-teles of around 330–320 B.C. (Fig. 2–21). The patterning of the drapery itself has Classical precedents. Indeed, we find a similar treatment of folds in regular arcs in the drapery of a Lapith from a metope of the Parthenon (Fig. 2–24). As for the face, its subtly modeled lips, chin, and cheeks and the meditative, inward-looking eyes owe something to late Classical and Hellenistic art (Fig. 2–21 and 3–2). The deeply grooved, loosely waving hair is characteristic of Hellenistic illusionism, and the proportions are much closer to those of Classical antiquity than to those of traditional Indian art.

Some elements point to a new search for abstraction that may be due in part to the growing linearism of the late an-tique art on which these Indian artists modeled their work, but it must also re-flect a local tradition: while the fabric of the garment still appears to be substantial, there is a dry regularity in the repetition of the folds, and the eyes and eyebrows have a linear stylization verging on harsh-ness. In another respect the treatment of the figure reveals an important conces-

sion to Indian tradition. The artist indicated the body under the drapery with a much greater insistence than a Hellenistic or a Roman artist would have, treating the drapery like a wet surface clinging to the body and revealing ample, faintly bulging, and melodiously rhythmic surfaces of flesh. Here, as in the case of the Karle "donors" (Fig. 21-2), we can talk of surfaces gently distended by an inner breath.

The iconography of the work reflects strict adherence to Buddhism. The Buddhist doctrine is founded on the teaching of Gautama Siddhartha, a prince born in Nepal who probably lived around 563–483 B.C. and was referred to by his followers as the Buddha, or the Enlightened One. The Buddha paid little heed to the existing deities or the demanding rituals and sacrifices of the Brahmanical religion prevalent in India, preaching instead a life dedicated to moderation and to upholding moral right. Allied to his concern for morality was a pessimistic strain that advocated a spiritual detachment sometimes verging on abnegation. Life was seen as basically sorrowful, and only a deliberate withdrawal from wordly concerns would enable the individual to achieve a state of moral enlightenment in this and future lives, ultimately leading to a state of total removal from the cycles of rebirth known as Parinirvana.

After Gautama's death, his doctrine became a religion. He was taken to be superior to the gods, and the story of his life was codified, each incident coming to be regarded as invested with specific reli-

gious symbolism. The fertility and nature cults as well as the tradition of Brahmanic deities of the popular religion were soon incorporated into Buddhist worship. Around the second century A.D., while the Buddha himself came to be regarded as an eternal savior, a number of bodhisattvas, secondary deities who chose to reject the possibility of reaching the state of Parinirvana, although they were fully eligible for it, were worshiped as supreme embodiments of the Buddha's virtues. The bodhisattva of compassion, in particular, was seen as struggling for the betterment of mankind. A whole new pantheon was thus established.

The first Buddhist statuary dates from the reign of Ashoka (c. 270–230 B.C.), whose empire stretched over most of western and central India. By that time Buddhism had won numerous adherents, and Ashoka gave it a major additional impetus by adopting it as the official religion. The sculptures of Ashoka's time refer to symbols of the Buddha's spiritual power and achievements but still never represent him. It was only later, perhaps a little earlier than the beginning of the Kushan rule toward the end of the first and during the second century A.D., that the Buddha was first represented. Although the earliest images may have been made in central India, the Romano-Indian tradition of the northwest contributed

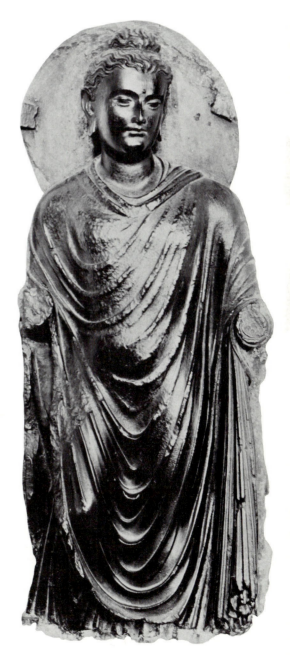

21-3 *Buddha* from the Guides' Mess, Hoti-Mardan, second century A.D.; stone. Copyright Archaeological Survey of India.

much to the formation of the Buddhist images of later times in the Far East.

The symbolism of the Hoti-Mardan Buddha is typical. Between the eyes is a tuft of hair, the *urna,* and at the top of the head is the protuberance of wisdom, the *ushnisha,* both birthmarks heralding the sanctity of the Buddha's future role. The elongated ears are reminders of the heavy princely jewels the Buddha wore before his renunciation of worldly pleasures. The plain, flowing monk's robe symbolizes the renunciation itself. The halo, a device that as we have seen originated in Mesopotamia and had already made its appearance in Rome (p. 54), is intended here to identify the Buddha as the Enlightened One.

In the fourth and fifth centuries, during the reign of the Gupta dynasty, a merging of the art of Gandhara and the more genuinely native traditions typified by the Karle "donors" gave birth to the classic image of the Buddha. The stone Buddha of the First Sermon from Sarnath in northeastern India (Fig. 21–4), which dates from the fifth century, ranks among the finest examples of this new style. Certain elements of the Romano-Indian tradition can be seen to have made their mark but in a much modified form. The stylization of the eyes and eyebrows of the earlier statue is even more pronounced here, resulting in a firmly rounded surface delimited by sharp edges. The hair is as deeply grooved, but instead of the wavy treatment reminiscent of Hellenistic illusionism in the Hoti-Mardan Buddha, we find here rows of rounded individual locks

going back to the earlier Indian tradition. The tendency toward abstraction has also affected the clothing; the still substantial drapery of the Hoti-Mardan Buddha has been replaced by a tight sheath suggested by means of highly understated linear elements, and it reveals the flesh almost as fully as in the Karle "donors."

Like the artists of Egypt, Greece, and Rome, the Gupta sculptors adhered to specific rules of proportion, but beyond this they favored simple overall geometric schemes, in keeping, perhaps, with the tendency toward abstraction noted in connection with the Hoti-Mardan Buddha. This particular figure can readily be seen to be related to a triangle the base of which is the top of the pedestal, the two sides going through the upper parts of the arms, touching the sides of the head, and meeting at an angle of thirty degrees at the top of the halo. Furthermore, except for the hands and feet, the figure is totally symmetrical, and the angle between the upper arms and the sides of the torso is bisected by the vertical. This geometric regularity is in marked contrast to the sinuous curves of the Karle "donors." It suggests order and stability and gives an overall static effect.

Nevertheless, Gupta art is essentially Indian. The linear elements of the face have vigorous and sensuous rhythmic curvatures. Despite the interest in an overall geometric scheme, body and limbs have the characteristic roundness and softness suggesting the gentle pressure of an inner breath. There is also something voluptuous about the curvature of the

lips and the gestures of the hands. The overall proportions, with their stress on broad shoulders and a narrow waist, bring to mind those of the male Karle "donor."

It would seem that the tendency toward abstraction, the stress on geometric simplicity, the overall restraint, and the static quality are related to the mood of abnegation of Buddhism. Indeed, in contrast to the figure of Buddha, the two animated angels against the halo (Fig. 21–4) have the dynamism and convey the impression of outward impulse that was to be characteristic of Indian art after the gradual abandonment of Buddhism in favor of the more worldly Hindu religion from the fifth through the twelfth centuries.

Iconographically, the Sarnath Buddha testifies to the skill with which successive generations of Indian artists managed to incorporate complex elements of Buddhist symbolism into an effective work of art. The Buddha has the usual attributes: the halo, the *urna,* the *ushnisha,* and the elongated ear lobes. He is seated like a Yogi ascetic, in the attitude of meditation, his legs bent with the soles facing upward. Yogi practices, one might add, consisted of breathing and other exercises designed to achieve a superior concentration in meditation and to establish union with the divine spirit. In this case, the nature of the meditation is indicated

21–4 *Buddha* from the First Sermon, Sarnath, fifth century A.D. Stele, Chunar sandstone (5′3″ high). Museum of Anthropology, Sarnath.

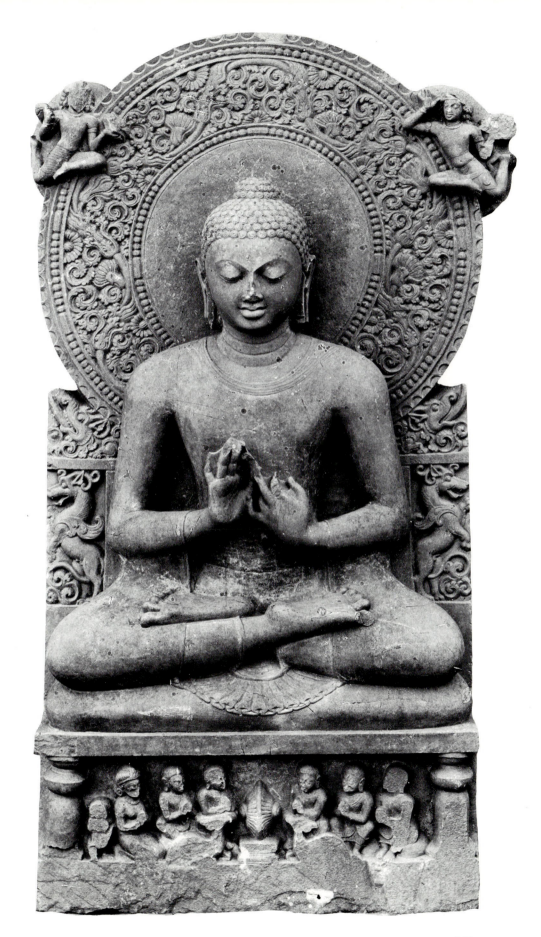

297

21-5 *Bodhisattva* from Hopei province, T'ang Dynasty, seventh century A.D. Marble (5'10½" high). Private collection, New York.

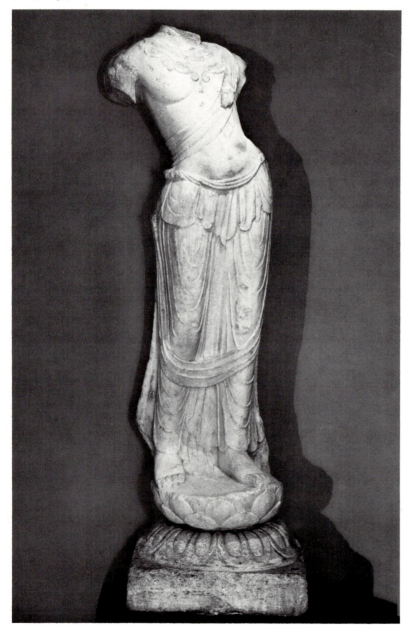

by the Buddha's hands, which are performing one of the codified gestures of Buddhist ritual, the turning of the Wheel of the Law, and thus refer to the very inception of Buddhist doctrine. The halo is incised with a rich pattern of plants, mostly lotus blossoms, the sacred flower of the earliest nature and fertility cults. The Buddha himself is seated on the lower part of his garment, pleated to emulate the form of a lotus flower.

The relief of the base is similar to early Buddhist representations in which the figure of the Buddha itself never appeared. It refers to a specific event in the life of the Buddha in which he is represented by a symbol. The scene shows six disciples gathered to hear him preach. At the center were two deer, which have been damaged and are not visible in the illustration. They refer to the Buddha's First Sermon in the deer park at Sarnath. The Wheel of the Law refers to the body of universal laws enunciated at that time and, in this instance, symbolizes the Buddha himself. By juxtaposing the small relief with the much larger figure of the Buddha, the artist was able to associate a specific event of the life of the mortal Buddha with the cosmic significance of his meditation and his doctrine.

It was in the Gupta era, from the early fourth through the mid-seventh centuries, that Buddhism spread to southeast and central Asia, China, and Japan along the trade routes linking India with those regions. This network soon became pilgrimage roads studded with shrines along which travelers from distant

lands came to worship in India and Indian monks traveled on proselytizing missions. There were Buddhists in China in the first century A.D., but China had its own vigorous and sophisticated religious traditions, and it was only in the early fifth century A.D., with the invasion of areas of northern China by Buddhist Tartars from central Asia, that the Buddhist faith made substantial progress there, eventually reaching Korea and Japan.

The Buddhist art that penetrated China had been somewhat transformed in the course of its progress through central Asia, and its impact on the already highly refined Chinese tradition did not at first have the happiest effects. The two traditions were eventually blended in works of great distinction during the T'ang Dynasty (A.D. 618–906), such as the marble bodhisattva from Hopei province in central China (Fig. 21–5). The complex twists of the body and the subtle modeling of the flesh may well stem from the sensual and dance-like attitudes of Indian prototypes. There are telling differences, however. In the first place, graceful though it is, the body has a svelteness and a nervous energy that distinguish it from the more languorous Indian examples. In the second place, the musculature is more precisely delineated, often by means of sharply intersecting surfaces like the line under the pectoral, so that the Indian suggestion of bodies swelled by the pressure of inner breath has totally disappeared.

The Chinese love of elegant rhythmic linear designs manifests itself in the deli-cate grooving of the garment to suggest folds. The idea derives ultimately from the regular fold pattern of such Indian works as the Hoti-Mardan Buddha (Fig. 21–3), but here it achieves an exceptionally graceful complexity. The forms are further complicated by the elegant swathes wrapped diagonally around the legs and torso. The pronounced sensuality of Indian sculpture has been transmuted into a lively, spiritualized grace.

Before the advent of Buddhism, Chinese thought was dominated by two principal trends. The first was Confucianism. In contrast to Christianity, which postulates original sin and claims that only faith can save man, Confucianism asserts that man is born good and that society makes him evil. Explicitly refusing to be drawn into arguments over the existence of a god, Confucius—the late-sixth-century-B.C. founder of the philosophy—directed his main teachings toward man's relationship with man. He stressed filial piety and duty to one's neighbor. Since he did not believe in rewards or punishment in afterlife, he advocated the practice of virtue for its own sake. Throughout his writing there emerges an attitude of sweet reasonableness, but he left no doubt that evil should be met with a firm hand. The tenor of his teaching can perhaps be described as human--oriented, rationalist, and aristocratic.

The other main trend, Taoism, made light of the legalism of Confucianism, claimed that one should return good for evil, and advocated simultaneously a superior detachment and an intimate under-standing of man and nature based on love. Taoist thought was thus antirational, idealistic, and essentially mystical. It eventually was much influenced by Buddhism. Like Buddhism, it stressed the importance of meditation. And, much as Buddhism had been affected by earlier nature worship, the Taoists believed that only an intuitive communion with nature could reveal to them what they called *Tao* or "the way." For the Taoists, however, the concept of nature was free of the strong sensual associations that it had had in India. They evolved a highly cerebral, subtly lyrical appreciation of the landscape.

Chinese Buddhist trends reached a climax in the seventh century. After this there was a gradual return to Confucianism and Taoism, while isolated sects cultivated the highly intellectual Ch'an (in Japanese, Zen) Buddhism. It was in the ninth century that Chinese painters and poets, whose interest in their natural environment had been stimulated in many cases by Taoist thought, developed a wholehearted and long-lasting attachment to the depiction of landscape. Significantly, many of the leading protagonists of this devotion to nature were Taoists and Ch'an Buddhists.

A scroll by an early-thirteenth-century painter, Hsia Kuei (active around 1180–1230), who was attached to the southern court of the Sung Dynasty at Hang Chou, is one of the masterpieces of Chinese painting. A section of *A Pure and Remote View of Rivers and Mountains* is reproduced in Figure 21–6. It was executed in water-

color applied with a brush on silk, and in its remarkably economical, delicate, and suggestive technique it is characteristic of Hsia Kuei and other Southern Sung painters—a technique, one might add, that contrasts markedly with the more meticulous and often very detailed execution of the masters of earlier centuries. Hsia Kuei's scroll can be compared with an equally delicate Western work, Rembrandt's *Winter Landscape* of about 1647, executed in *bistre wash,* a brownish watercolor, the pigment for which is extracted from soot, with a reed pen (Fig. 21-7). Chinese artists made use of a vastly greater variety of pens and inks than Western artists and had developed almost innumerable techniques for depicting natural forms and achieving textural effects. There are, however, several technical parallels between these two works. We notice the same rendering of surfaces by means of light applications of nearly translucent washes. There is the same alternation of areas of color and of unpainted paper to suggest variations of

forms and textures, the same reliance on the whiteness of the paper to suggest overall illumination, the same angular and furry strokes to suggest the outlines of objects, and not dissimilar scratchy strokes to suggest textural details and foliage. Although Rembrandt normally used cast shadows in his drawings, they are here reduced to a minimum. Only in the thick dark lines of the eaves of the group of houses do we sense the presense of shadows. On a gray day, with snow on the ground, cast shadows are practically nonexistent, but their relative absence in the drawing is yet another point of similarity with the work of Chinese landscape painters who used none.

It is when we consider composition that the differences become striking. In the Rembrandt, the horizontal grouping of houses and the long diagonal of the barrier, no less than the vertical scratches to the right, are clearly and firmly related to the shape of the paper. One is also aware of a center of gravity, the pattern created by the barrier receding to a distant

area on the left being balanced by the forms of the houses and the wooden structure at the lower right.

In contrast, the Chinese landscape seems willfully unbalanced; trees, rocks, and various ridges in the distance animate the right side, while the area to the left is treated with extraordinary economy. We cannot talk of a center of gravity; rather, the rhythmic succession of drooping lines of mountain ridges and rising lines of the ground draw the eyes beyond the picture to the left. This, of course, is due in part to the fact that we are seeing a long scroll. We are expected to wind it from one end to the other in order to look at it. Accordingly, the artist attempted to stress the continuity of the landscape, frequently arousing our anticipation of things to come. But even in the case of designs filling single sheets, the Sung artists cultivated a studied unbalance, often crowding the more animated patterns in one corner and leaving the rest practically blank, as if to stress the spontaneity of their vision.

21-6 *Opposite page:* Hsia Kuei (active c. 1180–1230), *A Pure and Remote View of Rivers and Mountains,* section of a scroll. Watercolor on silk (18¼" high). Collection of the National Palace Museum, Taipei, Taiwan, Republic of China.

21-7 *This page:* Rembrandt van Rijn, *Winter Landscape,* c. 1647. Reed pen and bistre wash (2⅝" × 6⁵⁄₁₆"). Fogg Art Museum, Harvard University, Cambridge, Massachusetts, Charles A. Loeser Bequest (*comparative illustration*).

Perhaps the greatest difference between the two works is the approach to the solidity of form. In both cases, the strokes were applied in a swift, nervous manner, evoking the sensitive responses of the artist as well as the forms of individual objects. In the Rembrandt, however, we sense an extraordinary familiarity with the shape, weight, and texture of physical objects. The scratchy strokes of the barrier convey the tactile qualities of the material. The granular shading obtained by allowing the lines of the paper to show through the wash suggests both the white incandescence and the blanket-like softness of the snow. The angular linear pattern of the houses reveals their geometric quality and their massiveness, while the slightly rounded curves of the roof lines emulate the effect of the snow that has accumulated over them.

Unlike post-Medieval European artists, the Chinese painters were much less interested in the physical characteristics of objects than they were in evoking space itself—space being identified with the white surface of the scroll—and objects are suggested rather than precisely defined, seeming to float on that surface. What is more, much as they experienced delight in the presence of nature, Chinese artists painted almost exclusively from memory or imagination, and this in itself added to the overall sense of fluidity. As a result, the large rock in the Hsia Kuei picture, despite the variation of values along the principal ridges and the crisscross of strokes to suggest texture, remains essentially a loose two-dimensional design, each stroke retaining the quality of handwriting on the surface of the paper. The trees likewise are fluid calligraphic patterns. Furthermore, the areas left white or shaded in very pale ink refer much less specifically to definite naturalistic effects than in the Rembrandt. To be sure, the streaks in the river effectively suggest the variegated surface of the water and the light fuzzy strokes delineate the clusters of trees on hillocks seen through mist, while the large areas of white can be regarded as the effect of haze, but it could be argued that the artist was primarily intrigued with the patterns of forms emerging from nothingness.

Finally, Rembrandt presents us with a receding landscape starting right where the artist was standing and stretching to the distant horizon, the various objects providing distinct milestones with which to gauge distances. Hsia Kuei, on the other hand, in characteristic Far Eastern fashion, shows us a landscape that begins at some distance below the feet of the observer, thereby creating the effect of a plunging view, while the various forms—trees, rocks, distant hills—look like successive stage props, their relative distances not clearly spelled out.

It would be wrong to attempt to assess the degree of naturalism of the Western and Far Eastern works by the same standards. From the time of the appearance of a new passion for objectivity in the Renaissance up until the late nineteenth century, Western artists, whatever the manner or mood of their pictures, maintained an interest in tangi-

ble representation. The Chinese painters, on the other hand, were concerned primarily with communicating their poetic experience in the presence of nature. An earlier Chinese writer, objecting to the naturalistic developments of his time, advocated a greater stress on spirituality. Clearly responding to the Taoist advocacy of an intuitive union with the universe, he explained: "In discussing painting, people usually pay attention only to formal aspects and effects, but the ancients did not make their paintings simply as records of their sites of cities and country districts...." Such old and venerable works of art "had their origins in forms, but these were made to blend with the spirit and to excite the mind." He went on to depict the kind of excitement the artist was endeavoring to instill in the forms: "To exert oneself with strange mountains and seas, with green forests and the soaring wind, with the foaming water and the rushing cascades—how wonderful! It needs only the turning of the hand to bring down the brightness of the spirit into the picture! Such is the delight of painting!" Characteristically, it is the "turning of the hand" that instills a poetic spirit into the work. In this respect the writer was stressing the importance of the brushstrokes as the means both of defining form and of providing a magical aura.

To Western eyes, even the most lyrical Chinese pictures appear somewhat restrained in their expression. Indeed, there is, by contrast, a stark poignancy in Rembrandt's depiction of a few houses in the

snow. Chinese artists, perhaps because they are guided by the Confucian rule of Li, which demands temperance and restraint in all one's actions, are much more tentative in their expression of mood. The most that one can say of the mood of Hsia Kuei's painting is that he stressed a feeling of quiet delight and spiritual elevation. Since such pictures are intended primarily to stimulate and guide the viewer's own meditation, the artist uses as much restraint in communicating a mood as he uses discretion in enumerating physical objects and, indeed, in handling those elements—volume, weight, consistency—that could overly stress their physical existence.

The Far East has produced another important school of painting, that of Japan. That nation's artistic heritage owes much to successive waves of influence from China, and its unique and very remarkable tradition of Medieval narrative scrolls can be traced back to eighth-century China. This form of painting achieved its greatest evocative power in the twelfth and thirteenth centuries. Among the most vigorous and dramatic of these scrolls is *The Burning of the Sanjō Palace* (Figs. 21–8 and 21–9), from the series *Tales of the Heiji Insurrection,* dating from the middle of the Kamakura period (1185–1333). It is a long scroll that depicts in numerous interrelated scenes a burning palace, battling troops, and escaping courtiers—incidents of a war between two warlord families that had taken place in 1159.

Whereas Chinese scrolls of the same period depicted chiefly landscapes, the

Japanese narrative scrolls were dedicated to dramatic stories and romances then popular in Japan and to recent historical events. Far from striving for the ethereal quality of execution and the lyrical mood of Chinese paintings like those of Hsia Kuei (Fig. 21–6), the artist here depicted figures and objects with considerable detail and clearly attempted to convey a sense of intense excitement. As in Chinese art, the design is essentially calligraphic. The linear elements are much more definite than in the Hsia Kuei, however; each figure is delimited by continuous, flowing lines as indicative of physique and dress as they are suggestive of attitudes and movement. Between the lines, moreover, areas of lustrous black and vivid hues of subtly varying intensity give a heightened rendition of figures, animals, and objects, suggesting with particular brilliance the elaborate dress and accoutrement of an era especially interested in sartorial splendor. The stress on both the continuous lines and the fairly uniform areas of vivid colors draws attention to the surface and contributes to richly decorative effects.

The disposition of the figures and objects adds to the excitement of the design (Fig. 21–8). To be sure, the raised viewpoint enables us to distinguish several figures placed behind one another and

21–8 Anonymous, *The Burning of the Sanjō Palace,* from *Tales of the Heiji Insurrection,* detail of escaping courtiers, late thirteenth century. Watercolor on paper (16¾″ high). Museum of Fine Arts, Boston.

21-9 Anonymous, *The Burning of the Sanjō Palace,* from *Tales of the Heiji Insurrection,* detail of burning palace, late thirteenth century. Watercolor on paper (16¾" high). Museum of Fine Arts, Boston.

thus creates an effect of recession, but the figures and objects have been arranged to create definite if complex surface designs. These are made up of sweeping, curving accents merging and breaking apart like flowing water. A stream of warriors encircles the scene at the top, surrounding the courtiers, their carts and attendants at the center. A detachment of horsemen sweeping down from the right is initiating a pincer movement that will block the courtiers' escape. In the center the crisscross pattern of the carts and the gesticulation of the drivers no less than the frantic lunging of the bullocks suggests utter confusion and helplessness. To add to the vividness of the narration the artist has distinguished between the carriages that are stationary, and those that are moving by showing the individual spokes in the wheels of the former and using concentric curves to suggest motion in the wheels of the latter.

In the scenes in which architectural elements are present, the dwellings are shown from above and the walls create geometric linear accents that add to the decorative quality of the picture plane while helping to separate different episodes of the story (Fig. 21-9).

To eyes accustomed to the unity of action, the stress on complex psychological relationships, and the dramatic lighting characteristic of Renaissance and later art in Europe, scenes such as *The Burning of the Sanjō Palace* may appear at first to be too diffuse in their arrangement and too naive in their overall configuration to have a powerful emotional impact. As in the case of the Chinese landscape scrolls, however, one must unwind these scrolls slowly to become immersed in the various scenes. One must accept the stylized forms and vivid colors as the keys to a world of fiction and fairy tales. Above all, one must observe the figures one by one in order to become involved in the various actions. When one looks at this scroll in this spirit, the silhouette of a racing bullock, the stance of an angry warrior, or the expression of a terrified courtier can take on an epic quality, and the whole action pertains at once to the world of storytelling and the world of everyday reality.

The tradition of these narrative scrolls was profoundly Japanese and, although it made way for other forms of pictorial expression in later centuries, its spirit survived in one of the last and most prolific traditional Japanese schools, that of the Ukiyo-e printmakers, active from the middle of the seventeenth century through the nineteenth century. We have already seen, in the woodcut from Utamaro's series, *Woman Looking in a Mirror* of around 1790 (Fig. 15-4), the same love of elegant flat patterning, with sweeping lines and vivid areas of uniform colors, as in the works of the Medieval period. The principal characteristics of the Ukiyo-e school were a further simplification of patterning; a stress on continuous undulating bands throughout the surface that tend to give equal importance to the background and to the figures, thus contributing to an even flatter overall effect; a delicate balance of asymmetrical ele-

ments; and extraordinary inventiveness on the part of the artist in the choice of a limited number of hues to achieve effects at once subtle and brilliant as well as evocative of impressions of real life. Incidentally, the linear treatment, the uniform color areas, and the limited number of hues were ideally suited to the woodcut technique.

The art of China and Japan had a profound impact on late-nineteenth-century developments in Europe. The elegantly asymmetrical arrangement of forms of such pictures as Whistler's *Nocturne in Blue and Green, Chelsea* of 1871 (Fig. 15–10) may well have a Japanese source, while the means by which "the evening mist...clothes the riverside with poetry," in Whistler's words, may ultimately go back to such Southern Sung masterpieces as the Hsia Kuei scroll (Fig. 21–6).

Similar Far Eastern elements, as we have seen, occur in the work of Monet after 1886, such as his 1904 *Water Garden at Giverny* (Fig. 15–9). They may well have accelerated the departure from naturalism

and the search for a pictorial language that turns everyday reality into a pretext for daydreams in which artist and onlooker can lose themselves. Let us add that the principal impact of Asia on Western art of the nineteenth and twentieth centuries came specifically by way of Japan. Perhaps because that country had been less accessible to the West and so appeared more remote and challenging to European imaginations, when commercial ties finally were established many Japanese works of art appeared in Western markets. Perhaps also because the narrative intensity and decorative exuberance of much Japanese art appealed more strongly to Western eyes than the restraint of Chinese art, it was to Japan that some of the greatest innovators of the 1860s, 1870s, and 1880s in England and France turned for inspiration. We have already discussed Manet's fascination with the strong value contrasts and elegant linearism of certain Japanese prints (Figs. 15–3 and 15–4), and Degas's lively response to the Japanese printmakers' fondness for unusual

profiles (Figs. 15–4 and 15–7). We have also seen how Seurat's use of fairly uniform areas and continuous outlines, and the flattening of his composition were inspired by specific Japanese prints (Figs. 16–3 and 16–4), and how Gauguin's Synthetist style sprang largely from the same source (Figs. 16–5 and 16–6). The Art Nouveau style, furthermore, owed to Japanese art its sinuous curve, its love of asymmetry and flatness and the fact that it paid as much attention to the background as to the objects depicted (Fig. 16–10). Finally, it was the robust elegance and refined rectilinearity of Japanese architecture to which Louis H. Sullivan and Frank Lloyd Wright seem to have turned for some of their major innovations (Figs. 16–11 to 16–17).

Since Japanese art owes much to the art of China, and that of China to the art of India, we may say that the stream of Far Eastern influences that affected Western art some one hundred years ago marks the partial merger of two very long lines of development.

Glossary

Italicized words are also defined in the glossary.

Abacus Square slab forming the top of the *capital* of a *Doric* column above the *echinus* (see Fig. 2–18).

Abstract In art, removed from the representation of objects; characterized by a stress on the play of line and color.

Academy Originally, Greek school of philosophy founded by Plato. An academy dedicated to the study of Plato and other humanistic subjects was founded in Rennaissance Florence under the Medici. The name has been given to artistic, literary, and scientific societies, such as the French Academy of Fine Arts, founded in 1648.

Additive Characterized by the use of more or less repetitive single units that are not thoroughly unified into the *composition* (see *unified composition*).

Aegean The arm of the Mediterranean Sea east of Greece. Also, the Bronze Age civilization of the Aegean islands and surrounding lands.

Aerial perspective See *perspective*.

After-image An *optical illusion* in which the complementary of a *hue* seems to appear on a white surface after one has stared for a moment at the original color. It is perhaps because of this effect that two complementary hues placed side by side seem to enhance each other.

Aisle Longitudinal space on each side of the *nave* of a church, between two rows of *columns* or between the outer row and the outer wall (see Figs. 6–5 and 6–6).

Allegory Action or scene that alludes to a truth or generalization, usually of a moralistic nature, by referring to a well-known mythological, religious, or historical event.

Ambulatory Passageway, usually semicircular, around the *apse* of a church. The extremities of the ambulatory usually face the *aisles,* thus providing a continuous passage for processions (see Fig. 6–6).

Anthropomorphic Pertaining to the ascription of the human form to nonhuman objects or beings.

Apse Semicircular, vaulted alcove; the semicircular or polygonal area at the *choir* end of a church (see Fig. 6–6).

Arabesque Originally, the sinuous design of Moorish decorative patterns. Now, any flowing linear pattern and, by extension, an undulating, three-dimensional design.

Arcade Consecutive *arches* carried by *piers* or *columns.*

Arch Rounded or pointed masonry framework spanning two *columns* or *piers* and supporting a wall or *vault.*

Archaic Pertaining to the early phase of an artistic development. Also applies to Greek art from the Orientalizing up to the Classical period.

Architrave The horizontal member at the bottom of an *entablature* directly over the *capital* of a *column* (see Fig. 2–18).

Archivolt Concentric recess between moldings in Romanesque and Gothic *arches* (see Figs. 7–4, 7–5, and 7–6).

Articulation The arrangement of elements (such as openings, projections, *ribs,* or *pilasters*) that creates a sense of order and gives emphasis to the configuration of a building.

Atrium Originally, the inner court of a Roman dwelling, open to the sky. Also, *porticoed* court at the entrance of early Christian churches.

Attic Pertaining to Attica, a region of Greece. Also, the story above the main *colonnade* of a building; more generally, space created by a slanted roof.

Axial Said of a building plan that has a strong emphasis along one direction.

Balustrade Short *columns* surmounted by a rail (see Fig. 9–11).

Basilica Roman civic building of oblong form, terminated at the narrow ends by *apses.* Roman basilicas were usually covered with a *trussed* timber roof supported by outer walls, and by two or more rows of *columns* inside the building (see Fig. 4–5).

Also, Christian church similar to civic basilica, but with a single *apse,* often pointed East toward Jerusalem.

Bay Rectangular division of a building, marked off by consecutive pairs of *piers* (see Fig. 6–6). **Bay window** A window whose surface protrudes from the building, and forms a small alcove.

Biomorphic style *Stylization* suggested by organic forms.

Black-figure technique A technique utilized by Greek vase-painters by means of which figures were depicted in dark *glazes* over reddish clay; the details of the bodies were incised over the *silhouettes* and sometimes painted in various colors.

Buttress A massive *pier* built against a wall to receive the lateral thrust of a structure. **Flying buttress** *Arch* abutting the side of a building and transferring the thrust to a vertical *pier* at the other end (see Fig. 7–11).

Calligraphism In art, the use of elegantly curved lines, scrolls, and flourishes to suggest ornate handwriting.

Camera Obscura A box with a small hole or lenses and a system of mirrors in the center of one wall, sometimes with a translucent screen on the opposite wall, on which the artist may trace the projected image. In some cases, the box may be a room.

Canon Codified rules of proportion applied by Greek artists. By extension, any traditional set of rules of proportion.

Canvas Surface of woven linen or other fiber on which an artist applies paint.

Capital The flaring element, usually decorated, at the top of a *column.* The three *orders* of Greek Classical capitals are *Corinthian, Doric,* and *Ionic* (see Fig. 2–18).

Caryatid *Column,* or engaged column, in the form of a human figure.

Cella In Greek temples, a rectangular enclosure, sometimes divided by a doorless partition, in which the cult image was kept.

Centering A wooden framework to support an *arch* or *vault* during its construction.

Chiaroscuro A technique for *modeling* forms in a painting, by which the lighted parts appear to emerge from the surrounding shade.

Choir The part of the church in which the service is sung, usually the *apse* (see p. 73).

Classicism The practice of utilizing stylistic elements and myths derived from the Greek Classical period.

Clerestory The upper story of the *nave* of a church, pierced by windows to let in natural light.

Cloisonné Technique of setting colored glass, semiprecious stones, or enamel between strips of metal over a metal surface.

Coffer Geometric recess in a ceiling (see Fig. 3–12).

Collage Technique, utilized by Cubist and later artists, of incorporating fragments of "real" objects, such as newspapers and wallpaper, on the surface of a picture.

Colonnade A row of *columns,* usually supporting an *architrave* or *arches.*

Color circle or **wheel** Arrangement of *hues* of the rainbow in segments of a circle, with the addition of purple, which does not exist in the rainbow. When the wheel is spun, it produces white (or gray, because of impurities) as the colors cancel each other out.

Column Upright post bearing the load of the upper structure of a building (see Fig. 2–18). **Engaged column** Half column projecting from a wall surface.

Complementary hues See *hue.*

Composition The organization of forms and colors in a work of art.

Contour line Line painted or incised within the *outline* of a figure, suggesting relief on the surface of the figure.

Contrapposto A combination of *déhanchement* and an axial twisting of the body.

Cool color A *hue* in the violet-to-green range on the *color circle.*

Corbeled vault See *vault.*

Corinthian One of the three *orders* of Greek architecture; it was developed in the fourth century B.C. by the addition of a foliage motif to the *Ionic* capital (see Fig. 2–18).

Cornice Projecting molding along the top of a building (see Fig. 2–18).

Course Row of stones or bricks that form a horizontal layer of a wall.

Crossing Area of *axial*-planned church where the *transept* and the *nave* intersect. It is usually surmounted by a *lantern* or a tower (see Fig. 6–6).

Crossribbed vault See *vault.*

Crypt A *vaulted* space wholly or partly underground; in Medieval churches, normally the portion under the *apse.*

Cupola Hemispherical or nearly hemispherical *dome,* usually small.

Curvilinear Said of a design that consists of curved lines.

Cusp Point formed at the juncture of two arcs.

Decorative intent An artist's aim of creating pleasing or striking effects through arrangements of line and color.

Déhanchement Lateral sway of the body—when its weight appears to be carried principally by one leg—that causes the shoulders and hips to be in different directions with respect to the horizontal.

Dome Hemispherical or beehive-shaped *vault* or ceiling over a circular opening. See also *pendentive.*

Doric One of the three *orders* of Greek architecture, consisting of a *column* without a base, a *shaft,* and a *capital* made up of an *echinus* and an *abacus* (see Fig. 2–18).

Drolleries Marginal designs, usually whimsical or fantastic, in Medieval manuscripts.

Drum The cylindrical structure on which a *dome* may rest.

Echinus The flaring conical cushion between the *shaft* of a *Doric* column and its *abacus* (see Fig. 2–18).

Eclecticism The practice of deriving compositional elements from a variety of styles.

Edge Linear separation between two color areas.

Egg tempera See *tempera.*

Elevation Front, side, or back view of the exterior of a building.

Engaged column See *column.*

Engraving A method of printing in which a metal plate that has been incised with a sharp instrument and inked is pressed against paper; also, a print made by this process.

Entablature Band consisting of *architrave, frieze,* and horizontal *cornice* surmounting the *columns* of a Classical building (see Fig. 2–18).

Etching A method of printing in which a metal plate, incised by acid through needle scratches in a wax coating, is inked and pressed against paper; also, a print made by this process.

Expressive intent The intellectual and emotional purpose of an artist.

Façade The front of a building.

Field Area in which a design or decoration is applied.

Flamboyant A style, originating in the mid-thirteenth century, that stressed curving *tracery,* often in flame-like patterns.

Fluted Said of a *column* whose surface has semicylindrical vertical grooves.

Flying buttress See *buttress.*

Foreshortening The apparent reduction in size of an object when it is at an angle to the *picture plane.*

Formalism *Stylization* based on traditionally accepted forms.

Four-square method A method of carving the human figure, begun in Egypt and adopted by *Archaic* Greek sculptors, in which the profile, front, and back of the figure are drawn on four sides of a rectangular block so as to provide a guideline to the artist.

Fresco A method of painting in which *pigments* diluted in water are applied to a thin layer of plaster over the surface of a wall while the plaster is still wet. The pigments become absorbed in the rough texture as the plaster dries.

Frieze In Greek Classical architecture, the middle layer, either plain or carved, of an *entablature.* Also, carved or painted decoration along a narrow band (see Fig. 2–18).

Gallery In church architecture, a story over the *aisle* opening onto the *nave* through an *arcade* (see Fig. 6–5).

Genre Subject matter taken from everyday life.

Geometric Pertaining to the style and culture of Greek civilization following the Dorian invasion. Also, any simple arrangement of lines and angles.

Gesso Plaster-like substance applied over wood panel before the application of color *medium.*

Giant order See *order.*

Glaze A layer of highly diluted, fairly transparent paint or enamel. Glazes of different *hues* can be partially superimposed to achieve subtle variations of tints.

Groin vault See *vault.*

Ground line In a picture, the line on which one or more figures are presumed to stand.

Heraldic Pertaining to a highly stylized rendering of an object as an emblem. **Heraldic opposition** Two figures, usually stylized animals, in symmetrical opposition suggesting a confrontation (see *stylization, symmetry*).

Hue The aspect of color determined by the wavelength of the light transmitting the color and giving the color its name. **Complementary hues** Two hues diametrically opposite on the *color circle.* When placed side by side, the two colors appear to enhance each other.

Humanism The renewed interest, at the beginning of the Renaissance, in the literature and art of antiquity. Also, a concern with the study of man.

Hypostyle Said of a hall constructed of many *columns.*

Icon Greek term for image that has come to refer to Byzantine and Russian devotional imagery.

Iconoclasm The repudiation of sacred imagery.

Iconography Originally, a group of pictures related to a particular subject. The word now refers to the conventions governing the use of symbolic elements in a work of

art. Also, the study of symbols and their meaning.

Iliac crest Line of demarcation between the body and legs; found in antique statuary.

Illumination Colored illustrations that adorned manuscripts; most prevalent in Medieval times.

Illusionism The use of technical devices to simulate the appearance of reality.

Impasto The heavy application of paint.

Intensity The relative concentration of pure *pigment* in paint or pure color in light.

Interlace See *zoomorphic interlace*.

Ionic One of the three *orders* of Greek architecture; characterized by a *capital* consisting of a double *volute* and a base under the *column* (see Fig. 2–18).

Kouros (*pl.* **Kouroi**) In art, sculptures of nude male figures that date from the *Archaic* period of Greek art. Feminine equivalents: **kore**, *pl.* **korai**.

Krater Tall, wide-mouthed vase, usually of earthenware, of ancient Greece.

Lantern A small *dome*, usually with windows around its *drum*, built atop a larger dome or a roof.

Linear perspective See *perspective*.

Linear style In painting, a manner of stressing smooth, uniform surfaces separated by continuous *edges* or *outlines*; opposite of *painterly style*. **Linearism** A tendency to stress lines in a *composition*.

Lines of force In Baroque art, three-dimensional linear patterns linking the most prominent elements of a work.

Lintel Horizontal structural element supported by two vertical members.

Lithography Method of printing in which a stone previously greased in certain areas to retain ink is pressed against paper. **Lithograph** A print made by this process.

Local color The color of an object as if it were seen in a white light (free of colors reflected from other objects and from any coloration of the incident light).

Mandorla An almond-shaped design, usually surrounding Christ in Medieval representations.

Medium The primary material—for example, paint, clay, stone—used by an artist.

Metope In the *frieze* of the *Doric* order, carved or uncarved areas between the *triglyphs* (see Fig. 2–18).

Miniature See *illumination*. **Miniaturist** An artist specializing in illuminations.

Modeling The shaping of form in a sculpture; the suggestion of volume in figures or objects in a painting. **Value modeling** In a painting, the use of darker colors for receding surfaces, to simulate roundness by the illusion of shadows.

Monumental Said of a work of art large enough to be displayed on a building or in a public place. By extension, the term applies to a work of art that may be small in scale but is so assertive as to warrant being enlarged.

Mosaic Decoration consisting of pieces of colored marble or glass embedded in a layer of adhesive material.

Mullion Vertical member separating two areas in a window.

Musicality In a work of art, expressive and/or harmonious effect achieved by appropriate handling of form, line, and color.

Naturalism The suggestion, in a work of art, of a direct observation of a figure or scene.

Nave The central portion of the body of a church, flanked on two sides by *aisles* (see Figs. 4–7 and 6–6).

Niche Recess in a wall, usually intended to house a statue.

Nonrepresentational See *representational*.

Obelisk Tapering *column*-like monument with four trapezoidal surfaces, surmounted by a pyramid.

Oculus Round hole at the center of a *dome*.

Odalisque An inmate of a harem; often portrayed in nineteenth-century paintings as a lounging woman.

Oil technique Use of *pigments* dissolved in linseed oil that can be spread in smooth, uniform layers.

Optical illusionism The property of a design that suggests forms that are different from, and frequently more complex than, the two-dimensional configuration

Order Architectural style of a column and the *entablature* above it. See *Doric, Ionic, Corinthian* (Fig. 2–18). **Giant order** An architectural order whose columns extend as high as two or more stories.

Outline Line marking the periphery of an object, normally different in *value* or in *hue* from the surfaces on either side of it.

Painterly style In painting, a manner in which forms are rendered by means of patches of color, suggesting the effect of light and shade, rather than by precise *edges*; opposite of *linear style*.

Paleolithic Second period of the Stone Age.

Palette A board on which a painter places small supplies of the colors he intends to use. **Palette knife** The knife used by an artist to spread colors on his palette. Some artists apply color directly to the *canvas* with the palette knife.

Palmette Stylized ornament of curved, leaf-like elements radiating from a central core (see *stylization*).

Papyrus A plant found in the Nile Valley; also the paper-like substance made with its fibers.

Pastel A chalky, colored crayon.

Patina A layer that may develop on a surface of metal, particularly bronze, that is exposed to the weather.

Pediment Triangular area over the *entablature* of the short sides of a Greek temple (Fig. 2–18).

Pendentive Concave, spherical triangle that fills the area between the circular base of a *dome* and the four corners of supporting masonry.

Perceptual effects Those sensations that stimulate our capacity to integrate coherently our awareness of the outside world.

Perspective The technique that enables a painter to suggest three-dimensional space on a flat surface by diminishing the size of objects proportionately to their distance from the *picture plane*. All parallel lines appear to converge at a point (the *vanishing point*); hence the term "linear" or "point" for this type of perspective (see Figs. 8–4 and 8–5). **Aerial** or **atmospheric perspective** The practice of depicting objects that are distant from the foreground of the picture as bluish and blurred to simulate the effect of the distance.

Picture plane The physical surface of a picture.

Picturesque Visually quaint, unusual, or even bizarre.

Pier Massive vertical masonry supporting the upper structure of a building or resisting a lateral thrust (see Fig. 6–6).

Pigment Coloring substance used with oil or other liquid medium to make paint.

Pilaster A rectangular engaged *column*.

Plasticity In art, the three-dimensionality of an object.

Point perspective See *perspective*.

Portal A *monumental* entrance.

Portico A porch with a roof supported by *columns* and usually having an *entablature* and a *pediment*.

Post-and-beam The oldest and simplest method of building an opening in a wall: two vertical members, or posts, support a horizontal beam (or *lintel*) above them (see Fig. 1–11).

Printing The process of reproducing an image by the impression of an inked matrix against a surface such as paper. See *engraving, etching, lithograph, woodcut*.

Pylon Entrance gate to Egyptian temples, with massive slanted sides to give the appearance of a fortress.

Rayonnant A late Gothic architectural style, stressing large windows, elongated *columns*, and delicate *tracery* over the *glazed* areas and walls.

Realism Attention to the objective depiction of figures and other elements.

Red-figure technique A technique used by Greek vase painters in which dark *glaze* is applied to the area around the figures, while the figures themselves retain the reddish color of the clay; the details of the figures may be suggested by lines of the dark glaze.

Register Horizontal bands into which the surface of a work of art has been divided.

Relief The depth of carving of a sculpted surface. Also, a shallow carving on a flat surface of wood, stone, or metal.

Representational In art, a style in which figures or objects are readily identifiable.

Respond An engaged *column,* often at the end of a *colonnade,* that helps support a *vault* (see Fig. 6-5).

Rhythm In art, the repetitive elements in the linear design or color pattern of an object, usually suggestive of order and/or movement.

Rib A curved, supporting band projecting from the surface of a wall or *vault* (see Figs. 6-5 and 7-8).

Rocaille Graceful, asymmetrical surface ornamentation of the Rococo period, probably inspired by shell patterns.

Rosette Circular decorative element suggesting the form of a flattened rose.

Rotunda A round building or interior hall, surmounted by a *dome,* usually with *columns* on the periphery.

Roundel A circular decorative element.

Rustication The arrangement of superimposed rows of heavy rectangular blocks with deep grooves between them.

Sacramentary Manuscript devoted to the text of the mass and other religious ceremonies.

Salon Exhibition, held in Paris, of the works of the members of the French Academy of Fine Arts. The initiatives of rejected artists in the late nineteenth century led to the founding of other salons, such as the Salon des Indépendants (1884) and the Salon d'Automne (1903) (see also *academy*).

Sarcophagus A stone coffin.

Scriptorium (*pl.* **scriptoria**) Workshop in which the manuscripts of the Middle Ages were executed.

Scumble Dense, opaque, discrete masses of paint between which the underlying layers of color often show.

Sepulchre A place of burial, a tomb.

Sfumato A slight blurring of the *edges* of figures and objects.

Shaft The main portion of a *column* between the base and the *capital* (see Fig. 2-18).

Silhouette In painting, the form created by filling the *outline* of an object with a uniform color.

Sinopia Sketch on a wall for a *fresco.* It may show faintly through the layer of wet plaster applied to the wall, and serve as a guide to the artist, but becomes concealed when the plaster dries.

Stage space The stage on which the principal figures are depicted in some late Medieval and Renaissance art.

Stucco Plaster used for wall coating or ornamental *relief.*

Style The treatment of form, color, and expressive content characteristic of a geographic area, a period, or an individual artist.

Stylization The simplification or accentuation of natural forms to make them conform to a particular *style.*

Support In a painting, the material—such as *canvas,* panel, or wall—on the surface of which a *medium* such as paint is applied.

Surface treatment An artist's handling of the physical elements of a work of art as they appear on the surface.

Symmetry Correspondence of size, shape, or other element of a design with respect to a point, an axis, or a plane.

Tactile Said of the property of objects and figures, both in painting and sculpture, of stimulating our sense of touch.

Tempera Viscous, protein-based paint *medium,* usually thinned with water.

Terra cotta Baked clay, often *glazed.*

Tessera (*pl.* **tesserae**) Individual piece of stone or colored glass used to make a *mosaic.*

Tone The combined effect of *hue* and *value.*

Tracery Decorative pattern with a lace-like effect.

Transept The lateral wings added to either side of the *nave* at the *apse* end of an *axial-*plan church, creating a transverse space that turns the plan into a cross (see pp. 72–73).

Triforium An *arcade,* often blind, below the *clerestory* of the *nave* of Gothic churches. A passageway is sometimes located between the arcade and the wall behind it.

Triglyph In the *frieze* of the *Doric* order, a group of three vertical ridges alternating with the *metope* (see Fig. 2-18).

Triumphal arch Originally, a monument, built to commemorate a great victory, with an open cylindrical *vault* that forms a passageway for pedestrians and vehicles. By extension, a flat wall, at the end of a *basilica,* into which an opening has been cut that marks the beginning of the *apse.*

Trophy Sculpted group, either in *relief* or free-standing.

Truss An assemblage of structural members forming a rigid framework under a roof.

Tympanum Flat surface usually carved on at least one side, that fills the top of an *arched* doorway.

Unified composition A *composition* in which the individual elements make up an integrated whole (see *additive*).

Value Relative darkness or lightness of a color. Light areas are said to be of high value, dark areas of low value.

Value modeling See *modeling.*

Vanishing point In a painting, a point at which parallel receding lines seem to converge (see *perspective*).

Vault Masonry structure covering a room or building. **Barrel vault** Semicircular section spanning two parallel walls (see Fig. 6-5). **Corbeled vault** Vault made to span the area between two walls by having each *course* protrude a little beyond the course below it. **Crossribbed vault** Modified groin vault made up of two pointed, irregular barrel vaults, whose intersecting curves are each contained in a flat plane; the groins are supported by intersecting arched *ribs.* **Groin vault** Intersection of two barrel vaults at right angles.

Vellum The treated and dried skin of calf, kid, or sheep on which Hellenistic and Medieval manuscripts were written.

Verism Frankness in the portrayal of human features and character; the term usually applies to certain phases of Roman sculpture, although it recurs in later periods.

Volute A spiral ornament.

Warm color A *hue* in the red-to-yellow range on the *color circle.*

Wash Water-diluted translucent *pigment.*

Web In architecture, stone or other material that extends between supporting *ribs.*

Westwork In a Medieval church, the western façade that includes the main entrance and is usually surmounted by towers (see Fig. 6-3).

Whiplash Curving line suggesting the undulations of a whip; frequently used in Art Nouveau decoration.

Woodcut A print obtained by pressing against paper an inked block of wood, gouged in *relief.*

Zoomorphic interlace Design of the early Medieval period, consisting of undulating, and often interweaving, strips that frequently had the head of an animal at one end and the hind quarters of the animal at the other. The animals were sometimes shown biting one another, or even themselves.

Bibliography

Several comprehensive and detailed art histories are available. The two works that will be particularly helpful are de la Croix, Horst, and Richard G. Tansey: *Gardner's Art Through the Ages,* 5th ed. (New York: Harcourt, 1970); and Janson, Horst W.: *History of Art* (Englewood Cliffs, N.J.: Prentice-Hall, and New York: Abrams, 1969). For a short general survey bringing out essential developments, see Cleaver, Dale: *Art: An Introduction,* 2nd ed. (New York: Harcourt, 1972).

In the individual sections below, general works that will be of greatest convenience to students are listed first. They will be followed by more specialized studies and, in some cases, by highly specialized works intended to provide background material for specific points made in the text.

Chapter 1:
Prehistory and the Ancient Near East

PREHISTORY
Broad surveys will be found in Graziosi, Paolo: *Paleolithic Art* (New York: McGraw-Hill, 1960); and Sandars, N. K.: *Prehistoric Art in Europe* (Baltimore: Penguin, 1968). A lively discussion admirably refuting some misconceptions about Paleolithic traditions will be found in Ucko, Peter J., and Andrée Rosenfeld: *Paleolithic Art* (New York: McGraw-Hill, 1967). A specialized study on Çatal Hüyük is presented in Mellaart, James: *Catal Hüyük: A Neolithic Town in Anatolia* (New York: McGraw-Hill, 1967).

EGYPT
Basic surveys are Aldred, Cyril: *The Development of Ancient Egyptian Art* (London: Tiranti, 1961); Woldering, Irmgard: *Gods, Men, and Pharaohs* (New York: Abrams, 1967); and Smith, William Stevenson: *The Art and Architecture of Ancient Egypt* (Baltimore: Penguin, 1958). Excellent illustrations and a concise survey are worthwhile features of Lange, Kurt, and Max Hirmer: *Egypt: Architecture, Sculpture, Painting in Three Thousand Years* (London: Phaidon, 1961). For recent revisions in dating of Old and Middle Kingdoms, see Drower, Margaret S.: "Egypt" (*Encyclopaedia Britannica,* 1972).

ANCIENT NEAR EAST
Basic surveys include Frankfort, Henri: *The Art and Architecture of the Ancient Orient* (Baltimore: Penguin, 1955); and Groenwegen-Frankfort, H. A., and Bernard Ashmole: *The Ancient World* (New York: New American Library, 1967). For a stimulating discussion of past archeological finds, see Ceram, C. W.: *Gods, Graves and Scholars,* rev. ed. (New York: Knopf, 1967). More specific information on Sumer will be found in Parrot, André: *Sumer: The Dawn of Art* (New York: Golden, 1961).

Chapter 2:
The Aegean and Greece

THE AEGEAN
For general studies see Marinatos, Spyridon, and Max Hirmer: *Crete and Mycenae* (New York: Abrams, 1960); Boardman, John: *Pre-Classical: From Crete to Archaic Greece* (Baltimore: Penguin, 1967); and Vermeule, Emily: *Greece in the Bronze Age* (University of Chicago Press, 1964).

GREECE
Students will find an old but elegantly concise survey very rewarding: Beazley, J. D., and Bernard Ashmole: *Greek Sculpture and Painting to the End of the Hellenistic Period,* reprint. (London: Cambridge University Press, 1968). Abundant, excellent illustrations are found in Arias, Paolo E., and Max Hirmer: *A History of 1000 Years of Greek Vase Painting* (New York: Abrams, 1963); and Lullies, Reinhard, and Max Hirmer: *Greek Sculpture* (New York: Abrams, 1960). For a survey of architecture, see Lawrence, A. W.: *Greek Architecture,* rev. ed. (Baltimore: Penguin, 1962). Richter, Gisela M. A.: *The Sculpture and Sculptors of the Greeks* (New Haven: Yale University Press, 1970) has a detailed study of Greek sculpture. Hellenistic art is discussed in Bieber, Margaret: *The Sculpture of the Hellenistic Age,* rev. ed. (New York: Columbia University Press, 1961); and in Havelock, Christine: *Hellenistic Art* (Greenwich, Conn.: New York Graphic Society, 1970). More specialized studies referring to works discussed in the text are Ashmole, Bernard, and Nicholas Yalouris: *Olympia: The Sculptures of the Temple of Zeus* (London: Phaidon, 1967); Holloway, R. Ross: "The Archaic Acropolis and the Parthenon Frieze" (*Art Bulletin,* Vol. 48, June 1966, pp. 223–36); and Kardara, Chrysoula: "Glaukopis, The Archaic Naos and the Theme of the Parthenon Frieze" (Archaiologike Ephemeris, vol. for 1961 [1964], pp. 61–158).

Chapter 3:
Rome

The most rewarding survey for students is probably Hanfmann, George M. A.: *Roman Art* (Greenwich, Conn.: New York Graphic Society, 1964). Consult also Kähler, Heinz: *The Art of Rome and Her Empire* (New York: Crown, 1968); and Bandinelli, Ranuccio Bianchi: *Rome: The Center of Power, 500 B.C.–A.D. 200* (New York: Braziller, 1970). For painting, Maiuri, Amedeo: *Roman Painting* (Geneva: Skira, 1953). For architecture, MacDonald, William L.: *The Architecture of the Roman Empire,* Vol. I. (New Haven: Yale University Press, 1965); and Robertson, Donald S.: *A Handbook of Greek and Roman Architecture* (New York: Cambridge University Press, 1954). For references to Etruscan art see Mansuelli, Guido A.: *The Art of Etruria and Early Rome* (New York: Crown, 1965).

Chapter 4:
Early Christian and Byzantine Art

The earliest phases are discussed in Grabar, André: *The Beginnings of Christian Art, 200–395* (London: Thames and Hudson, 1967). An

excellent survey covering this chapter and part of Chapter 5 will be found in Kitzinger, Ernst: *Early Medieval Art with Illustrations from the British Museum Collection* (Bloomington: Indiana University Press, 1964). Krautheimer, Richard: *Early Christian and Byzantine Architecture* (Baltimore: Penguin, 1965) is not only a splendid survey of architectural developments, but gives rich background material. Good pictures and a concise survey are helpful in Volbach, Wolfgang F., and Max Hirmer: *Early Christian Art* (New York: Abrams, 1956). For Roman history and a more specialized study, see Bovini, Giuseppe: *Mosaici Paleocristiani di Roma, Secoli III–VI* (Bologna: Patron, 1971). For a survey of Byzantine art history, see Beckwith, John: *Early Christian and Byzantine Art* (Baltimore: Penguin, 1970). For more specialized studies, see Grabar, André: *Byzantine Painting* (Geneva: Skira, 1953); Demus, Otto: *Byzantine Mosaic Decoration* (London: Paul Kegan, 1941); and Grabar, André: *The Golden Age of Justinian* (New York: Odyssey, 1967). Much material was borrowed from von Simpson, Otto: *Sacred Fortress: Byzantine Art and Stagecraft in Ravenna* (University of Chicago Press, 1948).

Chapter 5:
Pre-Romanesque Art

For an excellent overview of this period and those discussed in the next three chapters, see Kidson, Peter: *The Medieval World* (New York: McGraw-Hill, 1967); and Demus, Otto: *Byzantine Art and the West* (Greenwich, Conn.: New York Graphic Society, 1970). For a good survey of art during the time of the barbarian invasions, see Hubert, Jean, Jean Porcher, and Wolfgang F. Volbach: *The Art of the Invasions* (New York: Braziller, 1969); and Henry, Françoise: *The Carolingian Renaissance* (New York: Braziller, 1970). More specialized studies include Conant, Kenneth J.: *Carolingian and Romanesque Architecture* (Baltimore: Penguin, 1959), which also covers Chapter 6; Grabar, André, and Carl Nordenfalk: *Early Medieval Painting* (Geneva: Skira, 1957); and Dodwell, C. R.: *Painting in Europe, 800 to 1200* (Baltimore: Penguin, 1971). In the field of sculpture, Sauerländer, Willibald: *La Sculpture médiévale* (Paris: Payot, 1965) covers the pre-Romanesque through late Gothic periods in a masterly way. Much information was drawn from Bruce-Mitford, R. L. S.: *The Sutton-Hoo Ship Burial* (London: British Museum, 1968); and Henry, Françoise: *Irish Art in the Early Christian Period to 800 A.D.* (1965), and *Irish Art During the Viking Invasions, 800–1020 A.D.* (1967), both published by the Cornell University Press. For detailed information on the *Book of Kells*, see Alton, E. H., and P. Meyer: *Evangeliorum Quatuor, Codex Cenannensis,* 3 vols. (Bern: Urs Graf, 1951).

Chapter 6:
Romanesque Art

For a survey of French developments, consult Gantner, Joseph, Marcel Pobé, and Jean Roubier: *Romanesque Art in France* (London: Thames and Hudson, 1956); and Evans, Joan: *Art in Medieval France, 987–1498* (London: Oxford University Press, 1948), which also covers Chapter 7. See also Grivot, Denis, and George Zarnecki: *Gislebertus, Sculptor of Autun* (New York: Orion, 1961). For English developments, Rickert, Margaret: *Painting in Britain in the Middle Ages* (Baltimore: Penguin, 1954); Zarnecki, George: *English Romanesque Sculpture 1066–1140* (London: Tiranti, 1951); and Swarzenski, Hanns, ed.: *English Sculptures of the Twelfth Century* (London: Faber and Faber, 1954). For painting of this period, the major recent survey is Demus, Otto: *Romanesque Mural Painting* (New York: Abrams, 1970). For more specialized studies, see Conant, Kenneth J.: *Cluny, les Églises* (Macon: Protat Frères, 1968). Much specific information was drawn from Schapiro, Meyer: "The Romanesque Sculpture of Moissac" (*Art Bulletin,* Vol. 13, Sept. 1931, pp. 249–350; and Dec. 1931, pp. 464–531). Valuable information on the minor arts is found in Swarzenski, Hanns: *Monuments of Romanesque Art,* 2nd ed. (University of Chicago Press, 1967).

Chapter 7:
Gothic Art

There is a convenient survey—Martindale, Andrew: *Gothic Art from the Twelfth to the Fifteenth Century* (New York: Praeger, 1967). For a good overview of Gothic painting, see Dupont, Jacques, and Cesare Gnudi: *Gothic Painting* (Geneva: Skira, 1954). The best survey of French sculpture is Sauerländer, Willibald: *Gotische Skulptur in Frankreich, 1140–1270* (Munich: Hirmer, 1970). For developments in Italy, see White, John: *Art and Architecture in Italy, 1250–1400* (Baltimore: Penguin, 1966); and Oertel, Robert: *Early Italian Paintings to 1400* (New York: Praeger, 1968). A major text for architectural developments is von Simpson, Otto: *The Gothic Cathedral,* 2nd ed. (New York: Pantheon, 1962). Branner, Robert: *Gothic Architecture* (New York: Braziller, 1961) is a short but extremely lucid survey. A profound analysis of the spirit of Gothic architecture is presented in Panofsky, Erwin: *Gothic Architecture and Scholasticism* (Latrobe, Pa.: Archabbey Press, 1951). The best introduction to the iconography of the Middle Ages is Mâle, Émile: *The Gothic Image: Religious Art in France in the Thirteenth Century* (New York: Harper, 1958). For the transition from Romanesque to Gothic, see Collon-Gevaert, Suzanne, Jean Lejeune, and Jacques Stiennon: *Art roman dans la vallée de la Meuse aux XI, XII, XIII siècles*

(Brussels: L'Arcade, 1966). A good discussion of the Chartres statuary may be found in Katzenellenbogen, Adolph: *The Sculptural Program of Chartres Cathedral* (Baltimore: Johns Hopkins Press, 1959). The contribution of Abbot Suger is brought to light in Panofsky, Erwin: *Abbot Suger on the Abbey Church of St. Denis* (Princeton University Press, 1946). For an insight into High Gothic art, consult Branner, Robert: *St. Louis and the Court Style in Gothic Architecture* (London: Zwemmer, 1965). A discussion of the Morgan Bible is presented in Cockerell, Sidney C.: *Old Testament Miniatures* (New York: Braziller, 1970). For Pucelle, see Morand, Kathleen: *Jean Pucelle* (Oxford: Clarendon, 1962). For a comprehensive discussion of Medieval illustrations, refer to Porcher, Jean: *French Miniatures for Illuminated Manuscripts* (London: Collins, 1960); and Meiss, Millard: *French Painting in the Time of Jean de Berry* (London: Phaidon, 1968), which also pertains to parts of Chapter 8.

Chapter 8
The Early Renaissance

For a comprehensive study covering the entire Italian Renaissance (including material in Chapters 9 and 10), see Hartt, Frederick: *History of Italian Renaissance Art* (New York: Abrams, 1967); Murray, Peter and Linda: *The Art of the Renaissance* (New York: Praeger, 1963); and Smart, Alastair: *The Renaissance and Mannerism in Italy* (New York: Harcourt, 1971). DeWald, E. T.: *Italian Painting 1200–1600* (New York: Holt, 1964); Seymour, Charles: *Sculpture in Italy 1400–1500* (Baltimore: Penguin, 1968); Murray, Peter: *The Architecture of the Italian Renaissance* (New York: Schocken, 1966), as well as the monumental 3-volume *Introduction to Italian Sculpture* (New York and London: Phaidon, 1963) by John Pope-Hennessy all provide valuable additional information. Blunt, Anthony: *Artistic Theory in Italy, 1450–1600* (Oxford, England: Clarendon, 1962) presents a short and brilliant study that also covers the next two chapters. For northern Renaissance art, Cuttler, Charles D.: *Northern Painting from Pucelle to Bruegel* (New York: Holt, 1968); and Smart, Alastair: *The Renaissance and Mannerism in Northern Europe and Spain* (New York: Harcourt, 1972) will both be helpful. In addition, the student will derive great benefit from Friedländer, Max: *Early Netherlandish Painting,* Vols. 1 and 2 (New York: Praeger, 1967–71); and from Panofsky, Erwin: *Early Netherlandish Painting: Its Origins and Character,* 2 vols. (Cambridge, Mass.: Harvard University Press, 1953). Among the major books on individual artists are Clark, Kenneth: *Piero della Francesca* (London: Phaidon, 1951); Janson, Horst W.: *The Sculpture of*

Donatello (Princeton University Press, 1957); and Krautheimer, Richard: *Lorenzo Ghiberti* (Princeton University Press, 1956). For more specialized study, Wittkower, Rudolf: *Architectural Principles of the Age of Humanism,* 3rd ed. (London: Tiranti, 1962) provides valuable insights into this and later periods as well. Three discussions of iconographic problems are Gombrich, Ernst H.: "Botticelli's Mythologies: A Study in the Neoplatonic Symbolism of his Circle" (*Journal of the Warburg and Courtauld Institutes,* Vol. 8, 1945, pp. 7–60); Wind, Edgar: *Pagan Mysteries of the Renaissance* (London: Faber and Faber, 1939); and Panofsky, Erwin: *Studies in Iconology* (New York: Oxford University Press, 1939). Chastel, André: *The Age of Humanism: Europe 1480–1530* (New York: McGraw-Hill, 1964) offers a provocative linking of art with broader cultural trends.

Chapter 9:
The High Renaissance
For a survey, Freedberg, Sydney J.: *Painting of the High Renaissance in Rome and Florence,* 2 vols. (Cambridge, Mass.: Harvard University Press, 1961). Among the works on individual artists are Clark, Kenneth: *Leonardo da Vinci* (New York: Macmillan, 1939); and Leonardo's own writings in McCurdy, E.: *The Notebooks of Leonardo da Vinci* (New York: Braziller, 1958). For Michelangelo, see de Tolnay, Charles: *Michelangelo,* 5 vols. (Princeton University Press, 1943–60); Ackermann, James S.: *The Architecture of Michelangelo,* 2 vols. (New York: Viking, 1961); and Hartt, Frederick: *Michelangelo: The Complete Sculpture* (New York: Abrams, 1969). For discussions of Michelangelo's Medici tombs see Wilde, Johannes: "Michelangelo's Designs for the Medici Tombs" (*Journal of the Warburg and Courtauld Institutes,* Vol. 18, Jan.–June 1955, pp. 54–66); and Neufeld, Gunther: "Michelangelo's Times of Day: A Study of Their Genesis" (*Art Bulletin,* Sept.–Dec. 1968, pp. 273–84). For Raphael, see Fischel, Oskar: *Raphael* (London: Spring Books, 1948, tr. 1964); Panofsky, Erwin: *Albrecht Dürer,* 2 vols., 3rd ed. (Princeton University Press, 1948).

Chapter 10:
The Late Renaissance and Mannerism
For a concise survey of Italian developments, see Shearman, John K. G.: *Mannerism* (Baltimore: Penguin, 1967). A brilliant summation of Mannerism is found in Freedberg, Sydney J.: "Observations on the Painting of the Maniera" (*Art Bulletin,* Vol. 47, June 1965, pp. 187–97). For individual artists, consult Panofsky, Erwin: *Problems in Titian* (New York University Press, 1969); Wethey, Harold E.: *The Paintings of Titian,* Vol. I. (London: Phaidon, and New York: Praeger, 1969); Wethey, Harold E.: *El Greco and His School,* 2 vols. (Princeton University Press, 1962); and Ackermann, James S.: *Palladio: The Architect and Society* (Baltimore: Penguin, 1967).

Chapter 11:
The Seventeenth Century in Italy and Spain
For an overview covering Chapters 11 to 13, see Kitson, Michael: *The Age of the Baroque* (New York: McGraw-Hill, 1968); and Sewter, A. C.: *Baroque and Rococo* (New York: Harcourt, 1972). For regional histories, consult Wittkower, Rudolf: *Art and Architecture in Italy 1600 to 1750* (Baltimore: Penguin, 1958), which covers part of Chapter 13; and Kubler, G., and M. Soria: *Baroque Art and Architecture in Spain and Latin America* (Baltimore: Penguin, 1959). Individual artists are perceptively treated in Friedlaender, Walter F.: *Caravaggio Studies* (Princeton University Press, 1955); Wittkower, Rudolf: *Bernini* (London: Phaidon, 1955); and Hibbard, Howard: *Bernini* (Baltimore: Penguin, 1966). Valuable specialized studies include Haskell, Francis: *Patrons and Painters: Italian Art and Society in the Age of the Baroque* (London: Chatto and Windus, 1963); and Mahon, Denis: *Studies in Seicento Art and Theory* (Warburg Institute, University of London, 1947). Much information was derived from Soria, Martin E.: "Sources and Interpretations of the Rokeby Venus" (*Art Quarterly,* Vol. 70, Spring 1957, pp. 30–38).

Chapter 12:
The Seventeenth Century in France and the Low Countries
The best surveys are Rosenberg, Jacob, Seymour Slive, and Engelbert H. ter Kuile: *Dutch Art and Architecture, 1600–1800* (Baltimore: Penguin, 1966); Blunt, Anthony: *Art and Architecture in France, 1500 to 1700,* rev. ed. (Baltimore: Penguin, 1957); Gerson, Horst, and Engelbert H. ter Kuile: *Art and Architecture in Belgium 1600–1800* (Baltimore: Penguin, 1960); Waterhouse, Ellis K.: *Painting in Britain 1530–1790* (Baltimore: Penguin, 1966), which also covers Chapter 13; and Stechow, Wolfgang: *Dutch Landscape Painting of the Seventeenth Century* (London: Phaidon, 1968). For individual artists, see Friedlaender, Walter F.: *Nicolas Poussin: A New Approach* (New York: Abrams, 1968), as well as two short, up-to-date monographs on major artists, White, Christopher: *Rembrandt and His World* (London: Thames and Hudson, 1964); and White: *Rubens and His World* (New York: Viking, 1968). Valuable information was drawn from Blunt, Anthony: "The Heroic and the Ideal Landscape in the Work of Nicolas Poussin" (*Journal of the Warburg and Courtauld Institutes,* Vol. 7, nos. 3 and 4, 1944, pp. 154–68); Alpers, Svetlana L.: "Manner and Meaning in Some Rubens Mythologies" (*Journal of the Warburg and Courtauld Institutes,* Vol. 30, 1967, pp. 272–95); and Seymour, Charles: "Dark Chamber and Light-Filled Room: Vermeer and the Camera Obscura" (*Art Bulletin,* Vol. 46, Sept. 1964, pp. 323–31).

Chapter 13:
The Eighteenth Century
For a stimulating recent survey, see Levey, Michael: *Rococo to Revolution* (New York, Praeger, 1966). See also Schönberger, Arno, and Halldor Soehner: *The Rococo Age* (New York: McGraw-Hill, 1960); and Summerson, John: *Architecture in Britain 1530–1830,* rev. ed. (Baltimore: Penguin, 1958). For individual artists, Brookner, Anita: *Watteau* (London: Paul Hamlyn, 1966) is a helpful study, as is Morassi, Antonio: *Tiepolo: His Life and Work* (New York: Phaidon, 1955). The discussion of Chardin in this chapter was based partly on texts found in Rothschild, Henri, André Pascal, and Roger Gaucheron: *Documents sur la vie et l'oeuvre de Chardin* (Paris: Galerie Pigalle, 1931).

Chapter 14:
Romanticism and Romantic Naturalism
The principal surveys are Novotny, Fritz: *Painting and Sculpture in Europe, 1780–1880* (Baltimore: Penguin, 1960); Hamilton, George H.: *Nineteenth and Twentieth Century Art* (New York: Abrams, 1971), which covers also Chapters 15 to 19; and Hitchcock, Henry-Russell: *Architecture: Nineteenth and Twentieth Centuries* (Baltimore: Penguin, 1958). A group of more specialized studies covers the early years of the nineteenth century—Rosenblum, Robert: *Transformations in Late Eighteenth-Century Art* (Princeton University Press, 1967); Friedlaender, Walter F.: *From David to Delacroix* (Cambridge, Mass.: Harvard University Press, 1952); Irwin, David: *English Neoclassical Art* (Greenwich, Conn.: New York Graphic Society, 1966); and Honour, Hugh: *Neo-Classicism* (Baltimore: Penguin, 1968). A concise, up-to-date discussion of British developments is found in Detroit Institute of Arts: *Romantic Art in Britain, 1760–1860* (Detroit and Philadelphia, 1968). For naturalistic trends in France, see Herbert, Robert L.: *Barbizon Revisited* (New York: Clarke and Way, 1962). For individual artists, see Rosenblum, Robert: *Jean-Auguste-Dominique Ingres* (New York: Abrams, 1969); and for a more specialized discussion, Mras, George P.: *Eugene Delacroix's Theory of Art*

(Princeton University Press, 1968). Literary source material will be found in Eitner, Lorenz: *Neoclassicism and Romanticism, 1750–1850,* 2 vols. (Englewood Cliffs, N.J.: Prentice-Hall, 1970). Specific information was drawn from Berger, Klaus: "Courbet In His Century" (*Gazette des Beaux-Arts,* July 1943, pp. 19–40); and Sutton, Denys: "Constable's 'Whitehall Stairs' or 'The Opening of Waterloo Bridge'" (*Connoisseur,* Vol. 136, Dec. 1955, pp. 148–55).

Chapter 15:
Realism, Impressionism, and Romantic Symbolism
The most comprehensive survey is Hamilton, George H.: *Painting and Sculpture in Europe, 1880 to 1940* (Baltimore: Penguin, 1967), which also covers Chapters 16 to 18. There are excellent detailed surveys of narrower scope—Pommer, Linda Nochlin: *Realism* (Baltimore: Penguin, 1970); and Rewald, John: *The History of Impressionism,* rev. ed. (New York: Museum of Modern Art, 1967). For source material, Nochlin, Linda: *Realism and Tradition in Art, 1848 to 1900* (Englewood Cliffs, N.J.: Prentice-Hall, 1966). For individual artists, consult Elsen, Albert E.: *Rodin* (New York: Museum of Modern Art, 1963); Sutton, Denys: *Nocturne, the Art of James McNeill Whistler* (London: Country Life, 1963); Hanson, Ann C.: *Edouard Manet* (Philadelphia Museum of Art, 1966–67); Rewald, John, Dore Ashton, and Harold Joachim: *Odilon Redon, Gustave Moreau, and Rodolphe Bresdin* (New York: Museum of Modern Art, 1961); and Seitz, William C.: *Claude Monet* (New York: Abrams, 1960). Much valuable information was drawn from Nochlin, Linda: "Gustave Courbet's *Meeting*" (*Art Bulletin,* Vol. 49, Sept. 1967, pp. 209–22); Sandström, Sven: *Le Monde imaginaire d'Odilon Redon* (Lund, Sweden: Gleerup, 1955); Sandblad, Nils G.: *Manet* (Lund: Gleerup, 1954); and Wasserman, J. L.: *Daumier Sculpture* (Cambridge, Mass.: Fogg Art Museum, 1969).

Chapter 16:
The Post-Impressionists
The most comprehensive survey is Rewald, John: *Post-Impressionism,* rev. ed. (New York: Museum of Modern Art, 1962). For a stimulating treatment of principal developments, see Lövgren, Sven: *The Genesis of Modernism* (Stockholm: Almquist and Wiksell, 1959). For a history of the Nabis, see *Bonnard, Vuillard et les Nabis, 1888–1903* (Paris: Musée National d'Art Moderne, 1955). For individual artists, Tralbaut, Marc E.: *Van Gogh* (New York: Viking, 1969) is a good recent monograph; and Schapiro, Meyer, ed.: *Paul Cézanne,* 3rd ed. (New York: Abrams, 1965) provides a worthwhile short study. For more specialized

works, see Roskill, Mark: *Van Gogh, Gauguin and the Impressionist Circle* (Greenwich, Conn.: New York Graphic Society, 1970); and Herbert, Robert L.: *Seurat Drawings* (New York: Shorewood, 1962). The quotations from van Gogh's writing come from *The Complete Letters of Vincent van Gogh* (Greenwich, Conn.: New York Graphic Society, 1958); and those from Cézanne's are from Rewald, John, ed.: *Paul Cézanne, Correspondance* (Paris: Grasset, 1937). For those wishing to pursue the study of Japanese influence on Western art of this period, see Thirion, Yvonne: "L'Influence de l'estampe japonaise dans l'oeuvre de Gauguin" (*Gazette des Beaux-Arts,* 1958, pp. 95–114; spec. issue on Gauguin dated 1956); and Dorra, Henri, and Sheila Askin: "Seurat's Japonisme" (*Gazette des Beaux-Arts,* Vol. 73, Feb. 1969, pp. 81–94).

ART NOUVEAU
The main trends in architecture and applied arts are covered in Pevsner, Nikolaus: *Pioneers of Modern Design,* rev. ed. (Baltimore: Penguin, 1966), while the development of Art Nouveau is presented in Madsen, Stephan T.: *Art Nouveau* (New York: McGraw-Hill, 1967); and Selz, Peter, and Mildred Constantine, eds.: *Art Nouveau* (New York: Museum of Modern Art, 1959).

CHICAGO SCHOOL OF ARCHITECTURE
For background material on American developments, see McLanathan, Richard: *The American Tradition in the Arts* (New York: Harcourt, 1968); and Larkin, Oliver: *Art and Life in America,* rev. ed. (New York: Holt, 1960), both covering Chapters 16 to 19. For individual artists, see Morrison, Hugh: *Louis Sullivan,* rev. ed. (New York: Peter Smith, 1958); Manson, Grant C.: *Frank Lloyd Wright to 1910* (New York: Reinhold, 1958); and Scully, Vincent: *Frank Lloyd Wright* (New York: Braziller, 1960).

Chapter 17:
Before the First World War: Fauvism, Cubism, Futurism, Expressionism, Pre-Dada, and Metaphysical Painting
For a comprehensive survey, see Arnason, Harvard: *History of Modern Art* (New York: Abrams, 1968); and Bowness, Alan: *Modern European Art* (New York: Harcourt, 1972). Informative surveys of architectural history are found in Giedion, Siegried: *Space, Time and Architecture,* rev. ed. (Harvard University Press, 1967); and Banham, Reyner: *Theory and Designs of the First Machine Age* (London: Architectural Press, 1960), both covering Chapters 17 and 18. For sources and documents, Chipp, Herschel B.: *Themes of Modern Art* (Berkeley: University of California Press, 1968); and Herbert, Robert L.: *Modern Artists on Art* (Englewood Cliffs, N.J.: Prentice-Hall,

1965). A concise general study of Fauvism is found in Crespelle, Jean-Paul: *Fauves* (Greenwich, Conn.: New York Graphic Society, 1962). A masterful treatment of Cubism is available in Rosenblum, Robert: *Cubism and Twentieth Century Art* (New York: Abrams, 1961). Martin, Marianne W.: *Futurist Art and Theory, 1909–1915* (Oxford: Clarendon, 1968) is an excellent overview of that movement. Selz, Peter: *German Expressionist Painting* (Berkeley: University of California Press, 1957) remains the most provocative study in its field. Much information on Russian art history is found in Gray, Camilla: *The Great Experiment: Russian Art, 1863–1922* (London: Thames and Hudson, 1962). For individual artists, see Barr, Alfred H., Jr.: *Matisse* (1951), and *Picasso, Fifty Years of His Art* (1946), both published by the Museum of Modern Art, New York. Blunt, Anthony, and Phoebe Poole: *Picasso: The Formative Years* (Greenwich, Conn.: New York Graphic Society, 1962); Spear, Athena T.: *Brancusi's Birds* (New York University Press, 1969); and Gordon, Donald E.: *Ernst Ludwig Kirchner* (Cambridge, Mass.: Harvard University Press, 1968) all deal with the beginnings of modern art. Other books on individual artists are Soby, James T.: *Giorgio de Chirico* (New York: Museum of Modern Art, 1955); and Schwarz, Arthur: *The Complete Works of Marcel Duchamp* (New York: Abrams, 1970).

Chapter 18:
Between the Wars: Dada, Surrealism, and Geometric Abstraction
The most far-reaching survey in its field is Rubin, William S.: *Dada, Surrealism and Their Heritage* (New York: Abrams, 1969). The best text on another movement is Jaffé, H. L. C.: *De Stijl, 1917–1931, The Dutch Contribution to Modern Art* (New York: Abrams, 1971). For the Bauhaus movement, consult Wingler, Hans M., ed.: *Bauhaus* (Cambridge, Mass.: MIT Press, 1969). For individual artists and architects, see Jaffé, H. L. C.: *Mondrian* (New York, Abrams, 1970); Giedion, Siegfried: *Walter Gropius* (New York: Reinhold, 1954); Dupin, Jacques: *Miró* (New York: Abrams, 1961–62); Read, Herbert: *The Art of Jean Arp* (New York: Abrams, 1968); and Russell, John: *Max Ernst: Life and Work* (New York: Abrams, 1967).

Chapter 19:
After the Second World War
For studies covering various recent trends, see Rickey, George: *Constructivism* (New York: Braziller, 1967); Kultermann, Udo: *The New Sculpture* (New York: Praeger, 1968); and Seitz, William C.: *The Art of Assemblage* (New York: Museum of Modern Art, 1961). For architecture, see Banham, Reyner: *Brutalism*

(New York: Reinhold, 1966); Scully, Vincent: *American Architecture and Urbanism* (New York: Praeger, 1969). Good accounts of individual movements will be found in Sandler, Irving: *The Triumph of American Painting* (New York: Praeger, 1970); Lippard, Lucy: *Pop Art* (New York, Praeger, 1966); Barrett, Cyrill: *Op Art* (New York: Viking, 1970); Barrett: *Introduction to Optical Art* (New York: Dutton, 1971); and Kaprow, Allan: *Assemblage, Environment, and Happenings* (New York: Abrams, 1966). For individual artists and architects, see Dupin, Jacques: *Alberto Giacometti* (Boston: Boston Book, n.d.); Selz, Peter: *The Work of Jean Dubuffet* (1962) and *Mark Rothko* (1961), both published by the Museum of Modern Art, New York; *L'Art Brut,* intro. by Jean Dubuffet (Paris: Musée des Arts Décoratifs, 1967); O'Connor, Francis, V.: *Jackson Pollock* (New York: Museum of Modern Art, 1967); Arnason, Harvard: *Calder* (Princeton University Press, 1966): Blake, Peter: *Le Corbusier: The Machine Age and the Grand Design* (New York: Braziller, 1969); and McHale, John: *R. Buckminster Fuller* (New York: Braziller, 1962). Most valuable for specific information is Evenson, Norma: *Chandigarh* (Berkeley: University of California Press, 1966).

Chapter 20:
African and Pre-Columbian Art

For a concise and very broad survey, see Fraser, Douglas, ed.: *The Many Faces of Primitive Art* (Englewood Cliffs, N.J.: Prentice-Hall, 1968). For Africa, see Willett, Frank: *African Art: An Introduction* (New York: Praeger, 1971). A good account of the role of works of art in African rituals may be found in Cole, Herbert M.: *African Arts of Transformation* (Art Galleries, University of California, Santa Barbara, Nov. 24 to Dec. 20, 1970). Studies relevant to the works discussed in the text include Fagg, William, and Herbert List: *Nigerian Images* (London: Lund Humphries, 1963); Willett, Frank: *Ifé in the History of West African Sculpture* (New York: McGraw-Hill, 1967); and Goldwater, Robert: *Bambara Sculpture from Western Sudan* (New York: Museum of Modern Art, 1960). Much specific information was drawn from Imperato, Pascal James: "The Dance of the Tyi Wara" (*African Arts,* Vol. 3, Autumn 1970, p. 8); and Rood, Armistead P.: "Bété Masked Dance, A View from Within" (*African Arts,* Vol. 2, Spring 1969, p. 36).

CENTRAL AND SOUTH AMERICA
Worthwhile texts are Kubler, George: *The Art and Architecture of Ancient America* (Baltimore: Penguin, 1962); Rowe, John Howland, and Dorothy Menzel: *Peruvian Archaeology: Selected Readings* (Palo Alto, Calif.: Peck, 1967); Bushnell, G. H. S.: *Peru* (New York: Praeger, 1966); and Coe, Michael D.: *Mexico* (1962), and *The Maya* (1966), both published by Praeger, New York.

Chapter 21:
India, China, and Japan

GENERAL
Lee, Sherman E.: *A History of Far Eastern Art* (New York: Abrams, 1969). For a discussion on Buddhism, see Loehr, Max: *Buddhist Thought and Imagery* (Abbey Aldrich Rockefeller Inaugural Lecture, Harvard University, Vol. 74, 1961). Rowland, Benjamin: *The Art and Architecture of India* (Baltimore: Penguin, 1953); Goetz, Hermann: *Five Thousand Years of Indian Art* (New York: McGraw-Hill, 1959); and Hallade, Madeleine: *Ghandaran Art of North India and the Graeco-Roman Tradition* (New York: Abrams, 1968).

CHINA
Sickman, Laurence, and Alexander Soper: *The Art and Architecture of China,* 2nd ed. (Baltimore: Penguin, 1961); Cahill, James: *Chinese Painting* (New York: Skira, 1960); Sullivan, Michael: *The Birth of Landscape Painting in China* (Berkeley: University of California Press, 1962); Lee, Sherman E.: *Chinese Landscape Painting* (Cleveland Museum of Art, 1962); Loehr, Max: *Ritual Vessels of Bronze Age China* (New York: Asia Society, 1968).

JAPAN
Paine, Robert Treat, and Alexander Soper: *The Art and Architecture of Japan* (Baltimore: Penguin, 1955).

Index

Index

chance, 247, 250
Chapel of the Angels (Saint Sulpice), 190-93, *191*
Chardin, Jean Baptiste Simeon, 175-76, 208
 Le Bénédicité ("Saying Grace"), *175*
Charlemagne, and Carolingian Renaissance, 65-67, 69
Charles the Bald, 64-65
Chartres cathedral, 78-81, *79-81,* 84-88, *84, 85,* 96, 102, 106
Chavin culture (Peru), 285-86, *286,* 289, 290-91
Chephren, 9-12, *10,* 280-81, 286
Chevreul, Michel Eugène, 192, 216
chiaroscuro, 116
China, 279, 290, 298-99
 Bronze Age in, 290-91, *291*
 influence of, 185, 186, 211, 305
 Japan and, 302, 305
 painting in, 211, *211,* 299-302, *300*
 sculpture of, *298,* 299
Chirico, Giorgio de. *See* de Chirico, Giorgio
Chōsetsu (Kyoto), 229-30
Christianity and Christian art (*see also individual names, periods, subjects*), 47
 Baroque age and, 141-82
 Byzantine age and, 54-59, *54-55, 57-59*
 Carolingian Renaissance and, 62-67, *65, 67*
 Constantine and, 49-54, *49, 51, 53*
 Coptic, 62
 Counter Reformation and, 100, 130, 134-35, 147
 Crusades and, 77
 Dark Ages and, 61-68
 early, 47-50, *48, 49*
 Gothic art and, 78-96
 Hellenism and, 47-49
 humanism and, 104, 130, 147
 icons in, 59
 Middle Ages and, 77-96
 monasteries, role of, and, 69, 77
 mysticism and, 135, 147
 Napoleonic era and, 184
 Neo-Platonism and, 104, 113, 121, 122, 135
 painting, figurative, and, 60, 135
 pilgrimages and, 72, 77
 rationalism and intellectualism of, 104, 142-43, 175

Reformation and, 100, 130, 141
Renaissance and:
 early, 99-144
 High, 115-29, 130*ff.*
 late, 130-38
Rococo and, 175
Roman Empire and, 47*ff.*
Romanesque art and, 69-76
scholasticism and, 81, 104
Christ in Majesty (Berzé-la-Ville), *75,* 75-76, 91
Christ in Majesty (*Book of Kells*), 62-64, *63,* 227
Christ in Majesty (sacramentary of Charles the Bald), 64-65, *65*
Christ in Majesty (Saint-Pierre), *74,* 74-75
Christ in Majesty (Saint-Sernin), 70-72, *71*
Christ the Savior in the Tree of Life (illumination), 68, *68,* 96
churches (*see also individual names*):
 axial-plan, 51
 Baroque, 149-51, *150*
 Byzantine, 56-59, *57-59,* 66-67
 Carolingian, 66-67, *67*
 Constantinian, 50-54, *51, 53,* 72
 Gothic, 67, 76, 78-84, *79, 81, 83,* 96, *96*
 High Gothic, 84-89, *84, 85, 87, 89*
 Latin cross, plan of, 51
 Ottonian, 69, 70, 72
 pilgrimage-road, 72-73
 proportions of, 86-87, 107-08
 Renaissance:
 early, 106-08, *106, 107,* 124, *125*
 High, 124-27, *125-27*
 late, 135-36, *137*
 Romanesque, 69-74, *72, 73, 76, 106,* 106-07
 schools, 78
 west façade of, 67, 72, 86
cinematography, 275-76
city planning, 275
Classical antiquity (*see also* Greece; Rome), 41
Clarinet (Braque), 242, *242*
classicism:
 Baroque, 143-44, 149, 155, 166
 Mannerism and, 130, 131
 Renaissance and, 64, 104
 High, 119, 124, 130
 reaction against, 130

Romanticism and, 193-95
Climax, The (Beardsley), 226-28, *227*
cloisonné, 61, 220
Cluny, abbey church of, 75, 76, *76.*
collage, 242
 Cubism and, 242, *242*
 Dada and, 250, *251,* 268, *268*
 Pop Art and, *268,* 268-69
collectors, 186, 235
color:
 aerial perspective and, 119
 Chevreul's law and, 192, 216
 complementaries and, 192
 Cretan, 16
 Egyptian, 15-16
 Fauvism and, 237
 Greek art and 20, 26
 hue and, 15
 Impressionism and, 185-86
 intensity and, 53
 local, 114
 mosaic and, 52, 53
 musicality and, 193
 Post-Impressionism and, 216-18, 219, 223
 Renaissance, early, and, 110
 value and value modeling with, 52
Color Painting, 273, *274*
columns, 28
 orders of, 29, *30*
comparison, as art study technique, 1-2
composition (*see also specific art forms, periods, works*), 2
 linearism in, 38
 lines of force in, 145, 243
Composition with Red, Yellow, and Blue (Mondrian), 253, *253*
concrete art, 250
concrete, Roman, 42-44
Confucianism, 299, 302
Constable, John, 197-99, *198,* 206
 Whitehall Stairs (The Opening of Waterloo Bridge), *198*
Constantine, 49-50, *49,* 54, 108
constructions. *See* Sculpture
Constructivists, 255
content, 3
contour lines, 20
contrapposto, 33